THE SEA RANCH

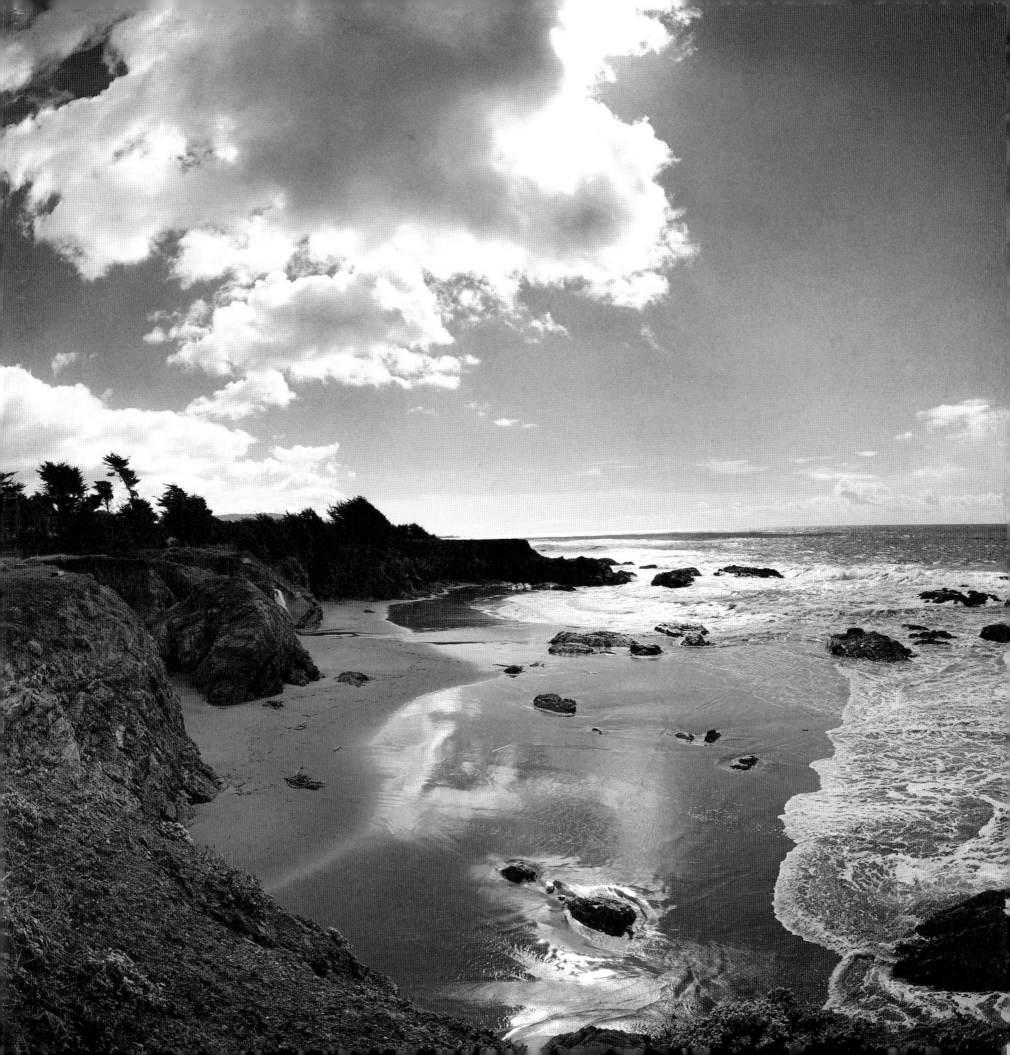

Published by
Princeton Architectural Press
37 East Seventh Street
New York, New York 10003

For a free catalog of books, call 1.800.722.6657.
Visit our website at www.papress.com

Every reasonable attempt has been made to identify owners of
copyright. Errors or omissions will be corrected in subsequent
editions. Portions of this text have appeared first in *Spazio &
Societa* (Space and Society) 73 (Spring 1996) and *Phi Kappa
Phi Forum* (Fall 2003).

Image credits: All photos © Jim Alinder unless otherwise noted.

A note on the photography:
Photographing The Sea Ranch presents several challenges
and opportunities. While it is a place of exceptional beauty, it
often is one of extreme contrasts. The dynamic range of film is
usually not sufficient to perfectly expose both outside and
inside in a single exposure, as the exterior is often sixteen
times brighter than the interior. Since the relationship between
interior and exterior spaces is of such importance at The Sea
Ranch, a technique had to be devised that would accommo-
date that contrast. Typically, two exposures were made from
the same camera position—one exposed for the inside, the
other for the outside—and were later blended.

For the interior photographs, Jim Alinder primarily used a
Hasselblad Superwide 903 camera. Other photographs were
made with a Hasselblad SLR with lenses varying from 30mm
to 250mm. He also used two panoramic cameras, a Widelux
1500 and a Fuji 617. A few images were made with a Fuji 690
and a Pentax 6x7. Black-and-white film was either Kodak T-max
100 or 400. Color film was Fuji Velvia or Provia. No artifical
lighting was added to any scenes. A tripod was routinely used.

Pages 18, 20–21, 24 right (top and bottom), 27, 288–295:
© Lawrence Halprin
Pages 24 bottom left, 28 bottom right, 43 bottom left, 60 bot-
tom right, 85 top right, 106, 147 top left, 188 bottom, 219, 257 top
left: © Charles C. Benton
Page 24 top left: Courtesy Michael Gates
Pages 33, 37 top right, 37 bottom, 43 bottom right, 118 top, 119:
Photographs by Morley Baer © Frances M. Baer Trust
Page 37 left (top and middle): © Joseph Esherick Collection.
Environmental Design Archives, University of California, Berkeley
Pages 39, 41, 70 bottom, 117: © Turnbull Griffin Haesloop

Page 42: © Richard Whitaker
Pages 76–77 bottom: © The Sea Ranch Association
Page 91 bottom left: © Alice Wingwall
Page 184: Photograph by Andrew Youngmeister © Turnbull
Griffin Haesloop
Pages 185, 190: © Reverdy Johnson
Page 294: © Donlyn Lyndon

Editing: Nicola Bednarek and Jan Cigliano
Design: Jan Haux
Color maps: Jane Sheinman
Editorial assistance: Krystina Kaza

Special thanks to: Nettie Aljian, Janet Behning, Megan Carey,
Penny (Yuen Pik) Chu, Russell Fernandez, Clare Jacobson,
Mark Lamster, Nancy Eklund Later, Linda Lee, Nancy Levinson,
Katharine Myers, Scott Tennent, Jennifer Thompson, Joe Weston,
and Deb Wood of Princeton Architectural Press
—Kevin C. Lippert, publisher

Library of Congress Cataloging-in-Publication Data

Lyndon, Donlyn.
The Sea Ranch / Donlyn Lyndon, Jim Alinder; essays by
Donald Canty and Lawrence Halprin.
 p. cm.
Includes bibliographical references and index.
 ISBN 1-56898-386-7 (alk. paper)
1. Architecture—California—Sea Ranch—20th century.
2. Architecture—Environmental aspects—California—Sea Ranch.
3. Planned communities—California—Sea Ranch. I. Alinder,
James. II. Canty, Donald. III. Halprin, Lawrence. IV. Title.
 NA735.S437L95 2004
 720'.9794'18—dc22

 2003015722

THE SEA RANCH

DONLYN LYNDON JIM ALINDER

Essays by
Donald Canty and **Lawrence Halprin**

Princeton Architectural Press, New York

CONTENTS

PREFACE AND ACKNOWLEDGMENTS ... 8

THE SEA RANCH: DIMENSIONS OF EXPERIENCE ... 12

THE FOUNDING VISION ... 18

ORIGINS, EVOLUTIONS, AND IRONIES ... 22
Donald Canty

COURTING THE WIND, THE LAND, AND THE SUN:
THE FIRST BUILDINGS ... 34

CONDOMINIUM ONE ...38
UNIT ONE ... 44
UNIT EIGHT ... 48
UNIT NINE ... 50
HEDGEROW HOUSES ... 54
HOUSE ONE ... 58
HOUSE FOUR ... 62
ESHERICK HOUSE ... 64
MOONRAKER ATHLETIC CENTER ... 68

LIVING LIGHTLY WITH THE LAND:
MANAGING THE LANDSCAPE ... 72

SEEKING A LARGER ORDER:
COMPOUNDS AND CLUSTERS ... 80

THE SEA RANCH LODGE ... 82
OHLSON RECREATION CENTER ... 88
DEL MAR CENTER ... 92
WALK-IN CABINS ... 96
 UNIT 52 ...100
 UNIT 53 ...102
CLUSTER HOUSES ON WHITE FIR WOOD
AND MADRONE MEADOW ...104
 UNIT 4 ...108
 UNIT 18 ... 110
EMPLOYEE HOUSING ... 114
THE COTTAGES ...120
 COTTAGE TWO ...122
SEA GATE ROW ...126
 LYNDON-WINGWALL HOUSE ...128
 MEADOW HOUSE ...134
 WENDEL-LYNDON HOUSE ...136

HOUSES THAT SUIT THEIR PLACE ... 140

HOUSES THAT CONNECT ... 144
 KIRKWOOD HOUSES ... 150
 HALLEY HOUSE ... 154
 BRUNSELL HOUSE ... 158
 MASLACH/ZIMBARDO HOUSE ... 162
 EWRY HOUSE ... 166
 MICHAEL HOUSE ... 170
 MCKENZIE HOUSE ... 174
 SOMERS HOUSE ... 180
HOUSES THAT SETTLE ... 184
 JOHNSON HOUSE ... 190
 BINKER BARNS ... 196
 RUSH HOUSE ...202
 WILDE HOUSE ...206
 BURDICK HOUSE ... 210
 RASMUSSEN HOUSE ... 214
 BRODIE HOUSE ... 218
 GILBERT HOUSE ... 222
HOUSES THAT ENFOLD ...226
 WHITAKER/EKMAN HOUSE ...230
 ANDERSON HOUSE ...234
 CLAYTON HOUSE ...238
 SCHNEIDER HOUSE ... 242
 YUDELL-BEEBE HOUSE ... 246
 BOYD HOUSE ...250
HOUSES THAT INHABIT ...254
 CAYGILL HOUSE ...258
 VEDENSKY HOUSE ...262
 MIGLIO HOUSE ...266
 LICHTER-MARCK HOUSE ... 270
 BAAS-WALROD HOUSE ... 274
 HALPRIN HOUSE ...280

THE HALPRIN PLACE: FORTY YEARS ON SITE ...286
Lawrence Halprin

DESIGNING FOR PLACE AT THE SEA RANCH ...294

PROJECT CREDITS/AWARDS ...298
SELECTED BIBLIOGRAPHY ...301
INDEX ...302
CONTRIBUTORS ...304

PREFACE AND ACKNOWLEDGMENTS

The Sea Ranch is a place we love very much. This book tells its story, which is also an invocation: a challenge to imagine dwellings that give life to their settings. More fundamentally, it is a call to join in taking care of places—here and elsewhere—that envelope lives with shared understanding, yet remain quick with the breath of imagination.

Ours is not a distanced history of this place; we are partisan. As one of the architects first on the site, Donlyn participated in creating the spirit of its first buildings, has a house at The Sea Ranch, and designs buildings here still. Jim has photographed The Sea Ranch for two decades; he has been a fulltime resident since 1990 and has been active in the evolution of the community. We both wish it well.

What we desire to do with this book (Donlyn conjuring with words, Jim with photographs) is to present the qualities that make The Sea Ranch distinctive and to recount the tale of its development. We portray the initial intentions, illustrate the buildings that embodied them, and show how the landscape has evolved. The Sea Ranch, as it has evolved, is primarily a community of individual homes. We include houses that we think are particularly instructive—that demonstrate how dwellings can be both individually spirited and appropriate for their place.

It is a great privilege to be able to include here essays by two people whom we greatly admire: Donald Canty, whose insightful writings about architecture and planning span nearly five decades; and Lawrence Halprin, who looms large in the tale of The Sea Ranch and whose integrative vision has been central to the development of its character.

We are very grateful to the many who have shared in the creation of this account. Al Boeke, who was the first to imagine what The Sea Ranch might be and brought others to join in elaborating the vision, has shared with us, and with generations of others, the stories of its founding and his astute observations of its potential. Larry Halprin, whose energetic leadership has been both evocative and sustaining for The Sea Ranch, has offered wise counsel and good friendship. His wonderful drawings included in this book capture the motivating mission. Charles Moore and William Turnbull, now each silenced by death, remain present in every thought about The Sea Ranch.

Richard Whitaker, who shared in the joyous architectural adventure that was MLTW/ Moore Lyndon Turnbull Whitaker, generously read through the manuscript confirming recollections and observations. Whitaker is now the director of design review for The Sea Ranch, shepherding the design committee process. George Homsey, also a member of the design committee and a former partner of Joseph Esherick, offered comments on sections relating to their early work here. William Wiemeyer, director of environmental management, also gave invaluable information and a critique of the section on managing the landscape.

The many owners and architects whose works (and lives) permeate this book are owed special thanks. They were exceptionally gracious in arranging for access to the houses and providing insights about the place and its development. They, their fellow members in The Sea Ranch Association, and the conscientious builders and professional community are the spine of its continuing vitality. We should note that our titles for the entries of individual houses follow the conventions of architectural history, identifying each house by the name of its original owner, and adding the names of the current owners.

Paul Kozal has provided Jim a lifeline of tactical support in the preparation and delivery of photographs for the book. Thanks are due to John Brock for his skillful piloting of Jim for the aerial photographs. A few of the photographs included are earlier images by Morley Baer that contributed to the widespread recognition of the first buildings. They have been included with the kind permission of the Morley Baer Trust. Several of Cris Benton's kite-view photographs have also been used: a professor of architecture at the University of California at Berkeley, he used his ingenious kite-borne cameras to take a large array of study photos that allowed us to see The Sea Ranch in a new perspective. Turnbull Griffin Haesloop kindly provided a number of maps and plans, and much important information.

Thanks are due to the University of California at Berkeley for support during this enterprise, and especially to the family of Eva Li who endowed the professorship that made it possible for Donlyn to involve many student colleagues in the preparation of the manuscript. These include, most especially, Hannah Brown, who kept searching out and gathering together materials that seemed bent on dispersal. Ana Sverko's encouragement and graphic wit helped give shape to the book; Tetsu Yaguchi and Kartika Rachmawati prepared most of the plan drawings, all to the same scale and conventions. Geeti Siwal updated and redrew the vicinity maps provided by The Sea Ranch design committee with assistance by Marianne Stuck and Dipti Garg; Abha Kapadia and Simi Hogue assembled background information; and

Laura Boutelle and Maria Fedorchenko helped with the assembly of plans and other information.

Elizabeth Byrne, Susan Koskinen, and the staff of the UCB College of Environmental Design Library gave friendly and timely assistance; Waverly Lowell provided access to the College of Environmental Design archives; and JoAnn Dixon and Merry Marsh assisted with the files of The Sea Ranch Design Review and Environmental Management Office. An early impetus for assembling the material came from a field conference sponsored by the Charles W. Moore Center for the Study of Place; and Kevin Keim, its director, has been ever helpful with research and valuable comment.

Donlyn's professional involvement as an architect at The Sea Ranch has drawn mightily on the skill and support of his former partner Marvin Buchanan and colleagues who worked at Lyndon/Buchanan Associates over the years, most especially Larry Strain, Stan Vistica, Bruce Brubaker, Terezia Nemeth, Liz Newman, Thomas Kronmeier, and Alicia Chavier. The firm's work was constantly informed by the sharp wit, constructive brilliance, and sustaining friendship of Matthew Sylvia. Before his death in 2002, Matt built more at The Sea Ranch than anyone else ever will—not only the first buildings and many of those that followed, but he helped build the spirit and love for the place in those who had the good fortune to work with him.

Working with the Princeton Architectural Press has been a great pleasure: Jan Cigliano patiently midwifed the conception of the book, Nicola Bednarek's sharp and graceful editing has immeasurably improved it, Jane Sheinman's three-dimensional maps lend it clarity, and the layout designed by Jan Haux handsomely carries the spirit of the endeavor onto the page.

Publication was aided by generous gifts from Elaine Jacobs, and Wayne and Terry Caygill. We are truly grateful for their confidence and support.

On a more personal level, those who know us will readily discern that the imaginatively precise thinking of Alice Wingwall and Mary Street Alinder is suffused throughout our work.

Donlyn Lyndon and Jim Alinder
The Sea Ranch, August 2003

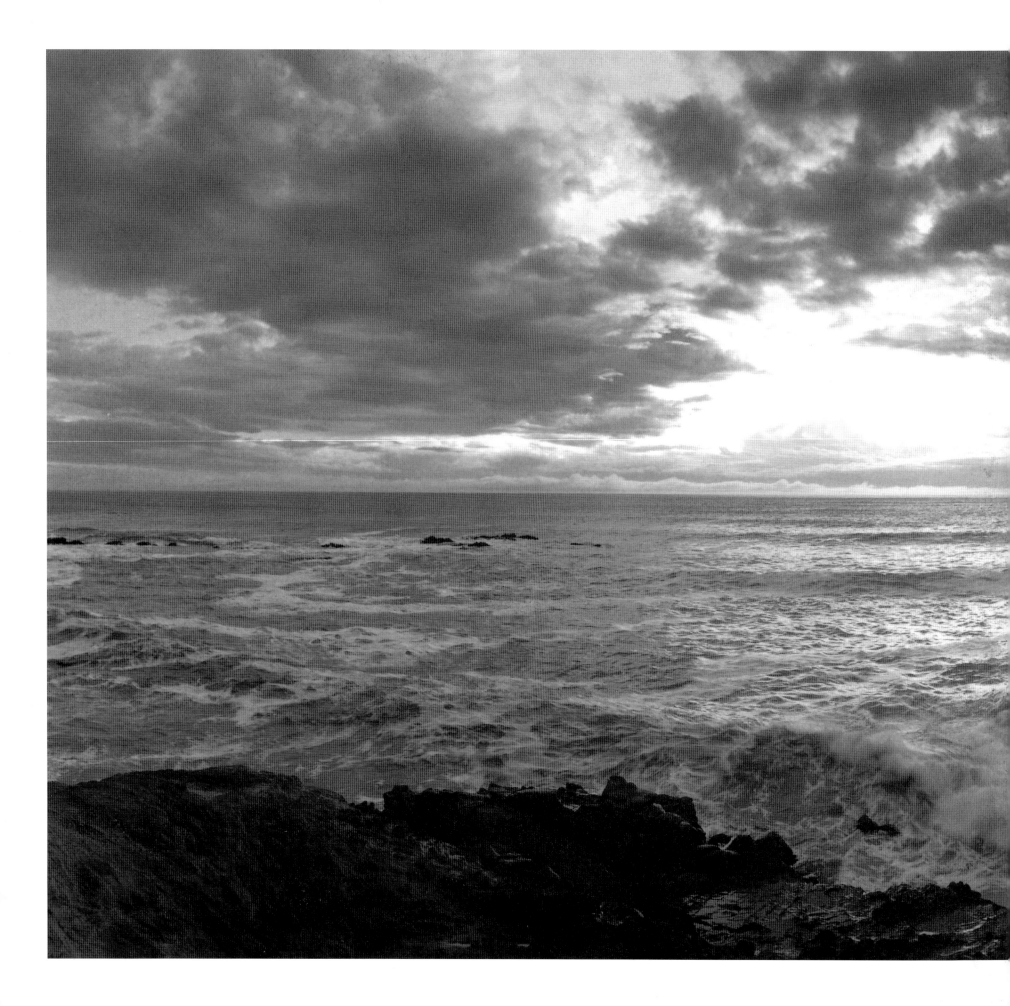

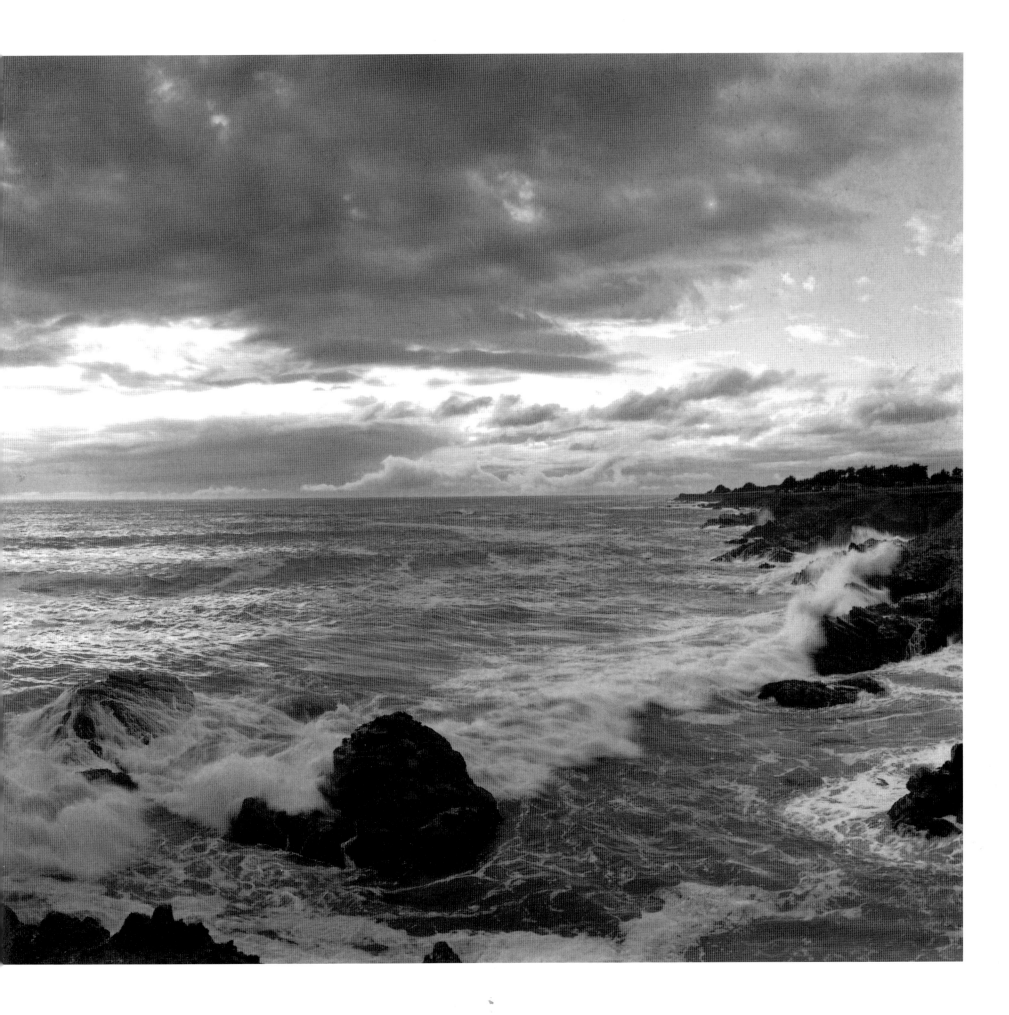

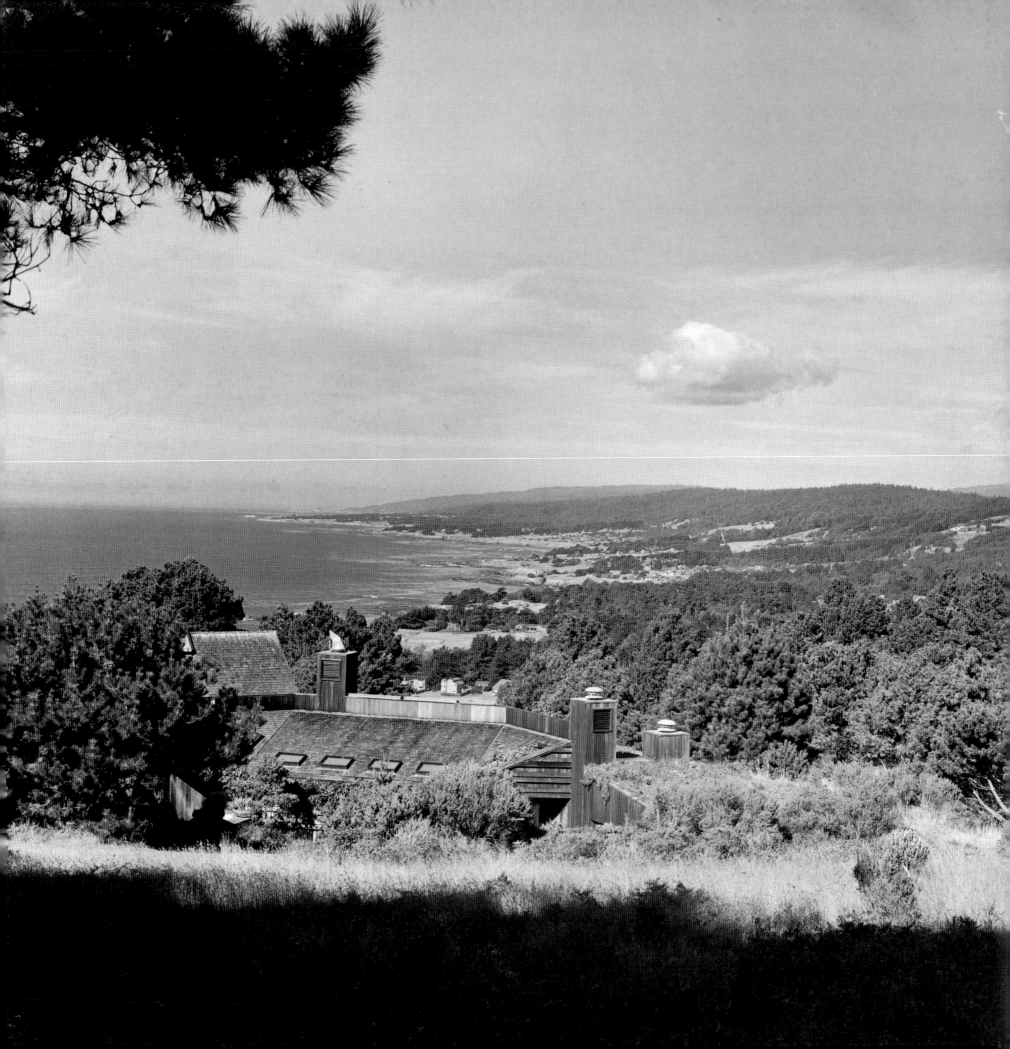

THE SEA RANCH: DIMENSIONS OF EXPERIENCE

The Sea Ranch is a unique example of landscape development, stretching for ten miles along the northern California coast. Geographic advantage and great natural beauty have been joined here with bold initial planning, place-related architecture, and a process of continuing nurture and evolution. As a managed landscape it draws upon the talents and skills of its stewards: the staff of The Sea Ranch Association, which oversees its comprehensive maintenance and development; the individual owners who invest in its evolution; and the architects and contractors who build here. Together, bound by a legal covenant to care for the land, they have fashioned an exceptional place.

Located on the Sonoma coast, at the western edge of the North American continent, The Sea Ranch is a little over one hundred miles north of the San Francisco Bay Area and three hundred miles south of the California/Oregon border, sitting just south of the Gualala River, the border between Sonoma and Mendocino counties. Gualala, founded in 1858, is immediately north of the river. Once a lumbering community, it is now a busy commercial center. Neighboring The Sea Ranch to the south is Stewart's Point, with a store, farm, and one-time hotel for lumberers dating back to 1868; to the east are a large area of rugged timber land, a small Pomo Indian Reservation, and the hamlet of Annapolis, with a region-serving elementary school. Farther afield to the south, on a promontory on the ocean is Fort Ross, a wooden complex built by Russians in 1812 and now a state park. It was the southernmost of their settlements along the northwest coast of the continent. Highway 1 stretches through The Sea Ranch, a spectacularly scenic road that proceeds, with sometimes perilous windings, north and south along the California coast.

The Sea Ranch community, founded in 1965, now consists of approximately 500 people who are in permanent residence (in 2004) and share ownership of 2,300 acres of common land with nearly 1,500 other members of The Sea Ranch Association. These own individual property within The Sea Ranch, visit with varying degrees of frequency, and in many cases share their houses with others through a rental program. At the end of 2002, there were approximately 1,600 houses, a lodge, several commonly held recreation and community buildings, and three commercial structures in the 4,000-acre development, with some 600 house sites and an expansion of the lodge yet to be developed.

Geologically, the locale lies along the western edge of the San Andreas Fault, an area uplifted by the collision of the Pacific and North American plates. The Sea Ranch boundaries reach to the top of Miller Ridge and nearly all of its land lies on the western face of that ridge. The experience of being here is thus dominated by the fall of the land toward the sea as well as by the constant call of the ocean. The slope of the land is often precipitous in the forests, whereas it is more gentle, undulating but inexorable, in the meadows of the coastal shelf west of Highway 1. Either way the slope leads to the sea, just as certainly as the eye is constantly drawn toward the shimmering horizon.

The joining of land and sea along the bluffs results in a rich and complex landscape of rocks, beaches, and endlessly varied cliffs. Numerous coves, each distinct, provide homes to the abundant wildlife above and below the surface. The shapes and colors of the rocks, which are littered with moss, lichen, or bird droppings; the strings of kelp that thread through the surf and lodge on the land; and the patterns of bird flight above, all combine to produce an astounding intricacy of texture, color, and movement. The coves and promontories give a structure to the land that can be named and remembered. Many of them are distinctly memorable, as their names—such as Black Point, Pebble Beach, Smuggler's Cove, Walk-on Beach, and Del Mar Point—suggest. Hiking trails run for nearly ten miles through land held in common along this ocean edge, with various points of access to the rocks and sand below.

The Sea Ranch is more than an encounter with the sea, however. Above the cliffs, trails lead across wide, open meadows, punctuated by cypress hedgerows, and up into the forests. Here a completely different ecology prevails among steep slopes and twisting ravines, with towering redwoods, fir, and pine; twisting red manzanita and white-barked pin oak; rhododendrons; wild azaleas; and ubiquitous pine needles and ferns, all cast in the shade except when highlighted by shifting pinholes of sun and occasional clearings. Finally, over the ridge and down by the side of the Gualala River lies the Hot Spot, a clearing along the forested shore that used to be a beloved picnicking spot, where children could swim in the shallow river immune from the surging tides and bitter cold of the ocean.

Interlaced through this landscape are clusters and strings of buildings that edge the meadows, recede into the forests, and occasionally stand out along the bluffs. Their weathered and grayed wood-surfaced walls, and their generally dark, sloping roofs soften their presence in the scene, especially

when backed up against the vegetation and away from the shore. There are few houses that look just alike, yet many that seem similar, sharing in some semblance of accord.

In parts of The Sea Ranch, houses coalesce into groupings that complement and help to define the distinctive form and character of this landscape; in other parts they spread aimlessly through grassy terrain. At their best, the buildings work with the ecology of the place, interacting with the land and the climate in ways that make it livable, without obliterating its essential character. Nearly always the awareness of nature remains prominent; in some parts just barely, in most parts triumphantly so. In the midst of this extended landscape there are many sites and buildings of real distinction, genuinely creative interpretations of what it can mean to build in this particular place— architecture that rewards close attention.

There is also an extensive social network threaded through these places, including The Sea Ranch Association and its governance and community facilities; association committees that hold forums to examine timely issues, conduct informative walks, and stage community picnics and events; as well as a number of cooperative engagements such as the Posh Squash Community Gardens and The Sea Ranch Thespians, a local drama group. Many of these networks are sustained primarily by permanent residents, but other members also partake in community activities, or organize smaller socializing opportunities of their own, based on common interests or background, or simply on neighboring. These affinity groups find their bonds strengthened and deepened by their common experience of this place and the chance to be together in a setting that has mutual significance. So, too, do the many groups of short-term renters and guests who come on visits to The Sea Ranch for professional or family gatherings or to celebrate special events. Often their time in this place marks out a memorable space in their lives.

It is the coast, primarily, that brings people here—the touch of the wild that is so vigorously embodied in the shoreline itself: its ceaseless surf, varying in intensity and threat; the traces of unfathomable time revealed in the layers of its bluffs and projecting rocks; the endless process of water eating away at the land from the sea and furrowing down across its surfaces in creeks and swales; and the limitless sky tingeing the earth with its fluctuating colors and floating great cloud forms above it. Within this encompassing frame we see, however fleetingly, the resurgent impulses of life. The clutch of mollusks, the darting and soaring of birds, and the scurry of fauna in neighboring grasslands and forests—each blade of grass and needle of tree recounts the tale of life within. They echo the recurrent and ultimately transient rhythms of our own lives. The Sea Ranch engages and nurtures our attention.

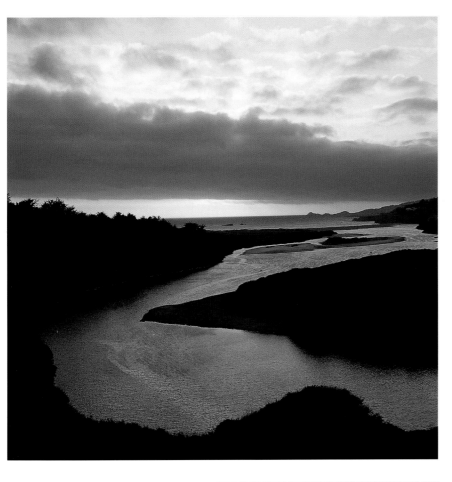
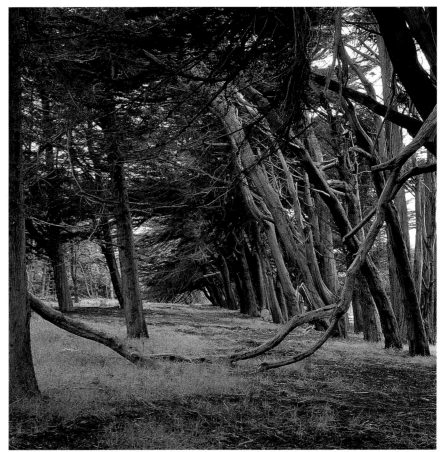

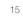

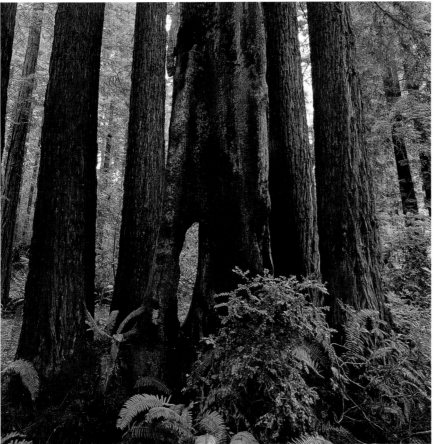
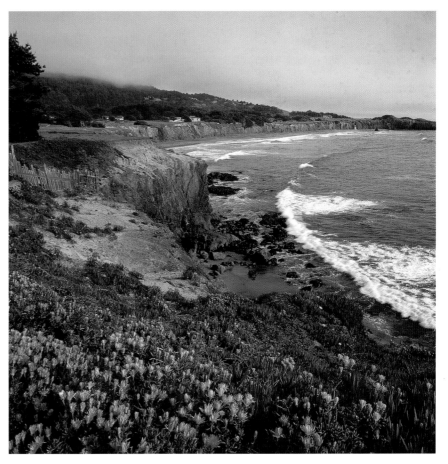

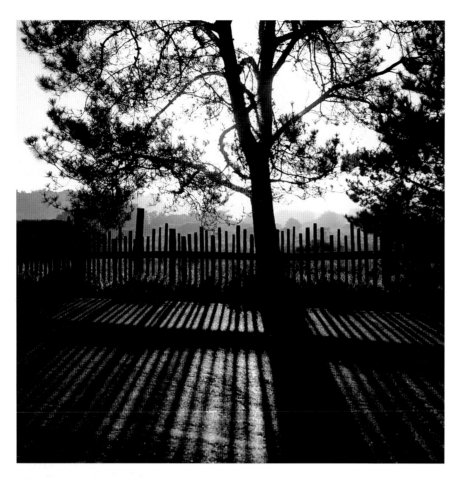

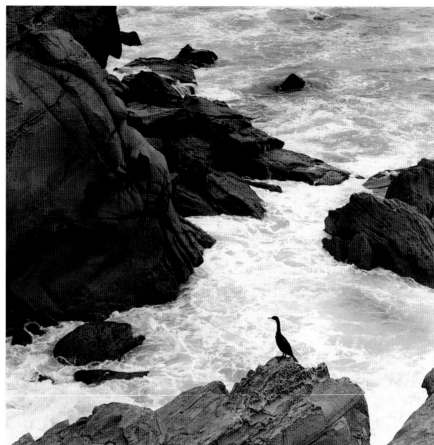

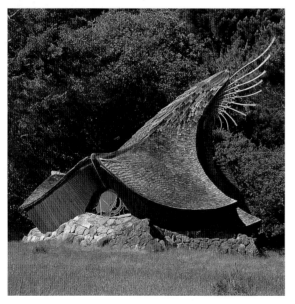

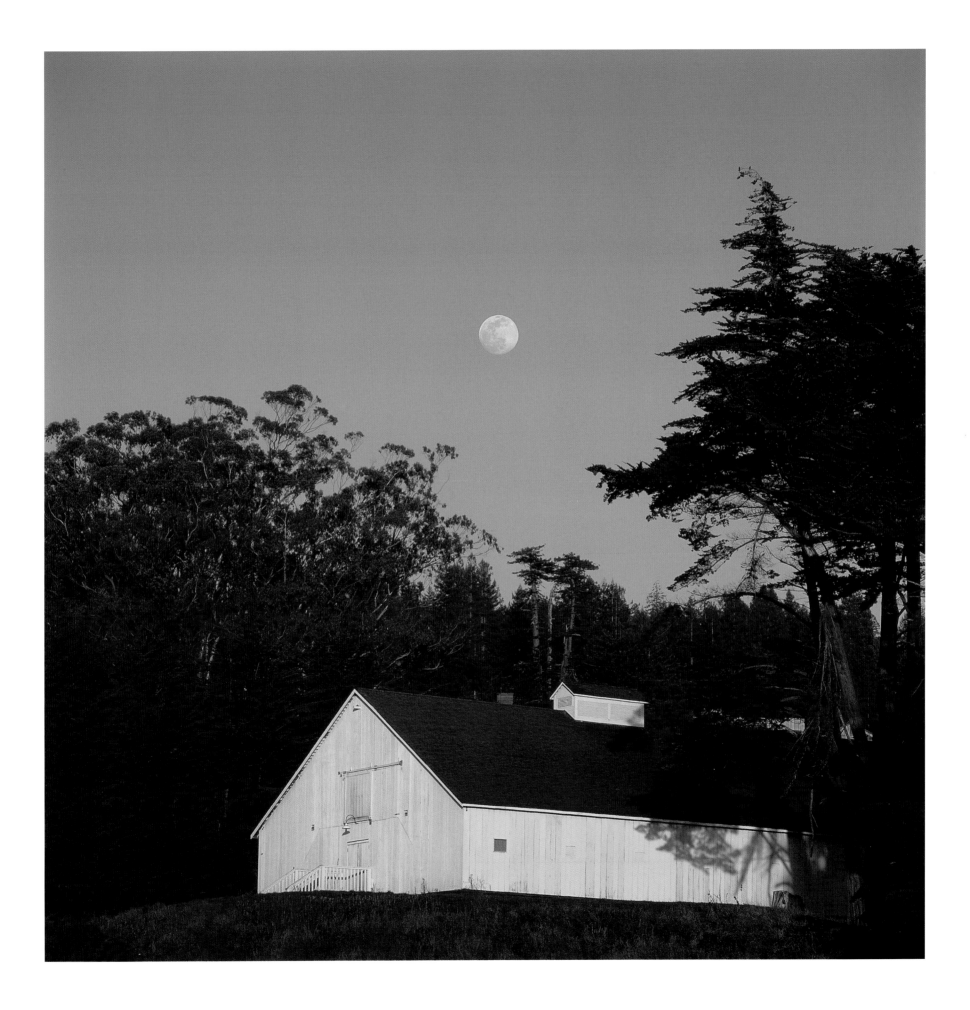

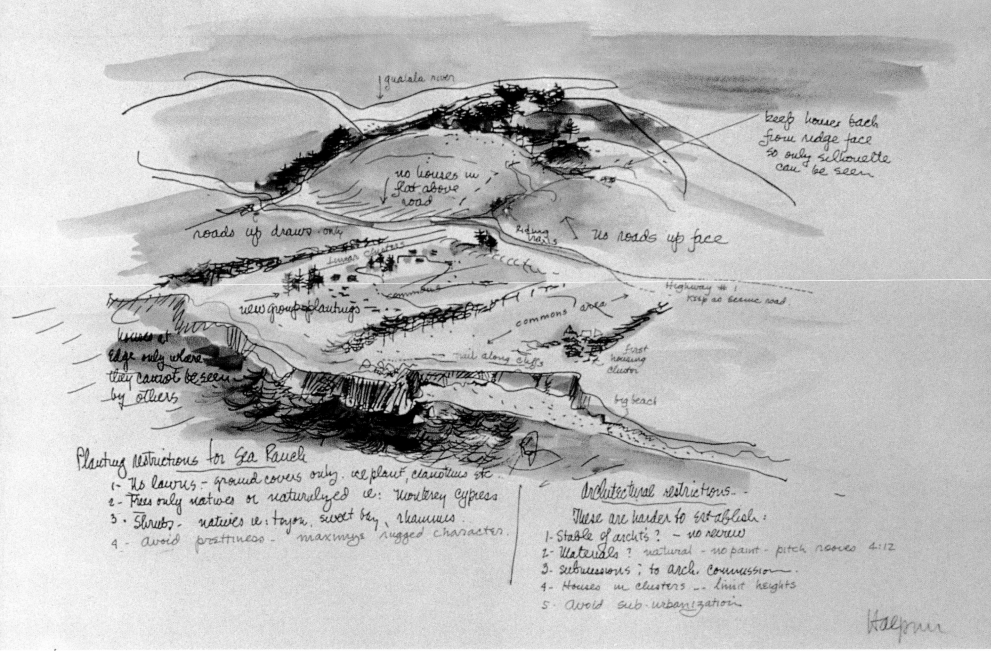

SEA RANCH — The basic premises.... Dec. 1963

gualala river

keep houses back from ridge face so only silhouette can be seen

no houses in flat above road

roads up draws only

Riding trails

no roads up face

Linear Clusters

Highway # 1 Keep as scenic road

new group plantings

commons

commons area

houses at edge only where they cannot be seen by others

trail along cliffs

First housing cluster

big beach

Planting restrictions for Sea Ranch
1- No lawns - ground covers only. ice plant, ceanothus etc.
2- Trees only natives or naturalized ie: Monterey Cypress
3- Shrubs- natives ie: toyon, sweet bay, rhamnus.
4- avoid prettiness - maximize rugged character.

Architectural restrictions-
These are harder to establish:
1- Stable of archt's? - no review
2- Materials? natural - no paint - pitch roofs 4:12
3- submissions; to arch. commission
4- Houses in clusters -- limit heights
5- avoid sub-urbanization

Halprin

THE FOUNDING VISION

The preservation and evolution of this costal terrain have been made possible by the far-sighted initial planning that Oceanic Properties brought to the place when they purchased Rancho Del Mar, 4,000 acres of coastal timber and grazing land, from the Ohlson brothers in 1963; and when Al Boeke, Oceanic's vice president for development, started an intense and innovative planning process led by landscape architect Lawrence Halprin.

The specific character of the landscape Oceanic purchased was the result not only of geological forces, which formed the wrinkled mountains along the coastal edge, and the land's subsequent erosion and forestation, but of decades of farming, ranching, and lumbering. Over the nineteenth and twentieth centuries, there had been selective clearing for timber, hedgerows had been planted to protect livestock from the wind, and the meandering State Highway 1 was constructed stretching along the base of the range.

Excavation and scientific analysis of the soils have suggested that the ocean shelf was primarily grassland long before any lumbering and ranching took place here. Possibly the meadows were kept from developing into forest by herds of wild animals grazing on the flatter lands. Later, the resident Native Americans, the Pomos, were likely to have set fires to manage the meadow's subsequent growth, and the hills were lumbered extensively in the nineteenth and twentieth centuries by European and North American settlers. At the time of acquisition, the area was being used as a sheep ranch.

In many respects the land had been abused, overgrazed, and rent by erosion. Yet the sweep of grassland from forest to cliff and the recurrent lines of planted cypress hedgerows marching across the land gave a scope and structure to the scene that was distinct and engaging. The richly varied surfaces, edges, and patterns of natural growth were interwoven with the bold, linear geometries of human intervention, already expressed here in hedgerows, fences, and roads.

Halprin's plan set out to take advantage of both of these characteristics, using arrangements that matched the ecology and the scope and scale of the landscape better than the conventional patterns of incremental, parcelized development would. Instead of dividing the land up into surveyor's sections, subdivided into private lots, the placement of building sites was to be related to the shape of the land itself and the prospects that could be gained from each position within it. Groups of building sites were placed within the folds of the landscape, almost like sculptures joining the force of the land. The parcels of real estate to be sold, and the roads and infrastructure that would make building possible, were placed not only to make great building sites, but also to form part of a larger physical design. Halprin stated the ambitions of the original vision with characteristic eloquence:

"A feeling of overall 'place,' a feeling of community in which the whole was more important than the parts. If we could achieve that—if the whole could link buildings and nature into an organic whole rather than just a group of pretty houses—then we could feel that we had created something worthwhile which did not destroy, but rather enhanced the natural beauty we had been given."[1]

The design gave pride of place to the unique characteristics of the site and to the establishment of large stretches of commons that would preserve the dominance of the natural setting for all who would come to live here. Halprin's drawings of the site and the score for its development eloquently capture the central vision for The Sea Ranch: the land should remain primary; the buildings added to it should complement the essential character of the landscape that they would inhabit. The experience of the coastline was to be shared, not sequestered in separate private ownerships, and there would be large areas of commonly held land that would ensure the perpetuation of the coastal ecology.

Over four decades the initial ideas for the development have been modified and altered (sometimes nearly obliterated) through changes brought about by time, regulatory policy, financial interests, and talent. New insights have been gained, and significant opportunities missed, but The Sea Ranch remains a place of exceptional beauty, with many important lessons to be learned and residents who enjoy an abiding sense of place.

1 Lawrence Halprin, *The Sea Ranch...Diary of an Idea* (Berkeley: Spacemaker Press, 2002), 29.

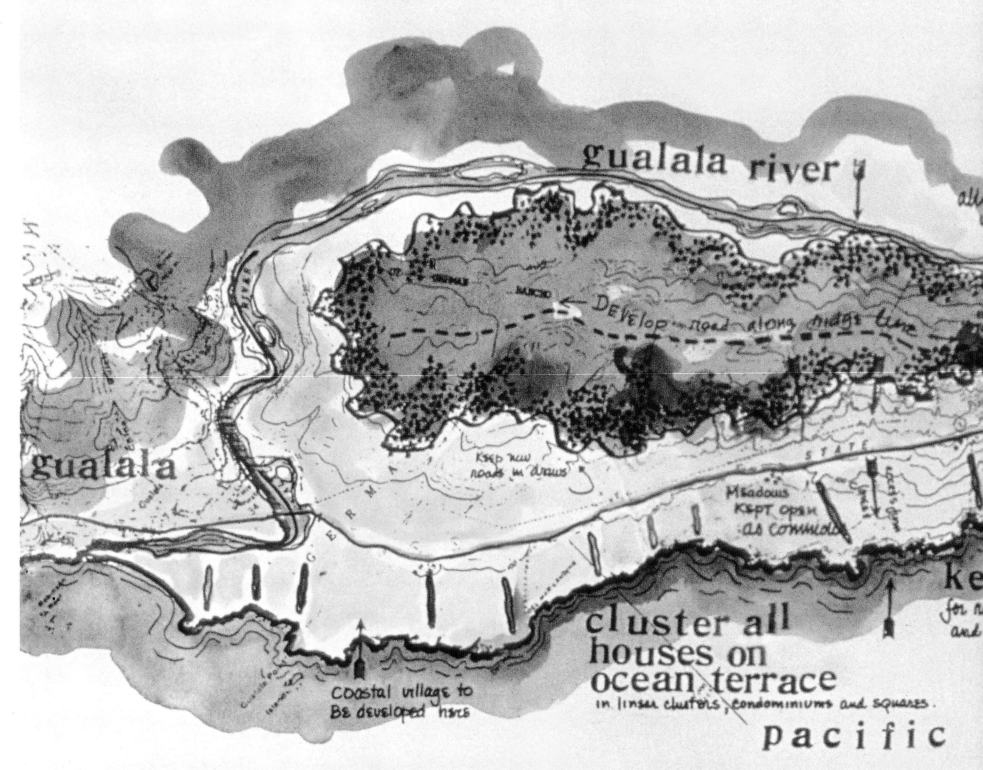

gualala river

Develop road along ridge line

Keep new roads in draws

gualala

Meadows kept open as commons

cluster all houses on ocean terrace
in linear clusters, condominiums and squares.

Coastal village to be developed here

pacific

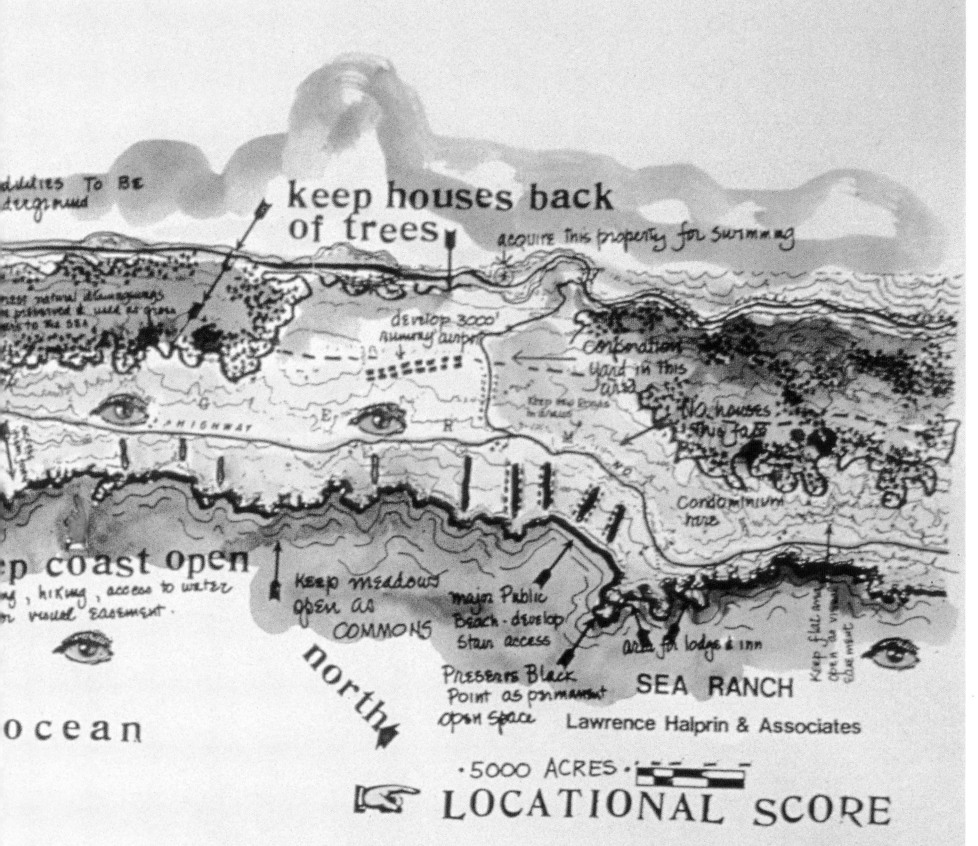

21

ORIGINS, EVOLUTIONS, AND IRONIES

Donald Canty

Over nearly four decades the evolution of this unique place has witnessed certain ironies. The Sea Ranch was born in the 1960s of environmental concerns, yet the environmental movement of the late 1970s almost killed it, and in the end the struggle resulted in landmark environmental law.

The site before development began was (and remains) compelling—a landscape of wild beauty and intimidating power, more challenging than comforting: hillsides thick with fir and redwoods; grassy meadows, mowed and mauled by sheep over the years; cypress hedgerows punctuated laterally up and down the long site; and, finally, the blue-green sea, surging against huge sculpted rock formations and steep bluffs, carving irregular inlets.

Lawrence Halprin, who was to become principal author of The Sea Ranch plan, tells of his early impressions of the area:

"In those days the North Coast was wild, unfriendly, mostly uninhabited and sometimes belligerent. The residents were oriented to forestry, logging, and commercial fishing. In the hills Pomo Indians still lived on their reservations. In many ways it had changed little in the 100 years or so since the early settlers arrived. The occasional barn and sheep sheds had strength of character and inhabited the landscape like rocks and landforms. Great sandstone cliffs stood against the battering surf and diving cormorants nested in the crevices. Seal colonies inhabited the rock outcrops and in the spring gray whales migrated north from the birthing grounds of Baja, California. The constant presence of the Pacific was dominant. It was magical."[1]

By the 1960s, Oceanic Properties, a subsidiary of the Hawaiian developer Castle & Cook specializing in planned communities, was looking for a site on the California coast to develop a new town. The search for suitable land was handled by Alfred Boeke, the vice president of Oceanic, who was an architect by training and had a personal interest in new towns—then a fad internationally; he had also spearheaded the building of Oceanic's largest master-planned community of Mililani, Hawaii. Rancho Del Mar, as The Sea Ranch area was then called, captured Boeke's attention during a flying tour over California's north coast, yet he realized it was too isolated to be developed as a town of full-time residents; instead he persuaded Oceanic that a second-home community on the site would fit well into its real estate portfolio. Oceanic bought the land from the Ohlson brothers for $2.3 million in 1963, and Boeke managed to convince Oceanic and Castle & Cooke that the place—the Spartan beauty of the meadows, the wildness of the sea, and the contrasts of forest and inland river—required a special kind of planning that would bring minimal disruption to the natural landscape.

Boeke's first step in planning The Sea Ranch was to engage Lawrence Halprin, who was to become one of the country's foremost landscape architects. Halprin had studied at Harvard University under Walter Gropius and Christopher Tunnard, and worked with Thomas Church before opening his own firm in 1949. He and Boeke had worked together successfully on Oceanic's Hawaiian town although they were quite different people. Halprin has a ferocious love of nature that animates everything he does. He is a thoroughgoing romantic. Boeke was a pragmatist, a builder, and, as we have seen, a persuader. He set about a two-year process of interviewing prospective members of The Sea Ranch design and planning team. On Halprin's recommendation he chose as architects the dean of Bay Area architects, Joseph Esherick, and the emerging Berkeley firm of Moore Lyndon Turnbull Whitaker (MLTW). The latter was an adventurous choice. Charles Moore, Donlyn Lyndon, and William Turnbull had met while architecture students at Princeton University. When they returned to California, Moore and Lyndon taught architecture at the University of California, and Turnbull worked in the San Francisco office of Skidmore, Owings & Merrill. They began moonlighting small projects, joined by Richard Whitaker, also on the architecture faculty, and soon coalesced into a firm. When brought to Boeke's attention, they had only designed a few modest houses, though, and some larger unbuilt projects. Moore, of course, went on to become one of the profession's most honored practitioners, head of three prestigious architectural schools and recipient of the American Institute of Architects' gold medal. The other partners also went on to notable careers in education and practice.

They were joined on the planning team by people from a then unprecedented wide range of disciplines: foresters, grassland advisors, engineers, attorneys, hydrologists, climatologists, geologists, geographers, and public relations and marketing people. There was, however, no one from the social sciences. At about the same time across the country a quite different kind of large-scale development planning was going on. Baltimore developer James Rouse was creating a new town, Columbia, in the Maryland countryside. Before his physical planners' pencils touched paper, a "work group" of

23

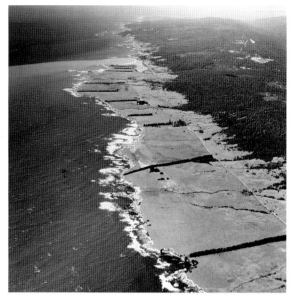

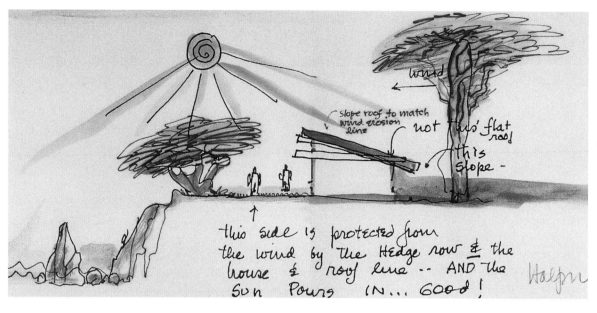

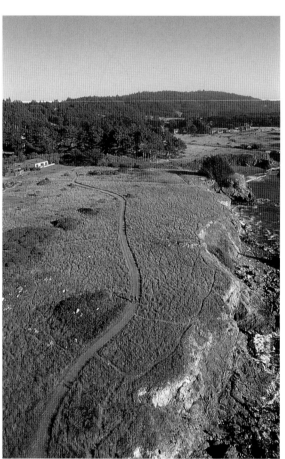

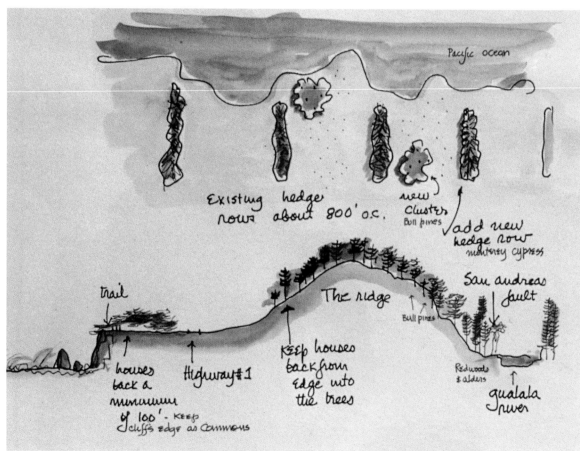

left/top: Early aerial view of open fields and hedgerows, circa 1964

left/bottom: Kite view showing forest, meadow, and houses set back from ocean front, 2002

right/top: Halprin sketch of building form and vegetation creating wind-sheltered sun pockets

right/bottom: Halprin diagram of hedgerows and section from coast to Gualala River

educators, health care professionals, sociologists, and others was formed to plan the community's basic institutions.

Halprin now says, The Sea Ranch "was not intended for just a few people who would use this area as a retreat, with no relationship to each other, but rather as an opportunity for people to form a community."[2] His thinking about The Sea Ranch was influenced by his experience in an Israeli kibbutz. He had something in mind much like what is now called cohousing, with residents having their own dwellings but doing a great deal, including having some meals, in common. The Sea Ranch as it evolved is almost an exact converse of the concept. Boeke is unapologetic about the design team's focus. "Our emphasis was on ecology," he says. "The Sea Ranch never was intended to be a town."[3] A "village" of shops and other community facilities was in the original plan, but since it was not a high priority with Oceanic, it did not materialize. To this day The Sea Ranch does not have a market, a bank, a school, a hospital, or a parish church.

The team spent an intensive year planning the new community, with a great deal of cross-fertilization among disciplines. As Halprin recalls, "the notion of making a community here seemed a great challenge. I felt that this could be a wonderful experiment in ecological planning. I was convinced that Sea Ranch could become a place where nature and human habitation could intersect in the kind of intense symbiosis that would allow people to become part of the ecosystem."[4]

Toward this end he brought in Richard Reynolds, a cultural geographer and an ecologist, to do exhaustive studies of the site. Reynolds analyzed the location of different types of soils, their water capacity, natural fertility, and permeability. He mapped the velocity and direction of the often heavy winds (Halprin and Boeke had to crouch behind their car on an early site visit to avoid being blown over) and also studied the extent of wind protection provided by the hedgerows. He offered some advice that was to prove prophetic: "To preserve the hedgerows additional plantings are needed; to preserve the open fields from brush and erosion mowing, grazing, or controlled burning need to be done at regular intervals, and the forest needs regular clearing."[5] (He and Turnbull advocated keeping some of the sheep to control overgrowth of the meadows but the idea got nowhere.)

The plan that emerged was strongly based on the characteristics of the site and protection of these resources. Halprin did not produce a conventional planning document; his only drawings were individualistic freehand sketches. The plan called for an average density of one house per acre, but not with each house sitting in the midst of its own acre. Instead houses would be clustered together on the meadows, and some development would take the form of condominiums; in all, half the land would remain open space in common ownership of all The Sea Ranch residents. This was a radical departure in real estate development, and the inclusion of condominiums in particular raised eyebrows.

The hedgerows in the meadows would be densified and new ones added to create a series of "outdoor rooms," in Halprin's phrase.[6] Housing clusters would hug the hedgerows leaving the center of each "room" an open meadow to be used and enjoyed by all. The hedgerows would also help shelter the houses from the wind, as they had the sheep.

Houses would be kept at least one hundred feet behind the ocean bluffs so as not to wall off views. Roads in the meadows would parallel the hedgerows and thus be perpendicular to the shoreline, giving the houses diagonal views of the ocean. The roads would follow the natural contours of the land as closely as possible, and would not have curbs or sidewalks so as not to interrupt the visual flow of the meadows. Sonoma County officials at first objected to this aspect of the plan but acquiesced when Oceanic agreed to add the curbs and sidewalks if their absence caused problems. (It did not.) Above the highway, roads would follow natural draws and would not be built up the faces of hillsides. There would be no development below the forest line on this side. Houses would be tucked into the woods as unobtrusively as possible.

The original plan provided sites for a store and inn, two recreation centers, and a golf course. Even the golf course was to have an ecological bent, its design emphasizing native rock outcroppings and vegetation. Halprin's plan was widely praised and published, and won a national environmental award. *House & Garden* magazine recognized The Sea Ranch as "an unparalleled melding of architecture and landscape" and "the preeminent planned community of our era."[7]

Ground was broken in 1964 for three demonstration projects: a ten-unit condominium by MLTW, who prepared a plan for eleven more to be strung along the south shore of the site; a set of six "Hedgerow Houses" by Esherick in a meadow; and a store near the condominium, also by Esherick. The architects, while all individualists, shared a belief in the basic precepts of the Bay Area school, one of the nation's strongest regional traditions. These precepts included a close relationship to nature and use of natural materials, windows placed to maximize light and views rather than create an artful exterior composition (although they often achieved that too), relaxed forms, and a general emphasis on buildings as human habitation rather than objects. The mainstream architectural world, however, was firmly in the hands of modernists who rejected regionalism and naturalistic design. As an editor of *Architectural Forum* at the time, I was watching this world closely, and my chief editor dismissed the works of Esherick and his ilk as "stick architecture."

Modernism had taken the offensive against tradition in the 1930s, scored a clear victory after World War II, and was consolidating its gains in the 1960s. Modernism was about rigid, abstract forms, about industrial materials and buildings as objects of pure art. It was about brutalism and rough concrete. Instead, what Oceanic got from its architects at The Sea Ranch was an original, even idiosyncratic architecture that sought, in a formulation agreed to by both Moore and Esherick, "not to be married to the site but to enter into a limited partnership with it."

Working separately, Esherick and MLTW came up with a common design vocabulary for The Sea Ranch: shed roofs to deflect the wind, with no overhangs for the wind to flutter; and cladding of vertical redwood boards with large windows punched through them. But there were differences in emphasis: Esherick's houses snuggled in against the hedgerow self-effacingly, while the MLTW condominium interacted more dynamically with the landscape. These demonstration buildings were influential also because they came at a time when ecology and the environment were becoming national

obsessions. Architecture was seeking ways to deal with these concerns, and the first Sea Ranch buildings offered an exceptional approach.

Oceanic described the Hedgerow Houses, condominium, and the store as "strong without being assertive, simple without being plain, responding to the spirit of the place, its terrain, its climate, its vegetation. . . . It is the spirit, not the forms, of the structures and their response to natural conditions that make the Sea Ranch experience unforgettable."[8] The developer took firm steps in the form of written covenants to see that owners would find for their own houses the same sensitive response that the first buildings showed. In fact, The Sea Ranch dates its birthday as May 10, 1965, when attorney Reverdy Johnson delivered to a Sonoma County title company in Santa Rosa a finely crafted 111-page "declaration of covenants, conditions, and restrictions" (CC&Rs) for development of The Sea Ranch. The CC&Rs became the guiding principles of The Sea Ranch and are incorporated into every deed.

The Sea Ranch Association, to which all property owners automatically belong, also dates from this day in 1965. It is the closest thing at The Sea Ranch to a local government—a nonprofit corporation formed "to be responsible for commons properties, to maintain the ranch, protect members and enforce the CC&Rs." The restrictions included a ban on hunting and wildfowl shooting, and a stricture that all structures, utilities, and vehicles blend into nature. The most interesting restrictions concerned specifics of design and landscaping.

These were to be implemented by a three-person design committee, which always included at least one architect and was appointed by the association board. The committee initially was dominated by Oceanic and in particular by the strong-minded and decisive Boeke. The CC&Rs gave it autonomy; its decisions were not subject to review by the association board. In 1980 the committee was expanded to five members including well-regarded design professionals and the association's staff director of design and planning.

The explicit restrictions on building in the CC&Rs were not too tight. A height limit of sixteen feet was imposed on ocean-fronting homes, and of twenty-four feet on homes on the meadows; roof overhangs were discouraged but not forbidden; and redwood or shingle exterior walls were mandated in muted colors, whereas reflective surfaces were forbidden except for hardware. Cars were to be screened from view. Interior design was unrestricted but brightly colored or white curtains were frowned upon as "disturbing the overall harmony and serenity of the ranch." Over time the CC&Rs were supplemented by design committee "rules." Boeke prepared a map prescribing the proper roof slope on every piece of property, more for the sake of "unity" than response to wind and sun conditions.

The restrictions on landscaping were tighter. Most importantly, the meadows were to flow around the houses with as little interruption as possible. The list of restrictions is formidable, such as: "Eye-catching design solutions using showy non-indigenous plant materials; excessive plantings which detract from the natural surroundings such as masses of one species with conspicuous blooming performance." Also forbidden are "contrived walkways, defined bed and formal borders, fine lawns, conspicuous specimen plants," and "obvious geometric shapes created with plant materials."

Boeke's team used covenants and the demonstration buildings, as well as peer professional review, as means to influence design undertaken by individuals—with uneven success. The demonstration buildings invited imitation and, in some cases, a sameness in what has been built. Many other houses, as Donlyn Lyndon has observed, reflect an unwillingness of subsequent architects to design buildings that are integral parts of a coherent whole.

EARLY PROGRESS AND TROUBLES

Early on, the real estate sales agents feared that the restrictions would slow sales but Oceanic faced a far larger obstacle in selling The Sea Ranch lots. The primary buyer market was to be found in the San Francisco Bay Area, linked to The Sea Ranch by the spectacularly beautiful but famously difficult Highway 1, seven miles of the most challenging road stretch between the town of Jenner, at the mouth of the Russian River, and Fort Ross, an early, picturesque Russian settlement. Steep, narrow, and continuously curving, Highway 1 had been carved out of a sheer cliff hundreds of feet straight up from the ocean. Blinding fog was common. The road was a perceived barrier to buyers and a real challenge for the seller.

After the first model buildings were constructed, Oceanic launched a sales campaign, including full-page advertisements and multipage inserts in Bay Area newspapers. Prospects were offered free trips to The Sea Ranch, including overnight stays and tours around the rugged site in jeeps and dune buggies. Once in the hands of the salespeople, prospects were offered lots for no money down and at bargain prices: $8,500 for a lot on the meadows, $4,500 in the forest. And if they agreed to build within a year, there was an additional ten percent discount. Some buyers were drawn by the beauty and isolation of the place. Others were impressed with the publicity and architectural awards given the demonstration buildings. For a surprising number of the pioneer buyers, it was a case of seduction at first sight. They would come with no intention of buying, often with friends who were serious prospects, and simply fall in love with the place and buy a lot.

In 1994 The Sea Ranch Association's newspaper, *Soundings*, conducted a survey of the remaining pioneers asking them, among other things, what had drawn them to The Sea Ranch. One responded, "the beauty, sea, remoteness and friendly people." For another couple it was "the unique ambiance, spectacular natural beauty, serenity, large open spaces to be left untouched, and privacy." Recalls another, "we were taken by the elemental and rugged beauty of rocks and sea, the serene stretches of grassy meadows, and the verdant hilltops of lofty redwoods and other conifers. We loved the rural aspects of the area, the grazing sheep and cattle, the old farm buildings and tiny historic towns." More than one respondent cited as an enticement the protection against despoliation provided by the design and landscape restrictions, contrary to the sales agents' fears.

Many of the early housebuilders respected the lessons of the demonstration buildings and The Sea Ranch design philosophy, and hired architects who would live up to them. In addition to the original architects it became de rigueur for every Bay Area practitioner of note to have a project at The Sea Ranch, and many did. The entire development became a kind of laboratory and museum of Bay Area architecture, and the overall quality level was

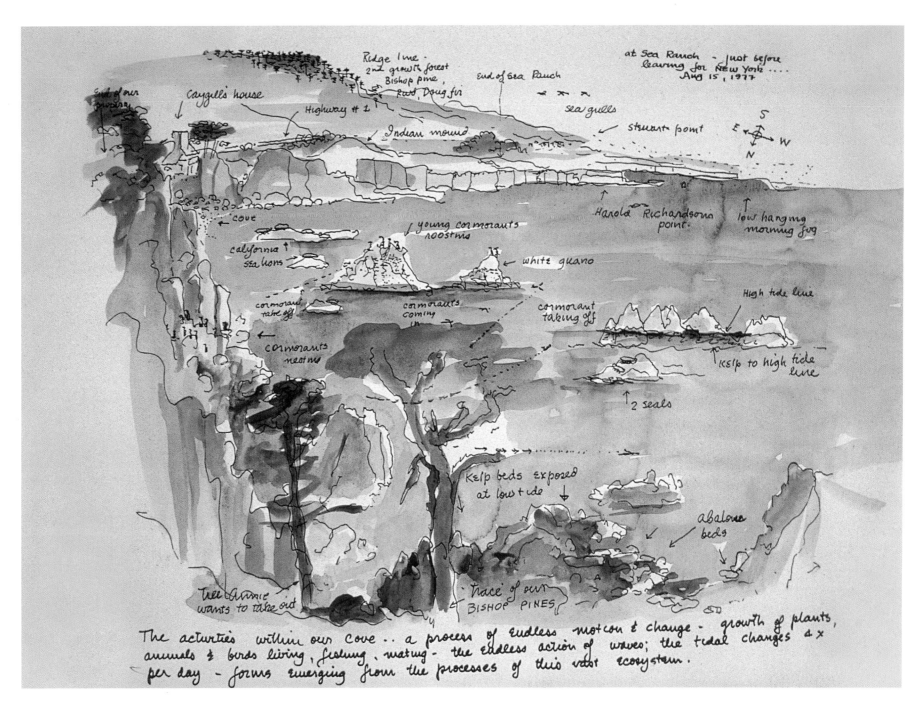

27

Sketch and notation of coastal conditions,
Lawrence Halprin, 1977

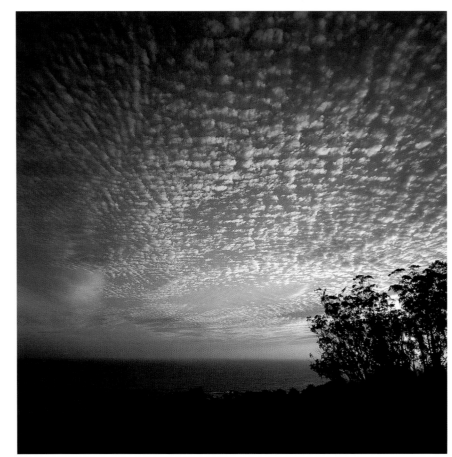
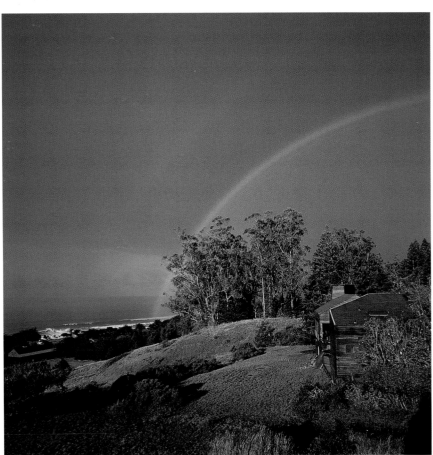
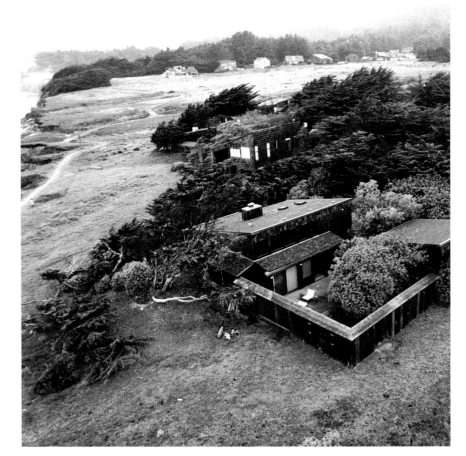

remarkably high. Thanks to the efforts of Marion Conrad, Oceanic's publications consultant, the awards given to the early houses and the Halprin plan attracted magazine and newspaper writers from around the country. Bay Area columnists carried numerous items about popular local figures weekending at The Sea Ranch. The place took on a special cachet. Oceanic had hoped to sell one hundred lots the first year but met its goal in just over eight months.

In some respects, the growing pains of success proved a challenge. The original planning principles proved surprisingly fragile. After just five years of construction, Halprin complained that houses going up in 1969 were being "scattered" on the meadows rather than clustered along the hedgerows. Moreover, houses were being built in the "front rows" of shoreline and forest, areas where they were forbidden by the plan. The Sea Ranch's Pebble Beach was the precise place where the principles began to change. Above and to the left of the bluff, the early houses that conform to the original plan are held well back from the shore, nestled in the trees. To the right, however, the next generation of houses is lined up in a row along the shore. On a narrow strip, Halprin had placed a road parallel to the shore. Boeke's planners compounded the damage on the next phase to the north when they laid out two roads parallel to the shore, inviting construction of a double row of houses against the sea.

In part, such departures from the plan resulted from a virtual revolt by the real estate agents of Castle & Cooke. They objected to not being able to market the most desirable home sites and claimed that condominium units and cluster housing were difficult to sell. Oceanic quickly backed off on the last point. The celebrated Condominium One turned out to be the only one that Oceanic built, and houses in a second cluster already designed by Turnbull were pulled apart.

Oceanic dismissed Halprin and the original architects in the late 1960s, and Boeke established his own staff of planners in the firm's Honolulu offices. This shift to staff designers, according to Boeke, stemmed from the fact that the basic planning work had been done, and Oceanic did not want to continue to pay the high fees that consultants expected. Boeke himself left at year's end 1969, and one of Oceanic's real estate agents took his place. His departure marked the beginning of the end of the heralded Sea Ranch plan. There was a change in Oceanic's leadership in Hawaii too. The risk takers, Oceanic President Fred Simpich and Castle & Cooke Chairman Malcolm McNaughton had been replaced. Few were left in the company who cared about The Sea Ranch, and an agent was sent over to arrange Oceanic's phased withdrawal from the project.

ENVIRONMENTALISTS AGAINST THE PLAN

The Sea Ranch was born in the era of Rachel Carson and Ralph Nader, the rise of the nation's awareness of environmental concerns, the introduction of the term *ecology*. In the mid-1960s, Congress passed legislation encouraging states to manage their coastlines, and California was one of the first to respond. California had come to the realization that only 100 miles of the state's 1,300-mile coastline were accessible to the public. Resorts, fast-food stands, and private property consumed more than ninety percent. The idea

that with the development of The Sea Ranch ten of the most beautiful and publicly accessible miles of the northern coastline would become a private "colony of nature lovers," was intolerable to many in Sonoma County and such increasingly powerful environmental organizations as the Sierra Club.

As recounted by one San Francisco newspaper reporter, the opponents saw The Sea Ranch as

"an example of coastal misuse, a symbol of privilege, locking out the public from access to the shoreline, reserving a spectacular area at the edge of the continent for the few able to afford it. There is fear that growth will severely alter the character of an unpeopled land…there is fear that more homes will lead to the overloading of Highway 1, bringing pressure to turn it into a freeway."[9]

Oceanic took its plan for 5,200 housing units to the Sonoma County supervisors. Public access to the beaches (tidelands were state property, guaranteed for use by all) was becoming a significant issue, and Oceanic sought to meet it by giving the county one hundred acres (later forty more were added) as a public park at the north end of its property. It was a beautiful point where the Gualala River met the sea. The supervisors agreed that this was sufficient public access and no more would be cut through The Sea Ranch.

Divers' clubs and other abalone lovers, however, formed an organization called Californians Organized to Acquire Access to State Tidelands (COAST), led by a veterinarian from the tiny inland town of Cotati named William Kortum. In 1968 it put an initiative on the county ballot to cut public access trails through almost every mile of The Sea Ranch. The initiative failed but it gave rise to a statewide movement called the Coastal Alliance, which put a similar initiative covering the entire California coast on the statewide ballot in 1972. It called for the creation of regional coastal commissions, backed by one statewide that would plan for the use of coastal lands with emphasis on public access and give the commissions the significant power to issue or deny building permits on the coast.

The planning of The Sea Ranch had been informed and inspired by the environmental movement but now the movement seemed poised to reject it. Many of The Sea Ranch pioneers were staunch environmentalists and supported the initiative, labeled Proposition 20. Proposition 20 passed easily, and the first blow against The Sea Ranch was struck in 1973 when the North Central Coast Commission denied a new lot owner a building permit on the grounds that his house would impede views of the ocean from Highway 1. Other rejections quickly followed. Attorneys for Oceanic and The Sea Ranch Association objected that actions were being taken against individual owners instead of dealing with the commission's problems with The Sea Ranch on an overall basis. The North Central Coast Commission responded with a set of conditions on which it would begin approving construction of The Sea Ranch houses. At the time some 300 houses had been built and 1,400 lots sold.

Proposition 20's principal conditions were that The Sea Ranch create public access paths with parking along the entire length of the site and remove 2,000 trees along the highway (which did not happen, however). Ironically, at Salt Point State Park on Highway 1 just south of The Sea Ranch and about the same length, there are just two points of public access to the beaches and solid walls of trees along the highway. Oceanic and the

association resisted the regional commission's set of conditions, but the statewide commission upheld them. It also raised another significant issue: the sheer size of The Sea Ranch as projected. The building of 5,200 houses could result in a population of 15,000, the commission staff contended, straining the water supply and septic system capability and clogging Highway 1 to the point where the entire north coast would become inaccessible from the Bay Area.

The Sea Ranch was badly divided over how to deal with the virtual moratorium on development. Many who had already built their houses were not too sorry to see further construction halted, yet other residents were among the leaders of the efforts to see The Sea Ranch completed. "There were as many opinions as there were Sea Ranchers," says one pioneer. "It was like families being split by the civil war." With the court cases still dragging on, Oceanic and the association sought legislative relief and hired a lobbyist who discovered that the local legislators found The Sea Ranch dispute too hot to handle; but a Southern California senator, Tom Bane, was willing to submit a compromise bill.

The bill, passed by the legislature in 1980, gave the North Central Coast Commission and state commission virtually everything they wanted; in return, the commissions' permitting powers over The Sea Ranch ended. According to the bill, The Sea Ranch would create five public access trails from the highway to the ocean, each with roadside parking; it would create "scenic view corridors" by tree removal and special height limits; and the number of houses at build-out would be more than halved, from 5,200 to 2,300. The bill required the association to grant the state easements for the five public access points by April 1981. If the association complied, the state would compensate it $500,000. In January 1981, with the deadline approaching, the association board voted to hold a binding referendum of the membership on whether to accept the legislation's provisions, or try to amend them, or continue to fight the case in court. A large majority (eighty-three percent) of the membership voted, rejecting the legislation's provisions by a vote of 1,043 to 418. But immediately thereafter a three-judge district court upheld virtually all of the coastal commission's conditions for completion of The Sea Ranch. The battered association board voted to accept the legislative compromise.

The protracted controversy affected the communal nature of the place. Having started as a colony of like-minded nature lovers dedicated to maintaining its beauty, The Sea Ranch was now fractious and factionalized. The physical impact of the legislation was minimal; public access points are minor incidents along the highway. The economic impact of the moratorium, on the other hand, was huge. As coastal land became ever scarcer, price inflation skyrocketed. A Sea Ranch house lot that had sold for $30,000 in 1968, then at the top of the price range, sold in 1996 for $700,000. Houses were built larger and larger.

As the physical character of The Sea Ranch changed in the 1980s, so did the nature of the population. While the pioneers had been largely academics and professionals, now came many retired executives and others of wealth. Land speculation, present at The Sea Ranch from the beginning, became a major industry as values soared. Houses were bought, left empty, and sold again within a matter of months.

The impact of the environmental legislation on the state was unarguably beneficial. California was left with one of the strongest coastal conservation mechanisms in the nation, and even most of the early opponents of The Sea Ranch seemed happy. But the impact of the moratorium on Oceanic was disastrous. At the beginning Oceanic had put an estimated $30 million into the development. Utilities were underground, the roads were of high quality, the landscape enriched by extensive planting, and the trail system created. Yet with all of this expensive infrastructure in place, Oceanic had sold only 1,400 lots (out of an originally planned 5,200), and now had fewer to sell (2,300). Moreover, the second-homes market was weak in the late 1970s and early 1980s, a time of recession and oil shortages.

RENEWAL AND NEW DEVELOPMENT

As the 1980s began and development resumed, Oceanic, which had suffered losses estimated as high as $70 million during the moratorium, began concentrating its sales efforts on premium lots. Whatever shreds were left of the basic concepts of the Halprin plan were unceremoniously dropped to develop the northern portion of the property.

A civil engineering firm was engaged to subdivide the northern section. Lots were laid out in typical suburban fashion, side by side along curving streets and cul-de-sacs. "Planning at the north end has been financial planning, not land planning," said a design committee member at the time, "carried out by accountants." In effect, there are today *two* Sea Ranches, each markedly different in character. The southern sectors, which were developed in the 1960s and 1970s, have an air of restraint and respect, their houses indeed in partnership with the land. In the northern meadows, houses put up after the early 1980s line up rigidly along the streets and form solid, view-blocking walls along the bluffs. Others protrude, exposed, from the forest above.

The relationship to nature in the post-moratorium subdivision plans is less respectful and more competitive. Even as the houses were getting bigger, the lots were becoming smaller, partly because of a change from septic tanks, which require large lots for leach fields, to sewers at the southern end, which benefit from close packing. Parcels earmarked initially for condominiums were resubdivided for single-family houses, contrary to The Sea Ranch plan. While the freestanding houses were easier to sell, they used up more land than did the originally planned condominium buildings. Along with this abandonment of the original planning principles, has come a decline in the quality of The Sea Ranch architecture. This naturally raised questions about the role (and effectiveness) of the association's design committee.

Contrary to the hopes of the original architects, design elements of the demonstration buildings became clichés out of context, imitated around the world and repeated nowhere more relentlessly than on The Sea Ranch itself. The result was an obvious sameness spreading through The Sea Ranch. This monotony has been lamented by critics and residents alike from the beginning, but becomes more stifling as build-out nears. Some of this might have been obviated by an early idea of dividing The Sea Ranch into precincts and varying the design regulations for each, particularly those on color.

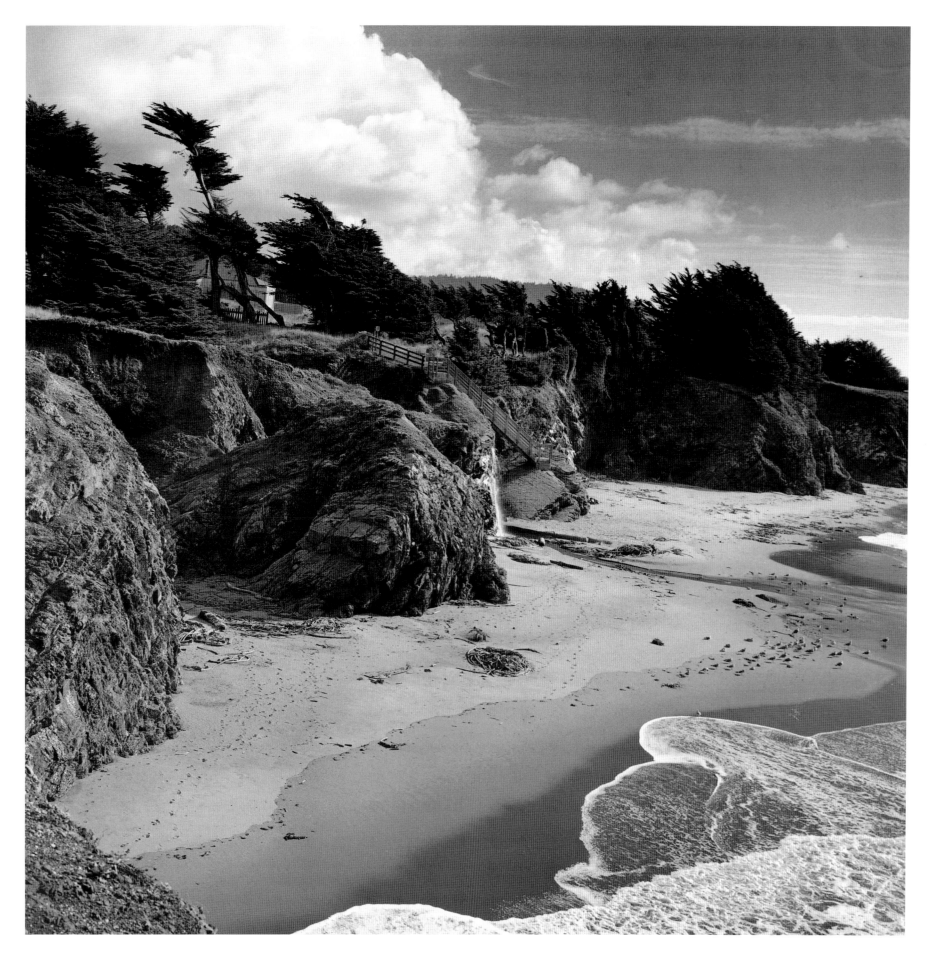

Ted Smith, a former director of planning and design for the association, defended the design committee on the basis that it could only deal with work that was brought before it. He estimated that ten percent of the houses that the committee reviews are wonderful, ten percent awful, and the rest middling. The committee has generally been successful in keeping out the awful, less so in encouraging the wonderful, and the middling has taken over The Sea Ranch. About seventy percent of the design submissions are approved. Smith saw staying out of litigation the key part of his job.

Yet there is a set of qualities that define a wonderful work of architecture: a pleasing overall form; consistency in use of materials; care in details; sensible scale and proportions; an overall coherence; and, above all, habitability. The first buildings had these qualities, plus the spark of originality. Smith pointed out, correctly, that much of the battle for design quality is won or lost with the election of the designer, over which the committee has no influence. A small group of self-chosen realtors that has clustered around The Sea Ranch and Gualala, on the other hand, frequently does influence the choice of designer. Often they recommend one of the architects drawn to The Sea Ranch's reputation and market. Realistically, real estate agents are the buyers' hosts and principal sources of information. When Oceanic had its own sales force, its agents conveyed the principles of the original plan. Since the real estate operation split off in 1985, independent firms have taken over sales. While some still emphasize the history and aspiration of The Sea Ranch, others are more inclined not to complicate a sale with notions of architectural standards.

Many design committee members have argued that it should be the association's task to inform new owners about The Sea Ranch design heritage. A comprehensive environmental plan drafted in the 1990s advocates a "proactive program" of educating realtors and prospective buyers by providing them with packages of design information, including a video on Sea Ranch architecture. The plan also intends for a "design library" of more extensive information and an awards program to spotlight architectural success at The Sea Ranch. Some of this has begun.

Even if the place has been overwhelmed by middling work built in the last two decades, it remains a success. The Sea Ranch is still a special place. Boeke credited the autonomy of the design committee with preserving some of The Sea Ranch character even in the northern sectors, while Halprin believes that the saving grace has less to do with the architecture restrictions than the landscaping rules. Allowing only native plant materials has preserved the primacy of nature in the meadows by placing the houses on a continuous grassy carpet. And even in the north there is still a great deal of open space, although it is cut up by the rigid rows of houses. William Turnbull observed in 1996: "you can stand a lot of mediocrity if the landscape is wonderful."[10]

In the 1980s, Oceanic completed development of the land along ten miles of coast; sold its remaining property and interest in the lodge and the golf course to The Sea Ranch Village Inc., a new entity led mainly by residents; and transferred common lands and stewardship responsibility to The Sea Ranch Association, which constitutes the residents' principal vehicle. It is an unusual entity: part local government, part community club, and part outlet for its members' energies and frustrations. It manages a maintenance staff, a security force, a planning staff and design review process, and a number of membership committees. There are also a volunteer fire department, a community garden, and a number of special-interest committees that sponsor activities.

When Oceanic withdrew as developer in the 1980s, the association took on multiple roles. Oceanic and the association had been virtual partners in the management of The Sea Ranch since the beginning. As Oceanic's tenure ended, they engaged one another in a round of suits and countersuits about issues such as water quality, septic tank performance, and restrictions on the undeveloped land. In the end, the association, with only a minuscule staff, found itself responsible for the daily maintenance and longer-term future of The Sea Ranch. Under these pressures, and with its new powers, the association board changed from a self-selective group of public-spirited citizens who ran for office out of a sense of civic responsibility to one that was intensely politicized. Issues today center on money (assessments), nature (views and privacy), and design (larger houses and monotonous architecture). Differences tend to stem from disparities in tenure, income, and age. While most of the older pioneers were, for instance, happy with quiet, grassy walking paths, younger Sea Ranchers, whose number is increasing, wanted improved facilities such as continuous bicycle trails. Even though some feared loss of privacy to peering cyclists, the bicycle paths were eventually approved. The young remain drastically outnumbered, though: over three-quarters of residents in 1997 were over fifty years old.

The landscape at The Sea Ranch remains wonderful, remarkably undisturbed by construction of more than a thousand houses and other buildings. And the best of these, the first exemplar structures, remain one of the most compelling ensembles of environmentally sensitive architecture anywhere.

Donald J. Canty

1 Halprin, *The Sea Ranch…Diary of an Idea*, 4.

2 Halprin, "Sea Ranch: Halprin's Recollections," *Progressive Architecture* (February 1993): 92.

3 Al Boeke, interview with the author at The Sea Ranch (1996).

4 Halprin, *The Sea Ranch…Diary of an Idea*, 17.

5 Editors, "Ecological Architecture: Planning the Organic Environment," *Progressive Architecture* (May 1966): 122.

6 Halprin, "Sea Ranch: Halprin's Recollections": 93.

7 Christopher Gray, "The Sea Ranch," *House & Garden* (September 1985): 62, 74.

8 Oceanic public relations brochure from the early 1960s.

9 Author's Interview with Joseph Bodowitz, first executive of California Coastal Commission.

10 William Turnbull, interview with the author at The Sea Ranch (1996).

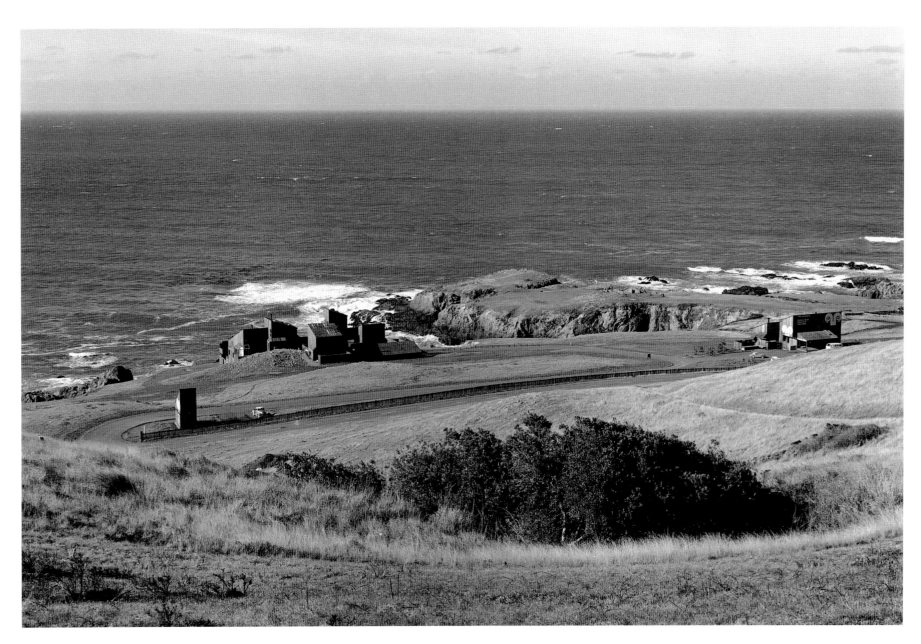

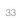

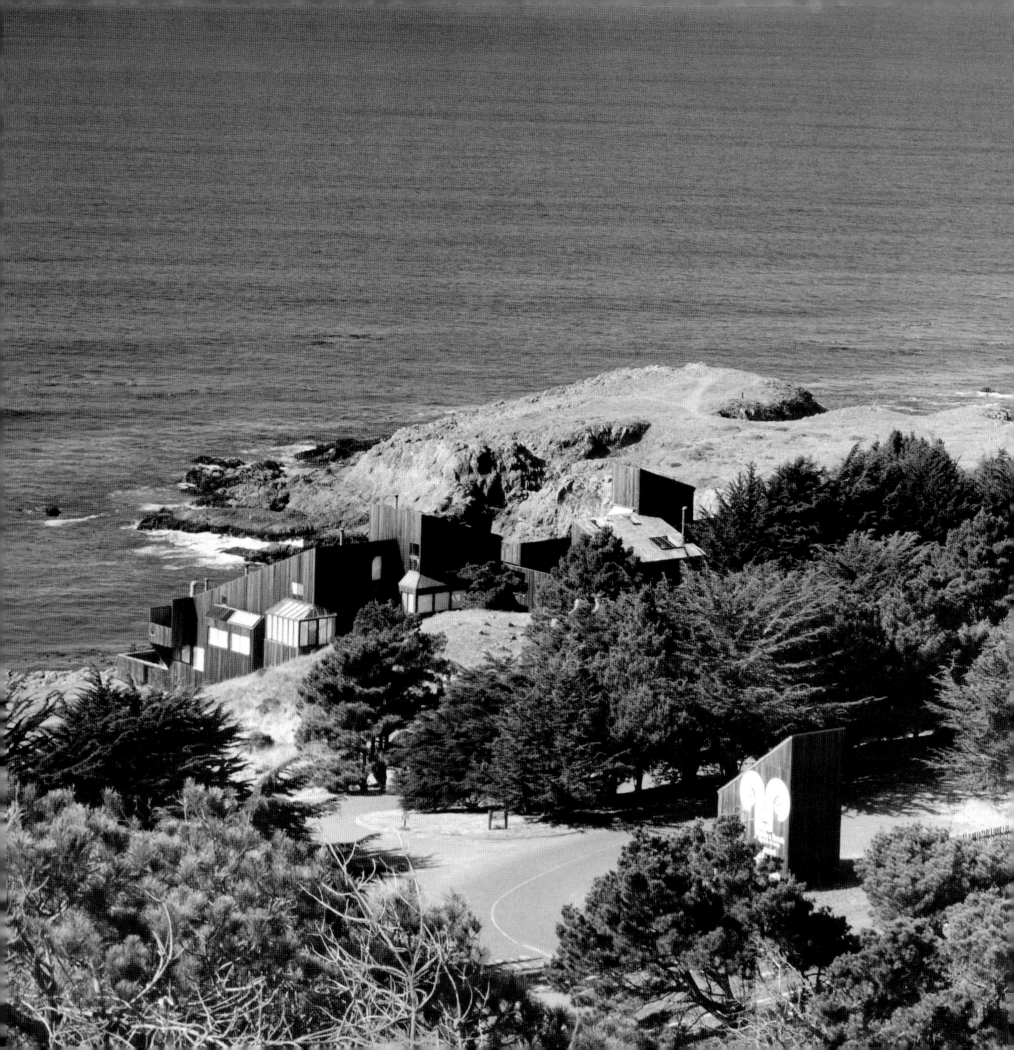

COURTING THE WIND, THE LAND, AND THE SUN: FIRST BUILDINGS

The first buildings commissioned by Oceanic at The Sea Ranch provided the opportunity and the mandate to think about architecture in a way that would be particularly suitable for this place. They were meant to show a fresh approach to the design of buildings, an approach that would respond to and take advantage of the special characteristics of this astonishing site. This also allowed us to further explore ideas that we were working with both in practice and in our teaching at the University of California, Berkeley (Esherick, Moore, Whitaker, and I were then all teaching in the Department of Architecture there).

Guided by Halprin and our own studies, our preeminent concern was with siting buildings in a way that would complement and draw advantage from the land. We did not, however, expect this to be a hands-off relationship. We wanted each building to engage the land, to become part of the way in which people could accommodate to this extraordinary, and often chilled and windy terrain. We wanted the relation between buildings and land to be complementary, to use the buildings to make the land more habitable, without destroying the very qualities that attracted people to this segment of coast.

The initial tasks given to the two architectural firms were quite different. Joseph Esherick & Associates were to show how a group of individual houses could be sited next to a wind-breaking hedgerow, and to indicate how building forms might work together to become a part of the larger environment. Our task at MLTW on the other hand was to demonstrate how larger buildings could be built on a prominent point of open land, exposed completely to the winds and with stunning views in all directions. Esherick's original sketches included studies that dug way down into the ground, with low, sod-covered roofs lifting slightly to capture sun. Our original cardboard model for the condominium consisted of a group of nine units and a sauna joined together like a Greek village around a common courtyard. Both firms were conscious of the continuous presence of the insistent wind, and the desire for sunlight. (Climate studies prepared by Richard Reynolds in Halprin's office had mapped the high wind speeds on the site in various locations and included bioclimatic charts that showed that for six months of the year additional warmth from the sun was needed to reach standard comfort levels.) Our charge was to design buildings that would relate to the land, its vegetation, the wind, and the need for solar radiation in both indoor and outdoor living spaces.

As the two schemes evolved, these considerations, combined with the specifics of the ground conditions on the two sites, led to differing but related outcomes. As they were finally developed, the Esherick buildings were built close to the ground, their roofs rising persistently toward the southeast to gain sun. Their profiles were designed to sweep the dominant northwest winds up and over the house to create wind-shaded courtyards on the southern lee. The sod roofs remained on some of the Esherick houses, though several were shingled, and most were still cut a little bit into the ground to lower their profiles and bring the level of the grasses up closer to eye level. The condominium, on the other hand, was refined into a larger, simpler form rising up from the cliff edge along the slope of a mound and built mostly on rock. It rises in consort with the land to a pair of towers at the crest that mark this place in the landscape. Its large wood-board siding emphasizes the big forms in a way that echoes the surfaces of the remnant barn a little to the north on Bihler's Point, where once there was a small settlement.

The borders of both sets of buildings are creviced and extended with small niches and projections that invite and reflect personal inhabitation. The designs for the Hedgerow Houses and the condominium share not only their respect for the force of the wind, their pleasure in the eastern and southern sun, and an interest in views along the coastline but also the conviction that buildings can and should become a part of the encompassing landscape; not by pretending to disappear from view, but by developing forms that are sympathetic to the forces that have shaped that environment and by building with materials appropriate to the locale. The buildings embody, too, a belief we shared: that no single repetitive building form could be adequate to the environmental complexity inherent in this place and in the varying circumstances of the specific sites within it.

When The Sea Ranch was founded, traveling up the coast north of Bodega Bay was still something of an adventure. We assumed that the people who would come here, who would seek respite on the Sonoma coast, would be drawn to the particular qualities of this place, to its ruggedness and relative isolation, its sense of a territory that had once been more active and was now dormant, waiting to be explored. We imagined that they would seek, in buildings that they would buy or build, qualities that were closely aligned with this character—ready to join in the adventure, and distinct from

those that were designed for more conventional domestic settings. The first buildings at The Sea Ranch pursue this spirit.

The third building constructed at the outset was The Sea Ranch Store, also designed by Joseph Esherick & Associates. The store, which has since been enveloped within The Sea Ranch Lodge, was a further embodiment of these intentions. Initially it carried simple convenience items and contained a small café, a real estate office, and a diminutive post office. It was a nodal point for the potential community. Set back from the cliff and the projecting forks of Bihler's Point and Black Point, the building was a wedge set on the open land, high enough on the coastal shelf to capture stunning views. Its ocean face was low, with sun-shaded windows offering vistas out over the points and up and down the coast. (The condominium was then visible in the south foreground, and the first hedgerow and its houses shaped a more distant edge across the meadow to the north.) On the north, the building face was folded and penetrated by stairs and bays. It was the east side of the building, though, that became its pride. Two stories high, it faced Highway 1 across an open meadow. The front of the building carried the bold and distinctive ram's head logo, which has become a trademark of The Sea Ranch, painted large and white across its face, above the wind-sheltered porch.

A little farther down the road, the mark was painted on a shed-roofed storage building that served, and serves still, as entry sign for the complex. The logo was part of a larger design program that was integral to the conception of the place as it evolved under Boeke's and Halprin's leadership. Barbara Stauffacher, a graphic designer in San Francisco whose clear, crisp, and inventive graphics were already known to Halprin, carried the logo's sense of imaginative analysis and Swiss precision into all of the graphics for the project, ranging from these large, brilliantly spiraling identity marks, to road signs, vehicle markings, bar napkins, and matchbooks—even to sweatshirts for sale that would carry the emblazoned full-chested logo far afield.

With the Moonraker Athletic Center, the fourth building in this initial set, MLTW's Charles Moore and William Turnbull, with the collaboration of Halprin and Stauffacher, took the design adventure one step farther, fusing landscape, building form, and graphics into a single unprecedented construction. The athletic center was to be of small size, to shelter a swimming pool and a tennis court, and to be set at the edge of a tremendous, windy sweep of open meadow. It sounded like a recipe for failure—a blip placed in the face of the wind and surrounded by chain-link fencing. The design overcame all these limitations by working the land and buildings into a series of excavations complemented by earth berms and wood walls that provide both wind shelter and a formal order without intruding on the larger scene. The tiny structures were made expansive inside by bold graphics that enlivened the spaces.

The situation of all these buildings has changed since then. The Sea Ranch Store was extended and transformed to become the restaurant, bar, and lounge, and today also contains a lobby and administrative spaces for The Sea Ranch Lodge (see p. 82-87). Major transformations have also been brought about by the growth of vegetation. Cypress rows that were planted on either side of the access road leading down to Condominium One, have thickened into dense hedgerows, so the condominium can no longer be

seen from the lodge, the highway, or adjoining commons. The original image of rugged buildings standing in the teeth of the wind to stake out a claim over bare landscape has been substantially transformed in the nearly four decades since construction began.

Two hedgerows north, the Moonraker Athletic Center now also sits surrounded by tall trees and is ringed at the bottom by a wooden and chain-link fence, which was added later to meet newly mandated county safety regulations. This severs the initial connection to the meadow. The women's locker room has been redone and its graphics altered, but the original graphics of the men's locker room have been mostly maintained and restored.

Despite these transformations the first buildings still retain their evocative character, and they have influenced many of the later designs at The Sea Ranch.

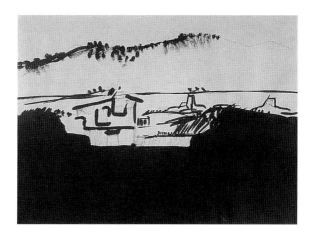

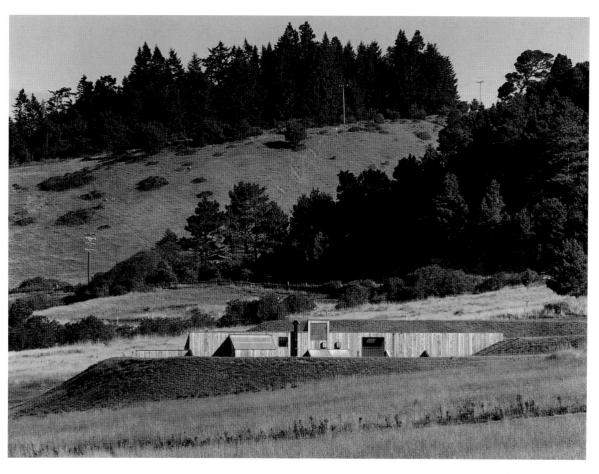

left/top: Early Esherick sketch for The Sea Ranch Store
left/center: Early Esherick sketch for the Demonstration Houses

left: Early photo of Condominium One showing entry to car court from north
above: Early photo of Moonraker Athletic Center with earth berm in the foreground

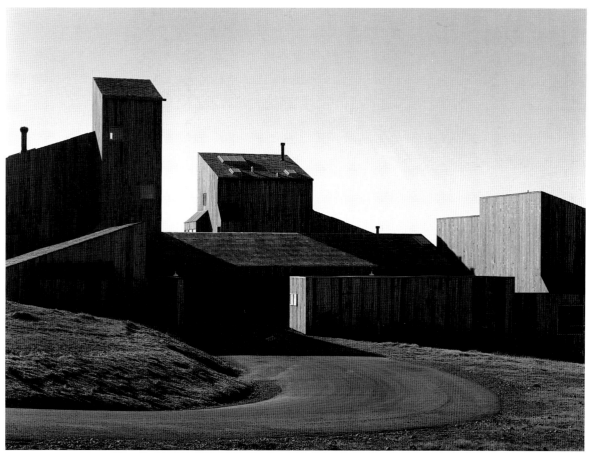

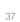

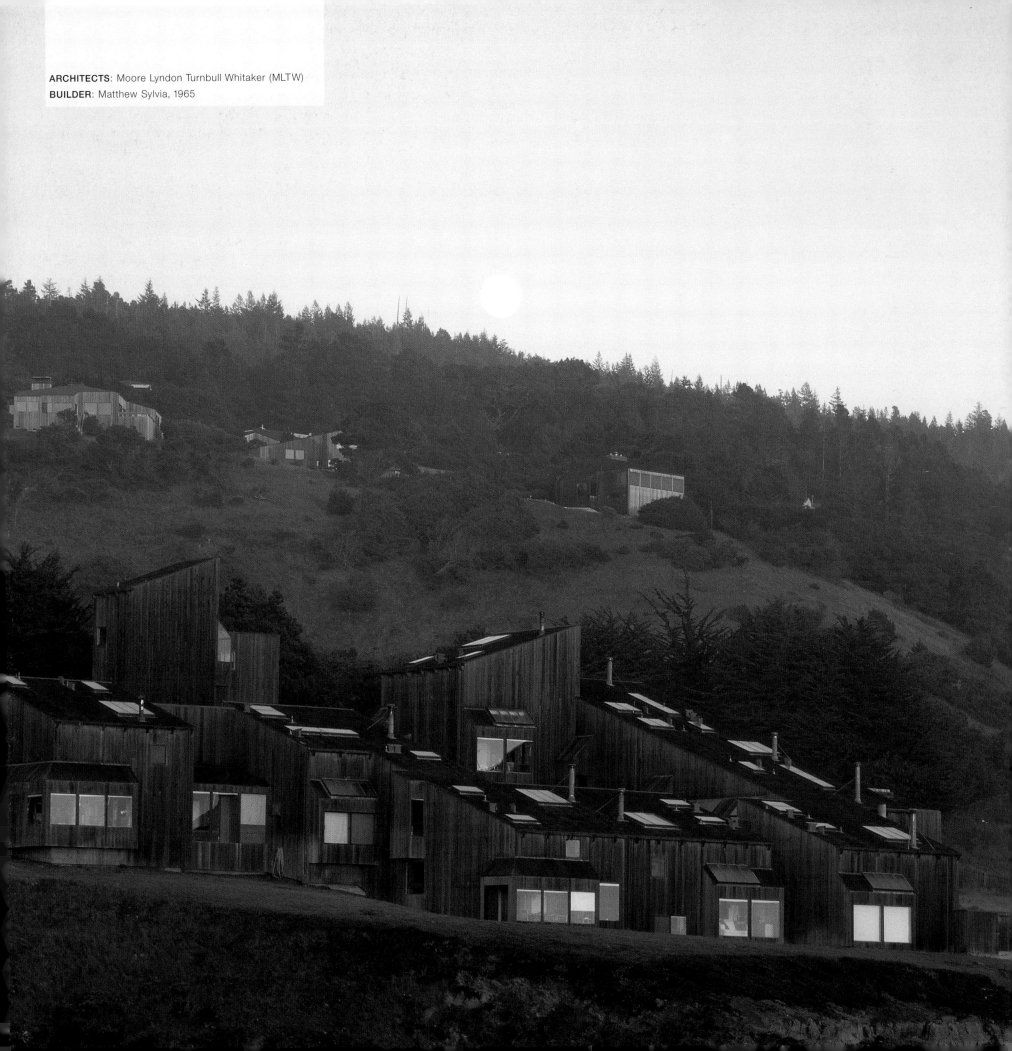

ARCHITECTS: Moore Lyndon Turnbull Whitaker (MLTW)
BUILDER: Matthew Sylvia, 1965

CONDO-MINIUM ONE

(Oceanic Properties [now ten separately owned condominium units linked by an Owners' Association])

Condominium One is dominated by a single roof plane rising toward the crest of the knoll. Sidewalls drop like cliffs from its irregular edges, themselves further modulated by bays, projections, and hollows as they reach to the ground. The volume they make is like a large, rectilinear landform, a wooden escarpment with edges that move back and forth like the boundaries of a cove.

The distinction between individual, separately owned dwellings is measured here in bays, courts, and wrinkles, not in gaps of space and separation of buildings. Each of the condominium units has a different way of relating to the outside—through a greenhouse, through a walled court, through a projecting bay window, through a panoramic spread of windows. Yet all are tucked into the encompassing scheme. The condominium, like the edge between land and sea, records a dynamic balance in the interaction between disparate life forces—in this case between shelter and exposure, and between simplifying ideas and the enriching potential of difference. The relation of the building to the land is not one of visual emulation; it is rooted in the basic organization of the plan and the diversity of its adjustments to the particular conditions of the site. They are erosions, if you will, of an initial geometric order. We looked to the landscape as mentor, learning from its forces what an architecture of the place could become.

The ten individual units in the complex are arrayed around a common court and car court.

They were built all at once, by Oceanic Properties, then sold to individual owners, who each also hold an interest in the whole.

In fact, Condominium One began life on a three-dimensional model of the site, a conventional gray chipboard model showing the contours of the site in stepped increments. The building was quite literally conceived when we began wondering how to represent and place buildings on that sloping form, then realized that the sugar cubes that were close at hand—initially destined for our coffee—were each the right size to represent a twenty-four-foot cube at the scale of the model, about the size units we were charged with making and with sufficient volume to allow for a capacious space on a small footprint. The central importance of this story is that the buildings were conceived as three-dimensional structures touching the land. Using the sugar cubes, units were stacked and assembled on the model in a way that would provide each with advantageous views, while adding up to a common, condensed form inhabiting the slopes of the knoll around which they were placed. They were adjusted, of course, many times, but the model gave us the basis for conceiving the building not as an image applied to the land—or worse as an area of square footage set within property lines—but as a complex and tangible form being brought into existence. To be sure, Esherick and we had the great advantage, working first on The Sea Ranch, that individual property lines for our

39

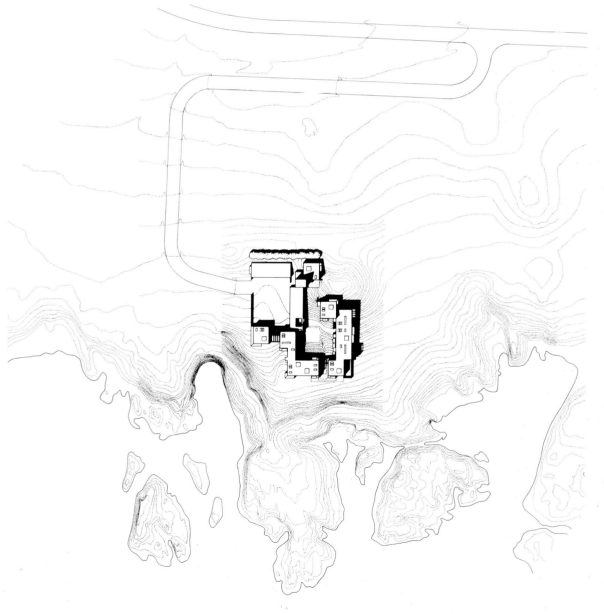

sites were not yet established. We were to place the buildings in a general area in a way that would work, and only then were legal property lines drawn up as a result—rather than as a determinant—of the appropriate building form.

We placed the cubes in configurations, dodging the massing so that each unit would have two sides exposed; each could have multiple views. When the pieces were positioned, we designed a roof that would encompass them all: a single slope covering most of the units was used to minimize junctions and establish a large strong presence in the land, similar to the great barns of the area.

Much has been made, in the architectural press, of the relation of The Sea Ranch Condominium to the vernacular barns and structures of the region. The farm buildings of this coast, with their direct but dignified ways of building, were certainly on our minds, as we admired them on our way to and from the site. There were many handsome examples along our route through the Petaluma Valley and along the coast; many of these have since fallen into neglect and been torn down, making the nearby barn at Bihler's Point and the large, white Knipp-Stengel Barn farther up the coast especially poignant.

Even more insistently present in our minds, since it then straddled the highway, was the great wooden stockade of Fort Ross. The restored nineteenth-century chapel, which occupies one corner, was especially moving, with its heavy board walls and delicate form; its interior radiant from light spilling through a partially internalized white-painted cupola, its walls bearing framed Russian icons brought from far away. The lantern and a small tower at the front formed a compelling silhouette that was firmly imprinted in our memories. The stockade, as Tim Culvahouse and Lisa Findley point out, is an evident precedent for the large car court of Condominium One, which sequesters all cars in one place.[1]

Other influences are visible in the planning for the inside of the condominium. We were then especially mindful of the teachings of one of our mentors, Louis Kahn. What in Kahn's terminology would likely have become "servant spaces"— bathrooms, kitchens, and closets—used to form thick boundaries for a centralized and more important "served space," in this place became

fanciful two-story pieces that stand about in the main volume like oversized furniture, independent of its structure. These are "Allies that Inhabit," sculpted forms that seem ready to spring to life and become our companions.[2] Like big faceted cabinets these smooth-surfaced forms accept layers of paint and capture the changing qualities of light from skylights.

In a similar mode we determined that the structure of the building should be an active element in forming the experience of the place, that it should not be hidden away as little wood studs concealed behind plasterboard. Again the promptings for this were diverse, with the muscular structure of Kahn's architecture whispering in the background, as well as the Bay Region traditions of exposed wood construction, recollections of the Big Sur Inn, and the ready example of barn structures close at hand. Moreover, this was timber-harvesting territory, and forests and mills were nearby. The structure, we determined, could be made of heavy timber, its framing exposed and sheathed outside with redwood boards that would be left to weather and change, like the barns themselves.

Patrick Morreau, whom we engaged as structural engineer, joined us in the delineation of this structure. To simplify the ordering, milling, and placement of lumber we decided to use just a few basic thicknesses, eschewing small adjustments in size that might have been achieved by close calculation but would be unnecessarily difficult to keep track of during construction. Columns would support horizontal beams—girts ten inches deep and four inches thick—at regular intervals vertically, to which wood planks would be nailed to make the wall surfaces. The outer surface of the planks was then covered with building paper, and a second layer of redwood boards attached to hold off the weather. The roof was made in a similar way, though surfaced against the weather more conventionally by wood shingles. An essential part of the assembly was that the horizontal members and roof beams would all pass beside the columns and be attached to them by bolts rather than placed on top of them, resulting in columns that would stand apart from the wall surfaces.

Light coming into the spaces thus always finds a complex set of surfaces to play across,

creating an inner texture of light and shadow normally found only outdoors. Roof beams stretched across the middle of the volume so that columns to receive them had to be placed in the center of two walls. The remaining columns, necessary to hold up the wall structures, were placed three feet from the corner on the perpendicular walls so that the corners themselves were left open. When bays or windows happen here, this results in an easy sense of the outer skin wrapping around inhabited space rather than clustering against a column. The changing intervals of columns along the walls also give an underlying vibrancy to the space.

Additional bays and projections were added to this fundamental structure, allowing each unit of the ten to develop individuality based on special outlooks or conditions pertinent to its position on the site. Since the height and direction of the roof plane inside was almost always determined by the shape of the larger building, and since the floors were set as close to the unevenly sloping ground beneath them as possible, each unit has a slightly different volume, resulting from the varied space left between the sloping roof and the flat floor. The pitch of the roof was set to still leave minimum headroom for a loft at its lowest end, near the ocean. In some units, on the other hand, the roof reaches as high as twenty-eight feet above the floor.

Light enters these spaces in three ways: through the window, through a large square skylight located over the main sleeping loft, and through skylights placed at the highest edge of the volume. The latter are centered on the columns beneath them and bathe their rough squared surfaces and the walls behind them with a shifting radiance that reflects through the space, highlighting the tangible presence and effort of construction. Balancing the light and view in these spaces was especially important, because they are so close to the sea. At its most extreme, the afternoon sun reflecting off the ocean can be almost intolerable. We considered the various ways of reducing the glare that are commonly used on the California coast (roller shades, extensive louvers and sunshades, tinted glass) and found them all wanting. In the end, we realized that there was only one really successful strategy—looking away from the sun. So we made

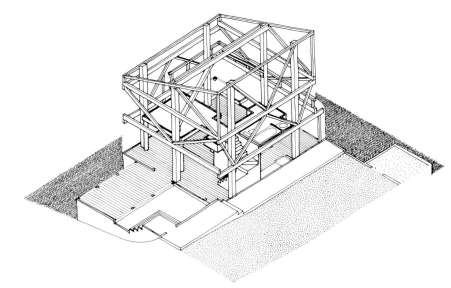

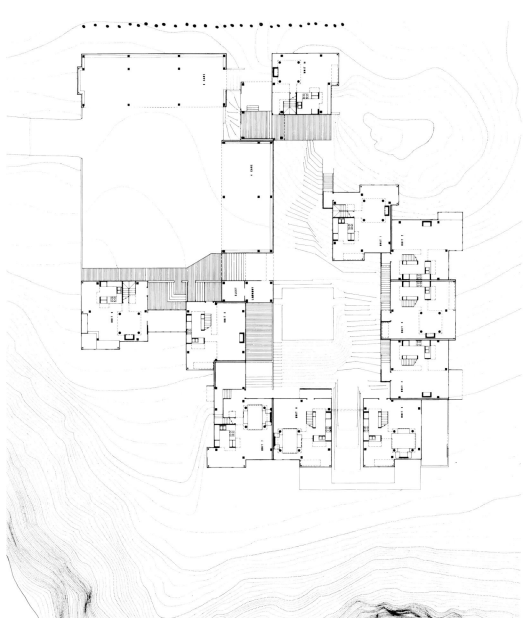

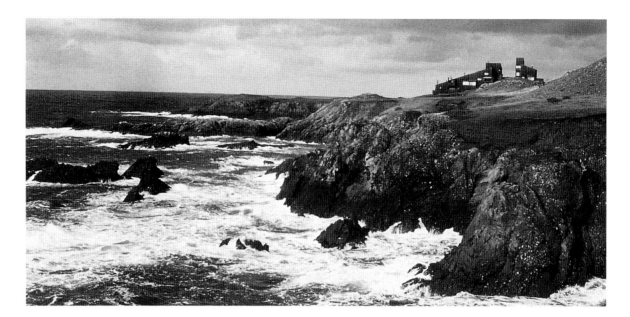

sure that each unit had multiple outlooks and alternative ways to receive light. This accounts, in part, for the many offsets that occur in the overall plan.

Even more important to the conception of these interiors was the notion of a "four-poster," a small square structure of four round posts and a box of space that would stand independently in the larger room, holding the bed area aloft in the high volume while making a place of special intimacy and focus beneath it. We were encouraged in our thinking about this by the frequency with which a four-posted pavilion occurs in the history of architecture throughout the world, and specifically by Sir John Summerson's book *Heavenly Mansions*. He writes eloquently of the way in which "the aedicule," a miniature semblance of a house, is a device that was used often in classical and medieval architecture and painting to enframe and give importance to a god or saint.[3] Others concluded that such inviting imagery is a thing of the past, discarded but wistfully remembered. We thought it was just the ticket for affirming in the present that people are the nexus of place.

Planning for the units then became a matter of placing within the twenty-four-foot square footprint the four-poster, the sculpted "cabinets" of kitchen and bath, and a stair to reach the upper levels of both. In the end we devised two sets of these elements, one with a one-bedroom–size four-poster and the other with a loft holding the equivalent of two rooms all across

one side of the upper space, with accompanying changes in the layout and form of the kitchen and bathroom blocks. We then set about examining each square volume in the plan. In the first site plans we had assumed that each enclosed unit of the complex would have an attached glass porch, itself a smaller square. These would serve to gather sun and to create places to sit outside the main volume, yet protected, in the face of the wind and the ocean. The recurrence of squares in these arrangements was not accidental. We wanted everything to be explicable in plan and elevations; the forms we used are either a self-regulating geometry (squares) or shapes that are evidently tied to specific circumstances (e.g., handrails, roof slopes, intersections with the ground). As the plan was refined, these abstracted porches became much more specific and transformed into simpler, more pertinent adjuncts: bays, courts, a greenhouse, an exterior balcony, each positioned to advantage along the perimeter of the complex—intimate spaces, poised on the edge of the rough and ragged shoreline.

The resulting building edge presents an array of differences that are enfolded within or appended to the encompassing mass of the whole. It is a political image, really: each part has its individual identity, its particular advantages; but together they create a place of singular distinction, a common form that has sufficient presence to become a part of this majestic landscape, "establishing a foot hold on a grand and sweeping site," notes

Henry Plummer, "that could never be accomplished by a single small dwelling."[4]

Christian Norberg-Schulz noted in *Architecture: Presence, Language, Place* that the condominium's planning,

"interpreted in a new and interesting manner a given place and a specific tradition. The stimulus in this case was offered by the 'windswept' northern California coast, and by the simple building volumes of the American West, faced with smooth redwood. These presuppositions, well comprehended and related to the present, imprinted the entire complex in a characteristic way. Even the *plan libre* was further developed, both in the open interaction of 'space in space' on the interior and in the mutual relationship of the volumes on the exterior. We might say then that Sea Ranch offers a convincing interpretation of the new art of place."[5]

1 Tim Culvahouse and Lisa Findley, "Once Again, by the Pacific: Returning to Sea Ranch," *Harvard Design Magazine* (Fall 2001): 44.
2 For more on this concept, see Chapter 7 of Donlyn Lyndon and Charles W. Moore's *Chambers for a Memory Palace* (Cambridge: The MIT Press, 1994), 149–175.
3 John Summerson, *Heavenly Mansions* (New York: W.W. Norton & Company, 1963), 3.
4 Henry Plummer, *The Potential House* (Tokyo: a+u Publishing Co., 1989), 214.
5 Christian Norberg-Schulz, *Architecture: Presence, Language, Place* (Milan: Skira Editore S.p.A., 2000), 340.

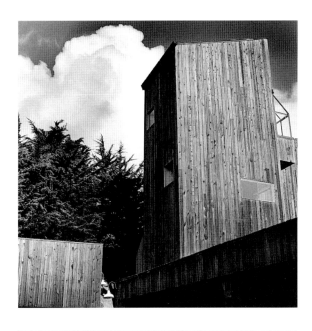

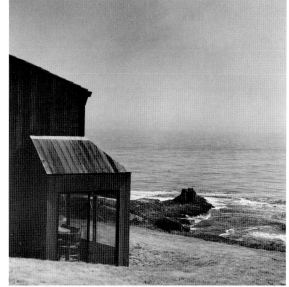

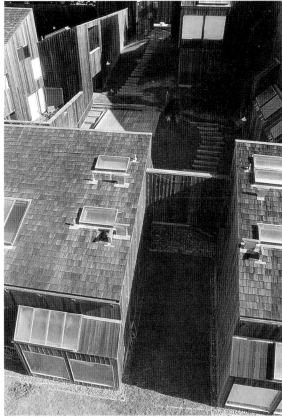

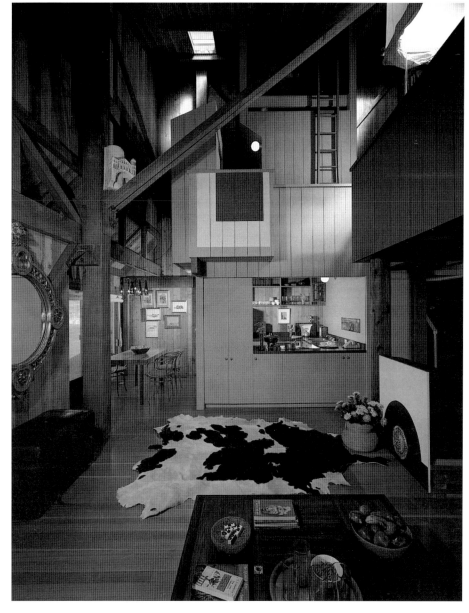

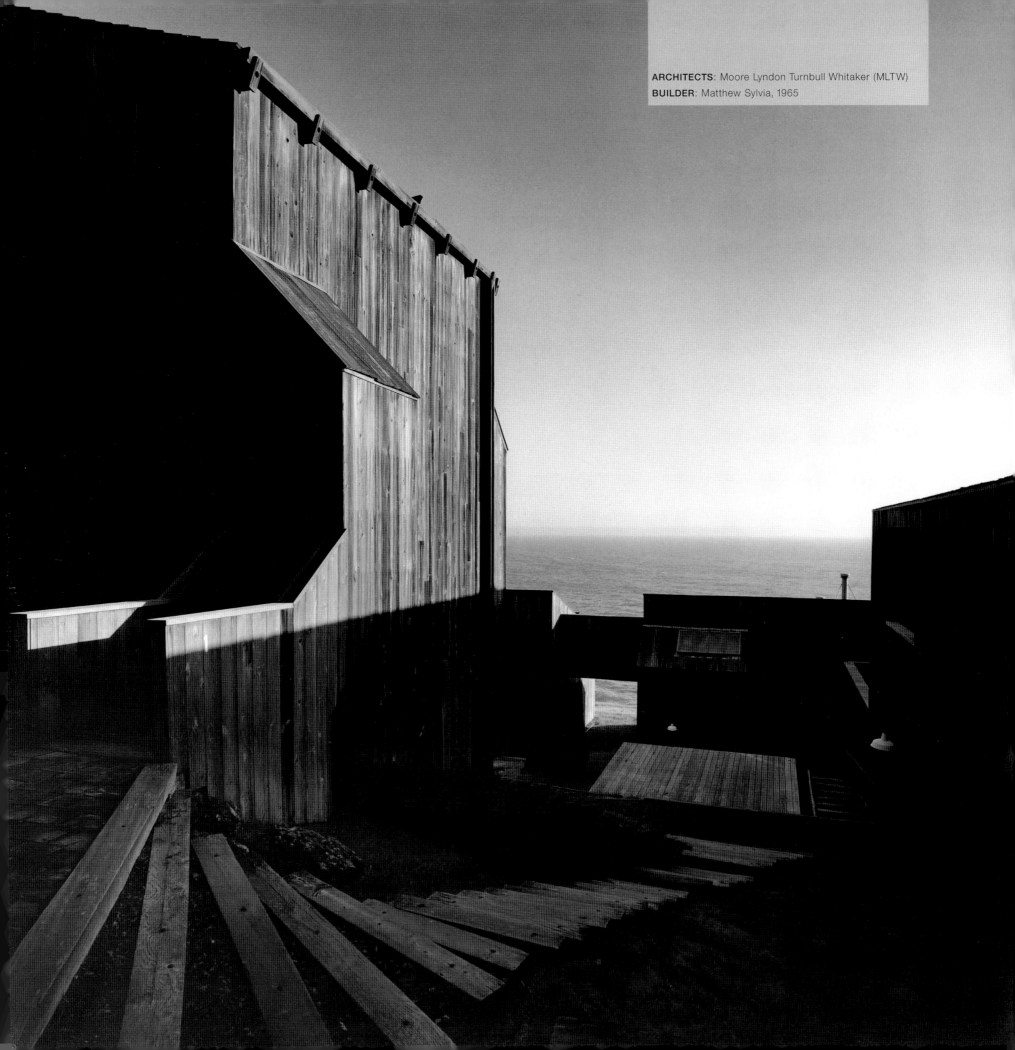

ARCHITECTS: Moore Lyndon Turnbull Whitaker (MLTW)
BUILDER: Matthew Sylvia, 1965

CONDOMINIUM ONE/UNIT ONE

(now owned by the Waltons)

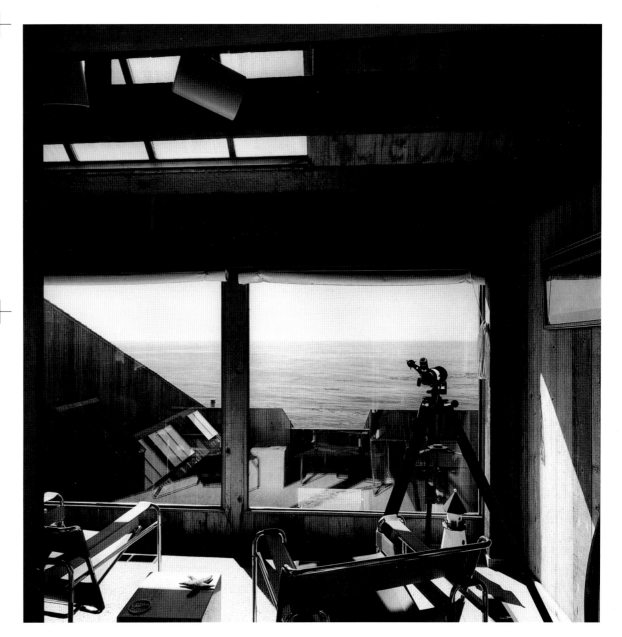

Unit One is at the crest of the long building, nestled into the edge of the knoll. It is one of only two units that do not lie under the common roof plane, with its roof oriented perpendicular to the larger one and its high side facing south. It pairs with Unit Ten, which is across the knoll in a separate building, to form the two towers that mark the condominium's silhouette from a far distance. The ground between them, with a magnificent view south down the coast, is one of the four knobs that originally defined a bowl in the land and was the basis for the condominium's siting.

Highest in the string of units that climbs up the hill on the south side of the court, Unit One is high enough so that its floor is well above the eye level of people passing through the court below. Redwood steps set into the hill rise up from the court to meet, near the top, a small entry porch and stair that projects out from the building's surface.

The inside of Unit One is traversed by three different lines of view: to the east, immediately close at hand, are the rocks and the pine tree of the knoll top, seen through a bay of three square windows, their sills lower than the crest of the rocks. That bay wraps around to the south where a sliding door opens to a dramatic view over the bowled meadow and down the ragged coastline. Redwood log rounds step down from here to the sloping ground. The four-poster occupies this corner of the room, its columns marking out a definitive place from which to see far beyond. Diagonally across the tall room a broad bay

opens to views over the top of the court, and out to the ocean's horizon and Bihler's Point. Above the four-poster is the space for the bed, enclosed by railing-height walls and flooded with light from the large square skylight above and from an exceptionally high window that brings in the first morning sun.

Alice Wingwall and I were the first owners of this condominium unit, and we have never put aside the memory of the expansive space, of the morning sun, and the views far along the coast, or down into the intimacy of the living space below, with the family table placed in the court-side bay. We had three young children then: the closet by the stair became a bedroom for the oldest, a wicker basket in the closet by the bathroom provided

for the youngest, and a specially designed high-stepped seating platform with a hidden door opened to become a bed chamber at night for the mid-sized. We were as happy as clams.

Shortly after we moved to Massachusetts, in 1967, the unit passed into other hands, and has had a succession of careful owners since. New floors have been put in, the smooth wooden walls of the kitchen/bath blocks and the four-poster's edge have changed colors. Arrangements of furniture inhabit the place differently with each owner, playing new riffs on the locations provided: in front of a woodstove in the highest part of the space, under the comforting four-poster, and in bays toeing the hill or thrusting out toward the sun and the sea.

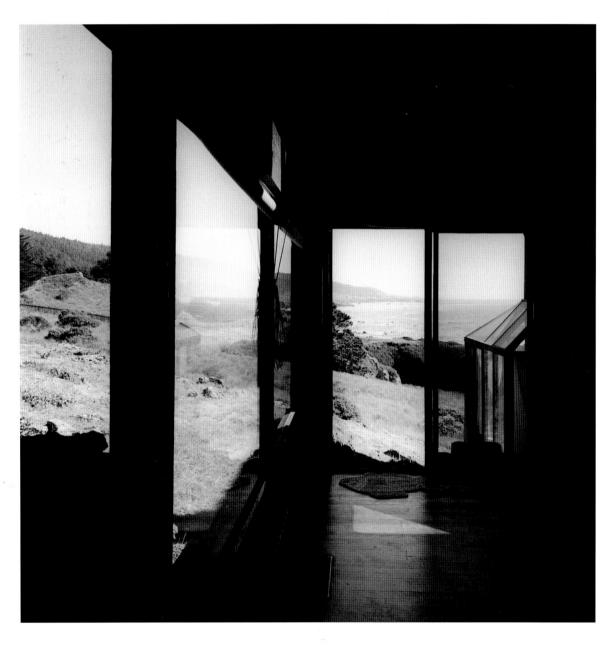

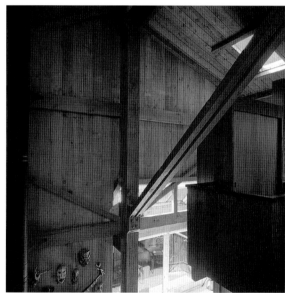

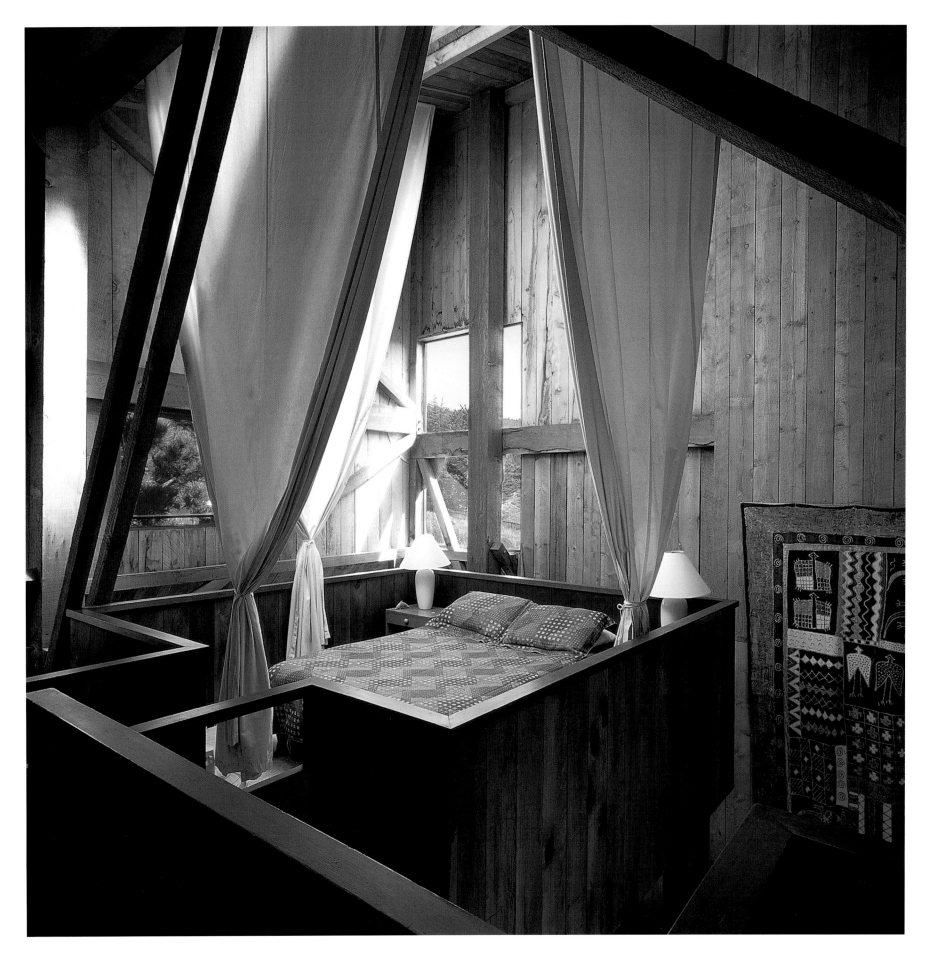

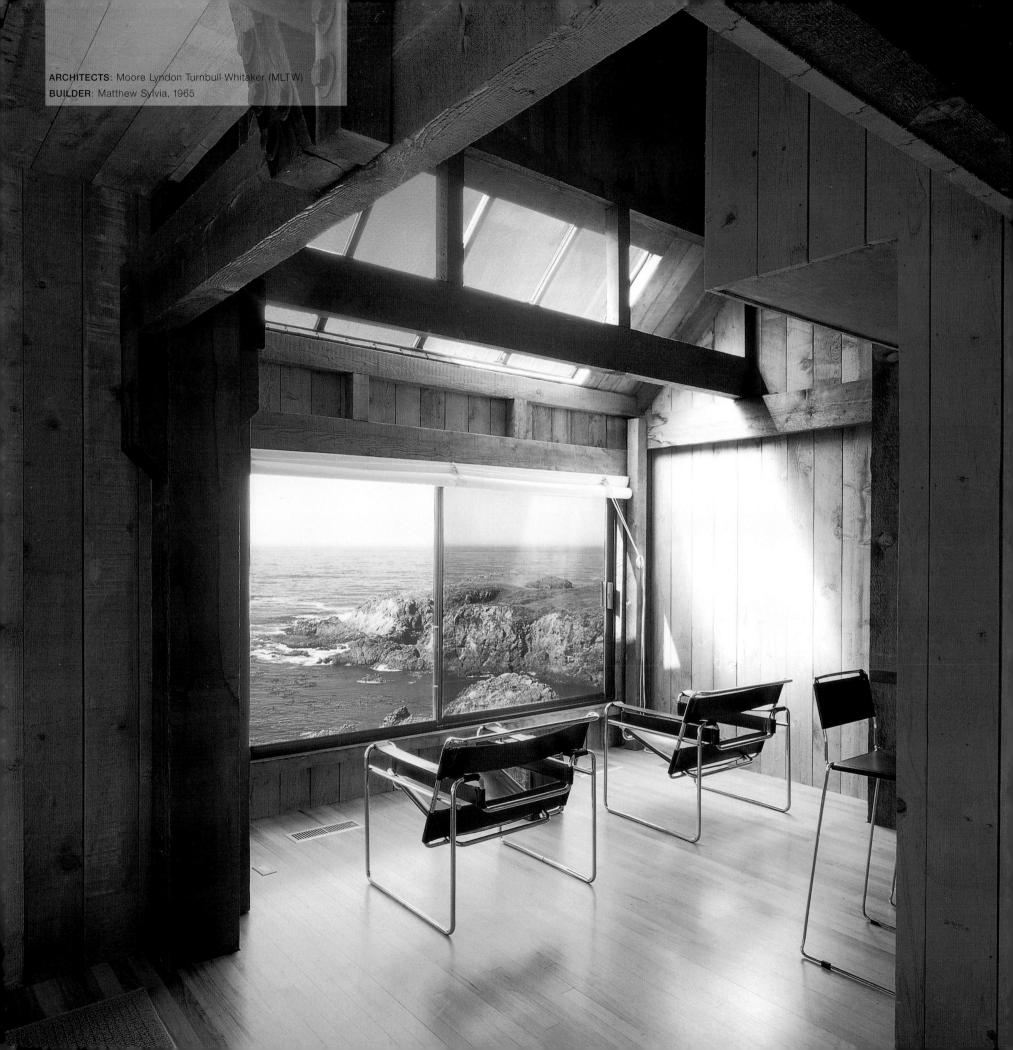

ARCHITECTS: Moore Lyndon Turnbull-Whitaker (MLTW)
BUILDER: Matthew Sylvia, 1965

CONDOMINIUM ONE/UNIT EIGHT

(now owned by Trulove/Duncan)

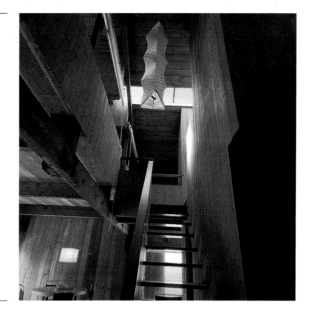
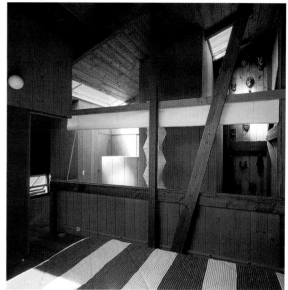
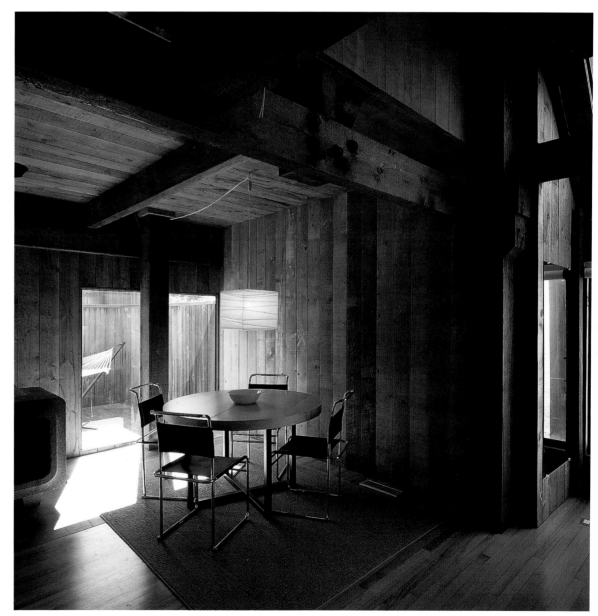

Unit Eight, entered through a small walled space that steps down from the car court, is quite different. Its interior gathers light from the great central court through large south-facing windows. At the living level a wide sliding door opens to an enclosed private deck, which spreads across the whole width of the space, soaking in the welcome southern sun and separating the interior from the great court it adjoins. The volume of this unit is half filled with a loft, divided into two spaces above.

The area by the court is covered by the loft above, setting intimacy to the living area. On the opposite side are the kitchen/bathroom assembly rising high into the volume with open-tread stairs that let light pass through the room. On the northwestern corner a twelve-foot-wide bay projects forward to open views to the rolling surf of Bihler's Point across the cove and the evening sunsets beyond.

This ocean-facing bay, like that of Unit One, has a skylight mounted in its ceiling, which casts light on its walls throughout the day, animating the stocky wood framing and diminishing the glare created by bright ocean views seen through dark walls. As in all the condominium units the outer walls of the main space are made of planks that have been resawn to gain a rough texture, while the walls of the interior divisions and partitions are smooth-surfaced boards, in this case stained a vigorous golden orange. The fall of light from high skylights is here especially important, transforming the narrow spaces between elements into vivid glimpses of the larger encompassing volume.

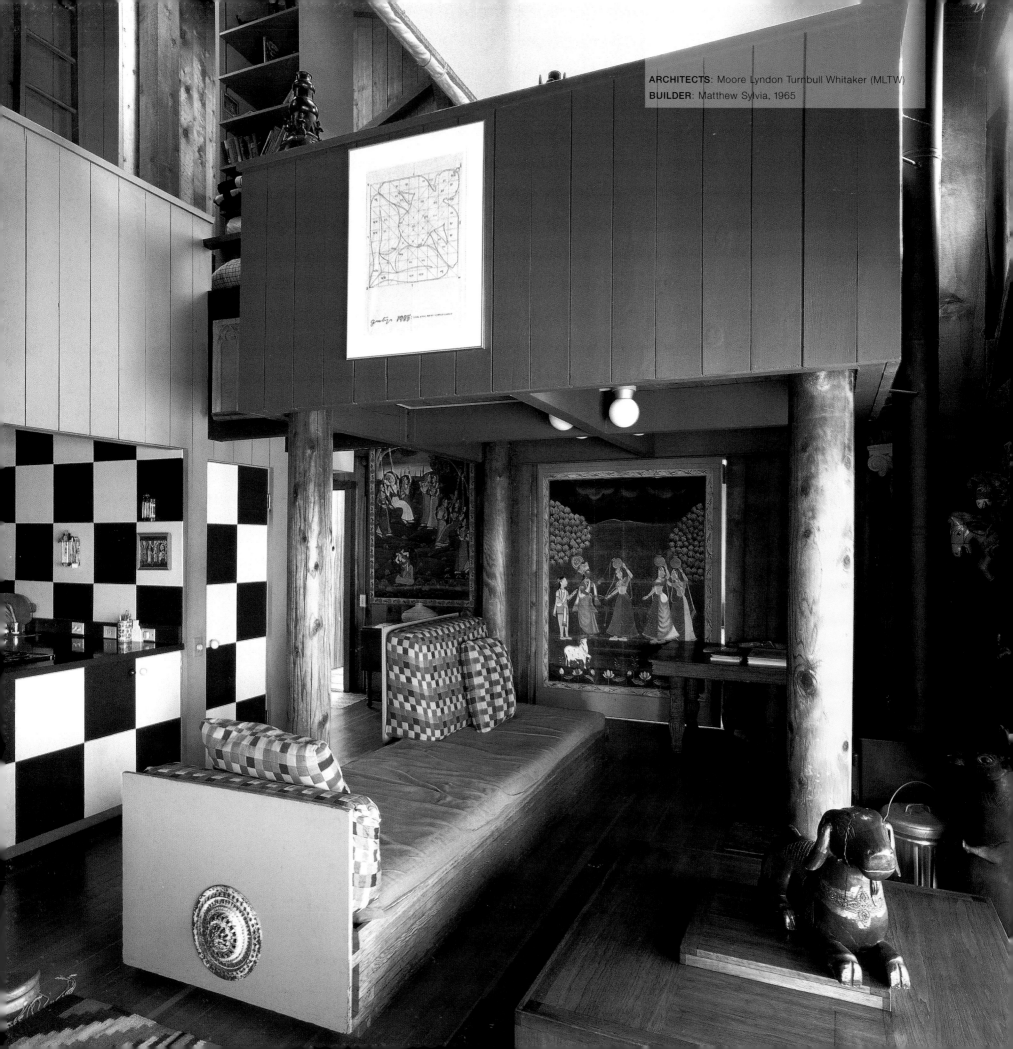

ARCHITECTS: Moore Lyndon Turnbull Whitaker (MLTW)
BUILDER: Matthew Sylvia, 1965

CONDOMINIUM ONE/UNIT NINE

(Charles Moore's unit, now owned by his nephews, the Weingarten brothers)

Unit Nine is the most well-known, the most photographed, and the most elaborated of the dwellings in the condominium. It belonged from the beginning to Charles Moore, and is now owned by his heirs. During the years that he owned it, Charles was continually reimagining the unit: adding objects and furniture that took his ever-active fancy, painting and repainting its "finished" surfaces, and filling it with his wit and companionship. It has been published throughout the world and visited by an endless succession of architects, many of them colleagues and students working on projects with Charles, or hoping to.

The situation of Unit Nine is unique. It is the northernmost of the ten and closest to the ocean, seeming practically to hang out over the cove formed by Bihler's Point. Like Unit Eight it is entered through a recessed court, walled against the cars, but bordered on the ocean side by a small room glazed on either side, close kin to the glass-box addendum of the original scheme. A solid door leads from the entry court into a corner of the large volume, between the stair and the four-poster. Diagonally across the room, past the round posts of the timber frame, a benched corner bay provides a striking view of the cove. "It contains you, out beyond the heavy structure, on a light, delicate ledge, just yards from the bluffs and the surf below," note Culvahouse and Findley. "This place, secure and comfortable, and yet in the edge and also reaching beyond the edge, beckons the moment you arrive."1

Almost simultaneously, though, the eye is drawn to a large ornate mirror that Charles brought to the place at the very beginning, and then on to a medley of objects, toys, and images that were assembled over the thirty years that Charles remained emotionally anchored to this place. He constantly roamed around the world—on commissions or for the fun of it—an inveterate traveler and chronicler of places, changing residences, places of work, partnerships and professorships, changing everything but his attachment to this place: "For the past 25-odd years, the Sea Ranch has been my Mother Earth; a place where I have gone, and continue to go, to have my energy and spirit rekindled. My condominium at the Sea Ranch has been a source of continuity and a constant in my life, which has been on the average anything but regular."2

He wrote this some months before his death in 1993. My count of his attachment to this place is thirty years, even though the building was not completed until 1965, because I am quite certain (though he never said so) that he knew from the outset of our studies that this would become the place that was his.

He shared it mightily: with friends, associates, and all comers. Charles was always welcoming when he was there and made the place available to others when he was not. At one point locals observed jokingly that "there's probably not an architect who visits the North Coast who does not know about the key under the pot on the deck," and there are tales of colleagues arriving from India for a visit, only to discover someone else already there, enjoying one of Charles's ubiquitous invitations. The place was always abuzz with activity, often with several groups of colleagues working on and discussing multiple design or writing projects. Over the course of his career Charles Moore formed many partnerships—MLTW in Berkeley, MLTW/Moore Turnbull in San Francisco and New Haven, Centerbrook when he was dean of architecture at Yale, later Moore Ruble Yudell in Los Angeles (where he also worked with the UCLA Urban Innovations Group), and finally Moore Andersson in Austin. Nevertheless, nearly every major project had some part of its conception and evolution in this room and the glass link beyond, which became a burgeoning workroom. Likewise, significant parts of most of his books were written here; *The Place of Houses* and

Chambers for a Memory Palace, which we co-authored, for instance, were written in many venues, but centered in this room—indeed, a chapter in the latter, titled "Images that Motivate," ends with a description of the view into the cove and the abundant sense of life that it contains.3

Unit Nine shares in that sense of life, not only in the memories that echo through it, and in the collections of folk objects and Indian paintings that filled it with vivid inhabiting images (most of which remain, since Charles's heirs have kept the unit intact and still make it available through a rental program), but in the inherent qualities of the structure itself. These include the play of light across rough wood surfaces, the vibrancy of a bold red-and-white checkerboard pattern that Charles painted over the lower surfaces of the kitchen block, and especially the energizing space that surrounds all elements as they stand free within the encompassing walls—the columns, the four-poster, the canvas canopy above it, and the furniture pieces, which Henry Plummer called, "smaller precincts of smooth wood, each brightly painted into a tiny beloved house, a happy collection of gaily-sculpted shapes piled to the ceiling."4

The space flowing and expanding and curving diagonally up through the nearly cubic volume, coiling around the objects, is like the animating void in a Chinese painting—suggesting the breath of life. With the condominium still on the drawing board, the following appeared in an article that I wrote for *World Architecture* 2:
"Chinese Art, we were taught by George Rowley at Princeton, proceeds from the ideational to the Empirical, from ideograms to wrinkles. We would like to conceive buildings that have the emotive power of the former and design them to the world-warped wisdom of the latter. [The design of Condominium One at The] Sea Ranch is a step in both directions."5

1 Tim Culvahouse and Lisa Findley, "Once Again, by the Pacific: Returning to Sea Ranch," *Harvard Design Magazine* (Fall 2001): 44.
2 Charles W. Moore, "Sea Ranch: Moore's Home Turf," *Progressive Architecture* (February 1993): 98.
3 Lyndon and Moore, *Chambers for a Memory Palace*, 293–295.
4 Plummer, *The Potential House*, 214.
5 Donlyn Lyndon, "Sea Ranch: The Process of Design," quoted from John Donat, ed., *World Architecture* 2 (London: Studio Vista Ltd., 1965), 38.

51

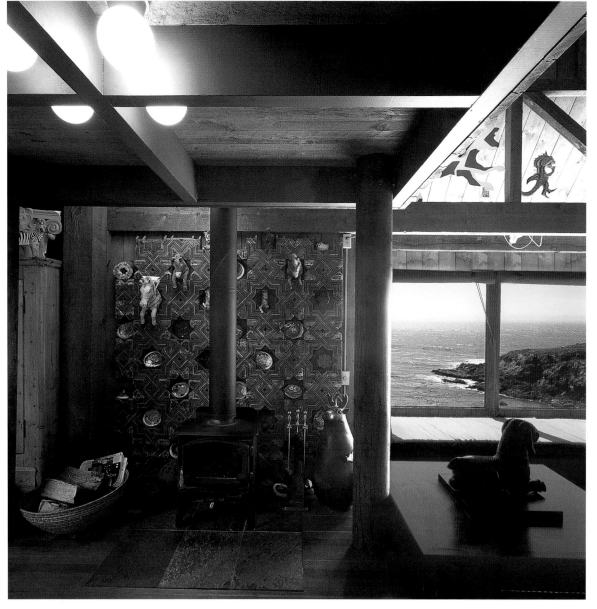

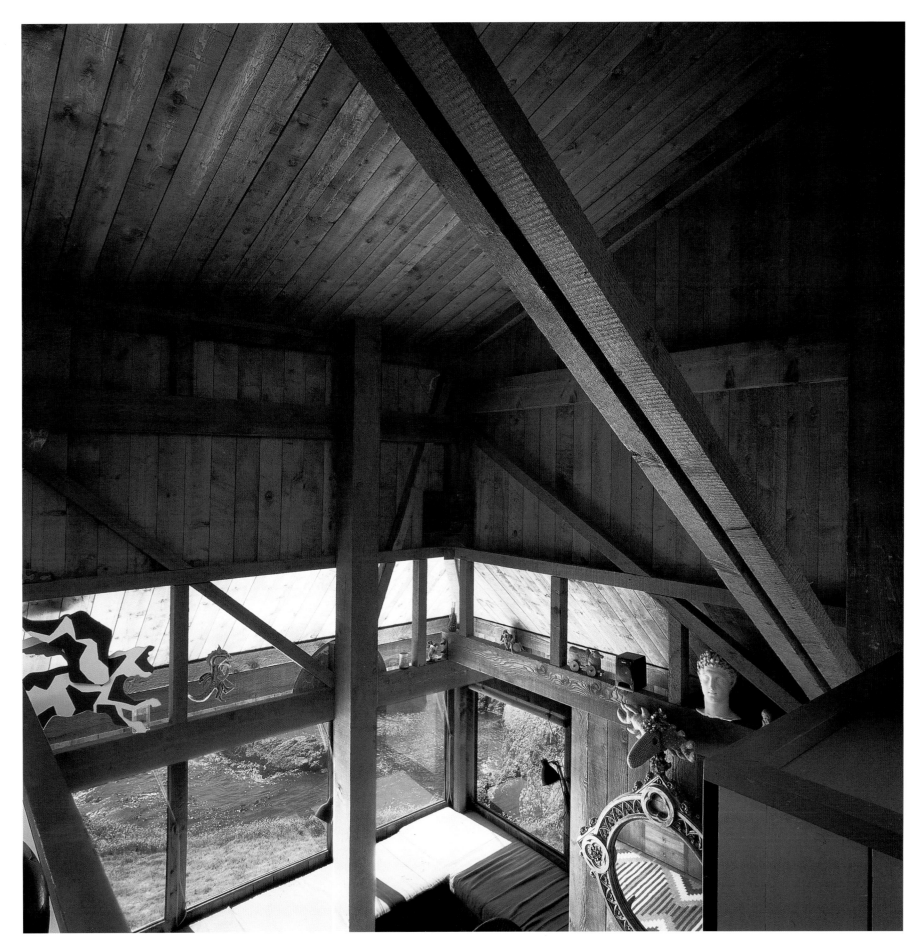

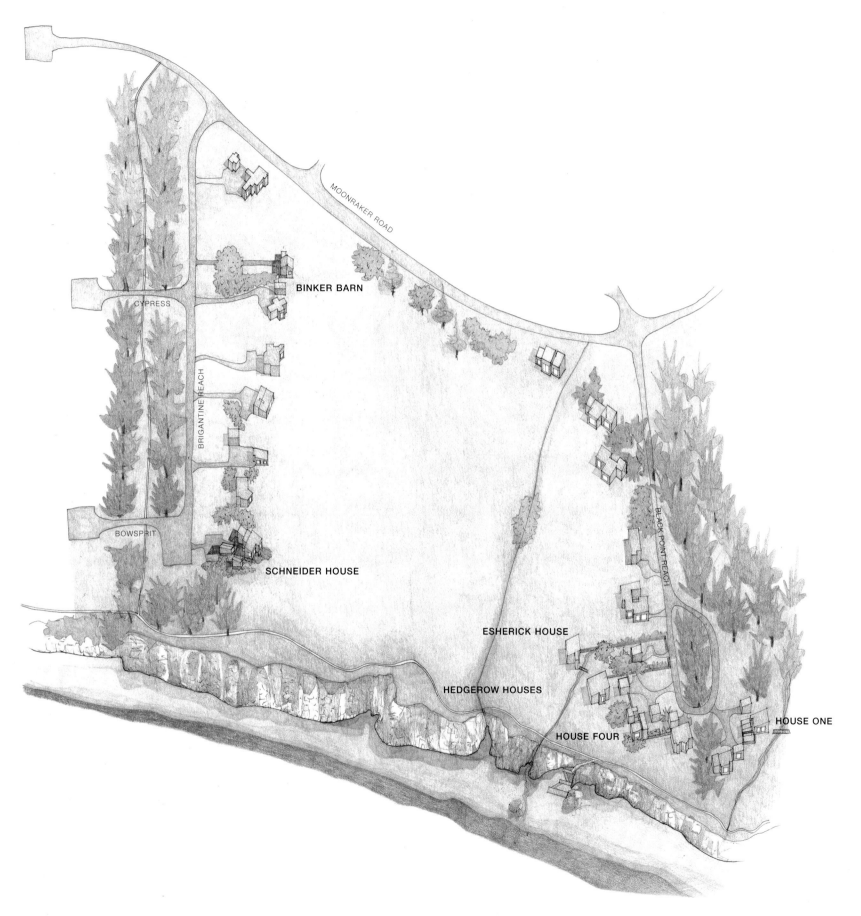

54

MOONRAKER ROAD

CYPRESS

BRIGANTINE REACH

BOWSPRIT

BINKER BARN

SCHNEIDER HOUSE

BLACK POINT REACH

ESHERICK HOUSE

HEDGEROW HOUSES

HOUSE FOUR

HOUSE ONE

HEDGEROW HOUSES

Demonstration Houses
(Oceanic Properties, now separately owned)

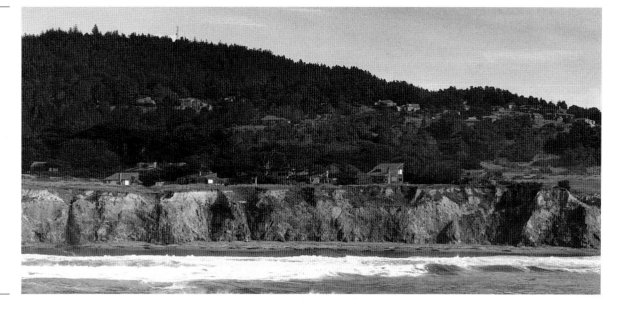

The roofs of each of the Esherick Demonstration Houses, which are clustered at the end of a hedgerow, follow the same general slope and orientation—down into the wind, up for the sun. Seen together from the north they lie along the edge of the meadow, their surfaces rising toward the hedgerow behind. They vary slightly in a manner that relates closely to the meadowland before them, which rolls irregularly as it slopes toward the cliff. Those houses with sod roofs are sloped at a lower pitch than those roofed with shingles, and some have protruding dormers that give light and outlook to second-floor rooms inside.

When the Hedgerow Houses were first built, they revealed more sharply than they do now the sensibility that has shaped them. With their insistently parallel orientation to the hedgerow, they were like swift brush strokes in an Oriental landscape, embodying the forces of the site with alacrity and skill. They infused the place with human energy, even as they submitted to the discipline of the forces that formed it—not only the wind, the land, and the tree forms, but the decisive, orienting line of trees, scribed across the meadow by earlier ranchers.

As vegetation in the sheltered courtyards and adjacent to the houses has grown—and as the hedgerow itself has expanded and changed over time—the Hedgerow Houses have become nearly indistinguishable from the mass of vegetation. They have fused into the landscape of which they are a part, like the cobbles embedded in conglomerate rock found just below in the bluffs of Black Point.

The hedgerow was planted in 1916; hence, the houses, built fifty years later, have now been a part of the place for nearly as many decades as the hedgerow had been when construction began. The clarity of the line set by the hedgerow has been muffled not only by its own growth and change, but also by a large stand of conifers planted in its lee to the south, intended by Halprin as a planting ground for trees that could later be transferred to other sections of The Sea Ranch. Many were, but a significant stand remains, broadening the original crisp line of the hedgerow at its end near the ocean. The decisive line continues, however, not only in the row of trees but also in the orientation of Black Point Reach, the road that loops around parallel to the trees to provide access to the houses and additional lots. The line is reinforced again in a row of continuous redwood board fences that stretches along the road, defining a crisp public/private differentiation on the access side and between lots, while leaving the connections to the meadow and the bluff open to the common lands, unmarked by fences.

Just as the Hedgerow Houses together form a gentle inhabited edge to the meadow on their north, the board fences on the southern face of these same lots present a model for quiet, thoughtful delineation of common boundaries. This roadside fence, its configuration, and materials, is an important aspect of the original planning and design that is often overlooked. The long row of simple board fence at the property line is made as a common face for the public

realm, and not as an individuated expression of the private properties beyond it. It speaks of continuity and common purpose. This is made abundantly clear toward the ocean end, where the fence steps back along the boundary of lot 7 and joins with the garages for lots 8 and 9 to create a common drive and parking court. Between the buildings the fence dips down to open, for passersby on the road behind, a splendid view up the coast to Gualala Point. Working in consort with the preexisting hedgerow and the geometry that it initiated, the ensemble creates a place of real distinction—a place that shows respect for the private worlds of each house, as well as for the common realms of street and meadow.

The houses themselves were all designed at one time, using three different compact and efficient house plans, modified slightly, for the six Demonstration Houses and a separate plan for the Esherick House, built somewhat later but within the same complex. The houses contain two or three bedrooms, and each has a double garage. The most frequently repeated plan shows a cross of circulation in its middle, with bedrooms and bath on one side and commonly used spaces on the other. Rooms inside are for the most part conventional, grouped within very simple rectangular volumes, with occasional additions to capture special views, add space, or accommodate utilities. The underlying idea was that these houses, larger than the condominium units, should be built simply and with compartmented spaces: "Living patterns don't change

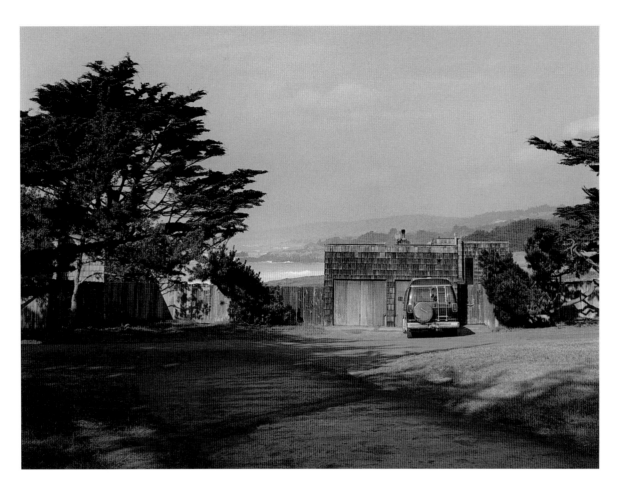

that much from town to country. Adult and chil-
dren cycles still conflict. Privacy is important,"
Esherick explained in an early publication in
Progressive Architecture. Or, as the editors
observed at the time, "The Esherick houses are
just conventional enough to deceive the suburban
housewife."[1]

As Esherick stated, he was "primarily interest-
ed in...producing a building form that got rid of
the wind and made for a comfortable shelter on
the sunny side of the building."[2] Accordingly, the
volumes were all made with slopes that were
designed to create wind-protected places on the
south. Esherick credits his associate and subse-
quent partner Peter Dodge, who was also teach-
ing at Berkeley, with the research for the ideal
slope, which included crude wind-tunnel tests,
leading to the conclusion that the most effective
wind shadows were created with roof slopes
somewhere between two and a half inches of rise
in twelve inches of run, to four and a half inches
in twelve. Esherick used both slopes, covering the
roofs that were too low for shingles with sod,
placed on top of waterproof membranes. The
varying pitches of the roofs, combined with slight

adjustments in orientation to fit the land, and a
staggered position along the bluff to give each
house views of the ocean, make the forms so
effectively sympathetic to the naturally varied
meadow surfaces. These variations, while wel-
comed, even sought out, were not initiated by
stylistic considerations; they derive from the spe-
cific conditions of the site, imbuing the buildings
with particularity, as do the syncopated windows
and the bays of various shapes that capture
specific aspects of view and light, bonding the
houses to their immediate locations.

1 "Ecological Architecture: Planning the Organic Environment,"
Progressive Architecture (May 1966): 130.
2 Joseph Esherick, "An Architectural Practice in the San
Francisco Bay Area, 1938–1996," 1996, an oral history con-
ducted in 1994–1996 by Suzanne B. Riess, Regional Oral
History Office, The Bancroft Library, University of California,
Berkeley, 1996.

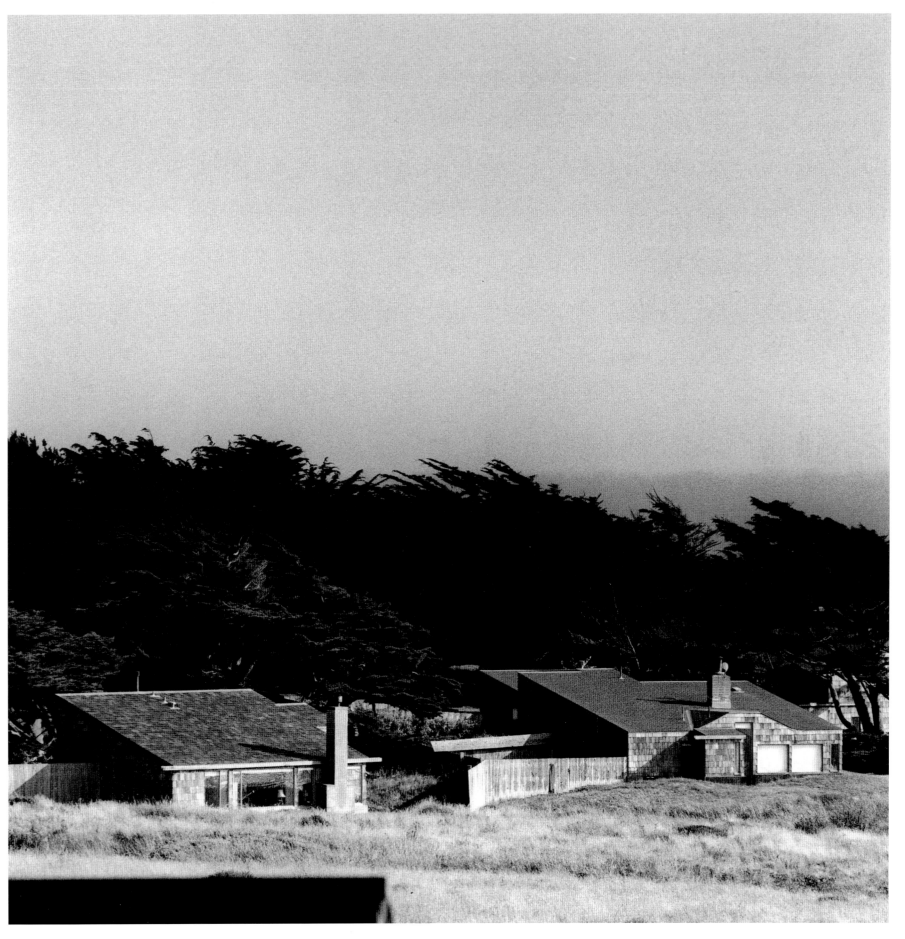

ARCHITECTS: Joseph Esherick & Associates
BUILDER: Matthew Sylvia, 1966
ADDITION: Robert Harstock, 1987

HEDGEROW HOUSE ONE

(now the Hudspeth House)

This Demonstration House sits on the south side of the hedgerow, protected from the wind but with its roof still rising to the sun, its footprint close to a stream that angles by on its way toward the north side of Black Point, where the beach begins at the bottom of the cliff. Its plan, which was not repeated in the first set of buildings, is exceptionally simple, even by Esherick standards, yet it interlocks wonderfully with its surroundings. Square, with a wedge-shaped volume, it was amended only by a projecting utility room and entry porch, and a nearly flat-roofed dormer with skylights, which projects from the middle of the roof to provide headroom for a compact upstairs bathroom. Spaces on the ground floor flow around a walled enclosure that holds the kitchen and some storage. The primary living spaces are a few steps down from the kitchen and dining area, following the fall of the land toward the stream.

Directly opposite the entry, a stair leads up to an open loft over the living area. Another loft room beyond it to the right is now used as a study, filled with sunlight and a broad ocean view. The most intimate part of the house, focused on a woodstove and with only limited exposure to the outside, lies underneath this loft. Whereas most of the house had originally been surfaced with resawn boards, the walls here have been resurfaced with gypsum board and painted white to give more light to the space.

The southwestern end of the room is splendidly linked to its site. A sliding glass door opens onto an eight-foot-wide flat wooden platform that projects directly out from the space to bridge the nearby stream in a single gesture. From this platform, or the corner of the room nearest to it, views lead in multiple directions—up and across to the rising open meadow to the south, back along the stream through the trunks of pine trees that have grown tall along the edge of the site, or, most dramatically, down the crevice of the stream as it cuts into the bluff, revealing bits of the Black Point cliffs and the white pounding surf below. From this place you *know* your position in the landscape.

In 1987 Robert Harstock designed an addition for the house, replacing a part of the entry court with a shed whose roof follows the direction established for the house. The entry has been redirected around it and is now into the same spot but from the side. A narrow entry court is to one side of the addition, and the added bedroom opens up to an enclosed patio, which is shared with the dining room and kitchen. Looking out from this space toward the ocean, the nearly blank wall and fence of the property adjoining to the north help to frame the view with an attractive sense of close neighboring, yet without mutual intrusions.

The house is both distinct to its place and a part of the larger enterprise—a demonstration that houses and yards can be grouped together in ways that enhance the landscape, while yet yielding great advantage for each individual building through attention to the specifics of the site.

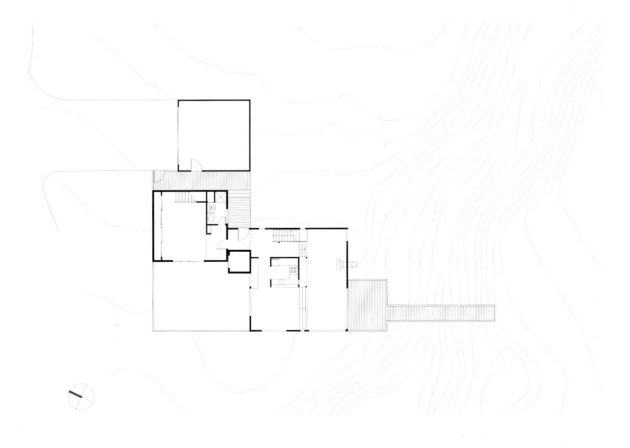

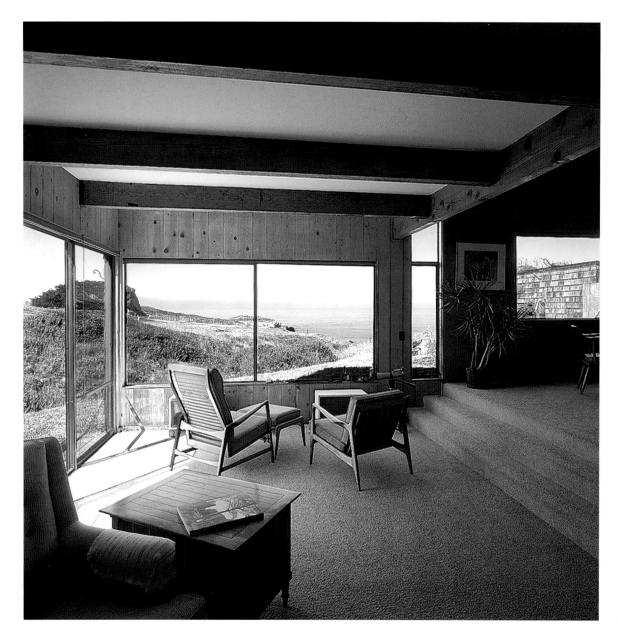

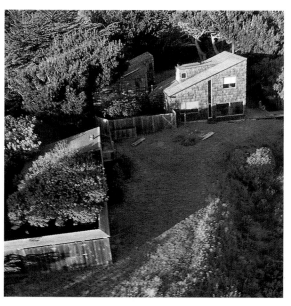

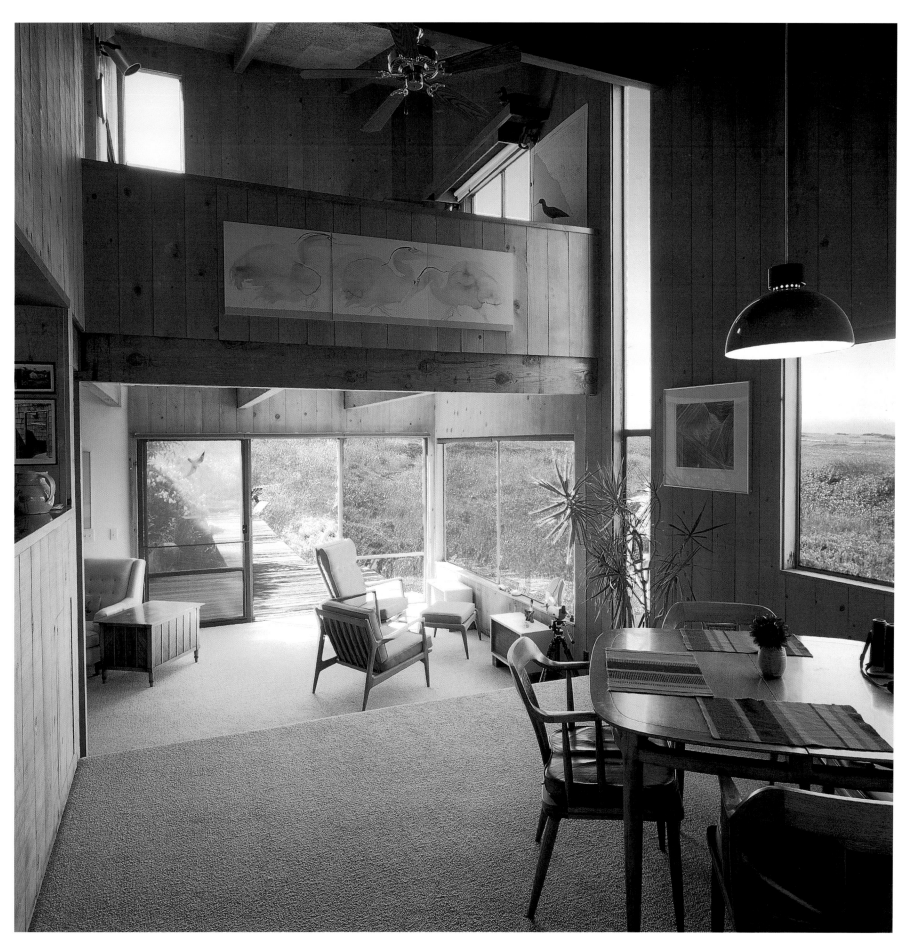

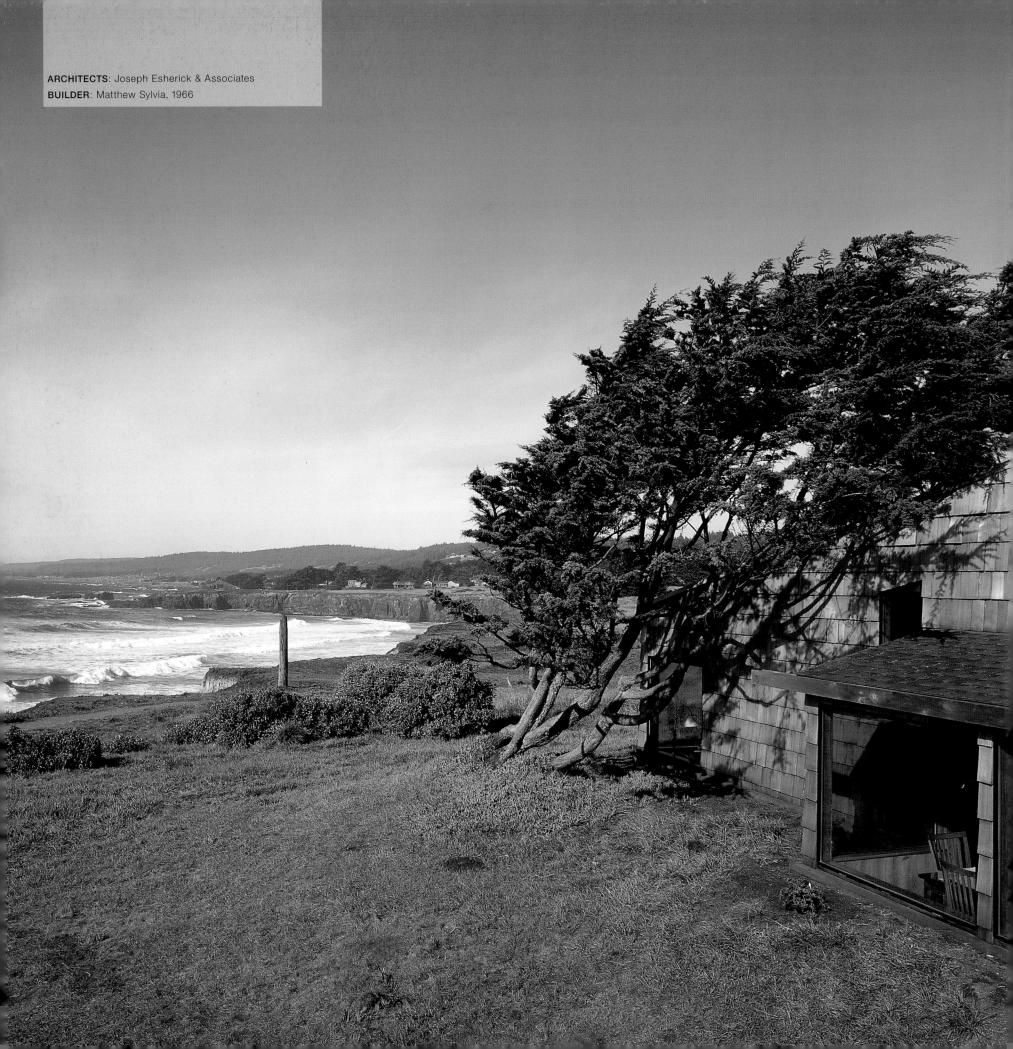

ARCHITECTS: Joseph Esherick & Associates
BUILDER: Matthew Sylvia, 1966

HEDGEROW HOUSE FOUR

(now the Jones House)

The Hedgerow House that now belongs to the Jones family is based on the two-bedroom plan that was repeated, with variations, in three of the Demonstration Houses. The house to its east had an additional bedroom slipped into a dormer on the roof; another house farther south was sited tight up against the opposite side of the hedgerow, with its major outlook to the adjacent Black Point on the west.

The Jones House sits out a ways in the meadow with its front face partially protected by some additional cypresses, now grown large. A later two-story addition provided space for more bedrooms, and its interior wood surfaces have recently been cleaned and restored. The courtyard on the south is protected by the house from the insistent wind pushing across the bluffs, and further enclosed by the garage to the east and a board fence with a canted wind-deflecting top on the west. The wind screening has been so successful that the space has become overcrowded with vegetation, which the Joneses have scheduled for thinning and removal.

As you enter the house from the courtyard, the view straight ahead leads directly out across to the meadow, through windows on the opposite side of the living room. The kitchen and eating areas are immediately to the left. The house is divided into quadrants, with those on the east holding bedrooms and a passage between. The living room lies across the northwestern front beyond a slim freestanding fireplace. The roof is low on its meadow side, rising from a full bank of

windows that project into the grasses. The whole house is set down slightly into the ground to make an immediate connection to the meadow. A high narrow window at the ocean end of the cross axis offers a glimpse of the water and casts welcome warm light across the tall wood-sided face of the kitchen block, which brackets the southwestern corner of the space.

The most dramatic place in this house, though, is alongside the kitchen—in a full-windowed bay that projects out from the main volume toward the ocean. This space, large enough for a table and a few chairs, with a close-fitting ceiling above, is completely exposed to the striking views up the far coast and the surf crashing on Black Point. The size of this space and its position beyond the main volume of the house— exposed on three sides to the elements, yet securely protected from them—make it a place that combines intimacy with grandeur in a moving and memorable way, a place of one's own dimension on the edge of the limitless sea.

Immediately adjacent to the ocean-facing bay, another extension projects south toward the courtyard. Here, sliding glass doors open directly into the domesticated garden. Above the low roof of this bay, south light streams through clerestory windows into the top of the main volume and into the kitchen.

The Jones House is comfortable and secure, lodged in its place with certainty and supplemented by the growth of its garden and additional construction.

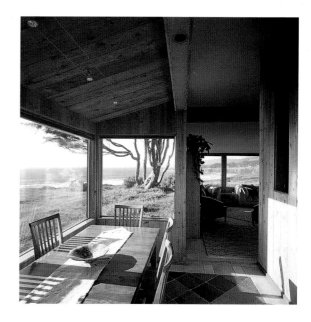

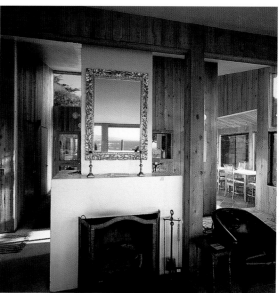

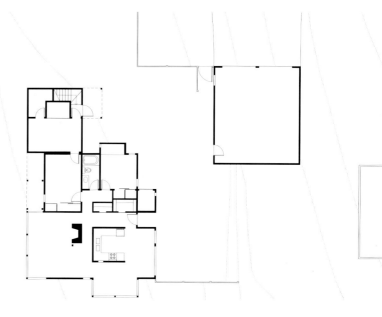

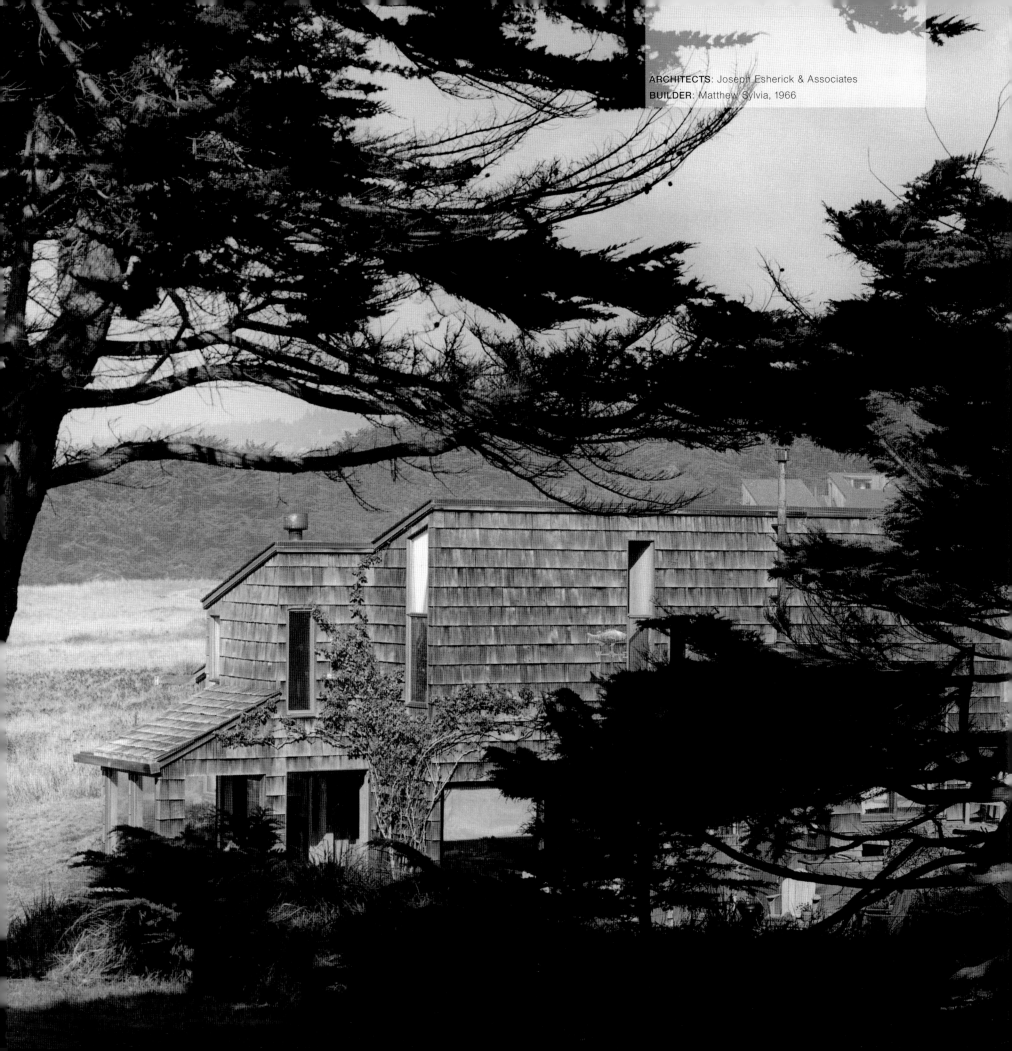

ARCHITECTS: Joseph Esherick & Associates
BUILDER: Matthew Sylvia, 1966

HEDGEROW ESHERICK HOUSE

(now the Friedman/Stassevitch House)

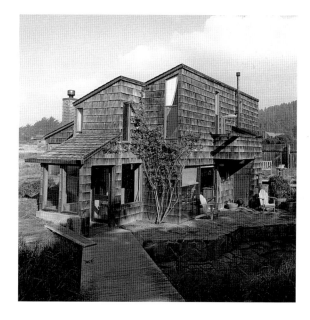

The house that Joseph Esherick designed for himself at The Sea Ranch is a masterly embodiment of the potential of the place. The last of the Hedgerow Houses to be built, and the farthest from the ocean, it sits in the meadow beyond a stream that courses through its site. Smaller than the others, it is exceptionally compact, even tiny, by today's standards. Nevertheless, it is surprisingly spacious in its impact. Set slightly forward of the other Hedgerow Houses, it follows their general form, with shingle walls and its roof set low into the wind.

The outlook from the house to the ocean runs along the face of the fence and front facade of the neighboring house, discretely registering its part in the construction of a larger pattern. Yet the house provides infinitely more than merely a "whitewater view." Views from the focal center of the Esherick house connect the people inside with all aspects of being at The Sea Ranch. From the area in front of the fireplace you can see not only the ocean to the west, but also the coastline stretching northwest to Gualala Point and the oncoming weather. The meadow here seems to almost extend into the house, its grasses blowing at the edge of the glass, with the stream passing behind the house and trailing to the sea. You experience ocean-dominated, windy vistas, as well as the sheltering sense of the tall, thick cypress hedgerow on the south and some additional pines immediately behind the house. And you can register the scope of the meadow descending from the forested coastal range hills; their crest can be seen through strategically placed windows in the bedroom that reach up high on the east to reveal their silhouette. All this is achieved, within a footprint of 875 square feet, by ingenious and exceptionally economical planning, which is closely tied to the contours of the site.

The house has three bedrooms, two baths, a living room, kitchen, and entry. All movement in the house takes place within an eight-foot-wide band of space that slides through its middle, rising gradually in an elongated spiral from the entry to the most capacious bedroom lodged in a loft above the kitchen. Entry to the house is through a small, separately roofed porch just at the edge of a little bridge crossing the stream. The porch fronts a small space, glassed against the weather and sized for shedding jackets and boots, which opens immediately to the kitchen/eating area. Both are at the level of a terrace that borders the stream to provide wind-protected, sunny eating and lounging space on the south.

Inside, the living room is up a few steps yet still recessed into the higher land of the meadow. A compact brick fireplace, now replaced by a woodstove, lies directly ahead, bordered by windows that stretch to either side in a panorama of meadow and coastline. At the ocean end of the room a built-in bench below a large window provides a comfortable place from which to enjoy the view out to the sea. At the opposite end of the space a door opens into the first of three bedrooms, where the eye moves out through the long high slit of window on the opposite wall to glimpse the hills beyond. A second bedroom at the same end is raised up a few steps, as is its bathroom, the level rising higher with the land behind it. A landing with another bathroom, and the largest, still snug, mezzanine bedroom, located above the kitchen/dining area, are tucked into the upper reaches of the rising roof. A thick cabinet wall separating this space from the living room is cut open to provide outlook to the living room below. It is supplemented by an extra niche, of sorts, flooded with sun from the south through two very small windows, one horizontal, one vertical. They are postcards almost, one filled with the sea, the other with the grasses of the meadow.

This house is as meticulous as it is inventive. The woodwork inside is elegantly spare, like shipboard cabinetry. The thick wall down the middle, around which the spiral of movement takes place, is especially beautifully made, its thickness created by finely made cabinets crafted by Esherick himself, with ship's hardware, bookshelves, and a bench. In each room, window openings are placed at the end of a wall so that their light brushes along the surface of the adjoining wall rather than being lost in the middle of the space as is often the case in conventional window placement. The Esherick House breathes of relaxed but alert intelligence, reflecting the ease of an accomplished and knowing professional, and embracing its inhabitants in thoughtful care and warm, inviting surfaces.

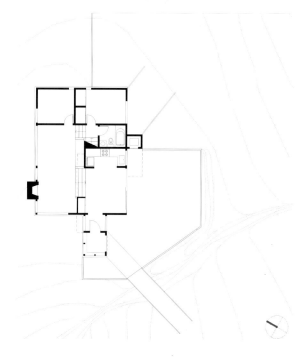

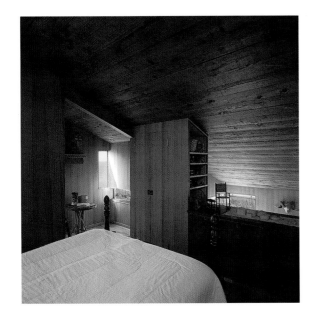

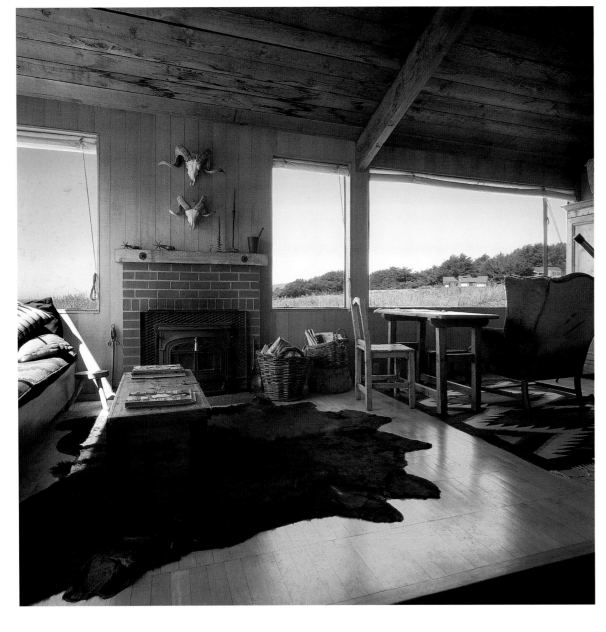

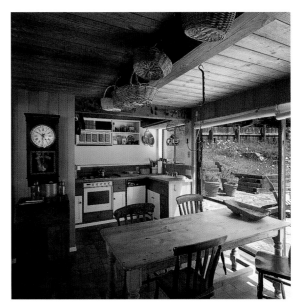

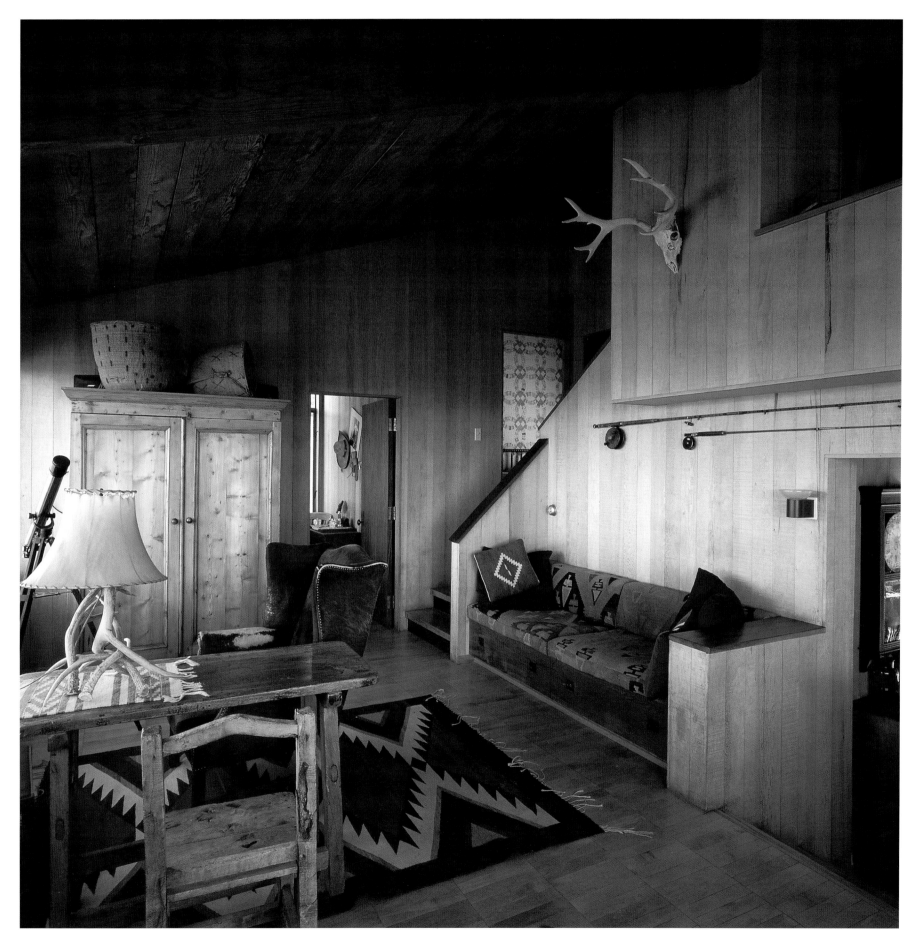

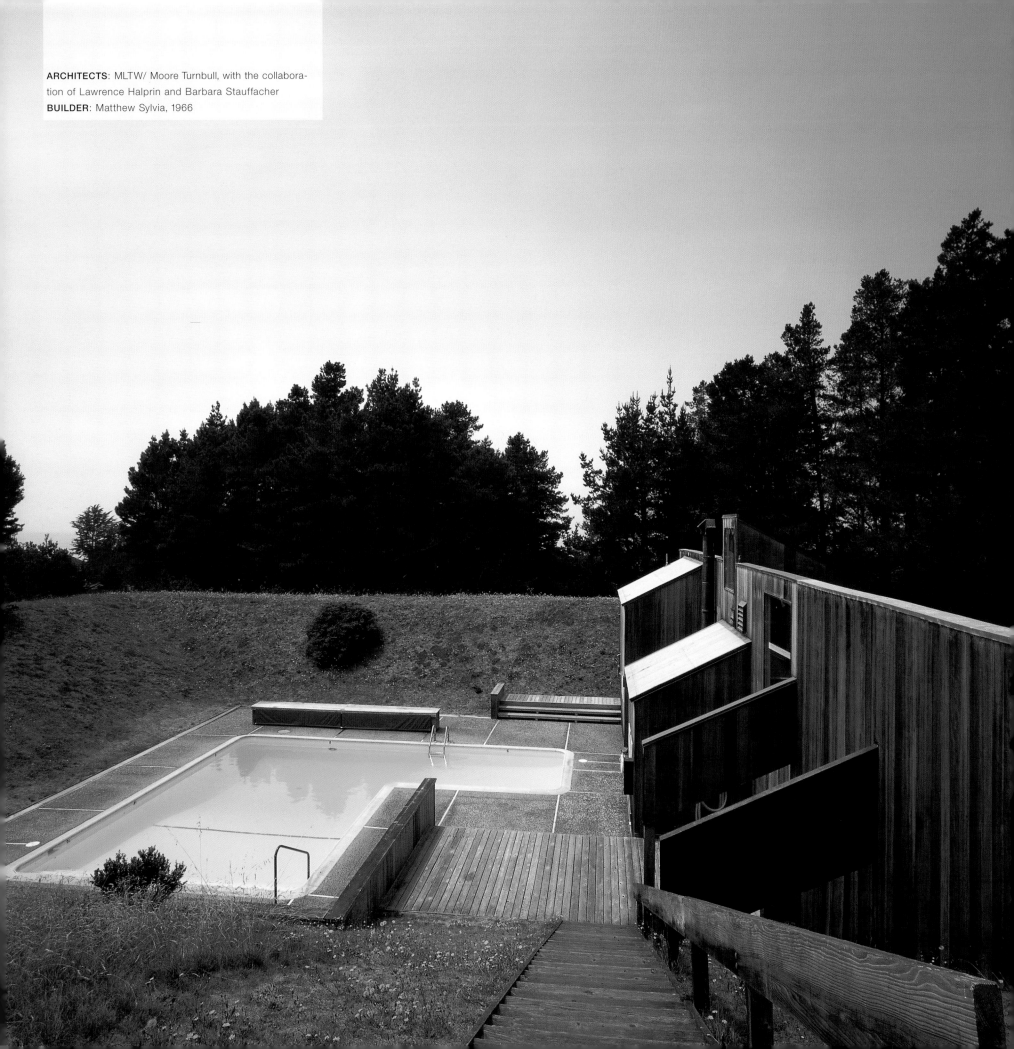

ARCHITECTS: MLTW/ Moore Turnbull, with the collaboration of Lawrence Halprin and Barbara Stauffacher
BUILDER: Matthew Sylvia, 1966

MOONRAKER ATHLETIC CENTER

(owned by The Sea Ranch Association)

The Moonraker Athletic Center, originally called Swim/Tennis Facility #1, followed hard on the heels of the condominium. It also won early notice in the architectural press and is every bit as inventive. It literally combines landscape and building design in seamless configuration, to create an oasis of wind-calm for basking in the sun. Its interior bathing, dressing, and sauna spaces, tiny and low-budget, are sites of tightly choreographed movement organized to separate wet and dry surfaces, and infused with large, vigorously colored graphic shapes that are painted on the walls and ceiling to confound the limitations of size.

Earth berms buffer the wind and hide the tennis backdrops; they are clear enough to form three sides of a court, with the fourth, northern and windiest, side protected by a long high wooden wall that is thickened in places to accommodate locker rooms and equipment. The wall is held in place by angled buttress walls, which are painted alternately black and white; its shed appendages are roofed with corrugated Plexiglas or wood decking covered with shingles, and house small but light and airy locker rooms. From within, the complex forms a magically calm and sunny place in the larger landscape, while from farther afield only the tip of a wooden light scoop and mysteriously regular landforms mark its place on the edge of the meadow.

Internally the building overcame its diminutive size with an altogether different strategy. The tiny space was expanded psychologically by the application of big graphic shapes and letters designed by Barbara Stauffacher—an early example of the use of what became known as "Supergraphics" in architecture, and which was widely published and emulated. Circles and diagonal stripes, and optically ambiguous trapezoidal shapes were painted in bold colors on white walls. The shapes, sometimes broken and displaced from one wall to the next, sometimes on the ceiling, were designed to cause the tight limitations of the rooms to dissolve among an array of cheerful and bright presences. These figures were sometimes applied whimsically (as in the splendid red arrow applied high in the space pointing skyward, which can be seen from the outside), but not arbitrarily. The positions of various shapes were carefully calculated to create illusions of depth and overlapping space, and to direct users through the rooms.

The heightened visual effects are paralleled by paths of motion through the tiny space that take full advantage of the three dimensions, with platforms and stairs kinetically engaging its users as they wind up through the small volume to upper levels.

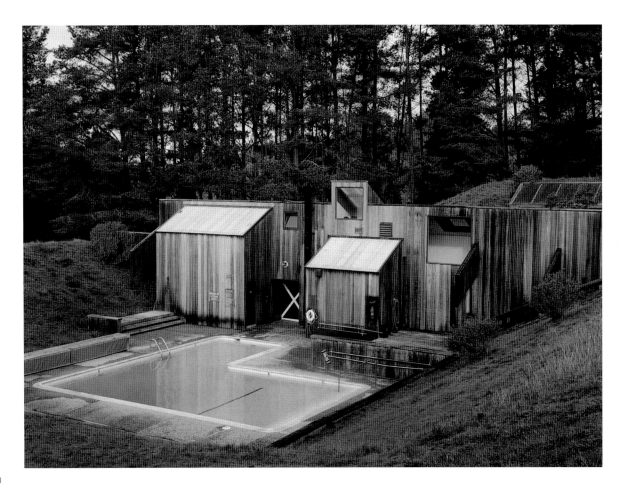

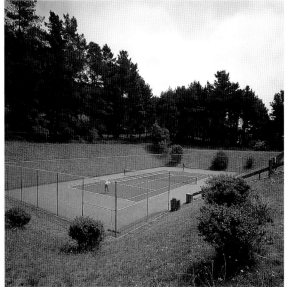

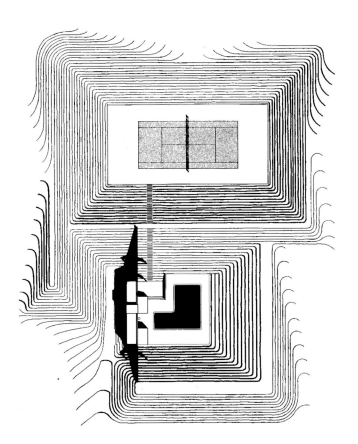

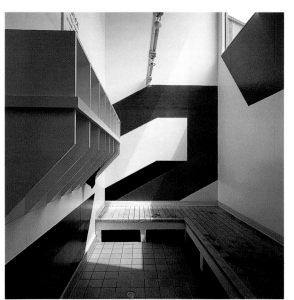

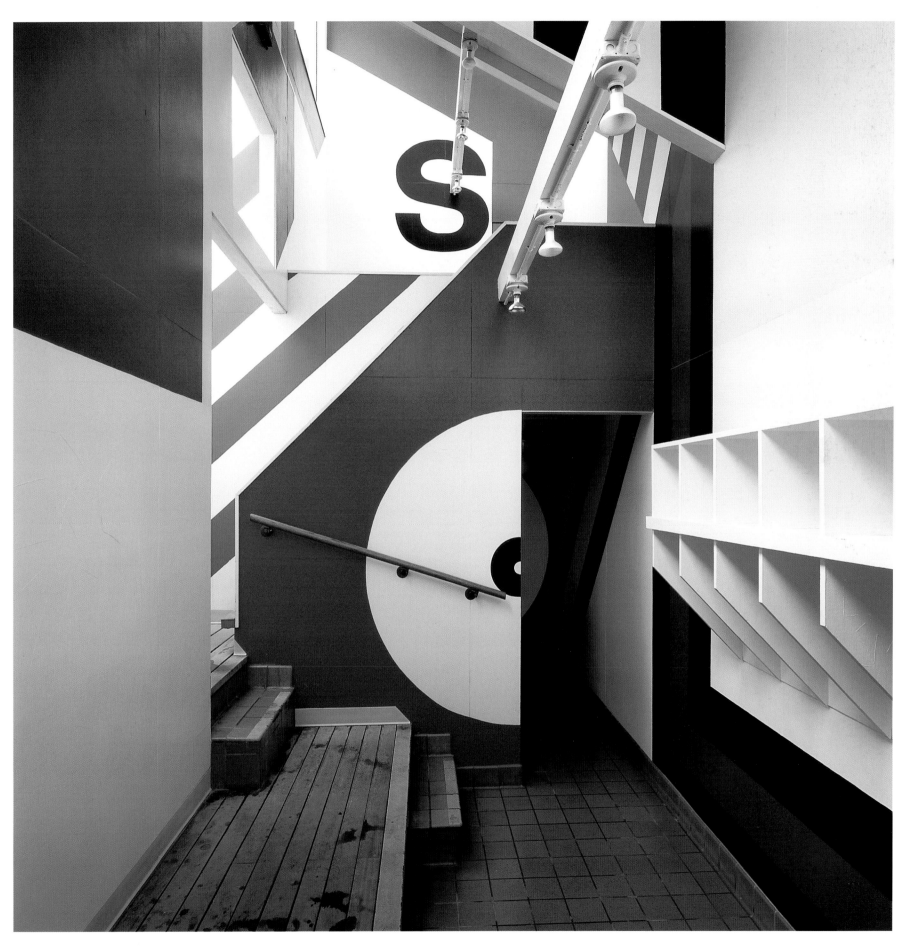

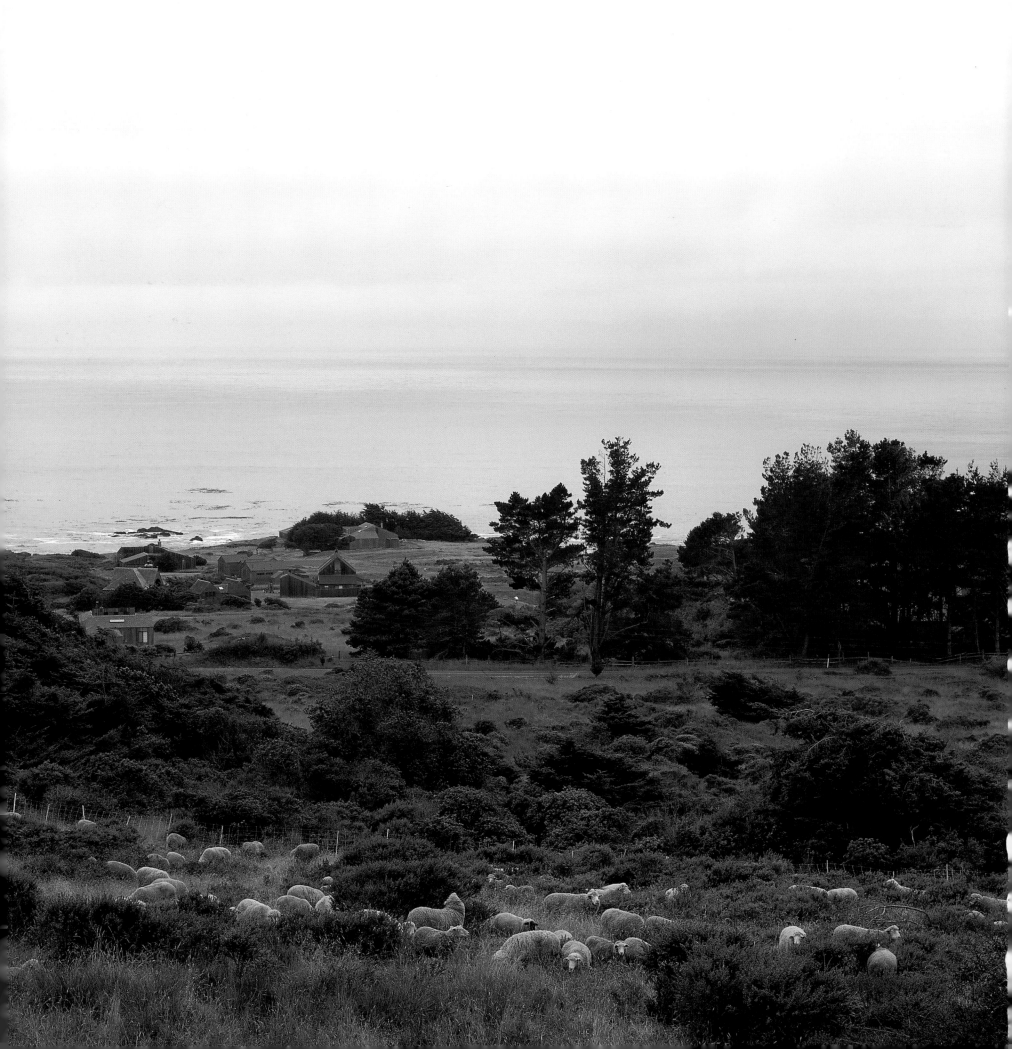

LIVING LIGHTLY WITH THE LAND: MANAGING THE LANDSCAPE

One of the most commonly agreed to and frequently repeated statements about the guiding principles of The Sea Ranch is that they can be summarized by the phrase "living lightly on the land." Used early by Halprin, citing Pomo sayings, this has become the mantra of The Sea Ranch. It denotes an attitude about building and maintaining the place in a comparatively natural state, rejecting the idea of transforming the site with massive earthworks or clear-cutting. It also means avoiding the transplantation of conventional patterns of building or cultivation that are unrelated to the existing character of the area. This formulation both acknowledges and slightly obscures an understanding that the present form of the landscape has resulted from a combination of natural processes and human interventions. The first changes were brought about by the Native Americans, who used the area for fishing and gathering, and altered it only slightly, with occasional burnings and the accumulation of shell mounds in places connected with shellfish harvesting. Then it was changed much more radically by lumbering camps during the nineteenth century, and by the provisions for grazing, with stretches of the land kept open for the sheep ranch that occupied the site before it was purchased by Oceanic Properties.

"Living lightly on the land" has been an enormously useful guide, relating to the initial development of roads and infrastructure as well as to the placement of buildings and the architecture that has developed. As envisioned in Halprin's plan (see p. 25), roads remained close to the contours, rising up into the forested hills through gullies and draws, and reaching down into the meadows along hedgerows and in consort with the slopes. They were mostly laid as simple ribbons of asphalt across the land, without curbs and storm drains that would unnecessarily overconstruct the terrain. Utility lines were kept unobtrusive, with the placement of local electrical and telephone cableways underground. The early houses, while for the most part connected closely to the conditions of the site and the contours of the land, kept largely to themselves, avoiding extensive intrusions into the fields and forests or elaborate terracing that would transform their sites. Buildings settled on the land gingerly, appearing often to graze in the meadows rather than to be implanted there.

Nevertheless, the phrase might be modified now to read "living lightly *with* the land," which suggests more accurately the responsibility that all involved now bear for maintaining and properly developing the landscape that has emerged. For the landscape of The Sea Ranch is not simply "nature," and it is not self-sustaining. It is a landscape that needs nurture and continuing intervention and care, as other inhabited landscapes do. The difference here is that the intention has been to construct and maintain a landscape that would preserve the larger patterns of the local ecology and which would be perceived as dominated by nature. The traditions of the picturesque embedded in our culture through landscape painting, photography, and park design have also served as guide for integrating the technical processes of site development into the patterns of nature. Buildings and layout were meant to return attention to the characteristics of the place itself, rather than stand out as evident agents of transformation, claiming attention for themselves.

There was no doubt, however, that human presence would be evident in this place. The meadows had already been cleared and hedgerows planted, and extensive trenching and construction were necessary to build the roads and develop the utility structure and drainage ways that made building possible. Oceanic Properties also undertook to reinforce the hedgerows to encourage new patterns of enclosure that would provide protection from strong winds across open fields and to create areas of more distinct identity within the overall landscape. Plantings along much of the highway were designed to soften its impact and to diminish the distractions of car and truck traffic along Highway 1. Halprin's plan called for the planting of Douglas firs, tanbark oaks, redwoods in the draws, and madrone on the outer edges, and those in turn have propagated more. Subsequent plantings of Monterey, bishop, and shore pines have been even more problematic.

What has emerged is a landscape with much more vegetation than when Oceanic arrived. In addition to the large-scale plantings that accompanied initial development, the forest has expanded of its own accord. Most significantly, the meadows are constantly changing through the invasion of field shrubs and plants that naturally take hold in a "succession landscape" that is no longer kept in check by agricultural grazing or mowing.

There has also been considerable change through plantings by individual owners on their own properties. These are subject to a design review (as are buildings, decks, and fences); in order to be approved, each house design must be accompanied by a landscape plan. While these plans are reviewed for consistency with the surroundings, with special attention given

to not obstructing neighboring views, they are seldom guided by a larger pattern of landscape intent. There are two primary controls on these landscape plans: plantings that are visible from the roads and commons must be native, selected from a list approved by the design committee; and any new plantings are considered to be "improvements," thus subject to the height limitations established for buildings by the CC&Rs and the Bane Bill (see p. 30). This latter, rather crude, constraint is somewhat improbable for trees. It leads, after several years, to some curious results—either to the effective elimination of the use of species that are too vigorous to conform to such limitations, or to aggressive pruning of a sort that most consider contrary to the intended sense that natural forces should be kept dominant. Farther north in older settlements along the coast are some spectacular instances of trimmed cypresses, and indeed, the "signature hedgerows" of The Sea Ranch were initially kept low and thick through an elaborate process of annual trimming. Only in a few places on The Sea Ranch, though, has significant group pruning been allowed, primarily along the bluff edge.

The signature hedgerows are of central importance to The Sea Ranch, not only as elements of protection from both northern and southern winds but also as marks of identity. The importance of these linear hedgerows in defining the character of The Sea Ranch cannot be overestimated. Their tall forms make great rooms of the meadows, giving distinction to the various segments of the coastal plain. Where they were used as a basis for planning they gave direction to the roads and often to their adjoining houses, absorbing the patterns of construction and access into groupings that are

dominated by the trees' towering rows and the additional vegetation that has grown up around them.

The hedgerows are also a management issue. Many of them, left untrimmed and with trees now reaching the end of their normal life span, have developed significant gaps where great branches, sometimes whole trees, die and fall to the ground, ripping through the vegetation around them. Wisely, many of the historical hedgerows were reinforced with additional rows of trees during the first phase of development. Subsequent planning was not always as foresighted, however: not only were the rows not supplemented, but private lot lines were drawn through them, so that access for repair and renewal is unnecessarily complicated. Many of the hedgerows now seem scraggly and not long for this world. The need to take active care of the hedgerows and to plan for replacements when the present trees begin to die has now been recognized by The Sea Ranch Association, and a program of action involving neighborhood volunteers, forestry crews, and weekend work parties has been put in place to renew them over time. Reconstituting the hedgerows forms an important part of the environmental plan drawn up in the nineties (see p. 75), and will take a decade to complete.

The landscape itself, of course, develops a life of its own, propagating in ways that are not subject to design intent. Curiously enough, anything that is a "volunteer growth," which is to say planted by squirrels and birds or resulting from seeds drifting in the wind, has license to go its own way, irrespective of established plans. These volunteers are presumably imagined to be agents of the natural order reasserting itself, but The Sea Ranch is a ranch—

a managed landscape structured to human purpose. Volunteer bushes and trees can be valuable, healthy components of an intended plan, but are only marginally "natural" within this context.

The volunteer growth is indeed one of the two problematic aspects of the succession landscape that has been emerging in the meadows of The Sea Ranch. In the absence of grazing or burning, the meadow grasslands fill with shrubs like baccharis (coyote bush), coffeeberry, myrtle, and willows, all bushes that eventually grow to the size of small trees. Where once there were flat, close-grazed grass meadows stretching from hedgerow to hedgerow, the meadowlands that remain are often dotted with large clumps of growth, obscuring the original sense of sweeping vistas and commonly shared grassland. In many cases these shrubs, especially the coyote bush, which grows quickly and accumulates dead branches, have added to the danger of fire, providing clusters of kindling that could aggravate and add fuel to the flames. Others, like the willows, are now being encouraged and planted in the draws to create firebreaks, since their moist leaves slow down or block grass fires that might otherwise rush past.

The other major force transforming the landscape today is the cumulative effect of individual actions by separate landowners. In the continuing life of the place, people, especially those who live at The Sea Ranch full-time, regularly invest further imagination and care in their landscaped "improvements." Thus, often the arrangements described in the initial landscape plans become somewhat more fiction than fact. Enclosed private gardens and courts, which are not visible from the commons and other properties, can be developed as cultivated gardens and often are, sometimes with a remarkable abundance of flora reflecting the personal enthusiasms of their owners.

Trees planted on individual sites create new patterns related to building sites, often obscuring the geometry of the original hedgerows. These plantings contribute to the overall reduction of wind speed; especially in the older portions of the ranch, the winds, while still significant, are far less threatening now than when the meadows were completely open. Conversely, many sections of the forest have closed in around houses, blocking views, and there are frequent requests for tree removal. These must be reviewed by the design committee, but there have been instances of pirating, which have taken place to everyone's disadvantage. The forest cover on hillsides has in some cases been badly compromised, and is generally becoming thinner, giving building forms more dominance than had been planned.

In some sections to the north where the hedgerows were less frequent, and comparable vegetative landmarks were not established, the areas are harder to distinguish among an aimless spread of roads and buildings. The development patterns here seem quite independent of the land and indifferent to the idea of contributing to a larger landscape. The development of careful but bold planting plans for these areas could yet yield distinct places, transforming featureless stretches of tightly constrained houses, which now have random vegetation, into recognizable and attractive groupings of buildings and trees. The Professional Consulting Group, which was commissioned in 1985 by Jack Cosner, then director of design, to review the progress of planning and design at The Sea Ranch, recommended just this: the development of three-dimensional neighborhood plans that would identify building

and planting opportunities, and establish guidelines appropriate to each area. The program was never funded, however, and two decades later its absence is notable, especially in the newer sections of The Sea Ranch.

Over a number of years, William Wiemeyer, The Sea Ranch Association director of environmental management, has been developing The Sea Ranch Comprehensive Environmental Plan, with the active participation of the association's planning committee. The plan has been endorsed by the board of The Sea Ranch Association, and many of its provisions are now being implemented. It also calls for neighborhood plans and lays out a set of goals and guidelines for further development and maintenance of The Sea Ranch. Drawing from the experience of building and living on this site and from analysis of the condition of the land and vegetation, it establishes a number of distinct environmental zones: the bluff edge, the signature cypress hedgerows, the meadows, the riparian corridors, the pine plantations, the forests, and "emergent forests/upland meadows (see pp. 76–77)." Each zone has its own character and special needs for careful tending, adjustment, and preservation, and sometimes for renewal.[1]

An "Inventory of Natural and Historic Features," developed mostly through volunteer committees, identifies special species, sites, and habitats that are endangered: "risks to these features include landscape management actions, view restoration, new construction and even natural processes such as plant succession."[2] The environmental plan also identifies the need for The Sea Ranch Association to pay attention to and seek to influence conditions and developments related to "adjacent resources"—the adjoining timberlands, parks and trails, the Gualala watershed, and the coastline itself—which are essential to the well-being of The Sea Ranch but owned and regulated by others. Potentially disruptive projects initiating in these areas range from recurrent clear-cut timbering plans to a mad scheme to capture water at the mouth of the Gualala River in huge bags to transport it to other locations. The interlocking interests that emerge in such areas can be illustrated by the case of the Hot Spot on the Gualala River, where a temporary dam was created each summer to enhance recreational swimming; it was subsequently determined, however, that this might be a threat to the local steelhead fishery and so the practice was terminated, subject to further study.

The most problematic aspects of landscape management are fire prevention and view preservation. Fire is an obvious threat, made even more obvious in recent years by nearby forest and grassland fires, one involving some Sea Ranch properties. The presence of houses constructed of wood, the growth of understory in the forest, and the unrestrained proliferation of dry grasses and shrubs in the meadows have created conditions that are vulnerable to fire (which in the long term is, of course, one of the recurring natural processes). Concern for fire hazards resulted in a Landscape and Fire Management Plan that set out a program of firebreaks and clearings to reduce the thrust of spreading fires. The need to reduce the "fuel load" has led to the thinning or removal of dead branches as well as of some diseased and/or vulnerable stands of trees; to further transformation of the landscape through plantings that can serve as firebreaks, such as willows and fire-resistant vegetation that gathers in creeks and draws; and to finally bringing

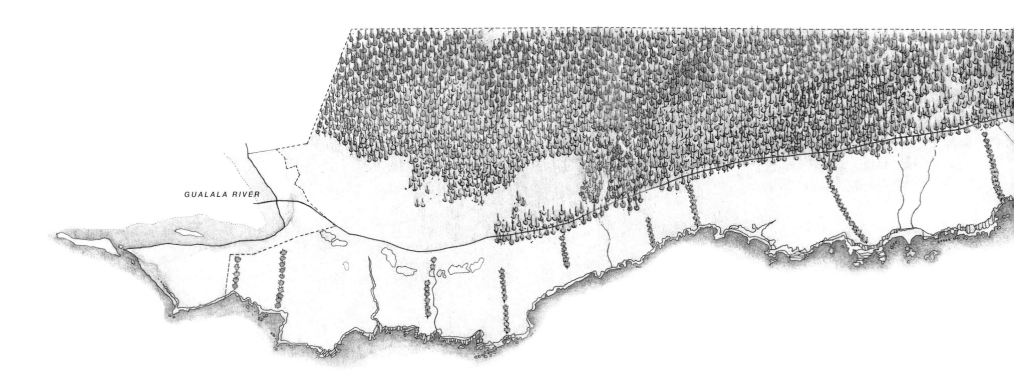

GUALALA RIVER

76

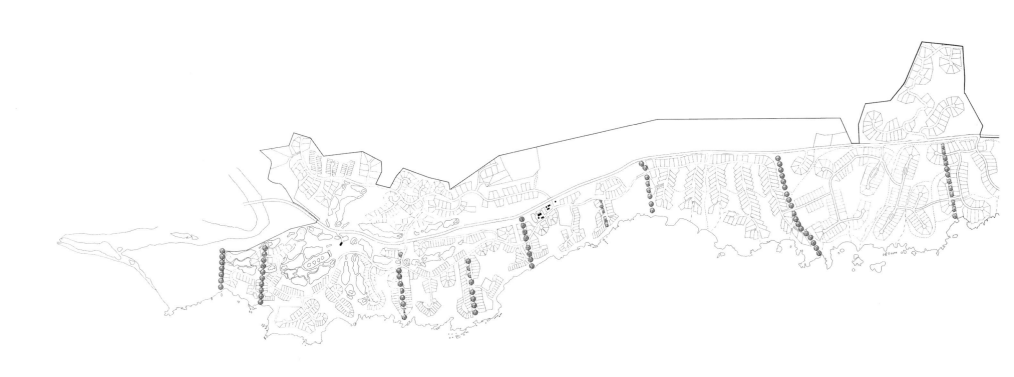

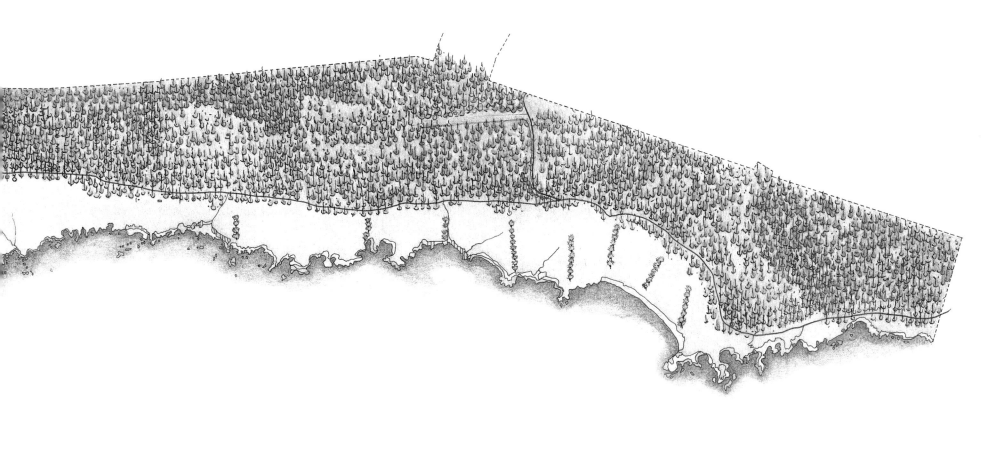

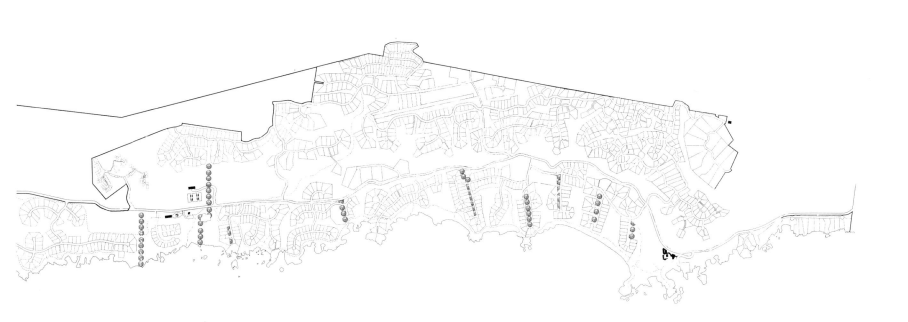

sheep back to The Sea Ranch. Under the oversight of a shepherd, and confined by temporary fencing that is moved from place to place, flocks of sheep advance voraciously through the commons devouring grasses. Their temporary status transforms possible annoyances into the amusements of the picturesque and mitigates any prospect of overgrazing. In places where the shrubs have been too sturdy for sheep, flocks of goats may eventually be used as backup. The program, at first considered by some to be laughable, then tried tentatively in the less controversial areas, has proved a great success; it has helped to bring the common meadowlands gradually back to a condition closer to the original design intentions.

View preservation is a more complicated story, sometimes pitting the professed interests of individual owners against those of their neighbors, or of the overall development framework of The Sea Ranch, which depended from the outset on the hillside forests to shield houses from view and to maintain the overall sense of The Sea Ranch as a place dominated by nature. The growth of trees in the forest over forty years has considerably changed the prospects for outlook from many sites that once had clear views of the coastline and now have nearly none. There have been many requests for the trimming or removal of trees, some of them legitimately prompted by, some masquerading as, concerns about fire or the dangers of falling trees. William Wiemeyer notes that some tree removal may be counterproductive; sunlight penetrating into the forest encourages the growth of understory, which is more dangerously flammable than the trees. The design committee must approve the removal of anything over six inches in diameter, and it attempts to balance the interests involved without losing the continuity of the essential characterizing tree cover. The most contentious of property tree removal requests result from false expectations brought to The Sea Ranch by buyers who supposed that the views from their lots would not change—even as further development took place on adjoining properties and the meadows and forests continued to grow and evolve, as they naturally would. Nevertheless, the placement and density of tree cover on The Sea Ranch has now been recognized as needing more active stewardship than it received after the first vigorous plantings were undertaken.

Many have become involved in considering these issues and charting a course toward sustaining the character and quality of The Sea Ranch. The board of the association has taken an active interest and has approved the reacquisition of some land sold off by Oceanic to create an environmental buffer. It has also initiated programs to gain community involvement in understanding the dynamics of the place and to reassert the intentions and values that have guided its development. Halprin has been asked three times now, in 1983, 1993, and 2003, to conduct community workshops to refine "The Sea Ranch Philosophy". These have been well-attended and effective sessions, and Halprin's continuing interest and passion have done much to maintain an understanding of The Sea Ranch's original intentions. Nevertheless, community involvement has normally been limited by the fact that most properties are second homes, whose owners live elsewhere. Active participation in stewardship of the place comes mostly from permanent residents and from a remarkably energetic and caring group of association members who are committed both to the idea and to the reality of The Sea Ranch and dedicated to guiding its evolution.

The 2003 workshop, in which 150 members participated, was dominated by concern for a list of major changes that have taken place at The Sea Ranch: these included a general perception that the quality of the architecture, which is increasingly shaping the character of the place, had deteriorated, and that there were now too many houses that are discordant "trophy homes" lacking relationship to the land and their neighbors. There was a general consensus that The Sea Ranch had become overgrown and that present efforts to control vegetation, graze the meadows, and renew the hedgerows were badly needed and should be continued. There was also a recognition that the community is aging and that many of the original owners have either passed away or had to move to locations with better health services than the local area can yet provide. Many also noted with great satisfaction the large number of committees, interest groups, and volunteer activities that have developed within the community; these have expanded to include a maturing sense of integration within the larger territory, including the Gualala community. It was generally agreed that the governance by The Sea Ranch board of directors and through extensive committee and volunteer activities, had become more involved and effective during the last decade. There remained a concern for more effective, widespread information, including "story telling" (narratives about the founding of the place) that would help to maintain and strengthen "The Sea Ranch Vision"—and carry it forward to absorb new interests, the needs of evolving populations, and changes in the regional and local economies and the available resources.

Good design is about relationships. The hedgerows and meadows and forest line are aspects of The Sea Ranch that architects and owners new to the community can use to advantage. That they exist with as much clarity as they do is an inheritance that should be used wisely. New owners benefit directly from the past decades of cumulative care, and their property values reflect it. It continues to be necessary to consider each building as a partner in its context, imagining how groups of buildings and vegetation together can create a larger sense of place with many distinct and interesting areas within it. For the continuing evolution and maintenance of The Sea Ranch there must be vigorous discussion and determined advocacy by the design committee, the planning committee, and staff, and—indispensably—attentive, thoughtful, imaginative response on the part of all those who plan to build here.

1 The Sea Ranch Association, The Sea Ranch Comprehensive Environmental Plan, section 3.1.2.3
2 The Sea Ranch Association, The Sea Ranch Comprehensive Environmental Plan, section 3.1.2.2

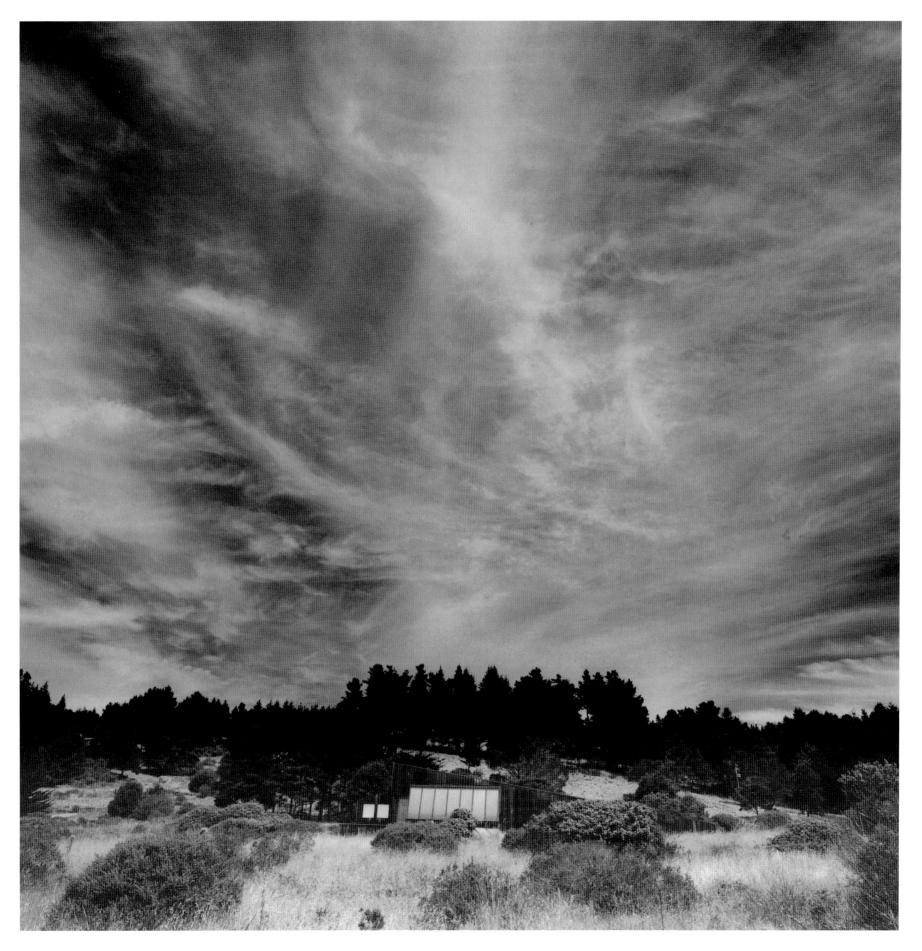

WALK-IN CABINS

REDWOOD RISE

MADRONE MEADOW

WHITE FIR WOOD

PINE MEADOW ROAD

80

SEEKING A LARGER ORDER: COMPOUNDS AND CLUSTERS

The Sea Ranch was conceived first in clusters and groupings. Under Halprin's leadership the planning was based not on areas of a map, but on ideas about how buildings situated on the land could become part of the larger place that the maps only dimly represented. The first buildings, the Condominium One and the Hedgerow Demonstration Houses, were built to show how dwellings could be designed in groupings on the land, thus preserving a larger pattern for all to enjoy. One of our objectives was to avoid randomly scattered individual buildings that would dissipate the qualities of this landscape and convert it into something far less majestic than the sweeping fields, decisive hedgerows, and clustered farm compounds that marked the north coast with a distinctive pattern.

While the intense pressures of real estate speculation eventually transformed and diluted this original hope, largely in response to the more conventional market demands for individual house sites, there were subsequent efforts to create larger segments of The Sea Ranch designed to common purpose. Many of these were buildings that were inherently bigger and would serve many people: the lodge and later the Ohlson and Del Mar recreation centers were each groupings of buildings that established a larger presence in the land. In addition, Oceanic developed buildings as clusters of units that could be built economically and serve a wider market of people who had neither the means nor the inclination to build freestanding individual houses of their own. Two sets of cluster housing and the Walk-in Cabins were established near the large, white Knipp-Stengel Barn, at the confluence of a number of hiking trails and near the Ohlson Recreation Center. Burbank

Village, a collection of inexpensive employee houses designed by William Turnbull in an ingenious interlocking pattern, makes a place of its own at the north end. More recently, there have been two attempts to construct a larger pattern in the land: Fiona O'Neill designed The Cottages, a set of houses built for one investor on a site only recently opened for development. Another group of buildings, which I have worked on, here called Sea Gate Row, was constructed as a series of houses on proximate sites, designed to create a common sense of purpose and intent, and to reinforce the structure of the larger landscape.

Nonresidential buildings are few. The Sea Ranch Association offices and three commercial rental buildings have been built near The Sea Ranch airport up on the ridge, along with the State Department of Forestry's fire station and Matthew Sylvia's lumber yard and hardware store; they are arranged, however, in ways that offer no semblance of community gathering or coherence. The white Knipp-Stengel Barn has been the scene of many significant meetings and performances and has played a large part in the history of the place, but its uses are necessarily limited to activities endorsed by the association. The Del Mar Center is the largest gathering place on The Sea Ranch, and many association members think of it as the heart of The Sea Ranch. But both in form and in use it is more like a domestic country club than a public place. There is no place at The Sea Ranch yet that can be imagined as its public persona, open to residents and visitors alike. The lodge comes close, with its post office, gift store, restaurant, and bar, but The Sea Ranch is developed enough now to merit a more substantial public place.

The plans for extension of the lodge presently include a small public center with a café, a gallery and market, the post office and business services, some meeting rooms, and a visitor center that would provide an introduction to the region and to The Sea Ranch, its history, and intentions. It is a project that has the potential to become a genuinely cohesive public locale—a place that residents and visitors could share, open to guests renting property or stopping over night, and to locals and tourists traveling the coast. Developed properly, it could be a center as distinct as the traditions it stands for, a memorable place within The Sea Ranch.

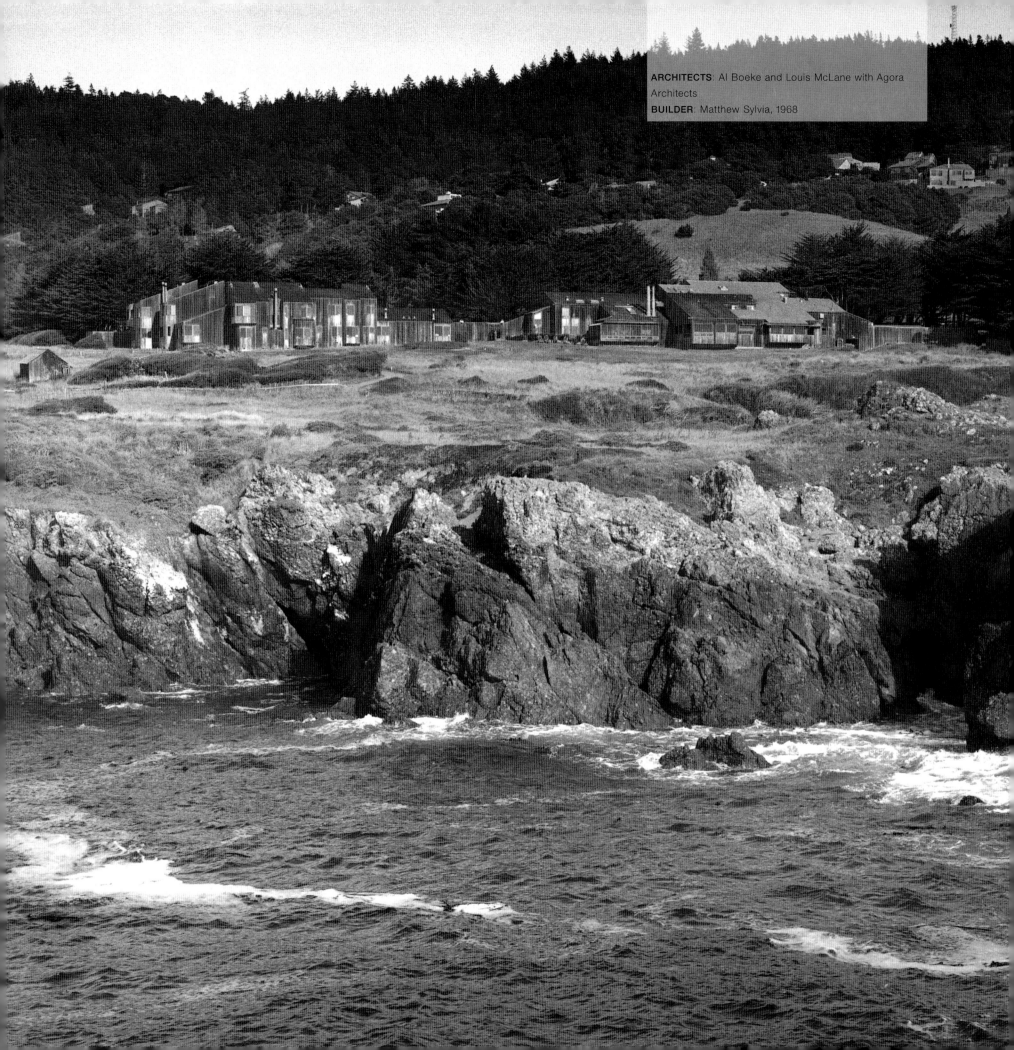

ARCHITECTS: Al Boeke and Louis McLane with Agora Architects
BUILDER: Matthew Sylvia, 1968

THE SEA RANCH LODGE

(owned by The Sea Ranch Lodge and Village LLC.)

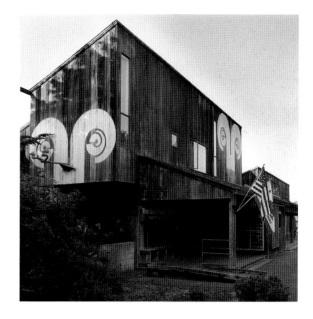

The first large complex to be developed after the model buildings was The Sea Ranch Lodge, which initially served as a center for the fledgling community, bringing people together as they picked up their mail and newspapers, or gathered in the bar and for meals. The main lodge building absorbed the original store, which was extended to accommodate more dining, the bar and lounge spaces, as well as real estate sales offices. Twenty guest rooms were added in a separate structure. As Halprin noted,

"The Lodge was designed to be a model statement about an attitude towards a public facility that blends with the land, thus different from the private models...we said it should not be cheap or trendy, or a "schlock" motel, loud and garish with visible parking. The Lodge is our symbol more than we think."[1]

The design was initiated by Esherick's office, but completed and executed by others, with Al Boeke leading the design team. The main lodge building has been further modified and adjusted by small revisions since it was built. It retains its original character, though, which was so closely related to the site that it still seems fresh. The main building and the bedroom wings are built with conventional wood construction, covered in large redwood boards applied vertically, and with dark aluminum windows. Originally, the roofs, like those of the condominium and the original store were covered with wood shingles; more recent regulations have made it necessary to reroof with composition shingles. The roof of the main building is made with large single planes sloping down toward the ocean, with one segment raised a few feet to let light into offices and restrooms in a small mezzanine over the bar. The bedrooms are built in the same way, but since they are smaller than the public rooms, the mass is thinner, with less dominant planes. To keep the bedroom wings in scale, they are made up of several components, some one floor high, some two, and some projecting forward, resulting in a fractured silhouette and a syncopated rhythm of bays and windows positioned for advantageous views.

Both sets of buildings are placed in relation to hedgerows that were planted early in development, which have significantly muted the winds across the points. The main lodge building and one of the wings containing the guest rooms run parallel to the ocean, stretching from the double hedgerow, which shelters a drive leading down toward the condominium, to the walls of the northern perpendicular wing that serves as a windbreak. This wing is extended by a hedgerow that reaches back to Highway 1, sheltering a parking area both from the winds and public view.

The lodge is fronted by a long, deep porch placed on its northeast, made with turned log columns. From here visitors enter through a bank of glazed doors that open into a parallel long lobby/corridor. At the south end of the corridor is the store, which has now been expanded. A small post office remains in it, serviced from the counter and with banks of boxes outside for residents. A group of real estate rental and sales offices occupies the other end of the corridor, with exhibit space and the welcoming lodge desk in between, just off the porch.

Adjacent to the desk, stairs begin a slow descent toward the dining room, reflecting the fall in the land. A few steps down, the Fireside Room opens to the right, surfaced with wide-board red cedar siding and focused by a big stone fireplace, made of stones from a basalt outcropping a mile or so to the north. The passage continues down a few steps more to the dining room, preceded by a long, low bar leading off to the left and a solarium stretching out to the right, with sensational views out to the points and up the coast. The dining room, while much larger than the first café, has the architectural character of the original. The rooms are designed with resawn wood siding on the walls and wide stretches of window looking out toward the ocean in several directions, providing stunning views up the coast past a succession of coves and points to Gualala, or out across the surf-splashed land forms of Bihler's Point and Black Point—with the recurrent passage of birds and of whales in season. Sunsets observed from here loom large in local legend. A handsome weathered barn and a shepherd's shed in the middle ground strike the themes of prior settlement with big simple forms made of local materials. Inside, the marvelous turned wood captain's chairs of the dining room are comparatively lightweight, yet have a pleasant sense of solidity and presence. All the spaces of the lodge, developed with integrity and restraint, share the warmth of natural materials, a simplicity of surface, and a fundamental sense of calm that serve the spirit of The Sea Ranch well.

The bedroom wings are separate, reached by a boardwalk that stretches north from the end of the long porch, then turns toward the hills to form two sides of a fenced garden. Rooms open off this walk, or from stairs that access segments of the building with rooms on an upper floor. Most have corner windows or projecting bay windows that offer outlook in both directions to the points, or up the long stretch of coast, with the sweeping meadow in the foreground. Inside, the rooms combine wood walls with smooth white surfaces and carpeting. The majority of the rooms, which are all equipped with woodstoves, have ceilings

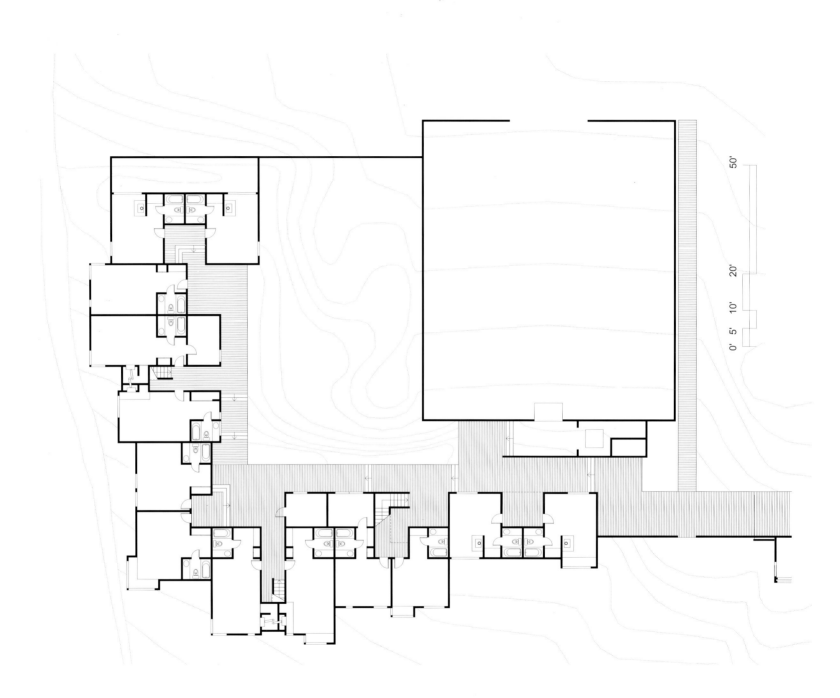

50'

20'

10'

5'

0'

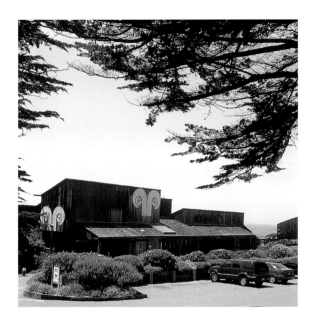

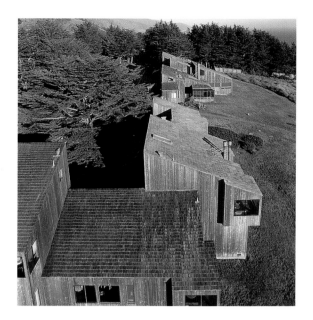

that slope up to high windows; light thus enters from both sides of the room. The rooms are distinct, given identity by their position in the complex and the views they absorb. Two, at the end of the boardwalk, open to private walled gardens with hot tubs.

The board wall joining the wings to the main lodge building buffers winds and separates the lodge's groomed forecourt from the meadow reaching out to the coast beyond. A barn door–sized opening in the wall connects between the two landscapes. Passing through it from the domestic to the windswept side, with the vigorous form of Bihler's Point protruding into the surf ahead, one used to feel like Alice popping into Wonderland—though here one entered a domain that was more primitive and real than fantasized. That sharp juxtaposition between the controlled and the wild, which retained the essence of the early Sea Ranch, has been toned down more recently. The ocean side of the lodge has been more conventionally tidied up, with Adirondack chairs, trimmed grasses, and a path to the barn used for wedding parties.

1 Bill Platt, "The Sea Ranch as an Intentional Community: An Interview with Lawrence Halprin," *Ridge Review* 3, no. 3 (Fall 1983): 14.

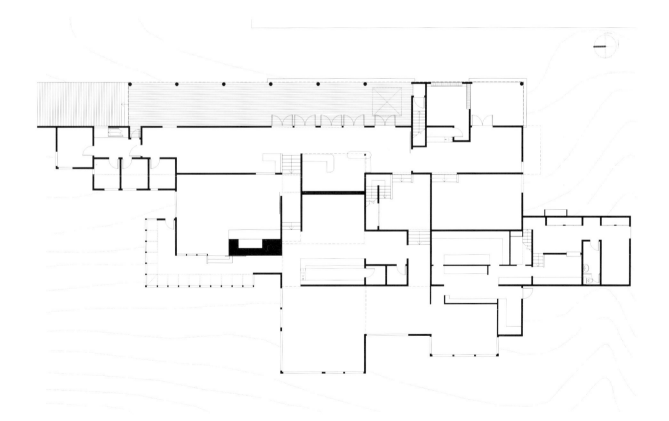

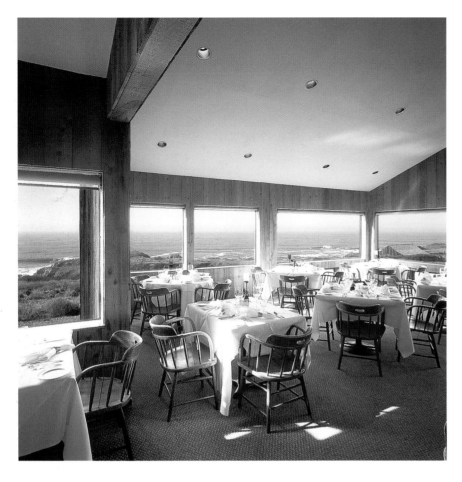

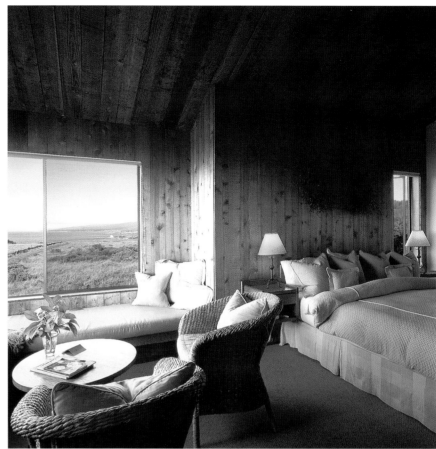

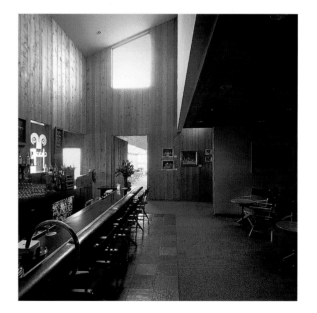

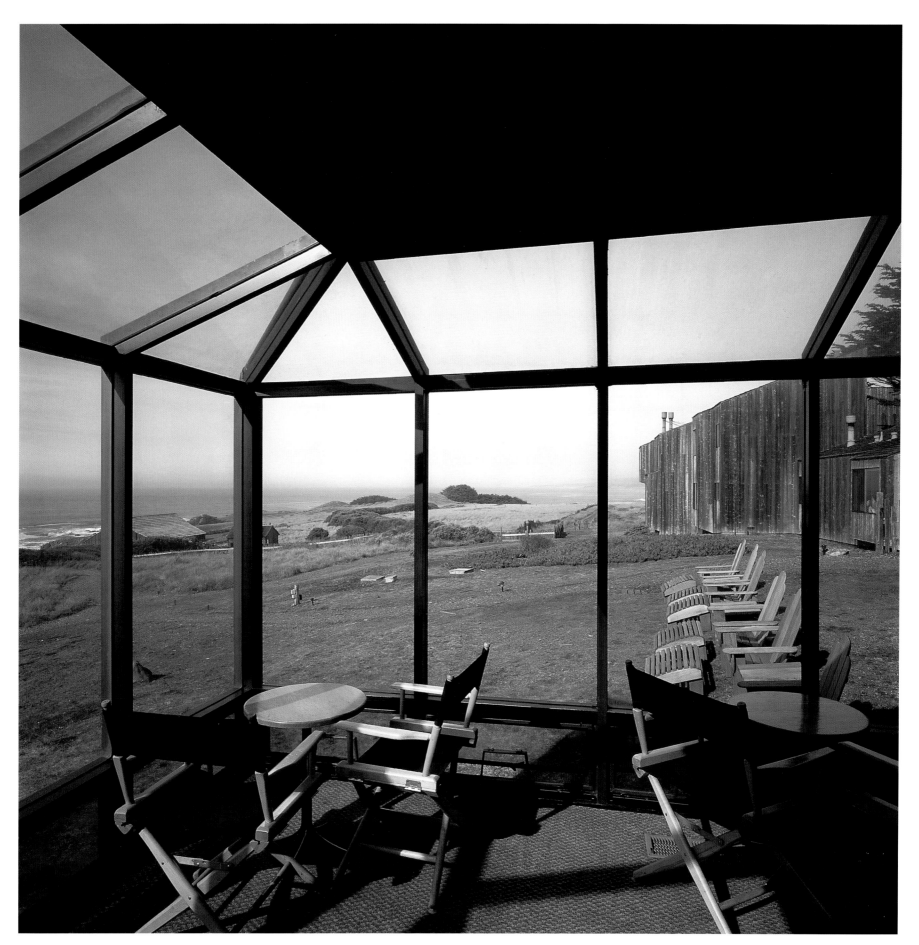

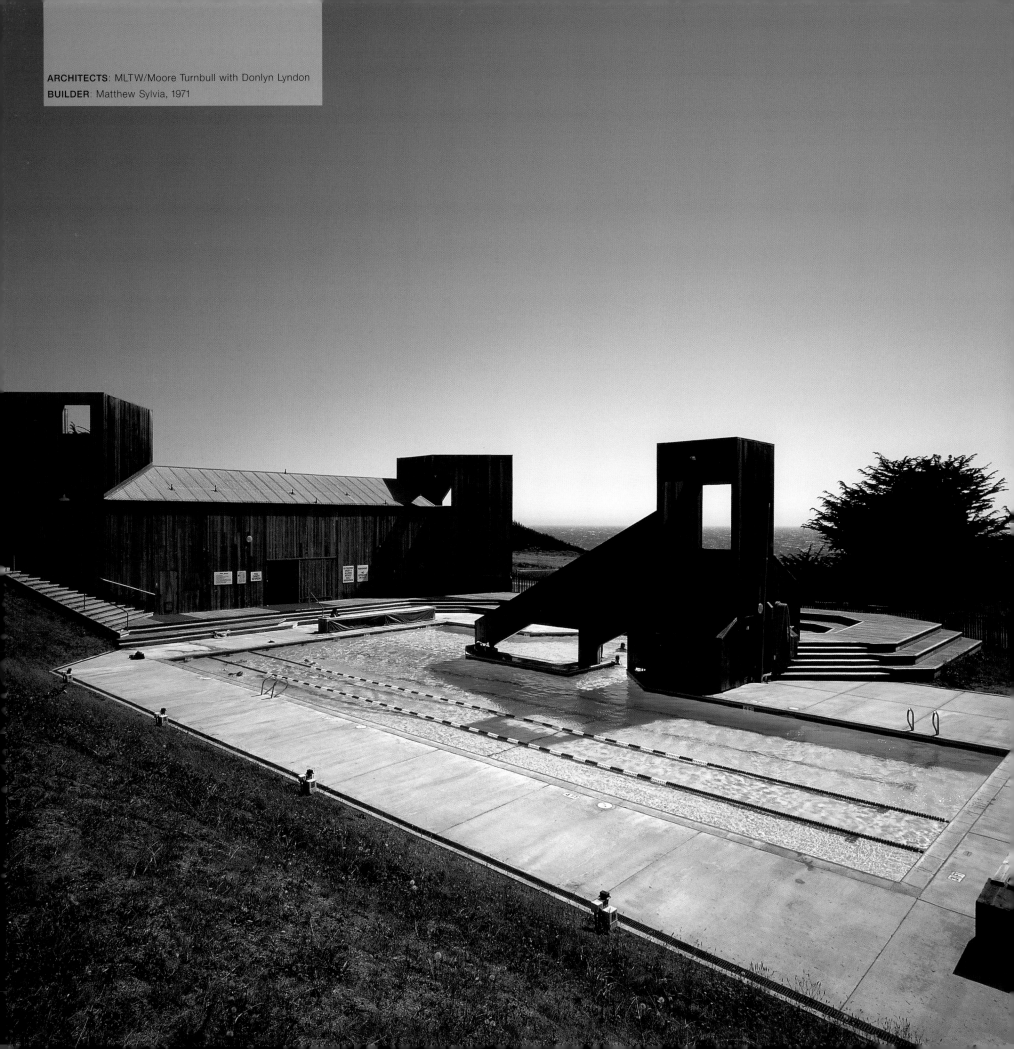

ARCHITECTS: MLTW/Moore Turnbull with Donlyn Lyndon
BUILDER: Matthew Sylvia, 1971

OHLSON RECREATION CENTER

formerly North Recreation Center
(owned by The Sea Ranch Association)

The Ohlson Recreation Center is a clear descendent of the Moonraker complex, expanded and adjusted to differences in site, but following similar principles. Like the earlier facility, this one fuses building, landform, and vegetation into a single composition. Whereas, for instance, the nearby white Knipp-Stengel Barn is a generic barn form set down on the side of a sloping hill and adjusted to it, the recreation center is conceived as an element of the landscape, a wooden hedgerow, if you will, that parallels a venerable cypress hedgerow on the north. Together they define an outdoor room for the pool, which is partially burrowed into the land between them.

The building is essentially a thick, long, high board wall—a "wind-dam" to use William Turnbull's words—that has locker rooms lodged within it.[1] The rooms are roofed with translucent corrugated plastic, to form light and airy spaces without privacy-shattering windows. The exterior walls, left essentially blank, are covered in vertically applied redwood siding, akin to barns. Recesses at the entrances are tagged by a big "M" and "W." Inside, the spaces are like long bright halls, creating a smooth but spatially entwined progression from changing rooms to shower to sauna or pool. The men's locker room consists of a level changing area at the top, from which stairs descend and angle down to a ganged set of showers at the lower level. The progression then folds under the women's passage above and leads out onto a common deck, a few steps above the pool. Movement along and through the mostly high, bright interior spaces is bordered by smooth-surfaced gypsum walls, painted in rich, strong colors, but without the intricate designs applied in the earlier Moonraker rooms. Since the hedgerow already provided some wind screening from the north, the locker building/wall was built to the south of the pool, sheltering the tennis courts behind it.

This recreation center is much larger than the Moonraker complex, providing a full-lap pool plus a children's wading area, and three tennis courts instead of just one. The pool is distinguished by a square tower that rises out of its midst, almost like a piece of furniture within the outdoor room. The tower, which holds pool equipment in its base, was once the bastion for a slide that descended from its top, offering an exhilarating plunge into the pool. The slide proved too exhilarating for some, however, and was eventually removed, as were the stairs to the tower. (Plunging has generally not fared well at The Sea Ranch. A similar, but twisting, open-air slide that delivered women from the sauna on the upper level of their locker room to a cold-water pool in a walled enclosure below—with glimpses of the ocean view midway—was also removed, along with a perfectly ordinary sauna plunge in the depths of the men's locker room—all victims of concerns for maintenance and liability, if not of prurience.)

Originally published as "Swim/Tennis Facility Number Two" and familiarly known at the outset as the "North Rec Center," this complex was

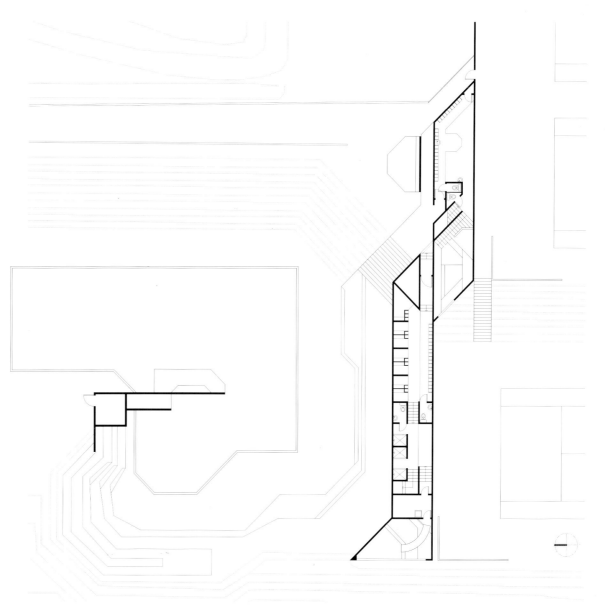

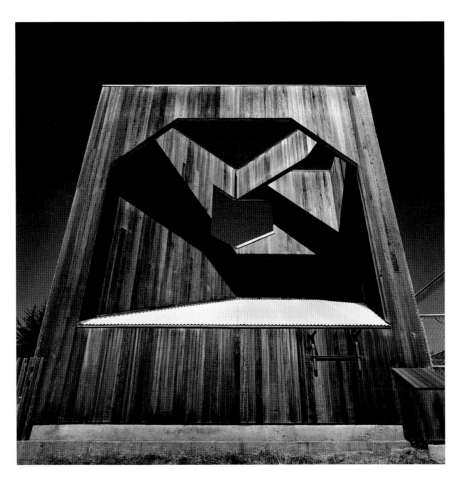

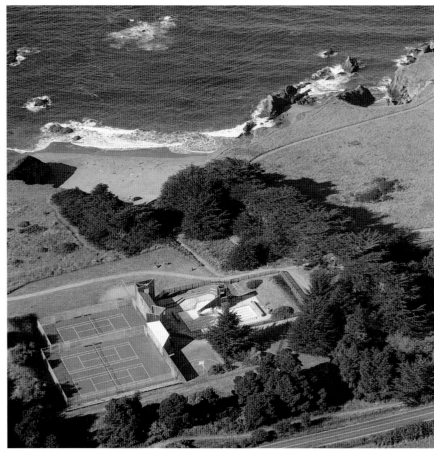

clearly slated for eventual renaming as build-out continued up the coast toward Gualala, and a majority of Sea Ranchers found themselves heading south for their swim. When the third pool was authorized farther north, near the Del Mar Ranch headquarters, this one was given the name of the Ohlson family, who had earlier owned the land and the diminutive postwar ranch house close to the site. It is a somewhat anachronistic label, since the dominant landmark of the place, indeed the most visibly evident landmark at The Sea Ranch, is the Knipp-Stengel Barn, a great white barn named for its nineteenth-century owners and listed in the National Register of Historic Places, while the Ohlson House is nearly invisible in a stand of vegetation and plays no significant role in the landscape. The house had been used for some time as a place for small meetings.

The Knipp-Stengel Barn has also been used for meetings, and for many it remains the heart of The Sea Ranch, despite the subsequent building of the Del Mar Center and its use for board meetings and most regular public events. The barn still holds a richer set of memories, and also holds more people. Meetings of special significance most

often happen here, and it is the regular home of performances by a local drama group called The Sea Ranch Thespians. The lore of this great white barn is complicated; it not only reminds early members of the horses that were kept there and worked out in the running track below (a site now consumed by a particularly inept piece of subdivision planning), but it also carries the echoes and scars of a several-year battle among The Sea Ranch Association members. A dedicated group of volunteers who undertook to restore the barn through weekend work parties was pitted against a contrary group that was adamantly opposed to its use for any purpose or to the expenditure of association funds on materials for its restoration. The episode stands now somewhat distanced, resting in memory as a nadir in the development of a Sea Ranch community. The barn itself, today handsomely restored and gleaming white, makes a fine mark of previous life on the land as cars pass along its side, traveling Highway 1.

1 William Turnbull, Jr., *Global Architecture Detail MLTW/Moore, Lyndon, Turnbull and Whitaker The Sea Ranch Condominium and Athletic Club #1 and #2* (Tokyo: A.D.A. EDITA Tokyo Co., Ltd., 1976), 6.

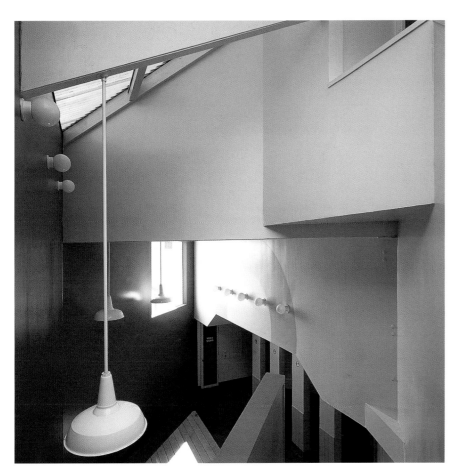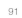

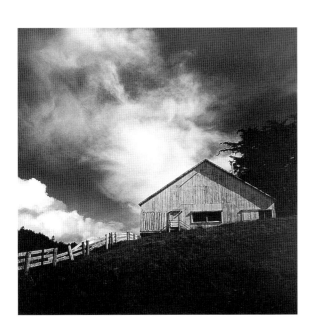

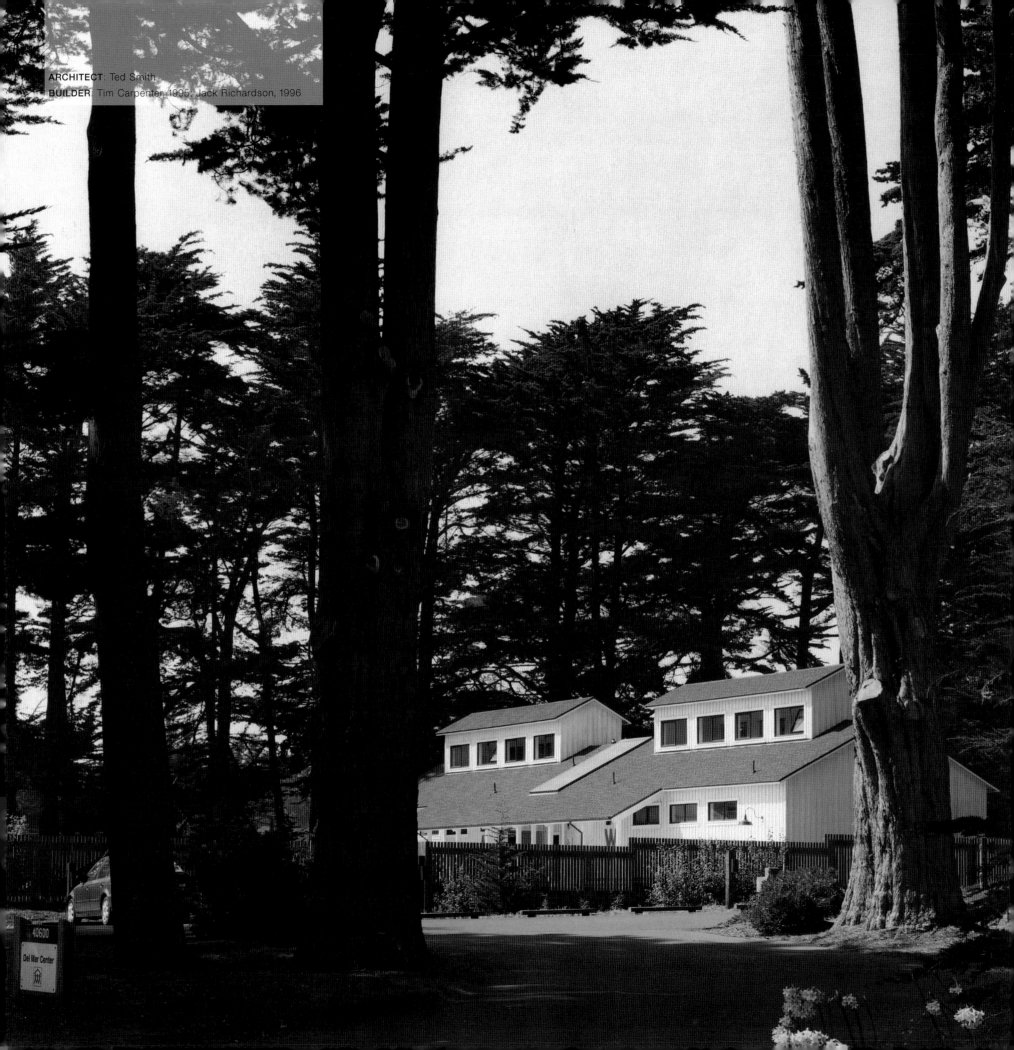

ARCHITECT: Ted Smith
BUILDER: Tim Carpenter, 1995; Jack Richardson, 1996

DEL MAR CENTER

(owned by The Sea Ranch Association)

If the Moonraker Athletic Center was an integration into the landscape, and the Ohlson Recreation Center was the creation of a wooden hedgerow/playground, the Del Mar Center is a conventional elaboration of a domesticated ranch settlement. The complex now includes meeting rooms, a recreation center, some utility barns, and a swimming pool and bathhouse. It occupies part of the earlier Del Mar settlement site, which grew up in the first decade of the 1900s in connection with a lumber mill and landing on the bluffs. Only a few remnants of that period remain, including a very small, white, board-and-batten schoolhouse still standing by the creek south of Halcyon Road and one of the barns since incorporated into the Del Mar complex. A house near Highway 1 that had been acquired by the Ohlsons when they bought the Rancho Del Mar in 1941 was torn down in 1953 and replaced by a low-slung, simple hipped-roof house that would be at home in most any Western suburb.

The building is now used for meetings of various sorts, and a large, barnlike but smoothly finished community building has been constructed to make a place for board and community meetings. Its architect, Ted Smith, had come to The Sea Ranch in 1988 from the planned community Sun River Oregon to become director of design and planning, and was responsible for the administration of the design committee until the year 2000. More recently still, a bathhouse, also designed by Smith, and pool have been added, the pool the largest, most lap-minded of the three

pools at The Sea Ranch. The newer structures are built of board and batten painted white; the older vertical-board barns are also white, with metal roofs rusted a glowing orange. Three parallel hedgerows previously bracketed a corral space now occupied by the pool, bathhouse, and parking. Beyond the northern hedgerow, a tennis court, fenced in black chain link, is parked loosely in a small meadow, exposed to the road.

Adjoining the original house, and enfolded between the community center and various outbuildings appended to it, is a lush garden. It winds around between thick coniferous and myrtle hedges, with pavilions and nooks, and beds of abundant flora, which can only be described as privileged in a landscape where native species have been decreed as required planting in publicly visible places.

The new large building works well; a couple of bays offer views out and places to gather, and a porch all along one side paralleling the garden, house, and outbuildings makes both a convenient passage and a modulated, broken-up series of spaces for schmoozing before, after, and between meetings. At its south end, the porch widens into a deck, providing a welcoming and comfortable place to gather outside in the sun.

The former ranch house has been refurbished inside, also by Ted Smith. Like the interiors of the new meeting center and the bathhouse, it has walls of white gypsum board, with natural wood trim at the openings and along the floor. The interiors speak softly and in monotone, avoiding all risk of adventure. The several small rooms of the former house have large internal glazed openings to allow casual supervision, and for the most part their windows open generously to the gardens on either side. One room in the remodeled house is reserved for archival material and includes a treasure trove of The Sea Ranch's early maps, photographs, and publicity material. Images of the early Sea Ranch buildings under construction are framed and placed about the building as historical mementos. The most prominent one, which was certainly destined for a magazine, foregrounds two comely young figures on horseback paused at a fence gate. They are looking across open golden meadows to Condominium One, its towers straight ahead, roofs sloping with the land toward the sea. From

the interior spaces and the gardens of the Del Mar Center, however, no meadows can be seen, no weathering boards, no slopes to the sea. Color is expunged, except for the abundance of irrigated flora in the garden and the encompassing green vegetation; it is a completely insular world. Reference to the founding vision and the initial buildings is confined to the files and encapsulated in the neatly bordered archival photographs on the wall.

Viewed from Highway 1, only the bathhouse and the tennis court enclosure are visible. The earliest buildings are screened from the road by vegetation, their only trace a handsome (and aberrant) stone wall paralleling the road. Some parts of the middle hedgerow have come down; they have been replaced, but for the moment are small. Trees in the hedgerow south of the parking lot have for years been trimmed up so that they now have wonderfully strong, sculpted, straight trunks with broad, healthy foliage at the top. These, the white-painted barns, and the diminutive and lovingly restored schoolhouse building are the only parts of the complex that speak directly of the earlier settlement that rooted here, along the banks of a creek.

Viewed from leeward, the preexisting barns and hedgerows, combined with the simple, but nicely adjusted forms of the big community building, are quite attractive and unobtrusive. The bathhouse building, assertive in its symmetrical form and with a vigorously contoured and patterned clerestory down the middle, is mildly at odds with the easy simplicity of the area. Presumably the young replacement cypresses, as they gain in size and join the others in modulating the overall area, will help the bathhouse building to settle in.

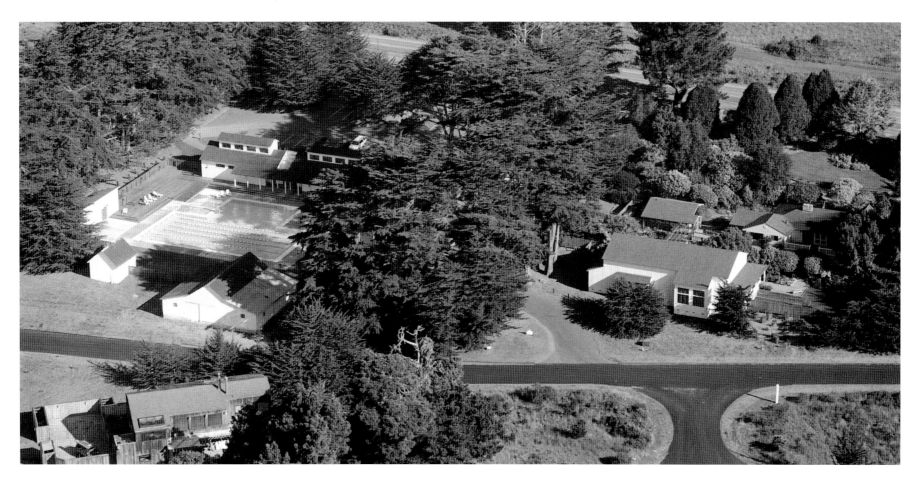

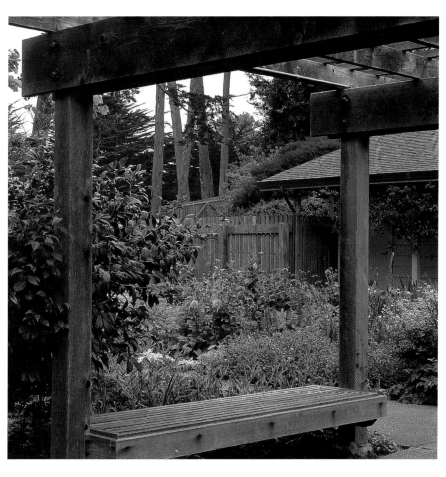

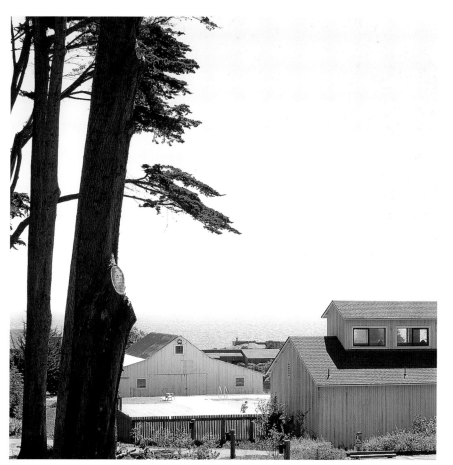

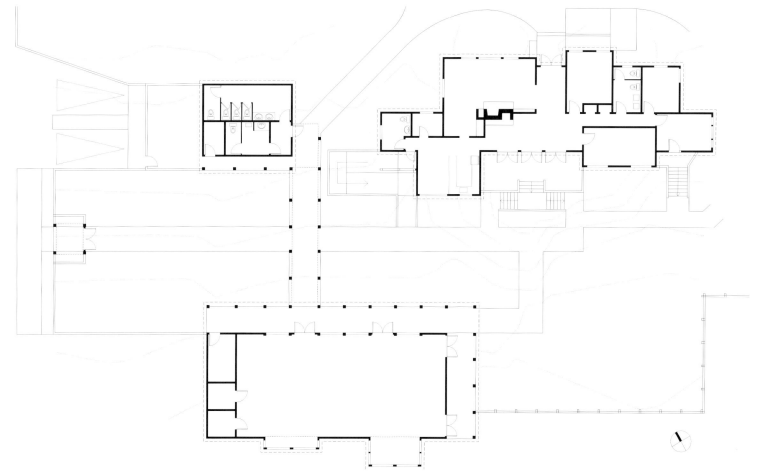

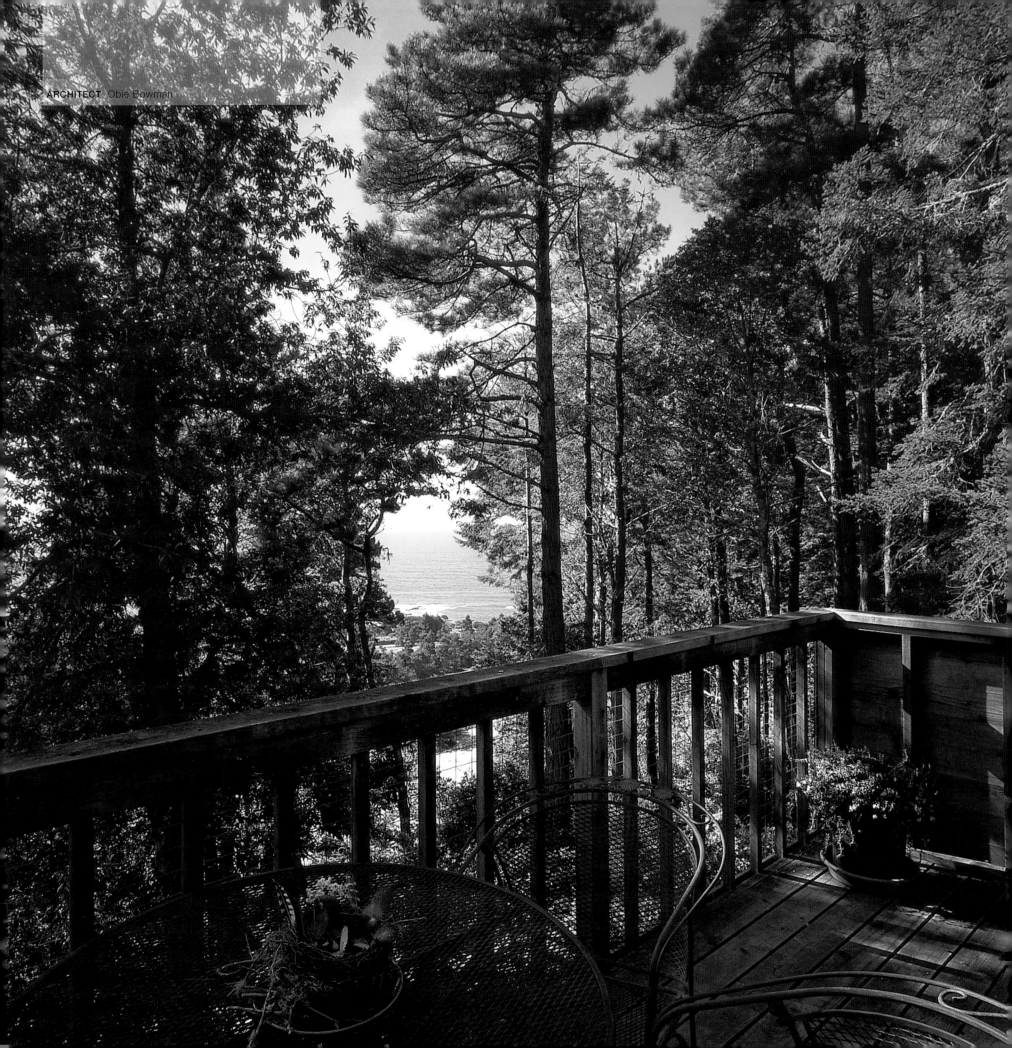

WALK-IN CABINS

(Oceanic Properties, now separately owned)

The Walk-in Cabins (originally more aptly called the Hike-ins) are both the most modest and the most adventurous repetitive house type built at The Sea Ranch. They are almost like a camp in the forest, a series of volumes scattered up the slopes in a redwood grove, each with a tenuous but secure foothold on sharply pitched land. They are curious, spirited structures, simple, distinctive volumes standing about on posts trussed to pile footings, and reached by stairs climbing up or down beside them. Each cabin is configured as a standard shell with living, cooking, and bathing spaces below and a sleeping loft in one corner above, all contained in a tight, almost cubic volume, twenty feet on a side. A flat, skylit roof covers a corner of the volume. It is large and high enough to give headroom to the loft, and bright enough to spread light down through the space, as though from bits of exposed sky seen up through the trees. From that high corner, the planes of the roof drop down like facets of pyramidal tents, slightly longer on one side than the other. These skillfully designed houses might best be called lighthearted.

The plan inside this volume cleverly tucks stairs, bunks, and bathroom under the sloping roof, and a kitchen below the loft. Nearly two-thirds of the space are left open. The low side of the form is made of continuous windows and a sliding glass door that opens onto a free-floating deck. Inside, a woodstove set along one face of the glass organizes a sitting area, and a single wood post rises up from the kitchen wall to hold

one corner of the flat-roofed segment above. Originally the wood stud framing was left exposed, to be sheathed according to the buyer's wishes and budget. Some now have light-bouncing gypsum inside, or areas stained with strong color; others had sheets of resawn redwood plywood installed at the outset.

The Walk-ins were Obie Bowman's first project at The Sea Ranch. He came here, introduced by a friend who was on Oceanic's project staff, from an unsatisfying practice in Southern California. It was a fortuitous moment, both for Bowman (who settled here, then later moved to Healdsburg) and for The Sea Ranch; his subsequent work has continued to be challenging and inventive, often testing the limits of accepted understanding of what it means to build here.

All fifteen of the cabins have the same form with only slight variations. What makes the distinctions among these houses is their siting, the way they fit in among the trees and adjust to the steep slopes. Is your friend's house above or below the path? Do you look down on it first, or up under the struts that hold it off the ground? Does it have a pair of trees right next to the front steps leading up to the deck, or is it set free in a small clearing? Does it have a view down-slope to the ocean or laterally into the top of the forest? These distinctions in position, which are closely tied to the experience of the place, say far more about the individuality of these houses than would the labored contortions of form that many larger buildings use in an effort to fabricate an identity on featureless sites.

The Walk-ins can only be approached on foot; cars are left at the bottom of the hill, except for deliveries. A well-graded path that can accommodate emergency vehicles and deliveries winds up through the houses. Steeper, more direct paths, sometimes with wood steps on the sharper slopes, drive an organizing spine through the forest. The houses were initially all clad in vertical redwood boards. Some have since been re-sided, or have had stain applied to their surfaces, resulting in subtle variations in material. They remain a friendly camp, a dispersed magic circle feathering its way through the woods. Used mostly as vacation homes, a few now house full-time residents.

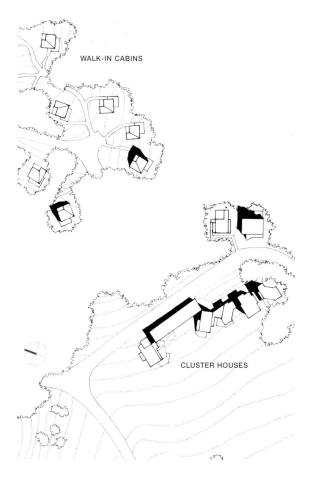

WALK-IN CABINS

CLUSTER HOUSES

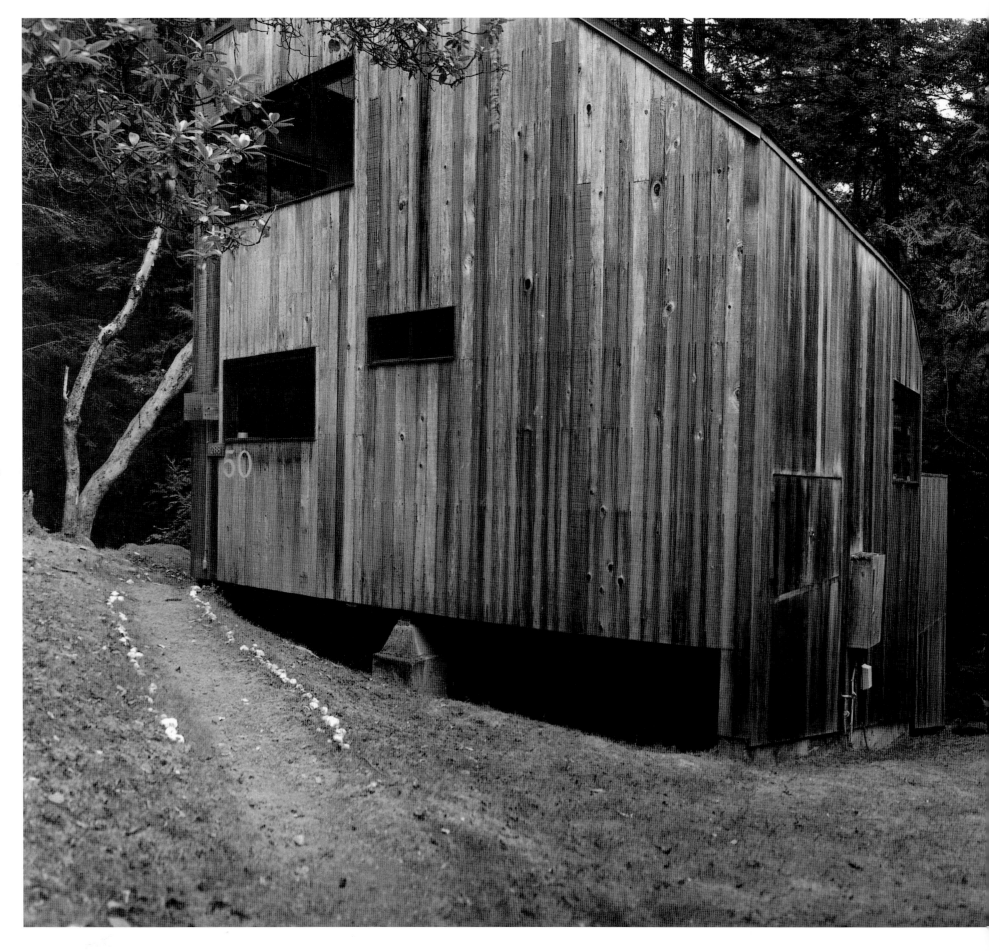

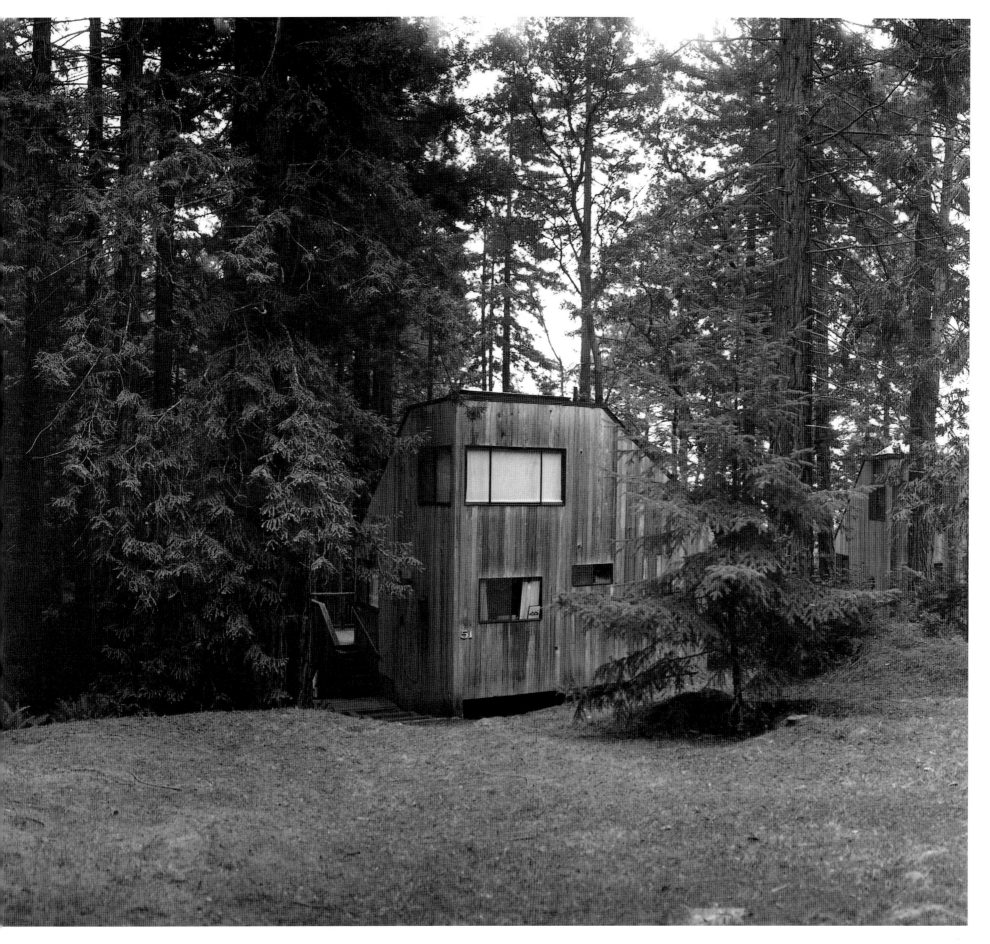

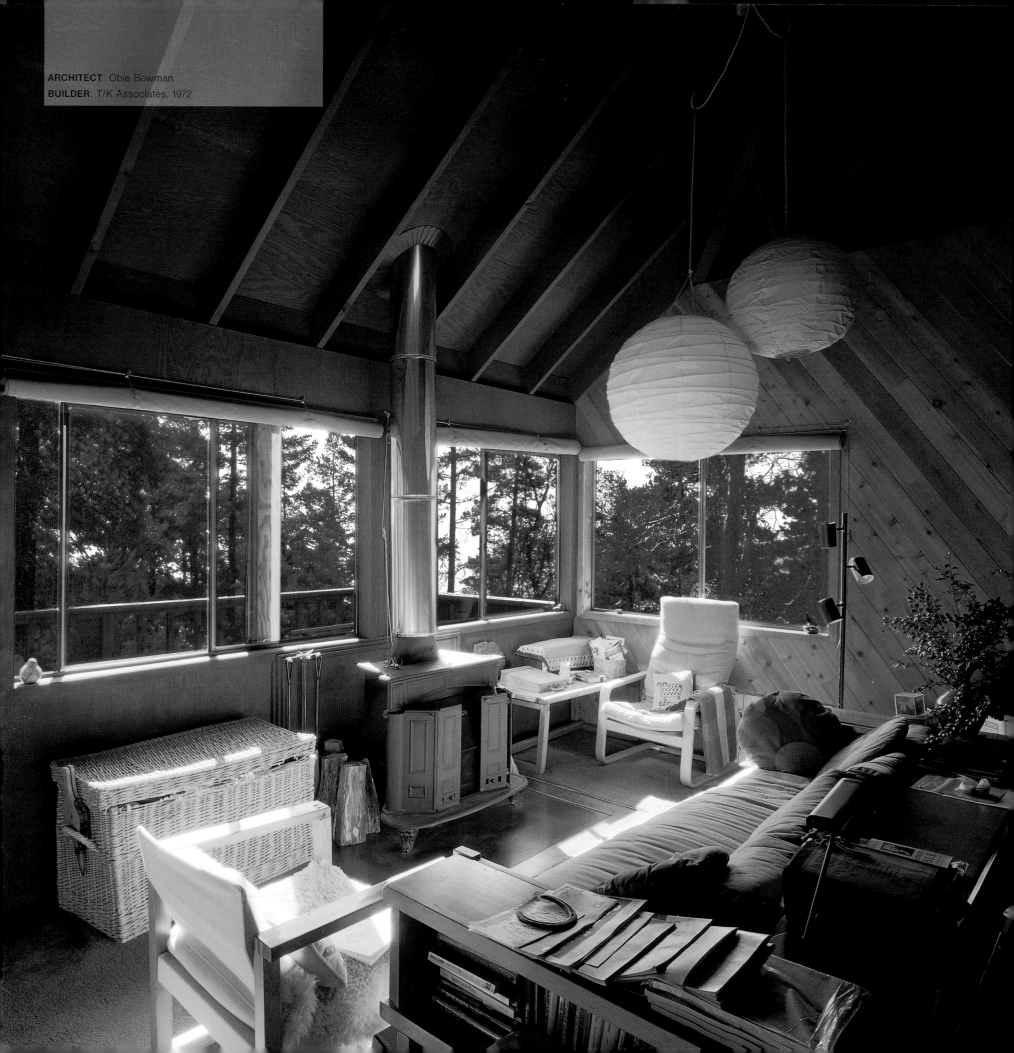

ARCHITECT: Obie Bowman
BUILDER: T/K Associates, 1972

WALK-IN CABIN
UNIT 52

(now the Strand House)

The cabin owned by Jan Strand is set slightly
downhill from the access road, looking farther
down the slope into a ravine, with distant views
off through the woods and glimpses of the ocean
on the west.

 The deck, facing south and standing out over
ferns and vegetation rising up from the slope
below, extends the sense of this tiny space with
its views into the tops of trees, joining it with its
immediate context. The walls inside have all been
covered with diagonally placed wood siding, but
the ceiling construction is left exposed, with small
rafters regularly spaced and the plywood roof
decking visible above them; they have been
painted a dark brown color to emphasize their
delicacy. The cabin, with its wood surfaces all
around and the redwood trunks just beyond, with
its wood deck hovering on struts below, and its
visible elements of roof construction on the
inside, is suffused with evidence of the acts of
building—of putting bits of wood together. It takes
on the aspect of a most marvelous tree house,
assembled from the place at hand, but secured
and maintained with deliberation and craft.

 The cabin has been lovingly kept, with Danish
furniture, richly colored fabrics, and the original
cast-iron woodstove. Jan Strand, who owned
another cabin higher up the hill before she moved
to this one, is an architectural historian by train-
ing, and one of the most ardent stewards of The
Sea Ranch, telling its tales and participating
actively in voluntary planning committees and the
collection of archives.

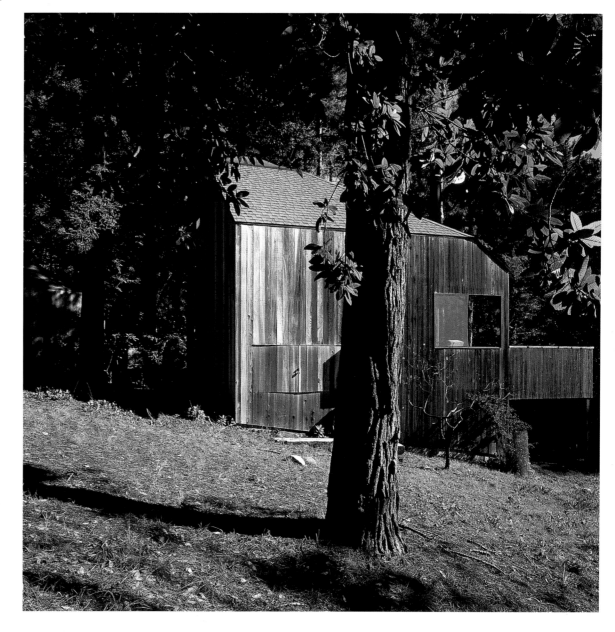

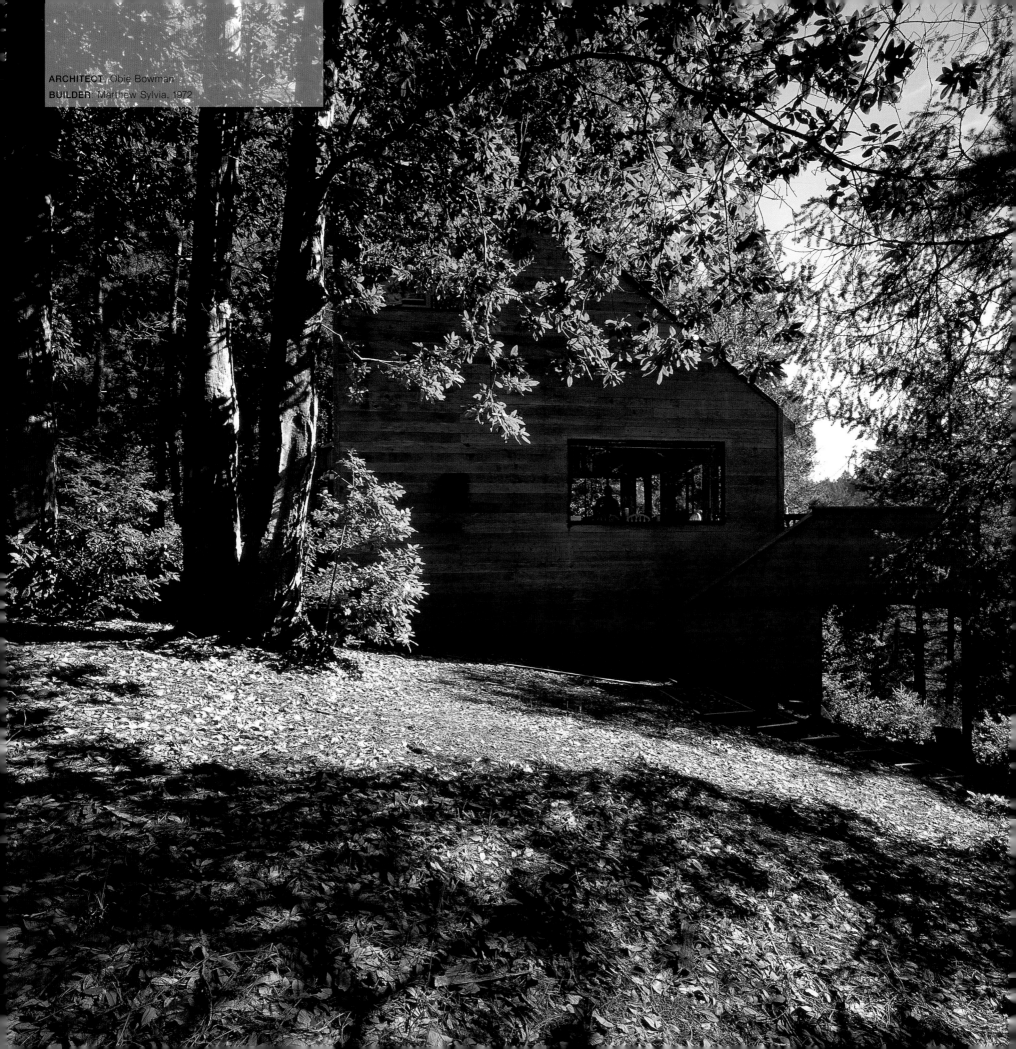

ARCHITECT Obie Bowman
BUILDER Matthew Sylvia, 1972

WALK-IN CABIN
UNIT 53

(now the Voorhees House)

Farther to the west and slightly higher on the slope, the Voorhees porch commands a fine view through trees and out to the ocean's ever-changing surface. It has been extensively changed inside, with vertical board siding on many of the walls and gypsum board on some. A ceiling covering of closely fitted finish siding has been installed to cover insulation that was added between the rafters; carpeted floors bounce the light. The cabin's deck and the stairs leading up to it quietly announce the special conditions of this site, but otherwise the house offers little that would surprise. The loft bedroom remains a delight, here with a translucent covering that diffuses the light. The lower floor is compact, closely fitted to its uses and enhanced by a modified kitchen.

With its extensive view, a position on the land that is almost level with the service drive, and its more conventional surfaces, this cabin feels more snug than the Strand House, ready to be the full-time residence that it has become for the Voorheeses.

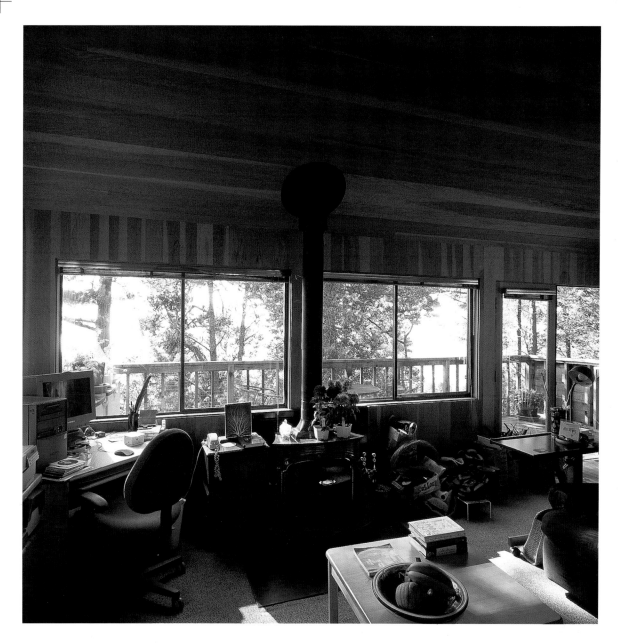

103

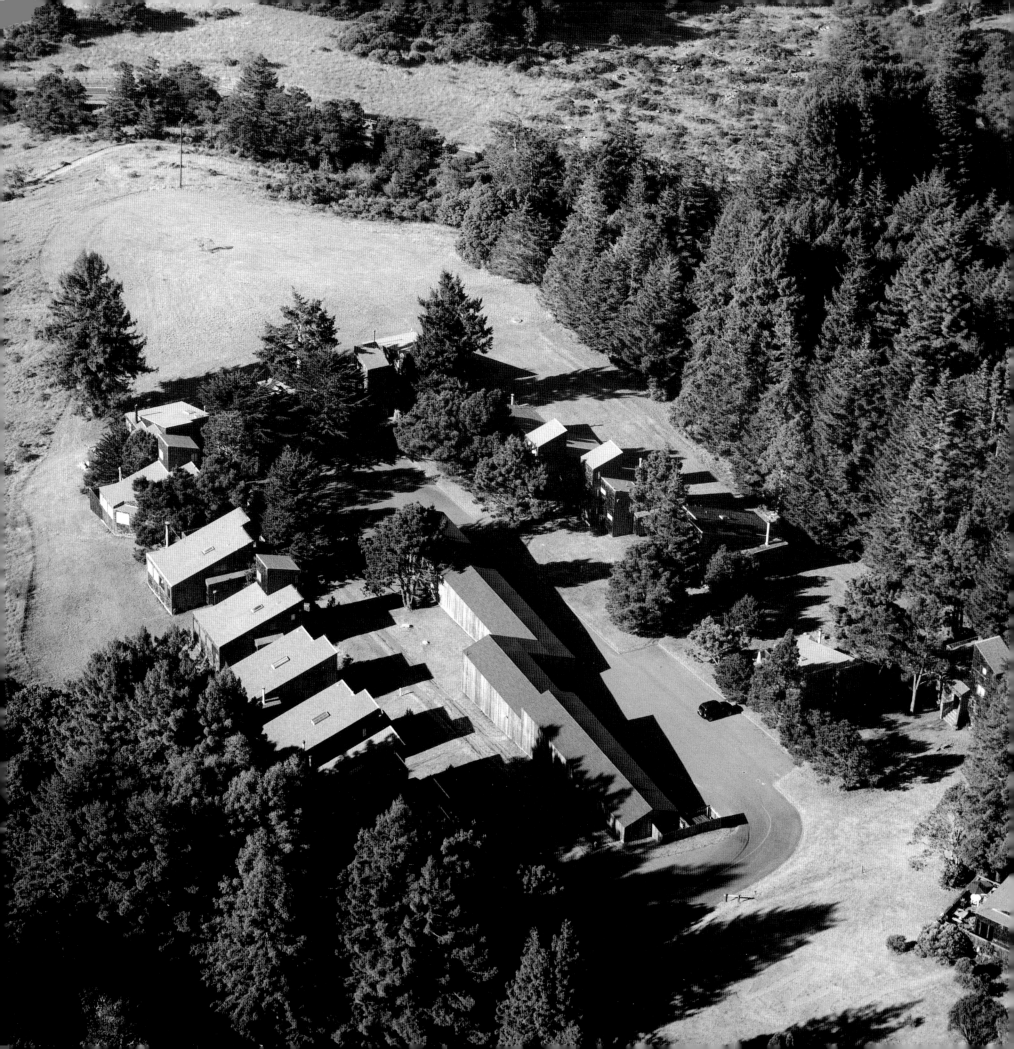

CLUSTER HOUSES

ON WHITE FIR WOOD AND MADRONE MEADOW

The Cluster Houses were developed by Oceanic Properties as a second round of buildings after the Condominium One and the Hedgerow Houses that shared a common purpose. The detached units, built in two places across the highway from the white landmark Knipp-Stengel Barn, are closely related to each other, but do not have the common walls and intermingled ownership of a condominium. One group along White Fir Wood surrounds a meadowed bowl leading gently down toward the barn, the other, clustered around Madrone Meadow, rides high on a forward-projecting plateau along a rising ridge of the hills.

These two places were also built in two phases. The first included general site planning and a cluster of demonstration houses designed by Turnbull. A subsequent, larger phase, was developed with revisions made by Oceanic's own architectural staff, with Boeke as consultant. Revisions included, in a cost-cutting move, a reduction in the number of unit types and much more persistent repetition of the same house plan. Both clusters use "car barns," partially open structures of wood framing under big shingle roofs. These large structures, kin to the agricultural forms of the region, subjugate and shelter the cars of the complex, removing their reflective surfaces from view and protecting the neighboring forest from intrusion. Placed in these barns, the cars, like agricultural animals on a farm, are recognized as essential, yet are confined to their own realm and are only occasional companions.

When these inexpensive cluster houses were being sold, as Boeke recalls, the real estate staff talked about them as "changing rooms"; their ideal clients would drive up from San Francisco in a sports car, park their car in the barn, go into the house and "change from suit and tie into jeans and boots," then go out for a hike in the forest, or off to ride on the horses then still kept in the barn below, or maybe to take a sauna in the Ohlson Recreation Center nearby.[1] It is a charming description, which targets the vigorous and active young weekend clientele that was intended for this kind of housing. It is quite unlike the current conventional real estate and rental listings for The Sea Ranch, with their rankings that list "blue-water" or "white-water" views, the number of bed-rooms and baths, and the presence or absence of hot tub, stereo, and TV.

While most of these houses do have distant views of the ocean, they were not, first and fore-most, places with a view, in which to be indolent. They were meant to be part of a larger, more active experience of the place. The houses are close together, yet they adjoin large tracts of undeveloped forestland and a central recreation area. A network of mostly steep hiking paths with names like "White Fir Wood Trail," "Ridge Trail," and "Big Tree Loop Trail" converges in this area to invite outdoor excursions. At the foot of the slope and across Highway 1, are access trails and stairs to Stengel Beach and the ocean.

The models that Turnbull designed are just beyond the first car barn on White Fir Wood. They are compactly placed, their fronts aligning, with a guest parking area and a boardwalk connecting them on the roadside. Viewed from the meadow, they make a wonderful knot of forms among a group of pine trees at the upper edge of the meadow. Their surfaces on this side align as well, but the cluster of forms is eroded by decks, insets, and diagonal walls, clearly fitting the build-ings to this particular place. They seem to have grown on the hillside they are rooted in. This is surprising, because the cluster of four is made of only two repeating plans. The plans differ consid-erably from each other, with one showing a diag-onal orientation that angles toward the ocean view and brings the group to life. The units are clothed in the same sheathing and built with the same heavy timber construction; the consistency

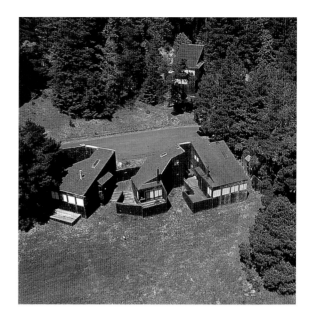

of both their surface and scale, and window sizes makes the whole read as a differentiated, but coherent grouping, measured to the edge of the meadow and with particularized outlooks.

1 Al Boeke, Selection from his presentation at The Sea Ranch Symposium sponsored by the Charles W. Moore Center for Study of Place at The Sea Ranch (November 1999).

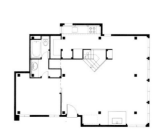
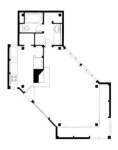

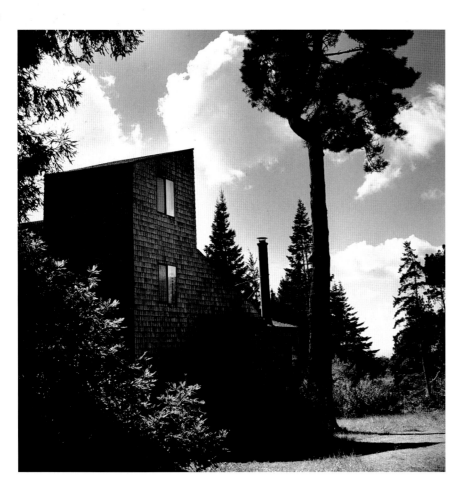
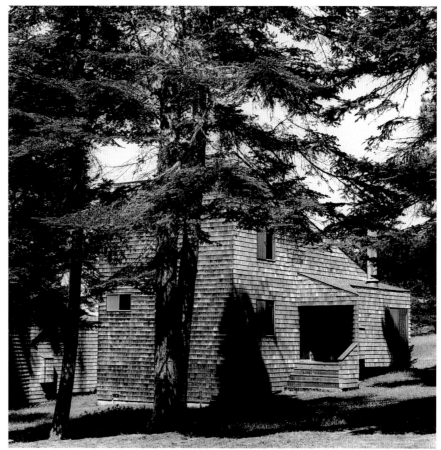

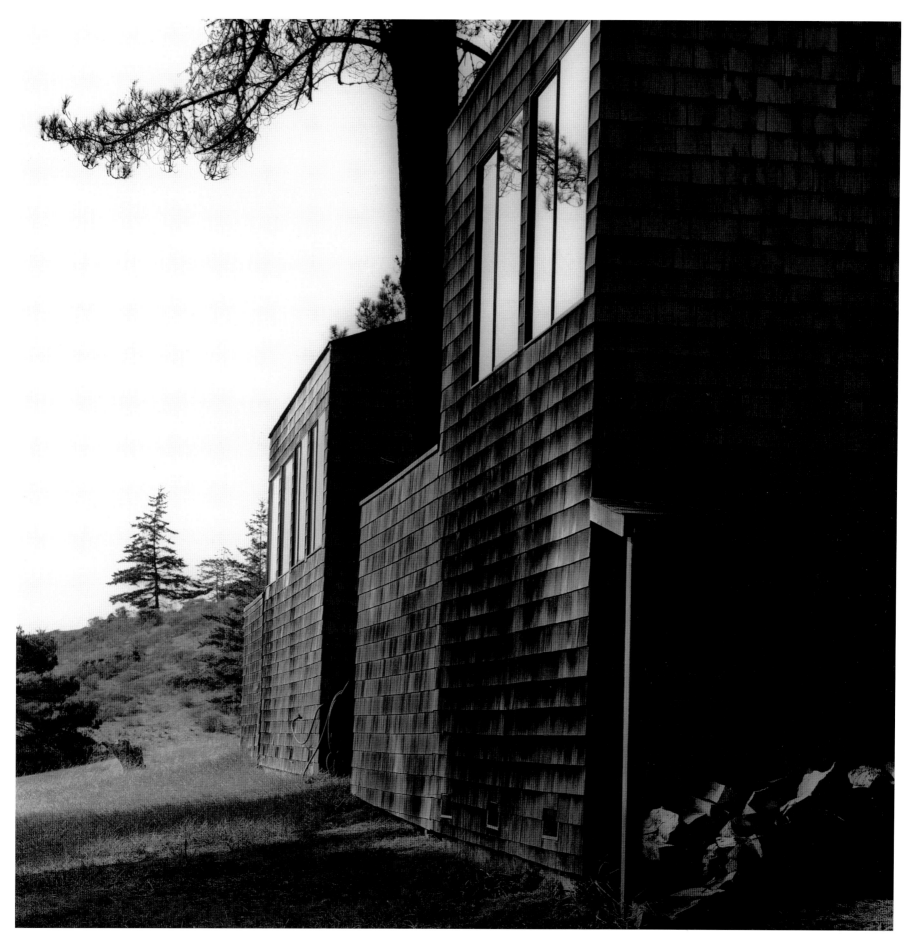

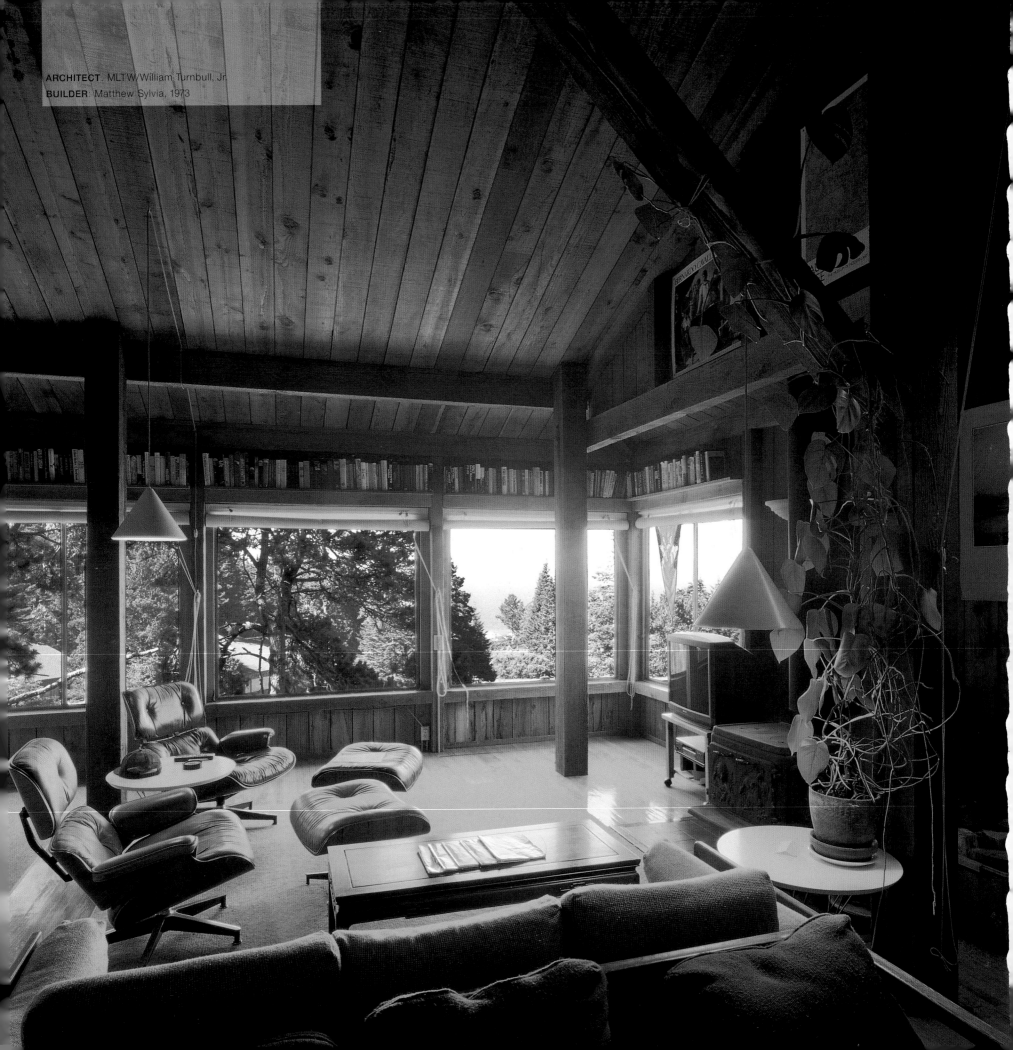

ARCHITECT: MLTW/William Turnbull, Jr.
BUILDER: Matthew Sylvia, 1973

WHITE FIR WOOD CLUSTER/UNIT 4

(now the Yuen House)

The house belonging to Pasteur and Theresa Yuen is a skillfully modulated rectangular box. Its roof starts low over a stretch of windows set forward of a line of columns on the meadow side, then rises uninterrupted toward the hill. At the upper level a screen wall makes openings for sleeping lofts, which can be closed by a large canvas drop. From the top of the space stairs plunge down through the middle in a straight run to a landing that is backed by a tall bookcase rising to the roof. Here the stairs turn abruptly and splay out into the room space toward the front entry. This motion animates the whole space with a sense of human presence, while the treatment of the staircase with low railing walls on either side makes it read as an independent element sculpting the space. Its placement in the room separates the kitchen from entry view, while retaining for the upper reaches of the room a great sense of spaciousness in a modestly sized space. The simple rectangular plan is amended to one side by a bay, which holds a fireplace, shelving, and a bench, the latter just next to the entry and topped by a skylight, providing welcoming light as you step through to the inside.

The framing of the walls is heavy timber with exposed diagonal bracing and hefty square wood posts. The handsomely proportioned volume conveys the sense of a clear and explicable order and shows many moments of ingeniously direct craftsmanship. The exposed plank walls and framing not only sustain attention, but also offer many ledges and layers to lodge objects and graphics of particular personal interest. The great charm of the place is that it is such a clear space, but yet is filled with human presence.

Outdoors, the space between this unit and the next is a protected wooden courtyard, which holds a hot tub in one corner. Entry to the neighboring house was originally not so protected, so that a view down the meadow could be shared by anyone approaching the cluster. The private hot-tub court, however, has appealed to the owners of this house, too, and they recently have placed a similar wall between their house and the next, blocking the view for any outsiders and diminishing the sense of the cluster's connection to the landscape.

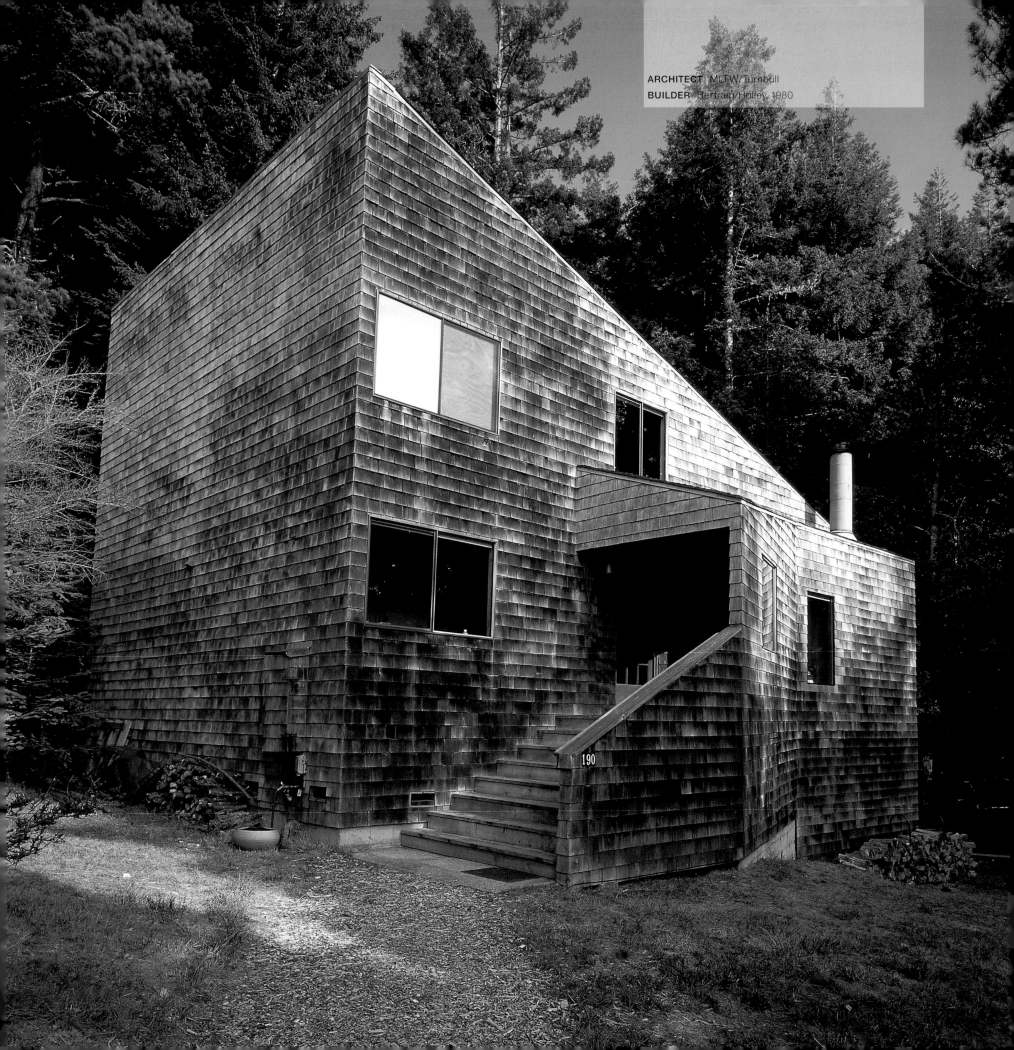

ARCHITECT: MLTW/Turnbull
BUILDER: Bertram/Holley, 1980

WHITE FIR WOOD CLUSTER/UNIT 18

(now the Rathmill House)

eye is immediately drawn across the width of the house and out through a small projecting kitchen bay, with broad windows and a skylight above, to the trunks of trees in the forest. This immediately sets measure to the width of the house and its position on the edge of a ravine. Farther into the corridor the view unfolds to the right through a large opening that reveals a continuous row of living room windows that look into the forest. A sliding door in the corner of this room opens to an ample deck standing over the land as it falls away into the ravine. The opposite end of the living room is furnished with a fireplace, shelving, and TV; a vertically proportioned window offers a select view to the ocean far off, over the houses and car barn clustered below.

Across the road and up the slope are two more models in which Turnbull had a hand. They make an interesting grouping, sitting along the ridge of a ravine that runs down around the meadow. Each house has a single-slope roof, with the roof of the higher house pitching back, up and away from the road; the lower house is the same type of volume, but perpendicular to the higher house, its roof slope pitched down toward the ravine. The two forms make an evident pair, but pitched as they are in opposite directions and bracketing an open space, they provide a very sculptural configuration, with the light playing on four faces differently as the sun passes through its daily course. The higher one, Unit 19, has a panoramic spread of windows looking past the car barn and the lower clusters to the ocean in the distance. The lower one, Unit 18, is approached sideways from the road, with mostly solid wall facing the street, while its panoramic sweep of windows is placed on the low end, looking into the trees and the ravine.

The two houses, similar in plan, have been sited to bring out the maximum potential in their site. As a result they are differentiated in their appearance and in the living experiences they offer. George Rathmill, who now owns Unit 18 but has owned and remodeled five different houses at The Sea Ranch, revels in this particular location and the organization of space and outlook provided by his house. Entrance is in the middle of the house, into a corridor space bounded by walls and open stairs up to the second floor and down to the basement. From the front door, one's

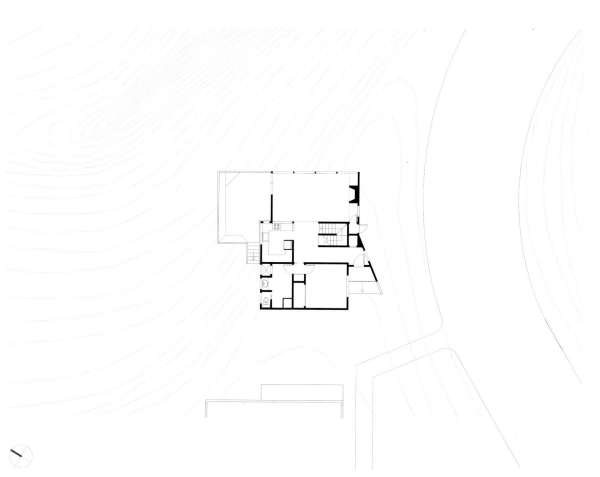

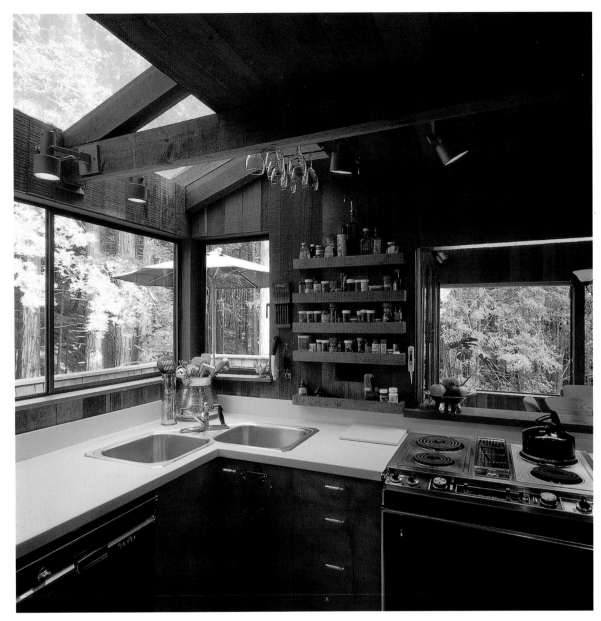

The volume of the house could hardly be more straightforward, yet it offers many different experiences. It is a simple rectangle, with the roof climbing from one end to the other, and the space organized in three layers. The generously proportioned living room is at the lowest end. The middle section, which holds the entry, stairs, and kitchen, has a mezzanine above, opening to the top of the living room on its one side. A wood-sided wall is on the other, decisively separating a two-story stack of bedrooms and bathrooms from the rest of the volume. The high wall at the back of the mezzanine is covered with book-shelves; a single window on each end offers a framed view to the rising trunks of trees at one end and to the ocean at the other. Sun enters through skylights in a couple of places, and through the south-facing window, where a read-ing chair capitalizes on the moment.

Beyond the wood wall, the roof continues up to make high space in the master bedroom, com-plete with a small upper storage or sleeping loft. The bedroom captures views again on the ocean side, while the forest side has a generous bath-room with a tall window end that places the over-sized tub practically among the trees.

Almost the entire house is built within two parallel walls and one sloping roof plane, an exer-cise in spacious frugality. The modifications to this volume are three: the small bay in the kitchen, the deck off the corner, and a marvelous projecting bay that runs along the road side of the house; beginning as a simple extension hold-ing the fireplace and allowing the chimney to rise clear of the main volume, the wall of this bay then suddenly bends out to encompass a set of stairs reaching from the sloping ground up to a porch at the entry. As the wall bends out, the roof pitch-es down farther, the two combined making a ges-ture that generously embraces visitors as they climb to the porch.

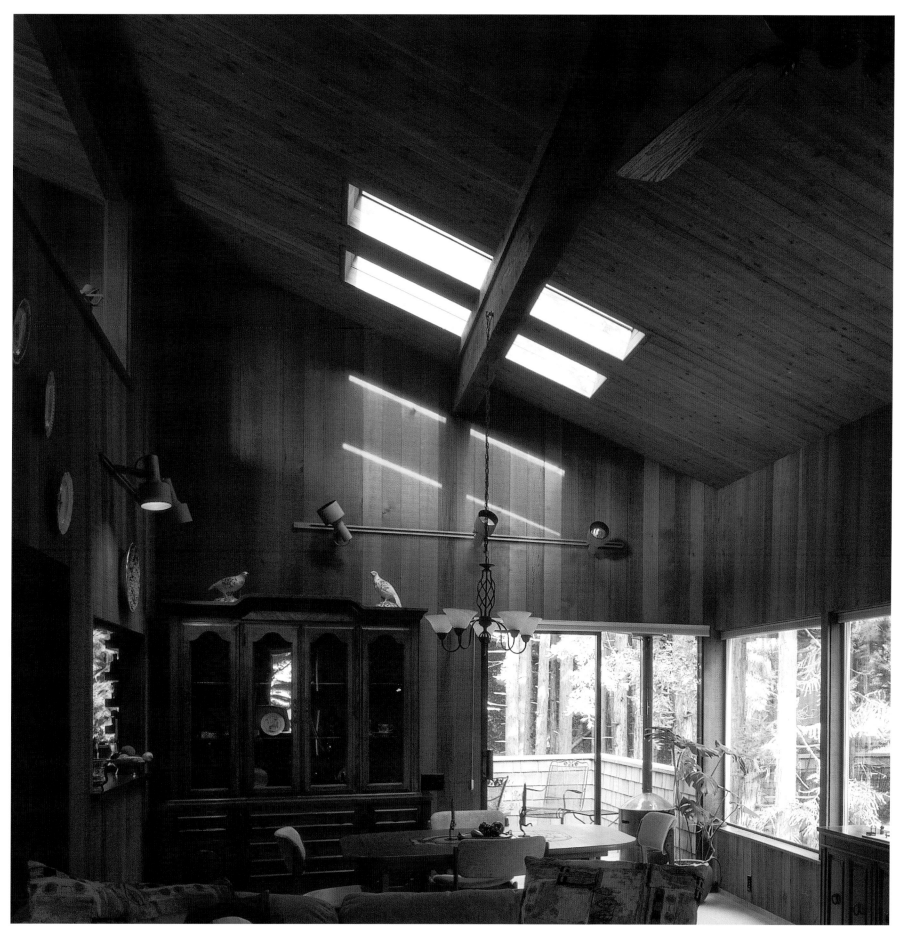

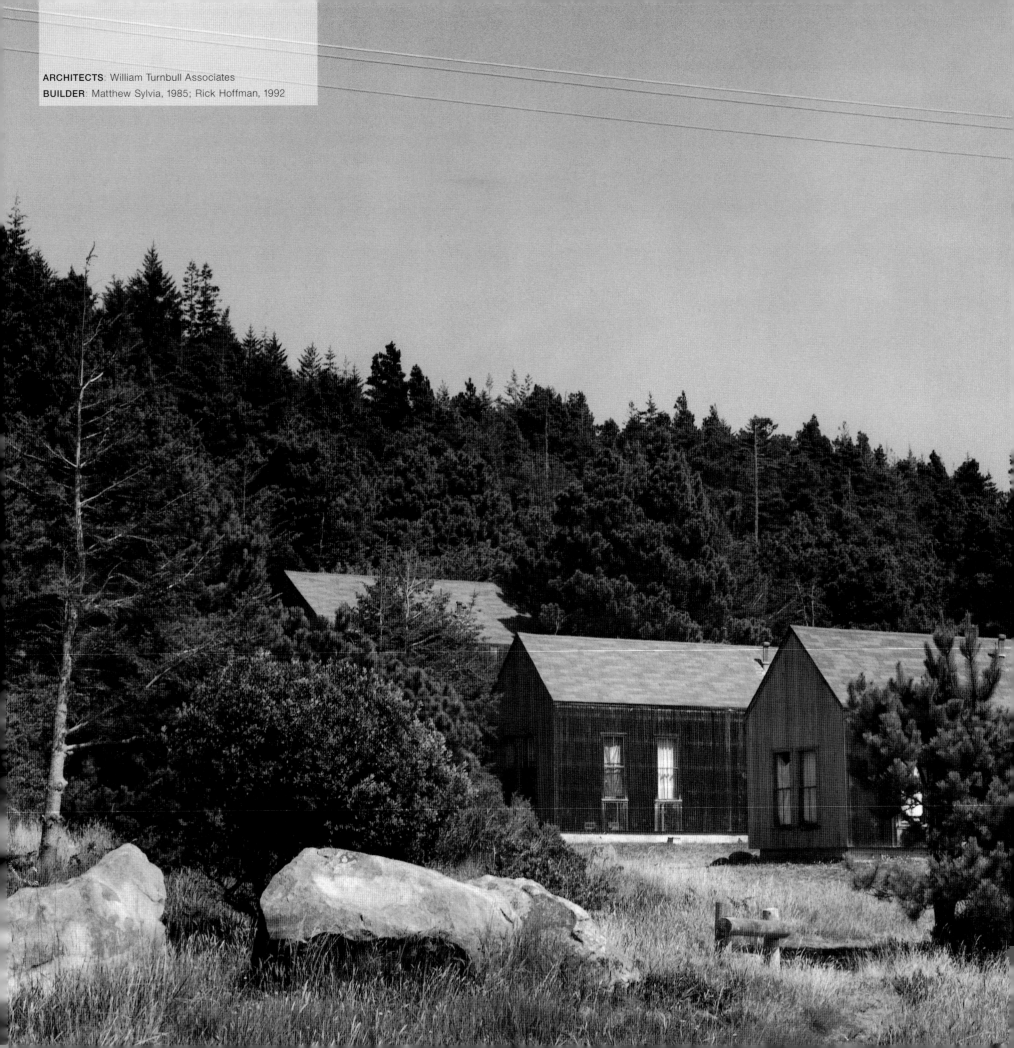

ARCHITECTS: William Turnbull Associates
BUILDER: Matthew Sylvia, 1985; Rick Hoffman, 1992

EMPLOYEE HOUSING

now Burbank Village
(owned and managed by Burbank Housing Inc.
of Santa Rosa)

One of the most instructive parts of The Sea Ranch is the segment now called Burbank Village. Consisting of forty-five dwellings clustered around three heavily vegetated cul-de-sacs at the very north end of the development, the complex is located just where the steep forested slopes of the ridge taper off into gentler, more buildable land. The forest too tapers off here, but only after making its way down among a complex of modest buildings that are ingeniously sited among the trees and in relation to each other.

It is a magic place, really, a lively collection of small structures set among thickets of trees—many of them conifer "volunteers" that grew into the spaces between buildings through natural proliferation. It is a place that is made special by this combination of intense vegetation, small buildings, and a spatial arrangement that is unusually varied and intricate. The village is also one of the few places at The Sea Ranch where children are always present, often confidently playing in the short, sparsely trafficked streets, which terminate at the edge of thick woods.

An early site plan for the whole complex submitted by Turnbull's office, as well as photographs taken after the first phase of development, show the buildings sited among far fewer trees. Another, exceptionally handsome presentation drawing from the office (illustrated on p. 117) shows very deliberately planted hedgerows located along the south side of the streets, protecting the houses from northern winds while allowing sun to penetrate into the spaces on the north. The lines of trees, curving to follow the roads previously laid out, were intended to circle around the end to define the terminations. As trees planted in the right of way, they would have belonged to The Sea Ranch Association and would have been subject to maintenance, nurture, and trimming by the associatoin. Apparently this landscape plan was not implemented, however, and the thickets that have grown up merely fill voids in the plan or reflect natural patterns of growth. Nevertheless they establish a distinct character for this place, especially when combined with the delicacy and intricate planning of the simple wood structures they enfold.

Burbank Village, which resulted from a design competition won by Turnbull, was built in two phases to the same set of three plans with two variations; five types, in all. They are very modest houses, ranging from 600 to 950 square feet on lots that are generally 60 feet wide. One of the variations combines two houses into one structure straddling the property line; otherwise, the houses are free-standing. The key to the success of this complex is that the site plan anticipated from the beginning that houses could be placed to mutual advantage if each was related to the particulars of the site. Thus, instead of setting an abstract code of setbacks and regulations, each house was placed in relation to the others, most often near or touching one edge of its property rather than adrift in the middle of its site. This allows the open areas between buildings to be

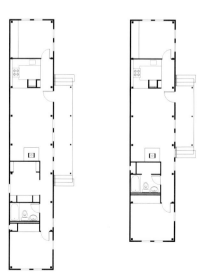

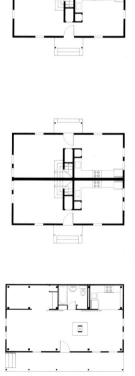

 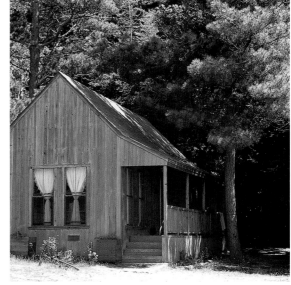

used to greatest advantage, with each house claiming the space to the next as its own; provided, as here, that they all open primarily to one side, with only minimal openings facing the neighbor behind.

Planning of this sort is readily achieved with these carefully conceived house types, which are mostly rows of rooms with porches attached on the open side, generally facing south or west. Often building walls are extended as board fences to separate the properties, with little storage and utility sheds attached at their ends to suggest a court and shield the cars, toys, and abundance of objects that accrete to these small houses. Rather than following a standard formula, the most suitable house types are chosen and set on each lot with attention to slopes, outlook, neighboring buildings, and existing trees. The house types themselves are similar, all derived from simple vernacular forms, yet distinctly different. All are based on the core structure of a rectangular gabled room and share a generic kernel of organization, a house form so iconic and clear that it lives on Monopoly boards across the country. Yet one stands proud and thin, and

sharply formed, another is chunkier and more dominating, the third and fourth stretch out in long slivers shaping the space beside them, and the fifth, with its double-slope roof, settles gently and comfortably into the land, recollecting many similarly shaped farm structures. These differing forms also act differently in the landscape, and when combined with each other, and their sheds, walls, and vegetation, they make a physical environment that is uncommonly alive and intriguing, comfortably suited to their rural setting.

Two aspects of the construction of Burbank Village bear special note, since they help explain its unique character. First, both the walls and roof surfaces of the one-story houses are built with planks spanning between the elements of an exposed timber frame, and surfaced with vertical redwood boards; they are smaller versions of the construction in Condominium One (this time with insulation), although made more intricate by the roof members that cross at midpoint to form a simple scissors truss, elaborating the rhythms and trace of the framing. Here, as at the condominium, the surfaces of the decking are resawn and exposed inside. This mode of construction,

developed and refined by Turnbull and Sylvia, virtually eliminates interior finishes. When combined with the narrow plans, gable roofs, and low heights of these units, which can easily be assembled by an experienced crew and do not require scaffolding, the unit costs of the construction system are quite low. The second aspect of importance in the construction of these houses, is their lean and graspable appearance. Most of these houses are only twelve feet wide, and those that are not still have approximately that dimension as a fundamental module of their structure and form. As a result, the forms are intimate in scale, presenting in their gable ends the size of a room that an individual or a small group of people can comfortably settle into. Traditional double-hung upright windows that reach almost to the floor are shaped even more closely to the human body. These sizes, revealed in the peaked roofs and facades, and measured across the sides of the buildings by well-positioned doors and narrow windows, give a personal friendliness to the place; the houses carry a sense of being shaped to human occupancy.

That this separate, diverse, and slightly magical world is actually subsidized low-income housing

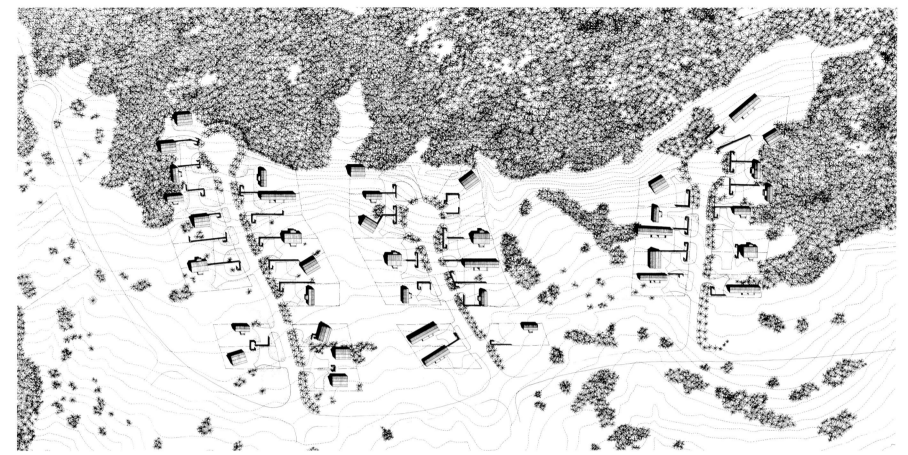

only makes it more interesting. The multiple cars, gardens, and apparatus that accompany these tiny houses, often packed with family, make a rich environment, albeit somewhat at odds with the carefully restricted and controlled spaces of the rest of The Sea Ranch. The house types themselves, in their simple dignity and with the variations that are played on them, are a thrilling rebuke to the punishing meanness that has so often characterized subsidized housing. As the jury stated in giving this project an AIA Honor Award for Design in 1990, Burbank Village has "a sense of inevitability—these houses and no others belong here. Humble, yet so assured, this project lends a quiet dignity to the spectrum of social housing."[1]

Burbank Village was originally constructed to be employee housing, mandated by the North Central Coast Commission as a requirement for Oceanic's completion of the development plan. The intent was to make housing available that would be affordable for lower-income employees working on The Sea Ranch, an obligation that was passed on to subsequent owners of the lodge and golf course. The subsidy programs that were used to help finance the project, however, could not be limited to Sea Ranch employees, so the village is now managed by Burbank Housing Corporation, a non-profit developer and agency in Santa Rosa that provides low-income housing for Sonoma County citizens who qualify for aid.

Burbank Village transcends its origins as subsidized housing and the inherent limitations of a place set aside for a specified income group. Turnbull's intense care and practiced skill have created here the setting for a place of real distinction, a place of which its residents and The Sea Ranch can be proud.

1 AIA Jury, quote from "Sea Ranch Employee Housing," *Architecture* (March 1990): 99.

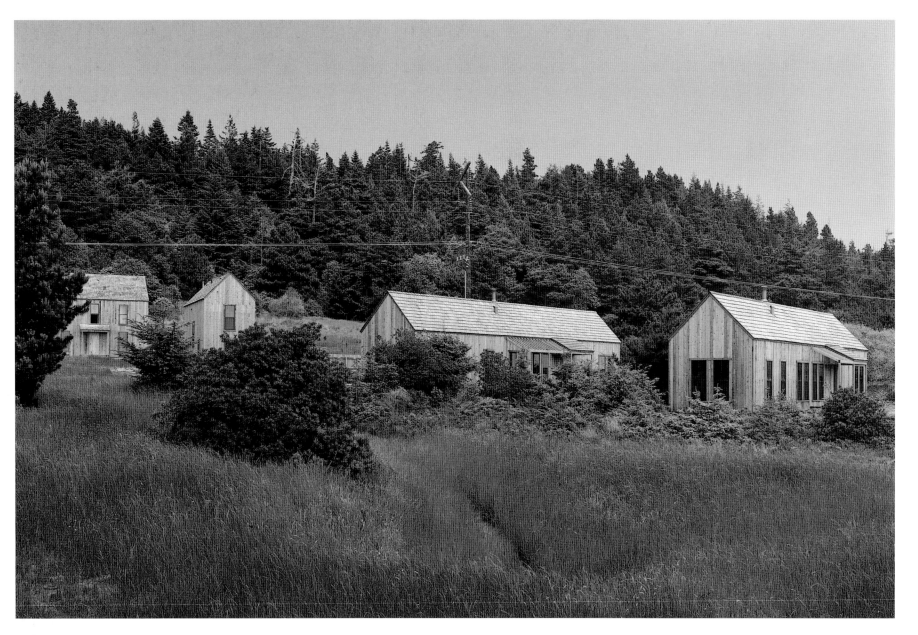

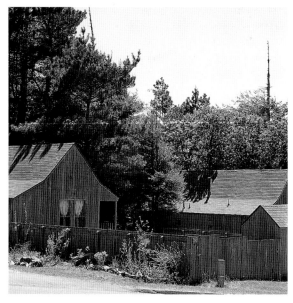

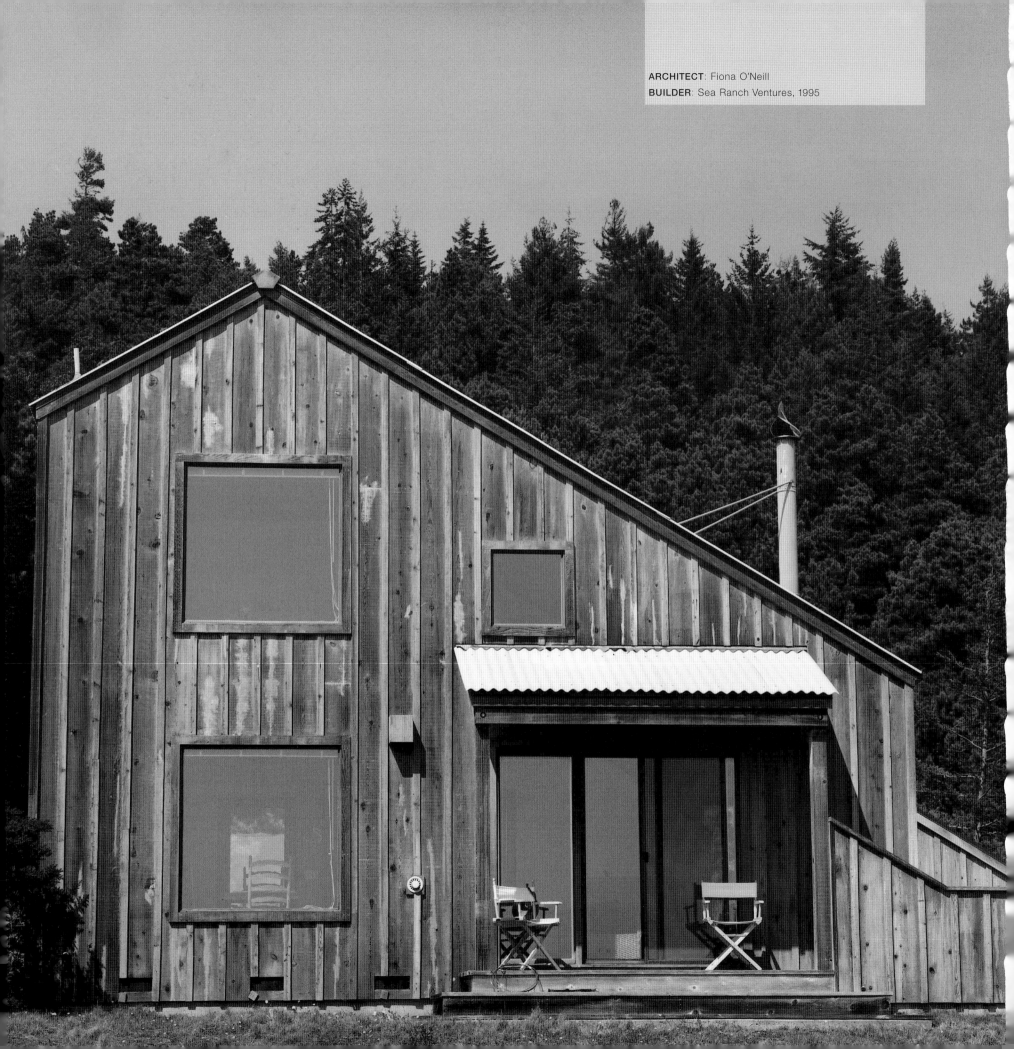

ARCHITECT: Fiona O'Neill
BUILDER: Sea Ranch Ventures, 1995

THE COTTAGES

(developed by Sea Ranch Ventures,
now separately owned)

The Cottages are the most recent attempt by one developer with a sizable segment of land to construct a group of houses that could be offered for sale. The seven cottages, sitting quietly in their sites at the rear of the coastal shelf, are modest and comely, a welcome addition to the place. They occupy rather large lots, parts of which are designated reserve, and the houses bear a family resemblance to each other: they are similar in size and built in a consistent way and with comparable forms, including some repeats. Roof forms vary to provide changing qualities of light and space, and to differentiate between the houses. The extended "family portrait" includes two sets of twins from different branches of the family and three siblings, whose profiles vary to give them distinction. The houses are comparatively inexpensive, offering opportunity to a wider range of people; they have small, compact footprints, and economical spaces that accommodate overlapping uses. Like the original buildings at The Sea Ranch, they are meant to provide the essentials for vacation in a way that is both spirited and affordable.

The land they occupy was part of the "Transfer Site," a section of property east of the highway that was transferred by Oceanic to the state's coastal conservancy as part of the Bane Bill settlement. It was intended to be a section that could again be planned with special attention to the land and its vegetation, and to allow housing for differing income groups. The land transferred was complex, with steep slopes, limited

access, and considerable sections of protected wetland. A power line crossing the site and obstructing the view to the ocean seemed troubling to conventional real estate interests. In 1993 Sea Ranch Ventures purchased a segment of the site from the coastal conservancy and developed The Cottages, designed by Fiona O'Neill, an architect who first moved to The Sea Ranch to apprentice with Obie Bowman, then stayed to open her own practice in 1991. The Cottages have been a considerable success; with initial prices lower than anything else being built at The Sea Ranch, and with their evident charm, they were quickly sold, and have been much admired.

The seven are divided into two groups: four are stretched along a road just at the foot of the hills, the other three, accessed by a common drive below them, are nestled in the meadow among groups of trees. The upper set, on Corn Lily Road, is edged into the beginning of the forested slopes. The houses are all approached from below, with drives reaching up to walled car courts cut slightly into the hill and sizable boulders revealed in the grasses. The houses and adjoining walls are board-and-batten redwood siding rising from the ground. Well-positioned bays and projections create a delicate and consistent scale that gives a continuity to the buildings as they are spaced out along the road and among the trees. The lower group of three houses is on a short segment of road reaching into the meadow. The most downhill house is low and stretched sideways at the edge of the site, sharing views across the empty meadow with its neighbors.

The houses have three basic plans that, though different, use similar devices, including wall kitchens that can be closed off from view by shoji screens; single, unelaborated bathrooms; fenced hot-tub decks; strategically placed woodstoves; and occasional dormers. An ingenious use of partial symmetries in their forms and elevations gives a sense of aspiration to the designs and helps to make them memorable. As the most charming of vernacular structures often do, these cottages have elements of simple, strict, and uncomplicated formality and alignment that might be found in much larger, grander houses (large gabled forms, centered and symmetrically placed windows), which are then distorted or extended

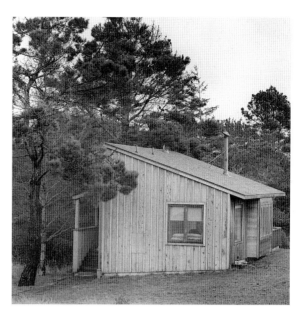

to make way for special conditions, often bringing eaves closer to the ground or extending walls to enfold decks.

Cottage Three, for instance (see p. 120) extends its gable, with a central stack of windows (and a loft behind) located under the peak of the gable, while one side of the roof reaches on down to a low eave and a sun-seeking deck on the southeast. A shed-roofed porch attached lightly to the front of the extension punctuates the play of formal centering and relaxed accommodation. This cottage represents vividly the theme that quietly bonds these houses together, harkening back to the modest and direct wooden buildings with which people first settled the region.

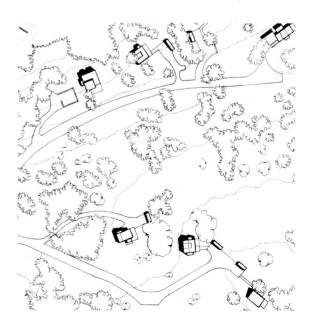

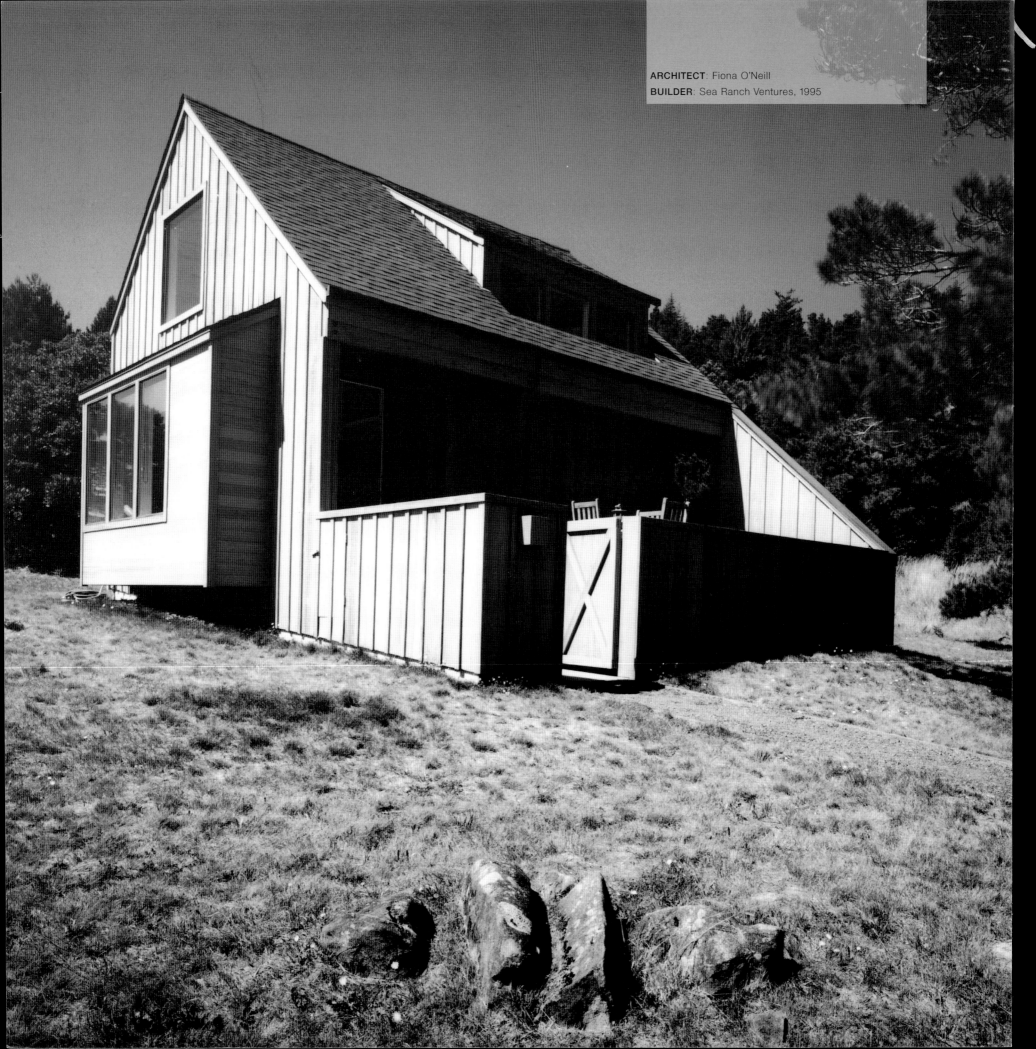

ARCHITECT: Fiona O'Neill
BUILDER: Sea Ranch Ventures, 1995

COTTAGE TWO

(now the Altes House)

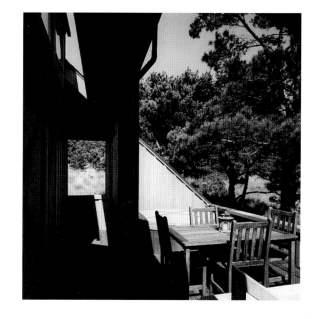

This cottage, which now belongs to Kathie and Bob Altes, exemplifies well the essential qualities of these houses. It is in total five hundred square feet, with a loft bedroom and a long counter kitchen that can be closed off by sliding shoji-like screens—all contained in one simple gabled volume, with an adjoining deck. The loft fits into the top of the volume at the rear—with a little help from shallow, lifted dormers that gain headroom for either side. One dormer provides room for a closet; the other holds a narrow band of windows that open for ventilation and allow the sun to penetrate into the space. A big square window in the rear wall looks up toward the forest and lets early morning light fall onto the bed backed against it under the peak.

The simple volume gives an airy and settled sense to the main space, even as the bedroom loft feels especially intimate by being tucked up under its eaves with a handsome open rail. A central bay window serves as a lens to the world outside and the ocean horizon. An altogether practical closet is placed next to the sliding glass door that provides entry from the deck.

Viewed from the exterior, the bay window and the entry closet are incorporated into the same shed projecting from the building's face, which deftly animates the principal facade by playing with conventional ideas about centering. The bay window itself is the center of the composition if only the symmetry implied by the peak of the gable is considered. But as the roof form is extended slightly farther on the south side to cover the entry and a bit of the porch on the side, the combined projecting bay is centered on the overall form. This is a subtlety that easily passes notice, but is the sort of adjustment (frequent in these houses) that keeps a house form lively. The rear wall extends even farther and then wraps around as an enclosure for the hot tub.

The conventional "house" image that this cottage presents is smoothly encompassing without being static. The slightly off-balanced gable gives the house a quiet vitality that serves it well, settling into the territory without attempting to dominate the scene. Its twin on the upper road, with its entry to the side reached from a short, steep drive up the hill, fits in equally well on a more pronounced slope. They are intelligently crafted examples: two houses of a single type that sit comfortably among the several other gentle houses that O'Neill has designed, sharing a common sensibility and respect for the place.

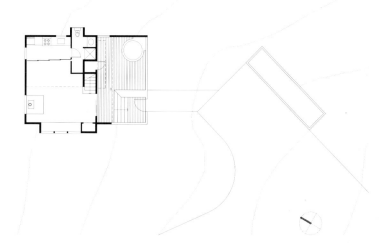

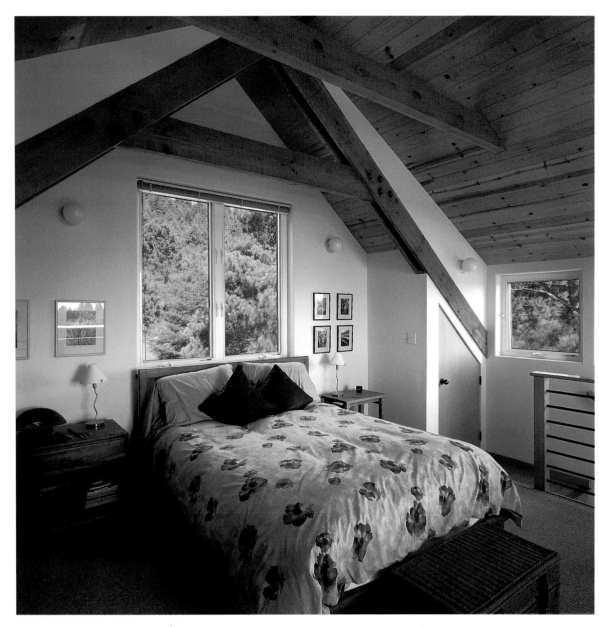

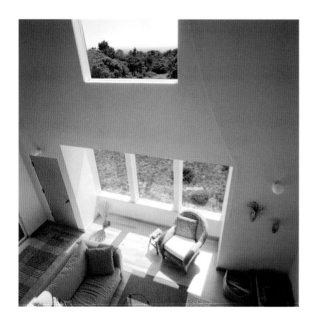

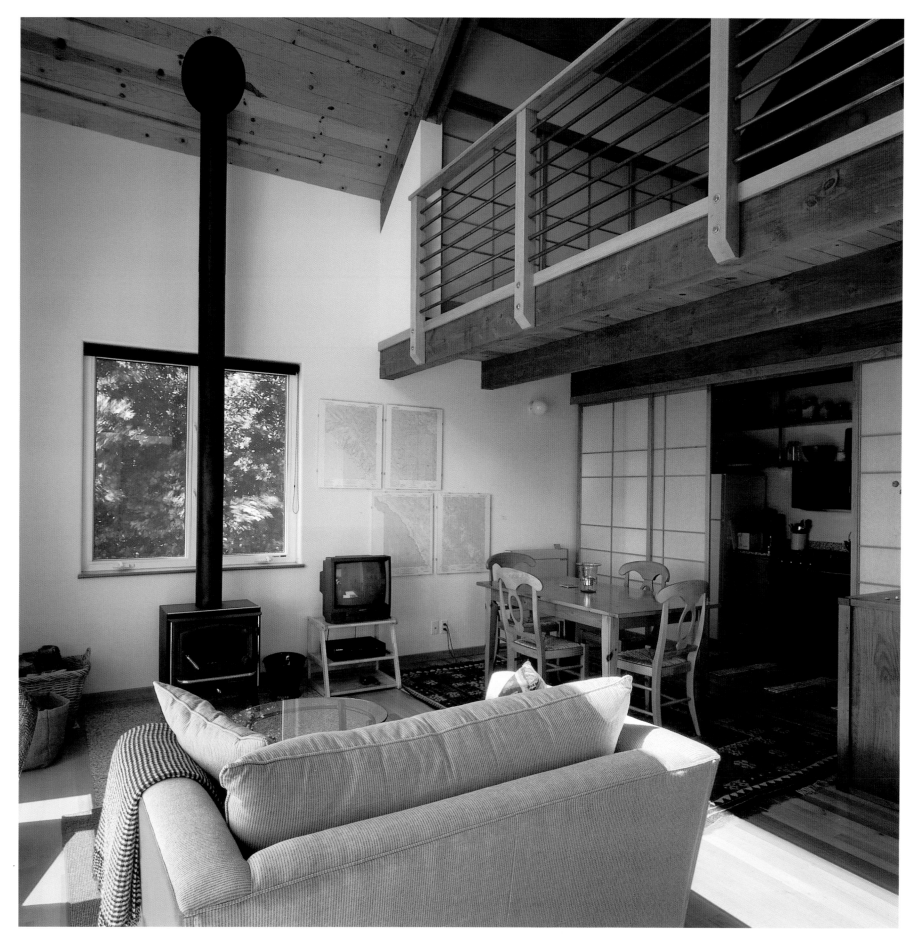

SEA GATE ROAD

WENDEL-LYNDON HOUSE

MEADOW HOUSE

LYNDON-WINGWALL HOUSE

SEA MEADOW DRIVE

RASMUSSEN HOUSE

YUDELL-BEEBE HOUSE

WHALER'S REACH

GALLEON'S REACH

SEA GATE ROW

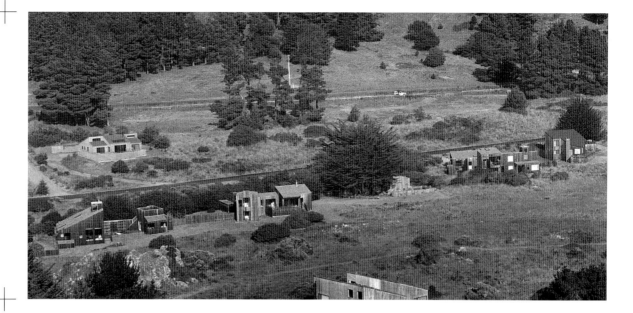

The houses in Sea Gate Row are part of a group of houses at The Sea Ranch that I have designed during the last fifteen years. They continue exploring the ways of building that my partners and I initiated with the design for the Condominium One in 1964.

The challenge and opportunity I faced with these houses, working as a design partner of Lyndon/Buchanan, was to explore how these ways of working could be adapted to smaller buildings. Sea Gate Row consists of individual houses, each with its own distinct configuration and identity, but they use a common vocabulary of forms and materials, and are sited along the edges of a characteristic Sea Ranch meadow. They explore the implications of the original building vocabulary, in each case turning its power to differing sites and purposes, but striving always to contribute to the larger structure of this particular place.

Sea Gate Road runs across the back of a very large meadow, paralleling Highway 1. Along this road I have designed three houses (and expect to do at least two more), which sit among several houses already there. These were built at different times but with a common intent—to use a consistent way of building to make houses that would each work to its own conditions, yet join to a common understanding of the site, all built with sizes that sit easily on the land and are visibly related to the presence of people within. The house nearest the hedgerow, my own, is the northernmost of the row, its face turned up to the

southern sun, with a wind-shielded deck reaching over to a room-sized studio building standing by itself. The volumes are linked by a garden wall that parallels a myrtle-lined stream running behind. The second house in the row is also made of two parts, but they are joined by a low, linking vestibule. One of its wings parallels the stream, the other angles off toward the west, presenting its narrow end as a companion in size to the studio of the first house. Their forms are different, but their materials and windows are similar, responding to the same elements in the landscape. The third house in the row is a house that was already there when we started; it sits quiet and low on its site, sheltered by a cypress tree at its edge, with its low, narrow face fronting the meadow. The stream and its myrtles continue behind it, joined by another, still higher, cypress making a landmark at the edge of the road. The next in the row is the most recent. It shapes the edge of the meadow, ducking behind a set of full-size baccharis bushes, even as the line of myrtles dies out with the flow of the stream, which first appears from underground at the back of this site. This house is made, like the others, with vertical-board redwood siding interrupted by dark aluminum windows that play out a rhythmic pattern on its face. The fifth and sixth along the road were already built, one an early Esherick, trim and narrow, with a single-pitched roof rising toward the hills and a pointed nose toward the meadow. The other, designed by Obie Bowman, is low and sod-roofed; it appears as a triangle of turf tilted

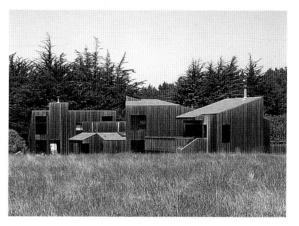

up from the meadow to reveal a greenhouse facing the western view.

From Sea Gate Road, the northern houses are barely visible, as the line of myrtles rises high enough to shield them, and the grasses between the trees and the road have been left to develop a life of their own, creating a swatch of natural landscape that reaches across a number of lots. Viewed from a trail that cuts across the meadow on the ocean side, the houses make an articulated edge, carrying the line of the stream while acting as an inhabited boundary to the common open space extending up from the ocean.

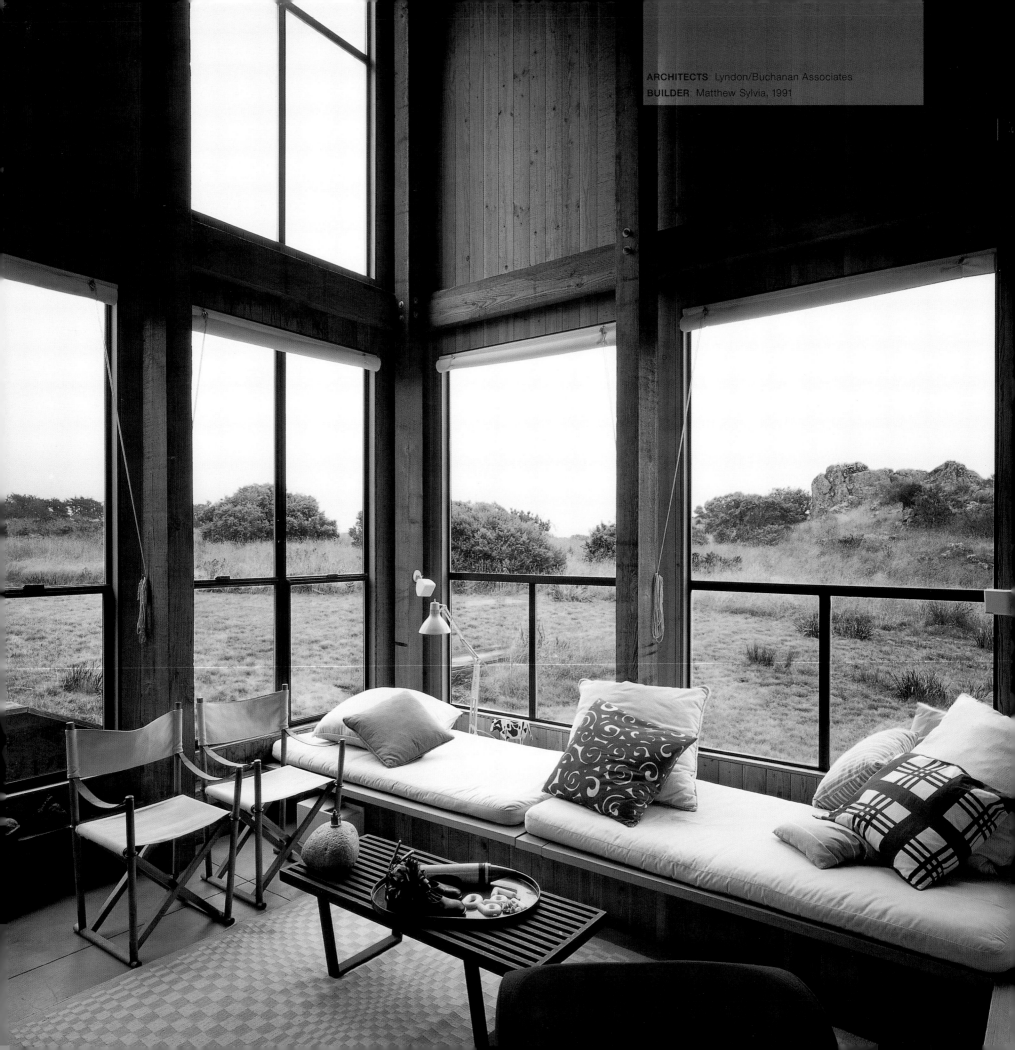

ARCHITECTS: Lyndon/Buchanan Associates
BUILDER: Matthew Sylvia, 1991

LYNDON - WINGWALL HOUSE

The first house built in what has become Sea Gate Row was the one I designed for Alice Wingwall and myself. It is a treasure house for light, a chamber in which to cherish the substance that has been so fundamental in both of our lives—captured in Alice's photographs, which layer the wall, playing freely across sculpture and architecture to illuminate the modeling of form, pacing across space to mark the measure of time. Light remains a messenger of joy, even as it disappears into blindness for Alice.

As the first of the Sea Gate houses, located nearest the hedgerow, it sought companionship in the landscape. The house consists of two structures, one big, one small, both clothed in weathering redwood to masquerade as wooden rocks. They court a third rock, a real and very present one, jutting forth from the meadow a stone's throw away toward the ocean. The bigger volume holds places for sleeping, lounging, listening to music, eating, cooking, and bathing. It has an inner sanctum for Alice's work space and a walled outdoor room for showering. The smaller structure serves as my studio, doubling, on festive occasions, as a guest house.

A wooden deck, providing space for sunny lounging or outside eating, stretches between the two forms, bounded by a board wall on its eastern side and by a seat that edges the meadow on the other. The deck is protected from coastal winds by the hedgerow to the north and the tipped form of the house itself, which dips down into the wind on the opposite side and here

presents its high face to the sun. A sliding barn door in the center of the wall can be opened or closed to modulate the breezes. Stepping through this sliding door one unexpectedly encounters an enclosed paradise garden, which is gradually accumulating old roses, and a young orchard, kin to root stock from the apples brought to nearby Fort Ross by colonizing Russians early in the mid-nineteenth century. A small stream cuts through the garden and runs alongside the orchard, nurturing a line of thick, large myrtle trees that trace its path through the landscape. This fence-protected enclave shelters the roses and apples from marauding deer, and leaves the meadow's flora and fauna running free, unsullied by domesticity, in the space beyond.

From the deck, stairs swoop up to a square outlook tower atop the studio, which offers views to the ocean in the west, with meadows all around, and the forested hills behind. At night, an uncommonly bright star-vault soars overhead.

The studio space has been problematic. Its very name conflated in my mind with the *Studiolo* in the Ducal Palace in Urbino, creating high expectations. It started life as a pure square, with addenda for bathing and study areas; windows and doors were placed cleverly off the axes and on the corners, resulting in formal clues that are so compounded that despite (or is it because of?) the presence of a reproduction of Robert Adam's *Iconografico Campi Martii* on one wall, and Charles Moore's *The Spaniards Introduce*

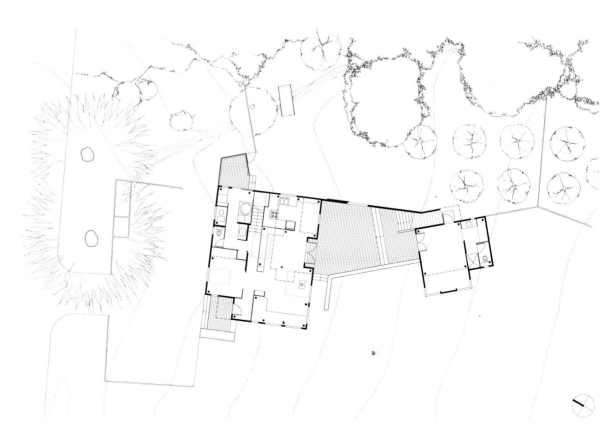

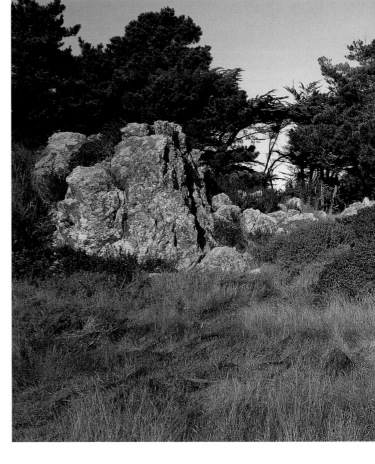

Palm Trees to Santa Catalina Island on the other, I cannot resist continual experimenting with the layout of furnishings and work surfaces.

The main house has been a source of unending delight. Windows were cut into the walls where they were wanted. Many were, and there is a great abundance of light and outlook, with framed views of the rock, the meadow, the garden, and the hedgerow. French doors open wide to the deck from both the big and little buildings. High windows on the tallest, southeast-facing wall flood the house with morning sun. Great rectangular windows that bracket the southern corner descend in part from Le Corbusier's Ozenfant studio (as, I suppose, does the much-expanded mezzanine sleeping space above). A chimney for the woodstove reaches up through a raised section of the roof, which forms a clerestory tower with windows that invite late-afternoon sun to streak the inside of the southeast wall. These windows exhaust hot air and draw cooling breezes through the space when needed. Not coincidentally, the little clerestory tower pushes up from the roof with an ungainliness that reminds us of small

Spanish early Romanesque churches, which charmed Alice and me.

In the center of the main room is a large skylight, placed to fill the space with enabling radiance, bringing strong light onto the dining table at all times of day and creating a sunlit drama in the kitchen at teatime. Bracketing the dining table are two yellow turned columns that suggest a sanctifying aedicule for the communal table, which is lodged against a long bench with yellow cushions.

Both buildings are made with an exposed-timber bolted frame, wrapped around with planks. Partitions inside are made with the same planks; all have a rough resawn surface on one side and are smooth on the other—when the smooth sides are exposed they are whitewashed to amplify the play of light.

These dwelling spaces—one spacious, one tightly formed—constructed with discrete, visible pieces (and Sylvia's indispensable building skill), are suffused with moving light; opened to select views of rock, meadow, forest, and sky; and layered with fabric colors, complex associations,

and photographs. Alice, who now dubs the house Clarity Rock, writes:

"Many years ago I received from my cousin a date book which contained a set of reproductions of the "Tres Riches Heures of the Duc de Berry."…I loved the architectural monuments.…These pages were like miniature dreams.…Photographs of buildings work in the same way. Often photographs act as a memory device; they stand in for the structures, become the structures in my mind. Three-dimensional architecture is transformed into small graphic images in and outside of our memories.

The most stunning full-scale facsimile I've seen is a kind of large "tent" in the Egyptian section of the Boston Museum of Fine Arts. Tents have always acted as surrogates for bigger buildings, light structures within which we can imagine all sorts of special things. The BMFA tent is a large box shape, with upright posts and horizontal crosspieces that could be folded in a rather tight package, or set up on site with curtains making the closure between.… The tent is a facsimile of a traveling room for Hetep-heres, the mother of Cheops (Old Kingdom, 4th dynasty). The original tent room was found at

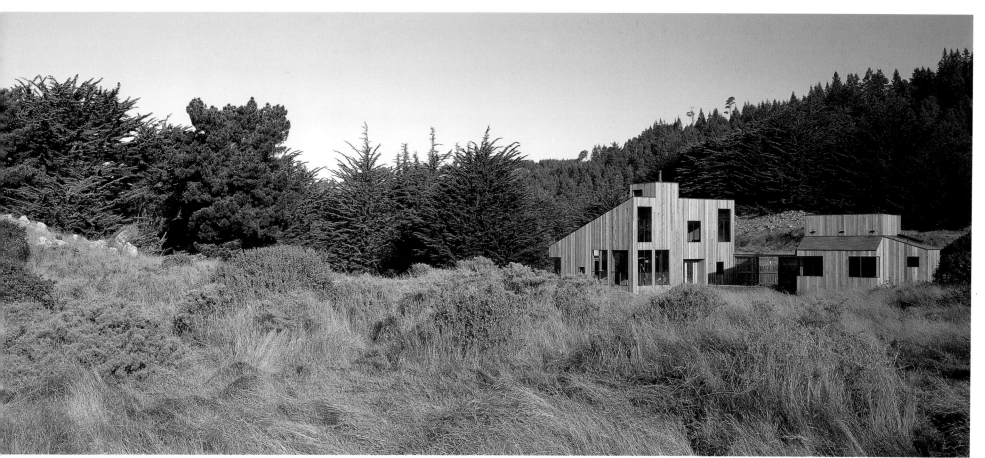

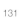

Giza, and is in the Cairo Museum....Memory took this magic box to California, to a meadow at The Sea Ranch. Donlyn designed a large box filled with giant windows to watch over the meadow and hedgerows and hills and the sea. There are beds and some chairs, all seeming to float in the encompassing light from the sky all around. The large tent box has settled at The Sea Ranch, near the sea, near paths and beautiful beaches, a facsimile palace filled with the love of special places."1

1 Letter from Alice Wingwall to Charles Moore and Donlyn Lyndon (re: *Chambers for a Memory Palace*), 1993.

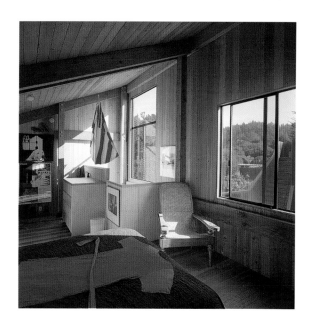

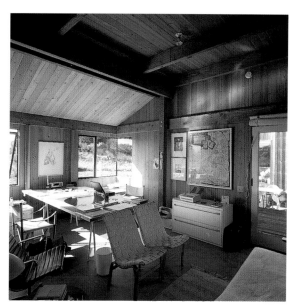

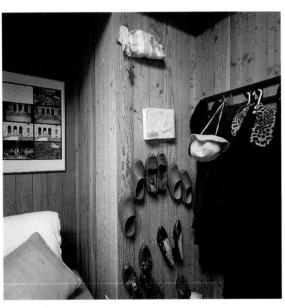

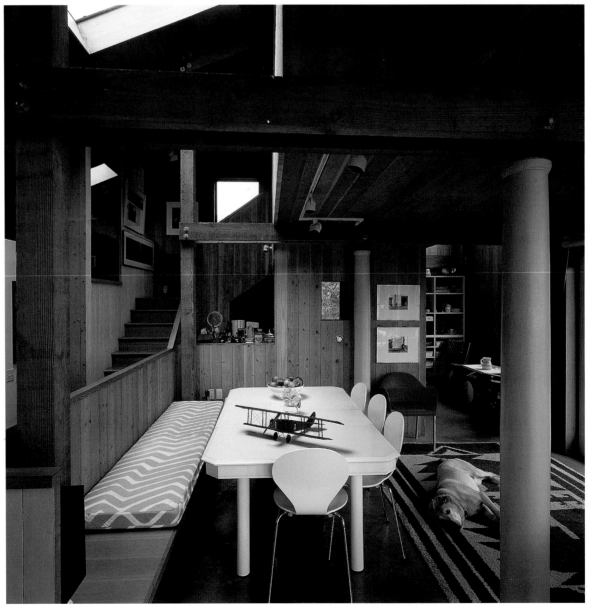

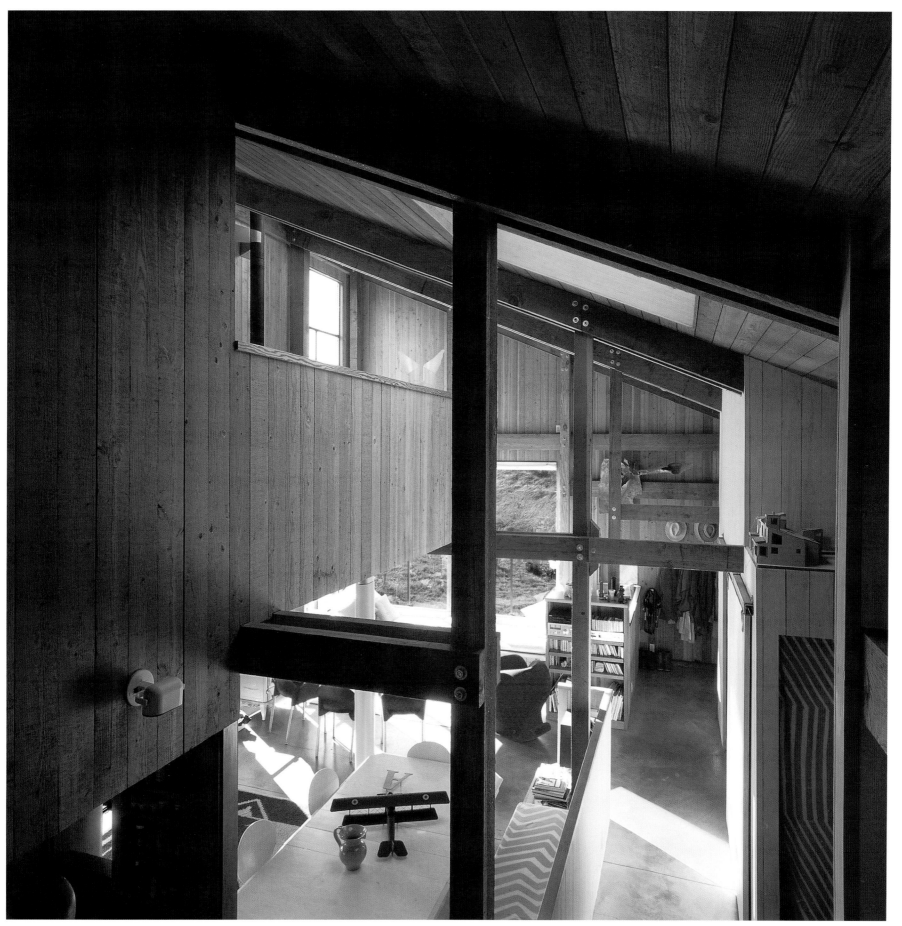

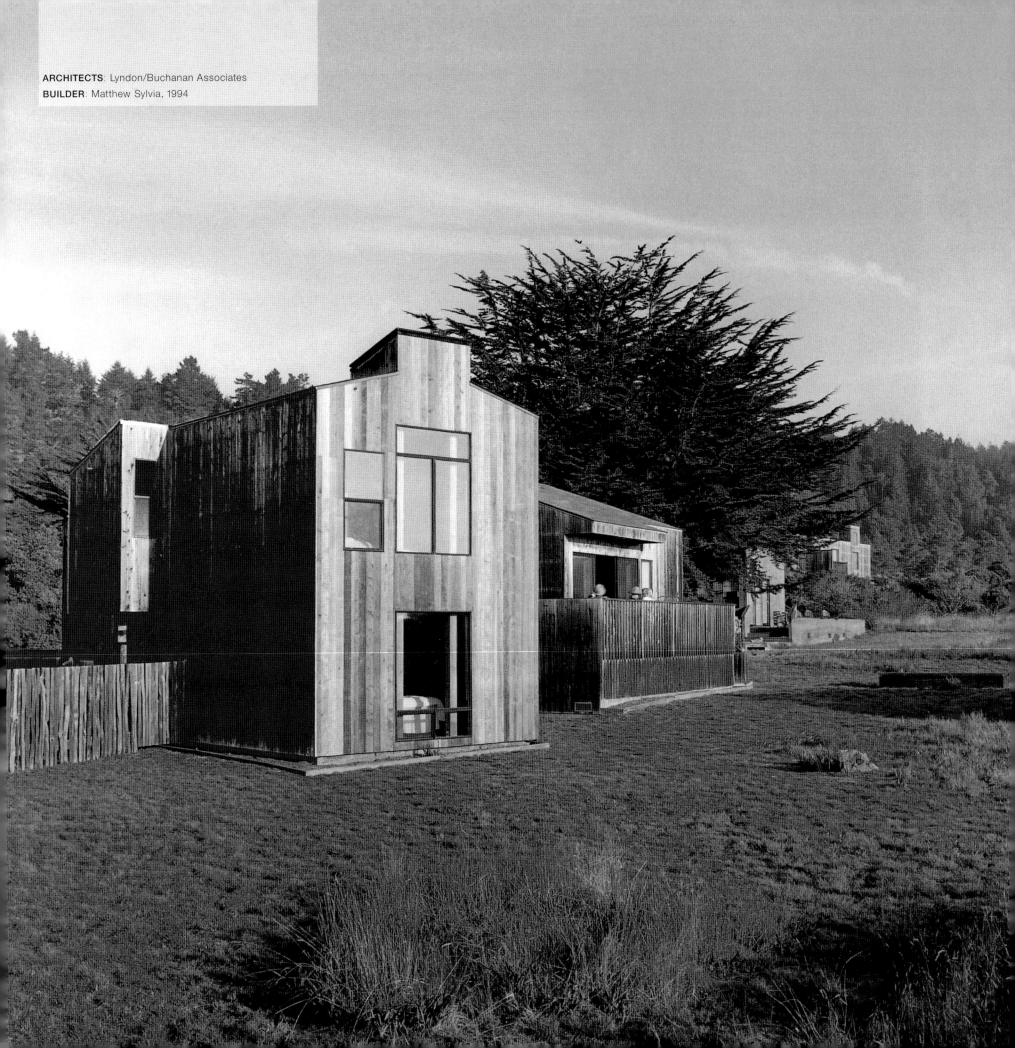

ARCHITECTS: Lyndon/Buchanan Associates
BUILDER: Matthew Sylvia, 1994

MEADOW HOUSE

(now the Day House)

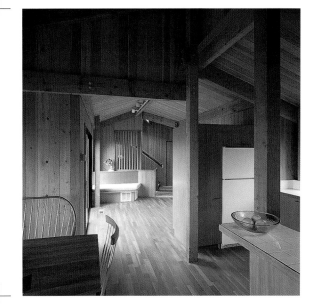
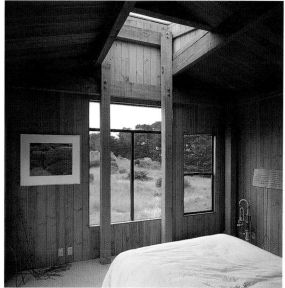

The Meadow House, next door to ours and belonging to Dr. Susan Day, was the second house we designed for Sea Gate Row. The stream and its band of myrtles continue across her lot, as do some apple trees, marching to the spacing that was established in our orchard. The house, a utility enclosure, the trees, and our studio wall and fence create a cherished neighborly courtyard between us.

The house is made up of two linked pieces: living spaces fronting the ocean on the southeast, and a stack of two bedrooms pointing toward the picturesque rock outcropping to the southwest. The link between the two wings is an expansive entry area opening out to a large deck stretching across the front. Protected from the prevailing northwest winds by the two-story bedroom wing and perched at mid-level, this sunny deck augments the living areas and becomes one of the principal spaces of the house. The kitchen, a compact skylit space on the back, opens across a serving counter to the music and conversation of the living/dining area, and to the view beyond. The forms of the house are made simply: a shed rises up over the living areas, an opposite, subsidiary shed covers the kitchen and entry, and a long sloping roof over the bedroom wing folds into a gable with a skylight crest at the end facing the rock.

The wood-frame construction of the house plays with the light falling on its interior surfaces, and the Douglas fir wood walls and floor glow with warmth in a climate where pullovers are generally welcome. Skylights again play an important role in bringing morning sun into the spaces and in balancing light throughout the day. The exterior surfaces are all clad in redwood siding, weathering to settle in among the meadow and the trees. Seen from above Sea Gate Road, the roofs of this house fold and break in a manner that is similar to the great rock in the meadow beyond.

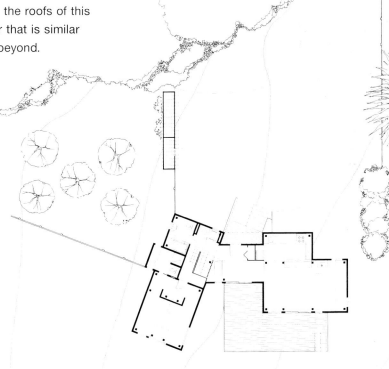

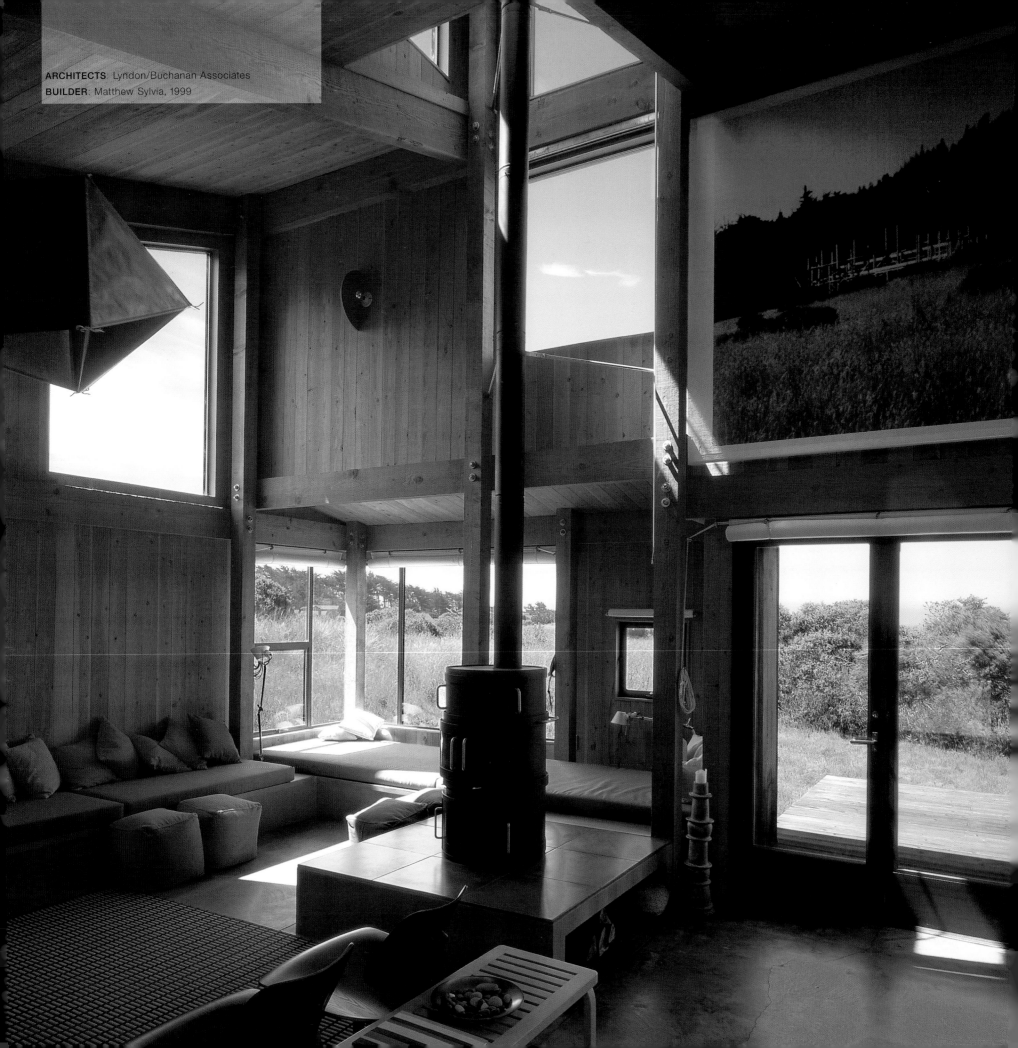

ARCHITECTS: Lyndon/Buchanan Associates
BUILDER: Matthew Sylvia, 1999

WENDEL-LYNDON HOUSE

meadow in the foreground and the Pacific horizon beyond.

The interior spaces, outfitted with cabinets and objects selected and designed by the owners, are enlivened by colorful fabrics, classic modern furniture, and the play of light across the Douglas fir structure and surfaces. In a modification of the heavy timber building system used in all my houses at The Sea Ranch, the smaller utility rooms along one side of the house have stud wall construction, surfaced inside with painted gypsum board.

Inside the main space, a row of tall posts marches "enfilade" along the length of the house, ending at stairs that climb a few steps to a landing. There, an angled white wall catches the sun to irradiate a small working area. The stairs turn and

The most recent house in Sea Gate Row has been designed for Lu and Maynard Hale Lyndon (my brother), who founded and own Placewares in Boston, and LyndonDesign, which specializes in the design of furniture and accessories.

There are two buildings in this project, one containing the principal living and study spaces, and a second with a workshop and guest quarters. The larger building includes a high, light-filled space with places for lounging, dining, and cooking; three smaller interconnected sleeping and working rooms on two levels; as well as a small tower that brings morning sunlight into a special bathing area. The two buildings and a fence frame a court/garden, which is sheltered from deer and views from the road. Adjoining stands of cypress, myrtle, and baccharis are left undisturbed. A double row of apple trees planted on the south side of the court will be kin to the apple trees growing behind the earlier houses designed along the row. These trees parallel an axis that reaches from an entry marker at the car court through the court to the glass front door, on through the house, and out to a deck fronting the meadow. The long stretch of flat facade that edges the meadow is animated by windows, porches, a balcony, and a low corner bay—each marking human presence. The wooden deck, edged by a bench, shelters behind large, already existing bushes, with select views to the neighboring grasses and out toward the ocean. The balcony off the upper bedroom offers uninterrupted views of the rolling

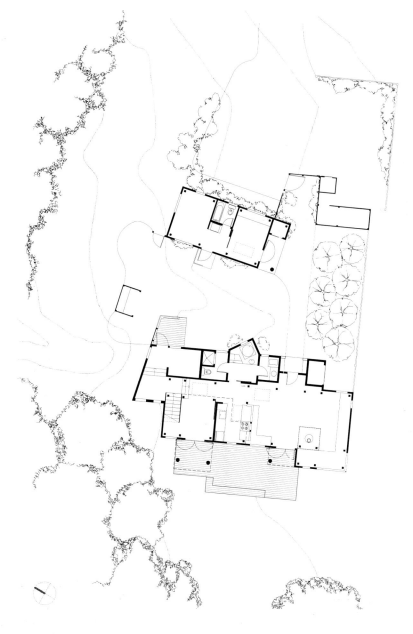

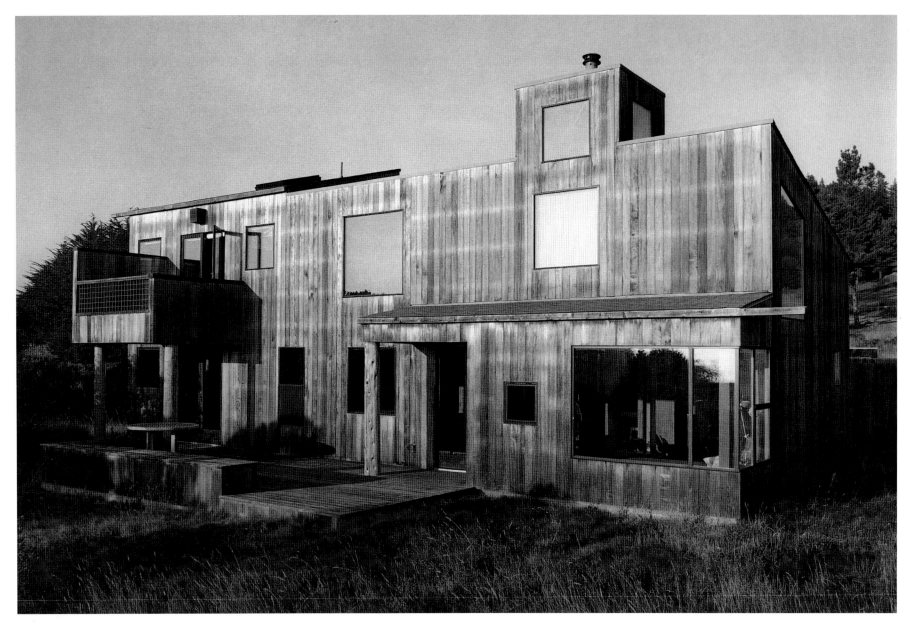

climb to the master bedroom, which is lit by windows from three sides and opens to the balcony. A second study area, under the bedroom and tucked behind the stair, looks out to the wooden deck through columns that support the balcony. Food preparation and eating spaces are at the center of the house, with the kitchen counter sociably fronting a benched eating nook. A room on the eastern side of the kitchen holds a platform and soaking tub behind a sliding barn door. Its roof angles up to hold high windows that capture morning sunlight. When the door is open, these windows also open views up and over the workshop building to the forested hills above.

The house provides ample shifting light throughout the day, views to the landscape beyond, and a variety of places to dwell with a book, sketch pad, laptop, or with companions. Working closely with Lu and Maynard Lyndon added immeasurably to the place. Their ingenuity is visible throughout the house, particularly in the layout of the kitchen and its furnishings, the selection of hardware and plumbing fixtures, and the objects with which they choose to occupy and furnish the house.

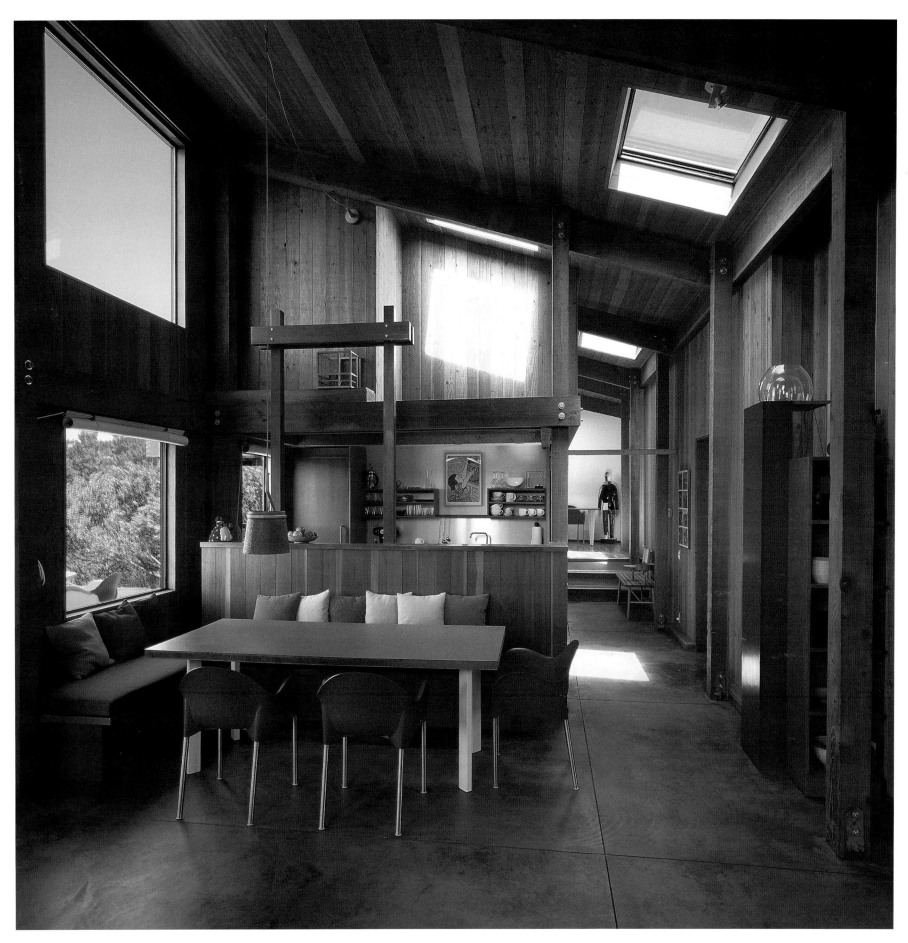

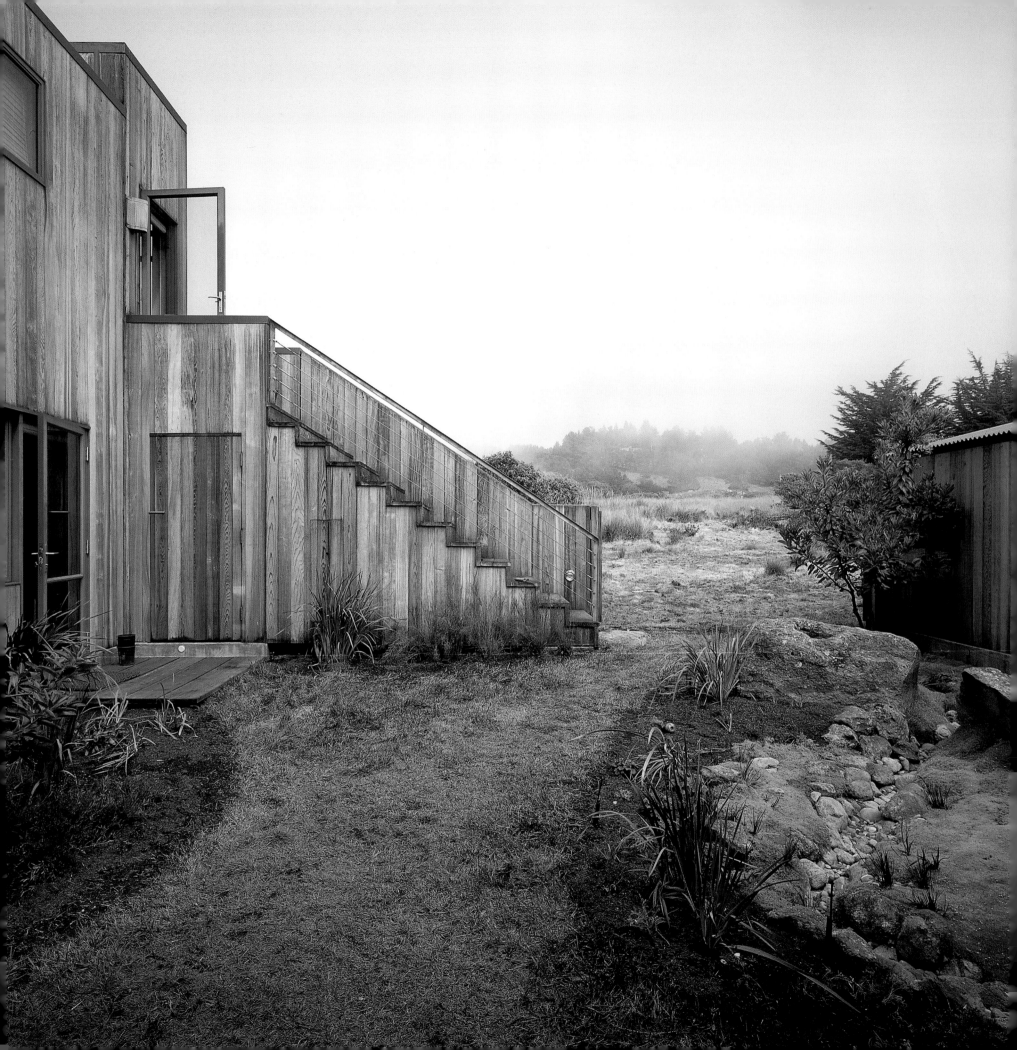

HOUSES THAT SUIT THEIR PLACE

Building in a place as special as The Sea Ranch invokes certain responsibilities. It is not enough to build a house here that suits its owners and is economical to build. A house at The Sea Ranch should return benefits to the place from which it draws so much of its value. The Sea Ranch has grown up under the guidance of a plan and design guidelines (and in accordance with legally binding purchase agreements that require a commitment to support that common environment), and precisely because of that its houses should be sited and designed in ways that enhance, rather than detract from, or dismiss, their surroundings.

The houses included in the following sections meet that obligation well. They show ways to build with imagination and care, and with a clear understanding of their place in the larger landscape. They are not just good houses that are shaped with concern and built well but houses that show a special understanding of how to make place within a place—houses that provide special, even dramatic and challenging, internal and external personal living spaces while contributing to, and becoming a sympathetic part of, the larger Sea Ranch landscape.

These houses are grouped here in four sections corresponding to the differing ways in which they work in their setting: houses that connect to their environment, houses that settle in their place, houses that enfold a place of their own, and houses that inhabit and enliven their sites.[1] Houses, considered this way, are active agents in the creation of environments, for the people who dwell within them, for the neighbors who live among them, and for The Sea Ranch as a living place that embodies distinctive values. These

groupings are, of course, at best useful fictions. Almost every good house relates to its site in several ways, and in some instances you will see that the houses might easily enough be placed in different groupings. Nevertheless, collecting the houses in this way stresses the importance of having a strategy for how a house works within the larger landscape.

"Houses that connect" are houses that are designed to form a part of something larger. They may be part of a cluster of houses that all take their forms from the same set of circumstances; they may be houses that merge directly with the immediate landscape that surrounds them. Houses may also connect directly to the environmental forces of the site, taking their form from the wind, the sun, the earth, and vegetation. Sometimes houses connect in our perception simply from the similarity of forms, materials, and sizes that they use. Fences and plantings, and subsidiary structures such as sheds and carports can also make connections that bind a group of houses together, creating a larger perceptible whole.

The first buildings at The Sea Ranch were dedicated to making connections of this sort. The units of Condominium One are joined under one roof that follows the force of the wind and the slope of the land. The walls join as well, and carports, entries, and terrace screens become a connected part of the whole. The Hedgerow Houses were formed primarily to connect to the forces of the site, to the undulating meadowland, the fierce wind off the ocean, and the presence of a large landmark hedgerow giving structure to the place. The houses, built with identical materials and with their low-lying roofs all sloping in the same direction, connect visually into a common, slightly undulating plane that reaches down from the hedgerow into the rolling meadow. Some of the roofs are covered with sod, furthering their visual fusion with the landscape.

"Houses that settle" are houses, usually on a relatively large plot, that settle the landscape—that claim their immediate territory in an effective way. They are usually capped by a gable or a hip roof, with forms that slope down toward the ground in several directions. When the land is lightly rolling, they literally settle into the ground, becoming a sympathetic part of the rolling, open landscape. These forms are the ones most often used by early settlers. They are building forms that in their self-sufficiency are easy to conceive and construct. They can be adapted effectively to the wishes, desires, and special conditions of the people who build them by adding bays and smaller gables, settling further into the landscape with particularities that register human use.

Often houses that settle are made up of several components built in the same way, which are arranged in a hierarchy of sizes, each successively smaller than the next. Sometimes later appendages are built or shaped in a different way, or use differing materials, but are made in a manner that remains aware of the qualities of the original and does not discount its value. Houses that settle can also make their mark in a different way: with a tower that acts as a marker, or a distinctive shape that registers its individual presence. At The Sea Ranch, in a landscape shared by many owners, these claims need to be modest enough to become a part of the landscape. If appropriately and delicately scaled, or if the "mark" is made by a component of the building rather than by a large and assertive mass, it may act like a

bay on the larger "house" of a meadow, or of a cluster of building and land-forms that make a coherent whole. Condominium One, for all its connection and similarity to the surroundings, also lays claim to its site. The most strik-ing feature of its landmark image is the pair of towers that rise up to bracket the crest of the knoll, each sized to the space of a single small dwelling. They register the presence of habitation within a larger set of building forms that settle more closely to the sloping land.

"Houses that enfold" a place of their own are shaped to create sequestered places that separate from the more general sweep of the land-scape. Their parts surround a space that serves as the imaginative center of the house or compound, from which all other spaces take their cue. Houses may encompass such imaginative centers within themselves, their forms may fold to wrap a segment of outside space, or they may be fashioned as a compound of rooms that are arrayed around a common garden or court.

At some level all good houses enfold a place of their own, but some do it more overtly than others, giving precedence to a space, inside or out, that governs the way in which people think about the house. The courts at Condominium One are places of their own, lending distinctive character to the building as a whole. One is dedicated to the car and its connections to the world beyond; the other, formed directly on the slope of the land, pro-vides a very specific grounding to one's experience of this place.

"Houses that inhabit" and enliven are especially effective in bringing their sites to life. They make the most of varying site conditions (exploit them, if you will) to provide for an extended and diverse experience of being in place.

142

Many of these houses exist where two differing site conditions come togeth-er—at the bluffs, or facing a draw through the meadow, or edging the bor-ders of the forest. They take full advantage of both conditions, establishing a choreography of movements and outlook—station points and vistas—that amplifies a person's experience of the place.

Of course, all the houses shown in this chapter make their sites more livable, but the ones that are included in this last category are notable princi-pally for the ways in which their architects have given special meanings to their place through careful accommodation of all that their sites have to offer. Variously placed along the junctures of stream, vegetation, meadow, and ocean, these houses draw attention to the specific conditions of their loca-tions. From inside the Esherick House, for instance, one is aware at once of both the grasses of the meadow extending from the foot of the window, and the stream behind, washed by the sun and backed by pine trees. The mead-ow stretching up to the hills, and the forest on the east are connected to the place as effectively as are the lines of surf rolling in from the west to crash against the broken rock of Black Point. Meanwhile, underfoot, you are engaged, consciously or not, with the subtle rising and falling of the land as you move down the slope, across the stream, and into and up and around the various rooms.

In the pages that follow, houses have been grouped according to the ways in which they partner with their sites. Yet each of these buildings shel-ters a story of its own, a story of expectations, achievement, and change.

Most of them begin with a passion for place, either The Sea Ranch as a whole, or some particular spot within it—an open field, a location in the for-est, or a house already built. The next part of the tale, for those who built the houses they own, often includes developing a new understanding of the place, a way of seeing it, which evolved through discussions with their archi-tect and builder—discussions that are often recounted with humor and affection. For those who came later, purchasing a house already in place, it was often love at first sight; over time, changes and additions have made the houses their own.

The house is of course a tale in itself. Its parts, its rooms, their arrange-ment, the windows, walls and doors, beams, steps, platforms and counters, all reflect decisions made and the exercise of craft. In turn, they prompt and support the actions of daily use, and the accumulation of memories and associations that attach to the place. The inner landscapes that these hous-es present open vistas not only of oceans, meadows, and trees, but also of the lives that people live among them and the associations that they bring to them. In the best houses these inner landscapes, varied, personal, often idiosyncratic, tell wonderfully rich stories about living at The Sea Ranch.

The sequences of houses in the groupings that follow are generally chronological. As it happens, they also generally follow a transition from houses that sit tenderly but abruptly on their sites—offering stations along the trails and passages through the larger common landscape—to larger houses and compounds that extend into the landscape, claiming it, enclos-ing parts of it, and capturing places to cultivate gardens. This reflects in part the settler's instincts brought by the greater number of people who have come to live here permanently and wish to engage the place more personal-ly. In many sad instances (not shown here), these instincts led to the triumph of conventionalized thought—thought that is dominated not by the place and the life that it can afford, but by the easy exchangeability of familiar imagery and sales points keyed to the real estate market—and thus to avoiding the challenging or the particular.

The houses selected here, on the other hand, celebrate spirited individu-al attention and derive their strength from contributing to the special qualities of The Sea Ranch and its traditions.

1 In *The Place of Houses* we noted that there are four ways of siting houses: Merging, Claiming, Surrounding, or Enfronting. Our expressions here are more closely tuned to The Sea Ranch. See Charles Moore, Gerald Allen, Donlyn Lyndon, *The Place of Houses* (Berkeley: University of California Press, 2000), 188–189.

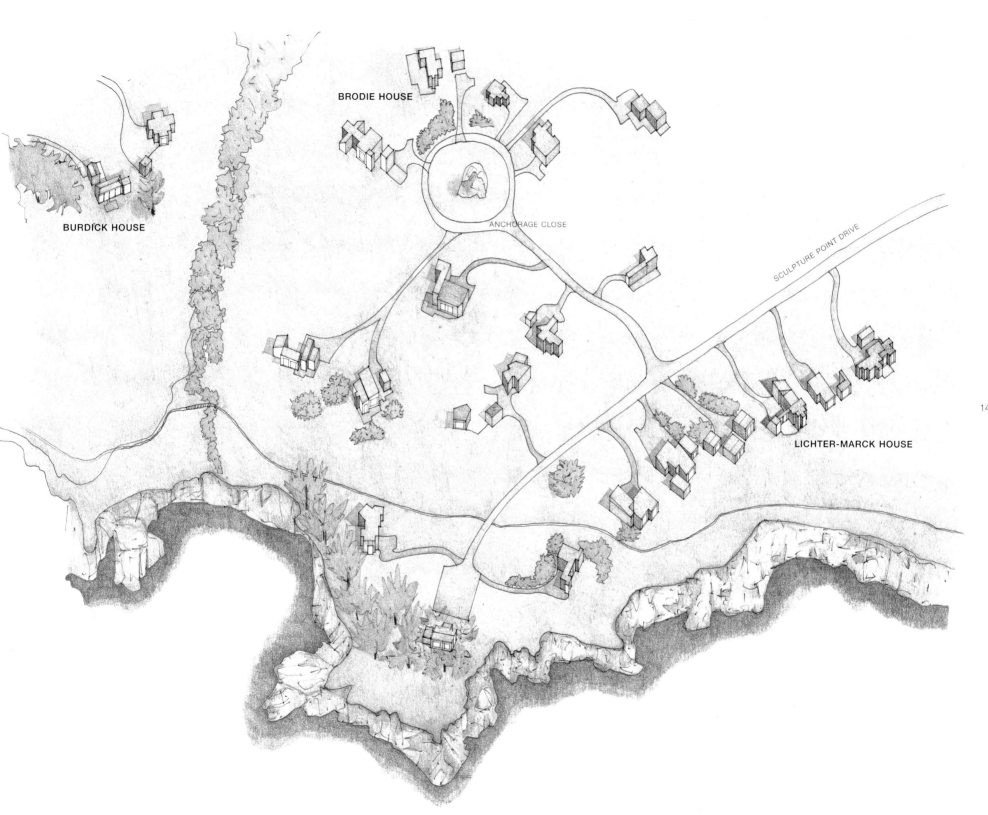

BURDICK HOUSE

BRODIE HOUSE

ANCHORAGE CLOSE

SCULPTURE POINT DRIVE

LICHTER-MARCK HOUSE

143

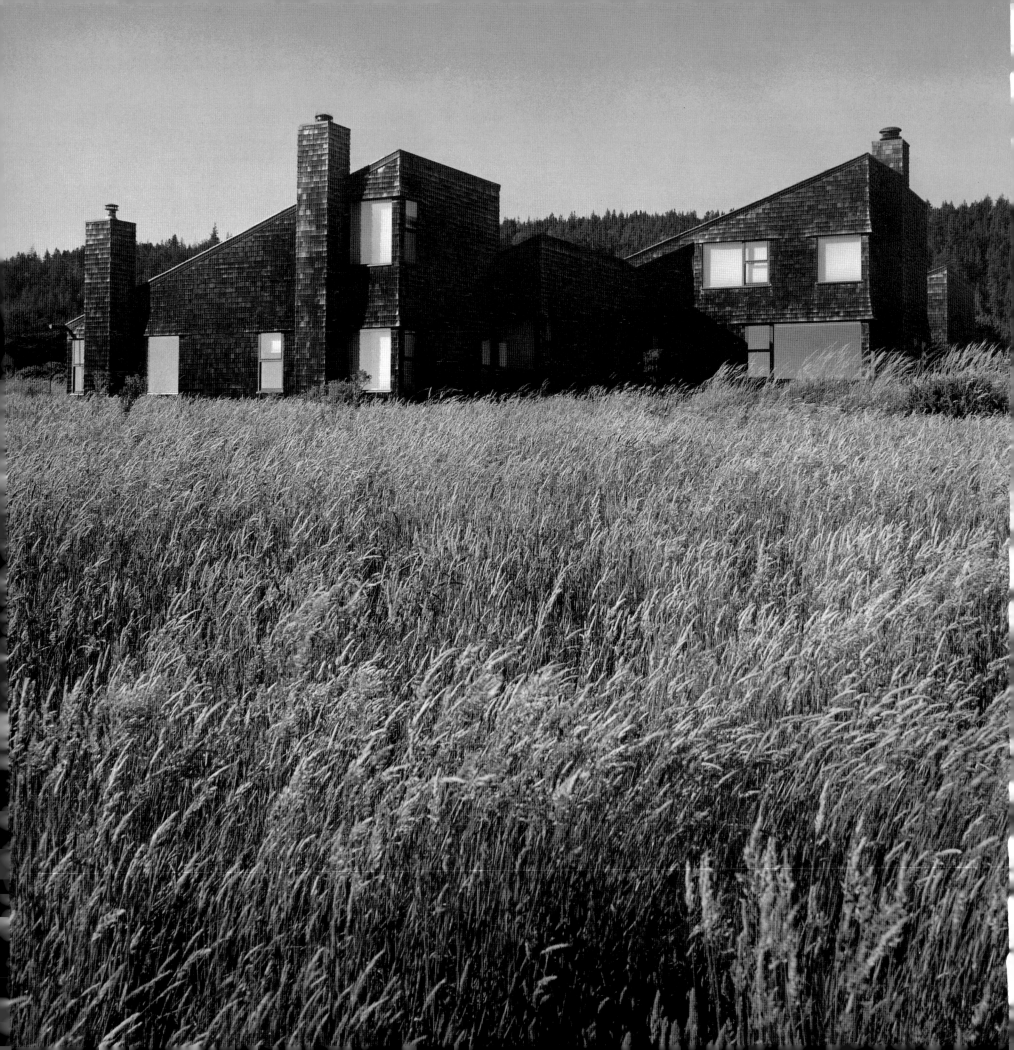

HOUSES THAT CONNECT

KIRKWOOD HOUSES (see pp. 150-153)

Two houses, planned and built together, connect directly to their site, the slope of a hill facing out toward the ocean. Each is made with narrow, low sod roofs, sloping down with the form of the hill. They are cut slightly into the edge of the land so their roofs read almost as continuations of the meadow. Long bands of sun-shaded windows, stepping back along the slope further emphasize the correlation between the two structures, celebrating their common position in the landscape.

Houses that draw their form from the forces of the site or from the shapes of neighboring structures, landforms, or vegetation have a good chance of adding to a larger order, making sense in the landscape. Much of the character of the initial buildings was based on making such connections to the forces embodied in the site rather than drawing on simple visual allusions.

Unfortunately, many later architects and builders merely adopted shapes found in the early buildings, disconnecting them from their sites. They created semblances of a "Sea Ranch style" without developing real relationships to the places at hand, leaving their houses adrift within property lines, unrelated to any neighboring conditions, or even to an order within.

The houses that follow connect well, displaying an understanding of their significance in the land. Their architects have created houses that have more than an incidental relation to their site, houses that speak to the ability of architecture and landscape to be joined in common pursuit.

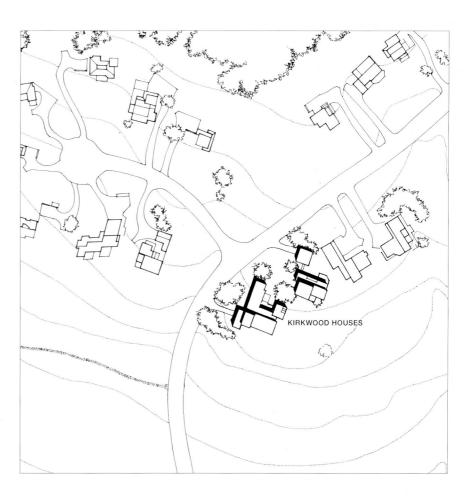

KIRKWOOD HOUSES

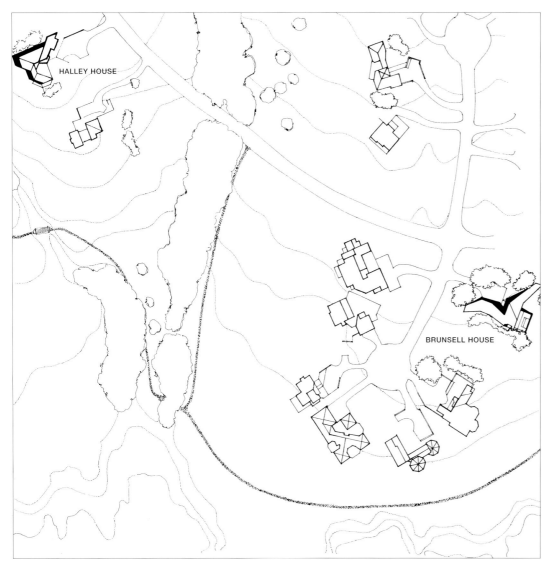

HALLEY HOUSE (see pp. 154–157)

One of several houses that follow along a low rise in the land, the Halley House is recessed into the hill to take advantage of the earth's thermal mass. Its roofs rise up in great slopes from close to the ground to a high crystalline solarium at the center. The roughly pyramidal shapes connect gently to the land; earth berms continue the transition. The polygonal wedges of the house are similar in spirit to those of the adjoining house to the south, creating a semblance of accord along the slope.

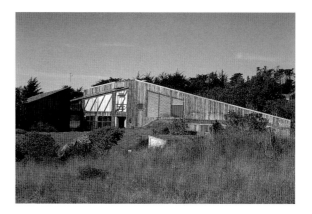

BRUNSELL HOUSE (see pp. 158–161)

The rising, bending, grass-covered slope of this roof merges directly with the land around it, emulating the undulations of the meadow. More than other, more insistently geometric sod roofs at The Sea Ranch, this one, through its ingenious shape combined with one simple change in the slope, belongs unequivocally to the land in which it is set. Vegetation placed around its perimeter, now overgrown, nearly obscures the effect, however, and adjoining houses on the point make no similar gestures of connection.

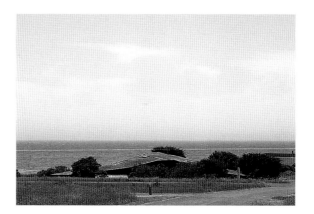

MASLACH/ZIMBARDO HOUSE (see pp. 162–165)

Each of the main forms of this house is covered with a single-pitch roof starting low on the wind side and rising high toward the sun. Set toward the front of the meadow on a free-standing lot near an exceptionally low stretch of ocean front, the house connects to the larger forces of the site in the way that was exemplified by the first buildings at The Sea Ranch—creating sunny, wind-protected spaces outdoors, staying close to the contours of the land, and allowing the form of the house to reflect these relationships.

EWRY HOUSE (see pp. 166–169)

Two wedges of building slip into a gap at the end of a long hedgerow. One, holding living spaces, thrusts its low edge under the branches of the cypresses, looking out through their trunks to the cove beyond. The other, a garage, slopes in the opposite direction, down toward the access road and a cluster of cypresses along the edge of the cliff. The space between them shelters a hot tub and deck.

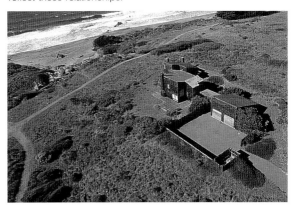

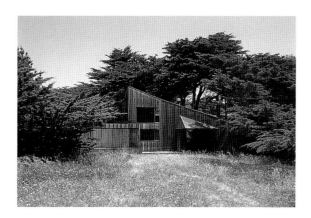

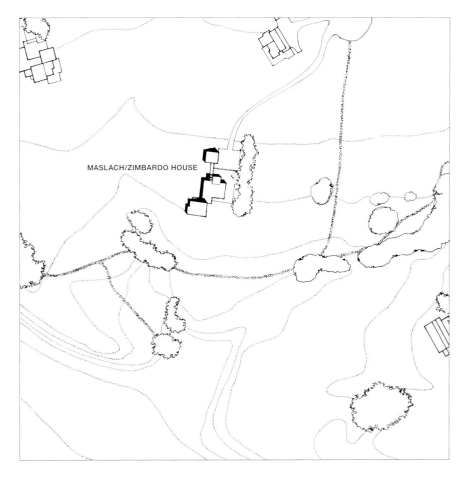

MASLACH/ZIMBARDO HOUSE

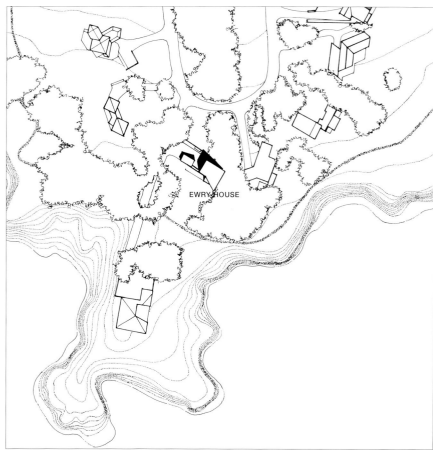

EWRY HOUSE

MICHAEL HOUSE (see pp. 170–173)

Sited on one of a series of narrow, ocean-fronting lots that
have no evident relation to the structure of the land, the
Michael House is organized by a very direct connection
between the road and the ocean; a canopied straight path
leads from the parking area through a frosted-glass front door
to a court overlooking the sea. Shallow, repetitive roof slopes
perpendicular to the passage deflect the wind and lend disci-
pline to the collection of rooms that cluster along the path.

148

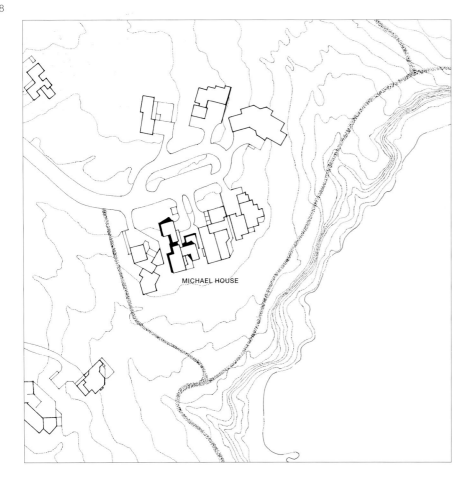

MICHAEL HOUSE

MCKENZIE HOUSE (below, with Somers House seen in background at right; see pp. 174–179)

The two main forms of this house start low on the meadow and slope up toward the trees of a hedgerow behind them One building stays high on the south, facing a sunny deck, the other folds over to make a barn shape, its low end edging the road. The court between makes a place of its own. The parts are connected by consistent, simple roof slopes and enclosing walls; the forms of the house bridge the high line of the trees behind and the rolling meadow in front.

SOMERS HOUSE (see pp. 180–183)

Seen from across the meadow, the Somers House visually connects very well with the McKenzie House, forming an extended compound; its roof slope is similar, its walls somewhat lighter, and it is unmistakably related to a larger sense of the landscape. Yet behind the house there is an open clearing in the hedgerow, which is shaped by the trees, the house, and a perpendicular study into an unexpected, sunny alcove off the larger sweeping meadow.

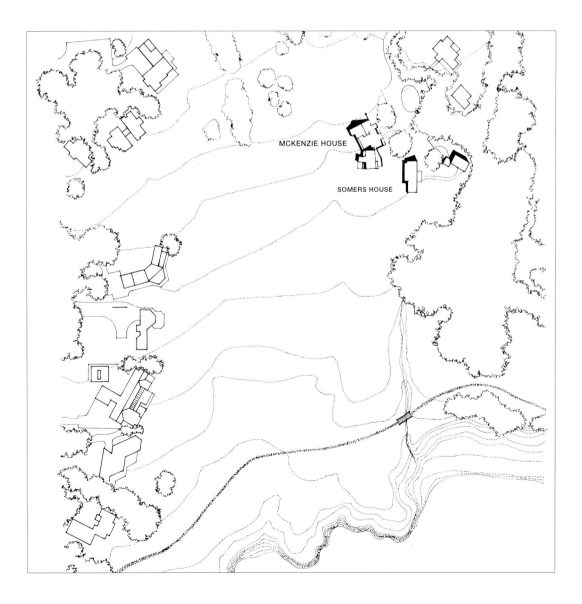

MCKENZIE HOUSE

SOMERS HOUSE

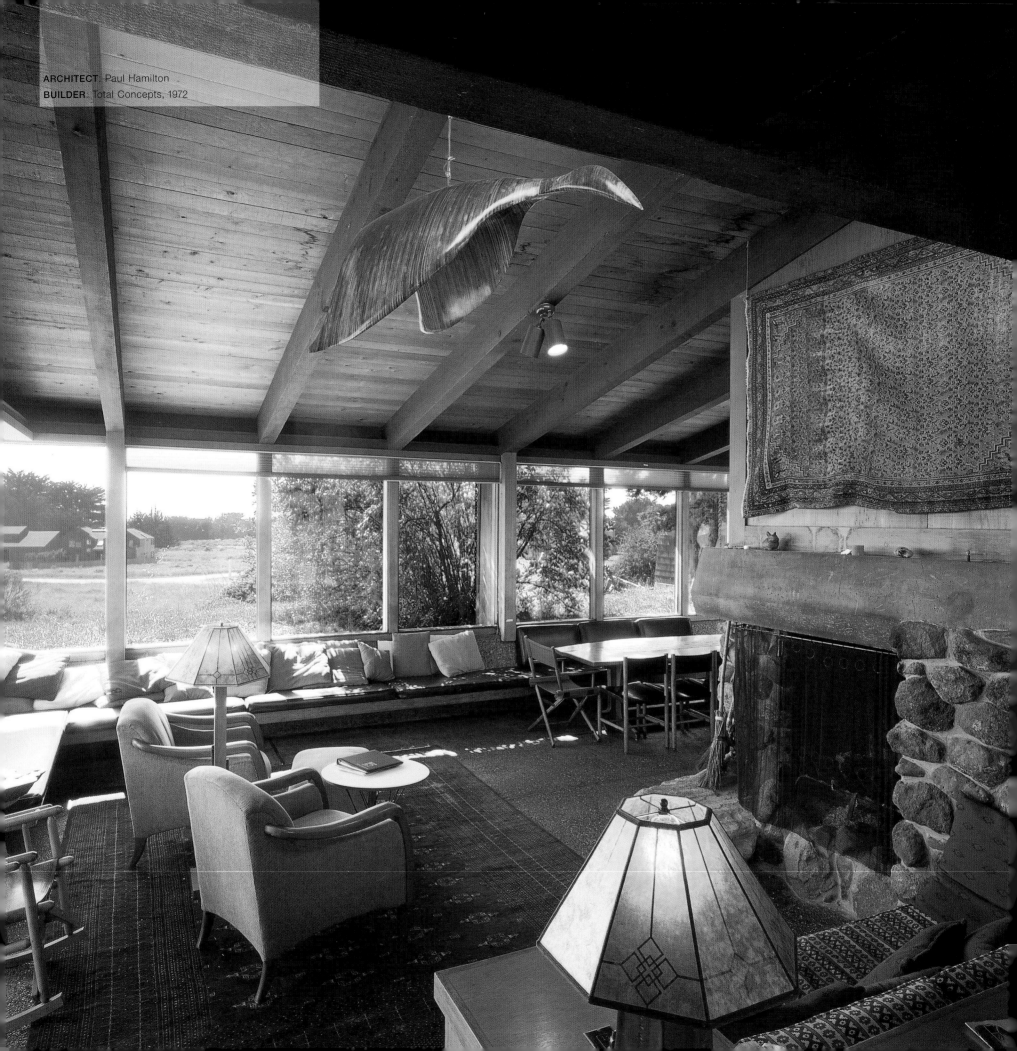

ARCHITECT: Paul Hamilton
BUILDER: Total Concepts, 1972

KIRKWOOD HOUSES

The two Kirkwood houses work exceptionally well, both in relation to each other and as a part of the larger landscape. They provide a moment of perceptible common purpose overlooking an area of houses that has been more generally characterized by random assertion. The two houses were built at the same time and with a common site plan, set into the rising face of a slope, with open commons below and to the south, the latter traversed by a shallow draw filled with low, water-loving trees. Both houses were designed by Paul Hamilton. The Kirkwoods came to him originally because they were interested in sod roofs, and he had done a well-publicized sod-roof project near Lake Tahoe. He has been in practice since World War II, primarily designing houses (six of them, now, for the Kirkwoods). The second house in this pair was originally designed for Kirkwood's mother.

The front, lower (and larger) house is incised into the land with a slightly pitched sod roof that covers the length of the main room and auxiliary segments stretching out along the road. The second, smaller house has a similar form, with a sod roof and a separate garage forming a wind-protected court behind it. The organization of the main house, which also has a court behind, is particularly interesting; a long sweep of low windows looking out over the tips of grasses to the ocean beyond is set over a bench that runs along the southwestern edge of a long room. This main space of the house holds a countered kitchen at the entry end, a dining table and

lounging area arrayed along the bench, and sliding doors opening to a terrace at the southern end. The opposite side of this space, up a few feet, is an open corridor that leads from the front entry on the north to a master bedroom suite on the south, its middle section opening through sliding glass doors to the courtyard. In between this passage and the main room are a fireplace and grill made with boulders, and concrete shelves and platforms that hold storage areas, all set as sculptural incidents along the edge of the raised passage. The whole reads as an inner landscape of concrete and stone elements, which emphasize the inherent, earth-bound character of the house. The southern terrace is incised into the ground with an enclosing bench,

a tall, forked wooden sculpture provocatively claiming its geometric center, and an animistic sculpted beam end projecting out toward it from the house.

At the northern end of the house, facing the road, is a sod-roofed double garage, with a small room built over it, accessed by a steep ladder/stair off the kitchen. The wing stretching along the road holds a set of small bedrooms fronting a common play space on the southeast, which opens to the sunny court. The master bedroom suite consists of a sleeping and storage room and a complex bathing room with a built-in sunken tub and a shower, also lodged within rocks. Backed against the court, it looks out over the meadow falling away to the south.

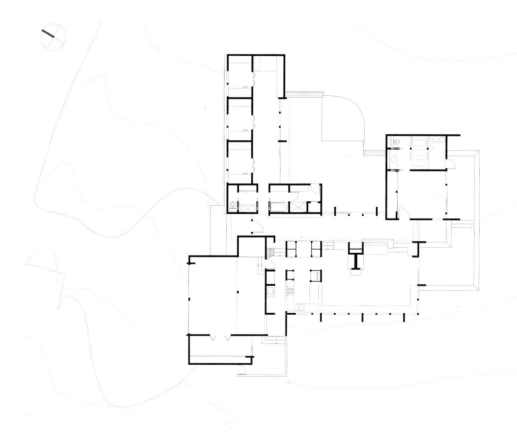

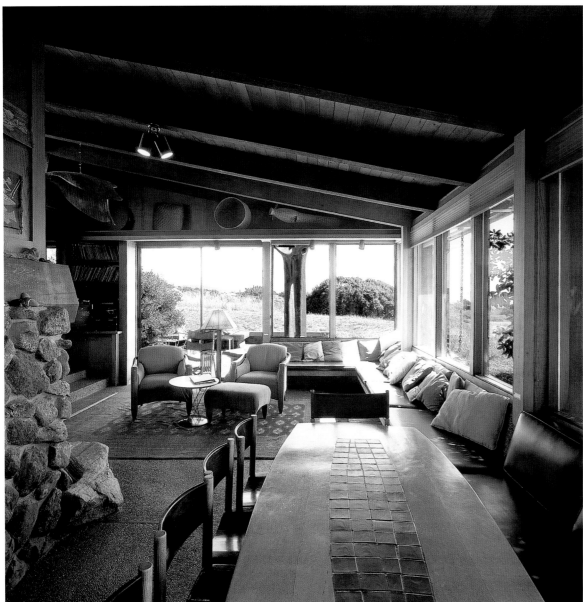

The house is a testament to building within and with the earth, here transposed into formed concrete. The gesture of its low sod roof and windows set close to the ground is compelling. Inside, sculptures, pots, and vigorously formed ethnic objects are distributed throughout the space.

The second house, set to the same orientation but staggered to look past the southern end of the main house, also has a glass-fronted living room and sleeping spaces beyond, with the terrace in this case set out in front, overlooking the meadow and ocean. It is built with the same vocabulary of construction and likewise contains elements that yield a sculptural presence within its smaller, less extended, yet handsome arrangement.

The two connect to their sites with clear logic and quiet. They are clearly formed for this particular place, yet bear the distinctive marks of individual interests and a well-honed, formal sensibility.

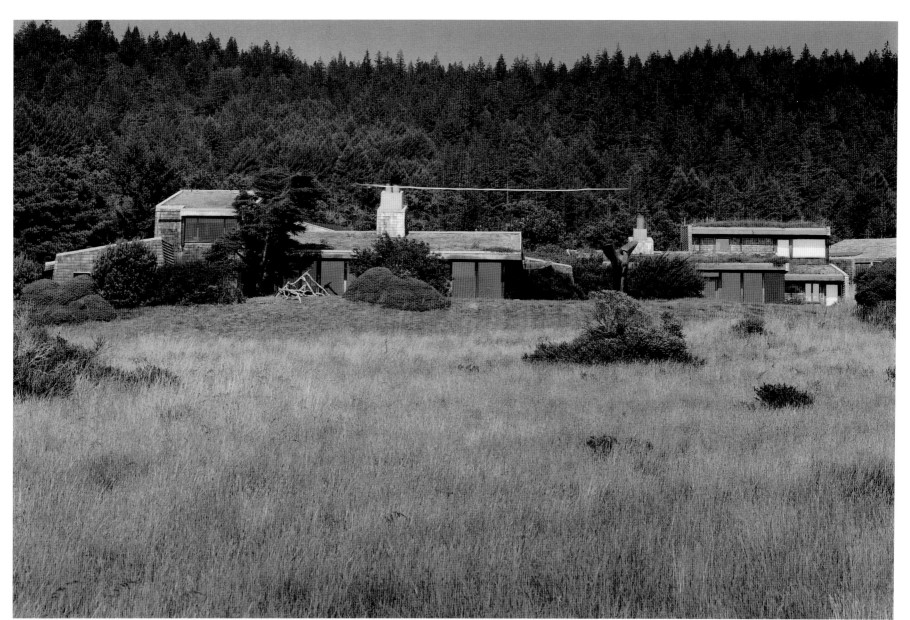

ARCHITECT: John Halley
BUILDER: John Halley with Richard and Sonja Halley, 1984

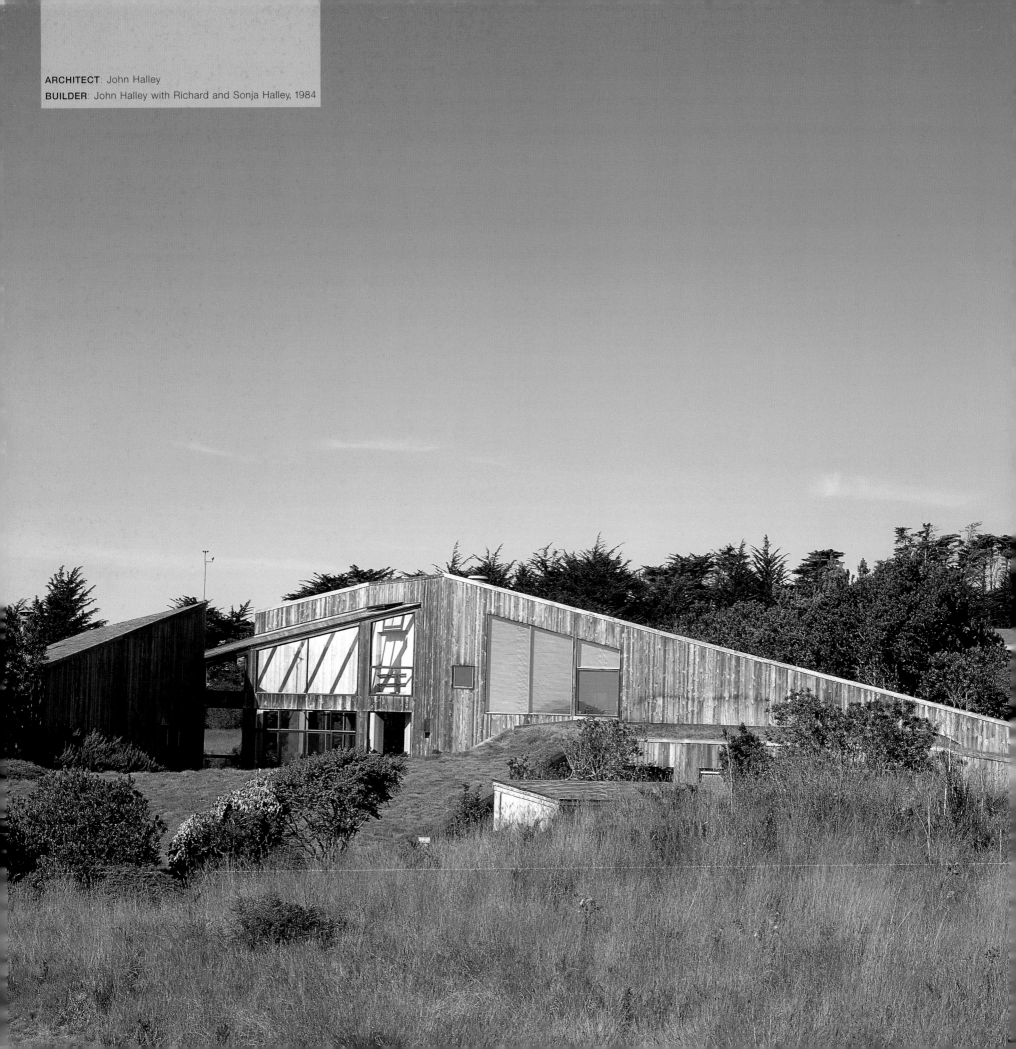

HALLEY HOUSE

The Halley House can be read as a modification of the site, transforming it into a mechanism for capturing climatic forces and translating them into a comfortable environment for dwelling. Its roof planes, some of them covered in sod, rise up from the land in an angular array to hold great sheets of glass, oriented as much to pull in the sun as to provide exposures to the view. Its forms connect both indirectly to the changing solar cycle and directly to the earth itself. Designed for his parents, Richard and Sonya Halley, by John Halley, who founded Comet Studio (a practice concentrating on environmentally conscious planning and design), it uses energy harvested in a solarium to heat the space. Convection air moves up through interpenetrating volumes to ventilate the house, and the temperature-stabilizing mass of the ground into which it is set balances extremes.

The principal port of solar capture is a tall, greenhouse-like solarium that extends off the kitchen as an eating space and opens to a sunken courtyard on the south. Its northern and northwestern walls, each nearly two stories high, have panels that can be lowered with counter-weights to segregate the solarium as it gathers in heat, or raised to allow free movement between all the rooms of the house. Air from the solarium rises up around chimney masses and through manipulable wall ducts to upper ventilation stacks, or is returned to the spaces below.

While the house may work as a mechanism, it does not in any way feel like one. Its spaces twine around a central, handsomely made concrete fire-place and chimney, anchoring the place firmly to the hearth. The mass of this center block both conceptually joins and physically separates the kitchen/eating area from the living room. Here it holds a large fireplace opening to the sitting area, while a woodstove nests in back of it on the kitchen side. Roof planes rise in three directions to this central mass, one starting over a garage sunk partially into the earth, another sloping up from the landward side to the east, and the third reaching up from the meadow on the north. The ocean side of the house is generally glazed, with angled, projecting walls embracing the solarium and a lower, ground-hugging set of slopes covering a small bedroom wing closer to the ocean.

Entry to the house is from a sunken car court fronting the garage, up a stepped passage that penetrates the house between living area and garage to reach a low porch on the uphill side. This, in turn, leads to an entry at the center of the house, which opens back down into the kitchen and solarium, set slightly into the ground. To the right of the entry a beautiful fir-paneled bookshelf wall leads out toward the glassy living room facing the meadow. To the left, bedrooms and a secret loft above the garage are fitted within the angular geometries of the house, which allow for effective modulations in the flow of air through it, absorbing radiation from the concrete floor and walls of the solarium and transferring warmth between rooms. Light, too, moves through these spaces

in mysterious ways, spreading along rich wood surfaces and reflecting back from the ground, or sliding through unexpected openings along the plane of the fir plank roof inside. The angular spaces combine with carefully formed and surfaced concrete elements and elegant cedar-sided walls to recall elements of Frank Lloyd Wright's work, though without the decorative overlay and with a studied simplicity of detail and clarity of execution that seems uncontrived and timeless.

Time asserts itself mightily, though, in the exotic Chinese furnishings of the living room, inherited from Richard Halley's family. They were given to his father by Chinese immigrants grateful for his services as a doctor in Stockton, California. Standing in intricate and somewhat convoluted splendor

before the great windows facing Asia, they suggest cultural refugees inhabiting this shore, sentinels of the complexity of California's heritage.

The facets, angles, and bends of the house deliberately relate to its neighbor on the west, while at the same time inducing a sense of engagement with the site—a spiraling into place that feels comfortable and secure, even as glass walls open brightly to the slopes of the meadow descending to the sea. The warm wood surfaces that embrace these spaces have been invested with precision and care by their owners, who crafted the interior surfaces themselves. The Halley House connects in many ways to its surroundings, literally, figuratively, and through association, transcending its technically informed origins.

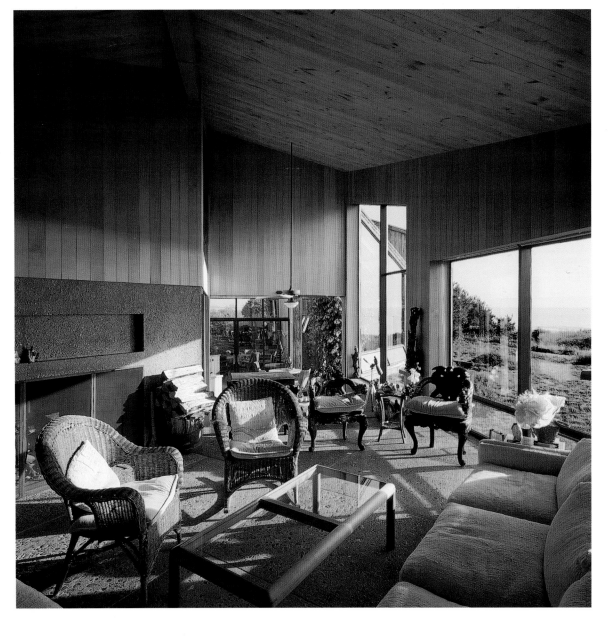

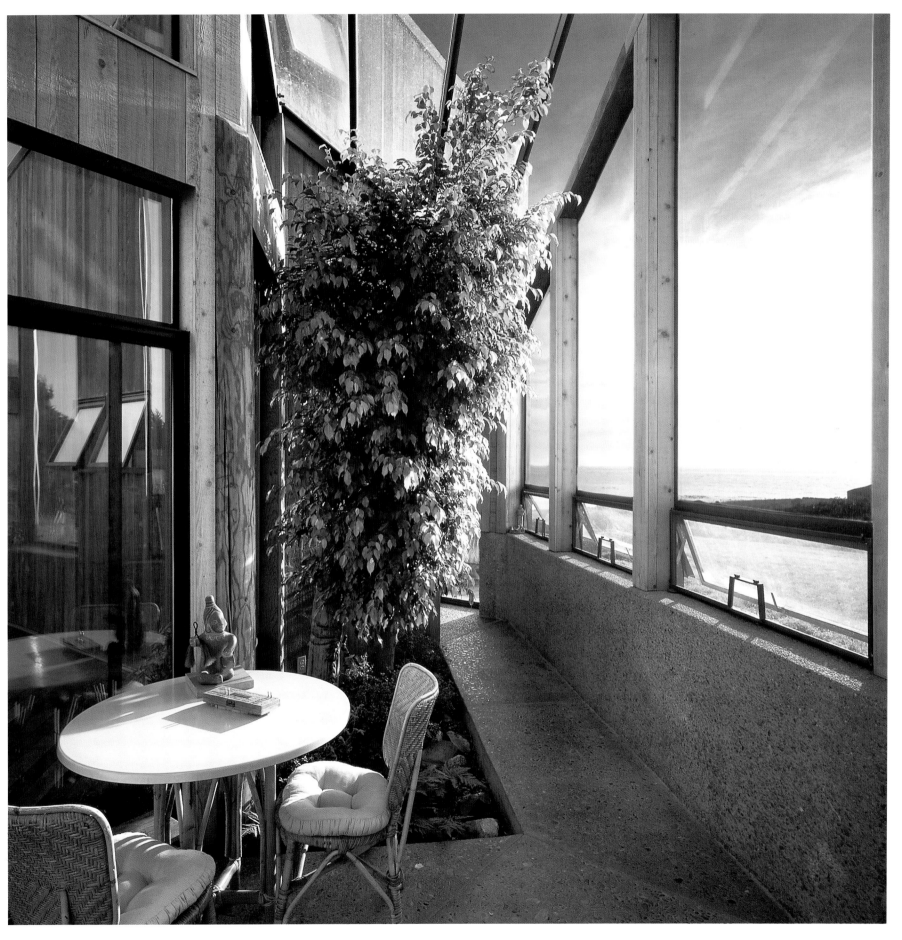

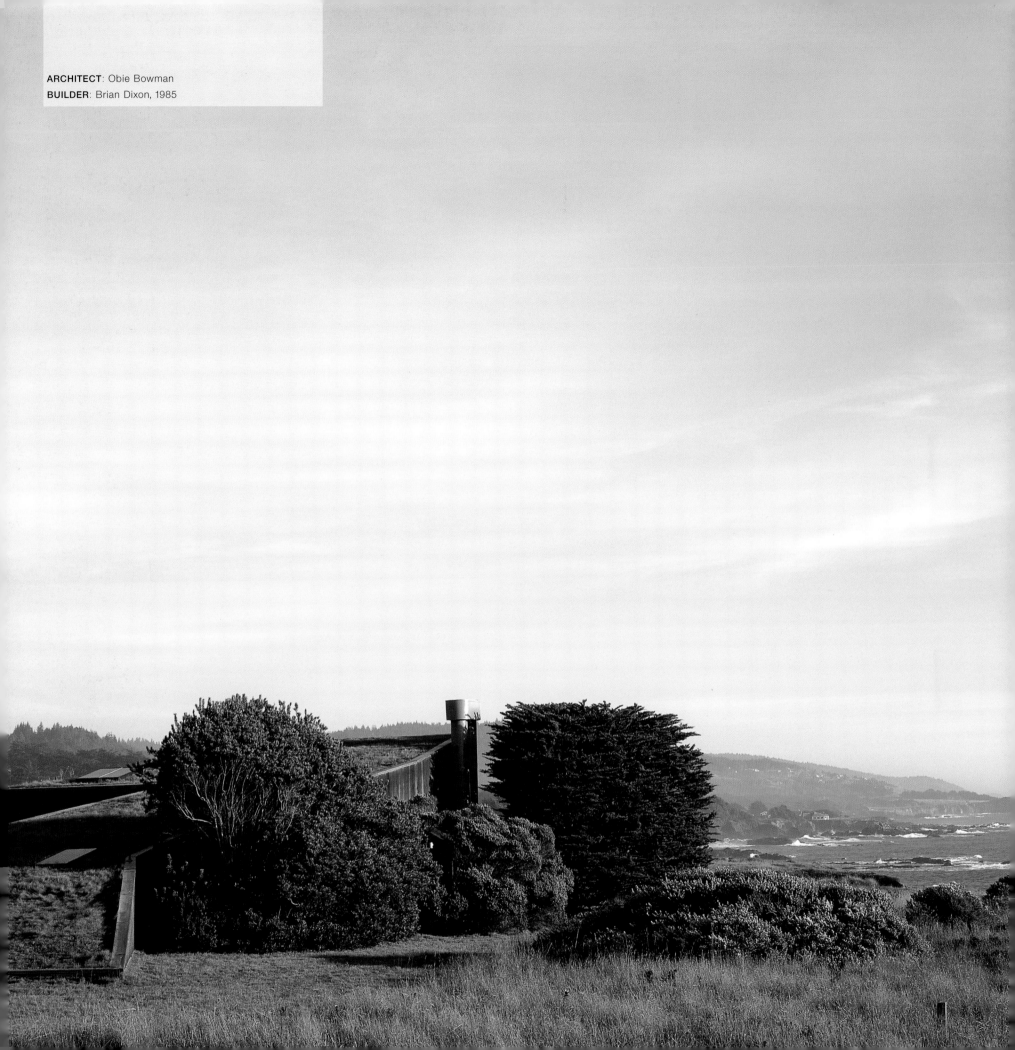

ARCHITECT: Obie Bowman
BUILDER: Brian Dixon, 1985

BRUNSELL HOUSE

(now the Sharples House)

Several houses at The Sea Ranch are built with sod roofs to connect directly with the land. They are always most successful when they form part of a larger pattern. The first were among the Hedgerow Houses, and were important for establishing their connection to the meadows in front. The Kirkwood Houses, designed as a pair, also encompass a larger part of the landscape than individual houses do, and with their sod roofs establish themselves as a part of the topography of the place. The undulating form of the Brunsell House, which encapsulates the variations of the land itself, connects masterfully to the rolling form of the land and vegetation as the meadow reaches the coastal bluff.

Located on the edge of a point jutting out into the ocean, the grass-covered wings of the house rise slowly from the land, twisting to form a chevron around a recessed drive, which also serves as entry court. The back of the house (which is what is visible from the properties behind it) is all slopes and recesses, continuing the flow of the meadow toward the sea. Only within the entry court, cut into the land, do major vertical surfaces present themselves, as segments of concrete wall that form the highest parts of the house and shape the entry. From there the long wings slope down to taper into the ground, first toward commons on the southeast, then bending back and sloping down again into the ground near the road. The site is exceptionally exposed, not only by its position along the coast, but by an intersection of roads: with Breaker's

Reach paralleling the coast and rising up into the meadows to the north, Lands End descending from the east toward the point, and a cul-de-sac extending out onto the point. The openness provided by these roads and the absence of immediately adjoining structures allow the earth-covered forms to be seen in the larger context that they support and from which they derive.

Obie Bowman's ingenious design of the Brunsell House relates responsibly to this particular place. It uses a strategy similar to that used by Charles Moore and Dmitri Vedensky in the original design (1968) for the small Shinefield House at the other end of Breaker's Reach, digging partway into the ground to reduce the intrusion of a front-row house on the views of those

behind, and covering parts of the roof in sod (see p. 297). The Shinefield House, ironically, met with resistance from the design committee when it was first proposed, and it was later added to with less success but still in small, low units of diminutive size. The Brunsell House is both larger and more ambitious. Bowman could build on experience with an earlier house he had designed on Sea Gate Road, which has a large triangular stretch of sod roof rising out of the ground. The Brunsell House advances to a more complex geometry, connecting evocatively with the larger landscape.

Approaching through the recessed entry court, the sense of descending into the earth is magnified by the way the entrance is tucked into

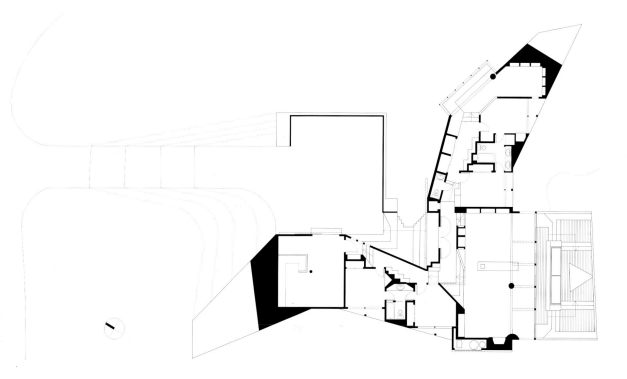

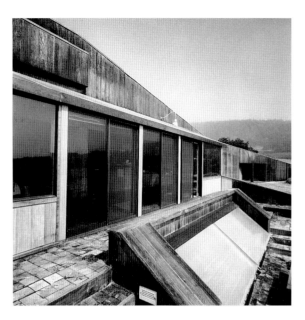 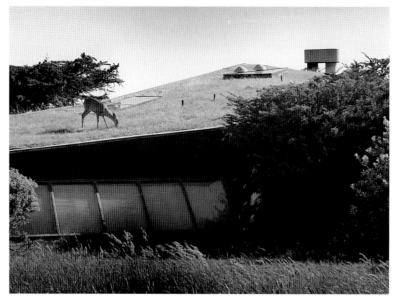

a fold of the front concrete wall, even as steps rise slightly to an entry platform. Inside, the same movement carries on into the house, angling up again a few steps toward the fireplace at one end of a long, rectangular glass-fronted room facing the ocean. The diagonal thrust across this simple rectangular space is reinforced by an enormous glu-lam. This built-up laminated wood beam spans across the room diagonally to a single log column standing off center under another great spanning element, a segment of wood-clad wall overhead that reaches across the entire front. Beyond that overhanging wall, sliding doors and a skylight front the sea in a burst of brilliant light. The sculpted brick fireplace that receives the attention induced by the diagonal approach has a suggestively veined slab of granite, looking surprisingly like a large coastal map, above its openings. Two types of brick intersect beneath it; one side of the fireplace is made with roughly set clinker bricks irregularly set and protruding from the wall, the other is coursed regularly and geometrically contained, with crisp, neat bands filling out the shape. According to Robert Brunsell this curious mixture charts out a dynamic that characterized his marriage, fusing the "adventurous, flighty, emotional" interests of his late wife, with his own more determined and "rational" thought.

The unusual form outside, and the diagonal thrust of movement and structure inside almost obscure the simple rectangular simplicity of this great room. Its one end is anchored by the fireplace, the other dedicated, across an open black-tiled counter, to an ample cooking and eating space.

The other spaces of the house are reached from corridors extending on either side of the entry. Two bedrooms and a study stretch along the ocean, while two additional bedrooms and a garage/workspace are perpendicular to the main room. Both corridors are angled, with notched cabinets stepping back along the walls to retain connection with the rectilinear orientation of the main room. All bedrooms have large windows set in recesses beneath the overhanging, often angled roof above. In the ocean-fronting wing, the bedroom farthest from the main space opens through such a deep recess to the ocean and a long view down the coast; behind it a recessed study, with its own sloped bank of windows starting just above the grasses, looks out across the meadows and hills, and up into the morning sun. The beam spanning these sloping windows rests on a log strut, which seems of a piece with tree trunks in the foreground outside.

The house was designed to use the natural climatic forces to advantage; large segments of concrete wall and brick-covered floor sunk into the land create a stabilizing thermal mass; strong solar gain through the southeast-facing skylight and glass wall further heats the space. In warmer weather a set of ventilating louvers and stacks are designed to release excessive heat. The sloped section of the oceanfront resembles a greenhouse made with large panes of glass, which here are shielded by operable solar blinds.

A wood-block terrace immediately outside steps down into the land, further emphasizing the connection to the earth, and creating pockets of usable space in the foreground that are lower and less exposed to the wind.

In all, it is a brave and thoroughly consistent design, which follows the call of this particular site by infusing the house, inside and out, with a sense of being connected to the ground.

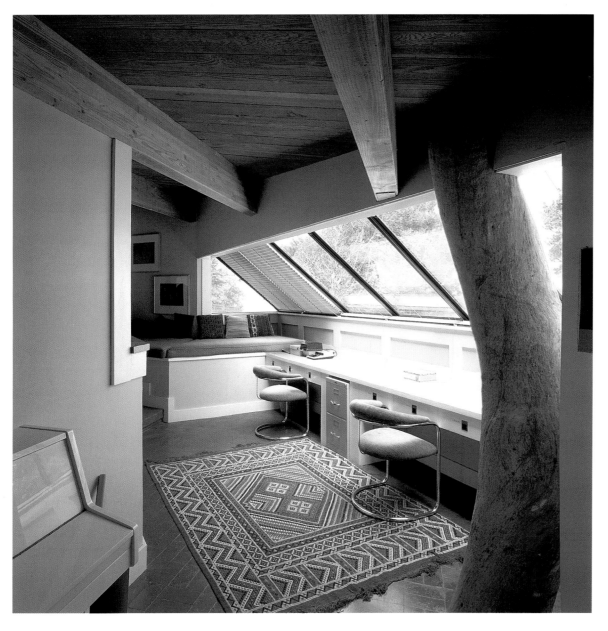

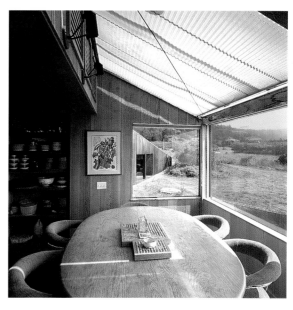

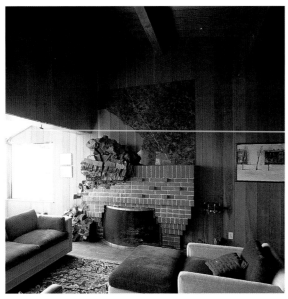

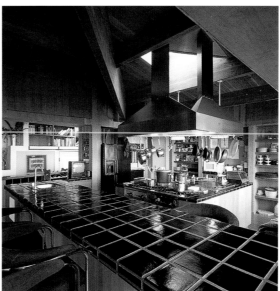

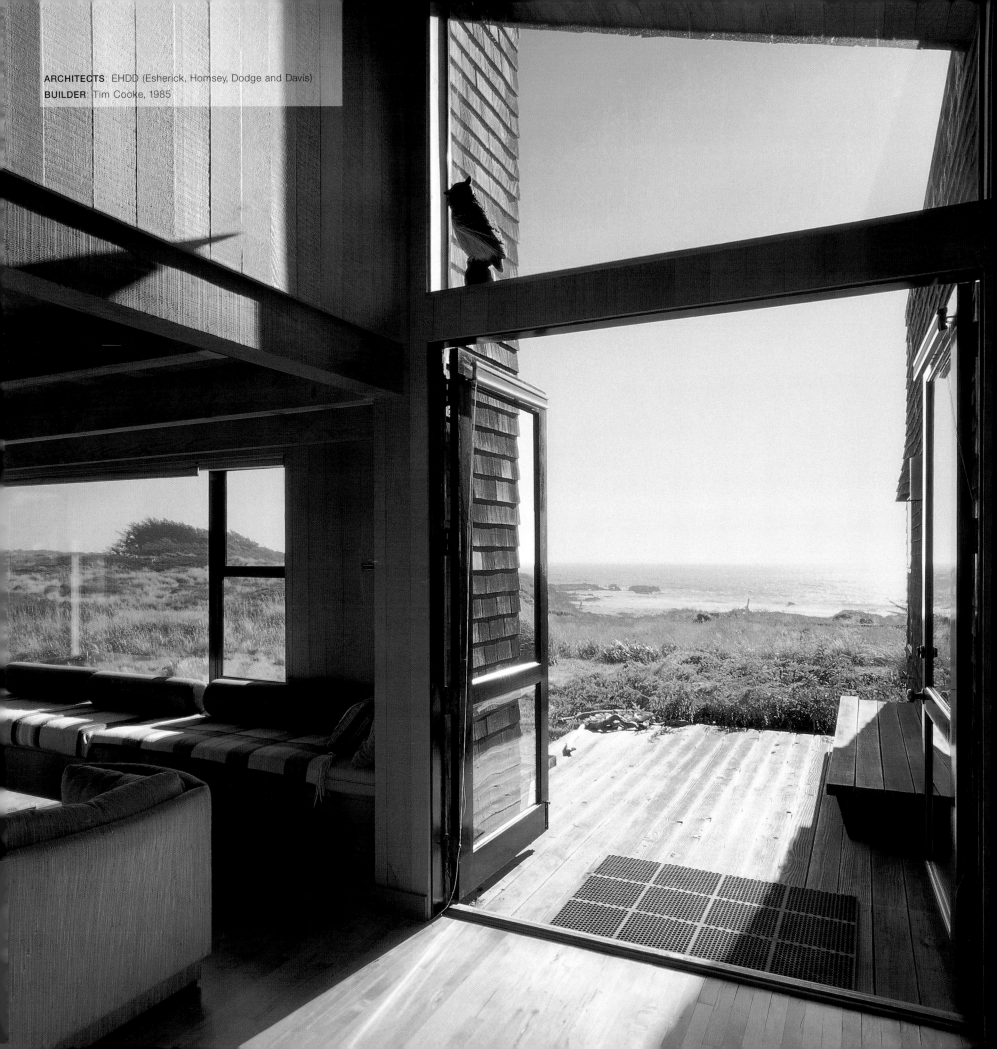

ARCHITECTS: EHDD (Esherick, Homsey, Dodge and Davis)
BUILDER: Tim Cooke, 1985

MASLACH/ ZIMBARDO HOUSE

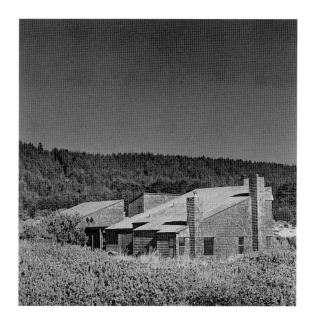

light and open out toward a cusp in the dunes facing the ocean; the sand almost seems to be a continuation of that line of passage, or, conversely, the force of the beach sweeps right into the house. The connection between the two, though actually distant, appears remarkably immediate.

Just before reaching the tall doors at the end, the corridor opens to either side in a broad cross axis. On the left, it reaches across the living room to a brick fireplace on the south wall, and on the right, through an ample dining area and great, wide sliding glass doors onto a broad deck. Esherick used the buildup of pressure created by the house form here to make a less windy spot on the north side of the house. The big deck reaching out to the meadow creates an

The Maslach/Zimbardo House connects to the forces of the site, drawing upon the same vocabulary of forms that Esherick used in the Hedgerow Houses, with some refinements in detail and in an arrangement that is keyed to this particular location and to the family for whom it was built.

The house sits remote from others, far down in the meadow, by a trail leading toward Walk-On Beach, where the land meets the sea in a stretch of sandy beach. Like earlier Esherick houses, this one is shingled, though here the shingles curve out slightly over the windows to protect them. It is also, as the earlier houses are, cut very close to the ground, thus making you more conscious of the fall of the land and joining you to it in a direct and interesting fashion. The several roofs of this house, for the bedroom wing, living area, and garage, all dip down into the wind with the same slope, creating a silhouette that settles into the ground to connect with the larger forces of the open meadow and its wind-trimmed vegetation. This arrangement also intrudes less massively on the view down the meadow from houses farther up than a long, continuous ocean-facing form would. Seen from a distance, the shingled forms lie low and attract little attention; they could be dark vegetative masses swept by the wind.

Inside, the connection to the land is equally strong yet varied. Walking through the front entry down a wide central corridor, you are immediately faced by the ocean beyond. At the end of that passage, uncommonly tall (seven feet and four inches) glass-paneled doors flood the spot with

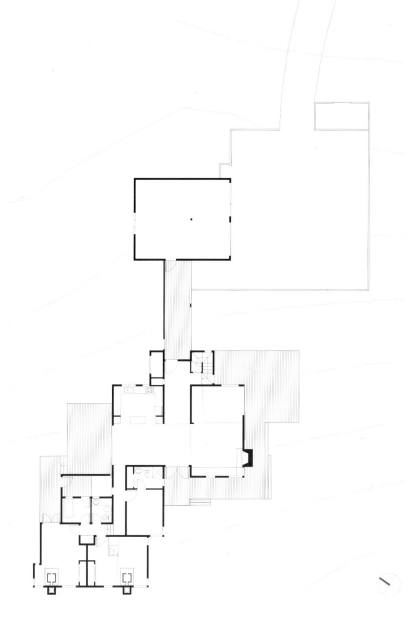

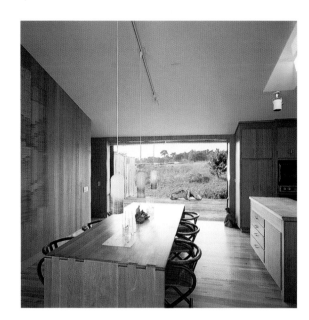

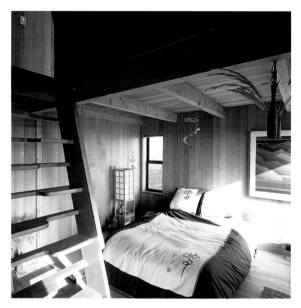

outlook for late-summer sunsets, with a foreground of water-seeking brush to the north and a dark hedgerow some distance beyond.

The house is made up of three major volumes: the largest holds common living and eating spaces plus a loft; the smaller one, shifted to the north, holds a row of bedrooms. The third volume is a two-car garage, sequestered from the house and the meadow by a walled car court but linked to it by a covered passage. An aberrant smaller volume pitched differently as a dormer, which changes the configuration near the entry, is in fact a bathroom squeezed in for the upper-floor loft over the living room. The loft, useable as a study or extra bedroom, covers only the front portion of the volume, leaving the other end as a high open space flooded with eastern sun. A large sliding door opens toward the southeastern deck. A fireplace and a built-in cushioned bench that stretches along the ocean side of the space lend a distinctively comfortable air to the lower level of the room. All wall surfaces are finished with finely crafted hemlock wood siding and counters—smoother than the rough shingle exteriors might suggest, and

reflective of a settled and well-appointed place of residence.

One of the reasons why the Maslach/Zimbardo House is especially interesting is that while being on one of the most prominent sites at The Sea Ranch, it is not dominated by the view, nor does it seem exposed. It is, rather, a very comfortable series of warm, well-proportioned, and nicely finished rooms, each with its own way of receiving light. Windows are usually placed in the corners of rooms, washing the adjoining walls with light, and frequently balanced by light entering from another side or corner of the room. Each room has its own character, taking advantage of its position in the site and within the larger volumes. The ocean-facing bedrooms in the smaller volume of the house, for instance, are each about the same modest size in footprint, but distinctly different in character. The farthest out in the tip of the volume is low, and made even more intimate by a small bay on the corner. Light enters the space from three sides, and it has access to its own deck. The second bedroom uses the high part of the volume to create a loft study over the bed reached by a steep stair/ladder. The two

bedrooms share a pair of ingeniously connected compartments for bathing and toilet, with an outside shower in a walled garden beyond. The living room, with its combination of intimate and high spaces, built-in benches and bookshelves, and adjoining deck, accommodates many different ways of spending time.

While all of the rooms have views, each has a life of its own that is not dependent on that view. Nevertheless, all movement into and through the house passes by the amazing set of doors, first evident on entering, that connect the whole place to the sometimes shining, sometimes ominous ocean, and its near edge. They are generous, but easy swinging doors that, in this location, connect person to place with astonishing certainty.

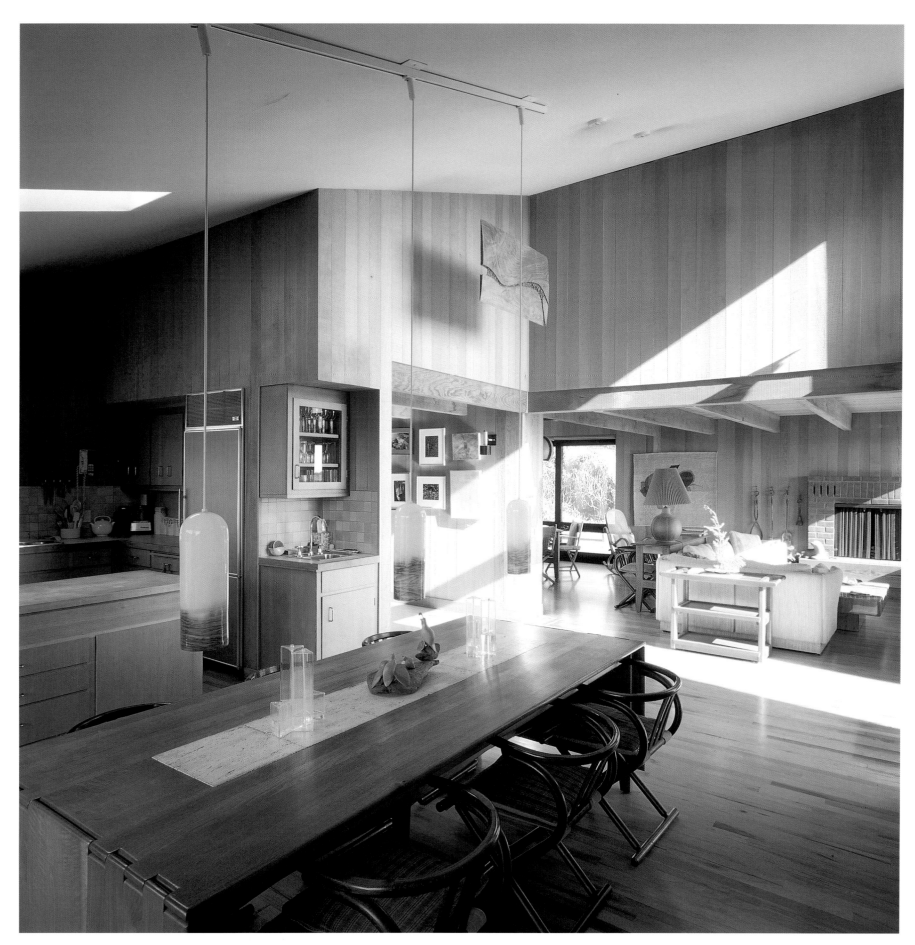

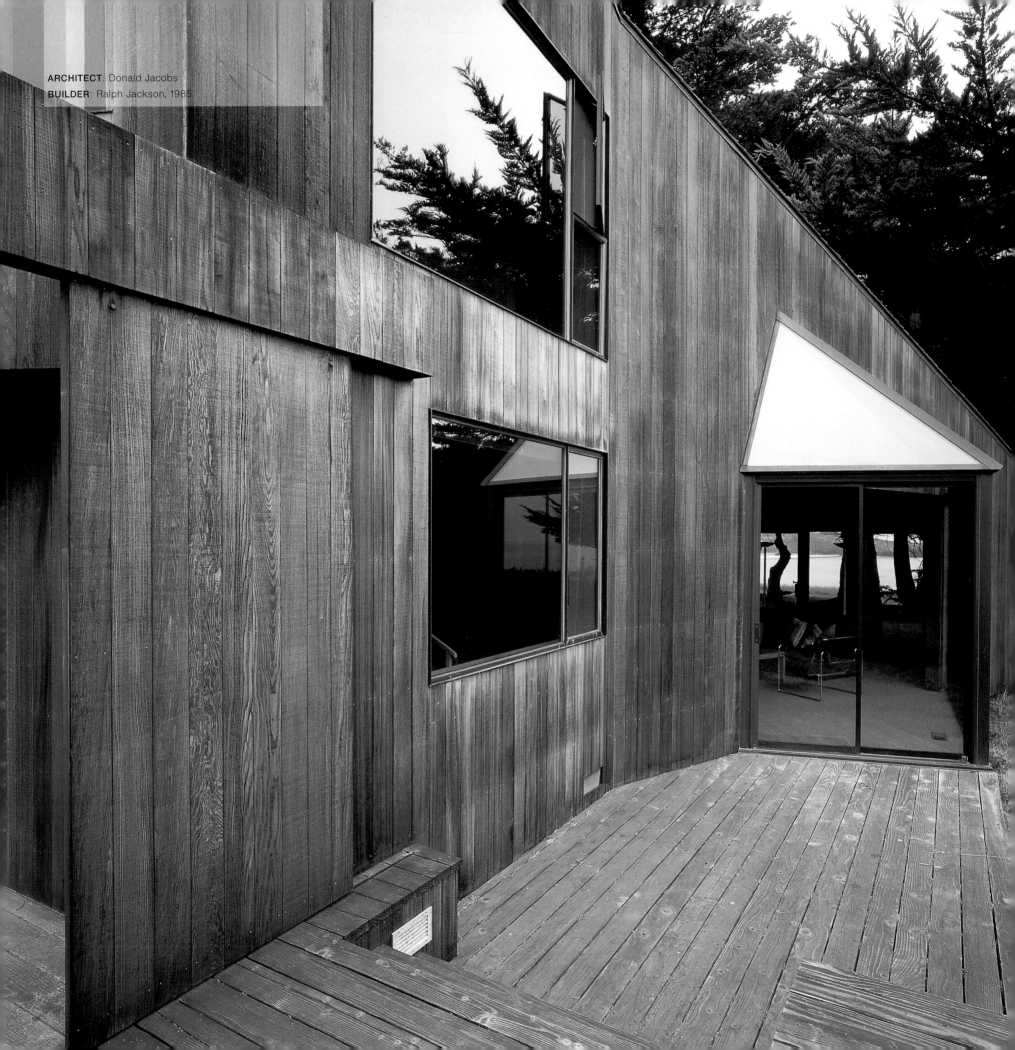

ARCHITECT: Donald Jacobs
BUILDER: Ralph Jackson, 1985

EWRY HOUSE

The Ewry House occupies a privileged position on a point, located at the end of one of the classic double hedgerows that structure the meadows. It fits well within the mass of trees, its forms nicely scaled and sculpted, its outlook extraordinary. Sitting as it does at the end of the row, it looks out to Black Point Beach on the south through the trunks and under the canopy of cypress trees. Its western face, wedged between the hedgerow and a cliff-hugging stand of trees to the north, looks across the narrow point that terminates Black Point Beach, to the next cove, scene of spectacular sunsets behind a bird-covered stand of massive outcroppings in the water. The house fits its site without dominating it, exploring inventively the early vocabulary of single-pitched roofs and simple volumes.

Donald Jacobs was the first architect to take up residence at The Sea Ranch. Like several others, he came here in part out of dissatisfaction with the nature of corporate practice. Jacobs graduated from the University of Cincinnati cooperative program, working both as an intern and then as a graduate for the offices of Skidmore, Owings and Merrill, in Chicago and San Francisco. In 1970 he took over the practice of Jorgen Elmer, a Berkeley architect who was killed in a car accident and had at the time several new contracts for work at The Sea Ranch. In the course of a long association with the place Jacobs has built more than a hundred houses, many of them award-winning, and served for several years on the design committee. He relocated to southern California in 1986, though he has continued to do some work at The Sea Ranch.

Inside the house, the single pitch of the roof reaches from a low wall of glass facing south in the living room to the upper reaches of a bedroom/ dressing room and bath at the peak. The space in between is commanded by a wedge-shaped, sloping form holding a fireplace and stairs. Its angles taper the ascending stairs, help bracket the entry, and tip the orientation of the living room so that its seating is directed toward a sun-catching bay that looks out northwest to the cove. The master bedroom up above opens to the sound of the surf with windows providing outlooks across the point in both directions. A faceted glass bay on the north face of the room is realized with most of its framing members out of sight, so that from inside it reads almost like an uninterrupted gap. The same element from the outside reads as a crystalline shape that is part of a series of small, form-sculpting moves throughout the house. The angles that have been introduced into this simply made clear volume make it come alive, animating the form and space of the building. Between the house and its shed-roofed garage is an enclosed hot-tub court, with a big sliding door offering protection from the wind and from people hiking on the nearby cliffside walk.

The house uses the shed-roof forms familiar at The Sea Ranch to make a viable connection to the sloping forms of the hedgerow it inhabits, while its faceted bay very clearly links the life of

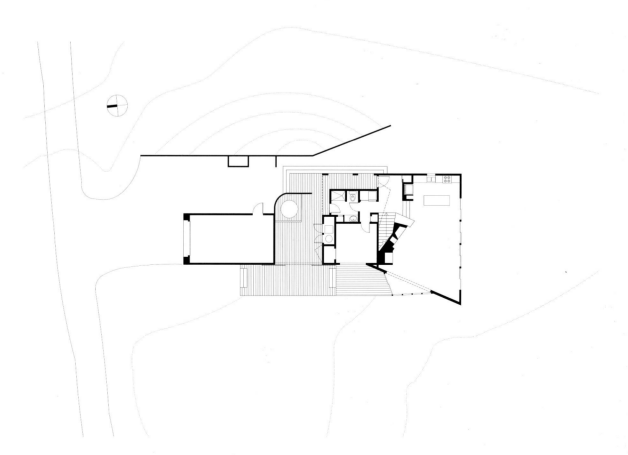

the house inside to the cove nearby. The reverse pitch of the garage roof and the countering face of the main house, with its inset and faceted window forms, charge the gap of space between with visual interest.

The Ewry House draws advantage from views through and around elements in its surrounding landscape, using the canopy of trees for shade and for protection from storms and passersby, while at the same time creating an enlivening framework for the views themselves. The angled fireplace, chimney, and bay shape and deflect views inside, creating a dynamic of vistas and proximities that enliven the spirit of the house.

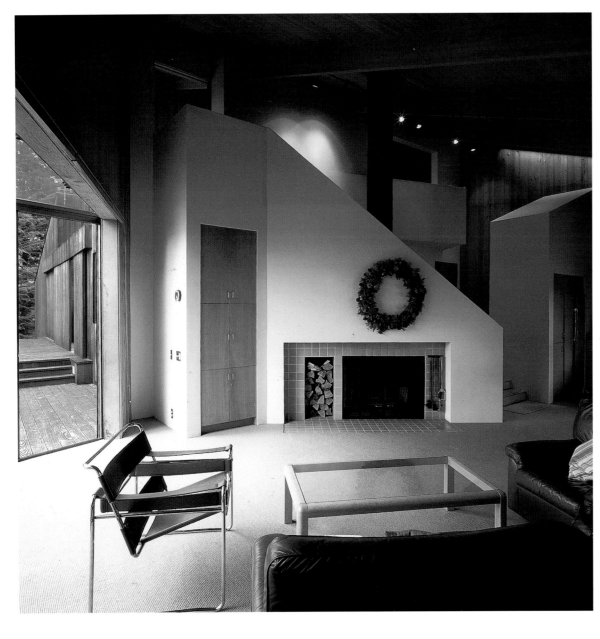

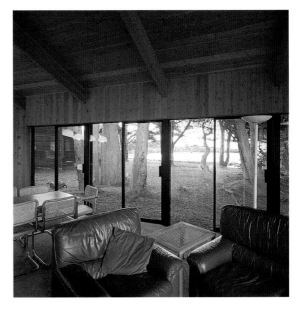

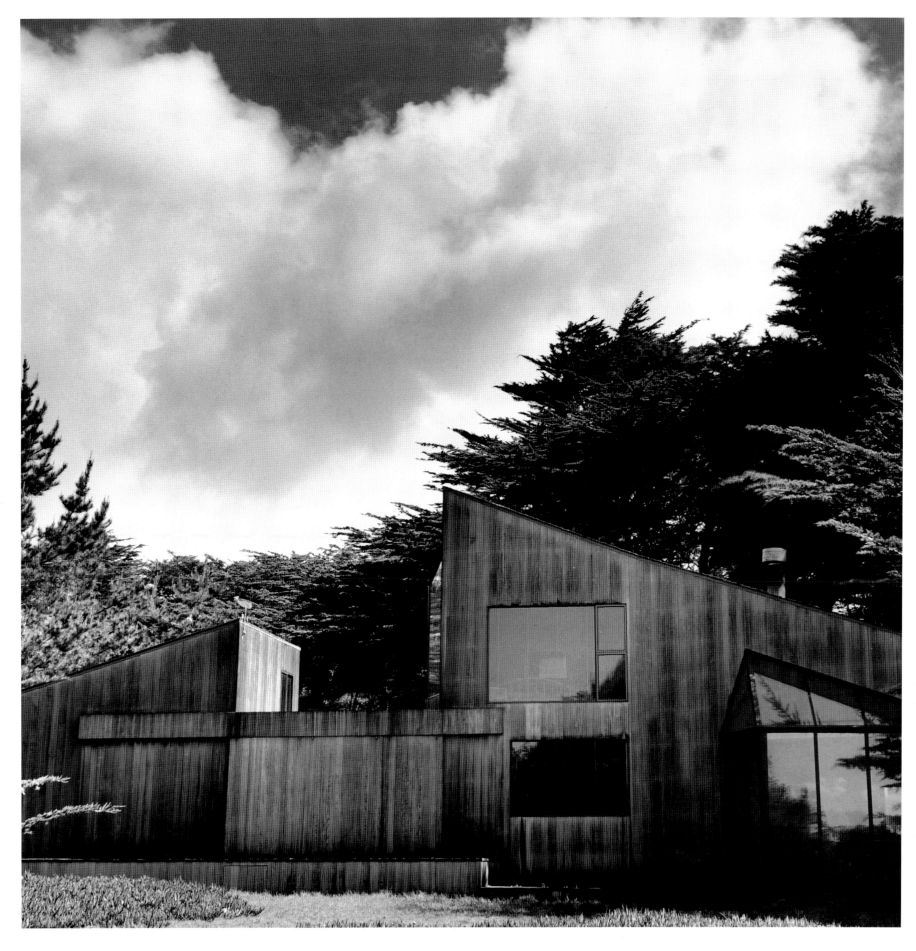

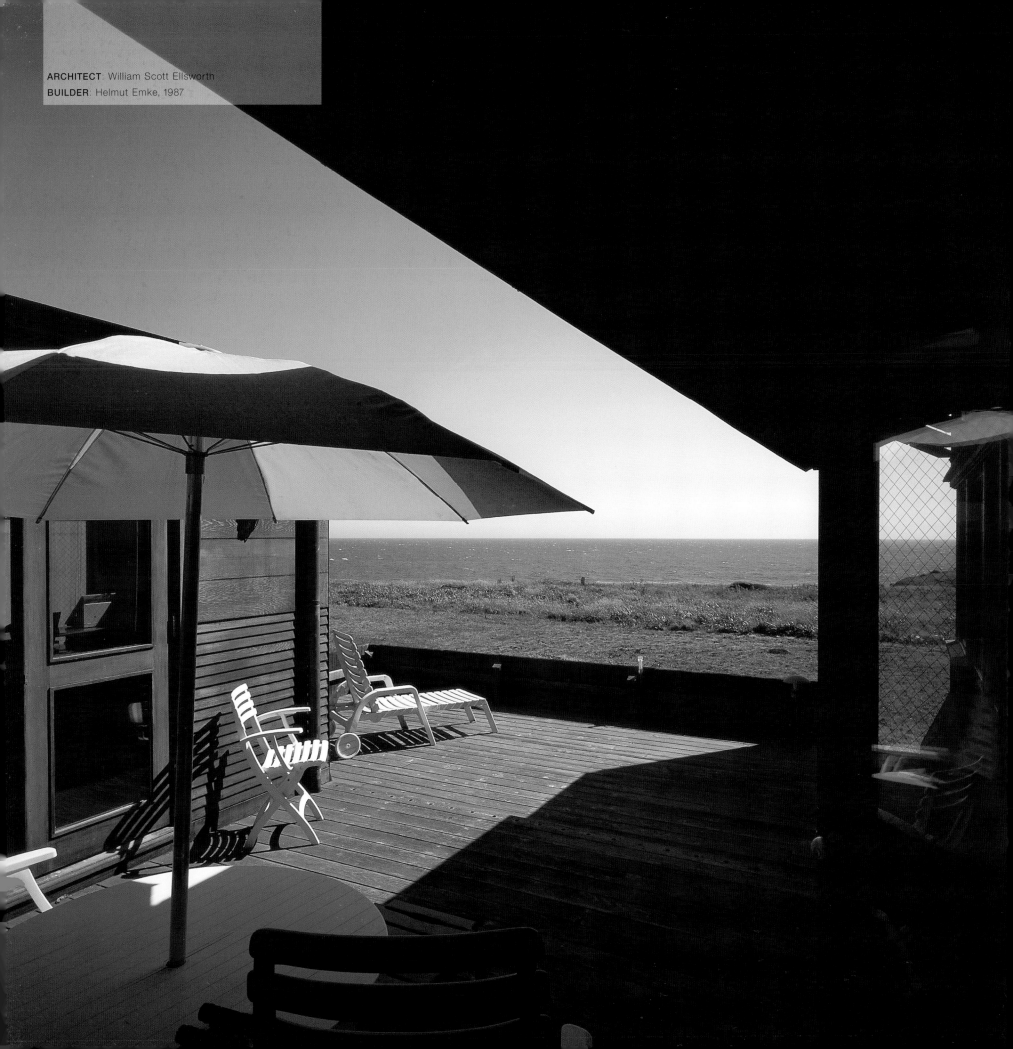

ARCHITECT: William Scott Ellsworth
BUILDER: Helmut Emke, 1987

MICHAEL HOUSE

(now the Partridge-Martin House)

wall along the property setback line and dip toward the entry.

The house makes good use of its narrow lot in a tightly packed oceanfront row of the sort that Halprin's early planning took pains to avoid. The axis that organizes its forms is registered first in a canopy, which starts alongside the garage, then bridges to the living-room block and a translucent glass door. The door opens into an entry passage linking the other two volumes with a cross axis that connects between the living areas and the bedroom suite. The canopy reappears on the opposite side outdoors, continuing along the edge of the deck to shade south-facing windows of the living room. This simple, straightforward organizing move is

This house, full of thought and invention, could have been a model for those that followed on this very tight cul-de-sac in the northern section. It is exceptionally well planned for its site, connecting to the climate in the classic Sea Ranch way. It is divided into several volumes, each with a single-pitch roof dipping down into the wind.

The longest wing of the house projects forward, placing the living area closest to the ocean with views along the coast. The master bedroom suite is in a smaller wing set back on the south, bracketing an intimate court. This court, protected from the wind by the longer building, creates a comfortable niche with a deck for soaking up the southern sun while surveying the ocean, passing birds, and hikers on the cliffwalk trail. Its front segment steps down, thus keeping the platform close to the slightly sloping ground, and subtly expanding the sense of spaciousness.

The recurrent sloping roofs, all oriented in the same direction and starting at the same height, cover rooms of differing widths, and thus rise to differing ridgelines, creating a silhouette that is varied but disciplined. It seems akin to a musical score, with repeating but varied strokes across a regular register, some joined, some separate, all persistently crisp and simple. Each of the principal rooms of the house has its own volume. The spaces located in the larger wing are aligned along an entry passage that sets an axis through the house and creates one common wall against which each of the volumes is stacked. Those across the axis share a common

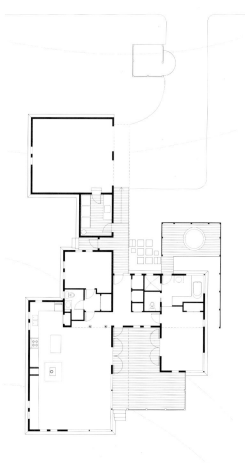

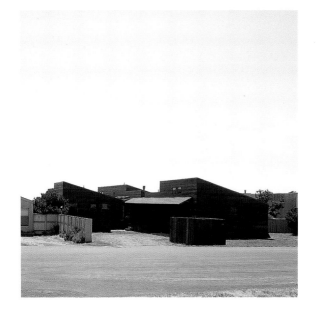

enhanced by an equally straightforward but adroitly imaginative detail: the canopy is held off the house on brackets angled up from the wall at the inverse angle of its slope, creating a welcoming canopy in perspective overhead, punctuated by notches in the rafters.

From the entry foyer, the ocean horizon lies directly ahead, while the main living space opens through a paired-column vestibule to the right. The space seems unexpectedly spacious, partly because all preceding elements are modest in dimension. The slopes of the roof are shallow, so walls never become very high, and both the canopy and entry passage are ample but close-fitting. Suddenly, stepping inside the highest part of the volume and looking across the stretch of the room and out through windows to the ocean, you seem to have entered a different domain of dimension.

Yet the space is not exceptionally large for a living/dining room and kitchen; it is just thoughtfully made and carefully choreographed. Details help: the windows on the far diagonal corner are not "picture" windows, but a set of small square openings that capture intriguing glimpses of the outdoors and splashes of light. The southwest corner, on the other hand, is all glass. A wood-stove stands midway in the room on a tiled hearth. A bold black-and-white tile pattern running around a built-in oven and up the wall, marks the change of use at the edge of the kitchen. It optically complicates the perspective of a long line of kitchen counters, desks, and

bookshelves that stretch the entire length of the long side wall. An additional bedroom, placed at the rear of the vestibule, with outlook into a small court, is sensibly located away from the view, so that it does not consume frontage along the coast.

The bedroom wing joins the main volumes at the front door, its roof sloping up from the entry point. A fine room with a view opens both to the ocean and to the court. It extends back beyond a closet and cabinet to become a sunlit tiled bathing room. A walled court opens off its back, placing the intimate function of an outdoor hot tub in the most wind-protected place, out of the common view and open to the southern and eastern sun.

All of the principal rooms of the house are shaped to the same proportions in plan, contributing to the harmoniousness of the place, a factor not lost on owner Loren Partridge, a noted historian of Renaissance architecture. The narrow frontage along Sea Lion Road presents the structure of the house clearly. The entry axis and canopy are evident from the road, while the garage/mudroom volume, extending its line across the site, opens sideways to a partially screened court, sheltering cars from view.

The exterior surface of the house differs from most Sea Ranch houses in that it is made with three different forms of horizontal rather than vertical siding. The upper portions are one-by-ten redwood boards, shiplapped and smoothly joined. The middle sections, corresponding to a

finished wainscot along sections of rooms inside, are smaller, shaped boards of finer quality, creating a ridged texture; at the very base of the wall, one-by-ten pressure-treated Douglas fir boards kick out at an angle, visually connecting to the ground without actually touching it. They leave an air space to ventilate the underside and prevent termites from climbing into the wood. The walls are stained with a dark pigmented stain, a welcome relief from the light gray blight that characterizes the northern reaches of The Sea Ranch. The windows are all square, of two different sizes, with soft green, baked enamel finish.

The most significant difference from its later neighbors, and from many other houses at the northern end of The Sea Ranch, is the discipline with which this house is made, each part clearly understandable. William Scott Ellsworth, an architect in San Francisco who works largely on his own, has clearly given it careful attention. Whereas many houses (especially those whose architects chafe at restrictions on height) dissolve into irregular, uninterpretable gray masses, the forms of this house show the variance and the discipline of natural process. It is an architecture that is invested with clear planning, imaginative details, thoughtful finishes, and sizes that are tuned closely to their use and to human presence.

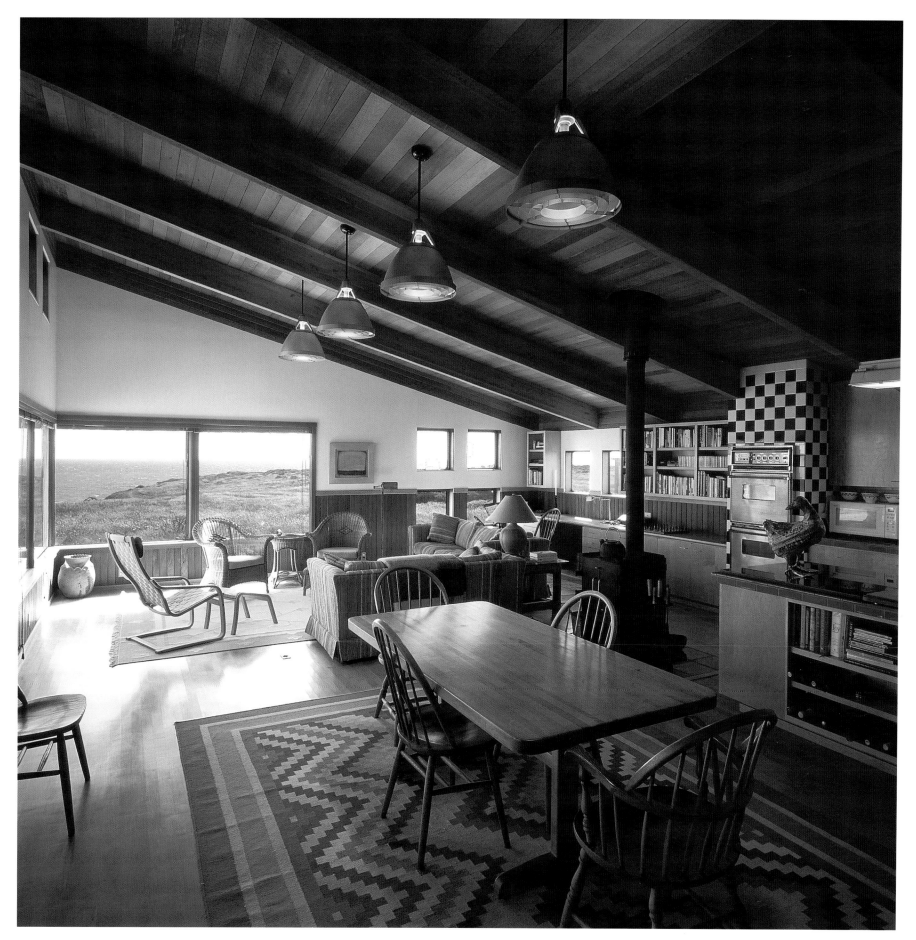

ARCHITECTS: Lyndon/Buchanan Associates
BUILDER: Matthew Sylvia, 1989
ADDITION: Donlyn Lyndon
BUILDER: Timothy Carpenter, 2002

MCKENZIE HOUSE

(now the Franklin House)

This house, initially designed for and with Dianne McKenzie, is the first house that I designed for The Sea Ranch after returning from an extended period on the East Coast. Its site is the edge of a meadow, on a cul-de-sac that parallels a hedgerow. Thus the house site is related to but not adjacent to the trees. Our response was to set the building complex as close to the road as setbacks would allow and to make the gesture of the house's roof toward the trees sufficiently strong to visually bridge the gap of space, connecting house and hedgerow when seen from across the meadow. Setting the house close to the road, rather than pushing it out into the meadow, also left clear lines of view for the lots farther east along the road.

The house is built in two parts across a courtyard, with the everyday living spaces on the western, ocean-fronting side, and a studio/garage on the eastern side. The roofs of the two buildings rise at the same pitch, as though cut from the same plane and bent just a little. That over the narrower house rises up in a single slope toward the southeast, with its maximum height bringing sun into the space through large windows. The studio roof starts in the same plane, but at its peak folds over into a gable; its downward slope encompasses the garage/work space and storage shed. The two buildings are joined by board fences tying the forms together and enclosing the central court. From the cul-de-sac the house presents two aspects; one building reads like a simple barn, the other as a high shed

reaching for light and sculpted by appendages, including a walled enclosure to the south, which provides a private wind-protected sundeck with hot tub and a framed view of the ocean.

Inside, the main living space is a long high rectangle that steps down gently toward the sea and harbors a mezzanine above with the bedroom, shower, and toilet spaces. Large, tall windows on the ocean end look out onto a meadow stretching toward the bluff; the opposite end of the room is open to the kitchen across concrete counters. The dining table is located in the middle of the space. From this center of hospitality in the house, the action moves off in all directions. The kitchen equipment is ready to hand on one side, the living area a few steps below on the other.

Two pairs of French doors, aligned across from each other on opposite sides of the house, create a cross axis through the space: one set of doors leads to a covered north porch and a view to the meadow beyond, the other pair opens to the walled sundeck on the south. Overhead, a bridge passes across the space, and a large, tall window on the southeast lets in the morning sun. It joins a long skylight that garners bright light from the sky throughout the day. Beside the kitchen, stairs climb to the second-level bridge that crosses the length of the space, leading past a toilet room, a long closet, and a freestanding glassed shower to end in a platform that holds the master bed, with an appended niche for meditation. Originally this area was kept away from the wall to

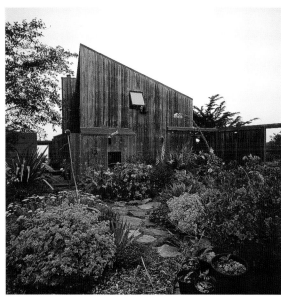

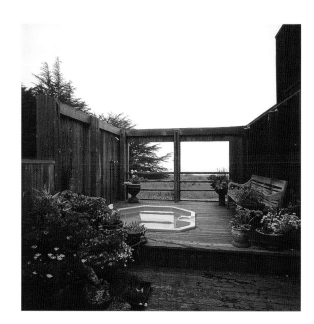

emphasize its separateness as an element in the large volume.

The studio in the second building is a large simple barn space that becomes very low on the meadow side to create a close nook for the woodstove, and rises up at the peak to cover an atticlike mezzanine study, with its own projecting balcony outdoors.

The McKenzie House was built with an exposed heavy wood frame of Douglas fir and plank walls and roof, a modified version of the construction system used in Condominium One. Additional materials were informed by Dianne McKenzie's adventurous enthusiasm and her commitment to experimenting with surfaces. (She has since joined John Halley in Comet Studios.) The living-area floors are slate tiles, which have since been used extensively at The Sea Ranch; the counters for the kitchen are cast concrete on industrial kitchen supports; the towel bars and accessories are fashioned of copper plumbing tubes; and the lights and conduit are exposed with industrial fixtures.

Wink and Laura Franklin, who now own the house, have invested it with another layer of

interests. Wink carves big logs into furniture and figures, while Laura has an intense interest in gardening. A number of Buddhist objects inhabit the house, lodged on framing members, in nooks and ledges, and on the walls. The most dramatic transformation under the new owners has been in the walled court, which is now a lush, extravagantly vigorous garden that produces all manner of blossoms throughout the year, suggestive of a northcoast version of Rousseau's famous jungle paintings. On the south a trellis further defines as garden the area that once was the car entry; cars are now parked in an area outside the walls, thickly screened by pine trees. Great, beautiful chunks of wood in various, stages of being carved inhabit the garden.

Small additions, which I have designed, have recently been completed, adding an extension to the studio building and expanding its bathroom. The main transformation in its role in the larger landscape is the addition of a short, windowed tower at the center between the two buildings. It adds another vertical incident, marking the presence of people in the long stretch of wall edging the meadow.

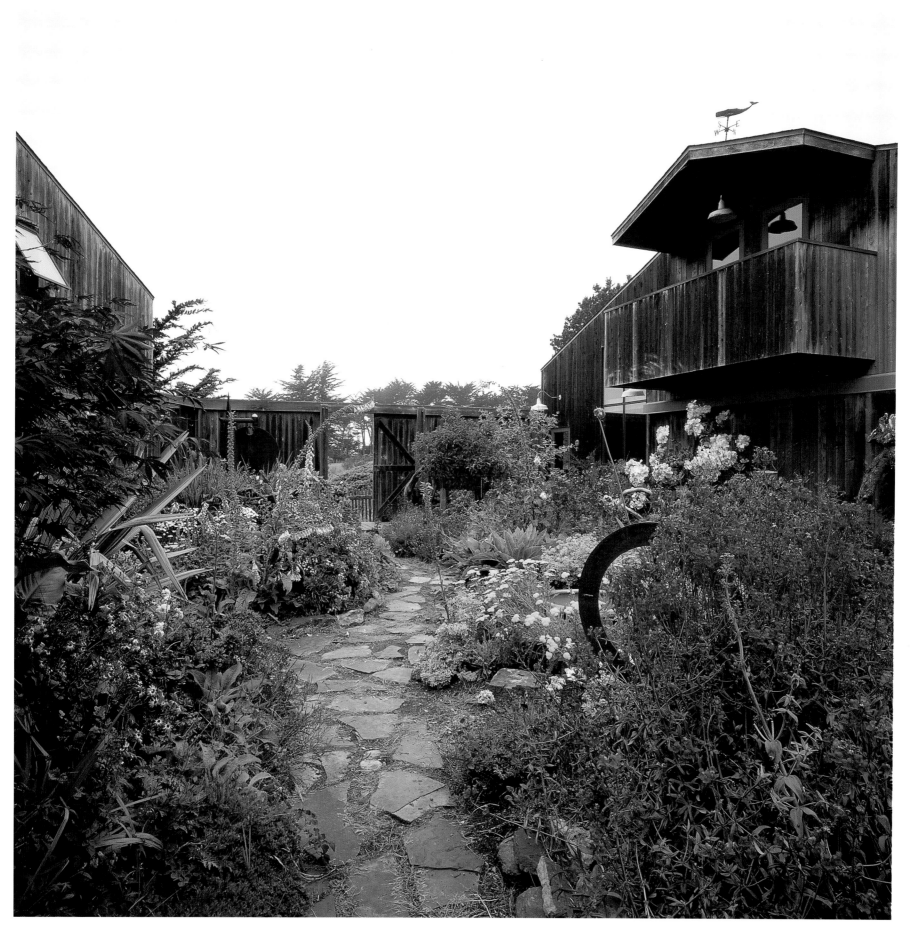

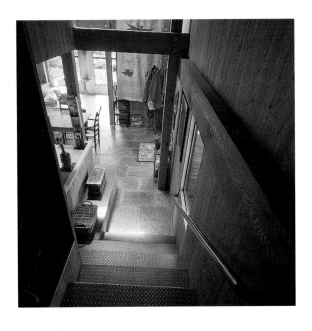

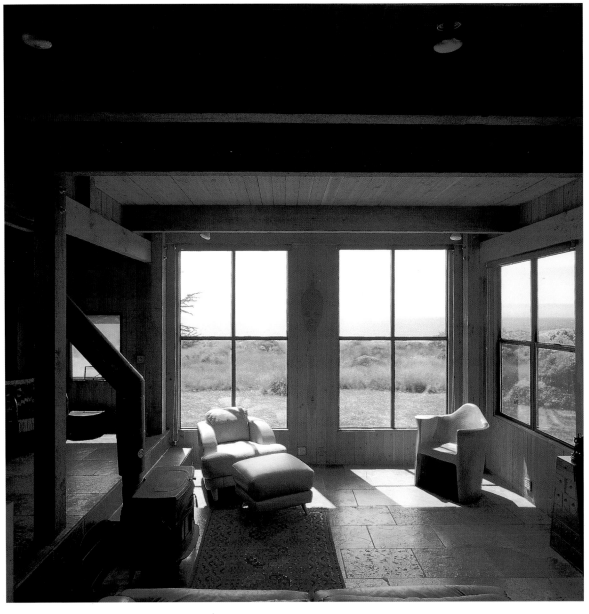

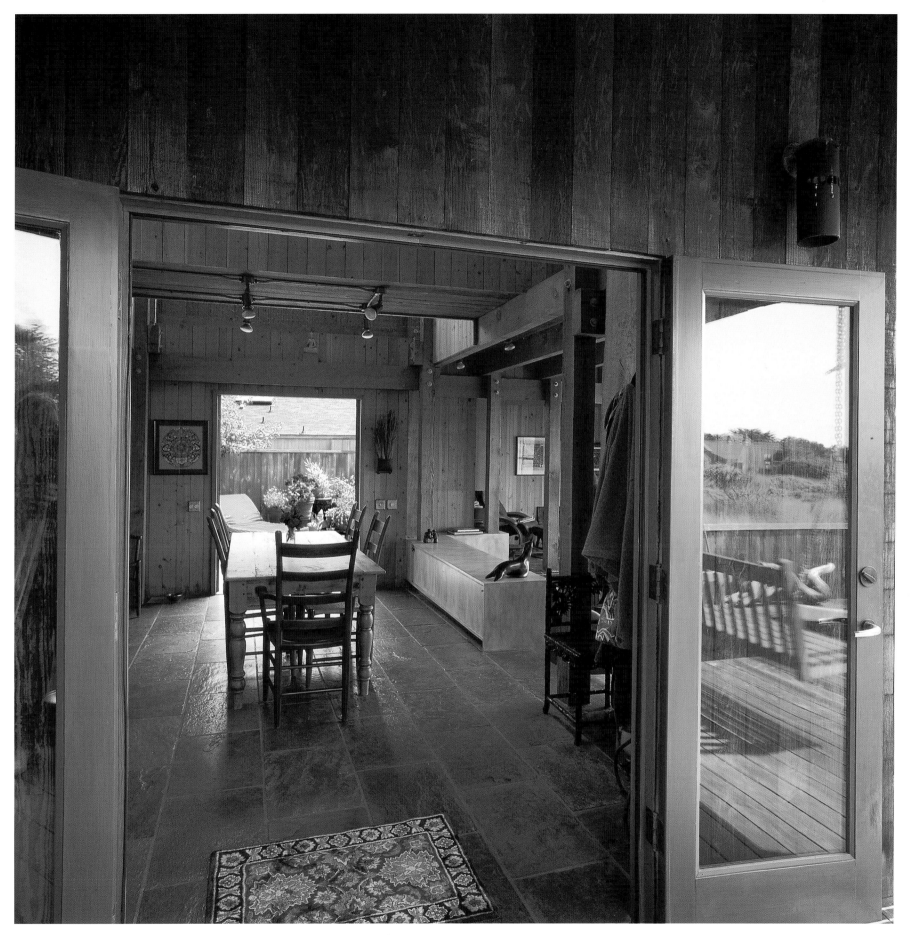

ARCHITECT: Robert Hartstock
BUILDER: Rich Fredrickson, 1996

SOMERS HOUSE

(now the Haswell-Mott House)

Just to the south of the McKenzie House is another, built seven years later, which also connects well to its surroundings. The Somers House, located between the McKenzie House and the line of trees that make the core of the hedgerow, sits among additional trees that have grown up to the north of it and next to a stream that runs down among them.

Robert Hartstock, its designer, first came here in the 1970s as an apprentice in the University of Cincinnati cooperative architecture program, attracted by the acclaim that The Sea Ranch architecture had received. His mentor was Donald Jacobs, himself an alumnus of the Cincinnati program. Smitten with the place, Hartstock returned to The Sea Ranch in 1983 and opened his own practice here in 1984.

With the Somers House, Hartstock took advantage of an opportunity to connect to a larger pattern by using a similar roof slope and massing to form a line between the McKenzie House and the dominant hedgerow.

There are two parts to the house, which embrace, together with the line of trees, a small clearing of their own, eddying off the larger meadow stretching down to the ocean. The main house has a simple single-sloped roof that nearly matches the slope and scale of its earlier neighbor. Seen from across the meadow they read together as a coherent grouping with the trees. The house is very simple and direct, with the wall facing the McKenzie windows and deck left blank to provide privacy between the houses. A projec-

tion allows the kitchen to look sideways to the ocean. The second building, nearly perpendicular to the first, was designed as a garage/studio with an upper room reached separately by an open staircase at one end. It separates the cars, parked under the trees, from the clearing, defining the edge of the domesticated space.

The major, quite grand and effective, gesture that gives the main building its unique character is an open porch cut into its form on the south side, with a large exposed truss carrying the roof across without interruption. This outdoor room, like a loggia in an Italian villa, makes a protected place for outdoor eating and gathering, while also serving as an entry. Just beyond it lies the kitchen, behind two pairs of French

doors, one side of its counter serving as an efficient passage between rooms at either end of the block. The living area opens toward the left with windows providing a view of the ocean beyond. To the right, past the bathroom, is the enclosed bedroom that occupies the eastern end of the volume.

The walls inside are gypsum board, mostly painted white; the roof is made with metal decking, its galvanized metal surface unexpectedly glimmering with reflected light inside. The exterior is clad, like its neighbor to the north, with wooden boards and gray composition shingles, easily blending into the general quietness of the scene. A recently revised deck steps out and down from the loggia toward the sun and the view toward

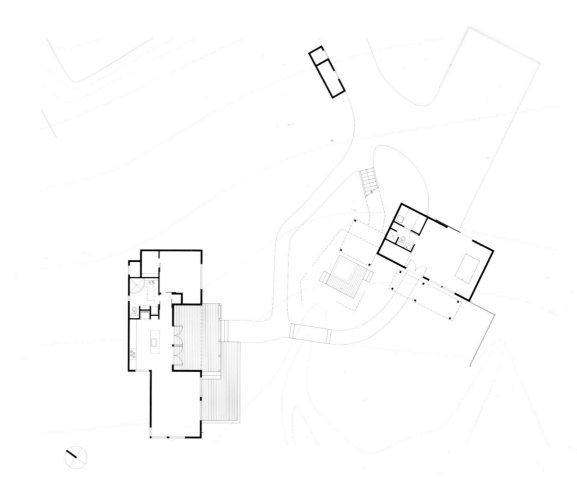

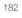

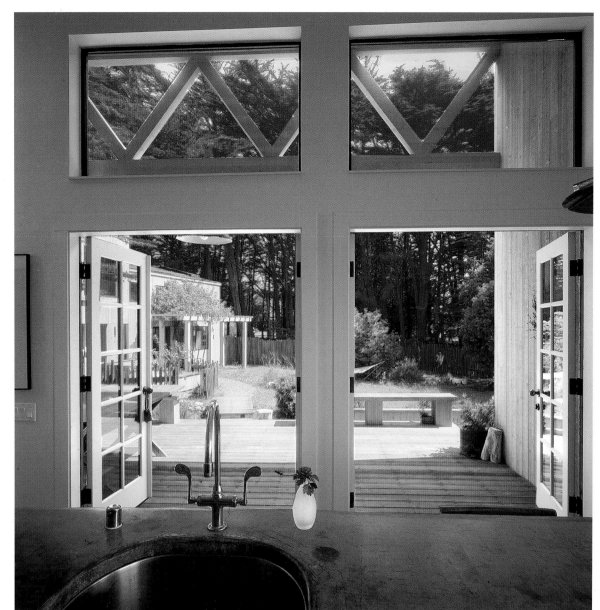

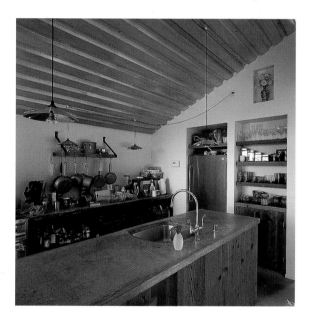

the ocean, a valuable inflection of the nearly sym-
metrical plan.

The second building, which visitors encounter
first, is similarly quiet. It is sparked, though, by an
injection of childhood fantasy, as the exterior
stairs rise nearly through the branches of a large
freestanding cypress, invoking the atmosphere of
a tree house. The small, close-fitting room at the
top is positioned perfectly to capture a view of
the ocean to the west. This building, now trans-
formed into an office and a guest room, has been
supplemented on the clearing side with a trellis
and hot-tub enclosure that domesticate the
space, even as the stream runs through the site
and on out to the meadow and the cliff.

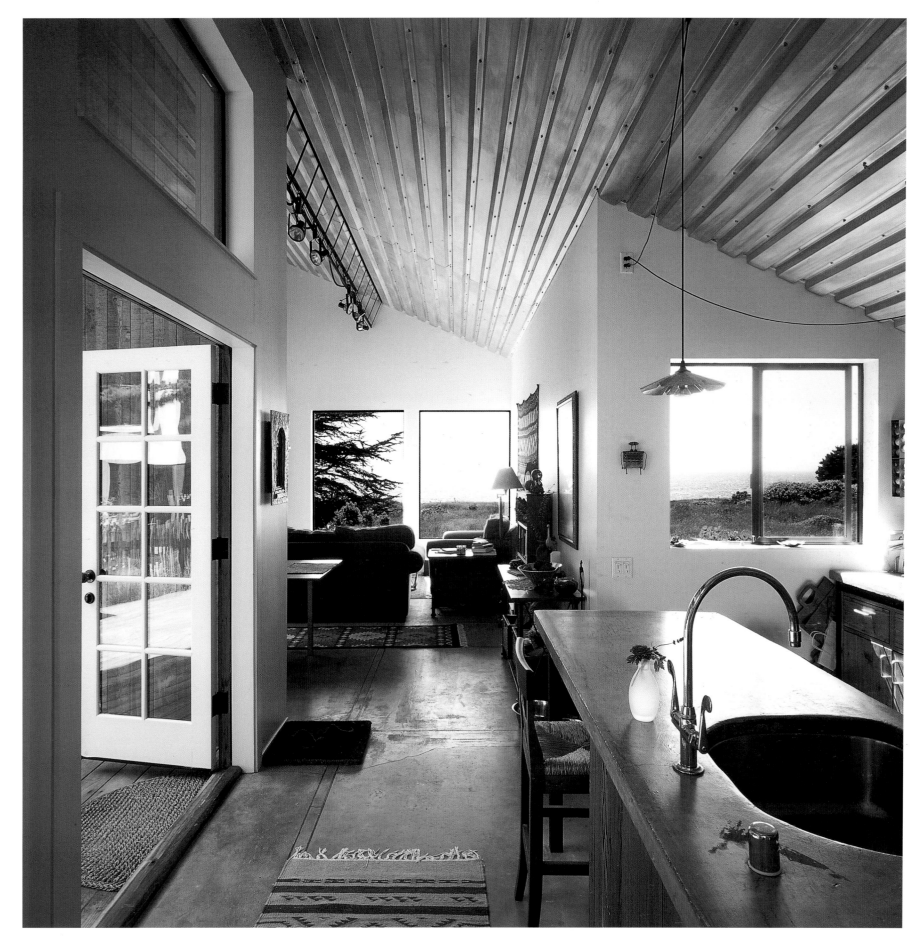

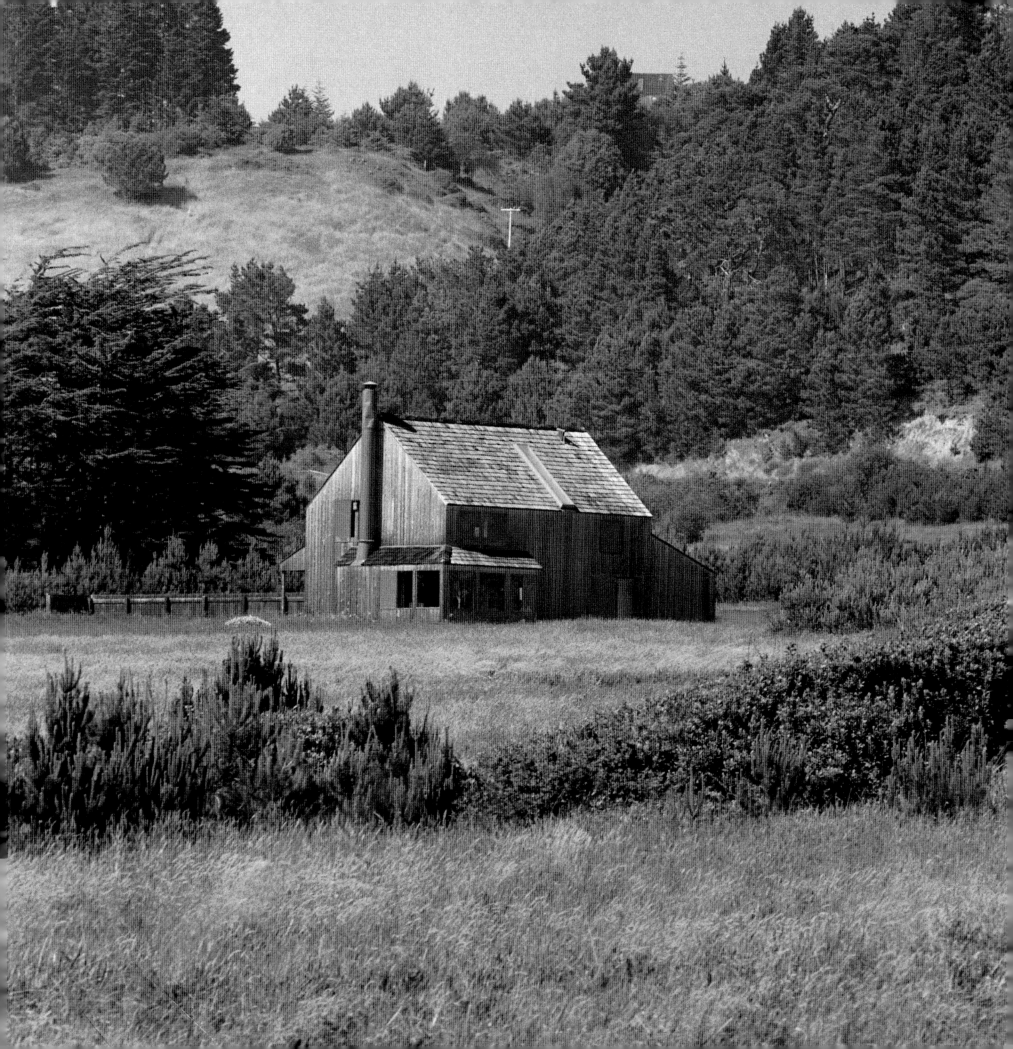

HOUSES
THAT
SETTLE

JOHNSON HOUSE (see pp. 190–195)

The original house was a simple hipped-roof hut standing by itself on the edge of the forest. The iconic form, with roofs spreading down from the peak in four directions, staked an evocative but gentle claim on the place, sitting comfortably among its much larger redwood neighbors. A later addition to the house took a different form, taller and more abstracted, linked to the original hut by a small passage.

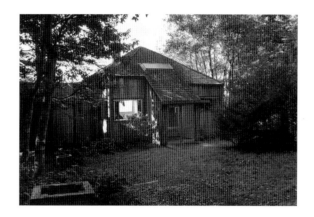

Houses that settle the land are made with forms that establish a suitable presence on their sites. They either use traditional forms, where the house settles down on open land, or employ features, usually in silhouette, that act like a landmark, distinguishing the place where they stand. The latter may result in a contested situation— one person's landmark becoming another person's distraction. Houses genuinely settle into The Sea Ranch when they are either sufficiently self-possessed to emanate clarity and purpose, or when they are delicately assertive, claiming a particular spot in the common landscape without attempting to colonize the whole. The following examples show differing ways in which this can happen, beginning with houses that harken back to vernacular forms used by early settlers, and proceeding to houses that make distinctive claims on our attention but at a scale that is suitable to their place in the landscape. They range from among the earliest to among the most recent houses that have been built.

185

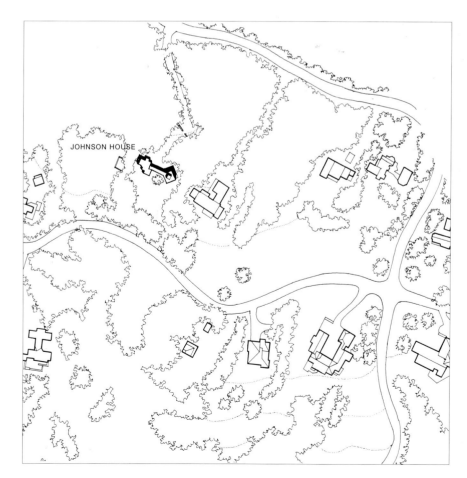

JOHNSON HOUSE

THE BINKER BARNS (see pp. 196–201)

Based on the forms and construction of a small barn, William Turnbull designed a house type that was repeated many times at The Sea Ranch. Its simple, clear gable, geometrically crisp and amply proportioned, is supplemented by lower appendages that slope down in each direction to accommodate bays, porches, and additional rooms. They settle into the landscape effectively in many different locations, appearing at once self-possessed and well adjusted to their sites.

RUSH HOUSE (see pp. 202–205)

Like a stake marking its place in the landscape, the chimney of the Rush House asserts is presence vigorously but lightly, with roofs stretching out and down from it to settle along one side of the site. The silhouette of the house makes it distinctive, while it keeps to one side of the site, and is contained within bounding walls, allowing the meadow to roll freely down toward the ocean.

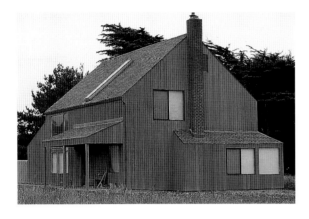

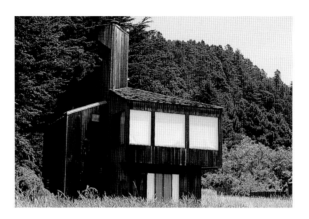

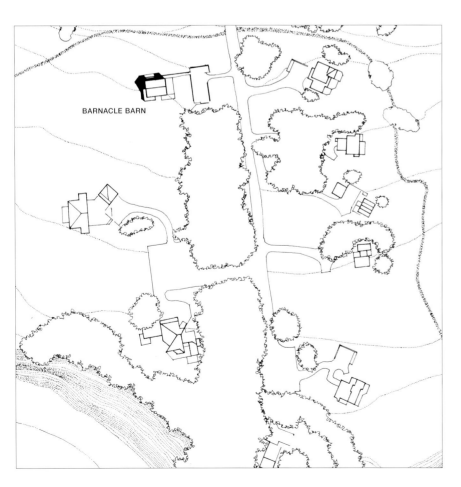

BARNACLE BARN

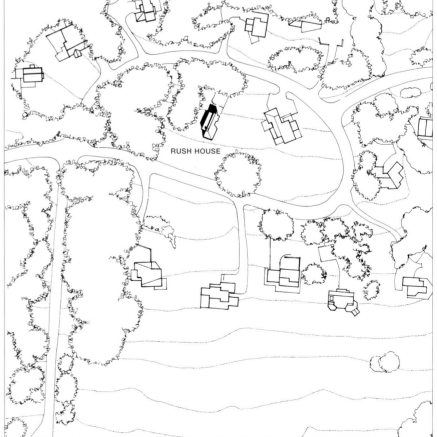

RUSH HOUSE

WILDE HOUSE (see pp. 206–209)

Set along the road at a cusp in the hillside, the Wilde House is fundamentally centralized around a clerestory that brings light to the interior of the space. The roof form extends on one side, however, to bring the garage under its wing; the drive is recessed into the slope, further diminishing the presence of cars in the landscape. Larger, and less crisply formed than the Binker Barns, the Wilde House nevertheless settles on the slope of the hill with quiet certainty.

RASMUSSEN HOUSE (see pp. 214–217)

Though larger than many of its neighbors, the Rasmussen House settles easily into the landscape; its two linked gable forms are backed against the trees and directed to the view along a draw that runs through the land to the sea. The neighboring house shows a similar orientation, so that the two reinforce each other's placement, abetted by a clump of sizable trees between.

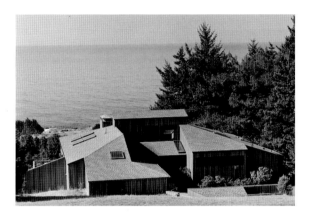

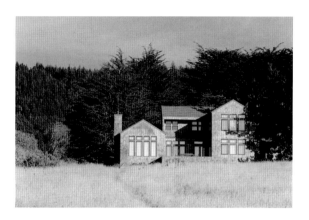

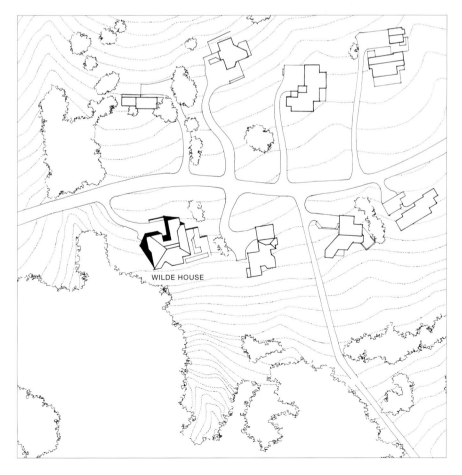

WILDE HOUSE

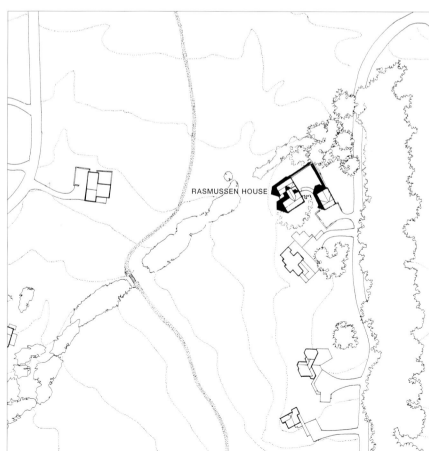

RASMUSSEN HOUSE

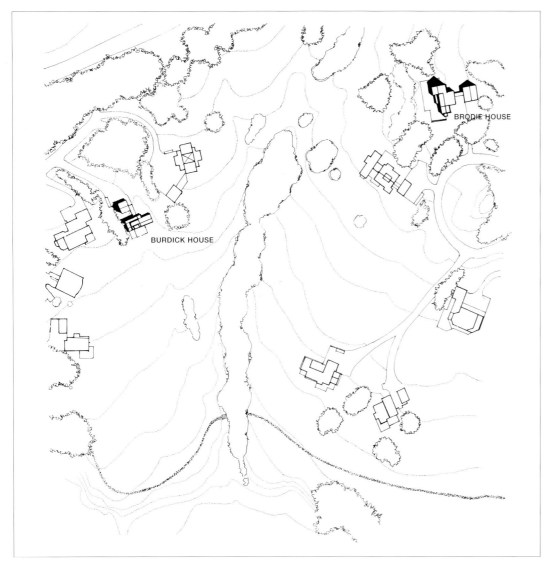

BURDICK HOUSE (see pp. 210–213)

Sited along a line of low trees facing the ocean, the Burdick House settles on its site with aplomb, creating an edge to the meadow. The long gable of the house and the terrace fronting it look down over a broad stand of brush that follows a stream toward the cove, a characterizing feature of the area.

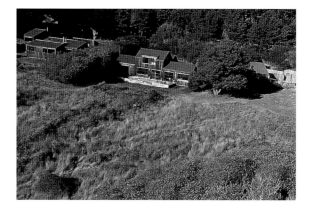

BRODIE HOUSE (see pp. 218–221)

Assembled of repetitive gable forms interlocking along the edge of a slope, the Brodie House settles into a stand of vegetation. It quietly stakes its own position within a sweep of brush and low trees leading to the cove, its forms edging forward to capture views down the draw to the ocean.

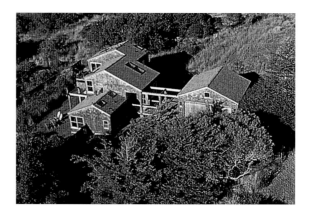

GILBERT HOUSE (see pp. 222–225)

Perched, more than settled, on the side of a slope leading down to a wooded crevice and the ocean far beyond, the Gilbert House is anchored to its site by a chunky tower at its rear, contrasting with a dominant single-plane roof and stilts that lift its surrounding deck off the slope. A passage through the middle of the block further complicates the imagery.

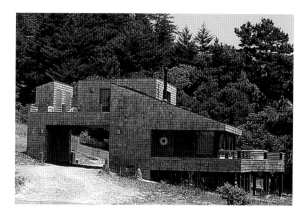

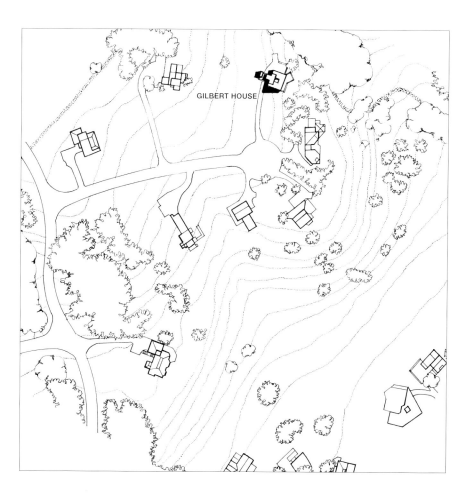

GILBERT HOUSE

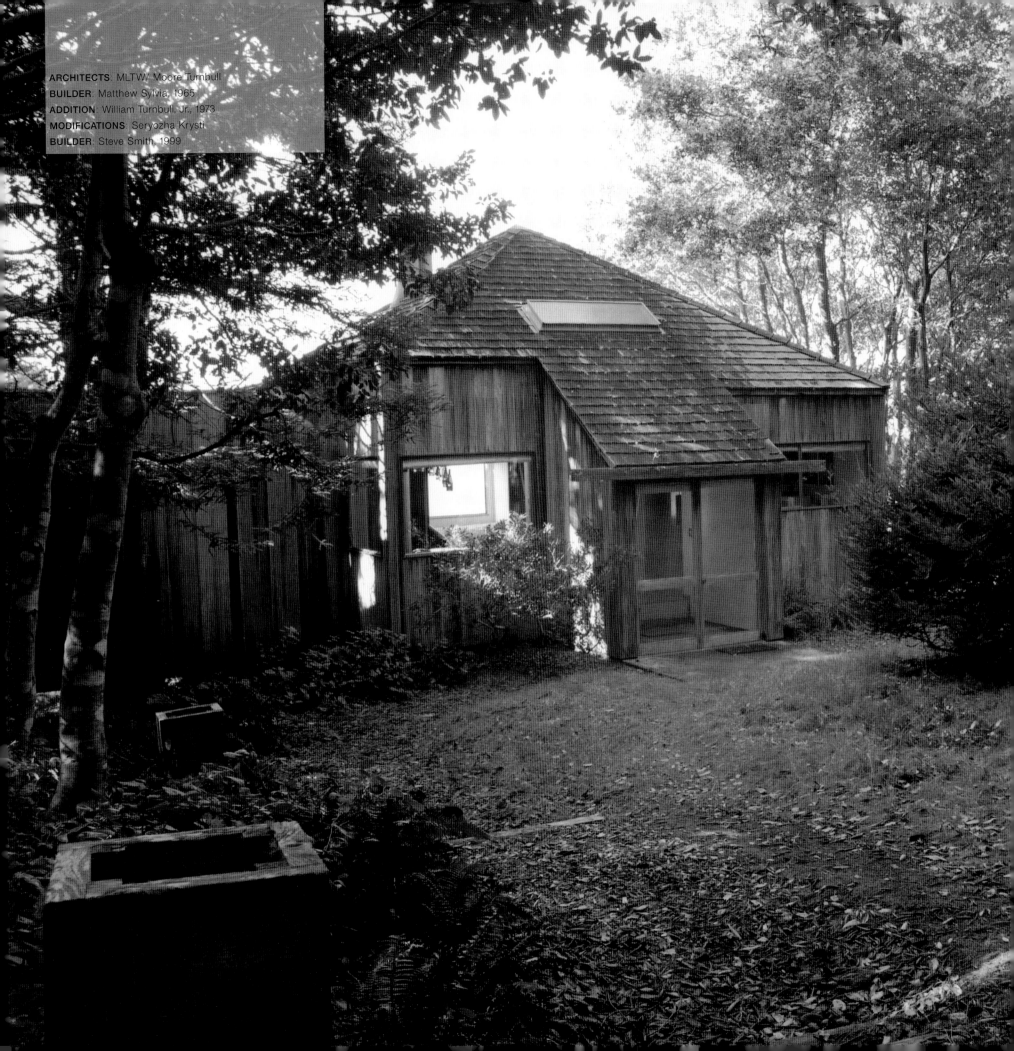

ARCHITECTS: MLTW/ Moore Turnbull
BUILDER: Matthew Sylvia, 1965
ADDITION: William Turnbull, Jr., 1973
MODIFICATIONS: Seryozha Krysti
BUILDER: Steve Smith, 1999

JOHNSON HOUSE

(now the Meyer House)

The house designed by Charles Moore and William Turnbull for Reverdy Johnson in 1965 was one of the first three individual houses built at The Sea Ranch. It remains among the most brilliant, settling, comfortably and confidently, on the edge of the forest, with redwoods and tanbark oaks for neighbors. In one small structure this house condensed the qualities of the place and the potential of its architecture in a way that presaged much of what was to follow at The Sea Ranch and in the subsequent development of Moore's and Turnbull's respective bodies of work.

Reverdy Johnson was the lawyer who was charged by Oceanic Properties with drawing up the CC&Rs for The Sea Ranch. He was therefore an animated participant in understanding and helping to form the character of the community. Great friendships between him and Turnbull, and builder Matthew Sylvia, developed from their work together. Some years later, Turnbull and Johnson partnered the Johnson/Turnbull vineyard in Napa; and later still, Sylvia built Turnbull's own house at Teviot Springs in Knight's Valley.

The wonder of the Johnson House is that it manages to fuse in one place the innocent charms of a small redwood board-and-shingle hut with the mysterious evocativeness of Byzantine centrality found in small early Byzantine churches and the wind-eroded forms of the landscape. It does this by persistently suggesting the obvious, then steadfastly refusing to accept conventional limitations.

The form at first sight could not be simpler: a pyramidal wood-shingle roof, with a small porch extension to provide entry. A second look shows, however, that the roof is not symmetrical, but extends farther on one side of the porch than it does on the other, like a plant grown from a central root, but slightly adapted in form. It is square, but not purely. On the other side of the house, the transformation is even more intense; the walls here are angled and the roof interrupted—the shapes reminiscent of bush and tree forms eroded by the wind.

Yet stepping inside is by far the greatest surprise. What seemed small now seems large, with views expanding in all directions—a space not bounded by the strict limits of a pyramidal hut.

This trick is pulled off by the superimposition of a second geometry, that of an octagonal pavilion—a gazebo of sorts—residing improbably inside the hut. The octagon, defined by a ring of yellow plywood walls, is held aloft on eight round wood columns. Once again the obvious is thwarted, for the octagon is not regular. The spacing of its columns, and thus the length of the walls above them, alternates subtly. At the top, the walls intersect the angled slopes of the pyramidal roof, varying between segments that are flat on the top and segments that angle up like the peaks of a crown. The peaked sections have rectangular openings cut within them, revealing the lower end of the sloping roof, while skylights behind the flat segments bathe the spaces beyond them in

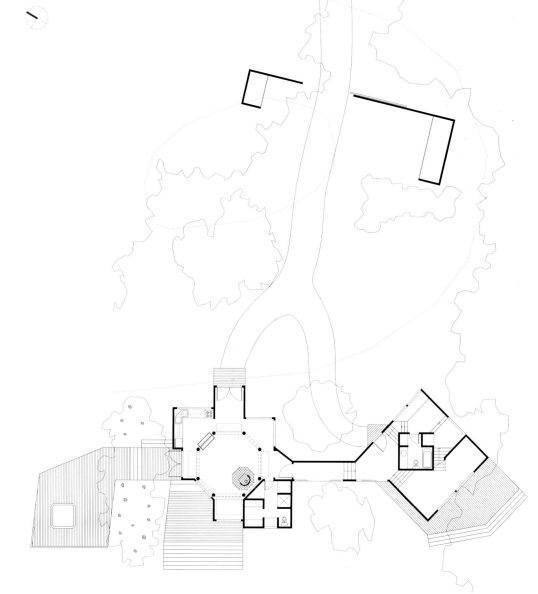

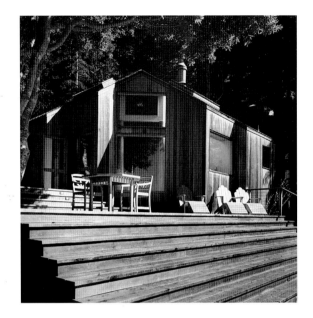

reflected light, softening the contrast with the far, bright view beyond.

The wider spaces of the octagon form a cross axis in plan. The entry vestibule on the forest side, with recessed concrete floor for shedding coats and boots, is aligned with a deep, double bed–sized bay on the opposite face. The perpendicular spaces are realized with large openings looking out into the trees—to redwoods on the south side and to a clump of tanbark oaks on the north. The plan as a whole begins as a square, whose corners are fronted on the diagonal by the shorter segments of the octagon. One corner is completely enclosed to house a bathroom and storage, and serves as background to a comforting woodstove. The opposite corner contains the kitchen. Both have bays added to the square plan, hence the roof descends slightly closer to the ground on those corners. A third corner of the square, bounded by big windows that catch eastern sun filtering through the trees, makes a place for a dining table. Originally it was famously graced by a chandelier made of wine bottles. The fourth corner is blown away altogether—to reveal a sensational view up the Sonoma coast. The effect created is an almost perfect embodiment of what Charles Moore described years later, in *Chambers for a Memory Palace*, as an example of an architectural fairy tale, "where the uncertain edge brushes up against the sheltered middle, as if a fresh breeze were blowing from a far off and mysterious place."[1]

The house has been written about often. Perhaps the most evocative descriptions were those of David Littlejohn:

"This extraordinary space lifts one like a cathedral, reveals more of its magic the more time one spends in it. The alternatively wider and narrower spacing of the side-altar niches, the careful positioning of glazed openings, read like a subtle musical score. The eye is constantly drawn up as well as out by the mystical circle of poles, the yellow band, the high windows, the converging planked planes of the ceilings, the central star."[2]

He referred to the space as a "little heaven-sized room."

This, we must remember, was a house unencumbered by size: "585 square feet," its architects were fond of declaiming. The magic it suggested was amplified by the wonder of its smallness, taking its place among "miniatures that magnify" in Charles Moore's lexicon of architectural phenomena.[3] It was a livable package because all its living spaces overlap and its owners furnished it sparsely, with cushions and bentwood.

The Johnson House shows how a house can settle quietly in its site and yet create wonders there. It shows that a house can be small and vernacular, and yet seem capacious and allusive. It shows that a plan can be both severely disciplined and richly accommodating. It shows that architecture is at best a thing of wit, executed with nimble precision.

The 1973 addition by Turnbull plays an opposite game in plan with equal ingenuity, spinning

spaces up and around a central closed figure. Like the earlier house, it involves a play of geometries, with one clear space surrounded by another, and various activities lodged in the spaces between. Here, the center and the periphery are both square, but their orientation is rotated and their centers do not coincide. The inner figure is a ten-foot-square tower, extending from the ground up through the roof, capped by a pyramidal skylight. Its base originally held bunks and a darkroom, the midlevel contains a bathroom, and the top makes a square chamber for sleeping under the stars. The space between this inner square and the outer rotated perimeter becomes a continuous winding stairway extending into platforms at each corner.

One of these corners serves as an alternative entry, linked to the original house by a corridor, which is glassed on one side to reveal the trunks of young redwoods outside, breathlessly close and "in your face." From this corner, the passage spills down toward the ocean side and climbs up toward the hills. The stairs lead down to a platform at grade, which afforded room for play and for the children's bunks, and extended outdoors onto a small wooden deck. The upward stairs wind into a raised corner landing that provides access to the internal bathroom and is edged by a great shelf of a desk, which ponders the trees of the forest. The steps continue up and around to another landing, then climb directly to the top.

The first house began with the conjunction of formal images—a sacred octagonal center inside

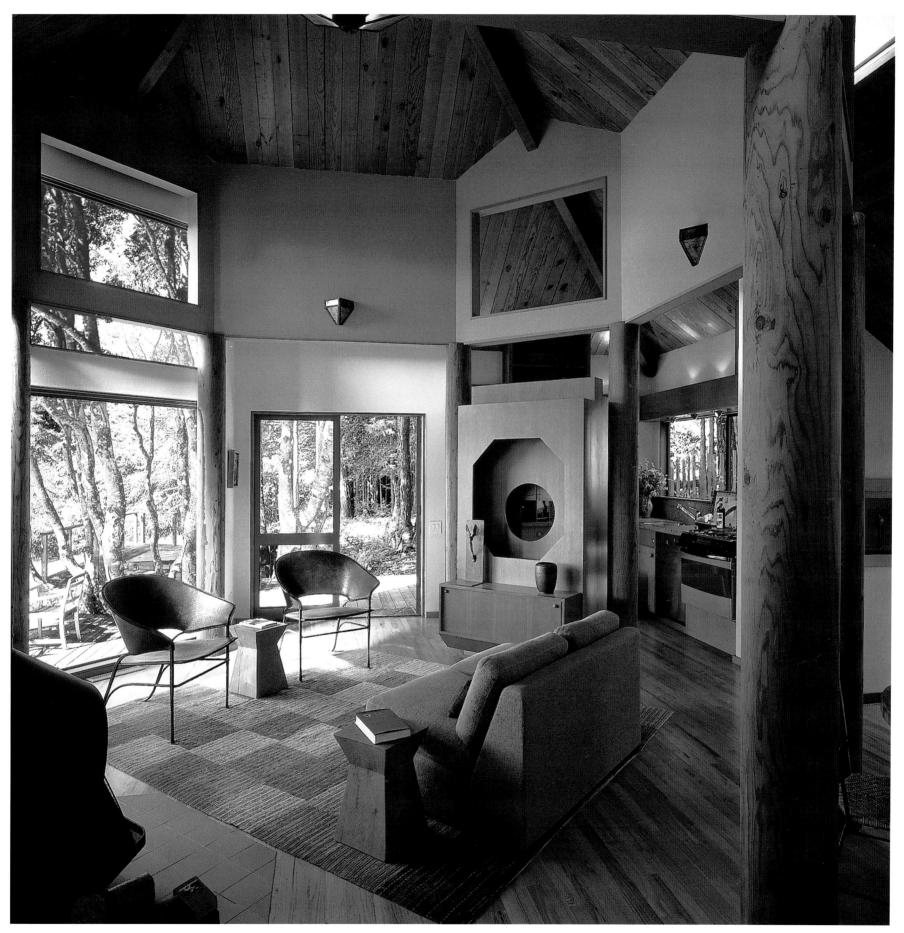

a profane square hut. While subtly adjusted to circumstance, both the inside and the outside retain postcard clarity in recollection. The addition, on the other hand, has an indistinct and evocative form that, like Condominium One before it, evolved from its place in the site and the logic of its plan. Lodged among the towering trees, the second building plays a quiet and improvisatory second fiddle to the more iconic and ancestral first.

The current owner, Lorna Meyer, has made a few changes, mostly to alterations made previously by an intermediate owner. A deck extending out to the north of the first house is divided into two sections, which are both accessed off a new pair of doors on the side opposite the corridor that links to the second building. One section of the deck steps down to create a platform three steps below the floor level, then reaches on down to the meadow. A second deck steps off the upper landing directly to the north and dodges around the tanbark oaks (which have grown into dramatically interlocking trunks, pruned and sculptural) to form a broad platform deck with a hot tub sunk more or less in the middle. The deck sits in part on the adjoining lot, which Meyer has purchased. Inside, the changes, except for the one pair of French doors, are in colors and materials. Surfaces have been repainted and restored, including the Douglas fir kitchen cabinets and the countertop, which has been replaced with earthy granite.

The addition has been changed more substantially, including, among other alterations, the rebuilding of the stairs to make them slightly less

steep and the addition of a small run of walled steps to gain access to the sleeping nook. The most significant change has taken place on the lower level, which has been transformed from a children's room with bunks and play area, and darkroom, into the master bedroom, with its own bathroom replacing the darkroom. The space is high, reaching up to the bottom of the deck above, with the twisted underneath of the stairs surfaced in gypsum, painted white, and a freestanding white column/wall layer where the edge of the bunks once was.

The house, its additions, and their subsequent transformations neatly trace three stages in the life of The Sea Ranch. The first house is a very small room for a young and adventurous couple, outfitted with minimal equipment for cooking and bathing but invested with great spirit and an ingenious array of central and subsidiary spaces, bathed in enlivening light. The addition was made to accommodate an expanded young family, and was guided by an inversion of the geometry of the first. It was a project that reveled in the disciplines of geometry, minimal dimensions, and the joy of moving up through space with a shifting outlook into the forest and beyond, culminating in a tight loft at the top. It used simple surfaces and materials, and was meant to expand the available space of the house without detracting from the wonder and resonance of the tiny first place. Its faceted, abstracted form has none of the iconic qualities of the first piece, but rises in the woods with fascinating plays of light

and window reflection, weathering redwood boards, and a roof high enough to be barely visible from the ground. The current interior renovations reflect a more established and affluent taste, and a willingness and ability to invest in comforting and reassuring surfaces.

Like Condominium One, the original house had only limited access to the outdoors, which here meant the immediate surroundings of the forest. There were no cultivated, tended leisure spaces adjoining the house, offering places for outdoor eating, sunning, or bathing. The earlier house anticipated hikers on excursions into the forest, camping out inside, as it were, with congenial improvised gatherings around the woodstove. The house provided a loose and mind-expanding cocoon of space, with a stunning view up the coast brought suddenly close, and the forest (if not the wolf) right outside the door. The house now offers pleasures for staying close to home, with a variety of tended, protected, and refined spaces, inside and out, embraced by the secure comforts of rich materials, soft furnishings, and objects of art.

Significantly, the octagon remains the spiritual center of the place, transformed now from an element that gathers and embraces, into the center point of a cross axis that organizes movements through the house and outdoors. The strength of the original geometric conception has guided subsequent change, and has been preserved by owners and designers wise enough to honor its strength, and skillful enough to work their own purposes in and around it.

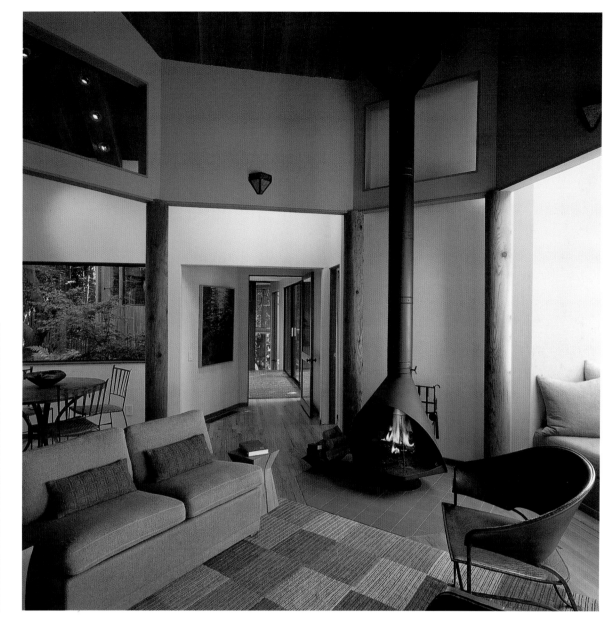

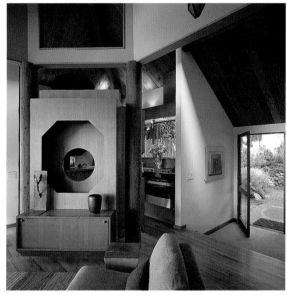

1 Lyndon and Moore, *Chambers for a Memory Palace*, 291.
2 David Littlejohn, *Architect: The Life and Work of Charles W. Moore* (New York: Holt, Rinehart and Winston, 1984), 204.
3 Lyndon and Moore, *Chambers for a Memory Palace*, 289–293.

195

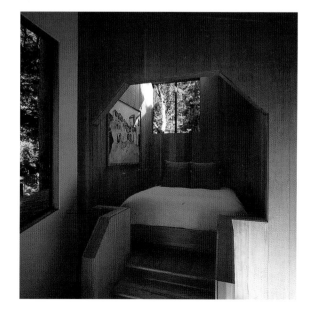

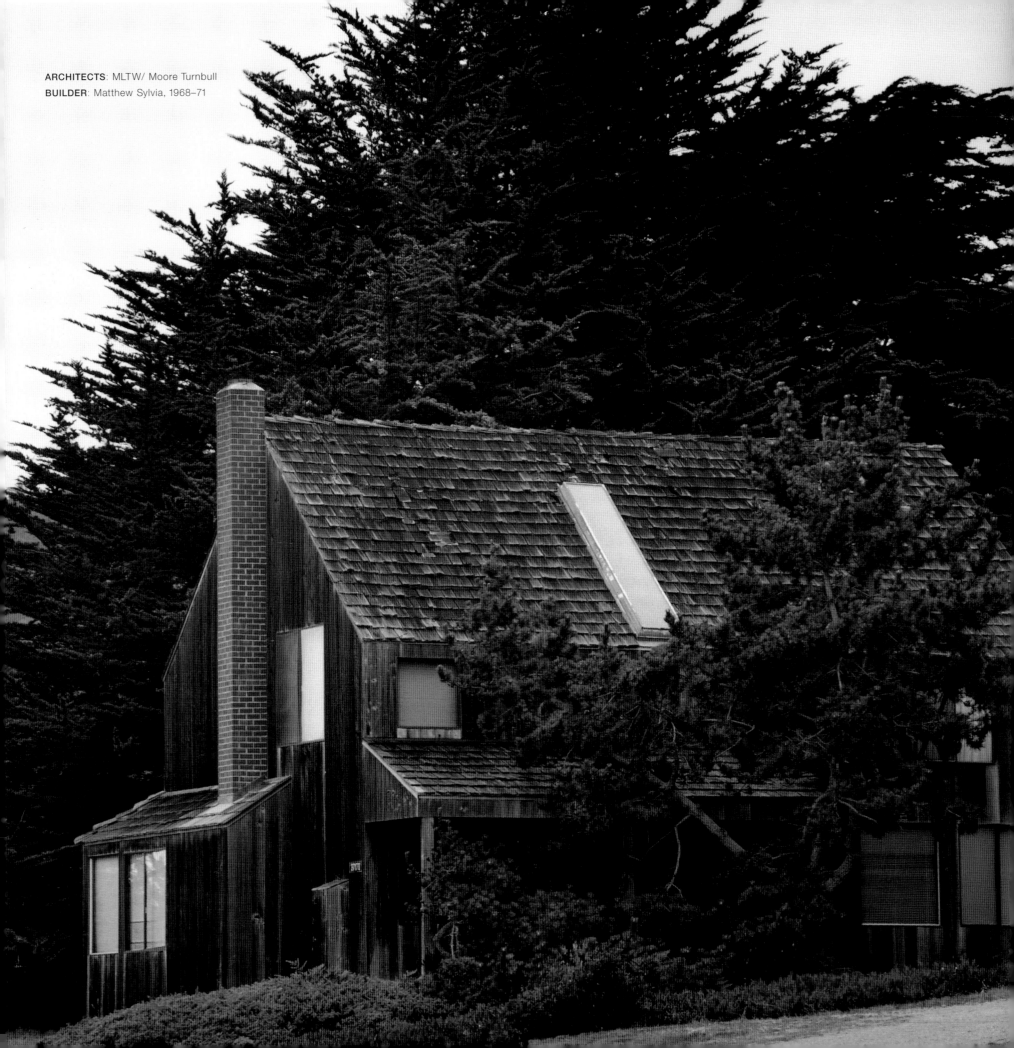

ARCHITECTS: MLTW/ Moore Turnbull
BUILDER: Matthew Sylvia, 1968–71

BINKER BARNS

The so-called Binker Barns,[1] designed by William Turnbull while still in partnership with Charles Moore, were Turnbull's first step at The Sea Ranch in working completely within forms that are related to the traditional vernacular of farm structures. They were also, along with the Walk-in Cabins by Bowman, an effort to develop a simple building type that could be repeated. Unlike the Walk-ins, which were all built as a kind of camp on one site, the Binker Barns were meant to provide owners with a stock plan that could be used for various sites and among quite differing situations at The Sea Ranch—in the open meadow, in the forest, or adjacent to stands of trees. The elements of the barn form are so deftly placed that they invariably seem to settle in their location.

The secret of the Binker Barns' success in siting lies in their form, which is made with a simple dominant volume supplemented by bays and porches that slope out to connect to the land and make adjustments to the spaces inside. The inherent hierarchical structure of a large gabled volume with attendant sheds makes the whole easily imaginable while still being complex. The smaller pieces not only relate directly to the size of people inhabiting the house, but also help the buildings connect to the ground, sloping out toward the surroundings. These are truly three-dimensional structures, claiming their sites with modesty but certainty.

They are "houses that settle" in both senses of the term. Their forms settle into their sites, like animals resting on the ground or birds in their nests, and they are houses that look like buildings that early settlers might have built. They are not, however, a simple barn image grafted onto a conventional house. Like Condominium One, they are actually built like barns, with heavy timber framing, and walls made of planks covered with redwood siding. Their structure is exposed inside, and the shell is articulated, as in the condominium, by framing members that hold everything in place and modulate the inner surfaces. The outsides are simple skins wrapped against the weather, except at the porches, which provide places of shelter near the entries.

Inside, the central volume is open to the roof, with stairs winding up the middle, and bedrooms and a bath captured at either end. High spaces on either side of a bridge across the middle contrast with low sections by the fireplace and kitchen, and lend a spacious dimension to the insides. Shafts of light from strategically placed skylights move through the house during the course of the day. Outlook from openings in the upper rooms reaches back across the spaces to give the whole a playfulness of outlook and connection that further animates the space. The Binker Barns share with the condominium a sense that the experience of the great expanse of the meadows, forest, and ocean outside should be matched by visual and spatial adventure inside the volume as well. A windowed projecting bay wraps one corner of the lower-floor plan, creating intimate spaces that open that segment of the house to the outdoors beyond.

The basic plan was already approved by the design committee, which speeded the process for individual owners, but the committee retained oversight of the siting. The scheme was so successful that seventeen of the houses were built on sites throughout The Sea Ranch, until finally, it seems, a subsequent design committee membership became concerned that the growing number of houses might produce a dominantly repetitive environment. Their approval was withdrawn and no more have been built, alas, since 1971.

The Binker Barns remain among the most handsome structures at The Sea Ranch. Given the repetitive nature of the design, it is instructive to see its adaptation to differing sites and by

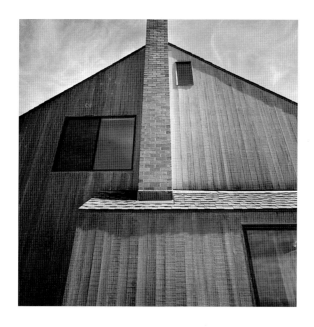

owners with varying dispositions. In the words of Janann Strand's "Self-Guided Architecture Design Tour,"
"The planes of roofs and walls make crisp shadows in the sun and are reassuring in fog and storm....Viewed from the bluffs, road or across the meadows, these barns belong to the land."[2]

1 Snap Binker, a real estate agent at The Sea Ranch, conceived the idea of this repetitive house type, and he and Matthew Sylvia built the first demonstration examples. Subsequent units were built on order for individual clients.
2 Janann Strand, "Self-Guided Architecture Design Tour," in *Surroundings* (The Sea Ranch Association, 1984).

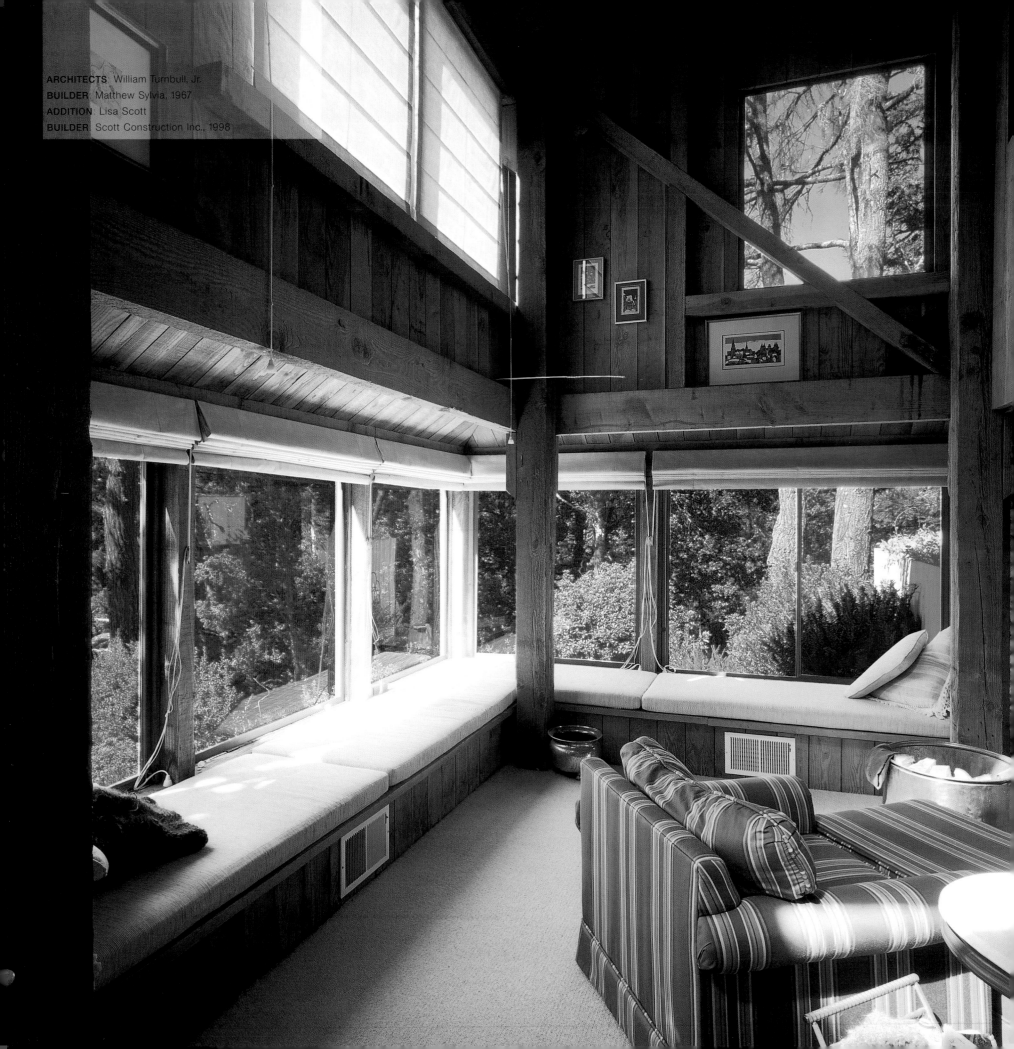

ARCHITECTS William Turnbull, Jr.
BUILDER Matthew Sylvia, 1967
ADDITION Lisa Scott
BUILDER Scott Construction Inc., 1998

PARK BARN
HOUSE

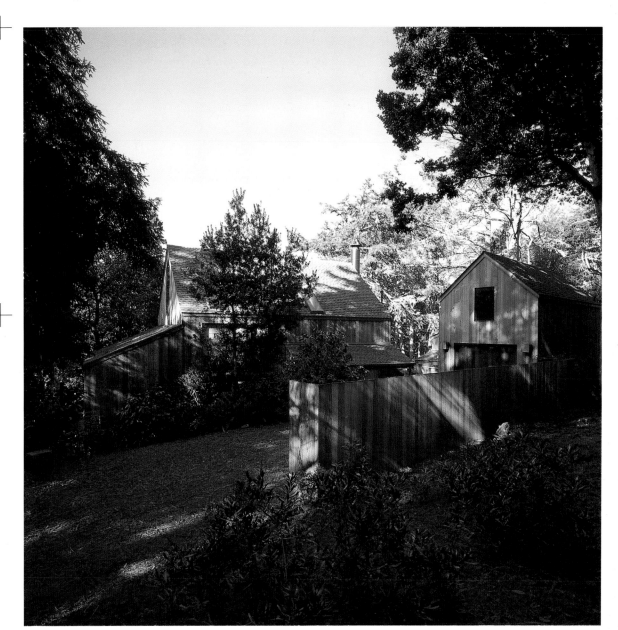

The Binker Barn owned by Kim and Brian Park on Chinquapin Lane in the midst of the forest sits parallel to a sharp down-slope along a projecting finger of land. Its view bay hovers over a lower terrace, looking out into the deep draw that has formed one side of the land. Its porch is set into a slight cut in the slope. The house is surrounded now by rhododendrons, ferns, and myrtles that thrive in the sun provided by a few selective clearings. The approach to the house has been modified by the addition of a smaller car barn and broad concrete steps that reach down from the drive to the house.

Inside the house, the windows at various levels provide for shifting bits of light and unexpected views up into the trees and down onto a lower terrace of planting, fenced from the deer. Off the kitchen to the ocean side, a wooden deck is propped above the falling land. Inside, the kitchen has been neatly expanded by twisting one side of the U-shaped counter out to provide more space and to form the edge of a breakfast counter. This comfortable eating spot protrudes into the morning light afforded by the tall space and its window.

The carbarn addition is admirably sited and formed. The modestly sized one-car garage, with its gable end facing the road, tips slightly away from the house to create a space between that deflects toward the entrance. At its rear, additional enclosed storage and work space is sheltered under a roof that hips off the back and reaches toward the house, bracketing one side of the entry court. It is a deft, simple piece of work that respects both the specific form and the spirit of the building to which it is added.

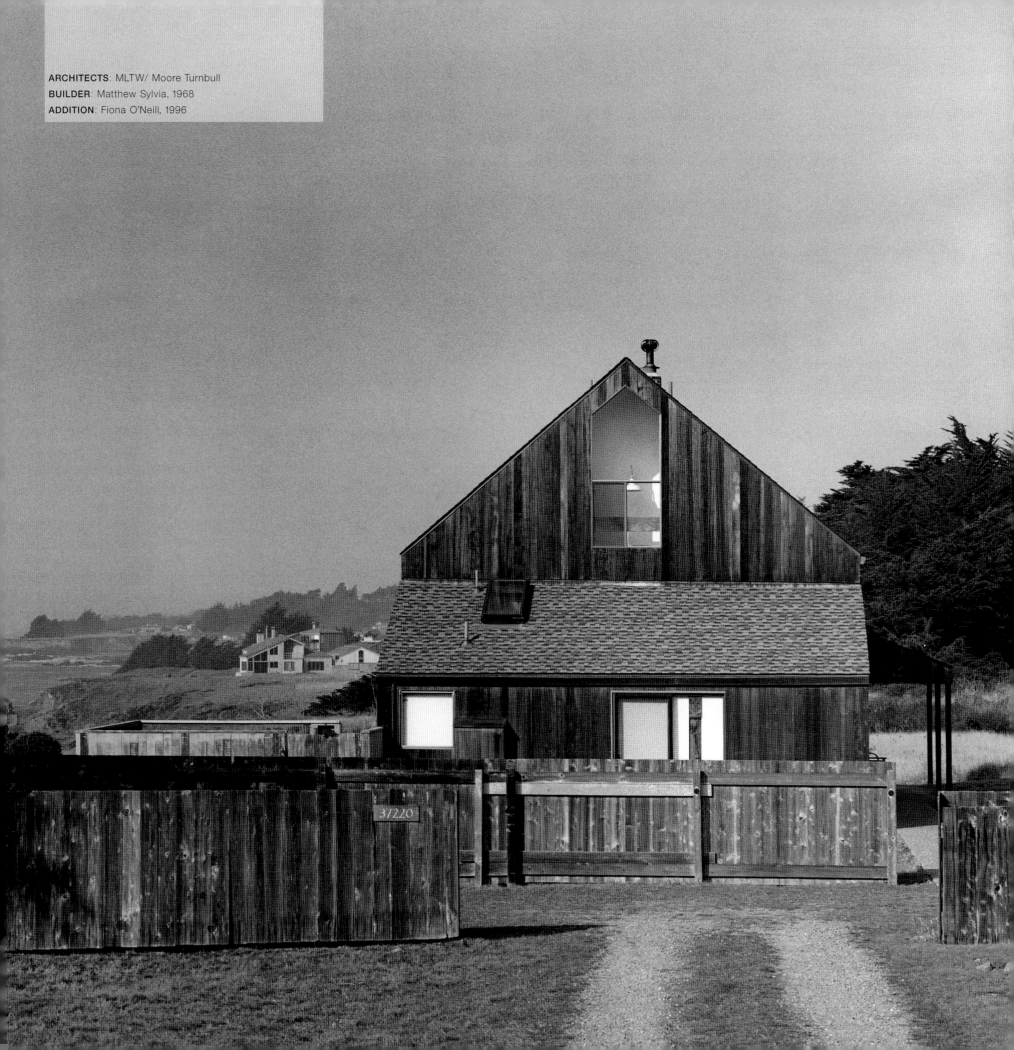

ARCHITECTS: MLTW/ Moore Turnbull
BUILDER: Matthew Sylvia, 1968
ADDITION: Fiona O'Neill, 1996

BARNACLE BARN HOUSE

(now the Crane-Murray and Benz House)

This Binker Barn, now also known as the "Barnacle," settles confidently and comfortably beside a sweep of meadow that reaches from a slight knoll on the east down toward the ocean, edged by a farther hedgerow to the north. Sited well back from the edges of its property, the barn's iconic form stands serenely on the edge of the grasses, beside a bicycle and pedestrian trail that stretches across the meadow. The house's form is modulated to the site by compact board-fence enclosures, which sequester cars and a hot tub, and by a welcoming porch that parallels the trail. A low wooden deck extends into the sun on the ocean side, and the full-windowed bay wraps around the northwest corner, placing its inhabitants on the edge of a great expanse of meadow and the ocean beyond. The effect has been diminished somewhat by the construction of a neighboring house that thrusts aggressively far into their outlook, lusting for ever more ocean view and leaving pointless grasslands back by the road.

The Barnacle Barn interior has recently been sandblasted, restoring the glowing luster of Douglas fir to its spaces. The bedroom and bath on the ground floor vary in layout from the original plan, and the kitchen has been modified by a long counter across the end wall of the main space. Otherwise, the barn serves happily in its original form.

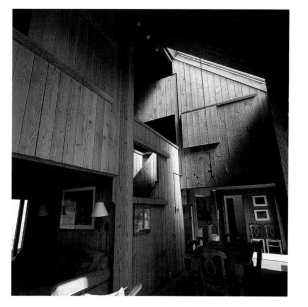
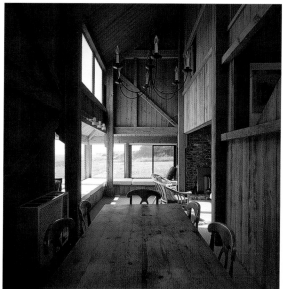

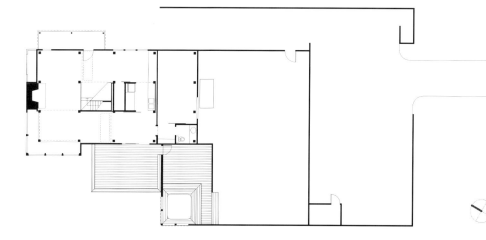

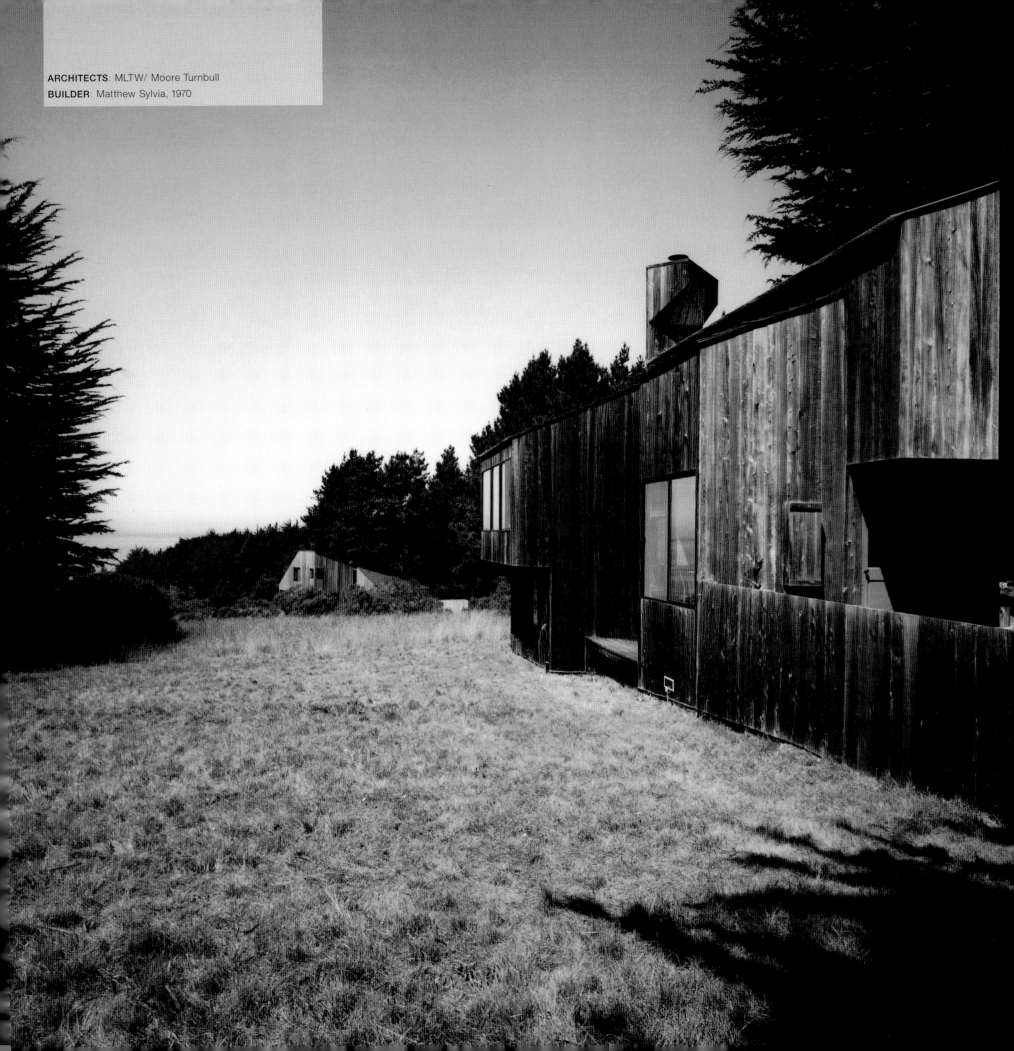

ARCHITECTS: MLTW/ Moore Turnbull
BUILDER: Matthew Sylvia, 1970

RUSH HOUSE

(now the Keller House)

The house designed for the Rush family in 1970 settles on the land by staking a vigorous but delicate claim, announced by a very distinct chimney. The chimney, around which the rest of the house form is organized, is a wood-encased flue that rises and twists into the sky, its form expanded and sculpted at the top like the knob of a walking stick. (Turnbull compared it to the land-marking chimneys of Stratford Hall in Virginia.)

The roof hangs from this chimney in three directions, forming a large canopied bay for the upper level, which reaches out toward a view across the meadow to the ocean. The fourth side is joined by a long, raised skylight that forms a cockscomb for the rest of the house, projecting out at the eastern end to make a box cover at the entry. The house stands proud and distinct from the land; entry is from within a board-fenced court and deck that confine its impact on the grasses. The meadow flows across the site, down the hill, and out to the sea. The house itself is small, barely twenty-six feet at its widest, so its claim on the landscape is more distinct than expansive.

The site is an unusual one at The Sea Ranch, a slight knoll surrounded by a loop road. The challenge here was to create a habitable place out of what was first merely a field ringed by road. A hedgerow was planted to the north near the path of a stream to give wind protection and an edge to the space. Coupled with a stand of trees to the south, it delimits a place in the larger landscape that is perfectly scaled to the vigorous delicacy of this stand-up cabin.

Arriving through the fenced court, which is backed by a cypress row shielding cars from the road, you step up onto a deck running the width of the house, focused by the projecting box bay overhead. A half-glass door opens immediately into high, light-flooded space, capped by a translucent corrugated fiberglass roof. The walls overhead are spaced four feet apart (the width of a comfortable passage); they are made of plywood, perforated on either side in a pattern of light, shadow, and color that is like a three-dimensional mosaic. Straight ahead are stairs rising to a landing a few feet above; from here a ladder climbs on up into an aedicular loft, the size of a small tree house, which announces the building's dedication to playful bunking.

Meanwhile, you have barely noticed that you are standing in the work space of the kitchen, between the counters to the hedge side and a windowed bay, which spreads out toward the ocean view just enough to house a comfortable dining table and absorb sun throughout the day. Proceeding up the stairs and to the left, the space spreads grandly to the horizon under a canopy of roof planks and a single diagonal beam that reaches down from the chimney wall. The living room has a giant bay window, projecting out in three directions, with a bench, wide enough for sleeping on, around most of its perimeter. The built-in metal fireplace, which spawns the central chimney, is absorbed in an angled wall that inflects toward the view and is

203

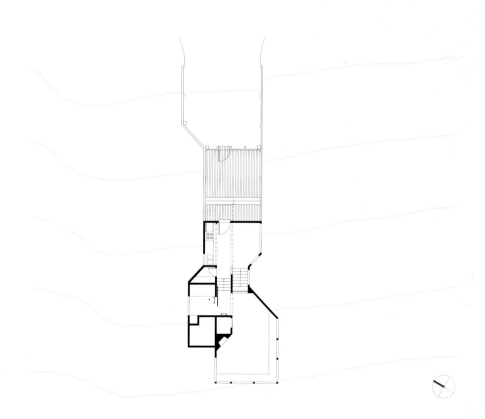

surmounted by an upwardly expanding array of shelves and chambers, filled with books, shells, and mementos.

Beneath the living room is the master bedroom, opening through a sliding door to the grasses at the lower end of the site. It shares, with a smaller bedroom, the use of a nearly two-story-high bathroom. Back at the top of the stairs, on the right, there once was a small opening through which a fireman's pole and a ladder could be seen, rising from the room below. These provided access to and from a stack of bunks four beds high, which housed the adventurous Rush children. That space has since been divided into two small stacked bedrooms, more conventionally accessed by stairs. Nevertheless, Annie Keller notes:

"The house inside seems built for climbing. I wonder if Turnbull (and Moore) considered how often kids would constantly be seen climbing the walls—literally. It's a vision of the house and my kids, that I go to often when I think about the space—the sunlight beaming in and spotlighting George and Grace six feet up in the air!"[1]

The house, both inside and out, is playful and distinct. Conscious of the encircling road that is its immediate setting, its architects set a diminutive landmark "lightly on the land"—anchoring imagination to place.

1 From an e-mail to Donlyn Lyndon by Annie Keller, October 21, 2002.

204

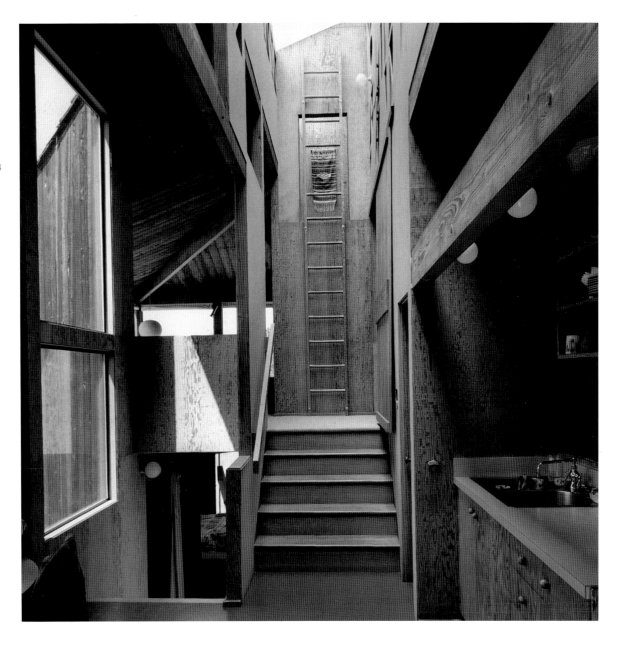

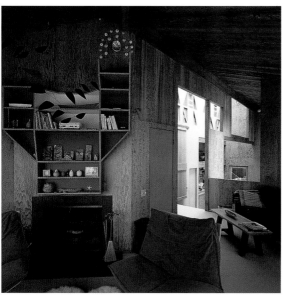

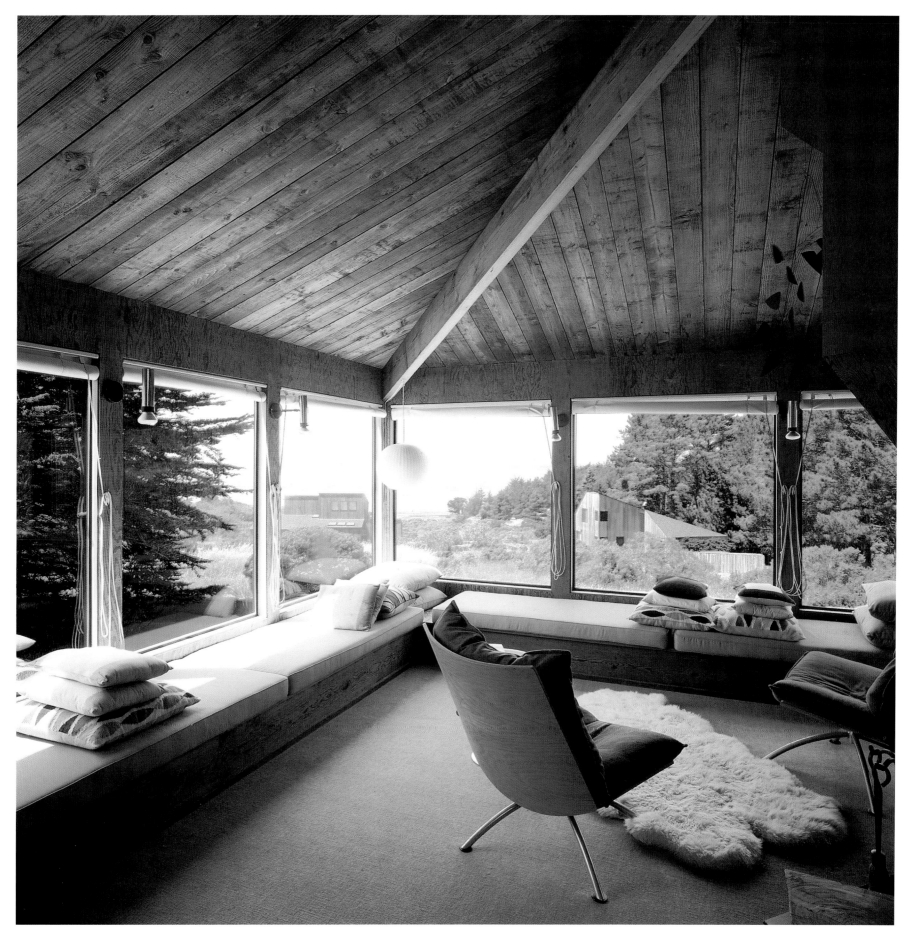

ARCHITECT: Donald Jacobs
BUILDER: Helmut Emke, 1985

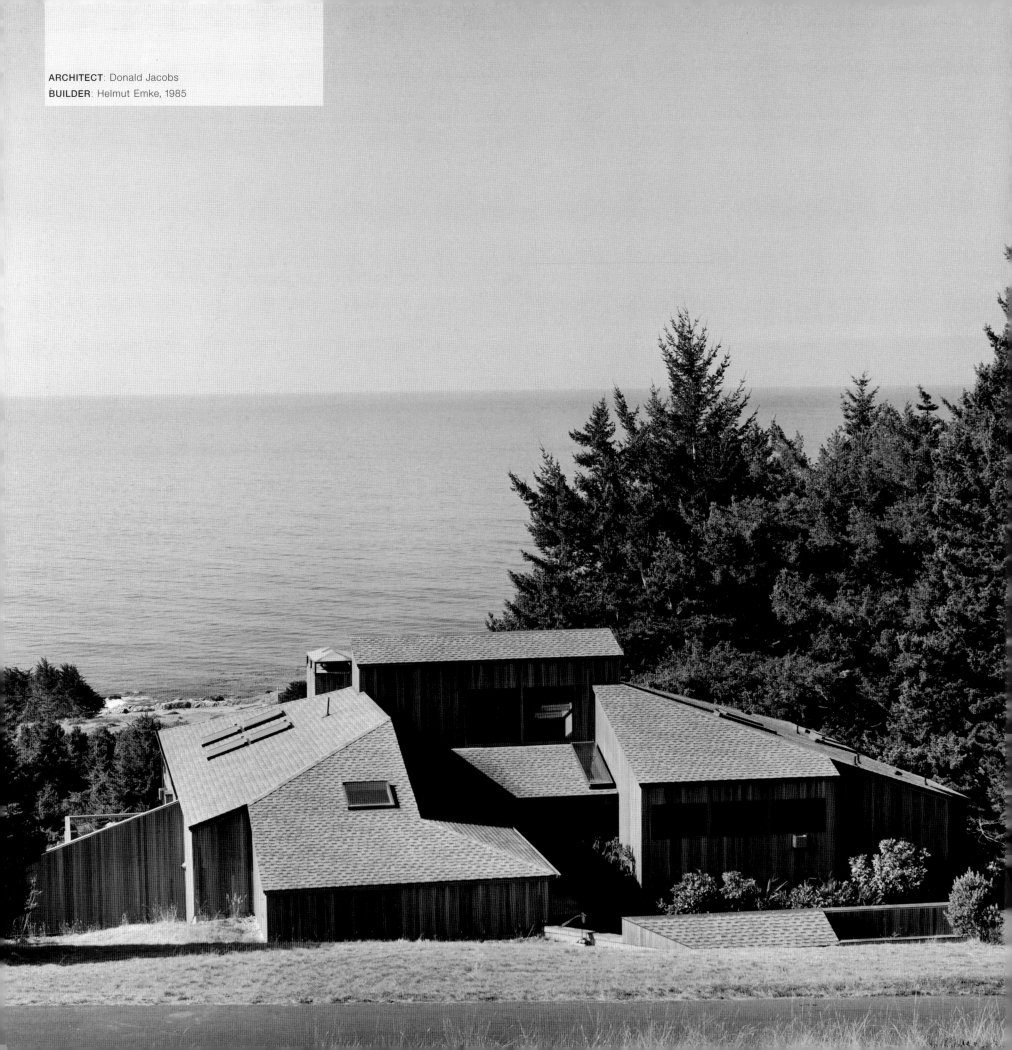

WILDE HOUSE

(now the Mattson House)

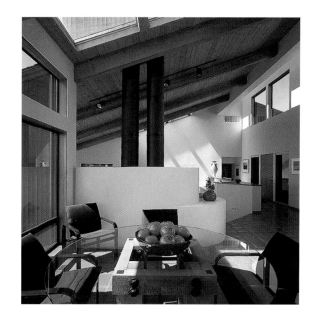

Perched high on the side of a slope overlooking the meadows below, and at the edge of a forested section, the Wilde House aligns to the road in a conventional fashion, yet its form settles down into and along the slope, gathering a number of large spaces into a compact arrangement sheltered by an encompassing roof. The roof tapers down in all directions from a central ridge, with the south slope extending east toward the road to enclose a garage in an arm that fronts the car/entry court. At the center of the building, a high monitor towers up for more light and to mark the location of entry, which is through a recessed entry porch fronting this section.

Inside, an open passage runs the length of the house, again parallel to the slope. The living room is set down a few steps below, looking on down to the ocean through large, syncopated windows. The passage, edged by deep, low cabinets, connects the dining/kitchen area at the south end to the bedrooms and study at the north. The plan, while spacious, is very efficiently arranged. A vigorously formed mass of a fireplace element punctuates the living room. Beyond it a spacious, well-equipped, and amply skylit kitchen flows freely together with an eating area that has sweeping views of the coastal shelf and coastline. This area opens through large windows and a sliding door to a sunny wooden deck and a graveled dog-terrace on the wind-sheltered south. Just a few feet down, a lap pool is tucked tightly and discreetly up against the lower edge of the house. At the

north end, the bedrooms and a study brush up against the forest.

The low-pitched roof surfaces and white-painted gypsum walls smoothly encompass the principal living spaces, augmented by a group of clerestory windows over the entry that bring in balancing eastern light. The whole has a relaxed expansiveness that is sympathetic to the Mattsons, who are frequent and generous hosts and have been very active in the community, Pete serving repeatedly on the board of The Sea Ranch Association and as a trustee of the Sonoma Land Trust.

The exterior is clad in cedar siding, which is oiled regularly for protection and is therefore a more intense golden brown than the weathered norm. Its forms wrap together to make a single, inflected form that sits reasonably well on a cut in the hill—a handsome and efficient, self-contained house settled in its site.

207

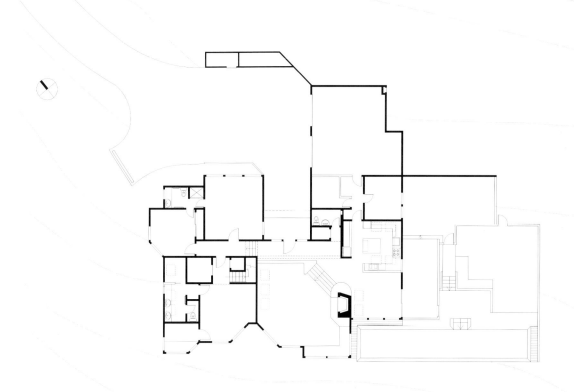

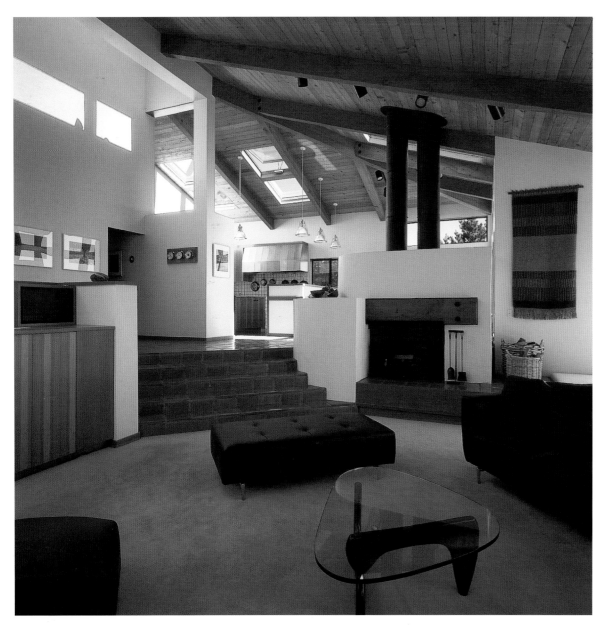

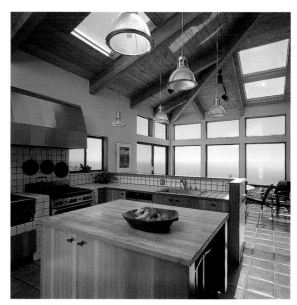

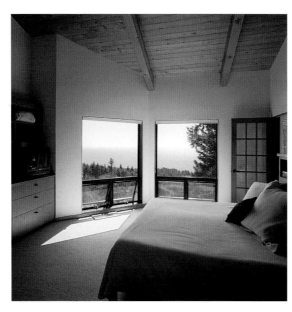

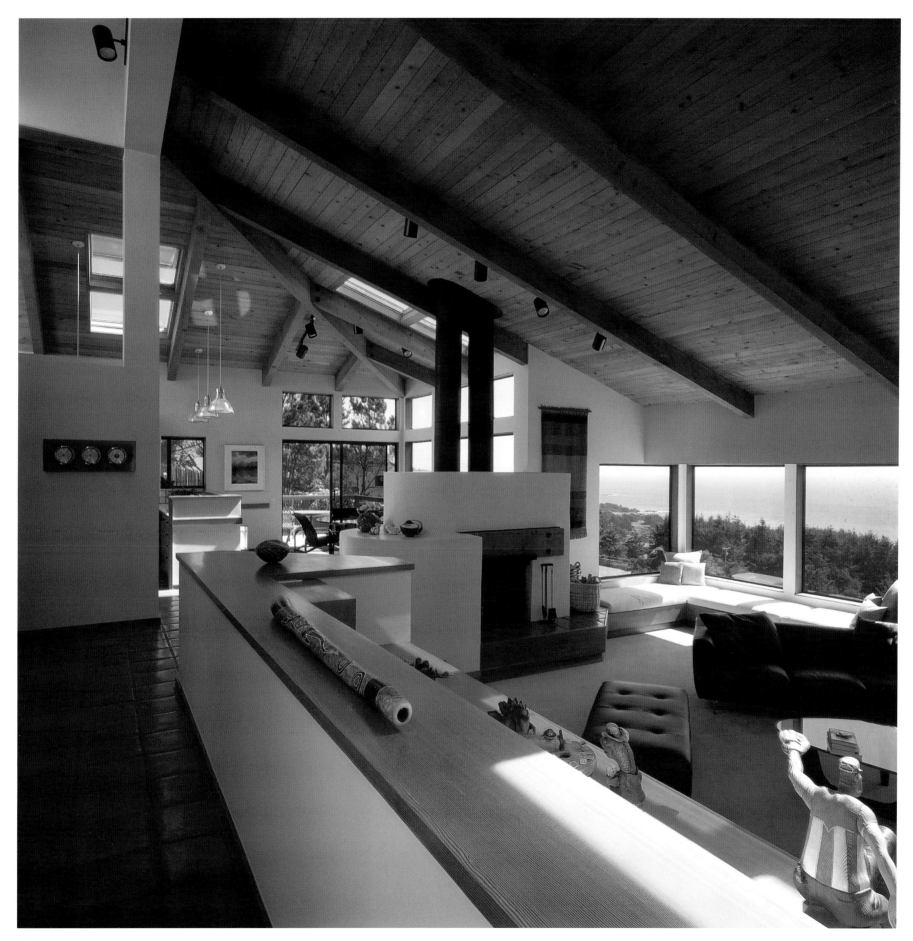

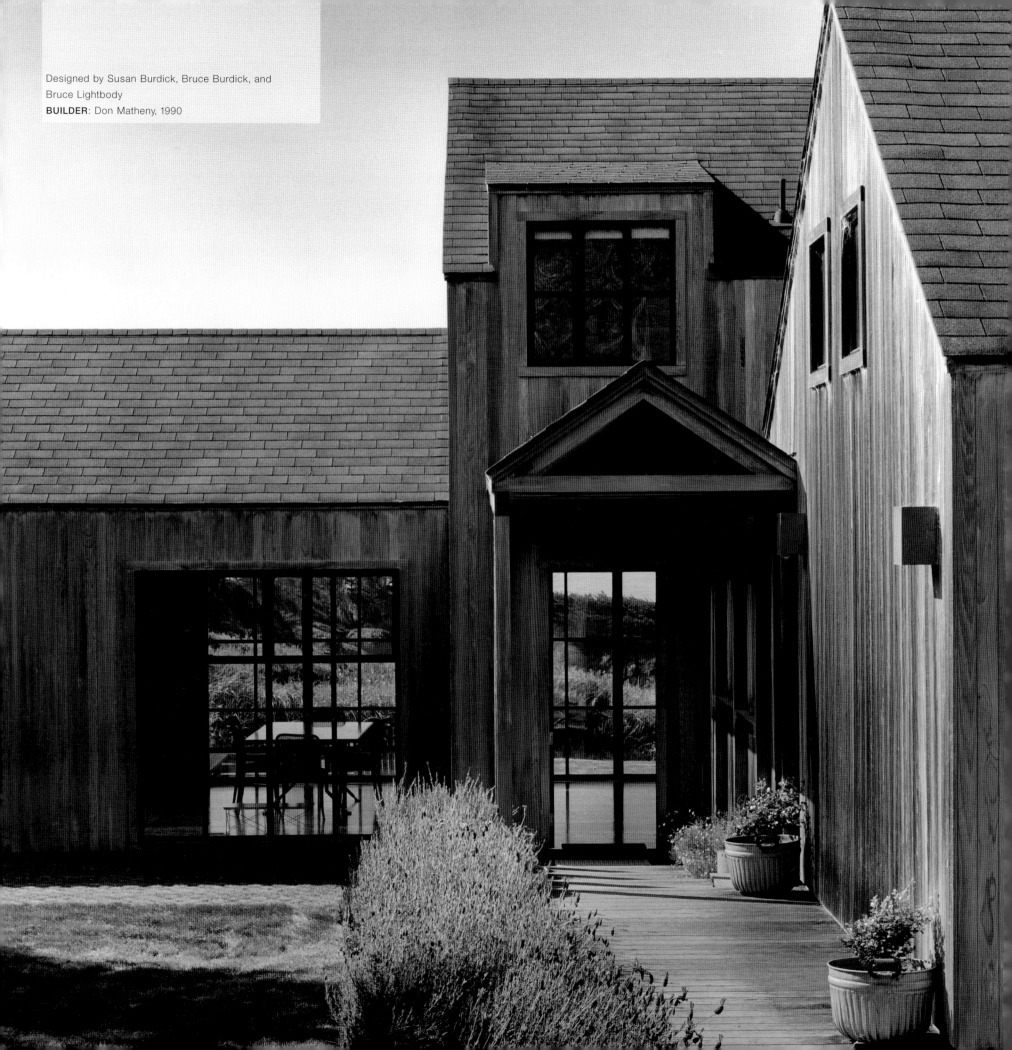

Designed by Susan Burdick, Bruce Burdick, and
Bruce Lightbody
BUILDER: Don Matheny, 1990

BURDICK HOUSE

An additional room beyond the kitchen wall is separable by a sliding door; it shares the lowered ceiling of the kitchen, which allows the bedroom spaces to be lodged above. Farther still, at the opposite end of the house, the full space of the gable opens up again, this time for a library, whose tall walls are lined with elegantly arranged shelving, books, and objects. It too fronts the deck. On the opposite side of the house, a band of enclosed space holds a private workplace with built in-desk and storage, a guest toilet, and an alternative entry, which opens to a hidden garden behind, edged by the garage and thick foliage. This tight, trim formal herb garden is sheltered from the wind and from all but private views from the house. It contrasts evocatively with the expansiveness and general open character of the deck on the southern, view-embracing side of the house, which provides outlook over the slope of the land, the sweep of vegetation in the draw, and the rugged point and cove beyond at the edge of the sea.

The Burdick House draws advantage from its position without commanding it, and comfortably takes its place in the landscape. Almost iconic in its formal simplicity, it is compactly and efficiently planned, adroitly sited, and filled with the elegance of orderly, intelligent craft, which its owners and creators, industrial designers, habitually bring to their work and lives.

The Burdick House easily settles into its site along a draw leading down to Smuggler's Cove. Its gable forms essentially parallel the slope of the land, folding into the edge of a thick stand of vegetation. The center section of the house is two stories high, with a dormer in the roof for a centered grouping of windows facing the coast. The end sections are one-story spaces, their gabled roofs at a lower height. This modified vernacular house form, clad in weathered redwood vertical-board siding, is modest, yet its openings are arranged in a symmetrical pattern that quietly echoes Palladian formality. It is fronted by a broad wooden deck on the south side, and backed by a smaller, gable-roofed garage and an entry passage leading in from the drive.

The entry passage, itself covered with a small, beckoning gable, leads alongside the garage to the middle of the house. The door opens into a tiny vestibule, with a view across to a bank of doors and gridded windows facing the deck. A neatly formed island counter for the kitchen lies directly ahead, while stairs lead abruptly up to the right. On the left the space opens into a crisply formal dining/living area, under the full height of the shapely gable, whose wood rafters and ceiling are left exposed to animate the space. Beyond the dining table a formally balanced grouping of built-in sofas and cabinets centers on a large, upright window, with a Danish cylindrical woodstove standing like an icon on the axis.

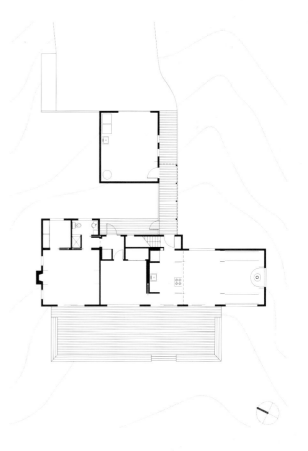

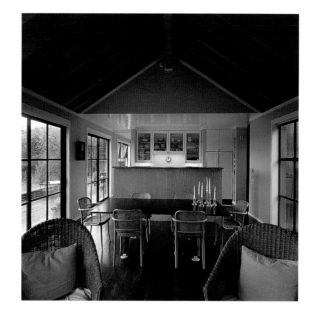

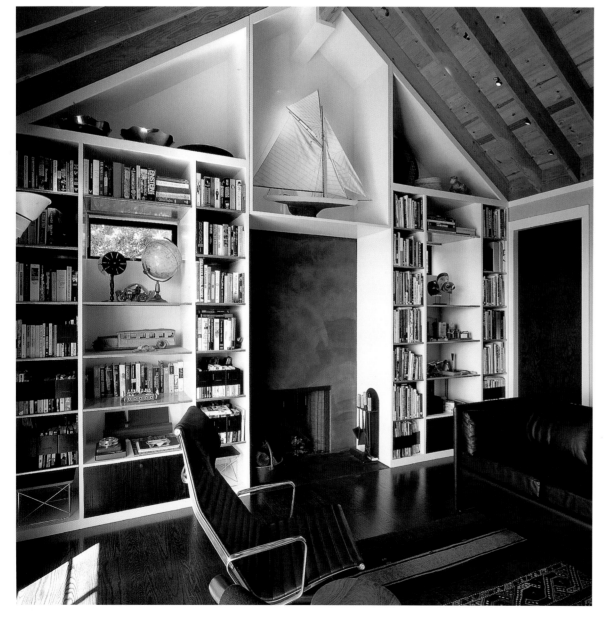

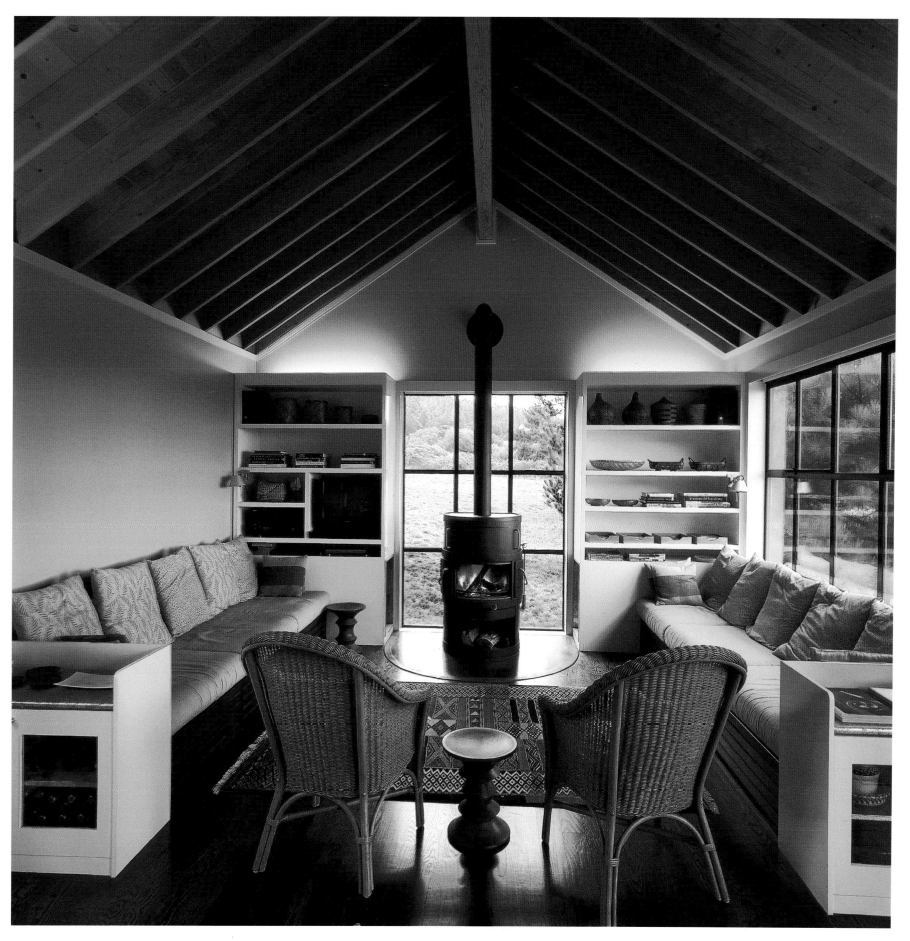

ARCHITECT: Daniel Levin
BUILDER: Helmut Fmke, 1990

RASMUSSEN HOUSE

The Rasmussen House on Galleon's Reach is a large shingle house, which uses an interlocking set of traditional gable house forms to claim its site on the edge of a meadow, facing west to the ocean. The site is defined by a stand of trees across the road from Galleon's Reach hedgerow. They follow a swale that runs down through the meadow. The house's orientation, set by the view across the open commons that follows the swale toward the sea, is thus determined more by the land and the trees than by the road behind it.

The form of the Rasmussen House is large, broken into pieces, with a separate garage building and studio closer to the drive. The two wings of the main house bracket a terrace, with the longer, lower but wider one housing the living room and eating area; the narrower two-story bedroom and study wing points directly to the view, and is a width that is easy to imagine housing a single comfortable room. Interior surfaces throughout are smooth, with painted walls, cabinetry, and trim. Windows are arranged in orderly, predictable groupings; the massing, though large, is carefully arranged.

The whole carries a sense of careful tending, with a sequestered garden at the rear and a comfortable position in the landscape. Daniel Levin, its architect, has lived and practiced at The Sea Ranch for many years and is also chief of the volunteer fire department.

215

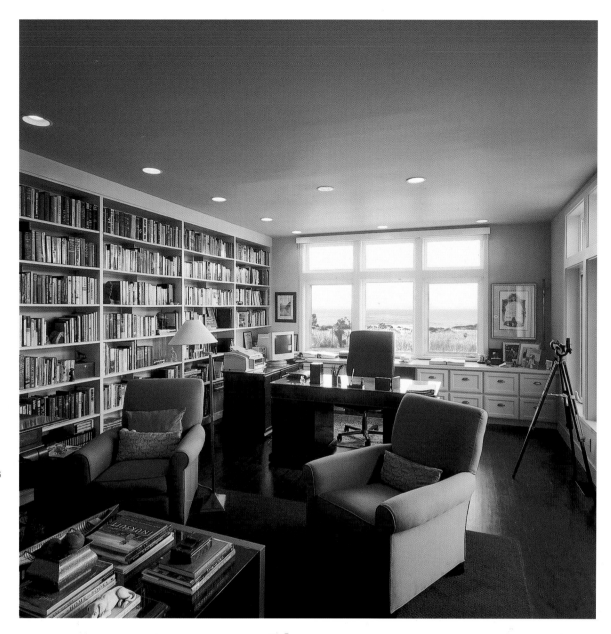

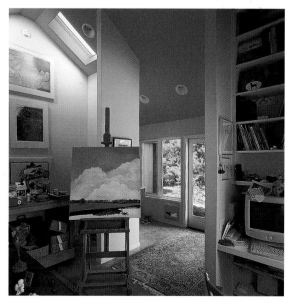

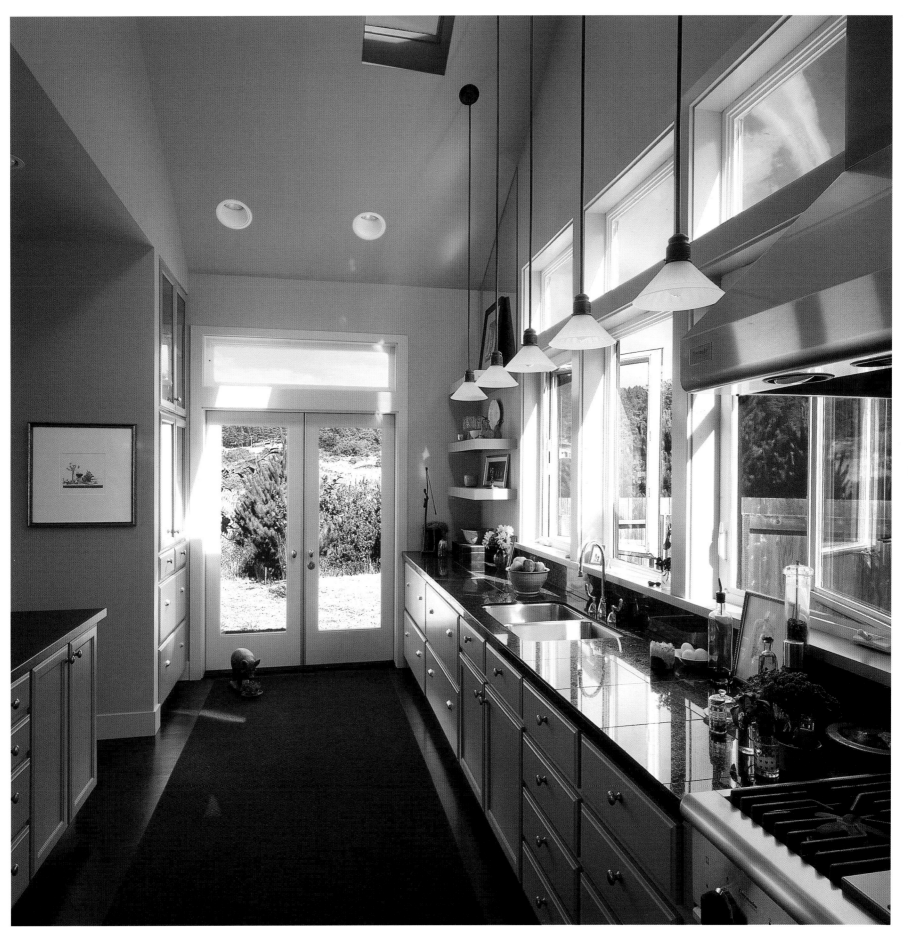

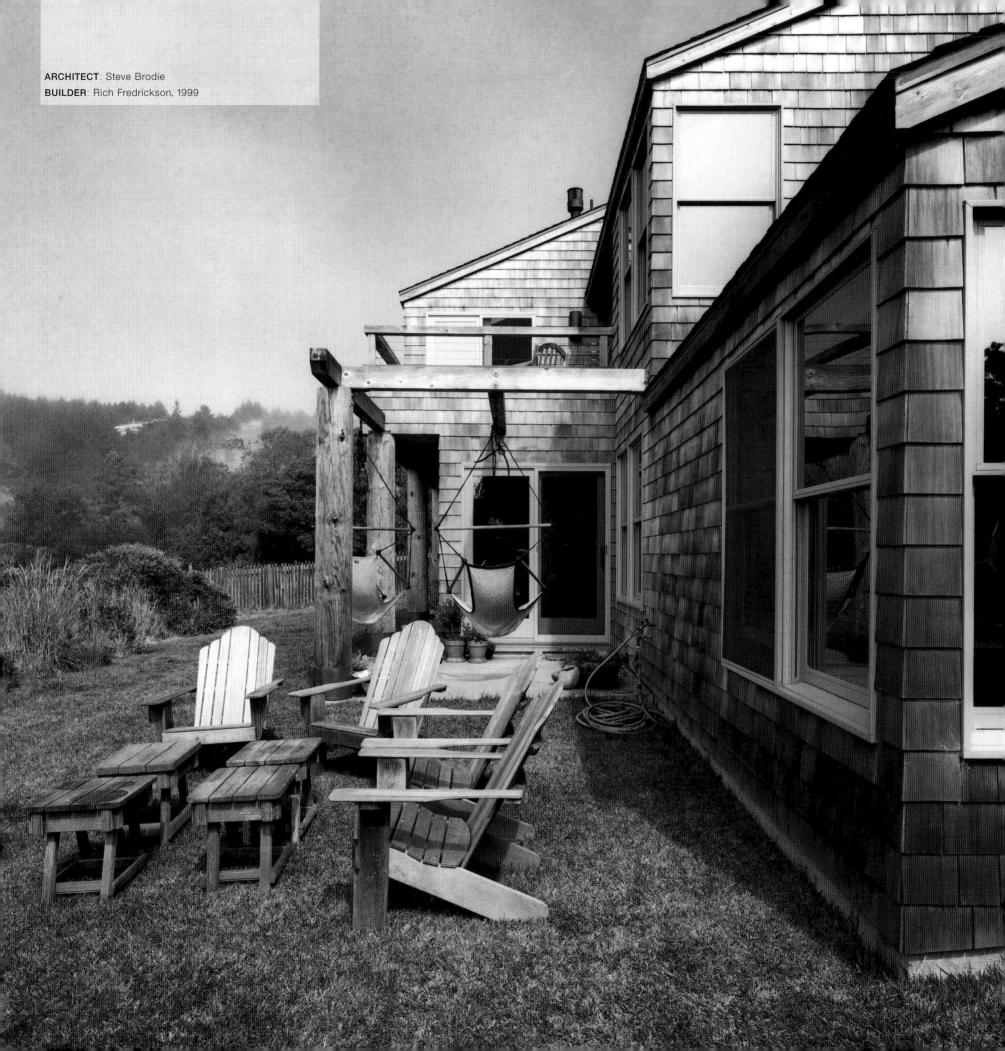

ARCHITECT: Steve Brodie
BUILDER: Rich Fredrickson, 1999

BRODIE HOUSE

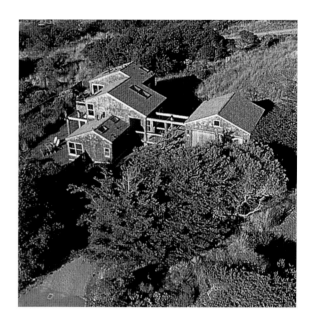

edges of the lower level with a grape-stake fence holding the shrubs at bay. All lower windows and several doors open onto this little clipped lawn. In some locations, wild, longer grasses have been allowed inside the fence, and they soften an otherwise decisive break with the surroundings.

At the upper level, a good-sized exterior balcony commands an expansive view of the swale; it can be reached either from the balcony inside or from the projecting bedroom beside it, positioned for views over a large area of wetland leading down to the ocean. The deck makes an effective linkage between the public and private spaces of the house.

The Brodie House is made with conventional construction and detailing. Windows and doors are

Located by a large swale of foliage that sweeps down toward the ocean, the house belonging to Steve and Linda Brodie is an example of the use of conventional vernacular "settler" forms to create a house that offers varied places from which to enjoy the site. Brodie, who moved his practice to The Sea Ranch from Grass Valley in the late eighties, has designed many houses here.

Set back from the road, the Brodie House can only be glimpsed down its drive through a break in a grove of myrtles (though it stands prominently when seen from farther afield across the draw or by Highway 1). The first view is of a passage linking the house to its garage. The latter is a completely ordinary gable garage; the house steps down the slope with a syncopated massing of roofs and walls. The linkage is made with round stripped wood posts and small beams spanning between.

The front door is at midlevel, leading to a shaft of two-story space with a big skylight above. Stairs descend to a lower level, where kitchen, living room, and dining interact, while the upstairs holds a master bedroom suite projecting to the northwest. The form of the whole is indistinct, but inside there is an array of views and light entering from various directions. The space is given a symbolic overtone by a small balcony deck inside the northern glass wall, with a rocking chair in the corner staring off to the view. It immediately pronounces that there is a larger context for contemplation.

The kitchen, open to the living space, looks out into a yard that surrounds the down-sloping

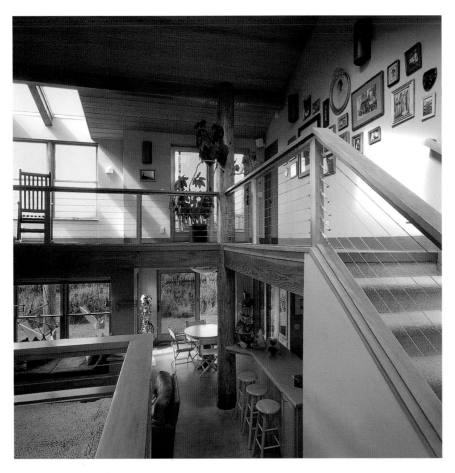

stock models, and gypsum-board walls are painted
with neutral colors. The predictability of its materi-
als and surfaces make the high, light space of the
main room, with its curiously suggestive balcony
and an open trellis loggia outside, all the more
intriguing—evocative probes into another way of
being. They unsettle the comforting suburban
imagery seen in other parts of this house, as does
the great swale of dense vegetation that lies out-
side its fence, murmuring of the wild.

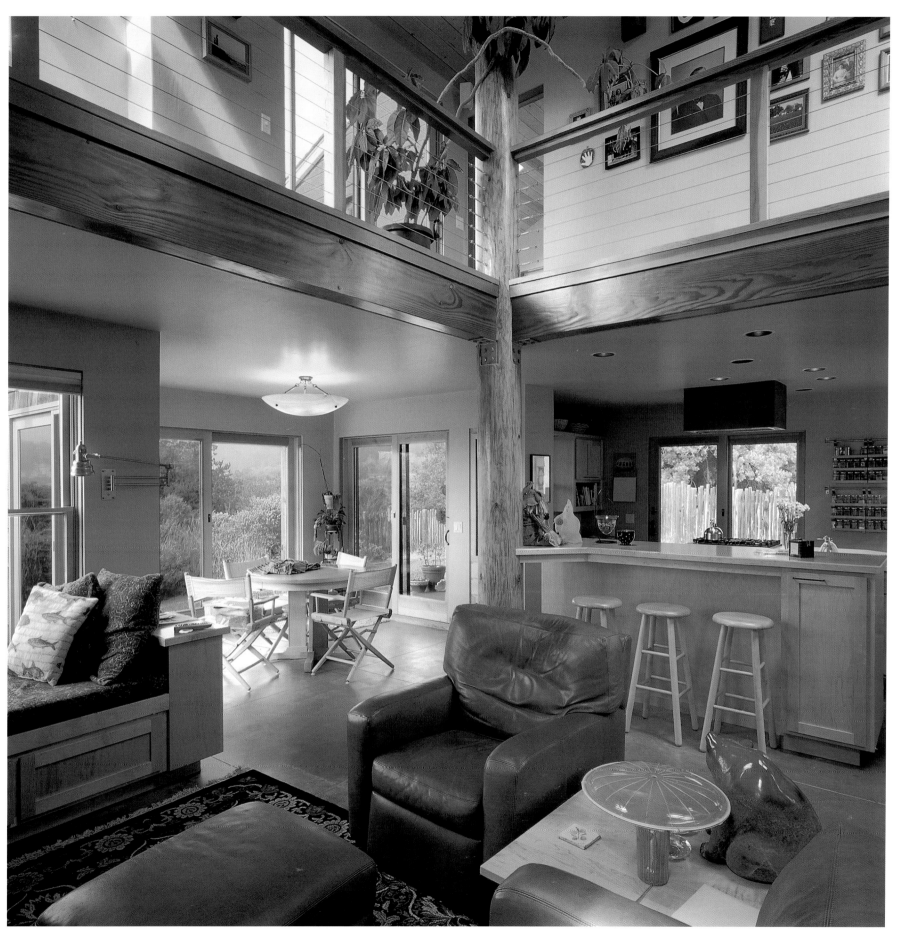

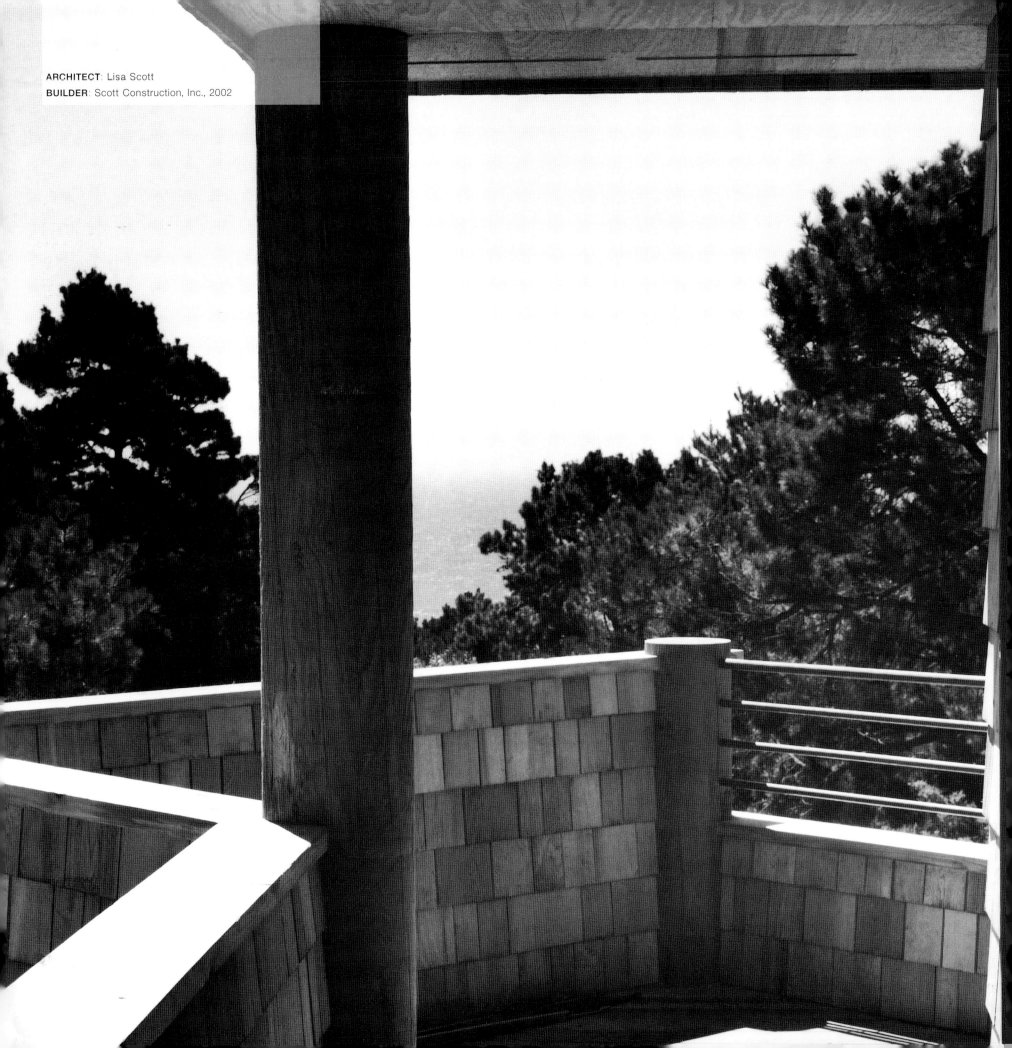

ARCHITECT: Lisa Scott
BUILDER: Scott Construction, Inc., 2002

GILBERT HOUSE

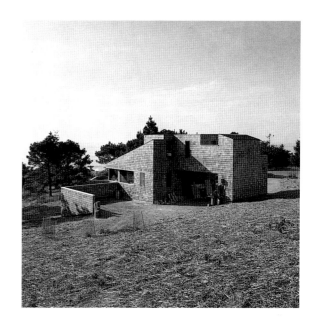

undisturbed to become part of the larger landscape descending to the sea. At the main living level a deck opening toward the draw is held off the sloping ground by a row of round trunk columns marching around the base. They break rank at the east end to step out and hold a rotated square of deck, which provides space for a future hot tub. Viewed from inside, this inflected segment of the deck skewers the house to the site while highlighting a sneak view down through the trees. This tree-framed vista of white water breaking on rocks off the coast is far more effective in capturing the imagination than most unframed panoramas.

The space inside is very tight; a central passage leads from the front door to the deck,

The Gilbert House claims its place in the landscape as a perch on the side of a slope. The land falls past it, and through a stand of pines, toward a thicket of vegetation that sweeps down a draw to the ocean. The house has a curious and interesting form, derived from its position on the site, and is in many ways more like a tree house than like a settled place on the land. It is small and compact, yet assembled of several parts that surprisingly include a drive through the midst of its volume. Its claim on the land is assertive, while its small size, and the open passage and decks make it appealing—more like a camp than a castle. It was built for Christine Gilbert, a schoolteacher from Sacramento, by the Scotts, a husband and wife builder/architect team, who are relative newcomers to the area. Lisa Scott studied architecture at the University of North Dakota.

The shingled form is dominated by a single-plane roof that slopes up parallel to the hill from the south until it reaches a small, flat-topped section. In the midst of the roof is an inset balcony for the second-story bedroom, looking south into the tops of the trees. From above, looking down from Highway 1, the house is puzzling but intriguing, with the big roof slope to one side, the flat-roofed section at its top—part dormer, part blunt tower—and an upper deck reaching from it across to a solid, thick storage wall bridging the drive below.

The roofed passage for the car allows for protected unloading, but the car itself is stored in a fenced court behind, shielded from the road above by plantings. The bulk of the site is left

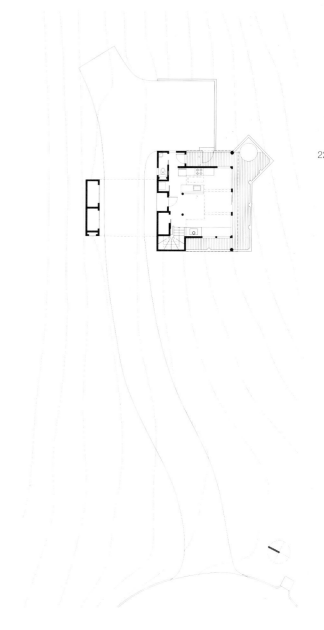

bracketed on one side by a woodstove and sitting space, and on the other by a kitchen counter and equipment. The whole space is a mere twelve feet across. The underside of the roof sloping up lends relief to the sides of the space, but the center segment remains low underneath a bedroom lodged immediately above. Windows on three sides fill the small main room with balanced light and provide pleasant views of the trees nearby as well as glimpses of the meadow and ocean farther beyond. The whole house seems like an extension of body space, with domestic arrangements close at hand and everything sized to use. Its abundant decks and balconies allow a selection among several ocean-viewing perches according to mood, wind, and time of day.

Tree house images come to mind in several elements: the upper-level decks, some lodged in the roof, others bridging masses; the lower deck, spanning rows of log columns; and the tight, intimate spaces inside, twisting up into the light. But after all, it is too solid for a tree house. It is hard to come up with an image that summarizes; it is not "house," not "tower," not "shack"—maybe closer to a really diminutive shingle castle. More locally, it also brings to mind photos that were once ubiquitous in Northern California: postcards of a touring car passing under a portal cut through the heart of a giant sequoia redwood.

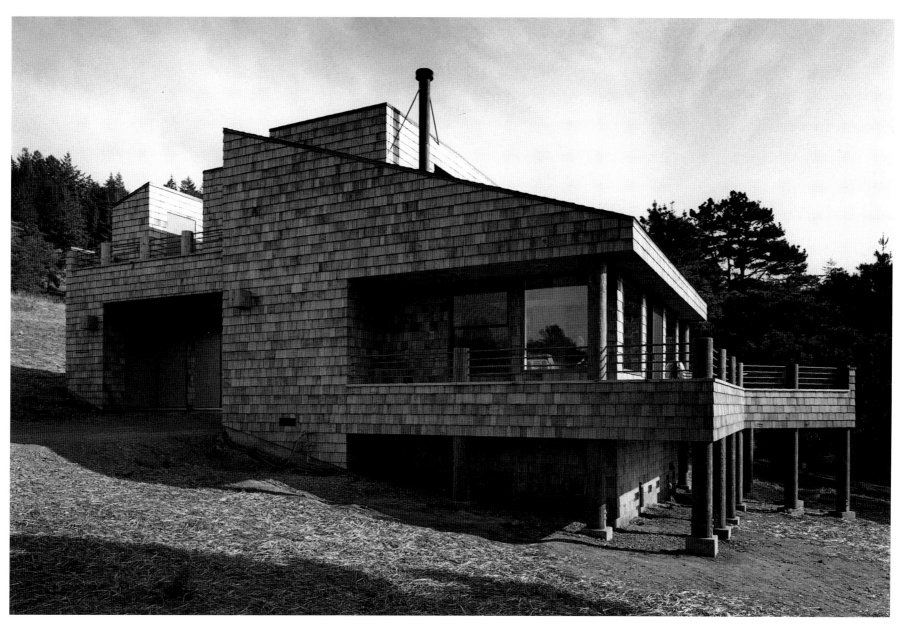

HOUSES THAT ENFOLD

ings, and outbuildings here always make something more; they form a set of relationships that themselves have meaning. "One Plus One Equals More Than Two," we called it in "Towards Making Places," our first manifesto, published in 1962.[1]

1 Charles W. Moore et al., "Towards Making Places," *Landscape* (Fall 1962): 31–41.

The houses shown in this section successfully enfold aspects of the outdoors within their basic structure, creating an effective link between defined spaces, indoors and out, while setting limits to the extension of built spaces into the surrounding landscape. All of the examples shown here have one significant space around which other buildings or rooms have been organized. In these houses spatial organization is inward-turning, creating compounds of rooms that are usually arranged for common environmental effect. The groupings of rooms, build-

WHITAKER/EKMAN HOUSE (see pp. 230–233)

Made simply and unassertively as a box sitting with its neighbors between the road and a large open meadow behind it, the Whitaker/Ekman House enfolds a surprisingly large high space inside its volume; this indoor room seems in scale and brightness more like a plaza than a living room. Rooms wrap around it on two levels, and light floods the walls from a skylight above.

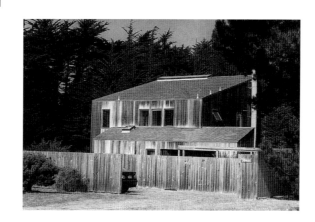

ANDERSON HOUSE (see pp. 234–237)

Elegantly direct, formed with low gables and one small tower anchoring its end, this house enfolds a protected open space between the wings of its plan and the previously existing stand of trees that parallel the shore. Further defined by a garage and diminutive studio building, the enfolded space forms a private yard, sheltered from the winds, sands, and passersby on the ocean side.

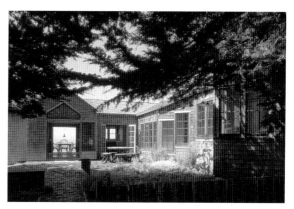

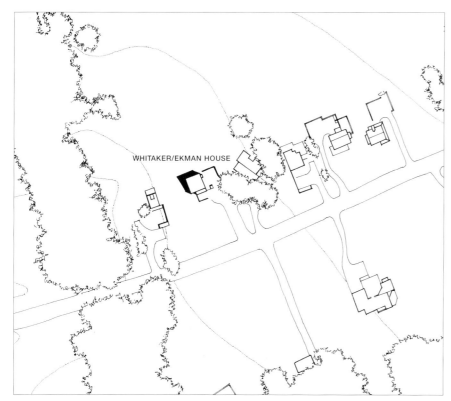

WHITAKER/EKMAN HOUSE

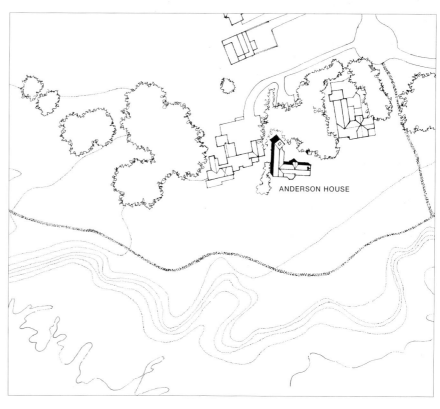

ANDERSON HOUSE

CLAYTON HOUSE (see pp. 238–241)

Literally encircling an open court, the forms of the Clayton House dramatically enfold the car court and a garden within walls of a virtual drum formed by walls of wood slats. The living spaces, a thick layer of rooms and passages, border one side of the court. The house is a lively act of spatial landmarking, with its curving forms and the great unexpected void in its center, yet it sits well as part of a row of houses backed against the hedgerow with similarly sloped roofs.

SCHNEIDER HOUSE (see pp. 242–245)

The Schneider House is directly across the meadow from Esherick's earlier Hedgerow Houses. Like those, it is developed with simple sheds rising from the meadow toward the trees behind, though here the effect of the roofs is more visual than environmental, drawing multiple connections to the site. The wings of the house enfold a court that is itself a place of quiet and repose, linked to the rooms of the house by a glass corridor, which offers a dramatic view out to the coast.

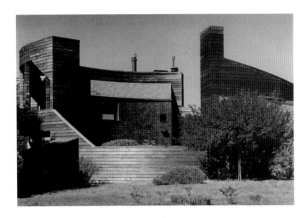

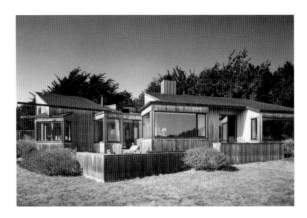

228

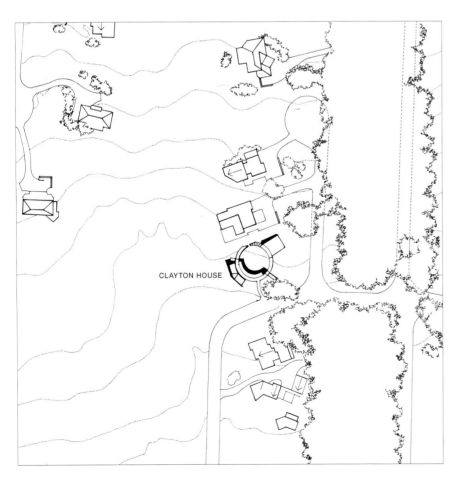

CLAYTON HOUSE

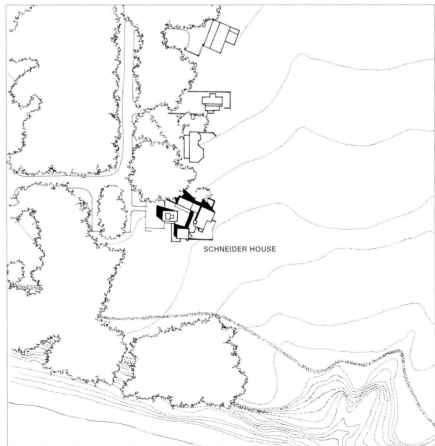

SCHNEIDER HOUSE

YUDELL-BEEBE HOUSE (see pp. 246–249)

Enfolding a moss-garden court at its center, this house at the same time captures the flow of the meadow to the sea, allowing a segment of its space to course through the court and the glass-walled dining space, and out through a porch to the sea. The shallow, sloped roofs of the house bend and rise from the meadow to higher walls that face the court and front the neighboring cul-de-sac.

BOYD HOUSE (see pp. 250–253)

Located at the end of a road cutting down through the meadow, the Boyd House formally encapsulates the approach. The rooms, all lodged in sharply formed gable structures, form a court on three sides, with a path threading down the middle from the end of the road; log columns create a shaded loggia around the court. A small building containing the garage and a hot-tub shelter is twisted out of orientation to capture a decisively framed view of the neighboring point.

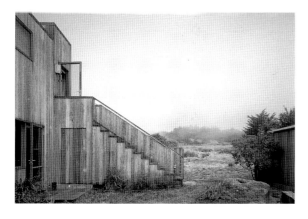

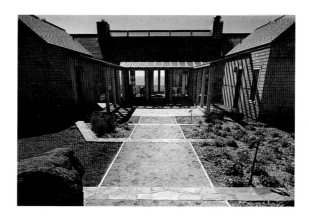

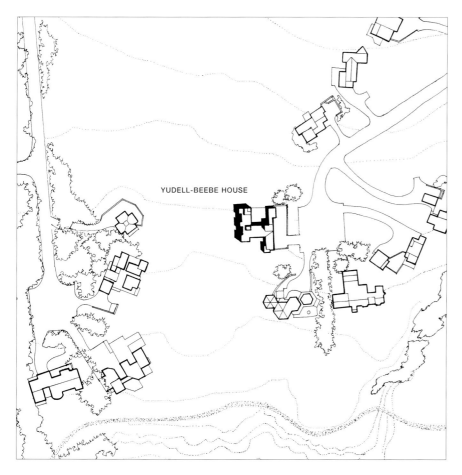

YUDELL-BEEBE HOUSE

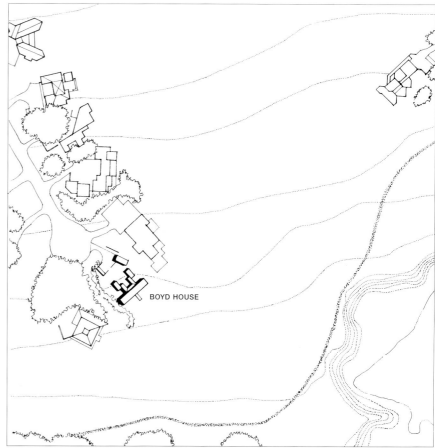

BOYD HOUSE

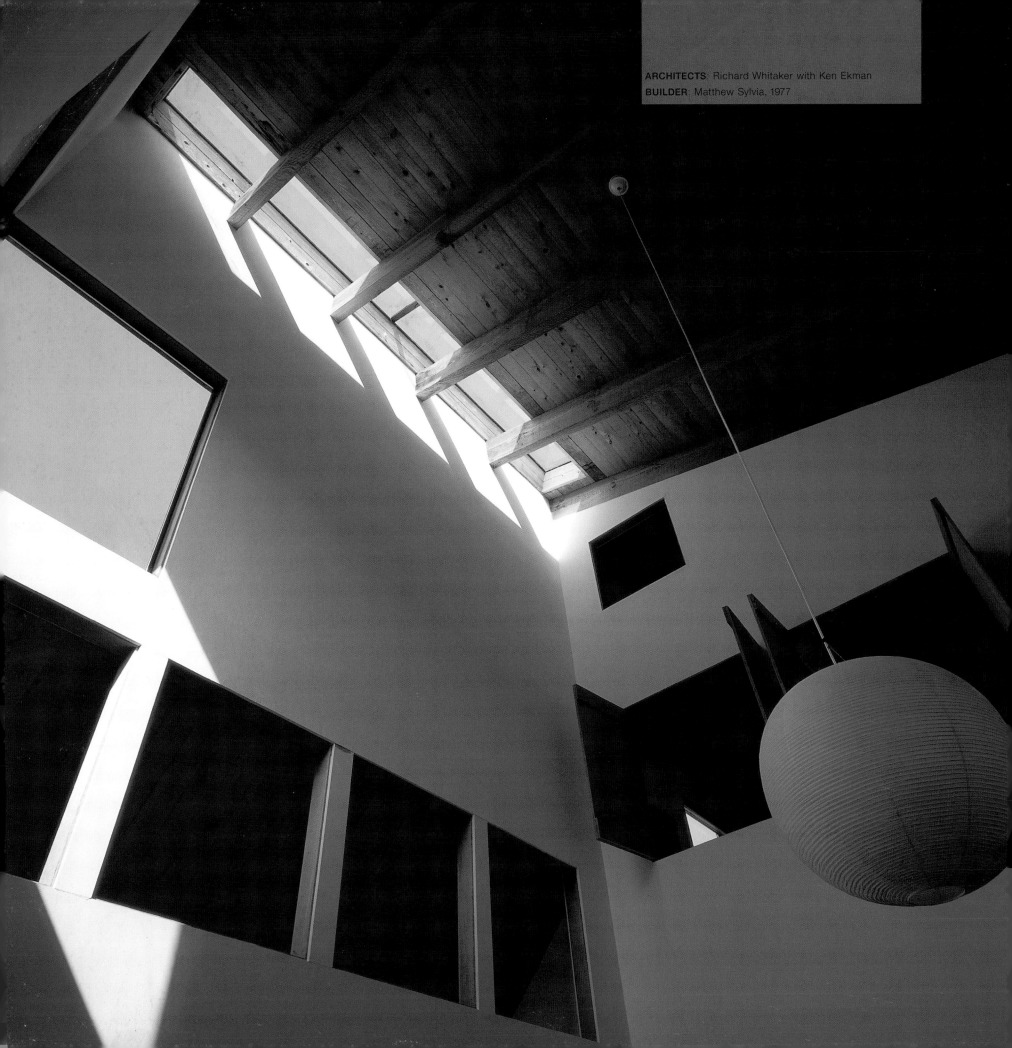

ARCHITECTS: Richard Whitaker with Ken Ekman
BUILDER: Matthew Sylvia, 1977

WHITAKER/
EKMAN HOUSE

(now the Goodman-King House)

Set along a road through the meadow that runs perpendicular to a hedgerow and opposite One Eyed Jack's (a community recreational gathering place—site of barbecues, volleyball, Frisbee, and improvised games), this house enfolds a surprisingly high, light volume—an enclosed court of sorts—within its simple form. Though literally on one corner of the house, this beautiful space forms its conceptual center. Two stories high, with a skylight along its upper edge and with high windows on the northeast corner that look up to the sky and the tip of the hedgerow, it is the imaginative focal point of the house. From this sixteen-foot-square radiant room, spaces reach out in all directions. A small benched bay that steps into the meadow offers views east across the open grassy land to a handsome knoll ringed with houses. Another, larger bay reaches north under its own shed roof to fashion a more intimate room to the side; it is used mainly for reading, study, and listening to music. Sliding doors join this space to a modest wooden deck that projects out into the grasses on the northeast corner.

The other two sides of the "court" walls are joined by low spaces at the ground level. Sets of wood-panel shutter doors on the upper levels open from bedrooms above. The lower alcoves provide ample room for a sofa before a fireplace on one side and space that opens into a kitchen on the other. Entry, stairs, and bathrooms occupy the corner. All the major rooms in this house face onto the common court space and borrow additional light and outlook through it. The rooms

below spill out into the court space as needed, and the life of the place courses through it. A table is there for eating, and great sets of cushions await improvised casual groupings; the whole has a wonderful air of the weekend.

Distant kin to the original Johnson House by MLTW/Moore Turnbull, with its hierarchy of spaces and common high focus, this house by Richard Whitaker, also a former partner in MLTW, is bigger, more conventionally built, and with full rooms attached to the figurative center. The court, with its openings inside and out, and with its strategically placed windows and skylight, plays masterfully with the light, giving the volume much of the dynamism and some of the whiff of faraway places that is induced by the geometry and sizing of the Johnson House.

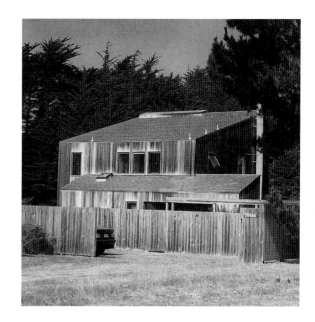

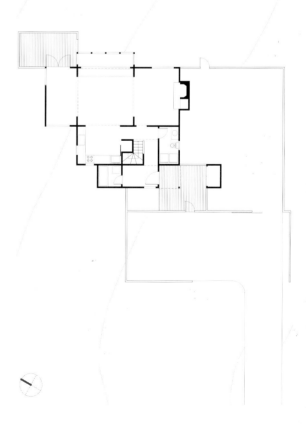

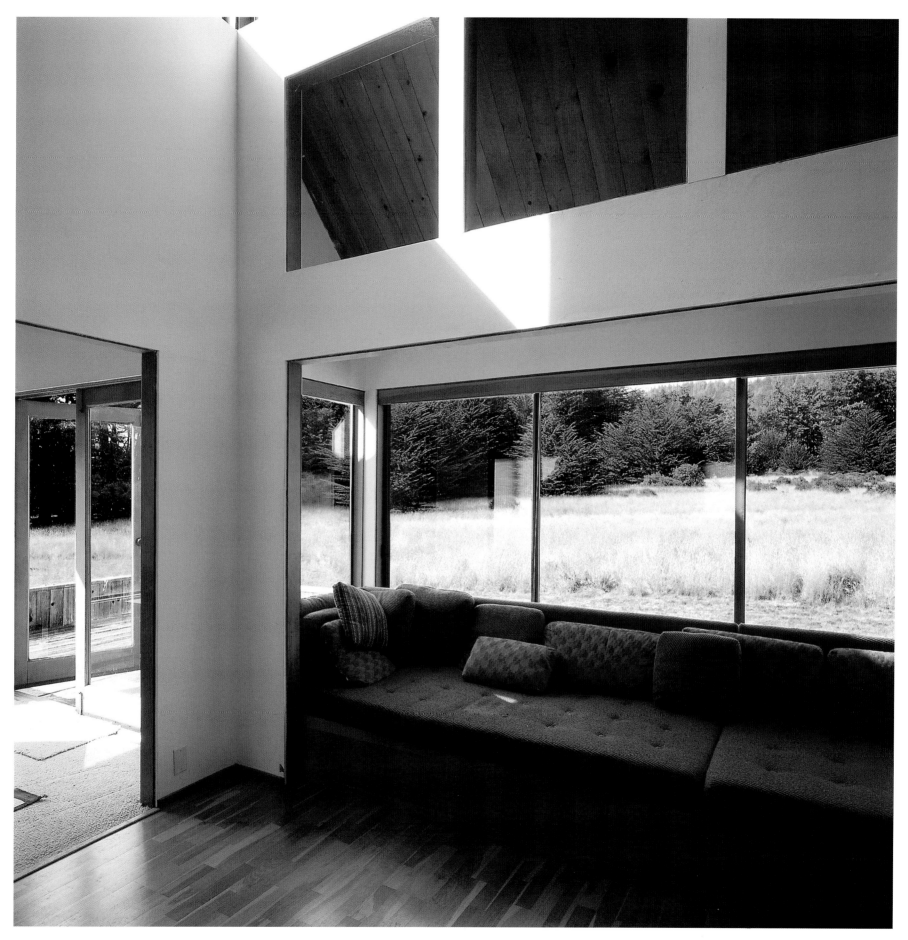

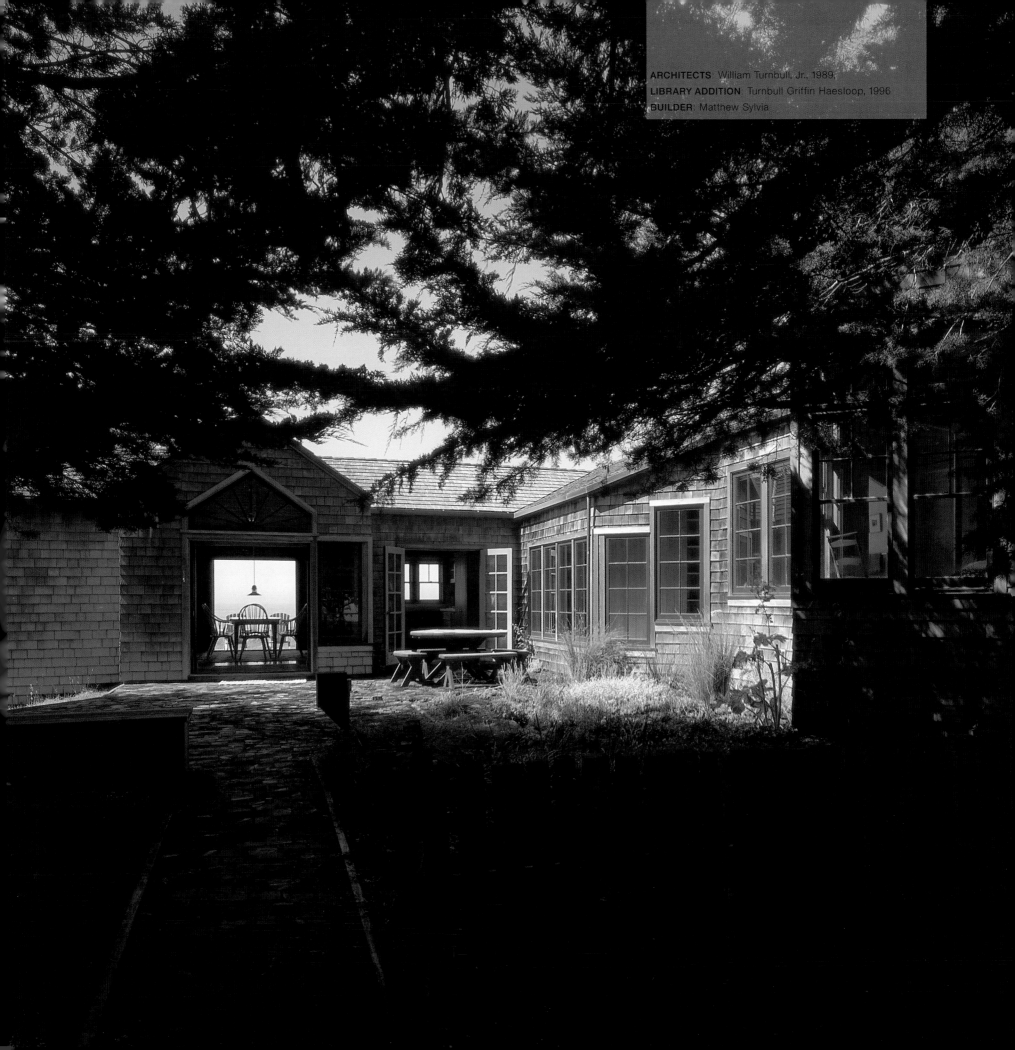

ARCHITECTS: William Turnbull, Jr., 1989,
LIBRARY ADDITION: Turnbull Griffin Haesloop, 1996
BUILDER: Matthew Sylvia

ANDERSON HOUSE

For the Anderson House, William Turnbull used simple vernacular forms, existing cypress trees, and a few strategic plantings to enfold a place that is uniquely suited to its position on the coast. While the gable-roofed, shingled form, with small-paned wood windows, at first seems to suggest a transplant from Martha's Vineyard off the coast of Massachusetts, it quickly becomes apparent that this house and its outbuildings were meticulously crafted for this particular site.

Edgar Anderson had been driving the north coast for years, exploring its geography and buildings, before deciding to build at The Sea Ranch. He and Turnbull shared an admiration for rural buildings. Turnbull had not only grown up on a farm but had for two decades been exploring the use of simple vernacular forms for his buildings in the wine country, and now at The Sea Ranch.

Vernacular buildings on California's north coast often bear resemblance to other places; their nineteenth-century builders brought ways of building and notions of comfort with them from the East and Midwest. These included tight windows for protection against the weather, overlapping shingles of wood, and structures assembled of small pieces of timber or of conventional stud-frame construction. Their sizes were small, their window and door placements usually simple and predictable, with occasional flashes of ingenuity directed to a specific need for light, air, or outlook.

The Anderson House conforms to the pattern, except that it is more than occasionally

adjusted to the particulars of the site. The configuration of the building works with adjoining trees and outbuildings to enfold and protect a quiet space on the edge of the ocean. The main part of the house is a single long room placed parallel to the bluff trail, with windows generously disposed along the side facing the ocean and a pair of French doors opening onto a small deck that steps out into the coastal wind. The living room end of this space is anchored by a fireplace and chimney, where the windows proliferate, opening views down the coast to the south. At the other end, a perpendicular wing of bedrooms projects slightly toward the ocean, providing some wind-shadow protection to the ocean face of the building. To the land side, that wing bends abruptly back on an angle, with stairs rising up a few feet into a diagonally placed small shingle tower that serves as the master bedroom. Its corner windows look south across the court to the receding coastline.

Despite its diminutive size, the bedroom tower commands the enfolded space on the land side of the house. It is capped by a miniature widow's walk, a small, railed observation platform that whispers New England whale stories as it rises among the branches of trees. The space is backed by a previously existing row of cypresses following the line of the shore, and further framed by a car court and garage entwined underneath and among them. A freestanding single-room library of nearly dollhouse dimensions was later slipped in among the trees at the southeast corner of the court. Only ten feet across in size, the external form of this little building is pure fisherman's hut. The craft is something else again. It is an absolutely pure space, with very fine vertical-grain cabinetry at one end, and top-grade boards for paneling inside. A large window looks out through the gable end to the ocean, and two pairs of French doors open nearly one whole side to the domesticated space on the north. The small size and elegant proportions of the study echo Turnbull's own vineyard house at Teviot Springs in Knight's Valley.

The long room of the main house is entered in the middle through a simple porch, graced with central double doors of small-paned glass and a radiating set of transom mullions that make it nearly Palladian. The inside is

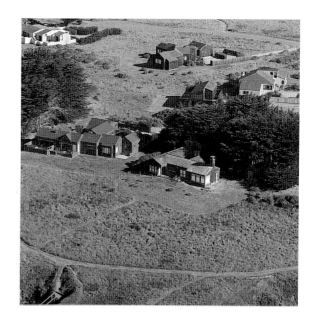

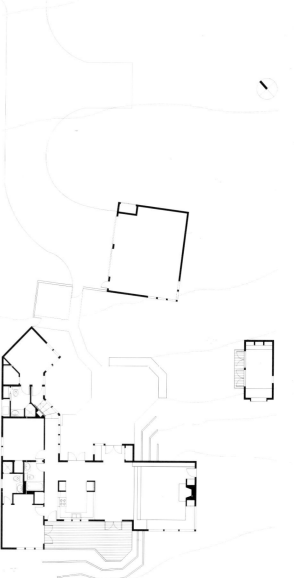

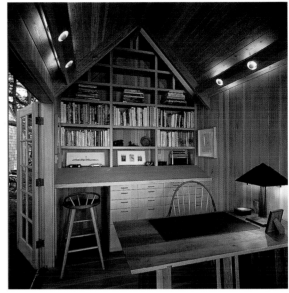

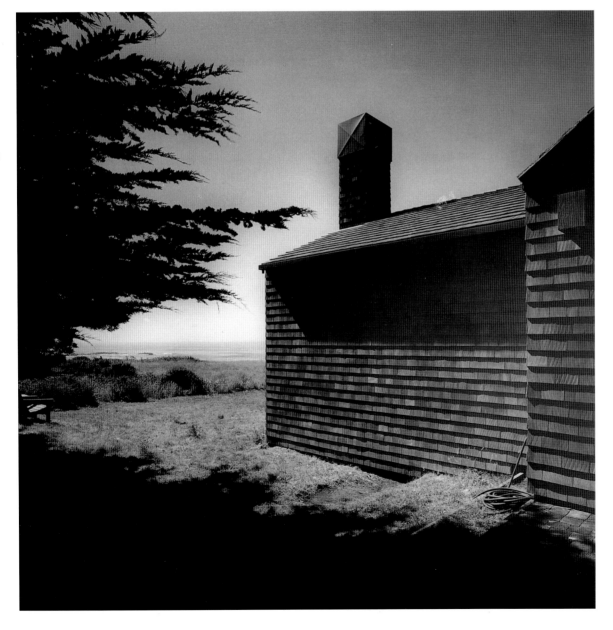

characterized by its beautiful wood surfaces: elegant exposed Douglas fir rafters and trusses overhead, wall siding and bookshelves, and vertical-grain fir floor. The high fireplace block focuses the living room end, which is set down a few steps to be closer to the land as it slopes down to the beach—giving a slightly more expansive height to the room. A dining table at the cross axis is served from a square counter-height kitchen enclosure with elegant vertical-grain Douglas fir cabinets and Corian counter. The precision of this small space is like that of a most elegant ship's cabin.

Everything in this house is done with Turnbull's masterly economy of space, tightly packed together but never in any sense cramped. The sizes of rooms, passages, openings, and building parts all resonate with the sense that they are appropriately scaled to each other, to people, and to the site. Charles Moore was fond of recalling how Goldilocks, when she finally settled into the properly sized chair, pronounced it "just right." Here this phrase seems just right.

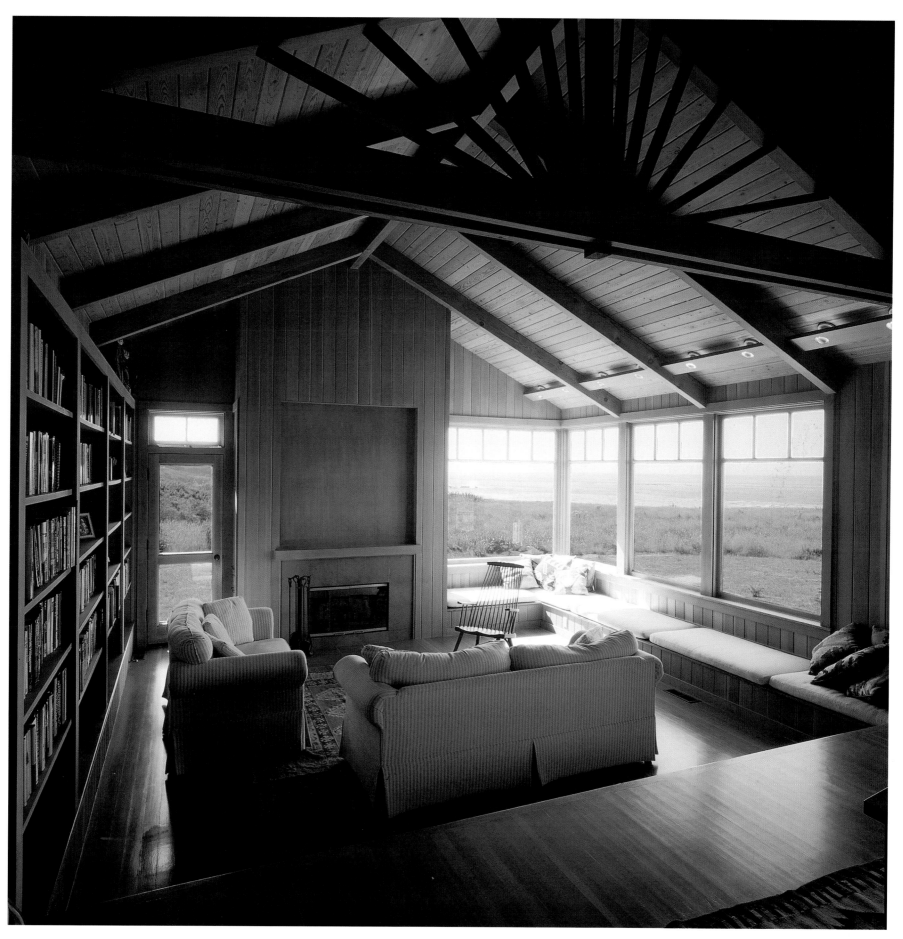

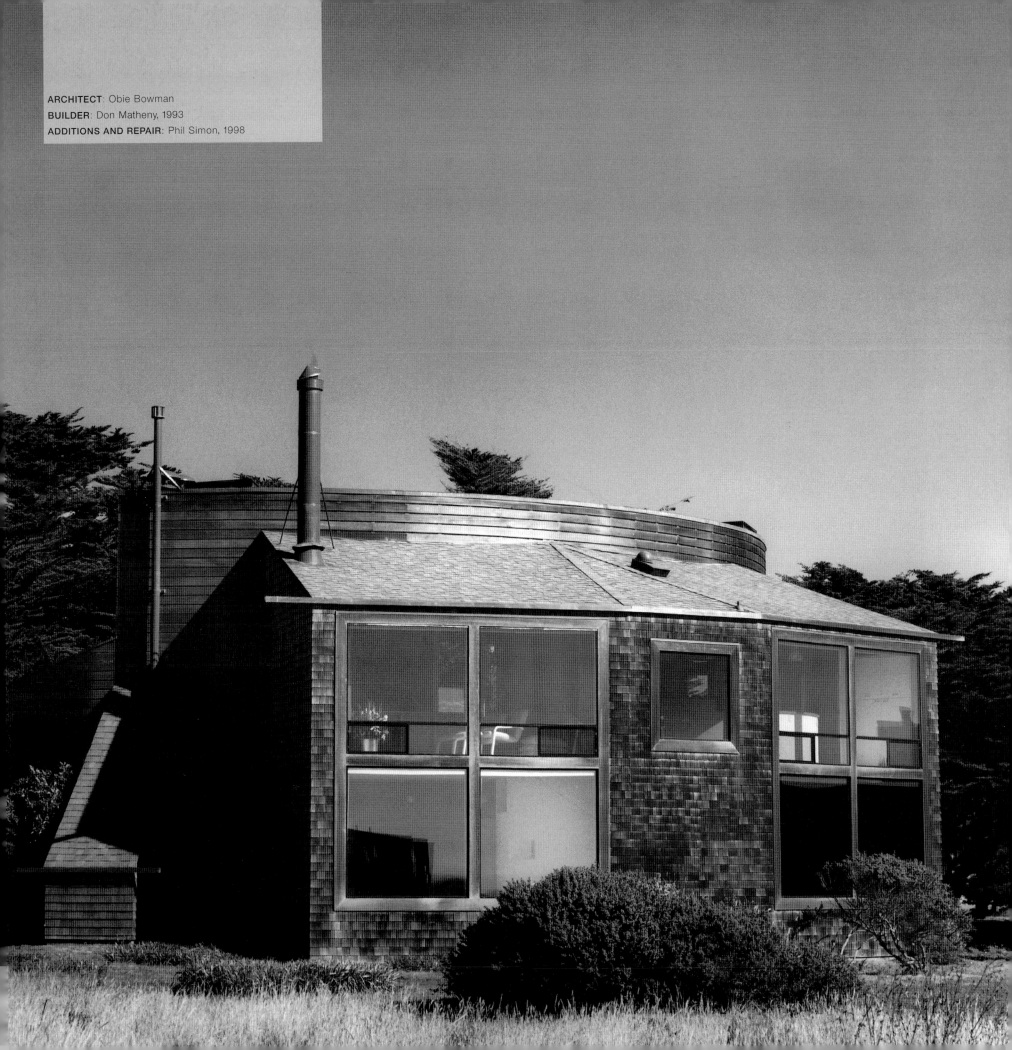

ARCHITECT: Obie Bowman
BUILDER: Don Matheny, 1993
ADDITIONS AND REPAIR: Phil Simon, 1998

CLAYTON HOUSE

drum and creating a shifting series of visual impressions as you pass by on Del Mar Point Road. The primary impression is of the portal, held aloft by a pair of hefty steel beams resting on even heftier concrete columns.

The spaces of the house itself are entered through a modest door and vestibule off the court. A staircase ascends along the inner face of the drum until it turns on itself and opens into one end of a single large room on the second floor, which is planned in three layers. The inner layer holds the stairs, a pantry, and a small bath. The second layer forms a circulation path following the curve of the drum until it opens to the portal deck at the opposite end. This passage is bounded on the court side by banks of shelving

The Clayton House plays an especially interesting role in its setting. With a roof sloping up toward a hedgerow behind its site, and redwood siding gone naturally dark, its surfaces (along with those of several of the neighboring buildings) merge with the cypress row when viewed across the meadows from the north and west. Yet when approached from the south through a gap in the hedgerow that parallels Helm Road, it offers a big surprise. The place turns out to be a hollowed circular drum, with an open court at its center. Rooms of the house arc along its perimeter on the northwest, a garage front forms much of the boundary to the southeast, a bridged gateway portal faces the road, and slatted walls complete the circumference. The court, forty-five feet in diameter, is at once car court and wind-protected garden—two elements that are ubiquitous in the north end of The Sea Ranch. But here they are combined and rendered with a formal coherence that makes the resulting space especially memorable, a reference point for the life of the house and on the mental map of the neighborhood.

Curiously, the curve of the drum is barely recognizable from across the meadow. The outside perimeter of the rooms, largely made in straight segments, is subtle enough, and the dark color of the exterior recessive enough, to minimize its impact as an independent volume, allowing it to join in gently with the adjoining houses and the trees behind. Conversely, as you approach the house, the silhouette becomes vigorous, capturing fragments of sky between the portal and the

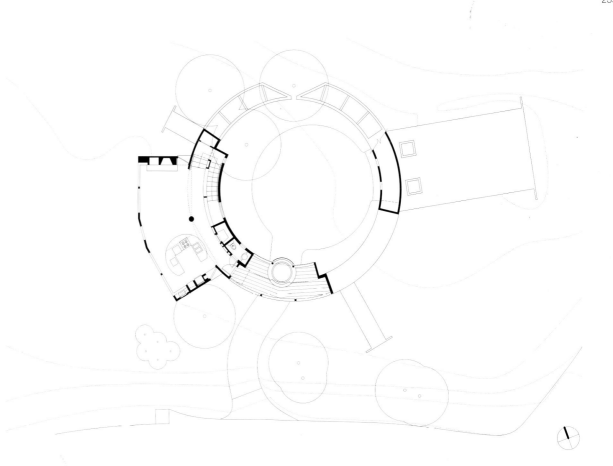

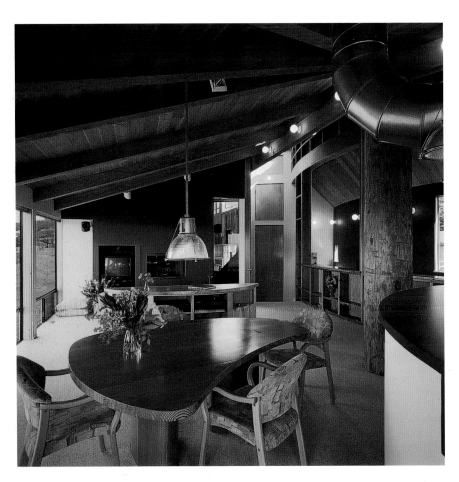 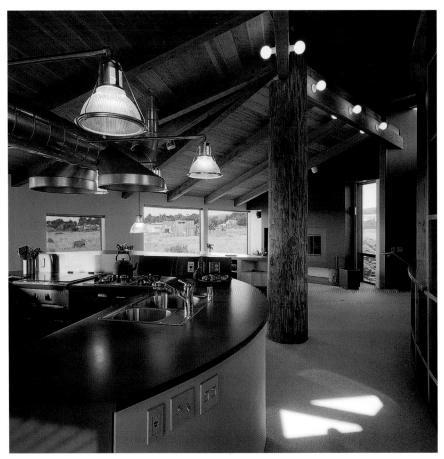

and capped by a flat roof with skylights at either end. While distinct, it is separated from the rest of the room only by a splendid tree trunk–sized wood column and the trace of some beams overhead. The widest layer of the room, along the meadow edge, holds space for comfortable seating, a dining table, and cooking area. Banks of very large square windows on either side and a smaller square window in the middle fill the room with light and outlook. An open kitchen is lodged in an encircling island of black counters. Hovering above these is a metallic cumulus of formally arranged ducts, fans, and lights. Capping the entire space are the exposed beams and decking of the roof, tilting up toward the inner ring. The lower level of the house contains the bedrooms, with large windows opening to the meadow.

The courtyard walls are made with spaced one-by-six redwood slats applied either to the surface of the buildings or to an independent timber frame. These slats cut the wind, lend privacy to the space, and define its memorable geometry. They make an ingenious version of the false front that lent urbanity to the Main Streets of many early Western towns, here turned in on itself to create a special enclosed place within the larger landscape. The walls bond the face of a large, low garage and utility area to the court, and frame views into and out of the central space. On the east the walls are tapered almost to the ground, creating an angled slot that reveals the nearly identical angle of the neighboring roofs and walls. The upper-level portal deck over the auto entry is oriented to provide views down Del Mar Point to the ocean. It may one day hold a spa tub with splendid (and windy) views.

In another location this house might prove to be discordant, centering attention on itself. Here, with its meadow front aligned with the neighboring buildings and gently bending back toward the gap in the hedgerow, it serves to connect with its place. It adds its striking form, clear intent, and arresting silhouette to the intersection of three Sea Ranch roads with the meadow and hedgerow, creating a valuable differentiating landmark.

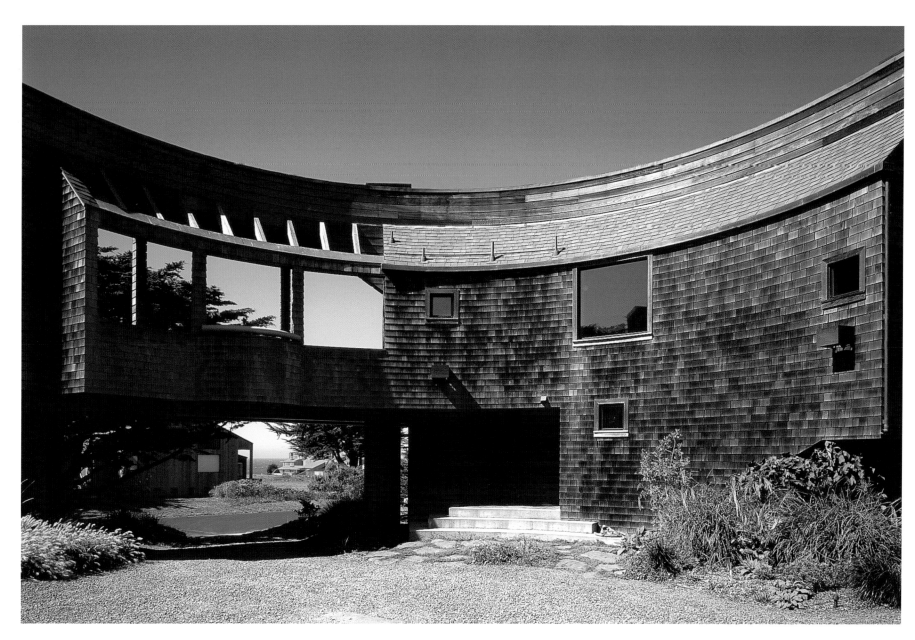

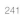

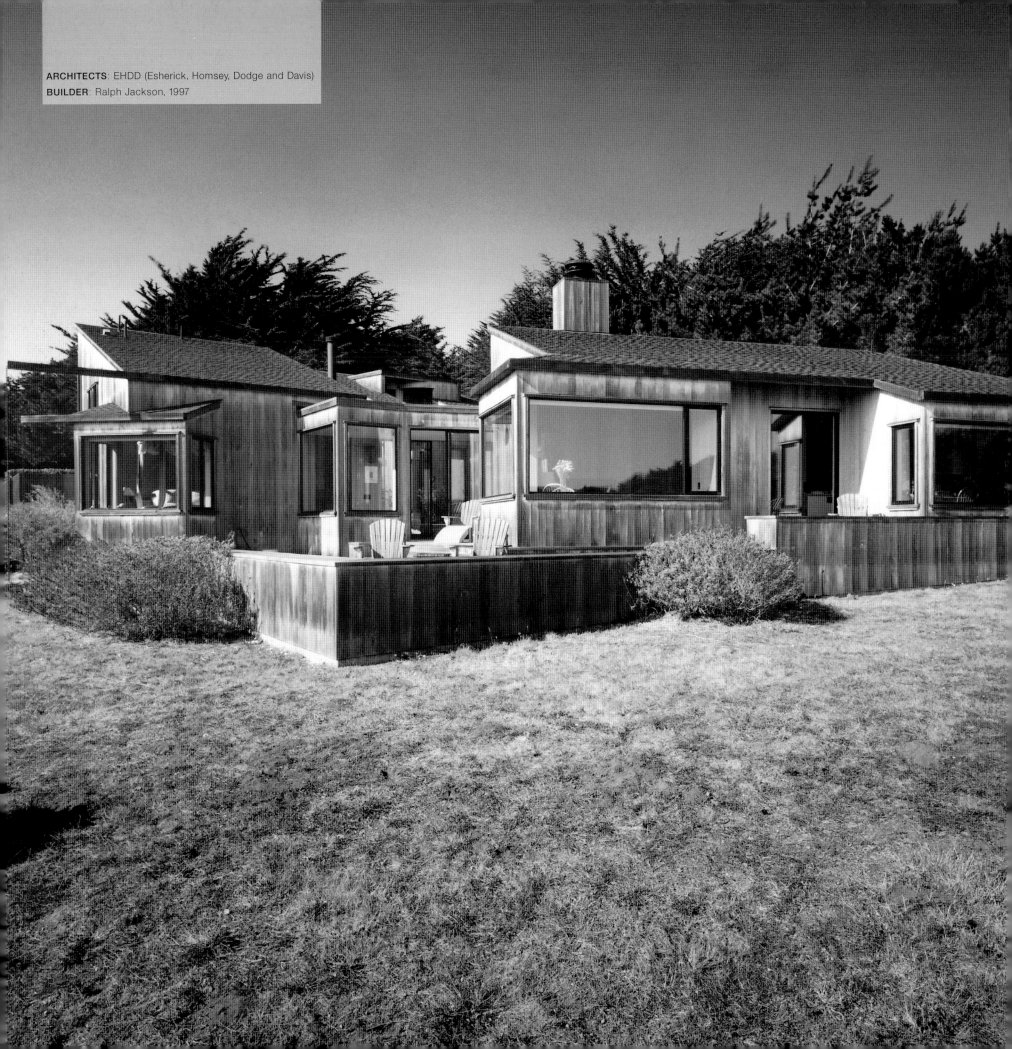

ARCHITECTS: EHDD (Esherick, Homsey, Dodge and Davis)
BUILDER: Ralph Jackson, 1997

SCHNEIDER HOUSE

one side of the court toward the front door, while in the opposite corner a glass-walled link to the master bedroom frames a beguiling view of Black Point. The court, a remarkably comfortable place to be in, is in touch with the scene but protected from the wind and bordered by things of human proportions: glass doors, the closely spaced posts of the trellis, a stove-sized wooden bay projecting off the bedroom wing, some seat-sized rocks, and a large block of wooden platform and bench that somewhat ponderously, but certainly, reasserts the play of alignments. From the court stairs ascend to the top of the garage, where, improbably, a hot tub is located in a dormer of the roof, offering protection from the wind and a spectacular view over the house

The Schneider House, the last of the houses that Joseph Esherick designed at The Sea Ranch, connects with his original Hedgerow Houses in spirit, sharing their single-pitch roofs that reach back toward the hedgerows behind them. It differs from its ancestors in that it is somewhat larger than most and more faceted. Most significantly, it has decks on the meadow side, whereas in the original set outdoor-use spaces were always sequestered behind the houses, in the lee of the wind.

Its situation, of course, is different. It is located to the south of a hedgerow and thus already sheltered from the dominant northwest winds, though it is still, by virtue of being out close to the ocean, subject to winter storm winds and rain from the south. Built in several linked volumes, the house enfolds a courtyard in its midst. The major volumes are oriented in two slightly different directions, with the main rooms stretching across the front, more or less parallel to the hedgerow but tilted slightly toward the dramatic view of Black Point projecting out into the ocean. The master bedroom volume remains more strictly aligned with the road (and, more pragmatically, with the adjoining lot line). The garage and car court also align with the road, while a fourth volume, housing additional bedrooms and bathrooms, stretches back perpendicularly from the living areas.

Together, these four bordering volumes mostly enclose the court. The linkages between them, while smaller, play an even more evident role in enfolding it: a glass-roofed trellis stretches along

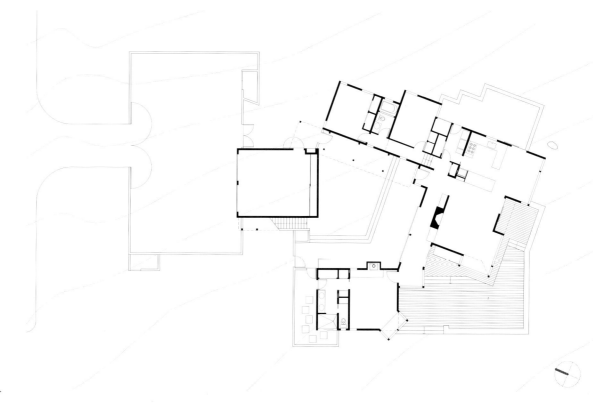

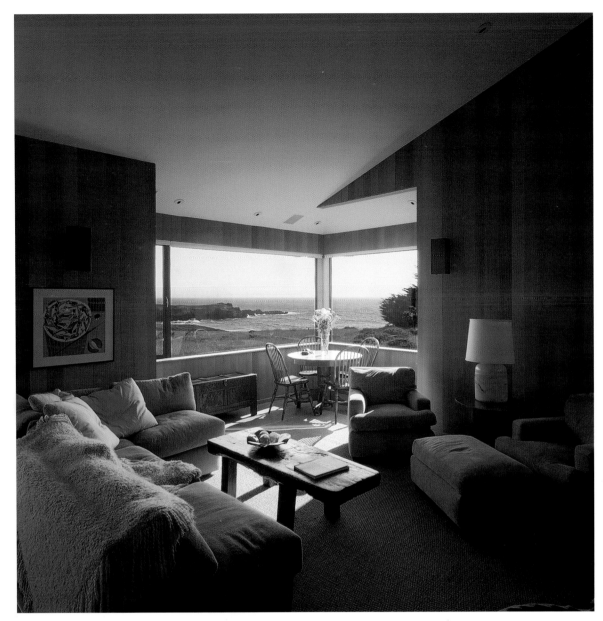

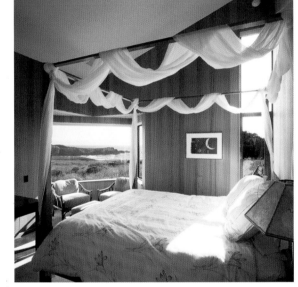

and court, and out to the meadow, the sea, and the sky.

As is usual in Esherick houses, the space planning is compact and efficient. The main living block incorporates at one end an open kitchen, with beautifully made cabinets, serving a projecting dining bay and an eastern terrace. A fireplace seating area and a view-seeking bay are at the ocean end. Black Point is a constant companion to the activities in this house. Balancing light washes across the ceiling and the ocean-facing wall from a high window on the court side and also through an opening from the living room into the glass-bordered corridor that links to the master bedroom. The bedroom volume features a playfully placed diagonal bay aimed somewhat

differently toward the view, and a splendid bathroom with outside enclosure.

The remarkable thing about this house is how much its comfortable sense of vitality derives from the use of two orientations. The subtly changing views, and the gentle angular spaces that they induce between the buildings, give it a liveliness that belongs in this place. This is especially evident in the decks. Their angles seem utterly natural, connected to the landscape of which they have become a part. The decks are edged with benches on the meadow side, limiting their intrusion on the larger common meadow, and are set down a few steps from the main level, so that their furniture does not impede the view. The changes of level are deftly absorbed in

linking platforms that provide additional south-facing, wind-protected niches, perfect places to bask in the sun on a wintry day.

Seen from the meadows or the bluff-side trail, this house is a collection of roofs swept into place at the end of the hedgerow, anchored in place by wooden walls and fences that step down along the meadow, enfolding a court within, and peppered with places to inhabit—bays, decks, niches, windows of obvious purpose, and a mysterious open dormer. The volumes of the house offer amplitude without excess.

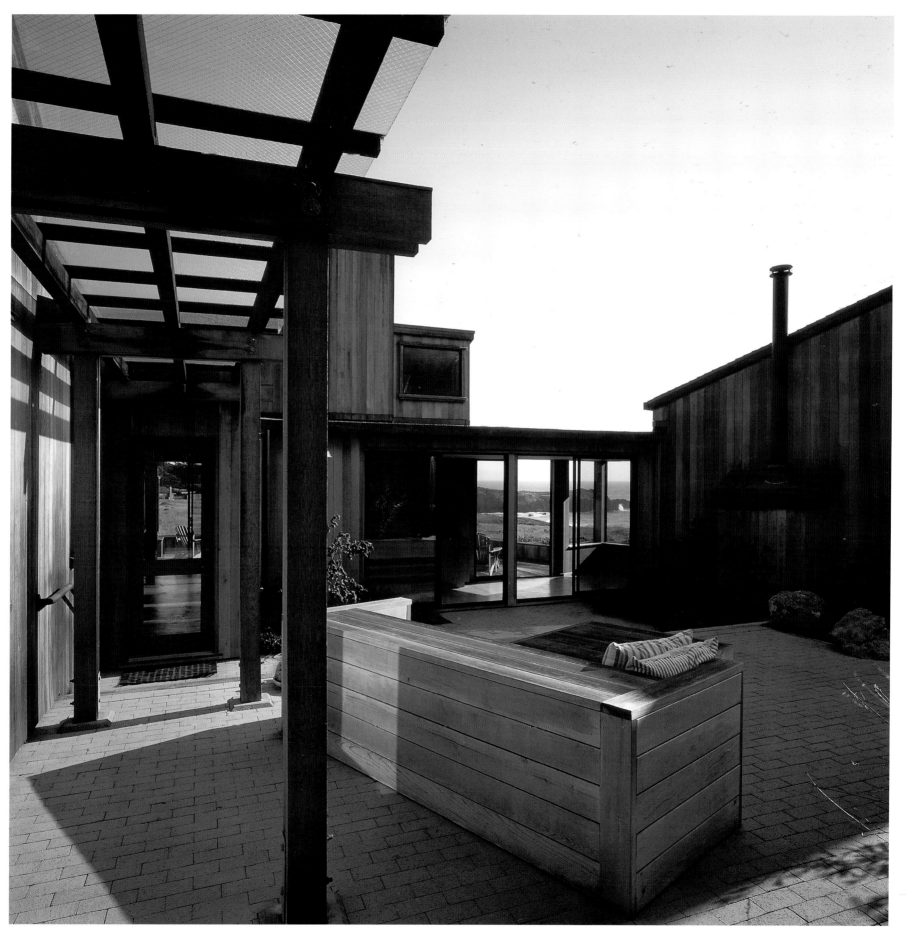

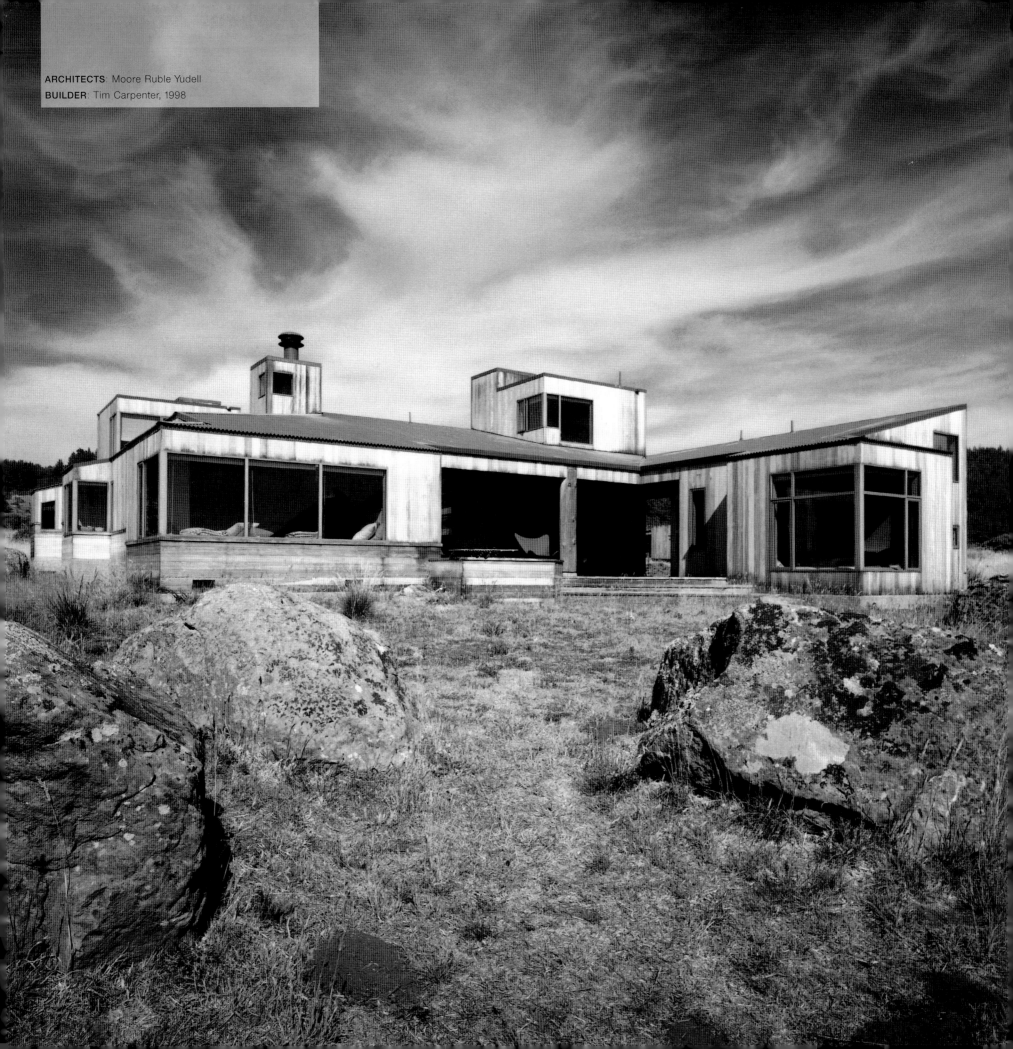

ARCHITECTS: Moore Ruble Yudell
BUILDER: Tim Carpenter, 1998

YUDELL-BEEBE HOUSE

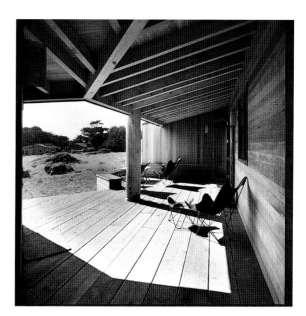

roof bends to make a room between the two wings. Large full-glass windows and doors open on one side of this room toward the hills of the coast range. On the opposite side similar windows and doors open to the deep porch, and the meadow and ocean beyond.

The Pacific Ocean here is hardly pacified, the surf crashing against great black crags that thrust foam in the air and serve as haven for flocks of shore birds. The metaphorical force of the rocks is brought closer to home by a set of subtly placed imported boulders embedded in the site's foreground. On a wall inside they are echoed again by an ink wash drawing by Charles Moore, mentor and friend to both Yudell and Beebe; the drawing depicts comparable rocks off

The Yudell-Beebe House enfolds the site into its organization without interrupting the sweep of the landscape. More than almost any other house at The Sea Ranch, it is conceived with the whole of its visible surroundings as its companion. The forms of the house respond with apparently effortless grace to the specific conditions that they meet, engaging in an environmental dance with the meadow, the ocean, the far hills, and the edges of the cul-de-sac it adjoins.

The facade facing the road presents a restrained rectilinear face, echoing ever so slightly the urban false fronts that make up a part of the north coast tradition. Its forms, which result naturally from the placement of roof ridges parallel to the cul-de-sac edge, speak quietly of an organization that recognizes the difference between the natural undulating flow of the meadow and the graded and paved community-constructing road. Gentle echoes of formality and privacy are continued in the design of the long planar face, with its rigorously composed openings and two large sliding doors that open to a recessed boardwalk entry passage and a garden. The meadow side, on the other hand, is all low slopes, a gently folding metal roof that reaches up from the wooden walls. Occasional windows penetrate the walls for specific outlook or light, but do not intrude on the serenity of the meadow.

The rooms of the house are held in two wings that run down the slope, enfolding in their midst a courtyard with a moss garden and a great porch opening to the ocean. Midway, the

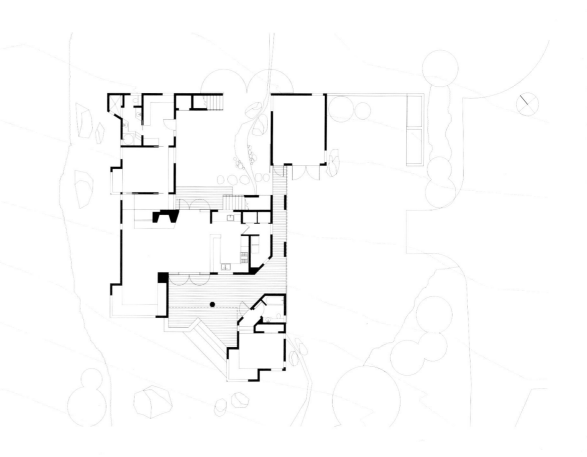

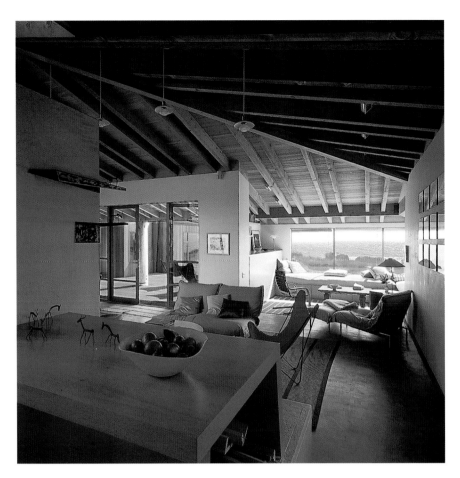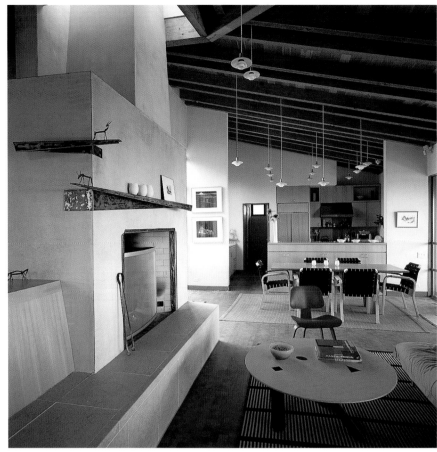

the Monterey Peninsula. Even fainter echoes reach us from lessons Charles was fond of teaching about the Japanese Ryoanji and Saihoji temples. Saihoji's famous moss garden is echoed in the small garden created by Tina Beebe between the two units, with rocks, moss, and blue beach glass creating a miniature faux stream.

Inside, the midst of this passage from meadow to ocean is occupied by the dining table. To the south are the kitchen and utilities, and across the entry porch a separate little guesthouse is folded under the roof of that wing. Immediately north of the dining area is a stuccoed fireplace, its chimney penetrating the roof in a bath of clerestory light. The room spreads out in front of it into a smaller, lower, more intimate section that is edged by benched bays fronting the ocean and the meadow. To the rear of the space, a few steps wind gently up behind the fireplace mass to enter the master bedroom and the bathing room, which has surprising glimpses of view and light radiating through tiny tiles, gently green.

The walls throughout are plastered in very soft colors marshaled by Tina Beebe to work with the light of the meadow and the rich framing and surfaces of Douglas fir overhead. Wood purlins are spaced across the roof with alternating intervals that give a subliminal vibrancy to the rhythms of the place; the floor, made with light golden end-grain blocks of hemlock, furthers the sense of glowing materials. French limestone counters in the open kitchen complete the medley of softly fusing colors. The whole is finished and furnished with exceptional care and delicacy, revealing the experienced sensibility of its owners/designers and the care in crafting brought by its builder. Yudell and Beebe both worked closely for several decades with Charles Moore (often in design sessions at The Sea Ranch), first as students at Yale, then becoming key collaborators in Moore Ruble Yudell in Santa Monica, where Yudell and John Ruble are the senior partners in a practice that has earned international reputation. Their significant, place-attentive works span housing, campus buildings, and performance spaces across the United States and in Japan, Sweden, and Germany, including the competition-winning design for the U.S. embassy in Berlin, now being implemented.

The enveloping warmth of the spaces in the Yudell-Beebe House and the subtle forming of the building to its landscape are thrust into spirited dialogue, with the wider surroundings by two small towers reached by separate stairs from the garden. These tower spaces, twelve feet square, are like four-posters in the landscape, marking the presence of people. They contain study spaces, marvelous close chambers that offer selected views of the surroundings in all directions, and small workplaces for drawing, painting, and reading. As an added bonus, the outside stairs by which they are reached bracket the court and run in opposite directions, filling this microcosmic moss garden with suggestions of lively movement and a hint of the romance of balconies.

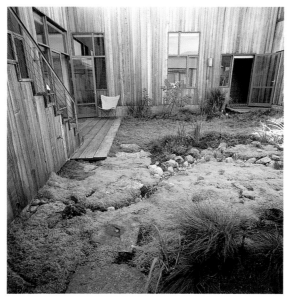

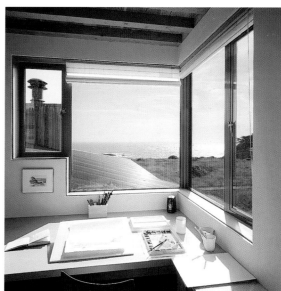

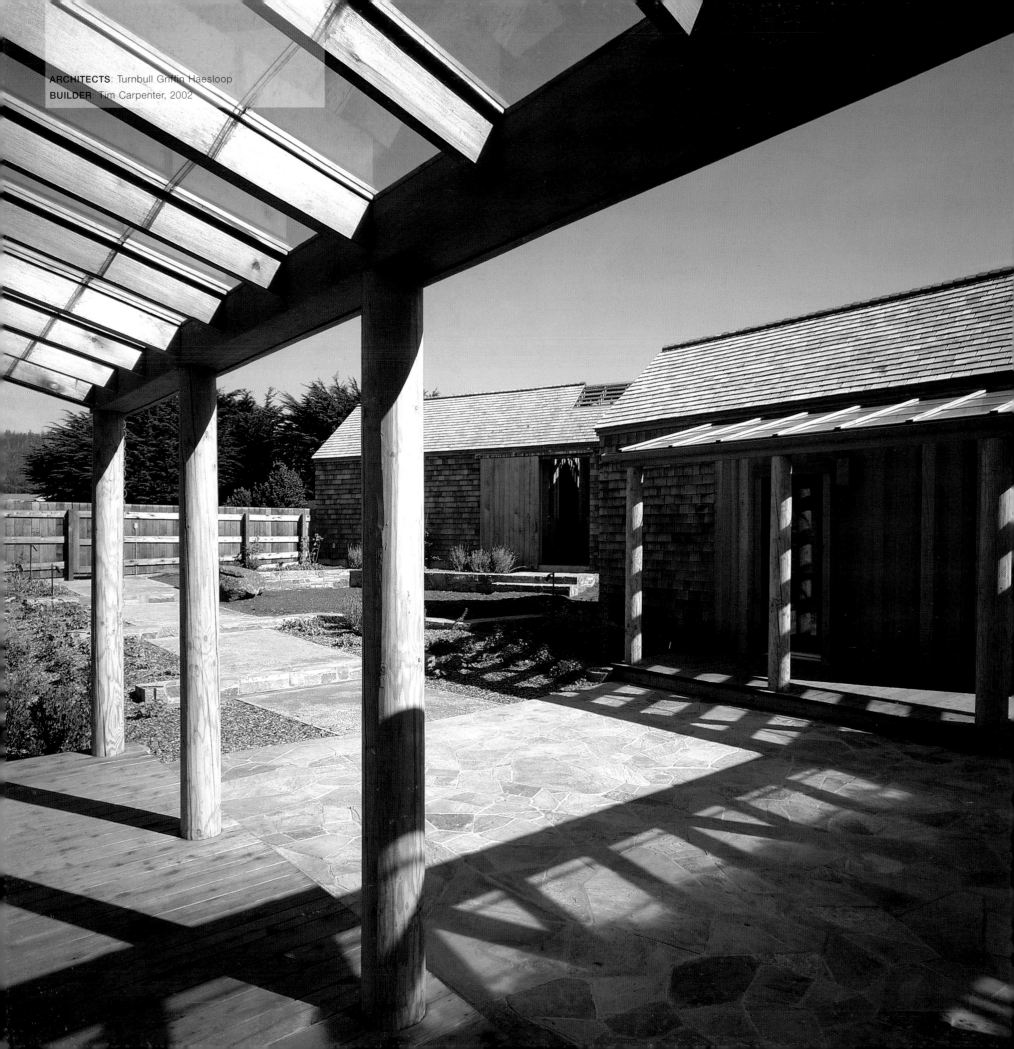

ARCHITECTS: Turnbull Griffin Haesloop
BUILDER: Tim Carpenter, 2002

BOYD HOUSE

study with windows wrapping toward the sun, is in a comparable position at the south end, each with attendant bathrooms and storage. The two smaller perpendicular buildings are for the two sons of the family—similar blocks differently arranged, one more open to multiple uses than the other. Both are formally distinct and separate from the house. A fourth volume, which serves as a garage, responds to the particulars of the site by being skewed to the side; sidelining the car, it also opens more space for the garden and aims its porch, which encloses a hot tub, toward a distant view of bluffs breaking up as they stretch into the sea.

The figurative and emotional center of the Boyd House, though, is the central space of the

The Boyd House terminates a short road that leads across the open meadow toward the ocean without any evident relation to the land. The house and its outbuildings enfold a court that absorbs and civilizes the formless space of the road, providing an internal focus for the place. Mary Griffin and Eric Haesloop continue the firm's use of the gabled vernacular forms that William Turnbull developed with such clarity before his death, imbuing them here with another level of formality.

The complex gathers exterior space in its embrace, and imprints it with a rigorous order of disciplined craft. Three blocks of rooms, each an elegant Monopoly block in form, are ranged around a courtyard and connected by a colonnade of round wooden columns, roofed with glass. The formal certainty of this arrangement, emphasized by the deliberate, centered patterning of windows and doors, is timeless, nearly abstract. The longest block, fronting the ocean, quickly asserts its hold on the site, containing a single long room in the center, between walls of wood-framed glass that open toward the domesticated court on one side and toward a magnificent stretch of oceanfront across the other.

The south end of the central space has elegant kitchen equipment installed on the wall, fronted by a fine wood-cabinet counter assemblage. The north wall is centered by a shallow Rumford fireplace. The ends of the central block hold smaller, more private spaces. The master bedroom is in the north end of the wing, while a

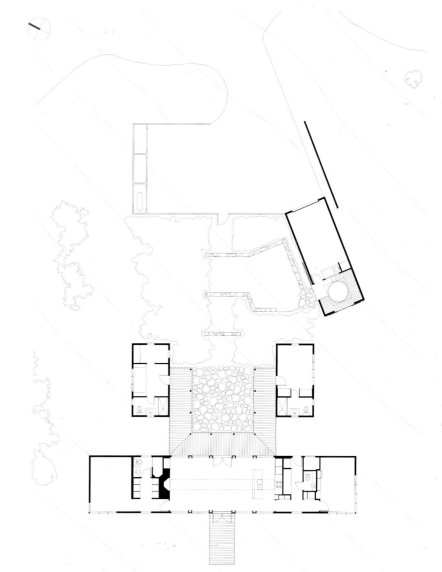

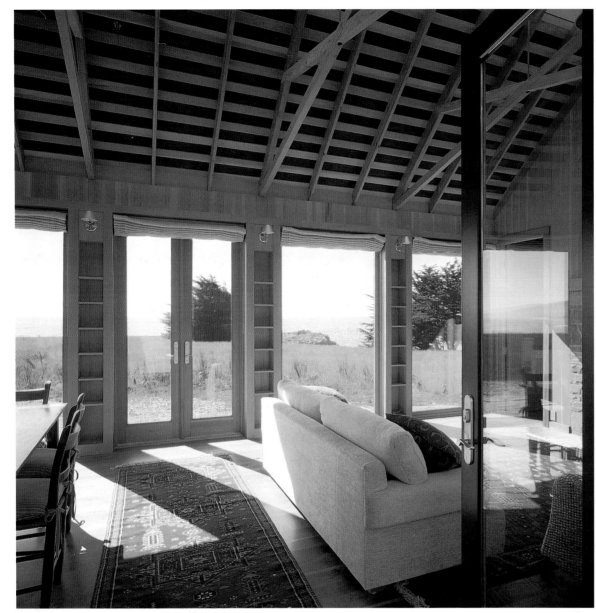

long building, an astonishingly bright, airy, and meticulously crafted room. Its delicately structured roof, with tightly spaced exposed framing interspersed with panels of blue-painted sheathing, carries the sense of a well-crafted wooden vessel, its outer surface shedding water smoothly, the inner surface lean and skeletal; it is reminiscent of the wooden skiff that Turnbull Griffin Haesloop have always had mounted in the center of their office as an abiding message of subtle simplicity and craft. The peak of the Boyd House roof is covered with a continuous skylight, so that shifting patterns of light descend through the network of exposed rafters and tie beams. The walls are nearly all glass, with only small segments of wall in between that serve to

support the rafters. Framed with shelving to give them thickness, these make the room look as if it were bounded by piers made of bookshelves. Beautiful natural linen Venetian drops can quickly blanket the windows, for privacy or to diminish the direct sun.

The Douglas fir selected for construction and cabinet surfacing is of exceptional quality, bringing a golden richness, warmth, and refinement to all surfaces in this house. Space is very economically used, as Turnbull taught; it is the materials and craft with which the house has been made that lend it an exceptional dimension.

The floor of the house is at the level of the court, and all rooms of the three buildings open easily to this enfolded space, creating a potential

center of activity there. The Boyd House, like earlier houses that were designed by Turnbull, sets tight limits on its intrusion into the lands of The Sea Ranch, while the space enclosed is invested with an expansive imagination.

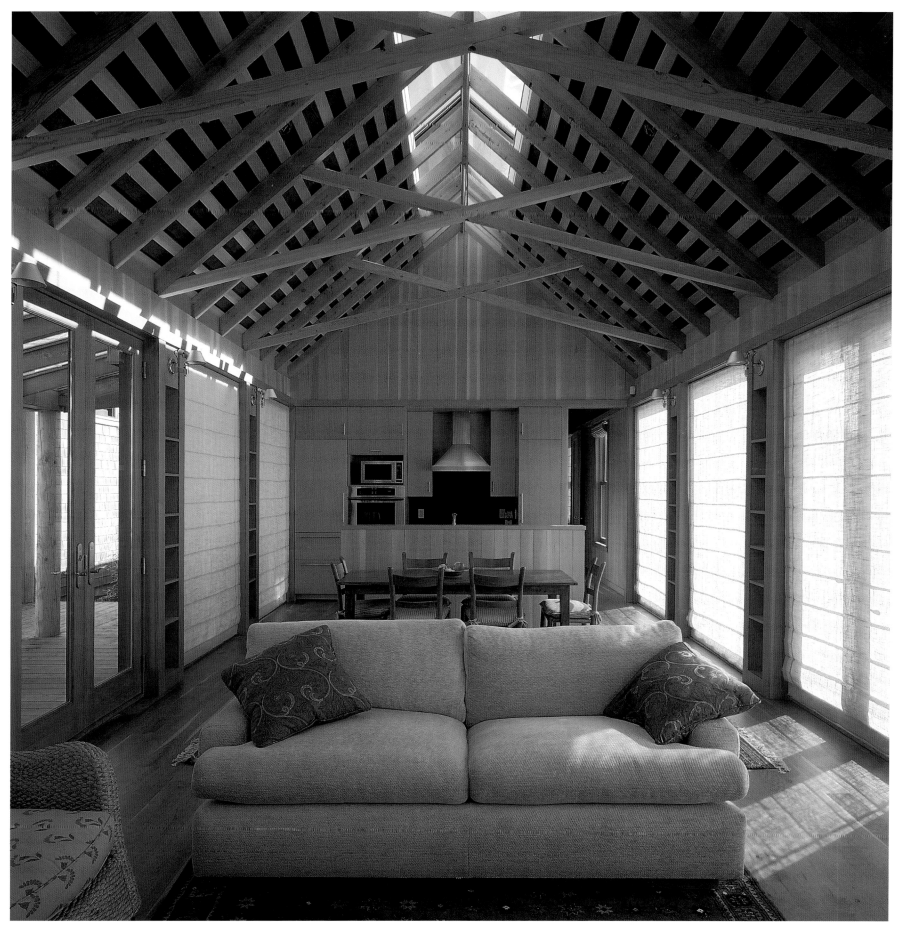

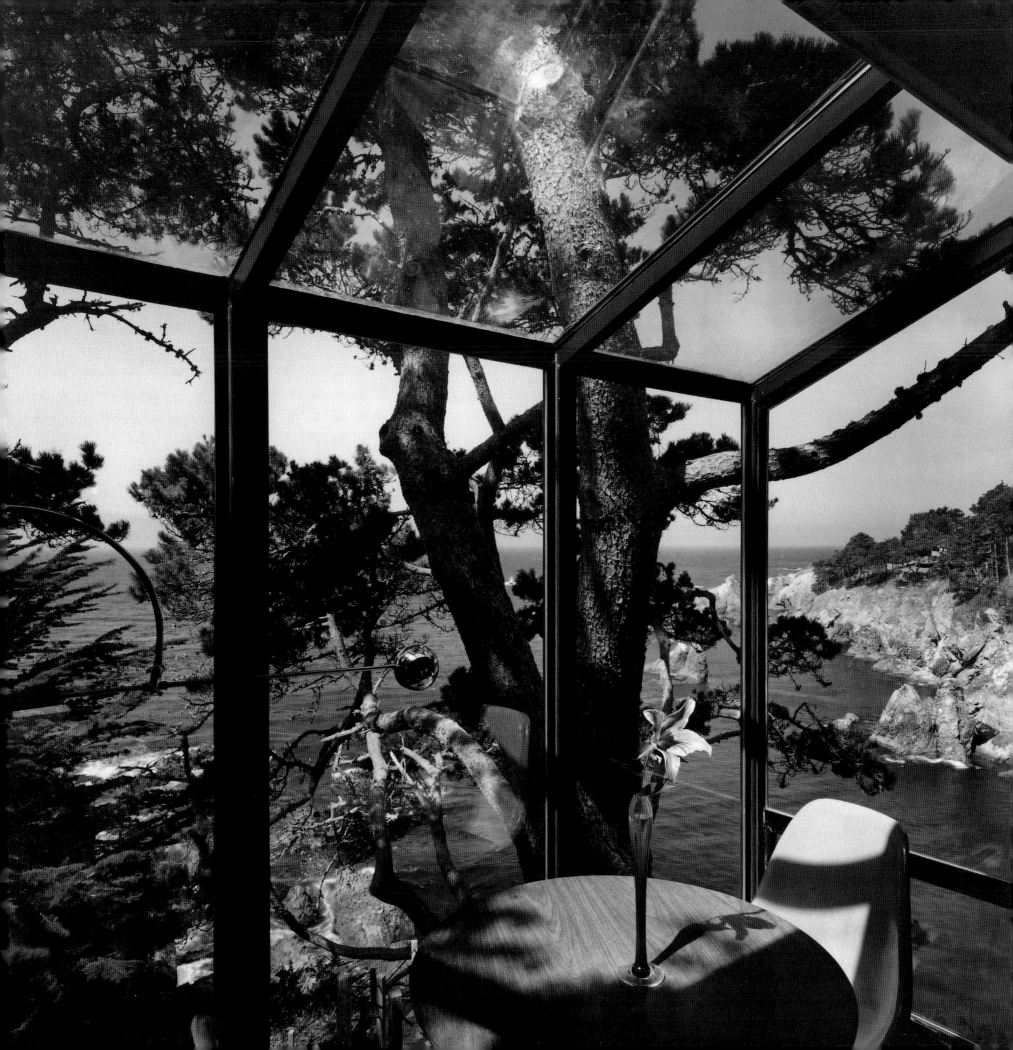

HOUSES
THAT
INHABIT

Houses, as we have seen, can relate to their sites in many ways; it is not a matter of decree or formula, but of being alert to the circumstances of design, thinking to a larger order, and making something that becomes a part of its place. The houses that follow have done this in multiple ways, developing their sites to allow a variety of experiences, forming relationships that interact in interesting and rewarding ways. In doing so they not only take advantage of their sites but confirm their particularity, registering the differences in environment that The Sea Ranch affords and bringing our attention to the splendor of its diversity. They are houses that are exemplary in many ways; but most fundamentally, they enhance and make vivid the pleasures of being in place—attending, enjoying, dwelling in the present, welcoming associations, creating the stuff of memory and thought. They inhabit.

CAYGILL HOUSE (see pp. 258–261)

Built on the brink of a spectacular cove, the Caygill House turns a mute face to the road, yet shelters a treasure of light, space, and stunning views within, offering a wide variety of places to dwell. The house's main living spaces are lodged within a large cube of light-filled space, penetrated by balconies and extended into intimate nooks that hover on the edge of the cliff.

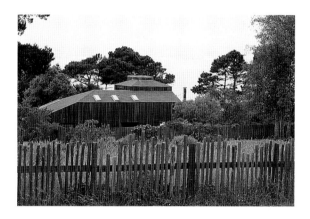

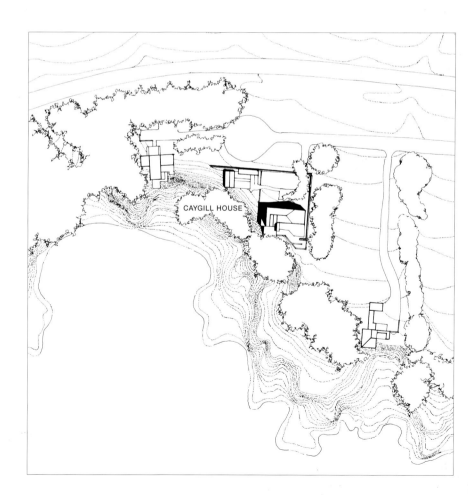

CAYGILL HOUSE

VEDENSKY HOUSE (see pp. 262–265)

This is another unassuming box that yields surprising riches within. The Vedensky House scarcely asserts itself within the redwood forest by which it is surrounded, yet it makes the most of its site among the encompassing trees. Great corner windows open to the lace of the forest, and the skylit volume admiringly captures the changing light of the woods.

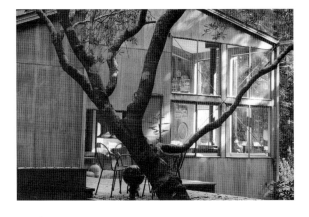

MIGLIO HOUSE (see pp. 266–269)

Sidling down the face of a slope, the Miglio House seems almost alive in its site. With its form gently making its way down the hill and its roof enlarging as it descends, the house was conceived with a close understanding of its site—transcending its transient life on the drawing boards to become a vital part of this place. The long, slender form, a row of rooms bent to take advantage of the slope, forms a perforated border between an upper, secluded meadow and open views out over the cul-de-sac to the spread of ocean below.

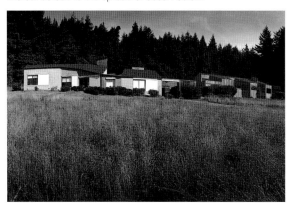

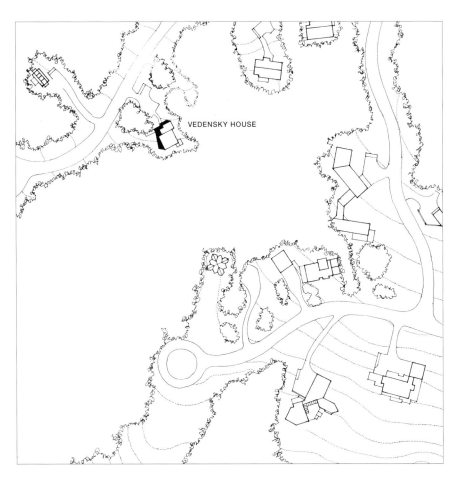

VEDENSKY HOUSE

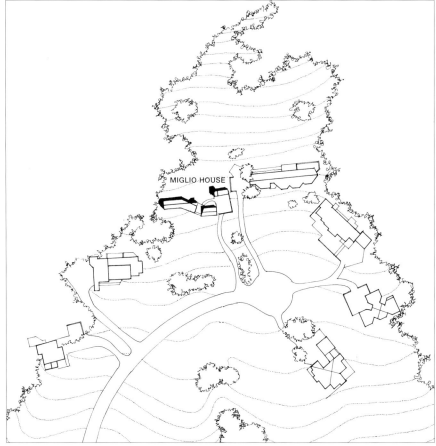

MIGLIO HOUSE

LICHTER-MARCK HOUSE (see pp. 270–273)

The various parts of this house cluster along a swale through the site. Placed in a row of houses that have a semblance of accord but effectively wall off views to the coast, the forms of this house are disposed to maintain a similar scale and character but to open views through the center to the coastline. The house is in two parts bracketing a deck, offering gradations of commonality and solitude, enclosure and expanse.

BAAS-WALROD HOUSE (see pp. 274–279)

Fronted by a sweeping porch, this house reaches across its hillside as a prelude to the forest behind. Its two sections respond to the site differently, one more assertively marking its place in the landscape than the other. The deck between the two forms opens to the expansive view over the rolling meadows to the distant horizon.

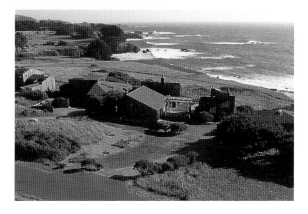

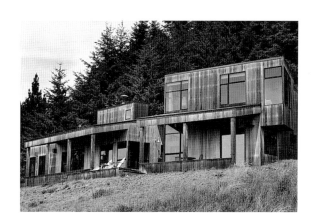

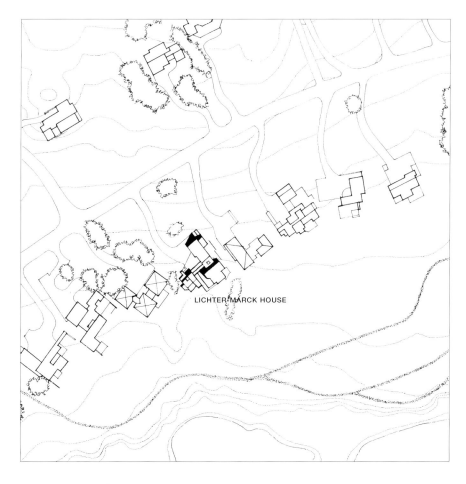

LICHTER-MARCK HOUSE

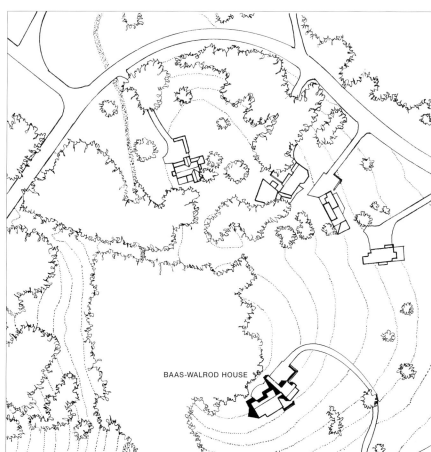

BAAS-WALROD HOUSE

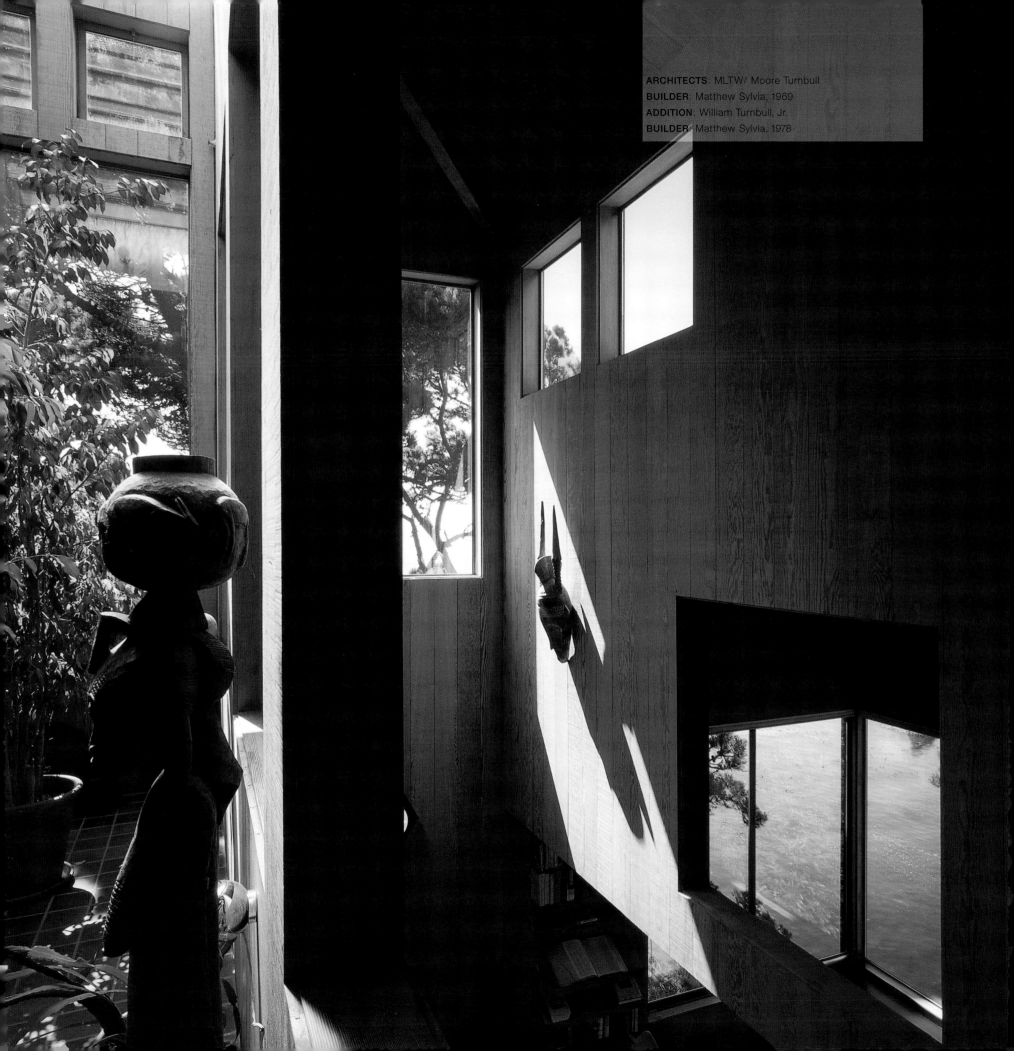

ARCHITECTS: MLTW/ Moore Turnbull
BUILDER: Matthew Sylvia, 1969
ADDITION: William Turnbull, Jr.
BUILDER: Matthew Sylvia, 1978

CAYGILL HOUSE

planning that explored the space In three dimensions, using a large-scale model that could be viewed from many angles. Typically, such a model would have been made of cardboard, often at a scale of one inch equaling a foot, with windows and skylights cut out of its surfaces to make way for the passage of light. Models such as this were used to imagine what the insides of the house would be like and how light would move through the spaces. The house was conceived in space and light, not just in plan; yet its volumes were controlled by an underlying geometric diagram—in the end barely visible, but generative nonetheless.

The overall form of the Caygill House seems simple, even ungainly, from the road. It presents, beyond the walled car court, a high, mostly

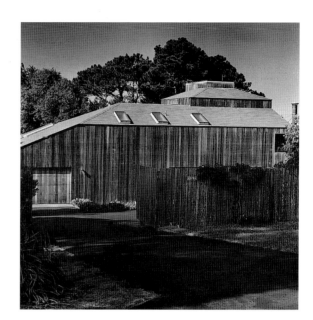

Hovering on the edge of a cove, the Caygill House is a great and comfortable construction, which fosters varied experiences of the site. Views from the house plunge down to the cove directly below, or out through a projecting study (and some close-up branches of trees) to the far horizon; there are views through openings and passages into a contained domestic court/terrace on the south, which are juxtaposed against glimpses up into the tops of tall trees and segments of the sky. These are not unframed panoramas demanding obeisance, but varied views framed through layers of openings—offering aspects of the place to be discovered, each differently rewarding.

Similarly, light moves through the house in continuously shifting arrays, bouncing from surface to surface, penetrating unexpectedly deep into the space from skylights and high windows, and passing across bridges and mezzanines on its way to the floor. Light in some houses is simply the incidental consequence of windows placed for pattern or outlook. In other houses, light is more deliberately cast into the space in order to emphasize a structural or formal concept. Light in this house has the immediacy of nature itself, coursing through layers of form and structure as it might penetrate branches in a forest.

The Caygill House shows perhaps more clearly than any other house at The Sea Ranch how MLTW's way of working influenced the outcome of design projects. The house's multiplicity of views, spaces, and light was the result of preliminary

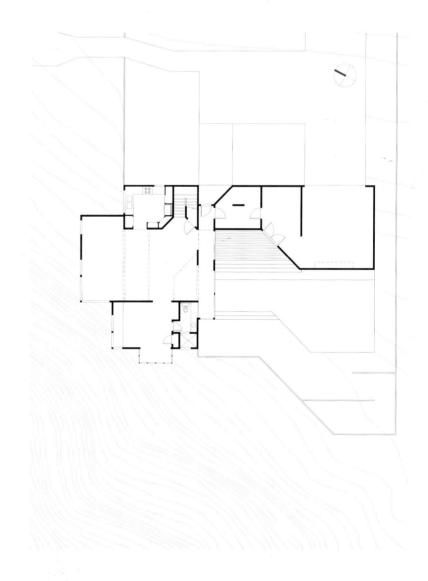

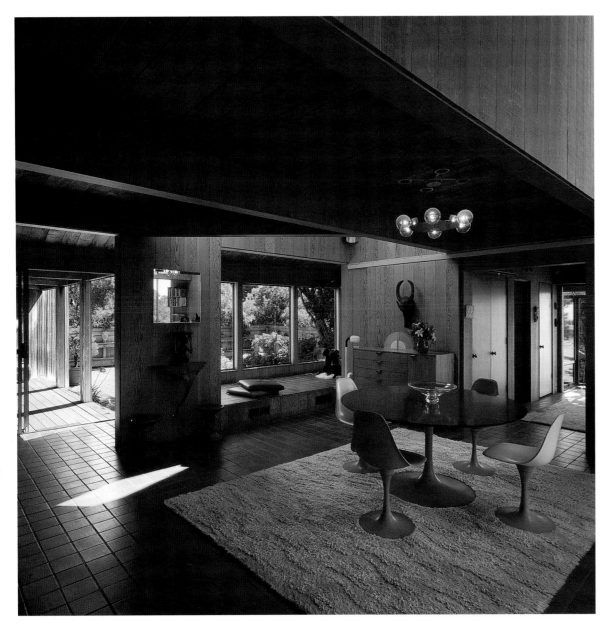

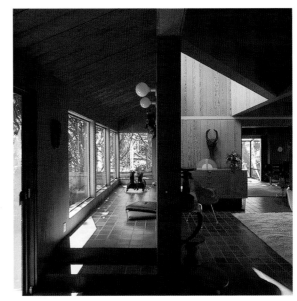

unbroken, redwood board wall, capped by a small segment of roof. In fact, the form is both clearer and more ingenious than it first appears, absorbing the two-car garage and the utility and storage spaces in an ell that separates the house and southern court from the noise and intrusions of the road. This ell nearly obscures the great cubic, hipped-roof volume that forms the core of the house, with a large skylight at its center and sheds that are appended to make lower, more intimate spaces on the sides toward the cove and the ocean. This multiply windowed central volume becomes clear only when seen from the southern court.

Inside, a hefty metal fireplace, placed on a bench platform, anchors a seating arrangement in the main space. Large windows beside it wrap around the corner of the room, filling the space with the life of the cove. Tables and chairs, and plants and sculptures variously inhabit the small platforms, passages, and lofts that make up the rest of the large, open space. A more contained room extending beyond the main space holds a library, desk, and study area still more dramatically poised on the edge of the cliff. A band of construction toward the road holds the entry, kitchen, stairs, and storage area, along a passage to the garage at the south end of the house. That band is repeated at the second level, with the master bedroom at one end opening to the living space below.

Wayne and Terri Caygill were among the first to build at The Sea Ranch, and they have lived in the house ever since, first regularly on weekends, later moving here for much longer stretches. Terri Caygill has developed a lush garden and greenhouse in a walled enclosure behind the house, facing, but not visible from, the road. A modest and separate guesthouse, reached through the garden, was added. It is vintage Turnbull, cast in the simplest gable-roofed vernacular garb, elegantly proportioned and handsomely made. It too hovers on the edge of the cove, with windows that carefully select views out and down through trees to the shore.

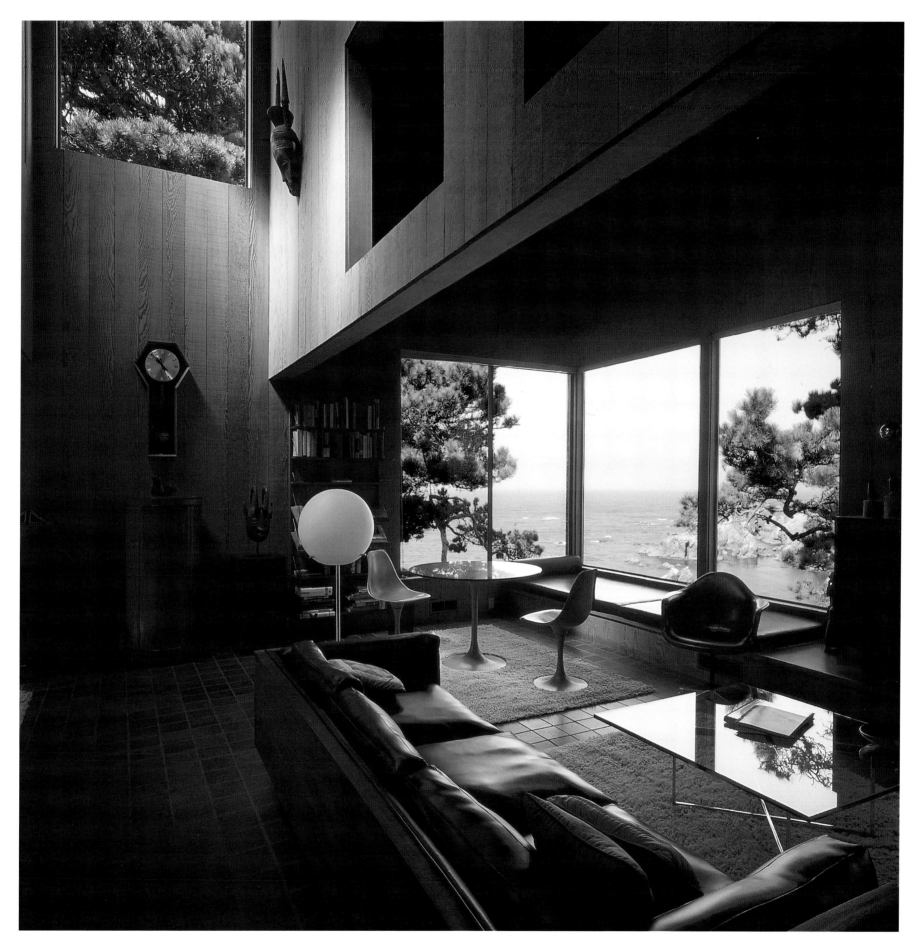

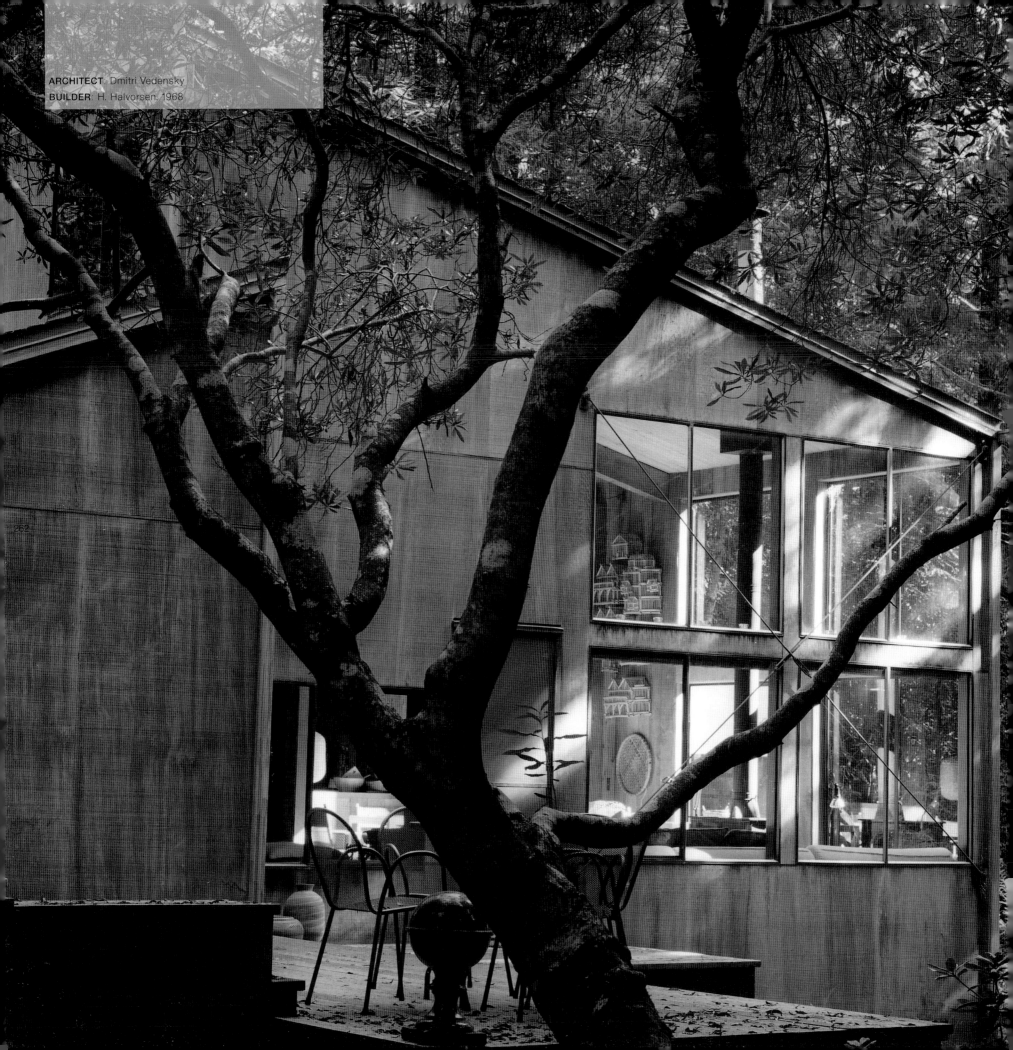

ARCHITECT Dmitri Vedensky
BUILDER H. Halvorsen, 1968

VEDENSKY HOUSE

(now the Whitaker House)

The Vedensky House is parked among the redwoods, midway up the ridge. It is surrounded by thick redwood forest and inhabits a world very different from that of the meadows. To those accustomed to the sun-baked open grassland, the site seems at first dark, even dank. The redwoods, with secondary growth ringed around ancient stumps, are for the most part three or four times the height of the structure. The ground is a mix of redwood needles, ferns, and dirt. But the apparent dark is deceptive. In fact, over time there is a constantly shifting array of differing kinds of light in this place. On clear days, shafts of sun pierce down through layers of redwood trees to create dappled screens of light weaving through the forest. At other times, the fog creeps around the house, enfolding it in quiet. On cloudy days, the towering spikes of redwood rise high into the gray sky, their trunks weaving a surrounding of soft red-brown wood laced with blackened green.

The inner world of the house translates these qualities into an experience that is like living inside a beautifully crafted wooden lantern. The light of the sky is brought directly down into the space through an oversized skylight. Placed in the high southeast corner of the volume, it captures light from the clearing made by the house itself, whose color is warmed by the rich wood wall surfaces against which the light falls. The opposite corner, containing the living room space, is almost entirely glazed, opening to the close-ranked trunks of redwoods outside, their vertical strokes blackening as the forest grows thicker

beyond. Ferns and redwood needles carpet the floor of the clearing, disappearing down the slope to the dark edge of a ravine. Glimpses of the sky and ocean beyond filter through the tree trunks.

Directly beneath the skylight is the bathing area, visually separated by a screen wall from the rest of the space but sharing its light and the spacious volume above. This area, opening through sliding glass doors to a deck on the east, originally held an imported Japanese soaking tub, and now makes a wonderfully capacious shower, with slatted wood underfoot. The kitchen also shares the high volume, tucked compactly behind a refrigerator/cabinet block and linked to the seating area across a tiled counter. Shelving climbs up high on the south wall, its displayed

contents mixing items of daily use with exotic vessels, objects, and masks acquired on various trips to Asia (and to the numerous Asian antique shops of San Francisco). The Asian undertones of the house are emphasized by a large Japanese lantern and by a continuous cushioned bench that borders the west windows, then bends out into the room to define the sitting area.

The theme becomes more explicit in a square tatami-matted cubicle whose lower floor opens through to a small guest room beyond, where a shoji screen slides down from above to provide privacy when needed. This spatial extension of the main room creates a small place of intrigue and association, borrowing from the traditional Japanese tokonoma, a space of

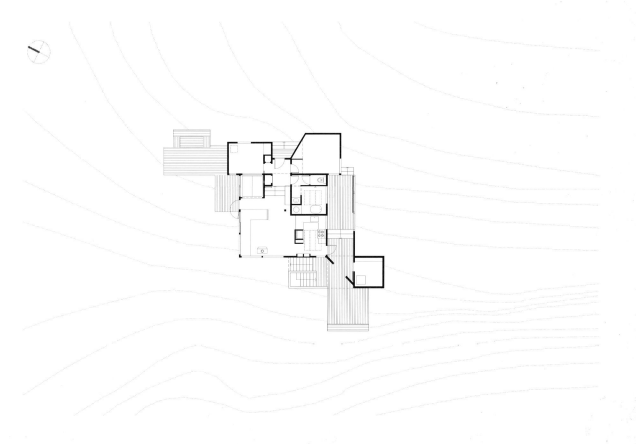

dedicated display, though here absent of sacred implications. Perhaps it was originally meant to be dedicated to the spirit of hospitality. Above this cubicle a ladder-accessed loft offers another sleeping nook and a perch to inhabit the space.

To the northwest of the house a simple set of wooden terraces reaches out into the forest to catch sun at the edge of a small clearing. The opposite, east-facing deck at the side of the house passes through a diagonally placed wall with a circular moon gate opening (borrowed rather literally from Chinese gardens) to stairs that climb toward an upper viewing platform.

Dmitri Vedensky, who built this house in 1968, studied at the University of California with Eric Mendelson and William Wurster, and was an architect working with Joseph Esherick when The Sea Ranch was initiated. Later he went into private practice and built a number of very fine homes. From 1986 until his death in 1997 he served on The Sea Ranch design committee. This house represents clearly his particular fusing of an elegant design sensibility with the specifics of the site, achieved with great economy of means. Richard and Sue Whitaker purchased the house after his death. Whitaker, who was one of the founding partners of MLTW, recently returned to California from Chicago, where he was dean of the School of Architecture at the University of Illinois, Chicago Circle. He has since become director of design, chairing The Sea Ranch design committee.

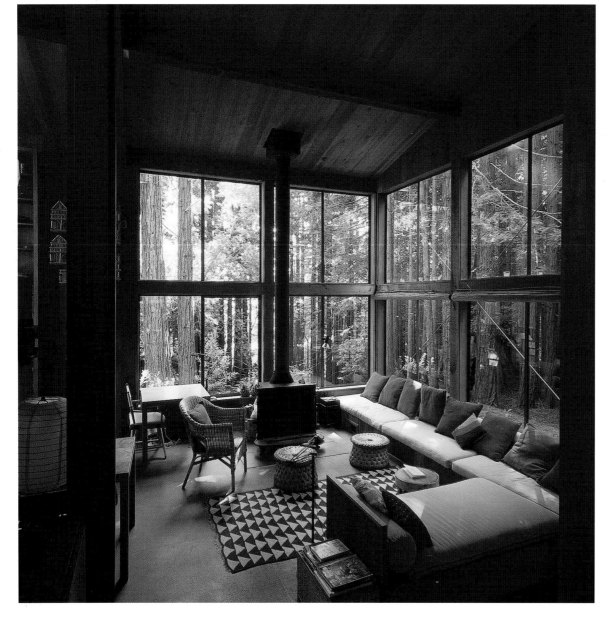

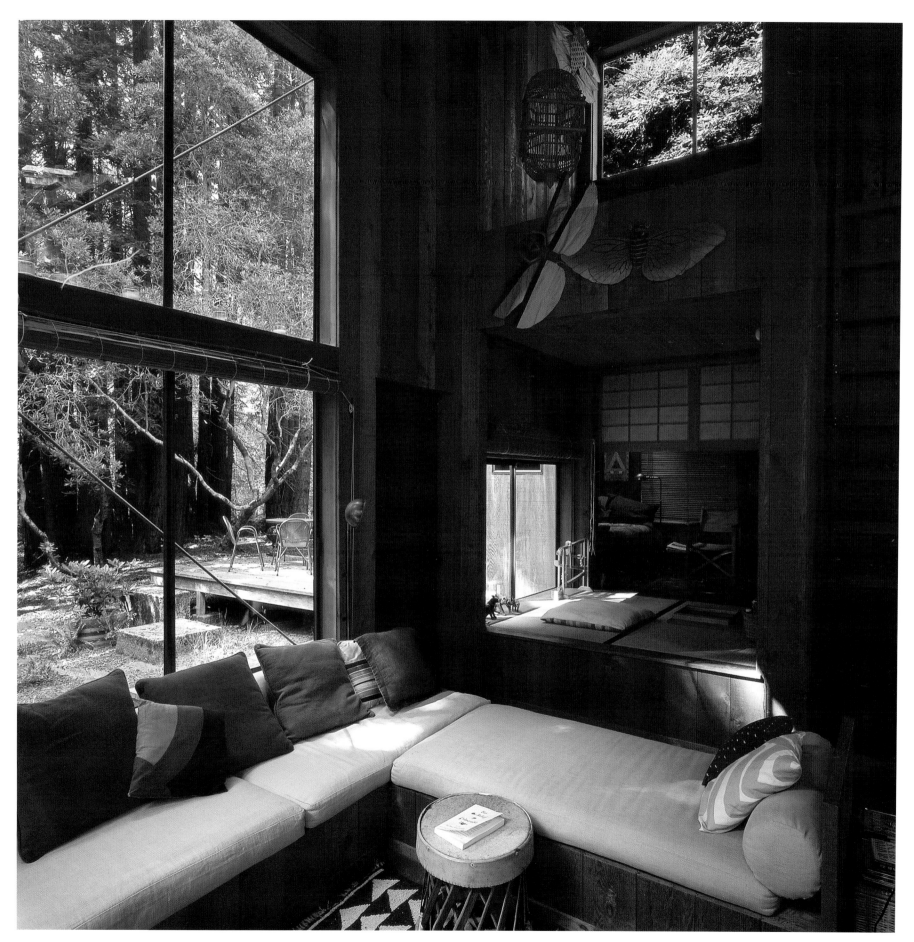

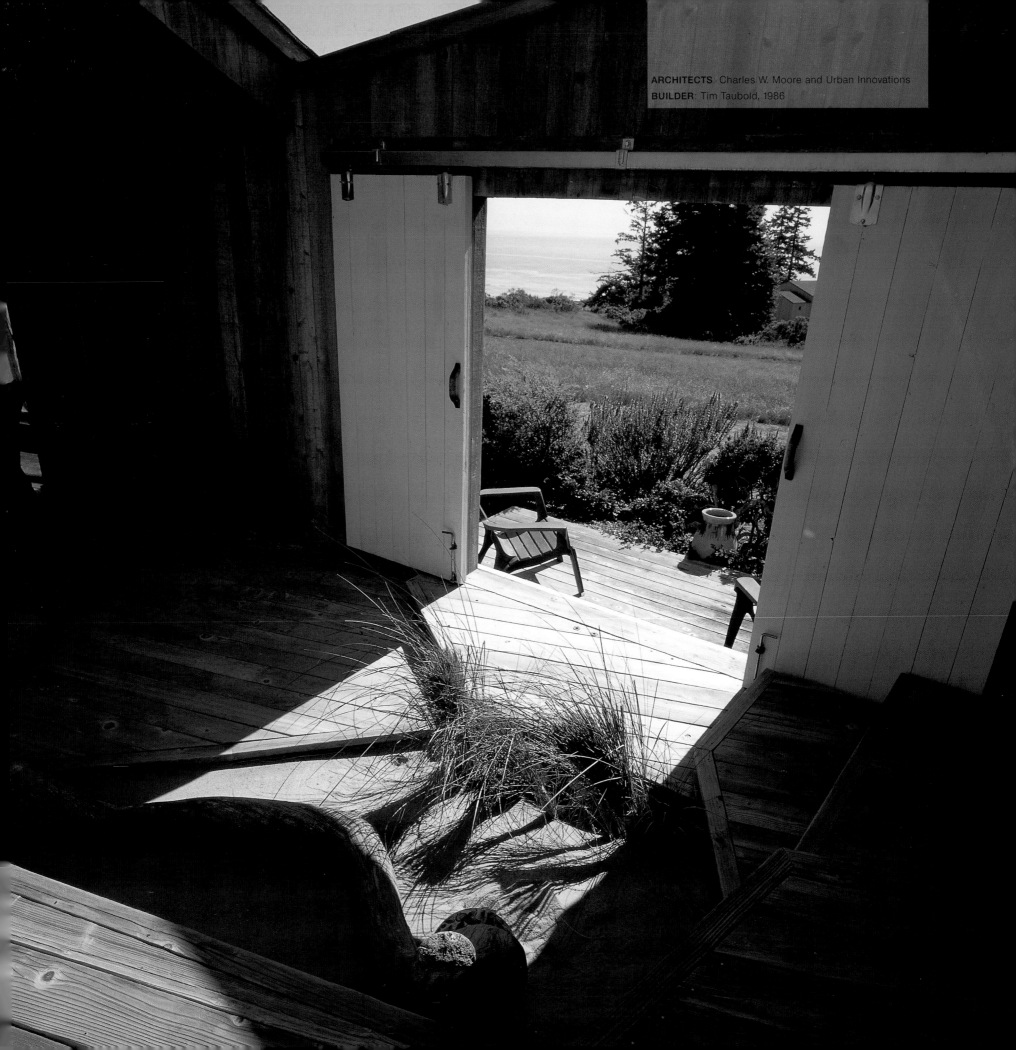

ARCHITECTS: Charles W. Moore and Urban Innovations
BUILDER: Tim Taubold, 1986

MIGLIO HOUSE

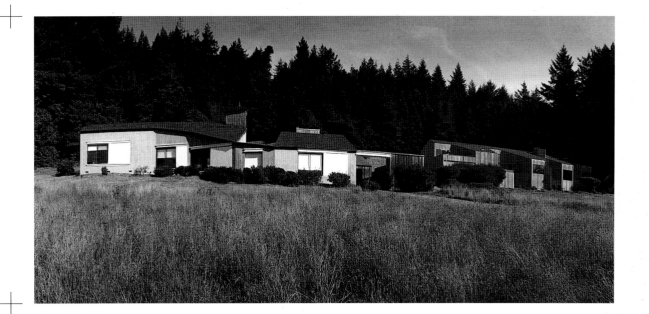

The house that Charles Moore designed for
Bruno and Rose Miglio is one of the most suit-
ably inventive and well-fitting houses at The Sea
Ranch. It is a long, thin structure, one room wide,
that consists of two linked pieces, now supple-
mented by a third. The original house slips along
and down the contours of a hillside, near the
edge of the forest. The highest room of the
house, a tightly defined bedroom or study that
fills the end of the volume, is reached by a corri-
dor on the ocean side, which also gives access
to the bathroom. The corridor then descends a
few steps to pass by the kitchen and become a
part of the dining area. The passage here spills
over a set of angled and spaced steps that cross
the room as it widens toward the ocean side and
becomes the main living space of the house.
From there a door opens into a stepped, walled
courtyard, serving as entry and as a link to the
separate bedroom and bath that complete the
house on the other side of the court.

 The roof starts as a simple gable over the
first bedroom, its ridge running parallel to the
slope. As the rooms step down and bend toward
the ocean, the ridge beam carries on straight,
becoming a truss that rides through the expand-
ed space. It terminates in the end wall next to a
small shaft of space that reaches up to form a
miniature tower. A high window in this tower lets
unexpected light into the end of the room as it
allows the stovepipe to climb up out of the space.
As the building widens and steps down under the
gable, the eave becomes lower, creating an

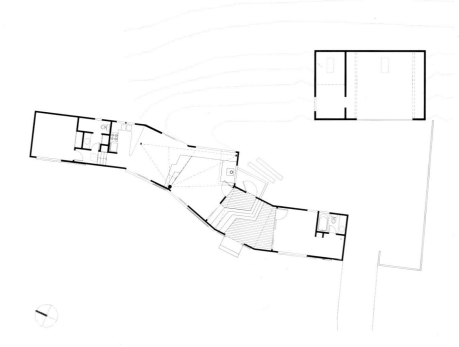

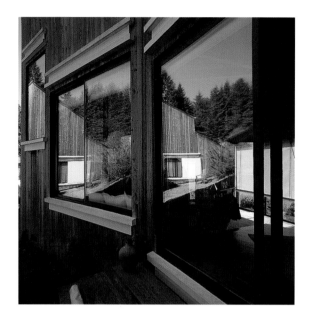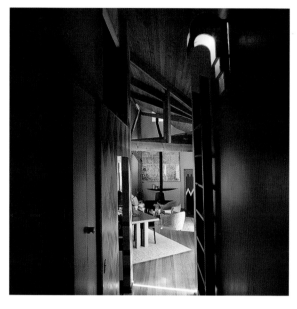

angled shape outside that directly translates the descent of the house into a shape that seems almost to slither across the land.

Cars arrive past the end of the house in a courtyard defined now by a garage and storage addition. Entry to the house is either from here or from the ocean side, where a wooden threshold deck steps down from the court. Inside, the space is altogether surprising and fresh, animated by the intricacies of the truss, beam, and strut system that radiates from a column in one corner of the living area and practically defies analysis. The traces of this mysterious structure and the light that falls across and through it provide ample amusement. Large, white, sliding barn doors can be used to cover glass sliding doors, which offer sweeping views to the ocean but are also vulnerable to sun and storm. On the uphill side, sliding doors open to a meadow pocketed between the house and the edge of the woods. The thinness of the house and its large openings to either side make it practically a lantern inside, filled with the light bounced from the ground. The light is warmed by the soft golden paint on the walls, the rich browns of the fir framing and ceiling, and the exuberant patterns derived from Indian paintings that bring multiple colors to wall surfaces in the kitchen.

The basic simplicity of room planning in this house is given magic by the ingenious complexity of its adjustment to the site. The rooms descend as they angle across the slope, with the roof taking on a life of its own as the walls extend downwards, while the ridge remains constant. Framed views up to the forest and down to the ocean connect the house further to its surroundings, while the small tower at the entry pins the complex to the site—and to the region, one might add, noting similarities in diminutive size to the chapel towers of Fort Ross.

Without attributing intent, it is tempting to consider a reference to this rustic Russian outpost south of The Sea Ranch as being suitable for the Miglio House's cosmopolitan owners, Bruno and Rose, born, respectively, in Italy and Germany, and with a second home in Sardinia. Their primary residence was initially in Palos Verdes, but when Bruno retired, they moved to The Sea Ranch as their principal home—building, along the way, another house in the meadows far below (also designed by Charles Moore) to be used for rentals, friends, and relatives.

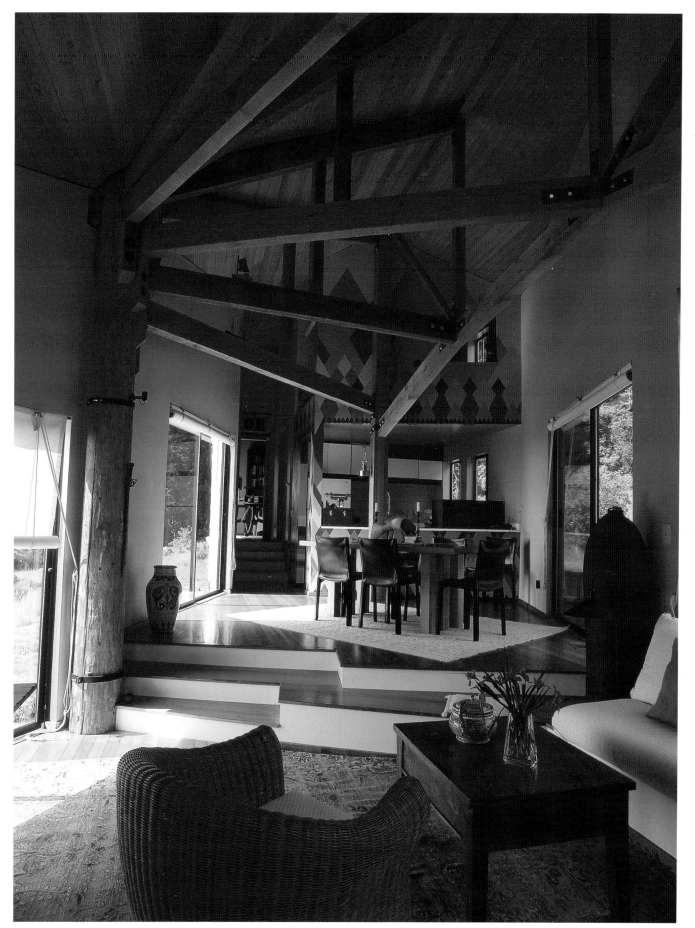

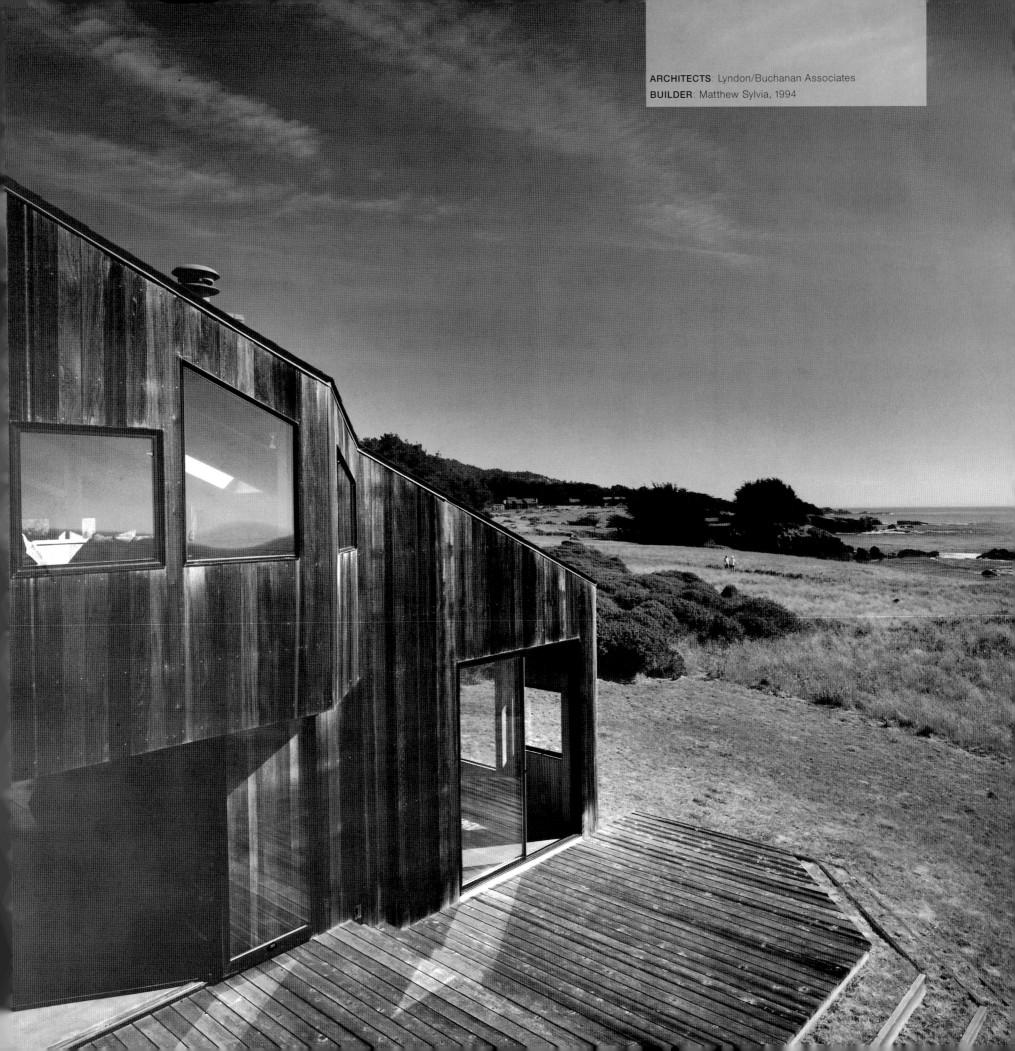

ARCHITECTS: Lyndon/Buchanan Associates
BUILDER: Matthew Sylvia, 1994

LICHTER-MARCK HOUSE

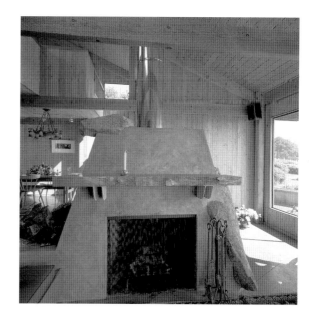

The house belonging to Linda Lichter, Nick Marck, and their three children inhabits the bluffs at The Sea Ranch, in a section with lots placed along a road that runs out onto Sculpture Point. Uncharacteristically for the early Sea Ranch, these lots make a waterfront row, though a trail along the bluffs does pass between the houses and the ocean edge about one hundred feet out from the buildings.

On this particular site a shallow swale bends up through the lot from the cliff, and a slight knob directly in front of the house on the ocean side shelters the living room somewhat from the trail, making a visible contour for the house to settle into. The house is built in two pieces, linked by a decked open space, which follows the swale and provides a common area from where the most dramatic views out and down the coast, or up to the point can be enjoyed. This open space, sheltered by a trellis, with a plastic roof below, also opens up the view for those on the road above to see through to the ocean—a relief from the wall of houses that mostly block the ocean panorama here.

The larger building volume contains the public rooms of the house—living and dining areas and kitchen—plus the children's bedrooms (each with a view across the deck to the ocean) and a guest sleeping loft. The smaller building holds a master bedroom suite, including a sitting area, a dressing room with a large antique bathtub, and a bathroom. Above this space is a splendid room that serves as a "project room,"

with adjoining deck, for anyone in the family who has a project for which they need privacy and outlook.

The long wing is, in itself, made up of three pieces with differing roof treatments: one has a roof that reaches up to let in the southeastern morning sun for the bedrooms; one has a flat roof over the kitchen to guide light across and onto the continuous deck; and one slopes down southwest into the winds off the ocean. From the corridor running the length of this wing, a garage is accessed at one end. A play space leads out to a deck in the east court, before the corridor steps down to the kitchen at the other end and reaches out into the living space, with views out across the grasses to the ocean.

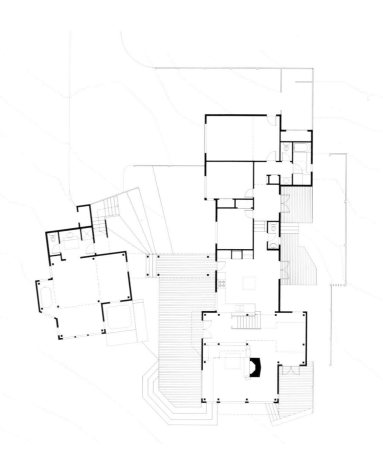

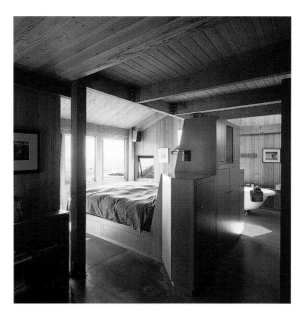

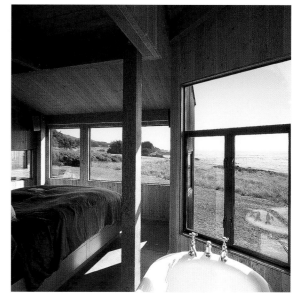

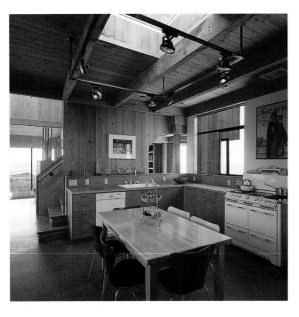

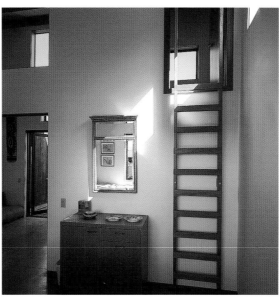

The big family-style kitchen, with a central skylight, looks out in three directions—east to a garden with roses, south through the living and dining room to the ocean, and west to the deck and ocean beyond. The dining area next to the kitchen has its own deck on the southeast side, sheltered from the wind. The living room steps down a few more stairs around a concrete fireplace that is marked with large local boulders and curls into a built-in bookcase-backed bench. The living area opens through a large sliding door directly to the lowest level of the deck and the ocean beyond. A bayed mezzanine stretches across the entry at the back of the living room block to the guest sleeping loft.

Light passes through and around the house in marvelous ways. Every point in it conveys a sense of its place in the land and the slope to the sea; this is achieved by the slight changes in level and a series of windows offering differing outlooks. The deck, spilling down wood-edged earth stairs into the mild swale on which it is sited, further emphasizes the progression of the land through the site.

The master bedroom block has a life and form of its own, providing refuge within a simple set of spaces that flow into each other, but are each distinct. In many ways this small house, with its own deck and its sculpted form, becomes an aedicule for the whole—a comprehensible element that is memorable and distinct, more approachable than the other, slightly larger forms. Nowhere does the house come across as big, although it is actually fairly sizable in square footage. All parts are in units that are easy to imagine inhabiting, and the forms are juxtaposed in a way that is clear. The separate discernible pieces of the house become part of the adventure of moving through and around the site. They ask that you reconsider your position in this space and pay attention to where you are, as you inhabit the spaces in and around it.

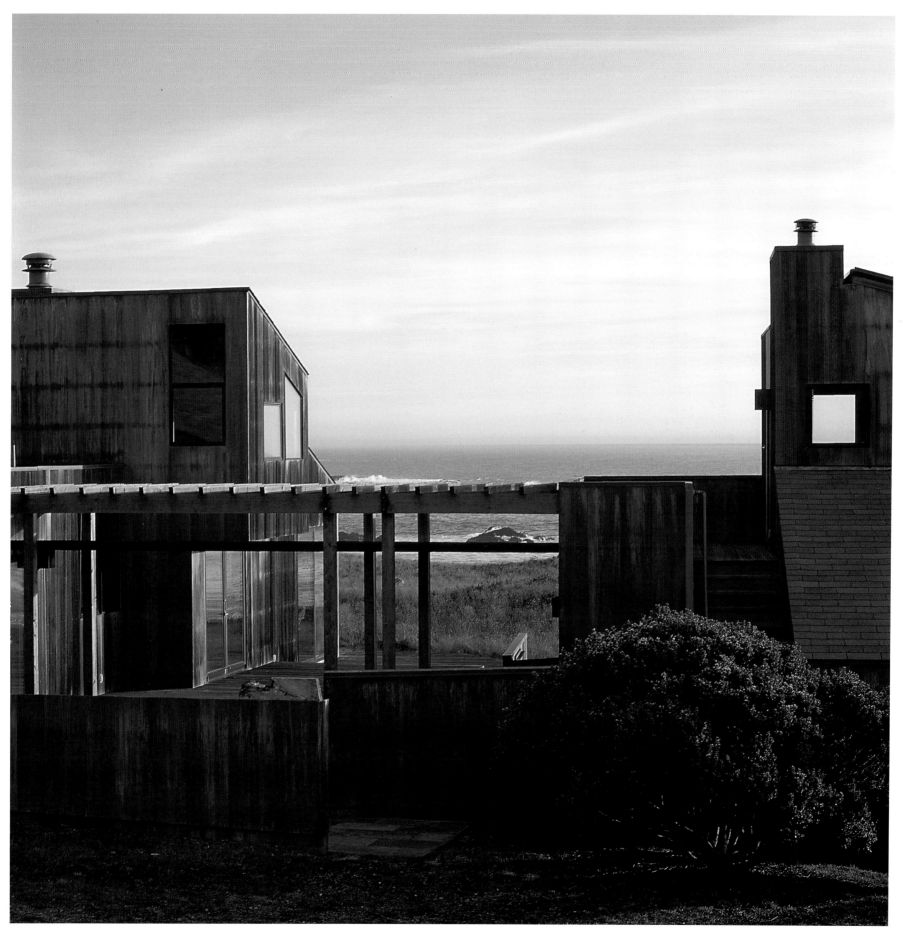

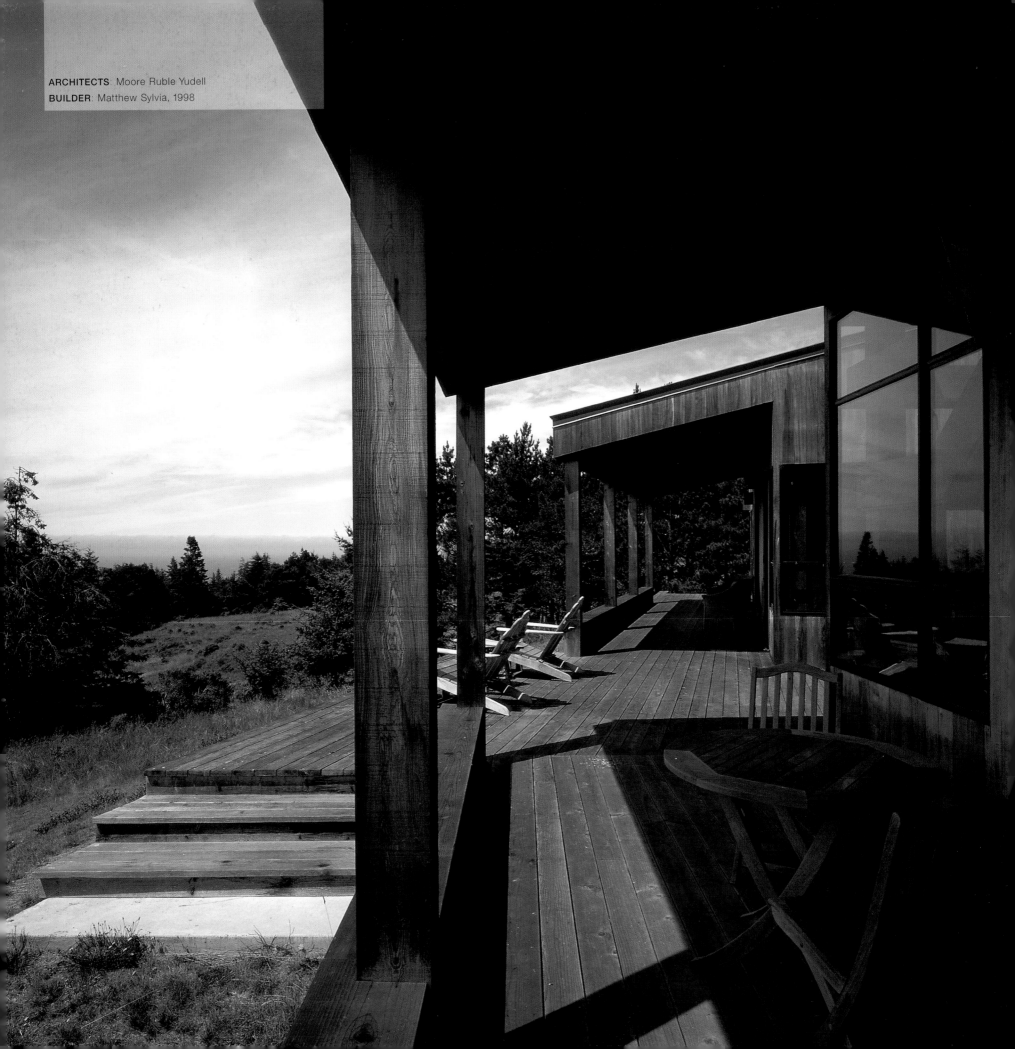

ARCHITECTS: Moore Ruble Yudell
BUILDER: Matthew Sylvia, 1998

BAAS-WALROD HOUSE

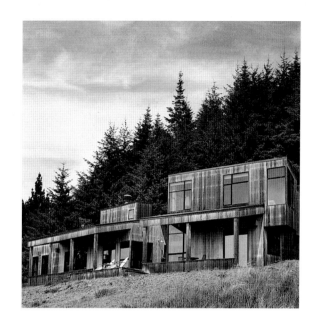

cleared landscape below and off to the distant sea. It is no mere add-on, however, but is inherent to the conception and the life of the house. Its columns mark out a rhythm that is continued in a wider spacing in the main living volume.

Inside, the space flows through three bays, big and clear, from the entry to the far end of the house, with the third bay partially screened by a cabinet and sliding door to shield the sleeping space. The beamed roof rises from the porch side toward the forest and a ridge that runs the length of the house. Opposite the first bay, a lower roof slopes back down again to shelter an open kitchen area with ample tile surfaces and a large island counter. The second bay reaches up

Sitting on a rising slope above The Sea Ranch Airport, the Baas-Walrod House forms the edge of the forest, facing the ocean view with a porch that, while not continuous, sets a measured pace across the front of the house; it is bent slightly to follow the slope of the land. The house itself is made in two distinct parts, separated by a gap. One volume holds the main living quarters; the other, two stories high, contains studies and can double as a guesthouse. The porch and its connecting deck bind the volumes together in a gesture that settles them into the land. While the house, standing forward and apart, does not merge with the forest behind, it reaches back toward the trees on either side to shape an enclosed terrace between.

Large porches are rare at The Sea Ranch; they were discouraged in early buildings, Al Boeke recalls, because there seldom was need for shade, and in his view the dark massive shadows that deep porches make often become unduly assertive in the landscape, modeling buildings in a way that emphasizes their individual sculptural presence.[1] Here though, the gesture seems altogether correct for this exposed and expansive location. The shadows of the house serve only to soften the contrast between the sun-bouncing boards of the house and the dark, light-absorbing conifers behind. The porch is wide enough to easily accommodate furniture; and its southeastern orientation make it sunny enough to provide, even on winter days, a comfortable place from which to look out over the

275

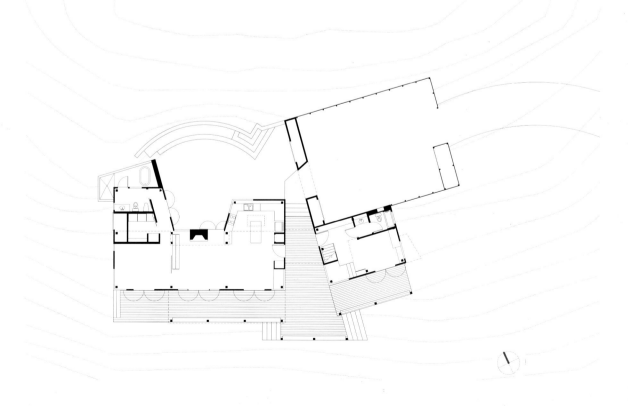

to a high, north-facing monitor that splashes light down into the space around the central fireplace. The structural frame is most intricate here, with four posts reaching up into the higher space and a stainless steel chimney rising through their center. The fireplace itself is an upright plastered block, integrally colored with a rich, gentle green mixed by Tina Beebe and closely akin to the vegetation that edges the court beyond. The high rear wall behind the fireplace is glass, opening to the court and leading the eye up to the tips of the rising redwoods. The third bay, with sleeping space, is bounded near its peak by a wall that separates the closet, toilet, and bathing space. (A shower and Japanese tub are outdoors in a sequestered open-air court.)

Light in the bedroom is especially beautiful; the brightness of a pair of large glass doors, which are not covered by the porch, is balanced by a small window placed against the rear wall, spreading radiance across its lightly stained, soft green wooden surface. Pairs of windows intersect in each corner of the long ocean-fronting wall that stretches along the length of the house. The last post at each end is thus framed in light and the window mullions disappear behind it, blowing the space open to garner light and outlook where normally rooms are most confined.

The experienced sense of a spatial reduction, from the wide, open eating area and kitchen to the more confined and elegant bedroom space, is quite different, and more subtle, than might at first be assumed from drawings of the plan. Here the kitchen and bedroom service spaces can be seen to balance the central fireplace and to shape a tapering open court behind. Edged slightly into the hills, this court is given evocative form by a concave set of stepped stone retaining walls, intimations of classical form. Lodged between the house and the forest, the court is more intimate and cultivated than the sweeping front.

The experience of the whole place is inflected by the sequence of movement through it, beginning with a fenced car court behind the studio building. A thick wall of storage spaces and a framed opening definitively sets this space apart from the more formal court of the house. Just beyond the entry portal the gap between the two buildings opens with a deck moving abruptly down the slope, as the slot between the two buildings splays outwards toward the airstrip below and the ocean beyond. The front doors to the main house and the studio face each other under the shelter of a short stretch of roof linking the two. Each of the doors is large and surfaced with resawn redwood, stained a soft Oriental red, with an inset grid of shallow saw cuts. Their quiet energy sparks across the space.

The studio building is a taller space, with a roof rising toward the ocean. It has two narrow bays; one is covered by a loft at the second level, with a bathroom at the rear underneath. The studio is a small volume filled with images of climbing and nesting and playful spatial complexity. Its sense of concentrated intensity is quite different from the house, which, despite the steady pace of its structure, has an open, relaxed, ambling air.

The two studies lodged in the second building are more like retreats than work stations—places to meditate in as well as study. The upper loft features a glassy angled bay projecting out at the peak with wide surveillance over the airstrip below and out to the forested coastal hills. The room below is stately, with many bookshelves, a built-in dictionary stand, and doors opening out onto the south end of the porch. Just by the front door, open-tread stairs climb and turn over a nook with a cushioned L-shaped bench, perfectly sized for crawling into. The improbability of this intimate corner makes it magical, the effect heightened by large windows that wrap around its edge, flooding the stairs, the nook, and the thick exposed wood framing with bright light.

The great wooden posts that march along the face of the house, inside and out, and the similarly hefty beams spanning the roof are heavy timbers, reminiscent of those at Condominium One. The recollection is not coincidental; Jackie Baas, a former client and friend of Charles Moore's, stayed in the condominium many times, and it carries for her powerful memories. She wanted her own house to partake in that spirit of place, which she had come to love.

The house partakes as well in the special qualities of the site. Its proximity to the airstrip has strong associations for Baas, whose father piloted small planes. She remembers fondly the

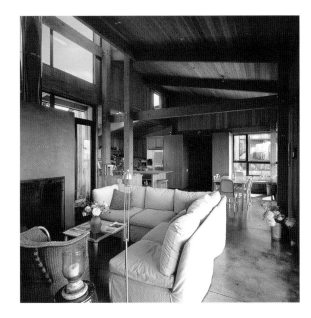

similar small landing fields of her youth, with expanses of space and silence interrupted only occasionally by the exhilarating buzz of planes climbing into the sky or settling down onto the leveled ground. Here, the paved level strip of landing space below sets the middle ground for a scene that absorbs the full scope of the place, reaching from the building's concrete floors, timber framing, and wooden decks to the wide view over the sloping forest to the distant and silent horizon of the ocean.

1 Conversation between the author and Al Boeke, 1999.

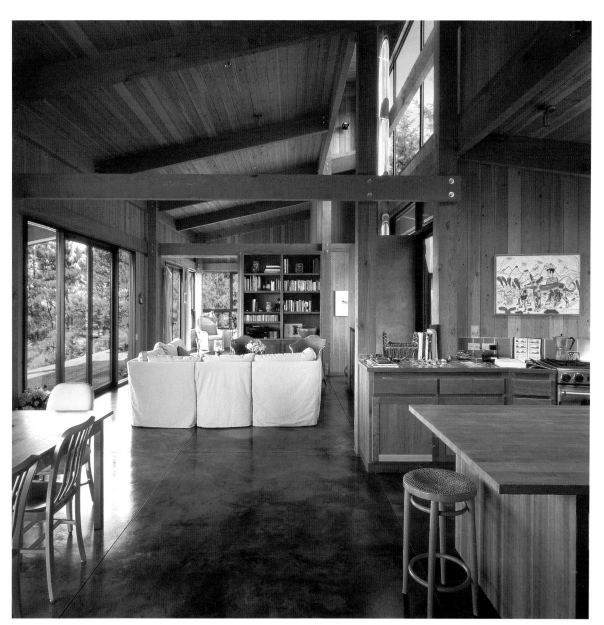

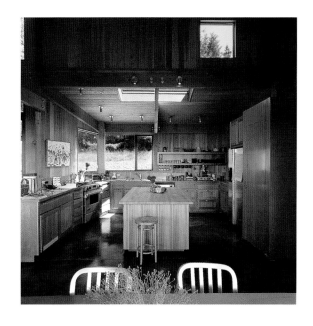

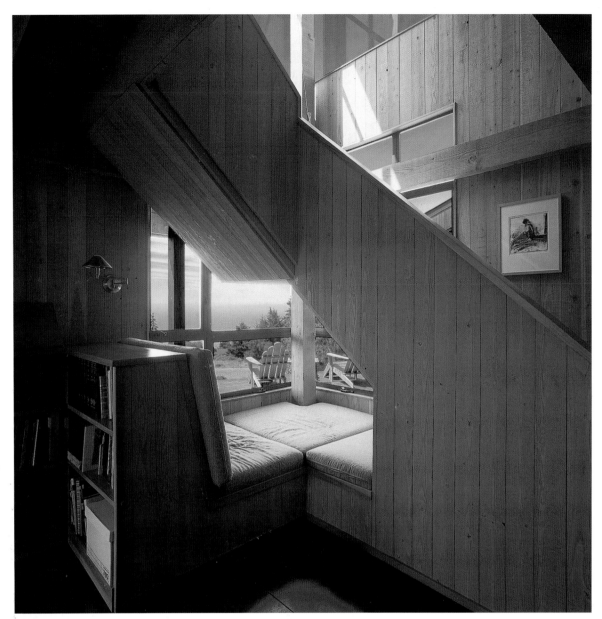

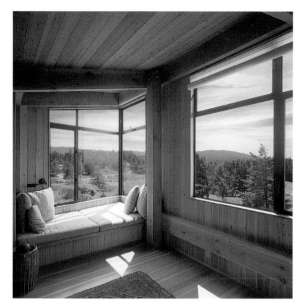

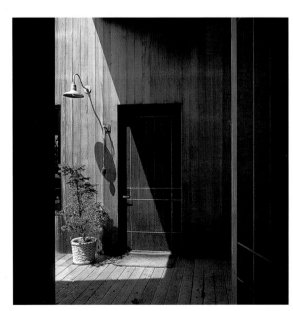

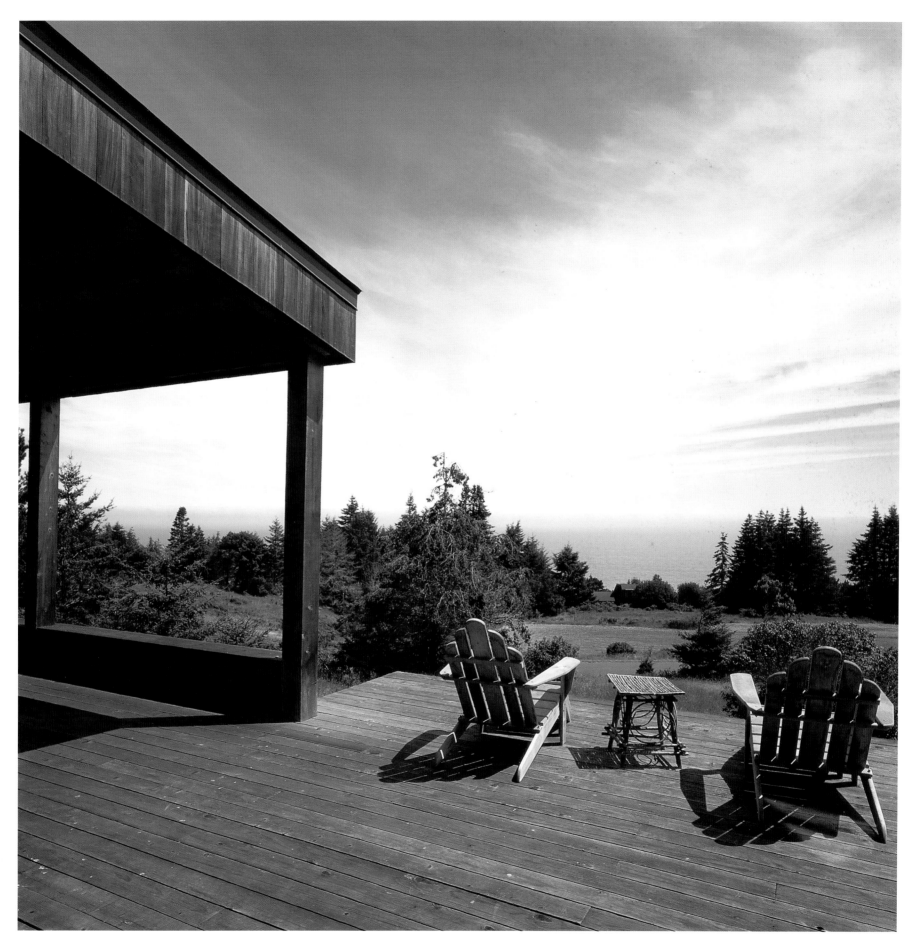

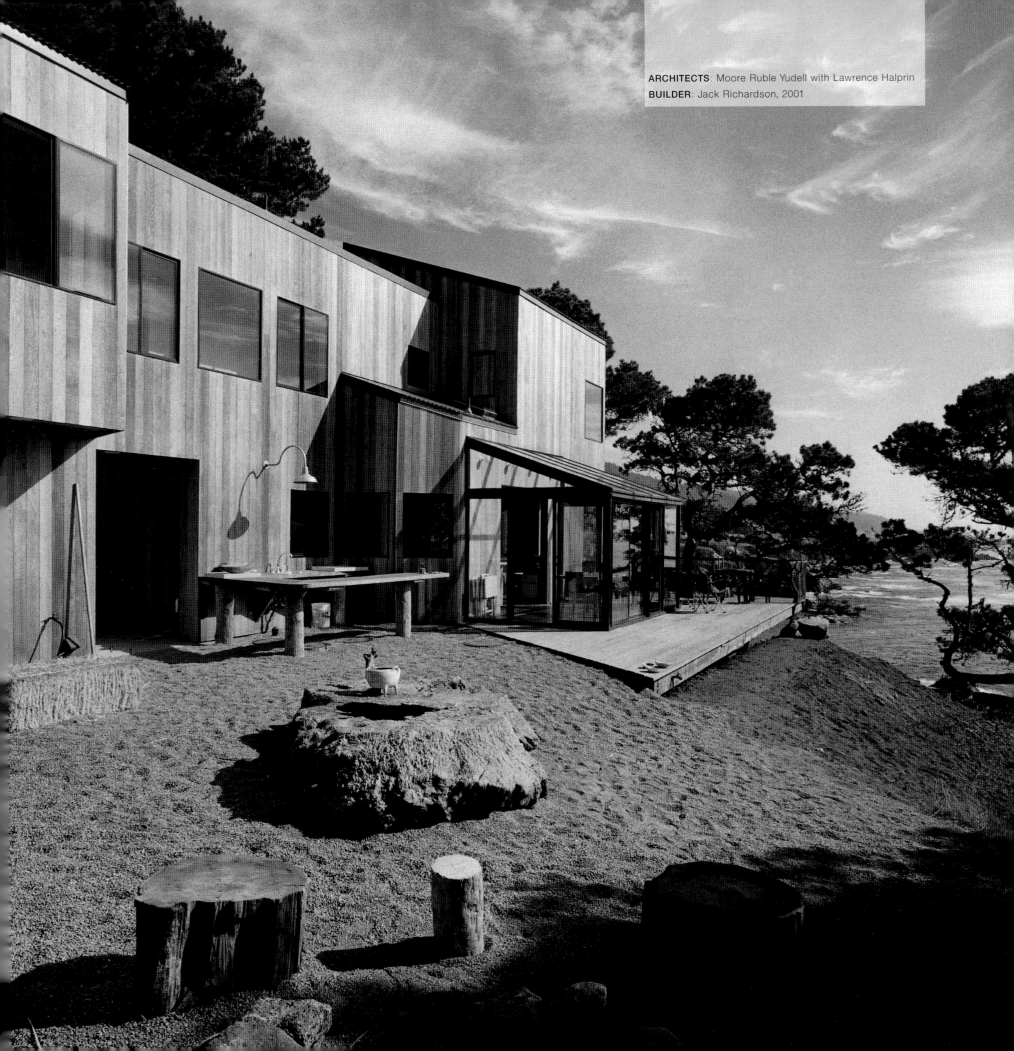

ARCHITECTS: Moore Ruble Yudell with Lawrence Halprin
BUILDER: Jack Richardson, 2001

HALPRIN HOUSE

studio on the northern side of the site remained. Within hours of this unspeakable loss, he was making sketches for a rebirth, imagining what their lives could now be, in this place that had become such a part of them. In a short while they engaged Buzz Yudell and Tina Beebe in this exploration, and the firm Moore Ruble Yudell became their architects. In a decisive first step it was discovered that the concrete foundation piles that supported the first house, nestled on the very edge of the cliff, had not been damaged and could be reused. Rebuilding within, or nearly within, the original footprint posed both a great opportunity and a disciplining challenge.

The house that has developed is very like the earlier one in spirit, though more amply

As Lawrence Halprin worked on the planning for The Sea Ranch, he and Anna Halprin, whose seminal work in dance has been widely celebrated, acquired one of its most beautiful sites, a point projecting out into the ocean, forming a sheltered cove to the south. The point projects out far enough to offer a truly stunning view down the coast, with big crags of rock and abundant wildlife inhabiting the cove in the foreground. Camping at first on the site, and exploring its intricacies, the Halprins eventually began to construct, with Moore, Turnbull, and Matthew Sylvia, a diminutive structure for dwelling. It grew in stages over the years, with small, well-defined spaces arranged ingeniously both inside and out, each filled with an intimate knowledge of the place and adding to the experience of living here. Abetted by Anna's deep and searching energies, the site also became a place for probing the fundaments of dance and for a creative exploration of the environment—a seedbed for the extended workshops and imaginative journeys with which Anna and Lawrence Halprin have transformed our understanding of what the fields of dance and landscape architecture could become. Over thirty-five years, the house evolved like a shell, absorbing and integrating the movements of the Halprins' lives, as well as becoming encrusted with objects and art they collected and loved; many of these were created by Native Americans and friends with whom they shared close ties.

In January 2001, the house and its belongings burned to the ground. Only Halprin's one-room

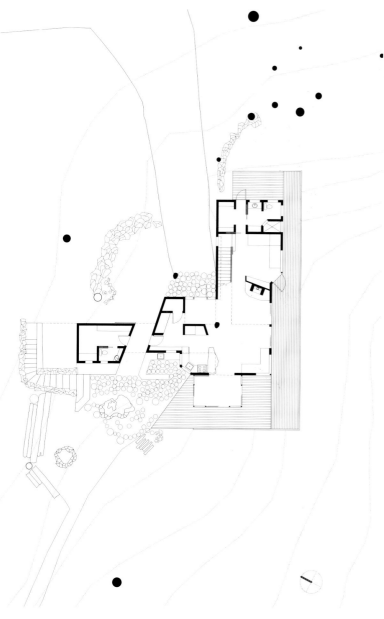

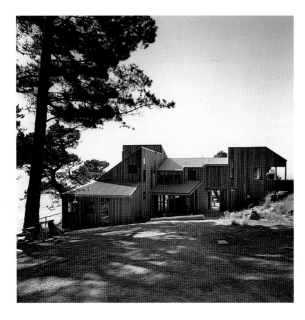

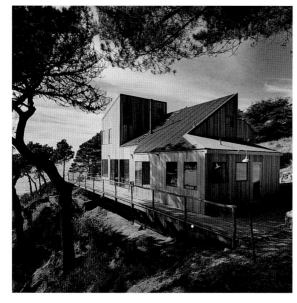

dimensioned and with fewer adventures in changes of level. The house is fundamentally "L"-shaped, with one two-story wing stretching south from a knoll outcropping that forms the core of this projecting landform. This wing forms a gate to the site beyond, with an angled passage that penetrates its lower level. The second wing, holding the main living space, extends parallel to the cliff, its roof hipped and descending toward the land. A deck borders the cliff edge, its sympathetic rail made from unmilled branches of madrone netted with unobtrusive metal mesh. At the western end the deck spreads into a larger seating area adjacent to a greenhouse porch used for eating and reading. Basking in the welcome sun, it is an element nearly identical to that of the earlier house. The forms of the building are angular and clad in redwood, with roof planes of warm gray corrugated metal that easily follow the intersecting volumes of the structure. The multiple angles of the roof signal right away that they are not simply a cap for a house claiming its domain, but part of what Halprin calls a "score" for the site, a program of experiences that govern movement through the site.

The west wall of the house, extending along the wing bridging to the knoll, forms (as it did before) a backdrop to the space before it, where a stone-ringed and stepped fire pit nestles into the rocks, away from the northern wind. Along the face of the wall an outdoor kitchen, fronting the one inside, stands ready for cleaning abalone from the cove below and preparing barbecues.

Farther toward the ocean the landform levels in a small meadow where dance can take place.

Immediately upon entering through the front door, two sensations conflate: the vivid near presence of an irregular column shaped from driftwood; and the free sweep of windows and glass doors gathering in the scope of a broad, coastal panorama. Ahead is the benched ocean end of a long space; the sleeping area and baths are at the opposite end of this wing, screened behind a partial wall of shelving and cabinets. In the middle of the main space, skillfully carved and fitted stones stack into a hearth in front of this wall, embracing the enameled metal firebox of a Danish Rais stove. This hearth was modeled first in clay by Halprin, then made, like the fireplace in the original house, from the same North Dakota granite that he had specified for the Franklin Delano Roosevelt Memorial in Washington. The granite enclosure, growing out of the floor and tapering in big rusticated chunks, anchors the house and its memories to the site.

Diagonally across the living space is the kitchen, with views to the gathering areas outside and easy access into the greenhouse. A broad and gentle wooden staircase with open risers, leads up from the back of the sleeping area to the loft overhead, used by Anna for working and study. The loft is joined on the opposite side by a corridor that reaches past baths and closets to a guest room in the west wing. Beyond it an upper-level wooden deck provides space for Anna's dancing. The deck just touches the rising ground

of the knoll, connecting to its force in the site but not disfiguring it. Stone-bordered stairs wind down from it across the rock to the fire pit below.

The house is filled throughout with gently interlocking spaces and meticulous craftsmanship. Warm wood surfaces pleasingly balance the light, and an extraordinarily enriching set of wall colors were selected by Tina Beebe. Soft blues and greens intersect at the upstairs corner window, mimicking the constantly shifting colors of the sea and sky. Amazingly rich and subtle apricot hues line the corridor beyond like afterglow from a sunset; soft, sunny yellow radiates through the guest room.

In all, the house, descended from its ancestor in spirit but assuming a life clearly its own, establishes once again the cherished patterns of living on this site, adding its own intricacies and pleasures to the exceptional store of images and memories lodged in this land.

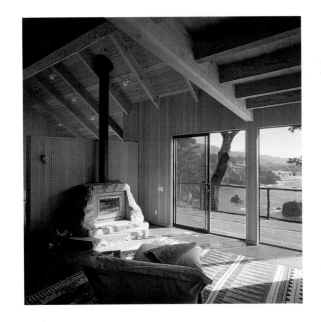

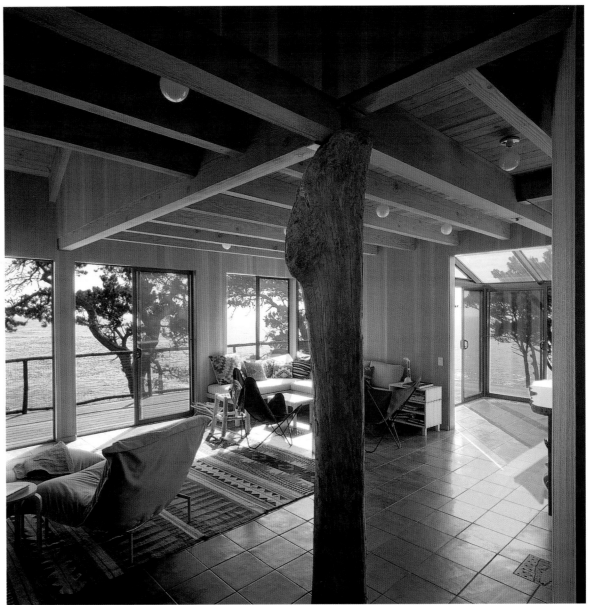

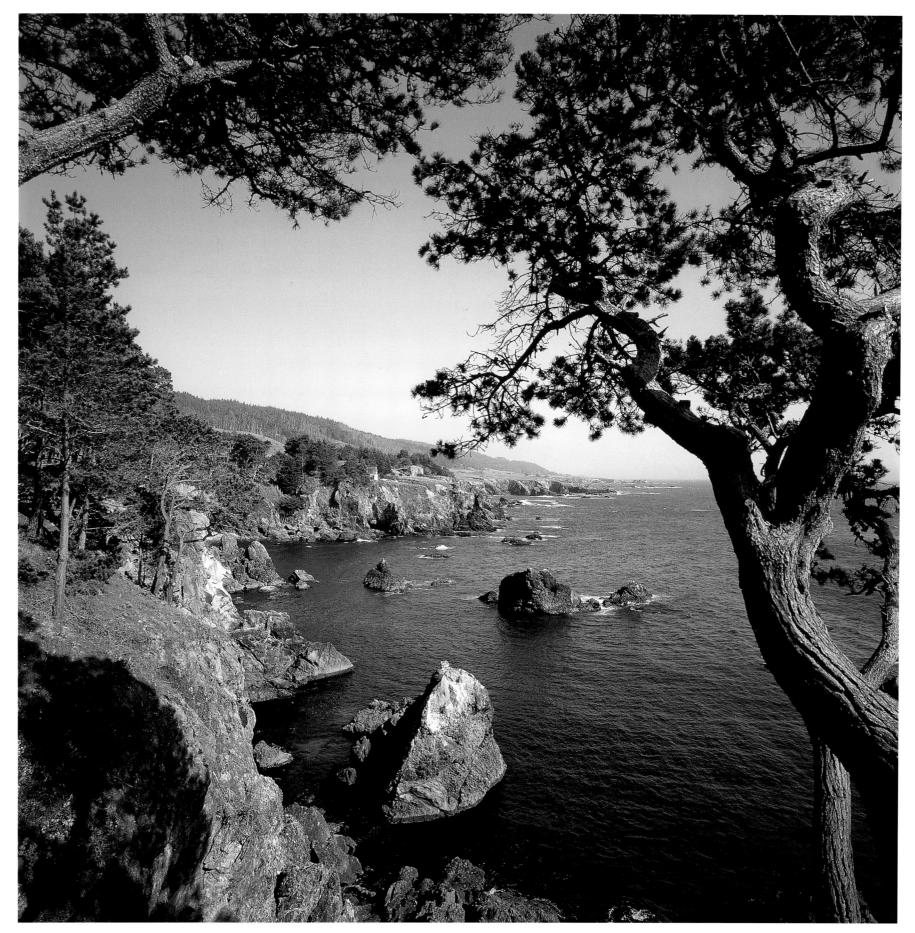

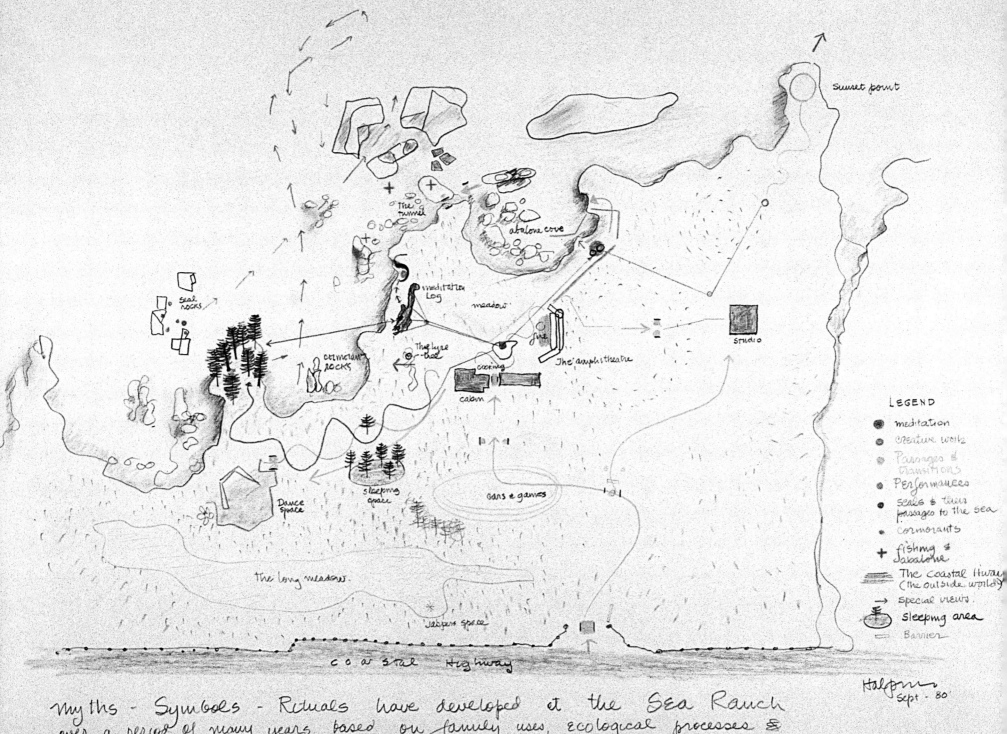

Sunset point

The tunnel

abalone cove

seal rocks

meditation Log

meadow

cormorant rocks

The lyre tree

fire

studio

cooking

The amphitheatre

cabin

oars & games

sleeping space

Dance space

The long meadow

sleeping space

Halprin
Sept · 80'

Jasper's space

coastal Highway

LEGEND

- ● meditation
- ● creative work
- ● Passages & transitions
- ● Performances
- ● seals & their passages to the sea
- ● cormorants
- ✛ fishing & abalone
- ▭ The Coastal Hway (the outside world)
- → special views
- ♨ sleeping area
- ⚊ Barrier

Myths - Symbols - Rituals have developed at the Sea Ranch over a period of many years based on family uses, ecological processes & the many varied workshops & people who have participated ---

THE HALPRIN PLACE: FORTY YEARS ON SITE

Lawrence Halprin

I had known the area north of Fort Ross quite well before I was introduced to the Ohlson Ranch in 1962. Professor Leland ("Punk") Vaughn, chairman of the landscape department at Berkeley, owned a place south of the Ohlsons', and we often camped there during the summers. So when Al Boeke invited me to start a master plan for the ranch, I felt knowledgeable about the north coast and delighted to be able to study it.

I started the planning process by hiking the eleven miles from Stewarts Point to Gualala several times, crisscrossing its width over and over, and camping with my family, particularly at the southern end. It was a difficult site for living. The flat western side of the ranch was wide open to the strong winds blowing in constantly from the northwest, and I soon realized that we would have to protect the house sites. I decided on planting local bishop pines throughout the ranch, and in addition determined that we would have to develop an ecological approach to the land. I felt that this could become a wonderful experiment in ecological planning. I was convinced that we could avoid another suburbia and instead develop a social community for people of like minds, with a love of nature and of this site in particular, for whom "living lightly on the land" would be a governing principle.

Following this concept as a basic idea, we decided to imagine the entire ranch as a community of people and design holistically. Instead of the usual developers' model of selling off five to ten acres with houses dotted here and there, we would cluster buildings densely as in a farm village; by doing so we could leave at least half the land open for nature, undisturbed. The large common areas around which the buildings would be grouped were to

remain open forever and form the matrix of the community. In addition, we would develop a vernacular architecture that would use natural materials and whose roofs would slope in the same way that the land had been eroded over time by the winds. In order to maintain a regional character, I insisted that all planted material be limited to those native to this area. This meant that mowed lawns so typical of suburbia would be outlawed. No palm trees, no flower beds, no prettiness. I also realized that we would have to avoid lining the cliffs' edges with houses in what we termed a "Malibu Wall." So I held all houses away from the cliffs.

I soon realized that the plan for this exquisite site was evocative of our own lifestyle and that Anna and I should find a place here to develop our own cabin. This I hoped would become a place where we could experiment with our art and develop ideas for students, as well as for our own family, to participate in. We had camped several times on a five-acre piece of land near Stewarts Point at the southern end of the ranch and it seemed ideal to us. The place had all the characteristics I had ever hoped for: a coastline swinging southward, shell mounds providing shelter from the northwestern winds, and a protected cove that would be relatively easy to climb down to for fishing. There were seals and bird life, and, primarily, a constant opportunity for close contact with the ocean. Once we had decided on the site, which was largely open meadow, we searched for the right spot to locate the house. We camped and ate in various locations. At the southern edge was a cluster of great bishop pines that framed the views; it was there that we would anchor the house, settling among the trees.

I developed our plan for the "cabin" together with Charles Moore and Bill Turnbull. Over a weekend, we drew all the necessary plans, elevations, and simple details. They were all done freehand but adequately enough in those years to hand over to Matt Sylvia for construction. The basic idea was simple: a small living and kitchen area overlooking the ocean, with a modest sleeping nook above. The rest was a two-story, wall-like, narrow open corridor wide enough for the children's sleeping bags. It provided a wind wall and also protected us from Highway 1. The outside area was very important to Anna and me—it was here that we intended to spend most of our time barbecuing food and conducting workshops. [fig. 1] The little cabin was a great start. Once built, Charles enlivened the living area with a magnificent and colorful two-story series of shelflike boxes in which we could display our collection of Southwest Indian kachinas and Acoma pots. [fig. 2]

Our first few years at The Sea Ranch were wonderful. The house and its outdoor places enhanced our lives and released our creative juices. Anna and I both perceive nature's processes as an inspiration and mentor rather than as a picturesque backdrop; and this place, embodying our mutual desire for interaction with nature, became a great resource for us and for our students. [figs. 3, 4]

Gradually we began to develop enhancements. Around the barbecue area we added logs from the beaches to provide an amphitheater-like space for family gatherings, singing, dancing, and meeting with students to dialogue about our workshops. [fig. 8] We found that the cabin space was too enclosed and needed to "break out of the box," so we made a small glassed-in transition zone on the way out to the terrace. We found that the meadow was too

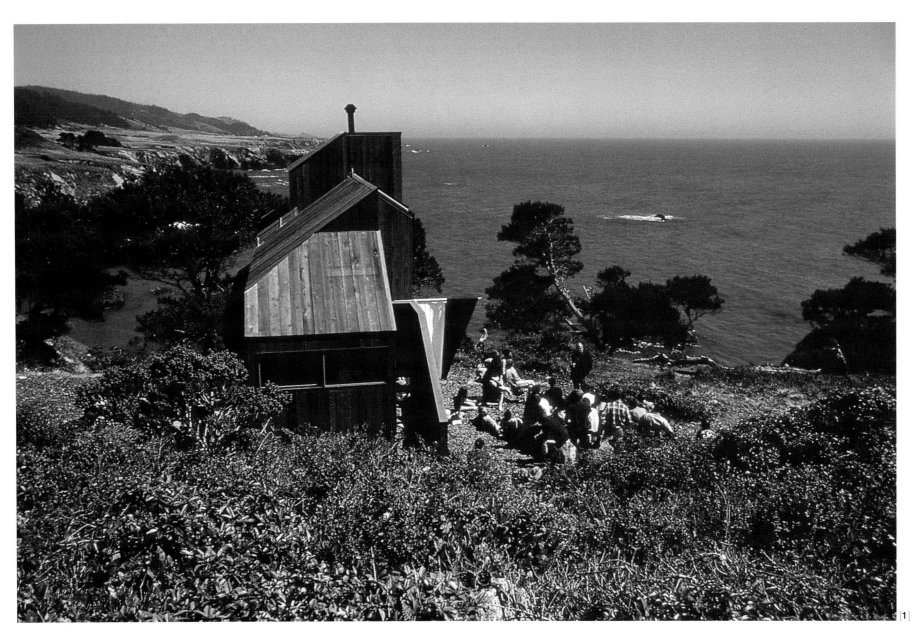

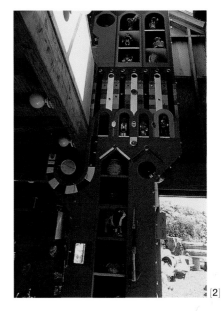

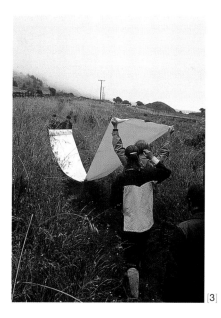

[3]

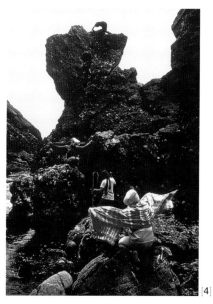

[4]

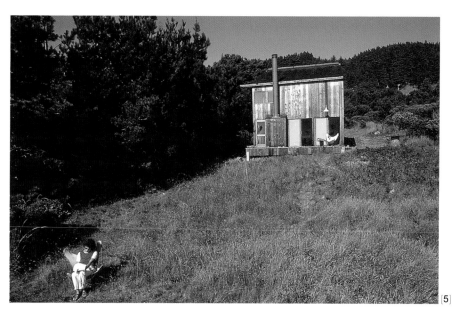

[5]

wide open and we were too vulnerable to the prevailing northwestern winds, and so we planted native bishop pine seedlings for enclosure and protection. We are now surrounded by a forest that has grown to a height of forty to fifty feet. As we spent more and more time at The Sea Ranch, I felt the need for a place to work at my designs and paintings. That place became a small studio, separate from the main cabin, where I could work seriously while away from my office in the city. [fig. 5]

In my office in San Francisco I had found that a twenty-by-twenty space with a high ceiling provided a natural and comfortable working space for me. A structure of that size fit easily on the east side of our site adjoining the northern drainage canyon, so I proposed to Bill Turnbull that we build a twenty-by-twenty-by-twenty cube with a narrow mezzanine under which I could place my drafting board. [fig. 6] The walls would provide plenty of pinup space for my drawings, especially since I wanted to use sheetrock for the entire interior.

The sheet rock proved to be the cause of one of the few major arguments I had with Matt Sylvia. He felt it would be too impermanent and he saw no reason to vary from wood. I finally won him over, on the basis that the sheetrock's white color would constantly reflect the varying colors of nature from day to day and season to season. Indeed, watching the incredibly wonderful and subtle color variations of the studio interior over time has been one of my great enjoyments in working here.

At the same time, Anna felt the need to develop a dance space that would allow her to work while at The Sea Ranch. Since she preferred to work out of doors, we went southward into a clearing in the forest where we could develop a level area along the cliff's edge overlooking the seal rocks. This space not only provided a space for Anna but also gave students and workshoppers opportunities to interact with Pomo friends in dance. [fig. 9] Here, too, Anna has continued her exploration with Loren Smith, who has guided Anna's students to find their own rituals based on his remarkable commitment to the rituals that play such an important role in Pomo Indian tribal culture.

By the mid-eighties, our family had begun to outgrow the sixteen-by-twenty cabin area. It had become overworked as a combination living, kitchen, and sleeping area for grandchildren and guests. We decided to build a proper living space, which would be dropped to a lower level to hug the ground along the cliff's edge and avoid railings on the new outdoor deck. The addition was not large but it was warm and hospitable. [fig. 7] Its high roof linked it to our sleeping quarters on the second floor, and at night we could cluster around the new granite fireplace. We built the fireplace out of Carnellian granite, the material of the Franklin Delano Roosevelt Memorial, then underway. This gave me a feeling of continuity with all the intense years I had spent designing and building the memorial in Washington, D.C.

The new living room added a great deal to our lives, providing new space for us and a more intimate relationship to the sea, its rocks, and their inhabitants. These inhabitants included a community of twenty-one harbor seals, cormorants, occasional nesting ospreys, and a large field of kelp, which rose and fell with the tide. Inside, we used the new walls to display some of Leonard Baskin's remarkable watercolors, Indian graphics, and wooden kachinas. From the ceiling we hung a fine wooden candelabra

289

[6]

290

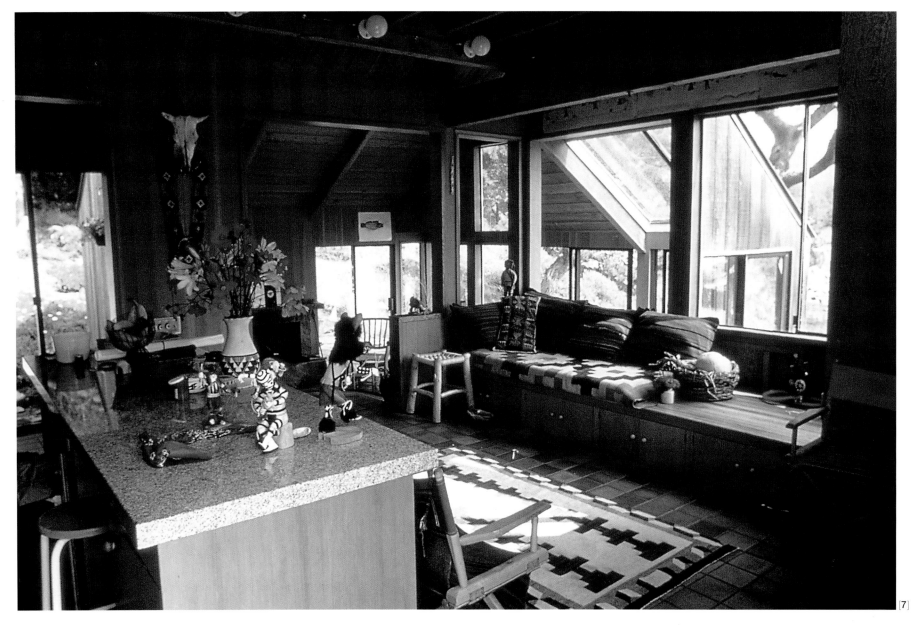

[7]

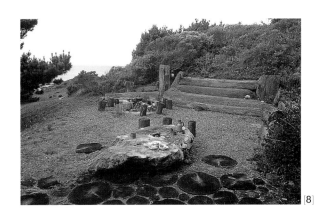

[8]

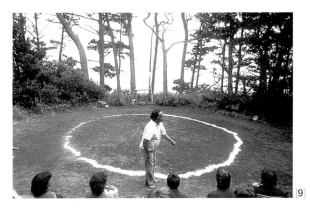

[9]

carved by my son-in-law, Jasper. It was based on one from his grandfather's Bar X Ranch in Montana.

This all came to an end over the New Year's holiday 2001. We left The Sea Ranch for a doctor's appointment in Marin County, and on our return that evening were stopped at our gate by the Sea Ranch fire truck and back-ups from all around. They gathered around and told us that our house was gone [fig. 10]. The impact on Anna and me was devastating but it also affected our whole family. For almost forty years the family and the house, with its various additions, had grown together. In many ways it was a symbiotic relationship. We grew the house and the house in turn expanded us, generating creative adventures that led to ideas, projects, and events beyond the limits of The Sea Ranch.

Planning for the new house to replace the old one was at once exciting and emotionally difficult and draining. We elected to build on the same footprint and used the old footings. We decided that the new design should acknowledge our seniority by keeping all our major living spaces at one level. Our architect, Buzz Yudell, with whom we worked on the new house, suggested we add a few amenities: a dedicated guest room on the second floor for our children and grandchildren, a larger kitchen, and a study for Anna.

Now that it is all built, we find that we need to grow into it. Instead of growing up with it in an organic way as we had with our old house, it has come to us as a complete new experience, no matter my intense involvement in its design. Its bare walls, empty shelves, and open spaces are waiting to be filled. What remains the same is our incredibly remarkable site with its mature trees, its views, the sound of the surf, the great rock formations, the horizon line, and the gray whales passing through on their way south to Scammons Lagoon in Baja California [fig. 11].

291

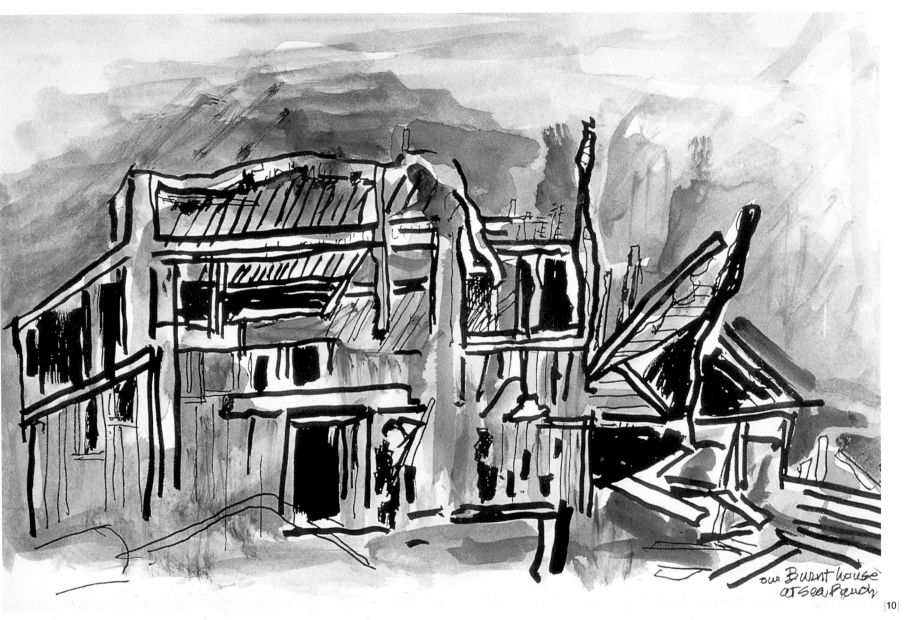

our Burnt house
at Sea Ranch

[10]

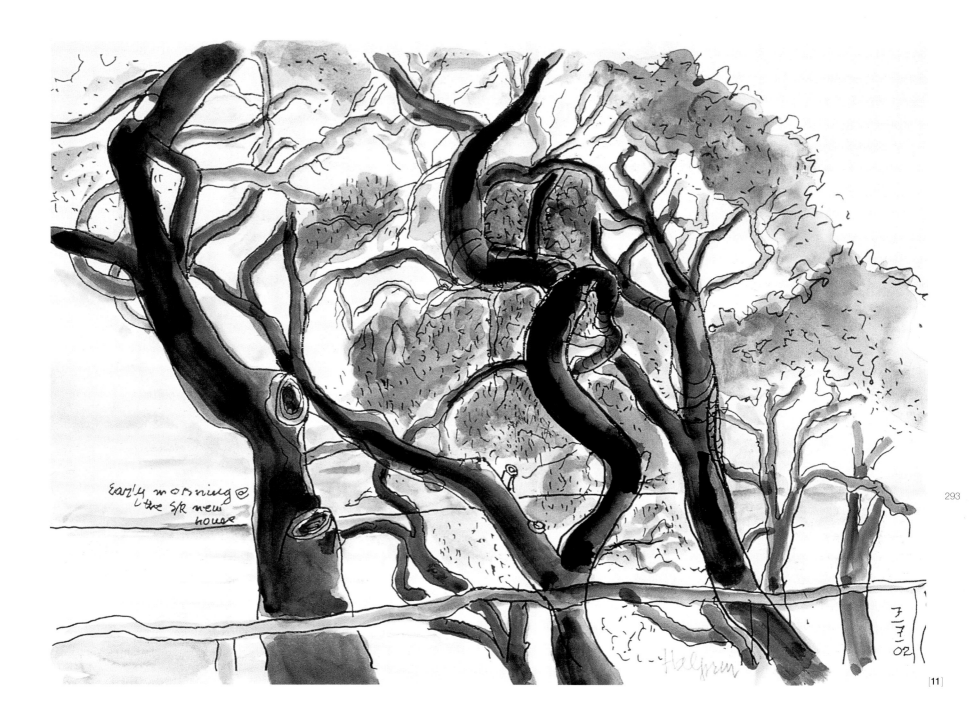

Early morning @
the S/R new
house

7/7/02

293

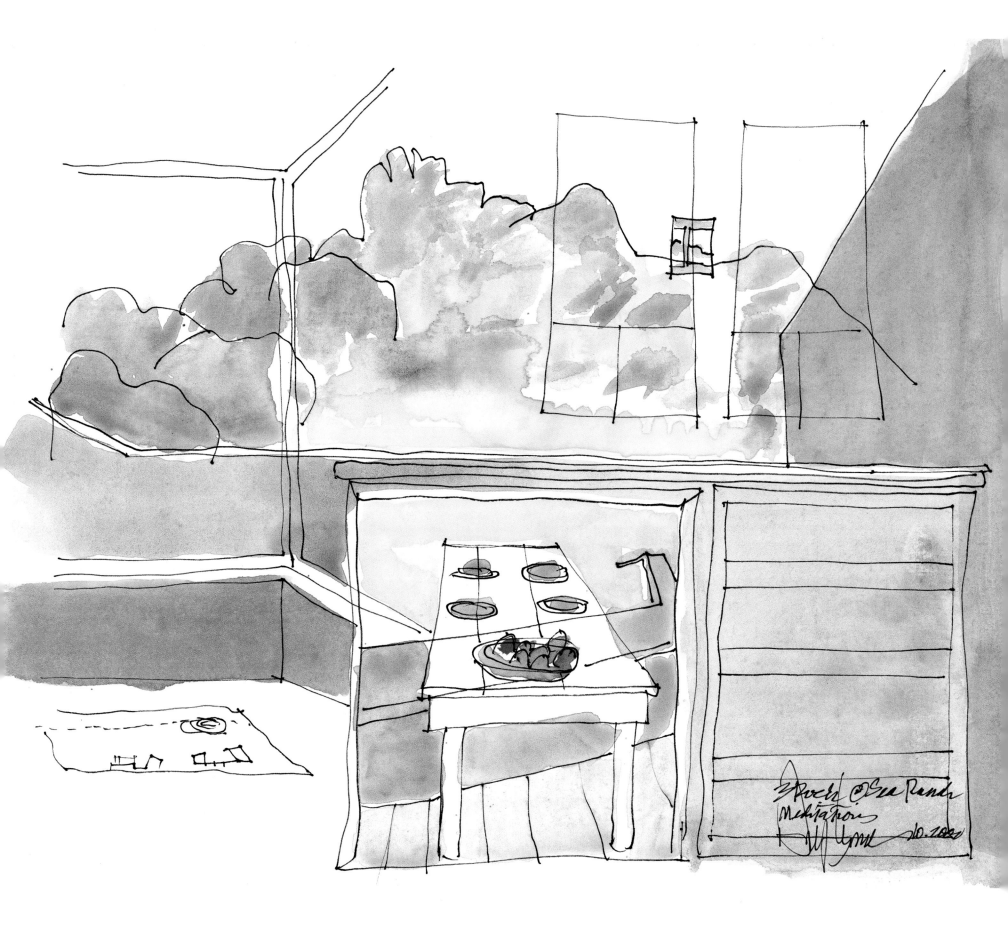

Porch @ Sea Ranch
Meditation
10.2020

DESIGNING FOR PLACE AT THE SEA RANCH

Designing for place at The Sea Ranch means understanding that buildings can dance. Buildings need not be stolid impositions on the land, they need not fear being lyrical. They can dance with each other, dance in their space; they can join in creating a magic ring.

Buildings can dance but they do not always; some are too shy to engage, some hope that simple routine poses will carry the day but these do not qualify. Neither do jerking and stomping. Passion and discipline are paired qualifications. Like dancers, buildings can take part in a larger pattern and thus lend significance to the particular movements they invoke, or to the stance they assume. They can improvise within a frame, connecting personal energy to collective aspiration.

In order to dance effectively it is essential to know the ground: to have a secure understanding of the space that is available, the disposition of its terrain, and the nature of one's companions. To dance effectively (and to make good places) it is necessary to blend imagination and care.

Designing for place at The Sea Ranch means paying close attention to the specifics of the site, registering the particularities of everything that makes up the domain. Highlighting the particular and the local has broad cultural value, for we need to pay close attention to the immediate world we live in and the people we live among if we are to resist stupefying abstractions that can be manipulated by others.

The Sea Ranch is a place, set carefully into the natural world, where we can become aware of the essence of life. It is in landscapes that we can most clearly read the intricacy and intensity of change and the interconnectedness that characterize natural processes. In nature, the different rhythms of the life cycle are played out in front of us, lending urgency to the moments as they pass.

Designing for place at The Sea Ranch means making forms that remind us not only of nature and its processes but also of the presence of inhabitants, of the ingenuity that people can bring to place—their need to find significance in what is their own, as well as their ability to find common cause and to care for each other. Buildings can be sized so that we can easily imagine inhabiting them. They can have forms that record the way people move through them; windows and stairs that reveal patterns of use and connection; bays and balconies that invoke the presence of people taking position on the edge of the outdoors; and terraces and shelters that invite dwelling in the sun.

Designing for place at The Sea Ranch means making room for people's collections—for objects and images and books and tools and plantings, items that are purposefully chosen and displayed as cherished reminders of value and as a means of connecting inner and outer worlds. It means learning to let buildings acquire soul within the frames that define them.

Designing for place at The Sea Ranch means considering windows as actors on a communal stage, projecting on the buildings' faces something of the life within. The tales they spin should be informative and lively, adding to the lore of the place. Styles of architecture are often determined in considerable part by how windows are treated; and cultural backgrounds lead to differing expectations of how windows should be arranged. As with other inherited standards, these patterns can make useful starting points; used generically, unmodified by the circumstances of use and the particularities of the site and its outlook, they can quickly seem dim-witted and tiresome. Playing purposeful improvisations and variations on such standards can bring multiple associations to a place and invest it with spirit.

Designing for place at The Sea Ranch means learning to play with the light. Light is ever changing and multidirectional: diffuse light from the sky, shifting light from the sun, bounced light from the ground; light that sparkles, light that washes across surfaces, light that suffuses through space, light that differentiates forms from each other, light that remains within darkness. Light gives presence to time.

The colors of surfaces and their relative lightness and darkness should relate to their surroundings. Designers should be mindful of the larger order of the landscape (which means usually that exteriors at The Sea Ranch should be dark) and attentive to appropriately enlivening the prospects for dwelling within (which means usually that Sea Ranch interiors should be light). This also means that reflective surfaces should be avoided and that shining cars should be sheltered from view in enclosures.

Designing for place at The Sea Ranch means incorporating views all about, not just panoramas of the ocean. It means making it possible to explore foliage; to vary outlook; to discover birds in the sky as well as whales in the sea; to watch the grasses wave in the wind, then wither, be reborn, and become abundant. It means watching the growth of the foliage over years, managing it carefully, and adapting to the changing circumstances that nature inevitably brings. It means learning to cope with what nature affords and providing the means to enjoy it.

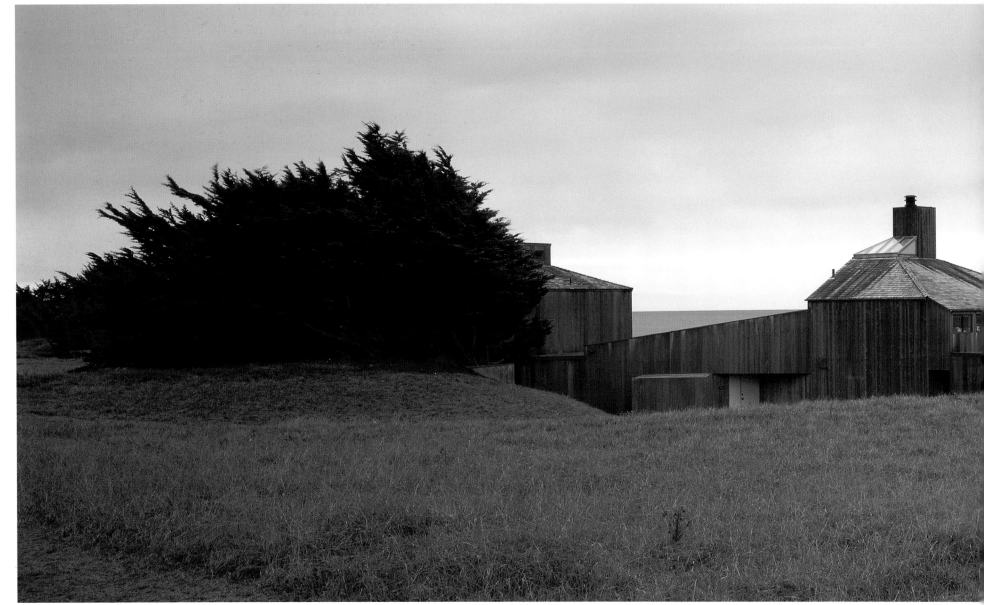

Designing for place at The Sea Ranch means reaching beyond convention to make works that bring genuine creative energy to the scene, not in flamboyant displays but through imaginative designs that are suited to their sites. The most fruitful creative energy shows possibilities that others might explore as well, leading to new understandings of how The Sea Ranch might evolve.

It means building with materials that are of the place and tracing the acts of building within the structures created, thus adding another dimension of connection to the surroundings. Using timber resources wisely can both achieve and demonstrate the value of sustainable practices. Designing for place at The Sea Ranch means accepting that buildings weather and age, but controlling this process to prevent damage to the integrity of the structures. Buildings should be able to be renewed and altered over time, not frozen in the "look" of a moment.

Designing for place at The Sea Ranch means knowing your place and thinking in three dimensions—absorbing into consciousness the slope of the land, the vault of the sky, the reach of the horizon, and the undulations underfoot. It requires building the land's contours into our fingers (or keyboard) as we draw, feeling the wind as it passes, knowing precisely the course of the sun, and acknowledging the presence of our neighbors—both those who have already built and those yet to come. It means containing the impulse to sprawl—working with the land, not spilling out over it. This is a precious landscape, a landscape that is not accidental but one that has evolved through design and through the investments of many. It depends on continuing care, ingenuity, and discretion.

Designing for place at The Sea Ranch means learning to be a part—even while being distinct. It means being a part of a larger landscape or grouping of buildings; being a part of a way of building that has its roots in the place; being a part of a community that has a covenant to care for its setting; being a part of a community that is continually searching and finding its way, evolving a place that is its own.

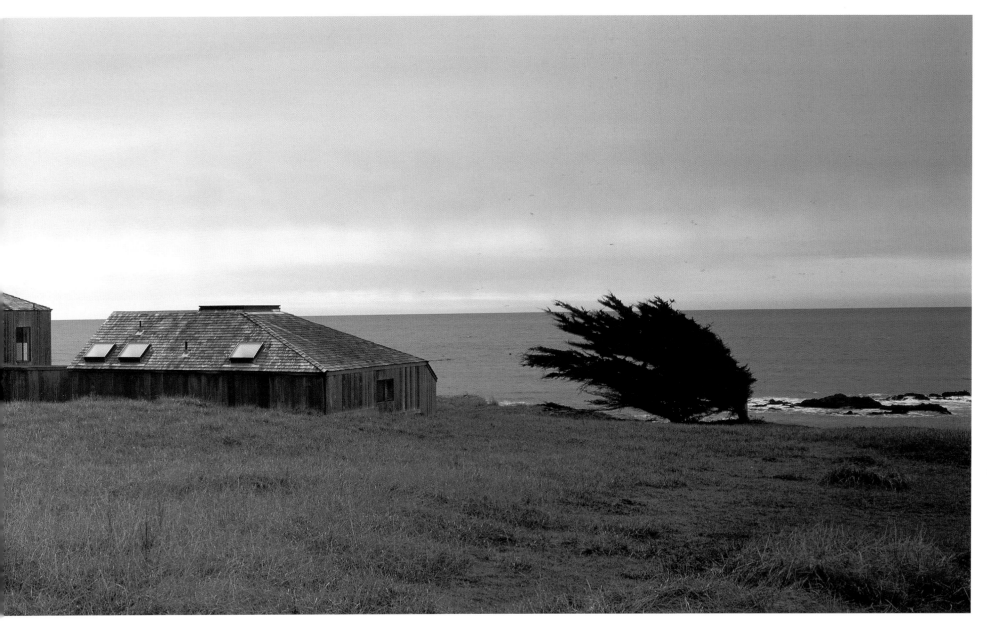

SHINEFIELD HOUSE (now the Owings-Perdue House)
ARCHITECT: Charles W. Moore and Dmitri Vedensky
BUILDER: Matthew Sylvia, 1968–77

PROJECT CREDITS/ AWARDS

CONDOMINIUM ONE

Awards: AIA California Council Twenty-Five Year Award, 1992
AIA Twenty-Five Year Award, 1991
Sea Ranch Design Award, 1972
AIA National Honor Award, 1967
"Homes for Better Living" Award, 1966
Progressive Architecture Citation, 1965

CONDOMINIUM ONE—UNIT ONE
Address: Sea Walk Drive
Architect: Moore Lyndon Turnbull Whitaker (MLTW)
Builder: Matthew Sylvia
Year: 1965
Client: Oceanic Properties
Owner: Susan and Lee Walton

CONDOMINIUM ONE—UNIT EIGHT
Address: Sea Walk Drive
Architect: Moore Lyndon Turnbull Whitaker (MLTW)
Builder: Matthew Sylvia
Year: 1965
Client: Oceanic Properties
Owner: James Trulove/Mallory Duncan

CONDOMINIUM ONE—UNIT NINE
Address: Sea Walk Drive
Architect: Moore Lyndon Turnbull Whitaker (MLTW)
Builder: Matthew Sylvia
Year: 1965
Client: Oceanic Properties
Owner: Weingarten family

HEDGEROW HOUSES

Award: Special Citation, "Homes for Better Living" Awards
Program, AIA/House & Home/American Home, 1967

HOUSE ONE
Address: 60 Black Point Reach
Architect: Joseph Esherick & Associates
Builder: Matthew Sylvia
Year: 1966
Client: Oceanic Properties
Owner: Rae Hudspeth
ADDITION:
Architect: Robert Hartstock
Year: 1987

HOUSE FOUR
Address: Black Point Reach
Architect: Joseph Esherick & Associates
Builder: Matthew Sylvia
Year: 1966
Client: Oceanic Properties
Owner: Buddington and Deloras Jones
ADDITION:
Architect: Joseph Esherick & Associates
Year: 1980

ESHERICK HOUSE
Address: 75 Black Point Reach
Architect: Joseph Esherick & Associates
Builder: Matthew Sylvia
Year: 1966
Client: Joseph Esherick
Owner: Jim Friedman/Suzanne Stassevitch

THE SEA RANCH STORE
Address: Sea Walk Drive
Architect: Joseph Esherick & Associates
Builder: Matthew Sylvia
Year: 1966
Client: Oceanic Properties

MOONRAKER ATHLETIC CENTER
Address: Moonraker Road
Architect: MLTW/Moore Turnbull with Lawrence Halprin
and Barbara Stauffacher
Builder: Matthew Sylvia
Year: 1966
Client: Oceanic Properties
Owner: The Sea Ranch Association

Awards: Sea Ranch Design Award, 1972
AIA National Honor Award, 1968
AIA Bay Region Award of Merit, 1967
Progressive Architecture Citation, 1966

THE SEA RANCH LODGE
Address: 60 Sea Walk Drive
Architect: Alfred Boeke and Louis McLane with Agora Architects
Builder: Matthew Sylvia
Year: 1968
Client: Oceanic Properties
Owner: Sea Ranch Lodge and Village LLC.

OHLSON RECREATIONAL CENTER
Address: (no address)
Architect: MLTW/Moore Turnbull with Donlyn Lyndon
Builder: Matthew Sylvia
Year: 1971
Client: The Sea Ranch Association

DEL MAR CENTER
Address: Leeward Road
Architect: Ted Smith
Builder/Year: house remodel: Tim Carpenter, 1995; meeting
hall: Jack Richardson, 1996; pool facilities: Coast
Construction, 2000
Client: The Sea Ranch Association

WALK-IN CABINS

Awards: AIA/Sunset "Western Home Awards" Citation, 1976
First Honor Award, "Homes for Better Living" Awards
Program, AIA/House & Home, 1975
Sea Ranch Design Award, 1974
The Environmental Monthly Annual Environment Honor
Award in Architecture and Engineering, 1972

WALK-IN CABIN—UNIT 52
Address: 282 Redwood Rise
Architect: Obie Bowman
Builder: T/K Associates
Year: 1972
Client: Oceanic Properties
Owner: Janann Strand

WALK-IN CABIN—UNIT 53
Address: 283 Redwood Rise
Architect: Obie Bowman
Builder: Matthew Sylvia
Year: 1972
Client: Oceanic Properties
Owner: Bill Voorhees

CLUSTER HOUSES ON WHITE FIR WOOD

CLUSTER HOUSES—UNIT 4 (now Yuen)
Address: White Fir Wood
Architect: MLTW/William Turnbull, Jr.
Builder: Matthew Sylvia
Year: 1973
Owner: Theresa and Pasteur Yuen

LOT 18 (now Rathmill)
Address: White Fir Road
Architect: MLTW/Turnbull
Builder: Bertram/Holley
Year: 1980
Client: Oceanic Properties
Owner: George Rathmill

EMPLOYEE HOUSING (Burbank Village)
Address: Green Fern Road; White Tail; Haversack
Architect: William Turnbull Associates
Builder/Year: Matthew Sylvia, 1985; Rick Hoffman, 1992
Client: Oceanic Properties (first phase), Sea Ranch Village
(second phase)
Owner: Burbank Housing, Inc.

Awards: AIA National Honor Award, 1990
AIA California Council Merit Award, 1989
AIA Redwood Empire Honor Award, 1988
American Wood Council Honor Award, 1988
Sunset Magazine Award of Merit, 1987
Pacific Coast Builders Conference Merit Award, 1987

THE COTTAGES

Award: Sea Ranch Design Award, 1998

COTTAGE TWO (Altes House)
Address: 41216 Ceanothus Road
Architect: Fiona O'Neill
Builder: Sea Ranch Ventures
Year: 1995
Client: Sea Ranch Ventures
Owner: Bob and Kathy Altes

SEA GATE ROW

LYNDON-WINGWALL HOUSE
Address: 88 Whaler's Reach
Architect: Lyndon/Buchanan Associates
Builder: Matthew Sylvia
Year: 1991
Client: Donlyn Lyndon and Alice Wingwall

Awards: Sea Ranch Design Award, 1998
AIA/Sunset Western Home Citation, 1996

MEADOW HOUSE (now Day)
Address: Sea Gate Road
Architect: Lyndon/Buchanan Associates
Builder: Matthew Sylvia
Year: 1994
Client: Hughes-Perry
Owner: Susan Day

WENDEL-LYNDON HOUSE
Address: 35428 Sea Gate Road
Architect: Lyndon/Buchanan Associates
Builder: Matthew Sylvia
Year: 1999
Client: Lu Wendel and Maynard Hale Lyndon

KIRKWOOD HOUSE
Address: 39307 Pacific Reach
Architect: Paul Hamilton

Builder: Total Concepts
Year: 1972
Client: Kirkwood family

Award: Sea Ranch Community Enhancement Award, 1986

HALLEY HOUSE
Address: 38665 Breakers Reach
Architect: John Halley
Builder: John Halley with Richard and Sonja Halley
Year: 1984
Client: Richard and Sonja Halley

Award: Sea Ranch Community Enhancement Award, 1979

BRUNSELL HOUSE (now Sharples)
Address: 286 Lands End Close
Architect: Obie Bowman
Builder: Brian Dixon
Year: 1985
Client: Robert Brunsell
Owner: Ken and Lucy Sharples

Awards: AIA/ACSA Competition on Environmentally
Conscious Architecture Citation, 1991
Honor Award, Redwood Empire AIA, 1988
Builder's Choice Design and Planning Award of Merit, 1988
The Sea Ranch Community Enhancement Award, 1986

MASLACH/ZIMBARDO HOUSE
Address: 105 Osprey Reach
Architect: EHDD (Esherick, Homsey, Dodge and Davis)
Builder: Tim Cooke
Year: 1985
Client: George and Doris Maslach with Phillip Zimbardo
and Christina Maslach Zimbardo

EWRY HOUSE
Address: Galleon's Reach
Architect: Donald Jacobs
Builder: Ralph Jackson
Year: 1985
Client: Ed Ewry

MICHAEL HOUSE (now Partridge-Martin)
Address: 369 Sea Lion
Architect: William Scott Ellsworth
Builder: Helmut Emke
Year: 1987
Client: Joe and Cecile Michael
Owner: Loren Partridge and Leslie Martin

MCKENZIE HOUSE (now Franklin)
Address: 115 Shepherds Close
Architect: Lyndon/Buchanan Associates
Builder: Matthew Sylvia
Year: 1989
Client: Dianne McKenzie
Owner: Winston and Laura Franklin

ADDITION:
Architect: Donlyn Lyndon
Builder: Timothy Carpenter
Year: 2002

Awards: Sunset Magazine Interior Design Award for
Materials, 1992
AIA San Francisco Chapter Award of Honor for Design
Excellence, 1991
Metropolitan Home Magazine Award, 1990
American Wood Council Award of Merit, 1990

SOMERS HOUSE (now Haswell-Mott)
Address: 112 Shephards Close
Architect: Robert Hartstock
Builder: Rich Fredrickson
Year: 1996
Client: Lewis and Elizabeth Somers
Owner: Clay Haswell and Sarah Mott

JOHNSON HOUSE (now Meyer)
Address: 249 Moonraker Road
Architect: MLTW/Moore Turnbull
Builder: Matthew Sylvia
Year: 1965
Client: Reverdy Johnson
Owner: Lorna Meyer
ADDITION:
Architect: William Turnbull, Jr.
Year: 1973
MODIFICATIONS:
Architect: Seryozha Krysti
Builder: Steve Smith
Year: 1999

BINKER BARNS

PARK BARN HOUSE
Address: 307 Chinquapin
Architect: Willliam Turnbull, Jr.
Builder: Matthew Sylvia
Year: 1967
Client: Wallace and Caroline Wilson; Wilton and Mary Lou
King; William and Virginia Moore
Owner: Kim and Brian Park
ADDITION:
Architect: Lisa Scott
Builder: Scott Construction, Inc.
Year: 1998

BARNACLE BARN HOUSE (now Crane-Murray and Benz)
Address: 37220 Albatross Reach
Architect: MLTW/Moore Turnbull
Builder: Matthew Sylvia
Year: 1968
Client: Kreps/Lavine families
Owner: Eileen Crane, Eric Murray, Christina and Jason Benz

ADDITION:
Architect: Fiona O'Neill
Year: 1996

RUSH HOUSE (now Keller)
Address: Ramsgate Road
Architect: MLTW/Moore Turnbull
Builder: Matthew Sylvia
Year: 1970
Client: Rush family
Owner: Annie and Dave Keller

Award: AIA House and Home Award of Merit, 1970

WILDE HOUSE (now Mattson)
Address: 36867 Greencroft Close
Architect: Donald Jacobs
Builder: Helmut Emke
Year: 1985
Client: Wilde family
Owner: Peter and Patricia Mattson

BURDICK HOUSE
Address: 36690 Mariners Drive
Designers: Susan Burdick, Bruce Burdick, and Bruce Lightbody
Builder: Don Matheny
Year: 1990
Client: Bruce and Susan Burdick

RASMUSSEN HOUSE
Address: 95 Galleon's Reach
Architect: Daniel Levin
Builder: Helmut Emke
Year: 1990
Client: Ralph and Dianne Rasmussen

BRODIE HOUSE
Address: 112 Anchorage Close
Architect: Steve Brodie
Builder: Rich Fredrickson
Year: 1999
Client: Steve and Linda Brodie

GILBERT HOUSE
Address: 37944 Sentinel Close
Architect: Lisa Scott
Builder: Scott Construction, Inc.
Year: 2002
Client: Christine Gilbert

WHITAKER/EKMAN HOUSE (now Goodman-King)
Address: 39486 Leeward
Architect: Richard Whitaker with Ken Ekman
Builder: Matthew Sylvia
Year: 1977
Client: Richard Whitaker and Ken Ekman
Owner: John Goodman and Karey King

ANDERSON HOUSE
Address: 209 Walk-on Beach
Architect: William Turnbull, Jr.
Builder: Matthew Sylvia
Year: 1989
Client: Edward and Kathleen Anderson
ADDITION:
Architect: Turnbull Griffin Haesloop
Builder: Matthew Sylvia
Year: 1996

Award: Sea Ranch Design Award, 1998

CLAYTON HOUSE
Address: 267 Del Mar Point
Architect: Obie Bowman
Builder: started by Don Matheny, completed by Phil Simon
Year: 1993
Client: Linda and Brad Clayton
ADDITIONS:
Architect: Obie Bowman
Builder: Phil Simon
Year: 1998

SCHNEIDER HOUSE
Address: 118 Brigantine
Architect: EHDD (Esherick, Homsey, Dodge and Davis)
Builder: Ralph Jackson
Year: 1997
Client: Schneider family

YUDELL-BEEBE HOUSE
Address: 47 Sea Meadow Drive
Architect: Moore Ruble Yudell
Builder: Timothy Carpenter
Year: 1998
Client: Buzz Yudell and Tina Beebe

BOYD HOUSE
Address: 39100 Curlew Reach
Architect: Turnbull Griffin Haesloop
Builder: Timothy Carpenter
Year: 2002
Client: Robert and Karen Boyd

CAYGILL HOUSE
Address: 33747 Yardarm
Architect: MLTW/Moore Turnbull
Builder: Matthew Sylvia
Year: 1969
Client: Wayne and Terri Caygill
ADDITIONS:
Architect: William Turnbull, Jr.
Builder: Matthew Sylvia
Year: 1978

VEDENSKY HOUSE (now Whitaker)
Address: 360 Westerly Close
Architect: Dmitri Vedensky
Builder: H. Halvorsen
Year: 1968
Client: Dmitri Vedensky
Owner: Richard and Sue Whitaker

Award: Sea Ranch Design Award, 1998

MIGLIO HOUSE
Address: 183 Lupine Close
Architect: Charles W. Moore and Urban Innovations
Builder: Tim Taubold
Year: 1986
Client: Bruno and Rose Miglio

LICHTER-MARCK HOUSE
Address: 36566 Sculpture Point Drive
Architect: Lyndon/Buchanan Associates
Builder: Matthew Sylvia
Year: 1994
Client: Linda Lichter and Nick Marck

BAAS-WALROD HOUSE
Address: 689 Spring Meadow Road
Architect: Moore Ruble Yudell
Builder: Matthew Sylvia
Year: 1998
Client: Jackie Baas and Steven Walrod

HALPRIN HOUSE
Address: 34500 State Highway 1
Architect: Moore Ruble Yudell with Lawrence Halprin
Builder: Jack Richardson (started by Matthew Sylvia)
Year: 2001
Client: Anna and Lawrence Halprin

SELECTED BIBLIOGRAPHY

AIA Jury. Quote from "Sea Ranch Employee Housing." *Architecture* (March 1990): 99.

Anderson, Michael. *The Sea Ranch: Case Studies and Observations Towards a Revisionist History of the Enclave.* Masters Thesis, Department of Architecture and the History of Art, University of Cambridge, Cambridge, England, 1998.

Bertelsen, Ann. "Back at the Ranch." *Northern California Home and Garden* (July 1992): 48–53, 86–90.

Bloomer, Kent C., and Charles W. Moore. *Body, Memory, and Architecture.* New Haven: Yale University Press, 1977.

Boeke, Al. Selection from a presentation in The Sea Ranch Symposium sponsored by the Charles W. Moore Center for Study of Place at The Sea Ranch (November 1999).

Burns, Jim. "Sea Ranch, Resisting Suburbia." *Architecture: The AIA Journal* (December 1964): 56–63.

Canty, Donald. "Landmark: The Sea Ranch." *Progressive Architecture* (February 1993): 84–91.

Clark, Susan M. "Sounds of the Past: History Notes." The Sea Ranch Association, 1994. A collection of articles from the community newspaper *Soundings* by resident historian Susan Clark and others. Archived at http://www.tsra.org/archives/Archive6.htm

Culvahouse, Tim, and Lisa Findley. "Once Again, by the Pacific: Returning to Sea Ranch." *Harvard Design Magazine* (Fall 2001): 38–45.

Dillon, Richard. *The Story of The Sea Ranch.* The Sea Ranch, CA: Oceanic Properties, Inc., 1965.

Editors. "Ecological Architecture: Planning the Organic Environment." *Progressive Architecture* (May 1966): 120–137.

Esherick, Joseph "An Architectural Practice in the San Francisco Bay Area, 1938-1996," an oral history conducted in 1994–1996 by Suzanne B. Riess, Regional Oral History Office, The Bancroft Library, University of California, Berkeley, 1996.

Frampton, Kenneth, ed. *American Masterworks: The Twentieth Century House.* New York: Rizzoli International Publications, Inc., 1995.

Gray, Christopher. "The Sea Ranch." *House and Garden* (September 1985): 62-74.

Halprin, Lawrence. *The RSVP Cycles: Creative Processes in the Human Environment.* New York: George Braziller, Inc., 1969.

———. "Sea Ranch: Halprin's Recollections." *Progressive Architecture* (February 1993): 92–93.

———. *The Sea Ranch...Diary of an Idea.* Berkeley: Spacemaker Press, 2002.

Keim, Kevin P. *An Architectural Life: Memoirs and Memories of Charles W. Moore.* Boston: Bulfinch Press, 1996.

Ketcham, Diana. "A Sea Change Where the View Once Ruled." *The New York Times* (May 31, 2001): B1, B10.

Littlejohn, David. *Architect: The Life and Work of Charles W. Moore.* New York: Holt, Rinehart and Winston, 1984.

Lyndon, Donlyn, and Charles W. Moore. *Chambers for a Memory Palace.* Cambridge: The MIT Press, 1994.

Lyndon, Donlyn. "Sea Ranch: Lyndon's Assessment." *Progressive Architecture* (February 1993): 94–95.

———. "Sea Ranch: The Process of Design," quoted from John Donat, ed., *World Architecture 2.* London: Studio Vista Ltd., 1965: 31-39.

Moore, Charles W. "Sea Ranch: Moore's Home Turf." *Progressive Architecture* (February 1993): 98–99.

Moore, Charles, Gerald Allen, and Donlyn Lyndon. *The Place of Houses.* New York: Holt, Rinehart and Winston, 1974. (Reprinted, Berkeley: University of California Press, 2000.)

Moore, Charles W., Donlyn Lyndon, Patrick Quinn, Sim Van der Ryn, "Towards Making Places." *Landscape* (Autumn 1962): 31-41.

Moore, Charles W., Donlyn Lyndon, William Turnbull, Jr., and Richard Whitaker, Jr. *Houses by MLTW.* Tokyo: A.D.A. EDITA Tokyo Co., Ltd., 1975.

Norberg-Schulz, Christian. *Architecture: Presence, Language, Place.* Milan: Skira Editore S.p.A., 2000.

Platt, Bill. "The Sea Ranch as an Intentional Community." *Ridge Review* 3, no. 3 (Fall 1983): 13-20.

Plummer, Henry. *The Potential House.* Tokyo: a+u Publishing Co., Ltd., 1989.

The Sea Ranch Association. *The Sea Ranch Comprehensive Environmental Plan,* April 1996.

Sexton, Richard. *Parallel Utopias: Sea Ranch and Seaside: The Quest for Community.* San Francisco: Chronicle Books, 1995.

Stout, William; Dung Ngo; and Lauri Puchall, eds. *William Turnbull, Jr. Buildings in the Landscape.* San Francisco: William Stout Publishers, 2000.

Janann Strand, "Self-Guided Architecture Design Tour," in *Soundings*, The Sea Ranch Association, 1984.

Summerson, John. *Heavenly Mansions.* New York: W.W. Norton & Company, 1963.

Turnbull, William, Jr. *Global Architecture MLTW/Charles W. Moore and William Turnbull, Jr. The Sea Ranch, California, 1966.* Tokyo: A.D.A. EDITA Tokyo Co., Ltd., 1970.

———. *Global Architecture Detail MLTW/Moore, Lyndon, Turnbull and Whitaker The Sea Ranch Condominium and Athletic Club #1 and #2.* Tokyo: A.D.A. EDITA Tokyo Co., Ltd., 1976.

Wayne, Kathryn M. and John V. Maciuika. *The Sea Ranch.* Bibliography #307. Chicago, Ill.: Council of Planning Librarians, 1994.

Whitaker, Richard R. "House in Sea Ranch." *Global Architecture Houses* (October 10, 1980): 66–69.

INDEX

Page numbers in italic indicate that the subject is illustrated. Entries in italics indicate title of publication.

A

Adam, Robert, 129
Aedicule, 42, 130, 272
Agora Architects, 82
AIA Honor Award for Design (1990), 117
Altes House. *See* Cottage Two
Anderson, Edgar, 235
Anderson House, *227, 234–237*, 300
Annapolis, 13
Architecture: Presence, Language, Place, 42
Athletic Center, Moonraker. *See also* Moonraker
 Athletic Center, *68–71*
Awards, 298–300

B

Baas-Walrod House, *257, 274–279*, 300
Baja California, 23
Balcony, 219, 220, 224, 137, *138*
Bane, Tom, 30
Bane Bill, 30, 74, 121
Barn. *See also* Car barn; Knipp-Stengel Barn
 83, 93
Barnacle. *See* Binker Barns
Barnacle Barn House, *200–201*, 299
Barn door(s), 138
Baskin, Leonard, 289
Bay Area architects, 23
Bay window(s). *See also* Window(s)
 39, 83, 123, 203
Beamed roof(s), 40, 275
Beebe, Tina, 246, 247, 248, 276, 281, 282
Bertram/Holley, 110
Big Sur Inn, 40
Bihler's Point, 35, 36, 40, 45, 49, 51, 83, 85
Bill of 1980, 30
Binker, Snap, 197
Binker Barns, *186, 187, 196–197, 201*
Bishop pines, 287, 289
Black Point, 13, 36, 55, 59, 63, 83, 142, 167, 243, 244
Bodega Bay, 35
Boeke, Alfred, 19, 23, 25, 26, 29, 32, 36, 82, 83, 105,
 275, 287
Boston Museum of Fine Arts, 130
Bowman, Obie, 96, 97, 99, 100, 102, 121, 127, 158, 159,
 197, 238
Boyd House, *229, 250–253*, 300
Breaker Reach, 159
Brodie House, 143, *188, 218–221*

Brunsell House, *146, 158–161*, 299, 300
Burbank Housing Inc. (Santa Rosa), 115, 117
Burbank Village. *See* Employee Housing
Burdick House, 143, *188, 210–213*, 300
Buyer market, 26

C

Cairo Museum, 131
California, 29, 131, 156
California coast, northern, 13, 42
Californians Organized to Acquire Access to State
 Tidelands (COAST), 29
Canty, Donald, 23
Car barn, 105, *199*
Car court, 137, 155, 164, *228*, 235, 276
Carpenter, Tim, 92, 250, 262
Carson, Rachel, 29
Castle & Cook, 23, 29
Caygill House, *255, 258–261*, 300
CC&Rs. *See* "Declaration of covenants, conditions,
 and restrictions" (CC&Rs)
Centerbrook, 51
Chambers for a Memory Palace, 51, 192, 195
Chimney, *186*, 203
Chinquapin Lane, 199
Church, Thomas, 23
Clayton House, *228, 238–241*, 300
Cliffs, 13, 260, 271, 287, *289*
Cluster Houses on White Fir Wood, *104–107*
COAST. *See* Californians Organized to Acquire Access
 to State Tidelands (COAST)
Coastline Alliance, 29
Columbia town, 23
Comet Studios, 155, 176
Commercial buildings, 81
Community events, 14
Compounds and clusters, 80–81
Condominium One, 29, *37–43*, 81, 93, 105, 116, 127,
 141, 142, 176, 194, 197, 276, 298
Condominium One/Unit Eight, *48–49*, 298
Condominium One/Unit Nine, *50–53*, 298
Condominium One/Unit One, *44–47*, 298
Construction, Employee Housing, 116
Cooke, Tim, 166
Cooperative engagements, 14
Corn Lily Road, 121
Corrugated plastic, 89
Cost
 of Employee Housing, 116
 of houses, 121
Cotati, town of, 29
Cottages, 81, *120–121*
Cottage Three, *121–122*
Cottage Two, *122–125*, 299
Court, 51, 142, 155, 159, 167, *172*, 230, 231, *239, 250,*
 251
Courtyard(s), 63, 109, 243, *245*, 251, *266, 267–268*
Crane-Murray and Benz House. *See* Barnacle Barn
 House
Creeks, 14, 75
Cul-de-sac, 171, 175, 247
Culvahouse, Tim, 40, 51
Cypress hedgerows. *See also* Hedgerows, 23, 89
Cypress trees, 36, 63, 65, 74, 93, 127, 137, 147, 167, 182,
 203, 235, 239

D

Day House. *See* Meadow House
Deck(s), 93, 101, 121, 127, 129, 135, 163, 181, 194, 199,
 200, 201, 207, 219, *223, 224*, 231, 240, *241*, 272,
 273, 276, 282

"Declaration of covenants, conditions, and restrictions"
 (CC&Rs), 26, 74, 191
Del Mar Point, 13, 240
Del Mar Point Road, 239
Del Mar Recreation Center, 81, *90–95*, 298
Demonstration Houses. *See also* Hedgerow Houses,
 54–57
 Esherick sketch of, *37*
Department of Forestry's Fire Station, 81
Development, new, 30, 32
Dixon, Brian, 158
Dodge, Peter, 56
Door(s). *See also* Barn door(s); French door(s); Shutter
 door(s); Sliding door(s); Swinging door(s)
 Baas Walrod House, 276
 Clayton House, 239
 glass, of Halprin House, 282, *283*
 glass, of Wendel-Lyndon House, 137
 glass-paneled, of Maslach-Zimbardo House,
 162, 163
 glazed, of The Sea Ranch Lodge, 83, *87*
Dormer, 55, 59, *122*, 123, 211, 223, 243, 244
Douglas fir, 201, 252
 boards, 172
 cabinets and Corian counters, 236
 kitchen cabinets, *194*
 rafters and trusses, *236, 237*
 structure, *137*
 wood frame, *176*
 wood walls, *135*
Ducal Palace, Urbino, 129
Dwelling clusters, Employee Housing, 115

E

Earth berms, *37*, 69, *146*
Ecological planning, 25
EHDD. *See* Esherick, Homsey, Dodge, and Davis (EHDD)
Ekman, Ken, 230
Ellsworth, William Scott, 170, 172
Elmer, Jorgen, 167
Emke, Helmut, 170, 206, 214
Employee Housing, 81, *114–119*, 299
Employees, lower-income, 117
Environment, houses that connect and, 141, *144–149*
Environmentalists, against The Sea Ranch plan, 29–30
Environmental plan
 of 1990, 32
 comprehensive, 75
 of the Cottages, 121
 of Employee Housing, 117
 The Sea Ranch, 76–77
Esherick, Homsey, Dodge, and Davis (EHDD), 162, 242
Esherick, Joseph, 23, 25, 35, 39, 56, 59, 65, 83, 127,
 163, 243, 264
Esherick Demonstration Houses. *See* Demonstration
 Houses, Hedgerow Houses
Esherick House, *64–67*, 142, 298
Evolutions, The Sea Ranch, 22–33
Ewry House, *147, 166–169*, 299

F

Fence(s), 55, 137, 175, *200*, 201
Findley, Lisa, 40, 51
Fire prevention, 75
Fort Ross, 13, 26, 40, 129, 268, 287
Four-poster, 42, *43, 50*, 51, 45, *47*
Franklin House. *See* McKenzie House
Frank Lloyd Wright, 156
Fredrickson, Rich, 180, 218
French door(s). *See also* Door(s), 130, *132*, 175, *179*,
 181, *183*, 194, 235

G

Gabled forms, *116*, 121, 123, 134, 174, 211, *219, 227, 234*,
 235, 251, 260, *267*
Galleon's Reach, 215
Garden(s), 63, 75, 83, 93, *95*, 164, 176, 211, 215, 248,
 249, 260, 215
Gazebo, 191
Gilbert House, *189, 222–225*, 300
Glasses, tinted, 40
Goodman-King House. *See* Whitaker/Ekman House
Grazing of land, 19, 25, 73
Griffin, Mary, 251
Gropius, Walter, 23
Gualala River, 13, *15*, 29, 75, *83*, 287

H

Haesloop, Eric, *251*
Halcyon Road, 93
Halley, John, 154, 155, 176
Halley, Richard, 154, 155, 156
Halley, Sonia, 155
Halley House, *146, 154–157*, 299
Halprin, Anna, 281, 287, 289, 291
Halprin, Lawrence, 19, 23, 25, 27, 29, 30, 32, 35, 36, *55,*
 68, 73, 78, 81, 83, 171, 281, 287
 diagram of hedgerows, *24*
 sketch of building form and vegetation, *24*
 sketch of The Sea Ranch, *18*
 map of The Sea Ranch, locational score, *20–21*
Halprin House, *280–285*, 300
Halprin Place, *286–293*
Hamilton, Paul, 150, 151
Hartstock, Robert, 58, 59, 180, 181
Haswell-Mott House. *See* Somers House
Hawaii, 23
Heavenly Mansions, 42
Hedgerow Demonstration Houses, *See* Hedgerow
 Houses
Hedgerow Esherick House. *See* Esherick House
Hedgerow House Four, *62–63*, 298
Hedgerow House One, *58–61*, 298
Hedgerow Houses, 25, 35, *54–67*, 81, 105, 141, 159, 163
Hedgerows. *See also* Cypress hedgerows, 13, 19, 25,
 36, 73, *74,* 75, 78, 83, 89, 93, 115, 127, 129, 130,
 141, 147, 149, 164, 167, 175, 181, 201, 203, 231, 239,
 240, 243, 244
Helm Road, 239
Hetep-heres, 130
Highway 1, 13, 19, 26, 29, 30, 36, 73, 83, 90, 93, 127,
 219, 223, 287
Hike-ins. *See* Walk-in Cabins
Hipped roof, 93, *94*, 185
Hoffman, Rick, 114
Hot Spot, 13, 75
House & Garden magazine, 25
House(s)
 groupings of, *14*
 number of, 29
 of The Sea Ranch, 140, 141–143
 in The Sea Ranch Community, 13
 sizes of, 30
Houses that connect, *144–183*
Houses that enfold, 141, 142, *226–253*
Houses that inhabit, 141, 142, *254–279*
Houses that settle, 141, *184–225*
Houses that suit their place, *140*, 141–143
Housing, Employee, *114–119*
Housing clusters, 25

I

Iconografico Campi Martii, 129
Images that Motivate, in *Chambers for a Memory Palace*, 51
Income
 employees of lower, 117
 housing for different groups of, 121

J

Jackson, Ralph, 166, 242
Jacobs, Donald, 166, 167, 181, 206
Jenner, town of, 26
Johnson, Reverdy, 36, 190
Johnson House, *185, 190–195*, 231, 299
Jones House. *See* Hedgerow House Four
Joseph Esherick & Associates, 35, 36, 58, 62, 64

K

Kahn, Louis, 40
Keller House. *See* Rush House
Kirkwood Houses, *145, 150–153*, 159, 299
Knight's Valley, 1991
Knipp-Stengel Barn, 40, 81, 89, 90, *91*, 105
Krysti, Seryozha, 190

L

Lake Tahoe, 151
Land
 and the Cottages, 121
 and sea, 13
Landscape, 30, 32
 development, 12–17
 houses and inner, 142
 Houses that settle and, 141–142
 management, 72–79
Landscaping restrictions, 26
Le Corbusier's Ozenfant studio, 130
Levin, Daniel, 214, 215
Lichter-Marck House, *143, 257, 270–273*, 300
Light. *See also* Sun light, 40, 42, 49, 155, 156, 164, 194, 197, 231, 252, 259, 272, 276
Lightbody, Bruce, 210
Littlejohn, David, 192, 195
Loft(s), *49*, 59, 109, 112, 123, *125*, 155, *164*, 194, 203, 271, 282
Lots
 number of, 29
 prices of, 26, 30
 sizes of, 30
 sold, number of, 30
Louvers, 40, 160
Lyndon, Donlyn, 23, 26, 131, 174, 204
Lyndon/Buchanan Associates, 127, 128, 134, 136, 174, 270
LyndonDesign, 137
Lyndon-Wingwall House, 127, *128–134*, 299

M

Madrone Meadow, 80, 105
Malibu Wall, 287
Management, landscape. *See* Landscape
Marin County, 291
Maslach-Zimbardo House, *147, 162–166*, 299
Matheny, Don, 210, 238
Matthew Sylvia's lumberyard and hardware store, 81
Mattson House. *See* Wilde House
McKenzie House, *149, 174–179*, 181, 299
McLane, Louis, 82
McNaughton, Malcolm, 29
Meadow House, *126, 134–135*, 299

Meadows, 13, 19, 23, 25, 26, 36, 55, 63, 65, 73, 75, 78, 93, 109, 111, 121, 127, 129, 130, 135, 137, 142, 147, 155, 156, 159, 163, 175, 182, 194, 201, 203, 215, 244, 247, 268, 282
Mendelson, Eric, 264
Mendocino counties, 13
Michael House, *147, 170–174*, 299
Miglio House, *256, 266–269*, 300
Mililani, 23
Miller Ridge, 13
MLTW. *See* Moore, Lyndon, Turnbull, & Whitaker (MLTW)
Modernism, 25
Monterey Peninsula, 248
Moonraker Athletic Center, 36, *37, 68–71*, 93, 298
Moore, Charles, 23, 25, 35, 36, 51, 129, 131, 159, 190, 192, 195, 197, 204, 236, 247, 248, 266, 267, 268, 276, 281, 287, 296
Moore, Lyndon, Turnbull, & Whitaker (MLTW), 23, 25, 35, 38, 44, 48, 50, 68, 88, 108, 110, 190, 196, 198, 200, 202, 231, 258, 259, 264
Moore, Ruble, Yudell, 51, 246, 248, 274, 280, 281
Moore Andersson (Austin), 51
Morreau, Patrick, 40
Moss garden, 229, 248, *249*
Myrtles, 127, 129, 135, 137, 219

N

Nader, Ralph, 29
New Haven, 51
Nineteenth century, 19, 73, 129
Non-residential buildings, 81
Norberg-Schulz, Christian, 42
North Central Coast Commission, 29
North Coast, 23
North Recreation Center. *See* Ohlson Recreation Center

O

Oceanic Properties, 19, 23, 26, 29, 30, 32, 35, 39, 73, 81, 105, 121, 191
Offices, The Sea Ranch Lodge, 83
Ohlson Brothers, 19, 23
Ohlson Ranch, 287
Ohlson Recreation Center, 81, *88–91*, 93, 298
One-eyed Jack, 231
O'Neill, Fiona, 81, 120, 121, 122, 123, 200
Origins, The Sea Ranch, 22–33
Owings-Perdue. *See* Shinefield House

P

Park House, *198–199*, 299
Partridge-Martin House. *See* Michael House
Pavilion, 191
Pebble Beach, 13
Petaluma Valley, 40
Plan libre, 42
Planning, 29
 of Condominium One, 42
 environmentalists against the, 29–30
 of Hedgerow Houses, 55
 of the Sea Ranch, 18–21
Plans
 of Cottages, *121*
 for extension of the lodge, 81
 of Walk-in Cabins, 97
Plantings, highway and properties, 73, 74
Plexiglas, corrugated, 69
Plummer, Henry, 42, 51
Pomo Indian Reservation, 13
Pomo Indians, 23

Pomos, 19
Pool(s), *88*, 89, 93, *94*, 207
Population, 13, 30
Porch(es), 42, 45, *65*, 83, 93, 103, 116, 121, *200*, 201, *234*, 235, 247, *274, 275*
Posh Squash Community Gardens, *14*
Post office, 83
Privacy, 56
Professional Consulting Group, 75
Progressive Architecture, 56
Project credits, 298–300
Proposition 20, 29

R

Rancho Del Mar, 19, 23, 93
Rasmussen House, 127, *187, 214–217*, 300
Rathmill, George, 111
Rathmill House. *See* White Fir Wood Cluster/Unit Eighteen
Redwood boards, 40, 55, *83*, 97, *116, 121, 127, 172*, 191, *194*
Redwoods, 23, 26, 42, 45, 129, *197*, 263, 276
Renewal, 30, 32
Reynolds, Richard, 25, 35
Richardson, Jack, 92, 280
Roller shades, 40
Roof(s). *See* Beamed roof(s); Gabled forms; Sloping roof(s); Sod roof(s)
Rouse, James, 23
Rowley, George, 51
Rush House, *186, 202–205*, 300
Ryans House. *See* Hedgerow Esherick House
Ryoanji temple, 248

S

Saihoji temple, 248
Sales campaign, 26
Salt Point State Park, 29
San Andreas Fault, 13
San Francisco Bay Area, 13, 26
Santa Rosa, 26
Scammons Lagoon, 291
Schneider House, *228, 242–245*, 300
Scott Construction Inc., 198, 222
Sculpture Point, 271
Sea Gate Road, 127, 135, 159
Sea Gate Row, 81, *126–139*
Sea Lion Road, 172
Sea Ranch community, 13
Sea Ranch Ventures, 120, 121, 122
Sharples House. *See* Brunsell House
Shinefield House, 159, *296–297*
Shingle hut, 191
Shingles, 55, 69, 83, *163*. *See also* Wood shingles
Shoji screens, 121, 123, 263, *265*
Shutter door(s). *See also* Door(s)
 Whitaker/Ekman House, *230*, 231
Siding
 board, *103*, 121
 board redwood, *127, 210*, 211
 cedar, *207*
 redwood, *88*, 89
 wood, *101*
 wood-board, 35
Sierra Club, 29
Silhouette, 163, 171, 185, 186, 239, 240
Simon, Phil, 238
Size, Johnson's House, 192
Skidmore Owings & Merrill, 23, 167
Skylight(s), *49*, 59, 111, *112, 113*, 130, *135, 160*, 175, 191, 192, *193*, 219, 227, *230*, 231, 240, 252, 259, 260, 263, *272*

Sliding door(s). *See also* Door(s), 49, 59, 63, 111, 129, 138, 151, 160, 162, 164, 167, 207, 211, 231, 249, 268, 275
Sloping roof(s), 56, *57, 110*, 111, 112, *134*, 135, *146, 171, 180*, 181, *190*, 191, 192, *238*, 239
Smith, Loren, 289
Smith, Ted, 32, 92, 93
Smith, Steve, 190
Smuggler's Cove, 13, 211
Social network, 14
Sod roof(s), *55*, 56, *145, 146*, 151, 152, *153, 154*, 155, *158*, 159, 160
Solarium, 83, 146, 155, *157*
Somers House, *149, 180–183*, 299
Sonoma coast, 13, 35, 192
Sonoma County, 25, 26, 29, 117
Sonoma Land Trust, 207
Soundings, 26
Stauffacher, Barbara, 36, 68, 69
Stewarts Point, 13, 287
Stockade, Condominium One, 40
Store
 The Sea Ranch, Esherick sketch of, *37*
 The Sea Ranch Lodge, *83*
Strand, Janann, 197
Strand House. *See* Walk-in Cabins/Unit Fifty-Two
Stratford Hall, Virginia, 203
Structure
 Condominium One, 39–42
Studiolo, 129
Subsidized housing, 117
Summerson, Sir John, 42
Sun light. *See also* Light, 130, 135, 137, 138
Sun-shaded windows. *See also* Window(s)
 Kirkwood House, 145
Sunshades, 40
Supergraphics, 69, *70, 71*
Swim/Tennis Facility #1. *See* Moonraker Athletic Center
Swinging door(s), 164. *See also* Door(s)
Sylvia, Matthew, 38, 44, 48, 50, 58, 62, 64, 68, 82, 88, 102, 108, 114, 116, 128, 130, 134, 136, 174, 190, 191, 196, 197, 198, 200, 202, 230, 234, 258, 270, 274, 281, 287, 289, 296

T

Taubold, Tim, 266
Telviot Springs, 191
Tennis court, Del Mar Center, 93
Tents, 130–131
Terrace, 160, 207, 215, 264
Terrain, preservation and evolution of, 19
Teviot Springs, *235*
The Life and Work of Charles W. Moore, 195
The Place of Houses, 51
The Sea Ranch, 12, 14–17
 aerial view of open fields and hedgerows, *24*
 designing for a place at, 295–296
 environmentalists against the plan of, 29–30
 first buildings, *34–36*
 founding vision of, 18–21
 guiding principles of, 72–78
 Halprin diagram of hedgerows, *24*
 Halprin sketch of build form and vegetation, *24*
 houses of, 140–143
 kite view of forest, meadow, and houses, *24*
 nature and the, 287
 origins, evolutions, and ironies of, 22–33
 planning of, 80–81
 renewal and new development of, 30, 32
 the site, 12–17

topographic map, 18, *20–21*
map of, *76–77*
The Sea Ranch Airport, 275
The Sea Ranch Association, 13, 14, 26, 29, 30, 32, 74,
 75, 81, 89, 90, 115, 207
The Sea Ranch Lodge, *82–87,* 298
The Sea Ranch Lodge and Village LLC, 83
The Sea Ranch Store, 36, 298
The Sea Ranch Thespians, 14, 90
The Sea Ranch Village Inc., 32
The Spaniards Introduce Palm Trees to Santa Catalina
 Island, 129, 130
Three-dimensional model, 39, 130
Timothy Carpenter, 174
T/K Associates, 99, 100
Tokonoma, 263
Topographic map, The Sea Ranch, *18, 20–21*
Total Concepts, 150
Towards Making Places, 227
Tower(s), *88, 89, 90,* 141, 142, *267*
Trails/system, 13, *22,* 30, 201, 235
Transfer Site, 121
Tunnard, Christopher, 23
Turnbull, Griffin, Haesloop, 234, 250, 252
Turnbull, William, 23, 25, 29, 32, 36, 81, 89, 105, 111, 115,
 116, 117, 186, 190, 192, 197, 203, 204, 235, 251,
 252, 281, 287, 289
Types, Employee Housing, *115,* 116, 117

U

UCLA Urban Innovations Group, 51, 266
Utilities, 30, 73

V

Vaughn, Leland "Punk," 287
Vedensky, Dmitri, 159, 262, 264, 296
Vedensky House, *256, 262–265,* 300
Vegetation, 115, 211, 223, 276
View preservation, 75, 78
Volunteer growth, landscape and, 74, 75
Voorhees House. *See* Walk-in Cabins/Unit Fifty-Three

W

Walk-in Cabins, 80, *96–102,* 197, 298
Walk-in Cabins/Unit Fifty-three, *102–103,* 298
Walk-in Cabins/Unit Fifty-Two, *100–101,* 298
Walk-in units, 81
Walk-On Beach, 13, 163
Wall(s)
 Brunsell House, 160
 Condominium One/Unit Eight, 49
 Employee Housing, 116
 Hedgerow House One, 59
 Meadow House, 135
 Ohlson Recreation Center, 89
White Fir Wood Cluster/Unit Four frames, 109
Weathered walls, 13
Weingarten brothers, 51
Wendel-Lyndon House, 127, *136–140,* 299
Whitaker, Richard, 23, 35, 230, 231, 264
Whitaker/Ekman House, *227, 230–233,* 300
Whitaker House. *See* Vedensky House
White Fir Wood, 80, 105
White Fir Wood Cluster/Unit Eighteen, *110–113,* 298
White Fir Wood Cluster/Unit Four, *108–109,* 298
Wiemeyer, William, 75, 78
Wilde House, *187, 206–209,* 300
Wildlife, 281
William Turnbull Associates, 114, 234. *See also* Turnbull,
 William

Window(s). *See also* Bay window(s); Sun-shaded win-
 dows, 85, 87, 111, *116, 121, 122,* 123, 127, *128,*
 130, *192, 162,* 164, 172, *173,* 175, *178, 198,* 199,
 207, *209, 224, 235, 246, 247, 260, 276, 282*
Winds, northwest, 135
Wind shadow, 56
Wingwall, Alice, 45, 129, 131
Wood shingles, 40, 83. *See also* Shingles
Wood stud framing, 97
Workshop(s)
 community, 78
 Park Barn House, 199
Wendel-Lyndon House, 137
World Architecture, 51
Wurster, William, 264

Y

Yudell, Buzz, 246, 281, 291
Yudell-Beebe House, 127, *229, 246–249,* 300
Yuen House. *See* White Fir Wood Cluster/Unit Four

304

CONTRIBUTORS

DONLYN LYNDON was one of the founding partners of MLTW, which won international recognition for the Condominium Number One at The Sea Ranch. He has practiced in Massachusetts and California, and designed several houses at The Sea Ranch. Lyndon has written extensively on architecture, landscape, and urban design, and is the editor of the journal *Places*. He has been recognized as one of the foremost educators in the country, receiving the ACSA/AIA Topaz Award in 1997. He is now the Eva Li Professor of Architecture at the University of California, Berkeley, and taught previously at the Massachusetts Institute of Technology and the University of Oregon.

JIM ALINDER is a world-renowned fine arts photographer who worked with Ansel Adams and whose images are in many museums, including New York and San Francisco's Museums of Modern Art. His images have been reproduced in numerous publications, including *Aperture, History of Photography, Progressive Architecture, Places, Artforum, American Photographer, Popular Photography*, and *Creative Camera*. Alinder has twice been honored with photographer's fellowships from the National Endowment for the Arts, Washington, D.C., as well as one from the Woods Foundation, Chicago. He currently lives and works at The Sea Ranch.

DONALD CANTY has written extensively on architecture, planning, and environmental change. He is former editor-in-chief of *Architecture* magazine, and was founder and editor of *City* magazine, managing editor for *Architectural Forum*, and editor of *Western Architect and Engineer*. His books include *A Single Society: Alternatives to Apartheid in America* and *The New City: A Blueprint for a National Urban Growth Policy*. He is presently architecture critic for the *Seattle Post Intelligence*.

LAWRENCE HALPRIN is one of the world's leading landscape architects and environmental planners, whose work includes, among other projects, the San Francisco Ghirardelli Square and the Franklin Delano Roosevelt Memorial in Washington, D.C. Among the numerous awards he has received are the Thomas Jefferson Medal in Architecture and the Gold Medal for Distinguished Achievement awarded by the American Institute of Architects. He has received honorary doctorates from the University of Pennsylvania and the California College of Arts and Crafts. More recently, Halprin has been awarded the 2002 National Medal of Arts by the president of the United States for his lifelong commitment to the field of landscape architecture, as well as the 2002 Teddy Kollek Award, given in recognition of his longstanding contribution to the landscape and views of Jerusalem. Lawrence Halprin currently lives and works in the San Francisco Bay Area.